HAROLD E. WETHEY

THE PAINTINGS OF TITIAN

I. THE RELIGIOUS PAINTINGS

Frontispiece:

Madonna and Child with St. Catherine. Detail from Plate 35.

London, National Gallery

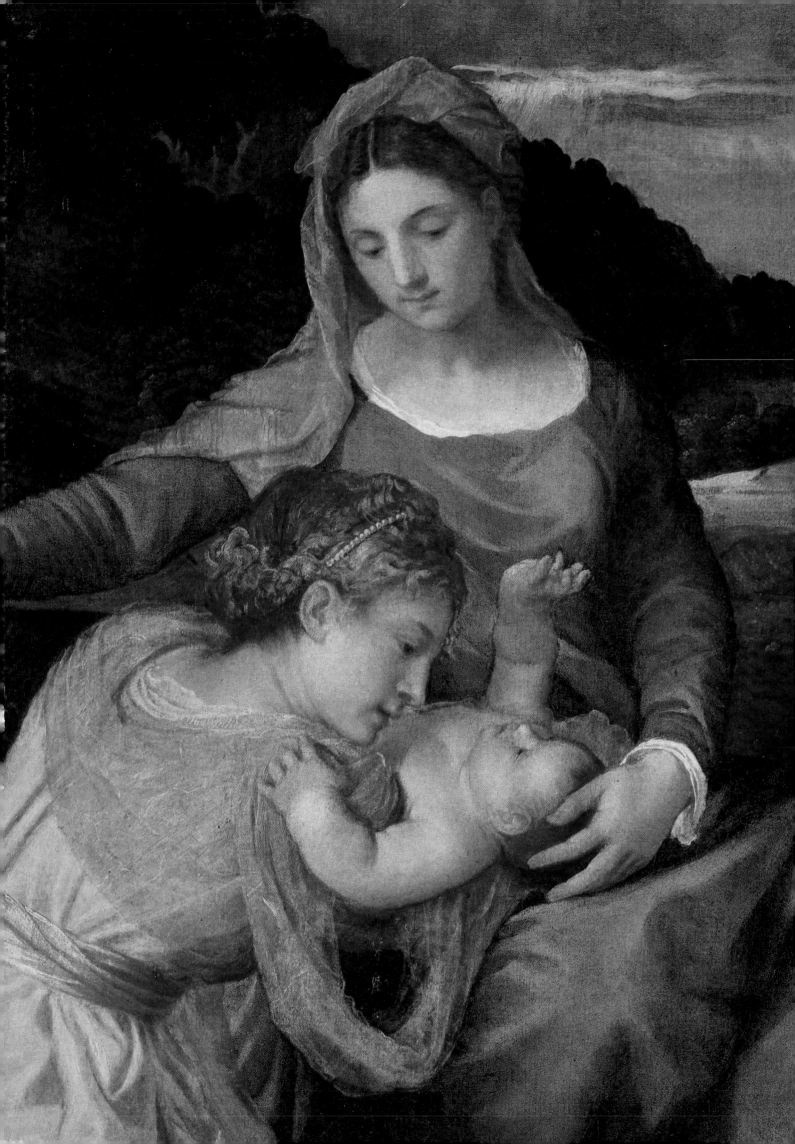

THE PAINTINGS OF

TITIAN

COMPLETE EDITION
BY HAROLD E · WETHEY

I · THE RELIGIOUS PAINTINGS

PHAIDON

© 1969 PHAIDON PRESS LTD · 5 CROMWELL PLACE · LONDON SW7

PHAIDON PUBLISHERS INC · NEW YORK

DISTRIBUTORS IN THE UNITED STATES: FREDERICK A. PRAEGER · INC

III FOURTH AVENUE · NEW YORK · N.Y. 10003

LIBRARY OF CONGRESS CATALOG CARD NUMBER: 73–81197

SBN 7148 1393 1

MADE IN GREAT BRITAIN

TEXT PRINTED BY THE UNIVERSITY PRESS · ABERDEEN

PLATES PRINTED BY R. AND R. CLARK LTD · EDINBURGH

CONTENTS

PREFACE VII

INTRODUCTION I

Titian and the Critics: page 1—Titian's Youth: page 7—
Titian and Giorgione: page 8—Early Independent
Commissions: page 9—Titian's Personal Life: page 13—
Titian and Central Italian Art: page 17—Titian and
Charles V: page 21—Titian and the Gonzaga of Mantua:
page 23—Titian and His Contemporaries 1535–1545:
page 25—Titian in Rome: page 28—Journeys to Augsburg
and Milan: page 31—Late Years in Venice: page 32—
Titian's Late Style and Technique: page 34
APPENDIX: The Date of Titian's Birth: page 40

BIBLIOGRAPHY 43

CATALOGUE RAISONNÉ 63

PLATES 181

INDEX 375

PREFACE

THE bibliography devoted to a great master of Titian's stature is abundant yet by no means exhaustive. In only one monograph, the *Life and Times of Titian* by Crowe and Cavalcaselle (1877), was an attempt made to include all known versions of every subject and to pass judgment on the quality and attribution of each. Most later books on the artist have been limited to selections from his works, especially that of Hans Tietze (1936), who primarily concerned himself with development of style in accordance with the German art-historical traditions of the earlier twentieth century. Although Tietze had less interest in historical problems, connoisseurship was to him a serious matter. William Suida (1935), on the other hand, represented the optimist in matters of attribution and added many pictures of mediocre quality to the previously cleansed lists of Crowe and Cavalcaselle and Bernard Berenson. The most restrictive regarding attributions were Theodor Hetzer's articles, in which the author excluded with obstinate subjectiveness many signed and well-documented canvases. Even Berenson passed over a number of fully authenticated masterpieces in the Spanish royal collections, which were damaged by the Escorial fire of 1671 and by the incendiary destruction of the Royal Palace at Madrid in 1734. The fullest of recent monographs is that of Francesco Valcanover (1960), where all major works are cited, even if in a somewhat abbreviated form because of the nature of the series in which his two volumes appeared.

My present monograph on Titian with catalogue raisonné is projected in three volumes: the first devoted to the *Religious Paintings*, to be followed by *Portraits* and completed by *Mythological and Historical Paintings*. My purpose in the present volume is to bring together in alphabetical arrangement by subject all paintings of religious themes. In the case of the Madonnas, St. Jerome, St. Mary Magdalen, and others, several originals by Titian as well as some workshop replicas and copies are grouped together to make the relationships as clear as possible. For example, the Magdalen and Salome, being among Titian's most popular pictures, exist in many replicas which were produced in the centuries following the artist's death, a fact that is further commented upon in the Introduction in the section 'Titian and the Critics'. For convenience catalogue numbers have been assigned to a few workshop pieces and to certain famous lost pictures such as the *Magdalen* and the *Salome* once in the collection of Queen Christina of Sweden.

The arrangement of the illustrations is also iconographical, beginning with the *Madonna and Child* and followed by the *Madonna and Child and Saints*, wherein the order remains partially chronological but is calculated to bring related compositions on opposite or successive pages. Themes such as the *Annunciation, Adoration of the Kings, St. Jerome, St. Lawrence,* and the *Magdalen* are likewise ordered together to permit visual comparisons of style and quality as well as to show Titian's method of treating the same theme in different periods. The major groups of illustrations, indicated by title pages, comprise the *Madonna, Life of Christ, Old Testament Subjects* and *Saints*.

In preparing a monograph of the present scope the author's debts to others are many. First of all my wife, Dr. Alice Sunderland Wethey, has typed the manuscript through several stages and versions, has aided in reading the proofs and in preparing the index, and has assisted in bibliographical work in European libraries. To the staffs of several institutions I am very grateful, in particular to Miss Steinbart and Mrs. Sanger of the Frick Art Reference Library and to Dr. Alessandro Contini-Bonacossi of the Kress Foundation in New York, as well as to the Hertziana Library, the Istituto d'Arte e d'Archeologia, the American Academy, and the Biblioteca Apostolica Vaticana, all in Rome. In Venice the Istituto Correr, the Fondazione Cini, and the latter's director Dr. Alessandro Bettagno have made my research easier. Dr. Friderike Klauner of the Kunsthistorisches Museum at Vienna and Dr. Robert Oertel, formerly curator of the Alte Pinakothek in Munich, now director of the Staatliche Gemäldegalerie in Berlin, permitted me to study school pieces kept in storage. I have repeatedly consulted the collection of English sales catalogues as well as the Witt photograph collection at the Courtauld Institute in London, where both the staff and Sir Anthony Blunt have graciously granted me every facility. An old friend, Mrs. Enriqueta Harris Frankfort of the Warburg Institute, has alerted me to developments on the English scene. Ellis K. Waterhouse of the Barber Institute at Birmingham with his characteristic generosity has helped me untangle some of the mysteries of British collections and British sales catalogues, on which he is the leading authority. Stephen Rees-Jones of the Courtauld Institute and Meryl Johnson of the University of Michigan kindly read the pages devoted to Titian's late style and technique.

In Spain Dr. Juan Ainaud de Lasarte and Señorita Aurora Casanovas of the Barcelona Museums gave me assistance on problems connected with prints after Titian's works. At the Escorial Padre Gregorio de Andrés, head librarian, showed a scholar's interest in my research. In Madrid at the Prado Museum Dr. Xavier de Salas has always been helpful in his usual friendly manner, and Dr. Annie Cloulas supplied me with copies of her important publication of Titian letters from the National Archives at Simancas.

A generous grant from the American Council of Learned Societies was awarded in connection with my sabbatical year spent in Italy in 1963–1964. The Rackham School of Graduate Studies of the University of Michigan also provided travel grants in 1964, 1966, and 1968. To colleagues and to graduate students who have taken my seminars on Titian I owe much in the matter of intellectual stimulation. Among colleagues in other institutions, Dr. Juergen Schulz of Brown University, who recently published his highly significant work, *Venetian Painted Ceilings of the Renaissance*, and Dr. Maurice Cope of Ohio State University have supplied valuable data. Finally Mrs. Fern R. Shapley, formerly of the National Gallery in Washington, now with the Kress Foundation, has shared with me her profound knowledge of Titian and Italian Renaissance painting. Too numerous to cite are the collectors and museum personnel whose assistance made it possible for me to complete my project.

Rome, 1 October 1968 HAROLD E. WETHEY

INTRODUCTION

TITIAN AND THE CRITICS

TITIAN enjoyed the rare fortune of being recognized as a great master early in his career, as soon as 1518, when he unveiled his epoch-making work, the *Assumption* (Plates 18–22) of the Frari. The great demand for his services at that time, involving the series of mythological pictures of the Alabaster Room in the d'Este Castle at Ferrara,[1] the subsequent commissions for the Gonzaga at Mantua, and his success in portraying Charles V from the time of his coronation at Bologna in 1530,[2] reflect the great esteem in which the artist was held. Most lavish in his praise was the celebrated writer, Pietro Aretino, from the period that he settled at Venice in 1527 until his death twenty-nine years later. To be sure, the two men became close friends, and Aretino acted virtually as a press agent, yet his great admiration for the artist was genuine, and the famous letter-writer had no need to invent preposterous stories in the style of twentieth-century advertisers. The 'divine Titian' Aretino repeatedly called him. When in a letter of 1537 he praised the *Martyrdom of St. Peter Martyr* (Plate 154), singling out the beauty of the cherubs, he wrote still more extensively of the dramatic action.[3] As a writer and a man of the sixteenth century, he was given to some literary effusion with effects for their own sake; nevertheless, in his description of the *Annunciation* (Plate 59) presented to the Empress Isabella in 1537, he touched upon the beauty of colour and landscape as well as upon the emotional implications of the subject.[4] His most celebrated passage is perhaps the description of the Grand Canal at sunset, which concludes with the regret that Titian was not there to paint the scene.[5] On one occasion he complained somewhat angrily about his own portrait which Titian had painted, saying that it was more sketched than finished, a rather amusing and highly human reaction,[6] for rare is the man who is pleased with his own likeness. However, the 'divine Titian', the greatest colourist, was without equal and even superior to Michelangelo, so states Aretino in the *Dialogo della pittura* of Lodovico Dolce (1557), in which Pietro Aretino and Giovanni Francesco Fabrini, a Tuscan grammarian, carry on the dialogue according to the literary convention of the Renaissance.[7] Here the opinions expressed are those of Aretino himself as well as Dolce's.

Even the Florentines spoke of Titian with great praise: 'particularly he was most excellent in portraits', says Borghini in 1584, but the writer also lauds the mythological pictures at Ferrara and

1. 1518–1523, see Walker, 1956. The mythological pictures will be studied in volume III of the present work.

2. Volume II will contain Titian's portraits. The letter of Leonardi dated 18 March 1530 to Francesco Maria della Rovere states that Charles V has been slandered by the story that he paid Titian only one ducat for the portrait of his majesty (Gronau, 1904, p. 13). This letter proves that Titian did paint the emperor's portrait in 1530 and that Crowe and Cavalcaselle were mistaken in denying the fact (C. and C., 1877, I, pp. 366–367).

3. Aretino, *Lettere*, edition 1957, I, p. 73.

4. *Loc. cit.*, I, pp. 78–79.

5. *Loc. cit.*, II, pp. 16–17, letter of 1 May 1544.

6. *Loc. cit.*, II, p. 106. Venice, October 1545, letter to the artist at Rome.

7. Dolce, 1557, edition by Paola Barocchi, 1960, pp. 148, 159, 200, 205, 206, and *passim*. See also Ortolani, 1923, pp. 1–17.

the 'very beautiful' effects of the lights in the *Martyrdom of St. Lawrence* (Plates 178, 179).[8] Giorgio Vasari, himself a painter as well as author of the lives of artists, wrote with great admiration of, among others, the early *Tribute Money* (Plates 67, 68) as 'maravigliosa e stupenda', and of the now lost *Martyrdom of St. Peter Martyr* (Plate 154), which he rated the artist's finest achievement. He singled out the *Christ Crowned with Thorns* now in Paris (Plate 132), the late *Crucifixion* at Ancona (Plates 114, 115), and the *Martyrdom of St. Lawrence* (Plates 178, 179).[9] Vasari believed that Titian and the Venetians in general were remiss in not making numerous preparatory drawings as studies for their pictures. He quoted Sebastiano del Piombo, the Venetian painter transformed at Rome into a follower of Michelangelo, as saying that if Titian had seen the works of Raphael and Michelangelo, as well as the antiques at Rome, he would have made magnificent works ('stupendissime') inasmuch as 'he was the greatest imitator of nature in the matter of colour'. In addition to this anecdote Vasari, in giving an account of Michelangelo's visit to Titian at the Belvedere Palace during his sojourn at Rome in 1545–1546, related that Michelangelo admired Titian's colour and style ('maniera'), although he added that 'it was a pity that at Venice they did not learn at the outset to draw well'. The picture that called forth this opinion was the *Danae* now in Naples, in which it is generally agreed that the Venetian paid more attention to solidity and structure of the nude body than was his wont; but all things are relative. In the mind of the sculptor-painter Michelangelo, strong design and the sculpturesque volume and weight of body were paramount.

Italian writers of the later sixteenth century lavished superlatives on every aspect of Titian's art, specifically the landscapes, beauty of colour, figures, and the painting of flesh. At a greater distance of time, after the death of the master, judgment having become more objective and less restrained, Lomazzo (1590) was able to declare Titian 'the sun amidst small stars not only among the Italians but all the painters of the world'.[10]

During the seventeenth century Titian's fame increased rather than diminished. The writings are less significant than the numerous replicas of the artist's works by great Baroque masters, above all Rubens, who from his early years in Mantua copied Titian's pictures. Among the most extraordinary are his adaptations of Titian's *Bacchanalia* from the d'Este Castle at Ferrara.[11] Later at the height of his fame, during his second visit to Madrid on a diplomatic mission in 1628, the Fleming is said to have copied all of the pictures by Titian in the Spanish royal collection. Even allowing for some exaggeration in this statement of Francisco Pacheco, himself a painter and the father-in-law of Velázquez,[12] the number of preserved compositions by Rubens after Titian is impressive. Only slightly less an admirer of the Venetian was Anthony van Dyck, as his own original paintings demonstrate, not to speak of his repetitions of Titian.[13]

8. Borghini, 1584, edition 1807, III, pp. 86–91.
9. Vasari (1568)-Milanesi, 1907, VII, pp. 425–469, *passim*.
10. Lomazzo, 1590, edition 1947, pp. 80–81; also further pp. 209–210.
11. For the Ferrara copies at Stockholm, see Walker, 1956, pp. 108–121. Rubens' Inventory after his death in 1640 listed eleven works attributed to Titian as well as approximately twenty-five copies after Titian by Rubens himself.

12. Pacheco, 1638, edition 1956, I, p. 153. See also Müller-Hofstede, 1965 and 1967; a consideration of Rubens' copies of Titian's portraits will appear in volume II of the present publication.
13. Van Dyck's Inventory after death contained nineteen pictures attributed to Titian and four copies by the Fleming himself (Müller-Rostock, 1922, pp. 22–24).

Among the other great non-Italian masters to whom Titian was a major force of inspiration, Poussin in his mythological pictures followed more than anyone else the Venetian's model. On the unchallengeable word of Pietro Bellori, his friend, the French master studied and copied the *Bacchanalia* from Ferrara when they were in the Ludovisi Collection at Rome.[14] More than that, Poussin's colour, the physical types, especially his cherubs, and the landscape settings in numerous compositions, such as the *Death of Narcissus*, *Shepherds in Arcady*, and related works, are Titianesque.[15]

In the early Baroque of the Bolognese school, rising less than a decade after Titian's death, the continuity with the late-Renaissance traditions of Titian and the Venetian school are logical and inescapable, most clearly in the first landscapes of the Carracci and their followers. Francesco Albani reflected the general sentiment of the day in his letters, saying that Venetian art refreshes the intellect and nourishes the desire to use colour in the imitation of the great Titian, whom he also extolled for 'beauty and tenderness'.[16] Throughout the seventeenth century Venetian precedent continued to loom large, also at Rome, where the Ferrara *Bacchanalia*, then still in the Ludovisi Collection prior to their shipment to Spain in 1637, were a fount of inspiration for young artists. Among them was Pietro da Cortona, a great decorator, who, despite his effulgent Baroque style, never forgot the lessons learned from Titian and the Venetians.[17]

Italian critics and historians of the seventeenth century even surpassed their predecessors in their eulogies of Titian. Carlo Ridolfi, author of the lives of the Venetian painters, who dated his preface 25 June 1646, not surprisingly ranks the master as the very greatest and his works as 'the most rare marvels of painting'.[18] Marco Boschini, another Venetian historian and also a poet, in 1674 held the same opinion: 'Titian was in truth the most excellent of all who have painted since his brushes always engendered expressions of life.'[19]

The demands for the artist's paintings continued unabated throughout the Baroque period. The major collectors such as King Charles I of England, the Earl of Arundel, and the Duke of Buckingham, Queen Christina of Sweden, Archduke Leopold Wilhelm of Austria,[20] and the Spanish viceroys in Naples, who collected for themselves and also presented important pictures by Titian to Philip IV, all avidly sought his works.[21] Fewer and fewer authentic masterpieces remained available to collectors, with the inevitable result that more pictures by Titian were painted to fulfil the demand in the seventeenth, eighteenth, and early nineteenth centuries. Early copies,

14. Bellori, 1672, p. 412.
15. See Blunt, 1967, pp. 59, 66, 73, 123-125, 268.
16. Malvasia, 1678, II, pp. 254, 272.
17. Briganti, 1962, pp. 32-33, 68, and passim. Pietro Cortona's copy of Titian's *Madonna and Child with St. Catherine*, then in the Ludovisi Collection, now in London, is reproduced by Briganti, pl. 285, no. 2. See also Cat. no. 59.
18. Carlo Ridolfi, *Le meraviglie dell'arte*, first published in Venice, 1648, edition by Hadeln, Rome, 1914-1924; also photographic reprint, Rome, 1965, I, p. 145. For a full study of Venetian art criticism, see Mary Pittaluga, 1917, 1918, and Ortolani, 1923.
19. Boschini, 1674, edition 1966, p. 711.
20. Francis Haskell, 1963, an important source for Baroque collectors; in my bibliography see Charles I of England, van

der Doort, edition 1960, and Luzio, 1913; for Arundel see Hervey, 1941; see Buckingham Collection; for Queen Christina see Stockholm, 1966; see Leopold Wilhelm.
21. For Spanish collections see Madrazo, 1884, Bottineau 1956 and 1958, Wethey, 1967. Among the most celebrated pictures that changed ownership in the seventeenth century were the *Andrians* and the *Worship of Venus*, both now in the Prado Museum, originally in the d'Este Castle at Ferrara, and subsequently passing to the Aldobrandini under Clement VIII, thereafter to the Ludovisi, who for political reasons sent them in 1637 to the Spanish viceroy at Naples, the Count of Monterrey, as a gift for Philip IV of Spain. See Walker, 1956; Garas, 1967, pp. 288, 343, nos. 29-30.

which may never have been intended to deceive, were understandably mistaken as originals by later generations. Among the painters so misunderstood were Alessandro Varotari (il Padovanino, 1588–1648) and Giuseppe Caletti (1600–1660) of Ferrara, both of whose paintings were sometimes sold as Titian's.[22] Conscious forgeries of Giorgione and Titian were apparently provided by Pietro della Vecchia (1605–1678), whereas Nicholas Regnier (Renieri, 1590–1667), a French Baroque master who lived at Venice, also sometimes catered to the demand by making Titians available.[23] One of the best-publicized cases of a famous master forging Titian and other Venetians was the young Luca Giordano, who, De Dominici tells us, was forced to do so by his father, and besides the pictures were sold to a foreigner Gaspar Roomer, who later forgave the young man![24] Giacomo di Castro, the Neapolitan painter, confirms this in a letter dated 26 January 1664 to a famous Sicilian collector, Antonio Ruffo: 'Here there is no occasion to apply or spend because nothing of quality appears, only some pieces that a certain Luca Giordano forging now Titian and then Paolo Veronese . . . he has done a good job and then he gives an antique tint which does not appear badly to Signore Gaspare nor to many others and merchants; however, it has been discovered'[25]

Although collectors' activities belong to a different category from written criticism, they reflect the taste of the period, and perhaps more accurately than the opinions of a few authors. The reproduction of famous masterpieces in the form of copies has been known since the time of the ancient Greeks and Romans. Even great collections such as those of the d'Este and the Aldobrandini, which later passed to the Doria Pamphili and the Borghese, had copies of Titian as early as 1592 and 1603.[26] A notable instance is the collection of Queen Christina at the time that it was in the possession of the Odescalchi in Rome and prior to its sale to the Duke of Orléans. In the Inventory of November 1713 by Giuseppe Ghezzi, a well-known Baroque painter, and Bonaventura Lamberti, there are listed in the palace of the Duke del Grillo on the Lungara Titian's original *Venus with the Lute Player* and a copy of it, the *Three Ages of Man* ('la vita humana') now in Edinburgh, as well as three copies, and thus with virtually all of the masterpieces of the collection.[27]

22. Bibliography in Thieme-Becker, v, 1911; XXXIV, 1940.
23. Thieme-Becker: Regnier: XXVIII, 1934; Pietro Muttoni della Vecchia: XXV, 1931. Renieri's activities as a dealer are noted by Waterhouse, 1952, p. 13.
24. De Dominici, III, edition 1763, p. 397, or IV, edition 1844, pp. 131–132; Haskell, 1963, pp. 207–208.
25. *Bollettino d'arte*, x, 1916, p. 288: '. . . qui poi non vi è occasione di applicare o spendere per che non comparisce cosa di gusto solamente certi pezzi che uno Luca Giordano contrafacendo ora Titiano ora Paolo Veronese tranne di quello copiato molte cose in tempo dell' almirante di Castiglia [who, because of dates, must be the Conte di Castiglia, i.e. García de Avellando y Haro] ce a fatto buona pratticha e poi ci da una tinta anticha che non fanno mala vista al Sig.re Gaspare [Romer] ne a molti e altri mercanti molti, però gia si è scoverto e così no si riceve piu. . . .'
 Although Castro names the Almirante di Castiglia, viceroy in 1644–1646, the man must have been the Conte di

Castiglia (1653–1659), since Luca Giordano was born in 1634.
26. d'Este Inventory 1592 (Pergola, 1959, p. 344, no. 23); Aldobrandini Inventory 1603 (D'Onofrio, 1964, p. 20, no. 46).
27. Odescalchi Archives, Rome, Palazzo Odescalchi, vol. v, D 2, 1713: *Venus and the Lute Player* (folio 39v, nos. 49, 50); *Three Ages of Man* (folio 82v, no. 174), copies (folio 42v, nos. 96, 98). Likewise, *Laura Dianti with a Negro Servant*, now in the Kisters Collection, Kreuzlingen (folio 85, no. 197), and five copies of it (folio 43, nos. 99–103); *Venus and Adonis* (folio 84, no. 190); six copies (folios 42 and 42v, nos 90–95); *Magdalen*, two copies (folio 43v, nos. 110, 111); the original appears in the sale to the Duc d'Orléans, 1721 (folio 1, no. 8); *Venus with the Mirror* (folio 85, no. 194); four copies (folio 45, nos. 113, 114, 118, folio 50, no. 167); *Venus Anadyomene*, now in Edinburgh, National Gallery of Scotland (folio 83, no. 182); two copies (folio 51, nos. 181, 182); *Christ and the Adulteress*, now in Glasgow (folio 75, no. 136) and two copies (folio 46, no. 125; folio 51v, no. 186).

There was no deception here since the originals and the copies are distinctly labelled as such. The explanation lies in the fact that copies of famous works are always in demand. In the case of Titian's *Entombment* (Plate 75), which belonged to Charles I of England, the king also had four repetitions of it, presumably placed in his various palaces.[28]

Titian's fame continued undiminished even though a late seventeenth-century pedant such as Roger de Piles ranked him below Raphael and the Carracci, but still as the best of the Venetians.[29] Sir Joshua Reynolds actually owed more to Titian in his own technique than he did to Raphael, whom he praised above all others because of the purity of his design. In his *Discourses*, ranking these two as the greatest masters of all time, he conceded that Titian did not neglect the general form of his object, 'although his chief glory lay in his colour'.[30] Clearly this statement is over-simplified in respect to both artists, yet Sir Joshua did point out intelligently the essential contrast between two different schools.

The situation remained much the same in nineteenth-century criticism, when David and Ingres the Neoclassicists in their own painting clearly revealed that they admired Raphael and the Florentines. Although Ingres stated his preferences when he placed Andrea del Sarto next to Raphael, his remarks in contrasting Titian's colour with Raphael's form almost exactly repeat the opinion of Reynolds on that subject.[31] Delacroix and the Romanticists, with their devotion to colour and highly charged emotional compositions, logically took the opposite position. Delacroix saw Titian as a classical Greek painter of the fifth century B.C., despite his own Romanticism, and he ultimately declared the Venetian to be the greatest master of all time.[32]

In the English-speaking world Ruskin became the oracle whose word was little short of divine in the mid-nineteenth century. His Victorian morality, the essential yard-stick by which he judged all art, is so thoroughly unsympathetic in the twentieth century that most of his opinions can no longer be taken seriously. Titian's admittedly voluptuous *Magdalen* (Plate 182) in the Pitti Gallery and his far more penitent saint now in Leningrad (Plate 185) drew the sharpest barb: 'the disgusting Magdalen . . . yet redeems all of his glory here, so that he cannot paint altogether coarsely.'[33] Some of Ruskin's judgments are altogether trivial: in referring to the famous picture of the *Martyrdom of St. Peter Martyr* (Plate 154), then still extant, he declares 'in spite of its importance because there is something unconvincing and unworthy of Titian about the undulation of the trunks, and the upper part is destroyed by the intrusion of some dramatic clouds'.[34] As for the nudes in paintings, Ruskin always felt a bit distressed, although he held that 'in the greatest studies of the female body by the Venetians, all other characters are overborne by majesty, and the form becomes as pure as that of a Greek statue.'[35] The Victorian comes nearer to the tenets of evaluation in art today in his discussion of Titian's *Assumption*, despite his worn cliché in calling it 'a noble picture', when observing: 'He painted it because he enjoyed masses of red and blue and faces

28. See Cat. no. 36.
29. Rosenberg, 1967, pp. 37–47.
30. Reynolds, edition 1835, II, pp. 25–27.
31. Henri Delaborde, *Ingres*, Paris, 1870, pp. 157–158.

32. Pittaluga, 1918, pp. 72–75.
33. Ruskin, 1910, II, p. 367.
34. *Loc. cit.*, II, p. 407.
35. *Loc. cit.*, V, p. 291.

flushed with sunlight.'[36] Never does Ruskin question the acknowledged fact of Titian's greatness, in spite of his myopic, Puritan disapproval of certain details.

When an Englishman and an Italian, Crowe and Cavalcaselle, began their great work, *The Life and Times of Titian* (1877), they set out to reconstruct the artist's biography, using the sketchy account of Vasari, Cadorin's brief but important study with documents, the letters of Pietro Aretino, the letters in the archives at Mantua and Ferrara, the correspondence at Parma and Modena, which other scholars had recently transcribed, in addition to the letters exchanged between Titian and the Spanish rulers preserved in the royal archives at Simancas, until then unpublished.[37] The joint authors' is the first sound historical account of the artist's life, which they also integrated with the history of the monarchs, popes, and princes with whom he was associated. Their major purpose was to establish the authentic pictures by the master, relying upon documentation and upon their own highly developed connoisseurship. They stand out among the pioneers of modern art-historical scholarship at a time when little discrimination existed as between originals by the master, school pieces, copies, and later imitations. They cut away a vast quantity of mediocre works which passed under Titian's name in public museums and in private collections, making some mistakes as was inevitable, primarily in questioning authentic works and rarely in being deceived by the spurious. Later scholars such as Giovanni Morelli, Bernard Berenson, Tietze, and numerous others whose names appear in the bibliography, notes, and catalogue of this volume have further refined what they began.

No one today would question the universal genius of Titian. One of the major portraitists of all time, he searched and penetrated the human mind and character, which he presented on canvas in the most brilliant pictorial fashion. His religious compositions range from the introspective tenderness of his early Madonnas to the tragic depths of the late *Crucifixion*, the *Entombment* (Plates 76 and 114) or the *Pietà* (Plate 136). His mythological compositions are unrivalled with the possible exception of those of Rubens, but the Fleming was all full-blooded sensual vigour, whereas Titian's gamut had a far wider scale. In his Giorgionesque beginnings the mood lies in poetic evocation, as in the *Three Ages of Man*, now in Edinburgh, the *Sacred and Profane Love* in the Villa Borghese at Rome, or the Ferrara *Bacchanalia*, now in the Prado Museum at Madrid. Later he evolved the vision of ideal beauty in the *Venus of Urbino*, and then moved on to the sumptuous eroticism of the *Danae* at Madrid and to the gay and pictorial splendour of the *Rape of Europa* in Fenway Court at Boston. In his late compositions of whatever subject, Titian struck out in new directions by the dexterous magic of his brush and by the precedent-breaking methods of his compositions. He achieved the ultimate fulfilment of the late Renaissance and he plotted the way through which the pictorial style of the Baroque was to come to fruition.

36. *Loc. cit.*, v, p. 292.
37. Vasari (1568)–Milanesi, VII, pp. 425–468; Cadorin, 1833; Aretino, *Lettere*, edition 1956, 1957; Braghirolli, 1881; Campori, 1874; Ronchini, 1864. The correspondence in the royal archives at Simancas has recently received a full and annotated publication by Cloulas, 1967.

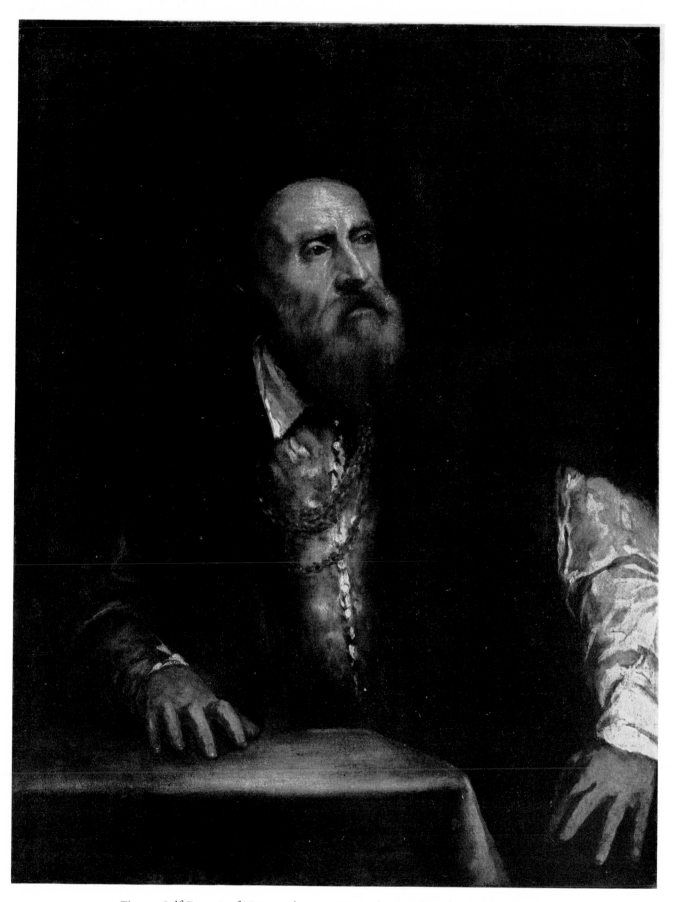

Fig. 1. *Self-Portrait of Titian*. About 1566. Berlin-Dahlem. Staatliche Museen

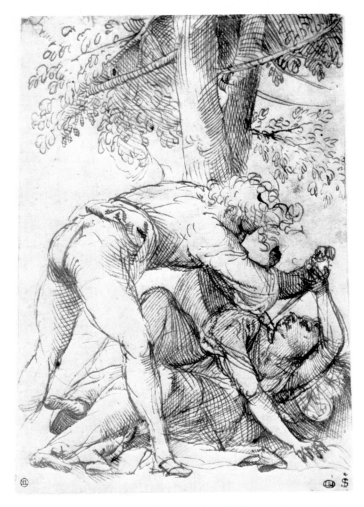

Fig. 2. Study for *The Jealous Husband* (Plate 141). Drawing.
Paris, École des Beaux-Arts (Cat. no. 95).

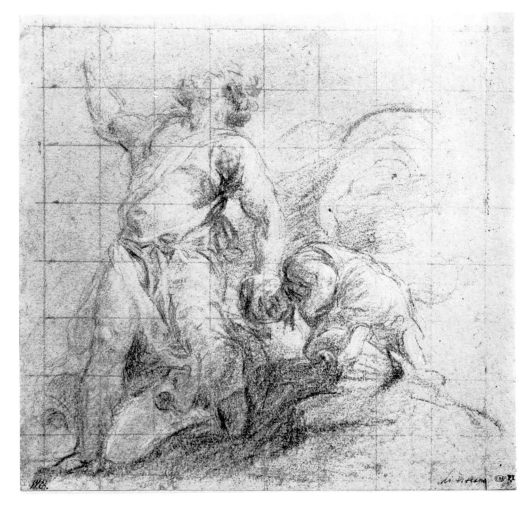

Fig. 3. Study for *The Sacrifice of Abraham* (Plate 158). Drawing. Paris,
École des Beaux-Arts (Cat. no. 83).

TITIAN'S YOUTH

THE small village of Pieve di Cadore lies amid handsome mountain peaks in the high Alps, due north of Venice. Well beyond Belluno, as the bird flies it is only forty kilometres from the southern border of the Austrian Tyrol. During the summer months of the mid-twentieth century it affords a tourist attraction for German-speaking people to pass a holiday in a cool land of mountain vistas. Here Titian was born about 1488–1490,[38] the son of Lucia and Gregorio di Conte dei Vecelli. His father was a man of modest attainments, who later fought for the defence of his native region of Friuli against the invading forces of Emperor Maximilian I of Austria in 1508 and held local offices as inspector and overseer at Cadore previous to his death, shortly after 1527.[39]

The house where Titian was born and passed his boyhood is now a museum, which exhibits a few documents as well as photographs, among them engraved self-portraits of the artist.[40] Built in Alpine style with a long balcony sheltered by a deeply projecting roof, it is modest but comfortable for its period, the interior divided into rather small wood-panelled rooms. Not far from the square where stand the house and a statue of the artist, the young Titian could see the great blue peaks of the Alps and, on a fair day, a distant lake of deepest ultramarine blue, memories of which are immortalized in the landscape settings of his masterpieces.[41] The artist's life-long attachment to the land of his birth is attested by his frequent visits there during the summer months throughout his maturity and even in his old age. As late as 1565, when he was seventy-five or, as some would have it, eighty-eight, he made the long arduous journey up the twisting mountain roads from Venice to Cadore.[42]

At the age of nine Titian, accompanied by his brother Francesco, set out for Venice to reside with an uncle and to learn an artist's trade with Sebastiano Zuccati, a famous master of the art of mosaic. This reliable detail comes from Titian's friend Lodovico Dolce (1557), who learned this as well as other biographical details straight from the master. Titian's first teacher of painting, Gentile Bellini, proved to be too old-fashioned, says Dolce, whereupon the young boy passed to his brother, Giovanni Bellini, from whom Titian learned a more advanced technique of painting.[43]

38. See Appendix for a discussion of the date of Titian's birth.
39. Ticozzi, Milan, 1817, p. 7; genealogical chart, Appendix I. Titian's mother had the name Lucia and that is the extent of our information about her (Ciani, edition 1940, p. 448; a résumé of Titian's life on pp. 575–601).

 The anonymous life of Titian, almost certainly by Tizian-ello, a distant cousin of Titian, was dedicated in 1622 to Lady Arundel, who was travelling in Italy at this time. He at first accepted her invitation to accompany her to England, but later declined (Hervey, 1921, pp. 200–201, 227). Tizianello, also named Tiziano Vecellio (1570–1650), was the son of Marco Vecellio (1545–1611). See Thieme-Becker, XXXIV, 1940, p. 172; Vasari (1568)-Milanesi, 1907, VII, p. 468, note; Crowe and Cavalcaselle, 1877, I, pp. 28–29.
40. Celso Fabbro, 1946, pp. 457–458; loc. cit., 1953. The museum was inaugurated in 1932: see Ugo Ojetti, 1932. Cadorin, 1833,

p. 23, reproduces a lithograph showing Titian's birthplace as it then appeared. In another print of Titian's house in the eighteen-sixties the balconies are lacking (Gilbert, 1869, p. 103).

 The documents include Charles V's royal decree of knight-hood dated 10 May 1533.
41. For example the Madonna and Child with St. Catherine in the National Gallery, London, and the Presentation of the Virgin, in the Accademia, Venice (Plates 35, 36–39).
42. Ticozzi, 1817, p. 238: document of 1565.
43. Dolce, edition 1960, p. 201. Dolce states that Gentile and Giovanni Bellini were at work on the large, now destroyed, canvas in the Sala del Maggiore Consiglio of the Ducal Palace when Titian arrived in Venice. Gentile left for Turkey in 1479 and the painting was continued by Giovanni (Lorenzo, 1868, pp. 88–92) at least until 28 February 1483, when he received the title of painter to the state. The exact later dates

Vasari, Ridolfi, and modern critics agree that this greatest of the *quattrocento* Venetian painters was without doubt Titian's real master. Just exactly when the young painter entered the shop of Gentile or Giovanni Bellini and how long he remained is unknown, but one may conjecture that he must have been a student for at least four or five years. Giovanni Bellini himself, approaching the end of his long career at the age of seventy in 1500, had developed an atmospheric style of painting with glowing richness of colour which was to be the point of departure of both Giorgione and the youth from Cadore. How much the nascent master owed to his elderly teacher is most evident in the *Gipsy Madonna* in Vienna (Plates 1, 3) where the composition is entirely Bellinesque, so like Giovanni's signed and dated *Madonna* of 1510 in the Brera at Milan; yet even here indications of independence in details and handling, as well as a new warmth of mood, are richly evident.

TITIAN AND GIORGIONE

MEANTIME, Titian had, of course, come to know the brilliant young poet-painter Giorgione, who had probably left the workshop of Giovanni Bellini. The two artists first worked together upon the frescoes of the Fondaco dei Tedeschi (the German Merchants' Exchange), Giorgione painting those on the main façade, which gives upon the Grand Canal, and Titian the others over the side portal on the street front, according to Lodovico Dolce. Even here dispute has arisen as to which figures were painted by Giorgione and which by Titian, although Dolce in 1557 is surely the writer to be trusted.[44] These works of 1508, the principal one by Titian representing Judith in the guise of Justice, are known chiefly in the etchings of Piccino and Zanetti of mid-seventeenth and mid-eighteenth century date respectively.[45]

of Gentile's activity in the Ducal Palace cannot be established so that these statements do not aid in the problem of the date of Titian's birth or the exact year that he reached Venice.

44. Dolce, 1557, edition of 1960, pp. 164, 201, seems trustworthy here. Vasari (1568)–Milanesi, VII, pp. 428–429, makes the same statement. However, in his life of Giorgione (IV, p. 96) Vasari contradicts himself and mistakenly ascribes to Giorgione the section containing *Judith as Justice*. Ridolfi (1648)–Hadeln, I, pp. 154–155, pointed out that Vasari was wrong in this detail, and all other writers have agreed except Minerbi (1936, pp. 170–177), who tried to argue that Vasari was right.

45. The correct distribution of the frescoes between Giorgione and Titian seems to be as follows:

By Giorgione: a seated nude male, seated nude female, standing nude female, clothed female with halberd (Zanetti, 1760, pls. 1–4).

By Titian: a standing nude female, engraved in 1658 by Piccino (Tietze, 1936, I, Tafel III; Valcanover, 1960, II, pls. 186–187, illustrates all of the figures by Titian); a female head together with a half-length female nude; Justice; a youth dressed in the varicolour hose, cloak and dagger of the Com-

pagnia della Calza (Zanetti, pls. 5–7). Members of this organization, founded in the year 1400, continued to wear the same colourful garb even in the sixteenth century. Young Venetian aristocrats and visiting princes comprised the members who led the festivities during Carnival and state occasions, important weddings, and religious festivals. Sansovino (1580)–Martinioni (1663, pp. 406–407) gives a contemporary account of the organization; see also Molmenti, 1910, I, pp. 257–260; C. and C., 1877, I, pp. 279–280.

Traces of a single nude figure by Giorgione (Zanetti, pl. 3) were transferred to canvas in 1937 and taken to the Accademia in Venice (Zampetti, 1955, pp. 46–47). In 1967–1968 Tintori removed fragments of the *Judith* as well as parts of a frieze (by Titian?), which have been exhibited in the Accademia at Venice (Valcanover, 1967, pp. 266–268). Remains of the *Compagno della Calza* are illustrated by Foscari, 1936, pl. 13.

Giorgione received final payment after 8 November 1508 for his work on the Fondaco (document in Gualandi, 1842, III, pp. 90–91; see also Foscari, pp. 36–46). The history of the rebuilding of the Fondaco dei Tedeschi in 1507–1508 is reconstructed by Crowe and Cavalcaselle (1877, I, pp. 80–93). The Fondaco, now the central post-office of Venice, has been

All critics, both contemporaries of Titian and those of later generations, have agreed that Giorgione and Titian are in many cases indistinguishable until the sensational appearance of Titian's epoch-making *Assumption* (1516–1518) in the Frari (Plates 18–22). Little agreement is forthcoming as to which master painted the *Christ and the Adulteress* (Plate 204) in Glasgow or the *Madonna with SS. Anthony of Padua and Roch* (Plate 203) in the Prado, although the colour in particular as well as the poses in both cases favour Giorgione.[46] In portraiture the puzzles are even more acute, notwithstanding the fact that certain problems seem now finally solved in favour of Titian, as for example *La Schiavona* and the *Man in Blue* (so-called 'Ariosto') in the National Gallery at London. Otherwise few critics concur about the attribution of such handsome works as the *Fugger Youth* in Munich, the *Bravo* in Vienna or the *Knight of Malta* in the Uffizi, and numerous others. The situation is even further complicated by Berenson's theory that the first two are Palma Vecchio's copies after lost originals by Giorgione.[47] Further enigmas in the form of *cassone* panels have provided material for discussion and hypothesis with little chance of full agreement.[48] Various critics have changed their minds on different occasions throughout their careers, yet there are clearly discernible tendencies on the part of certain writers to increase the number of Giorgione's works and of others to reduce them in favour of the young Titian.[49] The dream-like poetic mood, the creation of which is usually assigned to Giorgione, was anticipated by Giovanni Bellini as early as 1490 in such a work as the *Religious Allegory* in the Uffizi at Florence. Nevertheless, Giorgione and Titian were its greatest exponents, even though many of their Venetian contemporaries joined in the Arcadian spirit of the age. With Titian the style lingered on even after the *Assumption* of the Frari in such an exquisite painting as the *Madonna and Child with SS. Francis and Aloysius and Donor* (Plate 24), and it did not entirely end its course until the mid-fifteen-twenties.

EARLY INDEPENDENT COMMISSIONS

TITIAN'S first major independent commission came his way in the late autumn of 1510, when he journeyed to Padua to paint three large frescoes of the legend of St. Anthony (Plates 139–143) in the Confraternity i.e. Scuola di San Antonio opposite the pilgrimage church of that greatly revered Franciscan. After receiving the final payment for his work on

considerably remodelled by the addition of another story and a radical change in the fenestration with the inevitable result that none of the original fresco decoration remains intact. An eighteenth-century engraving shows the former exterior (Albrizzi, 1772, p. 232).

46. Titian's completion of Giorgione's *Sleeping Venus* in Dresden is, of course, a well-established fact, first mentioned by Marcantonio Michiel in 1525 (edition 1903, p. 105). For works in which the close similarity of Giorgione's and Titian's styles is especially notable see: *Christ Carrying the Cross* (Cat. no. 22); the *Gipsy Madonna* (Cat. no. 47); *Madonna and Child* (Cat. no. 48); *Noli Me Tangere* (Cat. no. 80); *St. George* (Cat. no. 102);

St. Jerome in Penitence (Cat. no. 104); *Salome* (Cat. no. 137); *Circumcision* (Cat. no. X–8). The problem of Titian versus Giorgione will be discussed in greater detail in the forthcoming Volume II, *Titian's Portraits*, and Volume III, *Mythological and Historical Paintings*.

47. Berenson, 1957, pls. 684, 685.

48. Zampetti, 1955, pp. 168–173.

49. Cook, 1907, and Richter, 1937, and Zampetti, 1955, are the leading pan-Giorgionists, while Suida, 1935, and Longhi (on many occasions) have promoted the early Titian, adding many border-line attributions.

2 December 1511, the young artist must have returned to Venice, having escaped the severe pestilence which had raged there in October. His reputation had been established; he was to go on to even greater accomplishments. The importance of these handsome Paduan murals in an understanding of Titian's early career can hardly be exaggerated, inasmuch as they are the first preserved works on which to base any idea of his independent style and personal gifts. At Padua he was already an accomplished composer, his gift of characterization is revealed, and his exceptional ability as a landscapist is fully in evidence.[50]

At the time of Titian's return to Venice from Padua in the winter of 1511–1512 peace had at last come after years of bitter warfare, for the Venetian republic and the Emperor Maximilian had agreed to a truce. During this same decade Pope Leo X, on the recommendation of Cardinal Pietro Bembo, invited Titian to work at the papal court in Rome, but according to Dolce the artist declined on the advice of Andrea Navagero.[51] His decision may, however, have been due also to his desire for public recognition in Venice, since he applied on 31 May 1513 for authorization to paint a still unassigned battle scene for the Great Council Hall of the Ducal Palace, where nearly all the famous Venetian painters of the past as well as the non-citizens, Pisanello and Gentile da Fabriano, had left celebrated compositions, now lost. Titian also asked for the first vacancy of a concession at the Fondaco dei Tedeschi, an appointment which carried a life income payable by the state salt monopoly. The stipulations, including the salaries of two helpers, the cost of colours, and minor expenses, were the equivalent of those granted to his former teacher, Giovanni Bellini. This petition has been regarded as a challenge to the eighty-three-year-old Bellini and as insolence on the young Titian's part, but that view of the situation, established by Crowe and Cavalcaselle, is open to question.[52] As a matter of fact the entry in Sanuto's diary of 29 May 1513 states simply that Titian was granted the privilege to work in the Great Hall, without salary, under the same conditions as Gentile Bellini, Giovanni Bellini, and Vittore Carpaccio.[53] However, on 20 March 1514 the appointment was revoked, whereupon Titian, replying eight days later that he

50. About this time, according to Vasari, Titian painted a picture of the *Judgment of Solomon* in the loggia of the Palace of the Curia at Vicenza. No description survives and no print remains of this work, which was destroyed within a few years in the reconstruction of the palace by Palladio. However, a payment of one-hundred ducats on 20 September 1521 for this work and for painting the vault of the loggia settles the issue of the date. See Vasari (1568)–Milanesi, VII, p. 431; Ridolfi (1648)–Hadeln, I, p. 155. The document of 1521 is published by Morsolin, 1892, pp. 89–90. It reveals that Titian was aided by Francesco Vecellio and two other assistants named Gregorio and Bartolommeo, these two probably journeymen.

Boschini, 1675, pp. 34–35, describes fragments of four putti and a mask on the façade of the palace, which some people associated with Titian or Campagnola, an attribution that was probably wide of the mark. See also Crowe and Cavalcaselle, 1877, I, p. 140.

51. Dolce, 1557, edition 1960, p. 67; Vasari (1568)–Milanesi, VII, pp. 204–205. Cardinal Pietro Bembo, the Venetian poet,

was appointed Apostolic notary by Leo X in 1513 (Pastor, 1908, VIII, pp. 193–196). Andrea Navagero (1483–1529), Venetian humanist, poet and diplomat, also lived many years at the papal court of Leo X; he was sent to Spain on a diplomatic mission, 1523–1528. See also note 95.

52. Documents in Lorenzi, 1868, pp. 157–158. In 1513 Titian specifies his desire to paint 'quella bataglia de la banda verso piaza'. Crowe and Cavalcaselle, 1877, I, pp. 153–165, give the fullest account of this whole affair, but add psychological motives not in the documents, and they exaggerate or even create the theory of animosity between Titian and his former teacher, Giovanni Bellini.

53. Sanuto, XVI, column 316: 29 May 1513. 'In questo consejo di X simplice fu preso che Tiziano pytor debbi lavorar in sala dil Gran Consejo come li altri pytori, senza però alcun salario, ma la expetativa solita darsi a quelli hanno pynto, ch'è stà Zentil et Zuan Belin et Vetor Scarpasa; hora mò sarà questo Tiziano.' The variation in dates in these records is of no significance, since the appointment must have been under consideration for weeks or months.

had begun the work, requested that the income from the salt monopoly start after Bellini's death. Thereupon the Council agreed to pay for the cost of colours and the salaries of two young helpers.

It is obvious that the elderly Giovanni, too old to paint on a large scale, had long ceased to work upon his canvas, since it is reported in bad condition in September 1515. At a meeting of the Council on 30 December it was reported that, since seven hundred ducats had already been spent for two canvases which had barely been begun, they should seek new painters. Titian himself offered on 18 January 1516 to complete his own picture of the *Battle* and also the other, i.e. Giovanni Bellini's, which had once been commissioned from Perugino.[54] The death of Giovanni Bellini on 29 November 1516 finally settled the matter, and on 5 December Titian received title to the income from the salt monopoly of the Fondaco dei Tedeschi, which Bellini had previously held.[55] Nevertheless, the battle picture which Titian promised at that time, the celebrated *Battle of Cadore*, had to wait another twenty-one years for fulfilment.[56]

The two large historical murals once located in the Sala del Maggior Consiglio of the Ducal Palace are lost to posterity because of their destruction in the fire of 1577. With Giovanni Bellini's composition only sketched in, Titian completed (*c.* 1518–1523) the scene of the humiliation of Frederick I Barbarossa by Pope Alexander III in July 1177, when the Roman Emperor kissed the feet of the pontiff, who is said to have placed his foot upon Frederick's neck. This work must have been almost entirely Titian's, for he surely transformed the early Renaissance style of Bellini into his own more developed mode. Moreover, Sanuto reports that the latter had only begun to sketch the composition.[57] Both Dolce in 1557 and Sansovino in 1561 name Titian as the painter without reference to the older man. Dolce objected rather naïvely to the inclusion of prominent Venetians of the early sixteenth century among the bystanders because the event had occurred four centuries earlier.[58] The artist had equally bad luck with the famous *Battle of Cadore*, another

54. Lorenzi, 1868, pp. 158–166; letter of 1514 also in Gaye, 1840, II, pp. 142–143.

55. *Loc. cit.*, pp. 166–167. That does not bring an end to the matter, for on 3 July 1518 complaint was lodged that Titian had not touched the canvas for a long period. In the summer of 1522 Titian was working during the mornings in the Sala del Maggiore Consiglio, a fact mentioned in the Ferrarese correspondence (Campori, 1874, p. 596). Finally by 3 June 1523 he must have fulfilled his assignment to finish Giovanni Bellini's mural. Then he received twenty-five ducats for the portrait of Antonio Grimani (Lorenzi, 1868, pp. 171, 175, 176) and no further reference to Giovanni Bellini's mural appears.

56. Lorenzi, 1868, p. 219. On 23 June 1537 the Council threatened to demand the return of all of the money paid since 1513, if he did not finish the *Battle* at once. Aretino's letter of 9 November 1537 praises the mural, then apparently open to public view (Aretino, *Lettere*, edition 1957, I, p. 79).

57. Sanuto, XXI, columns 425–426: on 29 or 30 December 1515 as follows: 'Ha trovato tra li altri do quadri, quali non è principiati a disegnar e costano da ducati 700 et li faria sopra di sè con ducati 250 . . . e fato con quel medemo pitor chiamato Tiziano uno novo mercato.'

58. Dolce, 1557, edition 1960, p. 168. A naïve objection since all through the Renaissance period it was customary to include contemporaries even in Biblical scenes.

Sansovino, 1561, p. 18, gives to Titian the Barbarossa story and the battle canvas. There seems to be every reason to believe that Vasari was correctly informed that Giovanni Bellini had begun the earlier mural, which Titian completed (Vasari (1568)–Milanesi, VII, p. 432). Milanesi in note 3, *loc. cit.*, preferred to follow Ridolfi, who stated that Giorgione had begun to paint the story of Frederick Barbarossa and that Titian finished it. Borghini, 1584, edition 1807, III, p. 87, may be the source of this confusion. Ridolfi added a long list of notables whose portraits were included here (Ridolfi (1648)–Hadeln, I, p. 157). Crowe and Cavalcaselle (1877, I, pp. 168–169) reasonably dated Titian's share in this mural *c.* 1522 because of our historical knowledge of personalities included among the portraits.

Hans Tietze proposed that Federico Zuccaro retained some elements of Titian's composition in his mural of the same subject (1936, I, p. 129). Tietze-Conrat repeated the same theory and also proposed that a drawing of the same subject attributed to Pietro Malombra (1556–1618) in the Metropolitan Museum may reflect Titian's composition (Tietze-Conrat,

canvas placed in the same hall; not completed until 1537, it also perished in the fire of 1577. Nevertheless, a mediocre painted copy and drawings preserve some notion of its composition.[59]

Little is known about the quality or the success of Titian's first important commission for the Venetian state. The vast canvases of historical and allegorical subjects by such great masters as Tintoretto and Paolo Veronese, as well as many by lesser painters, which still cover the walls of the Ducal Palace, are, in general, monotonous and boring. The nature and purpose of these murals in extolling military victories offered little opportunity for genuine inspiration. On the other hand, Titian's *Assumption of the Virgin* (Plates 18–22), unveiled in 1518 in the church of the Frari, was a triumph, one of the high points not only of his career but also of the entire Italian Renaissance. In it he created a new and overpowering composition of immense grandeur, the first really monumental achievement of the Venetian High Renaissance. By some not entirely explicable means Titian paralleled the High Renaissance designs of Raphael's Vatican murals, and he evoked the fury of Michelangelo's Sistine vault in the Apostles who view the miracle. Even though Titian had not yet visited Rome, he surely had heard much about these slightly earlier masterpieces, and he had seen drawings of them brought to Venice by travellers from Rome.

Henceforth Titian's activities were no longer restricted to Venice and the nearby cities of Vicenza and Padua; his pictures were sought by the great princes of Italy and in another decade his fame spread beyond the Alps. Alfonso I d'Este first induced Titian to visit Ferrara in 1516,[60] exactly for what purpose has never been explained, since it appears more likely that he repainted the landscape of Giovanni Bellini's *Feast of the Gods* on a later visit, when delivering one of his three 'poesies' painted for the celebrated Alabaster Room. In a letter to Alfonso d'Este on 19 February 1517 he sent sketches of a well in Venice, which the duke had requested, and added that he was working daily on his picture of a 'bath', that is a mythological work of female nudes about which no further information is available. During the next six years Titian's relations with Ferrara were constant until the completion of the three magnificent works, the *Andrians* and the *Worship of Venus*, both now in Madrid, and the *Bacchus and Ariadne* in the National Gallery at London.[61]

Meanwhile at home in Venice demands for Titian's services were not lacking. Jacopo Pesaro, who had earlier (*c.* 1512) ordered the picture of *St. Peter Enthroned Adored by Pope Alexander VI and Jacopo Pesaro* (Plates 144–146), commissioned from him the large altarpiece in the Frari (1519–1526), one of the great works of the Renaissance, the *Madonna of the Pesaro Family* (Plates 28–31). This Venetian aristocrat, holding the title of archbishop of Paphos (Cyprus) and one-time commander of the papal navy, had led Alexander VI's armada to victory over the Turks at Santa Maura in Cyprus on 30 August 1502. That victory, specifically commemorated in the first picture,

1940, pp. 19, 36, fig. 20). The style here, however, betrays the late sixteenth century, and both theories are devoid of reasonable foundation.

59. See Lorenzi, 1868, p. 219; Tietze-Conrat, 1945, pp. 205–208; *idem*, 1948, pp. 237–242. The mural was described by Francesco Sansovino as the Battle of Spoleto, perhaps for political reasons (Sansovino (1581)–Martinioni, 1663, p. 327).
Still another picture by Titian was lost in the fire of the

Ducal Palace of 1577, i.e. the *Madonna and Child with Saints and Andrea Gritti as Donor* (see Cat. no. 69).
60. Campori, 1874, p. 584; C. and C., 1877, I, p. 178. Titian probably delivered the *Tribute Money* (Cat. no. 147) at this time.
61. See Walker, 1956; Battisti, 1960, pp. 120–145. The Alabaster Room, now entirely rebuilt inside, still exists (Battisti, 1960, fig. 43).

is alluded to also in the epoch-making composition of the *Pesaro Madonna* by the introduction at the left side of a captive Turk and of the battle flag with arms of the Borgia pope. Donor portraits add splendour with the presence of not only archbishop Jacopo Pesaro but also other male members of his family, both young and old. As a portraitist of the single figure Titian's reputation had already been solidly established. Starting with his Giorgionesque beginnings, his fame increased during these later years with his responses to portray many famous rulers, including Alfonso I of Ferrara and Federico II Gonzaga of Mantua.[62]

TITIAN'S PERSONAL LIFE

NOTICES of Titian's personal life are scarce in the first two decades of the sixteenth century. Even letters, which were to become so numerous later, especially in connection with commissions from the d'Este of Ferrara, the Gonzaga at Mantua, and the Spanish Hapsburgs, are few prior to 1520.[63] The legend of Titian's romance with a young woman named Violante originated in a shrewd observation by Ridolfi, who noticed certain details of the *Andrians*, which involve the reclining girl holding a flute and lifting a wine cup in her upraised left hand. Two violets nestle in the edge of her low-cut blouse, and Titian's name is signed on a ribbon tucked in the same intimate spot. Ridolfi decided that the model's name was Violante, and concluded, not unreasonably, that she was the artist's mistress at that time (*c.* 1518–1520).[64] A few years later Boschini, in his poem *Carta del navegar pitoresco*, further embroidered upon the theme and made Violante the daughter of Palma Vecchio.[65] Thenceforth the legend flourished, and although it has been shown that Palma Vecchio apparently never had a daughter, the name of Violante persists.[66] Louis Hourticq, the French scholar, who never failed to detect *l'amour* at every turn, carried the legend to further heights: he saw the same model in *Flora* (Uffizi), *Sacred and Profane Love* (Villa Borghese), the *Young Woman at her Toilet* (Louvre), as well as in the female saint in the early *Madonna with St. Dorothy and St. George* in the Prado (Plate 13).[67] Nineteenth-century critics extended Violante's fame by recognizing her features not only in Titian's works, but likewise in those of Palma Vecchio, particularly the lovely blonde girl in Vienna, who also has a violet tucked at her bosom, and the so-called *Bella of Titian* by Palma, now in the Rothschild

62. The first-mentioned in the Metropolitan Museum in New York and the second in the Prado Museum, Madrid (Tietze, 1936, II, figs. 75, 76); to be discussed and catalogued in Volume II. Other early donor portraits by Titian include Altobello Averoldo at Brescia and Alvise Gozzi at Ancona (Plates 25, 72).

63. Those of 1517–1519 relate to the pictures for the Alabaster Room at Ferrara; see Campori, 1874, pp. 581–590.

64. Ridolfi (1648)–Hadeln, I, p. 159.

65. Boschini, 1660, pp. 368–369, 'Ghè xè quela Viola, o Vio-

lante, che fin Tician ghe volse dar del naso al bon odor; del resto qua mi taso: che no'l fù miga un vicioso amante.'

66. Molmenti, 1911, p. 162.

67. Hourticq, 1919, pp. 131–137, 156. Says Hourticq: 'Dans toutes ses peintures de ce temps, Titien nous fait respirer une atmosphère d'amour.' The saint in the Madrid picture, whom he identifies wrongly as St. Brigit, does not closely resemble the other blondes in this list.

Gerstfeldt in her article 'Venus and Violante', 1910, pp. 371–375, devoted mainly to *Sacred and Profane Love*, develops the legend of Violante.

Collection in Paris.[68] That these ladies represent a similar idealization of Venetian beauty, all critics concur and have done so for centuries. The violets worn by the Violante in Vienna and the girl in the *Andrians* do seem to make a case for an individual identity.

Somewhat later Titian brought to his house in Venice a young woman named Cecilia, daughter of a barber in the hamlet of Cadore, not far from the artist's birthplace at Pieve di Cadore. During her severe illness in November 1525 the painter decided to marry Cecilia and so legitimize their two sons.[69] The birth of the eldest child, Pomponio, in 1524 is established by Pietro Aretino's letter of 26 November 1537 by reference to the youth's age as thirteen and his further mention of the fine little brother Orazio ('vostro bel fratellino').[70] It is not rash to suppose that the birth of the two boys in rapid succession in 1524 and 1525 had undermined the girl's health. At that time Titian and his young family were established in living quarters in the palace of the Tron family in the parish of San Polo.[71] References to his preparatory studies for the *Battle* in the former palace of the Duke of Milan at San Samuele lead one to suspect that his studio, but not his residence, was located there, inasmuch as he still used this apartment for that purpose as late as 1528.[72]

Cecilia made an unexpected recovery from her grave illness in the late weeks of 1525 and survived another five years to present Titian with two daughters, one of whom died in infancy.[73] Knowledge about the daughter Lavinia, born c. 1529-1530, is fuller, thanks principally to portraits generally agreed to represent her, most of all *Lavinia as a Bride* and *Lavinia as Matron* in Dresden. In 1555, on her marriage to Cornelio Sarcinelli of Serravalle, Titian endowed her with a sizeable dowry for which purpose he wrote to Charles V requesting two hundred *scudi* from the Spanish coffers at Milan.[74]

Titian's elder son Pomponio proved to be the great disappointment of the master's life. Destined for a clerical career at the age of five, brought up in luxury as the son of a world-famous artist, he led such a dissipated life that Pietro Aretino wrote him a letter in 1550, when Pomponio was twenty-six, begging the young man to abandon his evil ways, return to his studies, and seek his father's forgiveness.[75] At the same time Aretino, urging the fathers to remember their own

68. C. and C., 1877, I, pp. 66-67. Klauner and Oberhammer, 1960, p. 132, give Kraft in 1874 credit for first attaching Violante's name to the picture in Vienna. See also Spahn, 1932, pp. 45-46, figs. 13 and 32. The *Violante* in Vienna is now attributed to Titian himself in the Vienna Gallery (Inv. no. 65) and by Longhi, 1946, p. 64, pl. 113.

69. Ludwig, 1903, pp. 114-118, discovered the documents referring to the marriage; Molmenti, 1904, pp. 211-218; also Molmenti, 1911, II, pp. 133-136.

70. Aretino, *Lettere*, edition 1957, II, p. 91; Cadorin (1833, p. 36) first discovered the importance of this letter in establishing the date of Pomponio's birth. However, he read the phrase as 'dodici anni' whereas the more recent publication interprets the words as 'tredici anni'. This reading is confirmed by the fact that both sons were born before the marriage in November 1525: 'ho due fioli maschi con lie la qual e inferma a ciò li siano legittimi' (Ludwig, 1903, pp. 114-118). Crowe and Cavalcaselle (1877, I, p. 340) followed Cadorin's reading as 'dodici anni'.

71. Ludwig, 1903, pp. 114-118, reference to the Tron palace.

72. Lorenzi, 1868, pp. 161, 187.

73. The baby girl who died had as godfather Francesco del Zuccato according to Titian's own testimony (Zanetti, 1771, p. 575).

74. Cadorin, 1833, pp. 56-57; see letter in Ticozzi, 1817, p. 310. For Lavinia as Salome, see Plate 192. Titian's portraits of Lavinia will be discussed in Volume II. The portraits in Dresden are catalogued by Posse, 1929, p. 87, nos. 170, 171; also Hadeln, 1931, pp. 82-87.

 Brunetti (1935, pp. 175-184) discovered the name of a third daughter, Emilia, who married Andrea Dossena about 1568. She must have been illegitimate, born of an unknown mother about 1548, long after Cecilia's death.

75. Aretino, *Lettere*, edition 1957, II, p. 351; also Cadorin, 1883, p. 41. Again in December 1553 Aretino (*loc. cit.*, p. 437) made another appeal to Pomponio.

less-than-perfect youthful behaviour, wrote letters to counsel tolerance to Titian and to Jacopo Sansovino, whose son Francesco, later to become a famous writer, was also giving free rein to the joys of young manhood.[76] Yet Pomponio paid no heed and Titian was forced to request in 1554 that the benefice in the town of Medole, which had been granted to his son in 1539, be transferred to a nephew.[77] Nevertheless, Titian relented later to the extent that in 1557 he obtained for Pomponio another sinecure in the benefice of S. Andrea del Fabbro, a small town in the province of Treviso, through the influence of Cardinal Trivulzio.[78] He also wrote to Cardinal Alessandro Farnese in 1567 begging his assistance in connection with the Milanese pension promised to Pomponio by Charles V.[79] Titian's numerous exhortations against Pomponio's profligate behaviour, combined with his pleas for ecclesiastical benefices in his behalf, throw ample light upon the love and devotion toward a worthless son, who was to outlive all his immediate relatives and inherit Titian's considerable wealth.[80]

About Titian's wife we have no further information than her name and parentage. No portrait can be identified as hers, although romantic writers have not neglected to presume that she served as model for Titian's early Madonnas. The artist was so disconsolate after her illness and her death in early August 1530 that he was unable to complete a portrait of Cornelia and a mythological compositio for the Duke of Mantua.[81] Shortly thereafter he called his sister Orsa from his home town of Pieve di Cadore to take charge of his household and his three young children, a responsibility which she appears to have fulfilled well.[82]

In 1531 Titian decided to move to more spacious and luxurious quarters in keeping with his fame as an artist and with his higher social status. He rented part of a large palace, recently built by a patrician Alvise Polani, which came to be known as the Casa Grande, and five years later he

76. Aretino, *Lettere*, edition 1957, II, p. 348, letter of September 1550 to Titian and Jacopo Sansovino.

77. Cadorin, 1833, p. 42; C. and C., 1877, II, p. 507.

78. Cadorin, 1833, pp. 39–40; C. and C., 1877, II, p. 257.

79. Charles V made Pomponio a citizen of Spain in 1539 and promised a Milanese benefice of five hundred *scudi*, which apparently was never paid. See Tizianello, edition 1809, letter XXI; Ticozzi, 1817, p. 316; Cadorin, 1833, p. 38; C. and C., 1877, II, pp. 507–508. Ridolfi confused Orazio and Pomponio, believing that the former was involved here. Hadeln corrects the error (Ridolfi (1648)–Hadeln, I, p. 222, note 2). Cloulas, 1967, p. 224, note 2, republishes the letter and follows Ridolfi.

80. Pomponio engaged in a litigation with his brother-in-law, Sarcinelli, after Titian's death in 1576. He sold the house in Cadore as well as the mansion known as the Casa Grande in the parish of San Canciano, where Titian lived in considerable splendour for thirty-five years. The last mention of him shows him alive in 1594 at the age of seventy and residing in the parish of S. Pietro in Castello at Venice. See Cadorin, 1833, pp. 42–43.

When in 1581 Pomponio sold to Cristoforo Barbarigo the Casa Grande together with a precious collection of pictures, the house had earlier been robbed at the period following Titian's death, before the new owners took possession. Sub-sequently the house was occupied by Francesco Bassano and thereafter by another painter, Leonardo Corona (Cadorin, 1833, p. 31, and documents, pp. 77–78; contract of sale, pp. 98–101).

Titian's house is now a tenement, much to the shame of the city of Venice. It should be a museum, for which Cadorin pleaded as long ago as 1833.

81. Benedetto Agnello's letter dated 6 August 1530 at Venice says that Titian's wife was buried the previous day (C. and C., 1877, I, pp. 448–449) and that the artist was so grieved that he had been unable to finish the portrait of Cornelia or a picture of 'nudes' for the duke of Ferrara.

Francisco de los Cobos, the powerful secretary to Charles V, wanted the portrait of Cornelia Malaspina, with whom he had had a love affair (Keniston, 1959, pp. 136–142). The portrait, now lost, was dispatched to Mantua on 6 September 1530 (C. and C., 1877, I, p. 346). About the mythological work which Titian called the 'nudes' nothing further is known.

82. Orsa remained in Titian's house until her death in 1550. Aretino's letter of condolence to Titian on her death is dated March 1550 (Aretino, *Lettere*, edition 1957, II, p. 325). Titian had two sisters, Orsa and Catterina, the former a spinster and the latter married, apparently in Cadore (Ciani, edition 1940, p. 440; Ticozzi, 1817, p. 302, Appendix I, Tavola genealogica).

leased the entire building. Located in a region called the Biri, to the north of the parish church of San Canciano, its gardens reached to the water's edge and its view embraced the islands of San Michele and Murano in what were then the outskirts of Venice, seemingly remote from the busy Rialto. As early as 1595 the Fondamenta Nuove (the new embankments) were built along the shore and subsequently buildings were erected, completely eliminating the rural environment which Titian enjoyed to the end of his life.[83]

The splendour of Titian's life here is vividly described in a letter written by the famous author of a Latin grammar, Francesco Priscianese, who attended a banquet which he styled a 'Bacchanale' in the Casa Grande on 1 August 1540. Present were Jacopo Sansovino, Aretino, and an elderly Florentine historian Jacopo Nardi, living in exile in Venice, who dedicated his translation of Livy to the Marchese del Vasto.[84] At the start the four men looked at Titian's pictures, 'of which the house was full', a statement to stagger the imagination: paintings of the great master in their pristine state; but the writer never thought to specify any subjects. Thereafter they walked in the garden, engaging in conversation, previous to partaking of a supper of 'most delicate food and most precious wines'.[85]

Earlier in the same year Titian had ordered a harpsichord from a famous maker of instruments, Alessandro Trasontino, called dagli Organi.[86] The artist's fondness for music in a city celebrated for that art is no cause for wonder, nor should it be supposed that this instrument was the only one in the Casa Grande.[87] A lute as well as a portable organ may also have been among the master's possessions, if one is to judge by his celebrated pictures of *Venus with the Organist* and *Venus with the Lute Player*.[88]

During the fifteen-twenties, such critical years in Titian's personal life, his artistic production continued not only to flourish but to make unprecedented strides. In addition to his established relations with the d'Este at Ferrara, the Gonzaga at Mantua now made demands upon his services. The portrait of Alfonso I d'Este (1523–1525) had drawn such praise that Francisco de los Cobos, the Spaniard, coveted it for his emperor, Charles V, to whom Alfonso decided to present it as a gift.[89] A few years later Titian added the portrait of Federico II Gonzaga, Duke of Mantua, to his gallery of notables.[90]

83. Documents and the history of the Casa Grande, as well as a lithograph of the house and garden in its state in the early nineteenth century, in Cadorin, 1833, pp. 29–33, 83–101, 111–112; also C. and C., 1877, II, pp. 37–47. A picturesque description of the neglected garden and the house reduced to a tenement was written by Anna Jameson, 1846; also edition 1878, pp. 220–224.

84. The dedication took place the same year, 1540 (Aretino, *Lettere*, edition 1957, I, p. 176).

85. The Italian text of the letter describing the banquet in Ticozzi, 1817, pp. 79–80; first published in Francesco Priscianese, *Gramatica latina*, Venice, 1540; English translation, C. and C., 1877, II, pp. 40–41; also partially, Gronau, *Titian*, 1904, p. 233.

86. Aretino's letter, 7 April 1540 to Alessandro Trasontino (edition 1957, I, pp. 154–155) calls the instrument an 'arpicordo'. Crowe and Cavalcaselle (1877, II, p. 47) mistakenly make it an organ. A harpsichord made at Bologna in 1521 is illustrated by Emanuel Winternitz, *Musical Instruments of the Western World*, New York, 1967, no. 23.

87. For a brief account of music in Venetian life and art see Molmenti, 1911, II, pp. 312–328.

88. These subjects exist in many copies as well as originals in the museums at Berlin, Cambridge, Madrid, and New York. They will be studied in Volume III.

89. Probably the work now in the Metropolitan Museum, New York; see Wehle, 1940, pp. 192–193. For the historical background, see Keniston, 1959, pp. 153–154.

90. Now in the Prado Museum, Madrid, no. 408, dated *c.* 1523.

That princes and rulers were not the only subjects expected from the brush of a great Renaissance master is demonstrated by Titian's portrait of an animal newly arrived from Alexandria, which is presumed to have been a gazelle. Agnello, Federico Gonzaga's agent at Venice, wrote to his master about this very strange animal on 6 June 1532, and shortly afterwards he announced that Titian's picture of it was ready to be shipped.[91]

Meantime, during the late twenties, the artist created some of his most enchanting religious compositions, works which combine Renaissance idealism and human warmth in a way that Titian alone could achieve: the *Madonna and Child with St. Catherine and a Rabbit* for Mantua (Plate 34), the *Madonna with St. Catherine and the Infant Baptist* (Plate 35) for Ferrara, as well as the monumental and epoch-making *Madonna of the Pesaro Family* (Plates 28–31). At the same time the *Entombment* (Plate 75), destined for Mantua, plumbed the depths of tragic despair with the measured restraint which the greatest Renaissance masters achieved. In the minds of his contemporaries, however, it was the *Martyrdom of St. Peter Martyr* (Plate 154), now destroyed, that marked the culmination of Titian's powers up to that time. Vasari in 1568 went even further in his praise and described it as the 'most celebrated, the greatest work . . . that Titian in all his life had ever done'.[92] The decorative splendour of the landscape combined with the violent action of the assassination produced a dramatic climax thus far unprecedented in Titian's art. No doubt can be entertained that his increased knowledge of central Italian art, particularly Michelangelo's, underlies the more stentorian tones of this and certain subsequent pictures. The power of physiques and energy of movement had been foreshadowed in just one earlier work, the great *Assumption* of 1518 (Plates 18–22).

TITIAN AND CENTRAL ITALIAN ART

D URING the later fifteen-twenties the artistic interchanges between Venice and Rome increased rapidly. Ecclesiastics, nobles, and artists had always made the journey from north to south, but never so many as now. Lorenzo Lotto had worked in the Vatican during 1509 at the same time as Raphael, previous to the completion of Michelangelo's paintings in the Sistine vault.[93] Because of the early date of his visit the effects of this sojourn were not notable either in the career of Lotto or in any detectable reverberations in Venetian art in general. The Florentine masters Leonardo, in 1500, and Fra Bartolommeo, in 1508, made visits to the city of the lagoons, the consequences of which have been diversely evaluated, but they were too brief in duration to have made impressions of consequence.[94]

91. Letter of 19 June 1532 from Benedetto Agnello to Federico Gonzaga (C. and C., 1877, I, pp. 454–455; Braghirolli, 1881, pp. 56–57).

92. Vasari (1568)–Milanesi, VII, pp. 438–439.

93. Berenson, 1956, pp. 23–24. A payment of the considerable sum of one hundred ducats for frescoes in the upper floor of the Vatican still remains unclarified. Possibly these works were destroyed shortly thereafter to make way for Raphael's murals.

94. Effects of light and atmosphere were achieved by Giovanni Bellini more than a decade before Leonardo's sojourn in Venice. To Bellini, rather than to the Florentine, Giorgione's style is indebted, although Vasari with understandable Florentine pride said the reverse (Vasari (1568)–Milanesi, IV, p. 92). Richter (1937, pp. 63–64) believed that Leonardo's composition of portraits affected Giorgione's, but otherwise he discounted any influence of the Florentine in Venice.

Two great Venetian humanists and writers, Pietro Bembo and Andrea Navagero, passed long periods at the papal court, and they frequently returned to Venice in the first two decades of the sixteenth century.[95] Navagero was there on 10 November 1515, when he delivered the funeral oration in honour of Bartolommeo d'Alviano. In the following January he took charge of the library of Cardinal Bessarion and received the appointment to continue the *History of Venice* as successor of Sabellico.[96] The close association of these men with artists and with other humanists is recorded in Pietro Bembo's letter (1516) when he tells of a visit to Tivoli near Rome in company with Raphael, Baldassare Castiglione and Beazzano.[97] Thus it is no cause for wonder that Titian and other Venetian masters were well aware of the latest artistic creations of Michelangelo and Raphael in Florence and Rome. Travellers must have returned to Venice with drawings of the works of these masters. A proof of this fact is the composition (1520) of Titian's *Madonna and Child with Saints Francis and Aloysius* (Plate 24) at Ancona, which unmistakably betrays knowledge of Raphael's *Madonna of Foligno* (1511), then on the high altar of the church of the Aracoeli in Rome. No print which in any way reveals Raphael's composition had been engraved before that time.[98] Two years later, in 1522, Titian in the St. Sebastian (Plate 74) of the altar of the *Resurrection* at Brescia (Plate 72) demonstrated as clearly that he had seen drawings after Michelangelo's *Bound Slave*, now in the Louvre at Paris.

The Laocoön, discovered in 1506 in Rome, had also come to the knowledge of the Venetians by various means: Marco Dente da Ravenna (died 1527)[99] made an engraving of it, which may or may not have reached Titian before he painted the Brescia altarpiece, dated 1522. No proof whatsoever exists to support the oft-repeated statement that Titian himself owned a cast or copy of the Laocoön group.[100] On the other hand, Cardinal Domenico Grimani, who died in Rome on 27 August 1523, bequeathed to the Venetian state his collection of antiques, including a Laocoön, which he had acquired in the ancient capital. Sanuto records on 12 September 1525 that they had been installed in a room in the Ducal Palace next to the chapel.[101] If Vasari's account in his life of Jacopo Sansovino is correct, the Grimani collection included a small bronze cast made from

95. Life of Andrea Navagero in Cicogna, VI, 1853, pp. 169–348. An excellent recent biography of Bembo by Dionisotti, 1966, VIII, pp. 133–151. Titian's portrait of Cardinal Pietro Bembo, datable 1540, is in the National Gallery at Washington (Tietze, 1936, II, p. 304); to be studied in Volume II.

96. Sanuto, XXI, 10 November 1515, column 276; 30 January 1516, columns 484–485.

97. Cicogna, VI, 1853, pp. 169–348.

98. See Cat. no. 66.

99. Bieber, 1942, fig. 2; a history of the Laocoön in Amelung, 1908, pp. 181–205. For the proposed influence of the Laocoön on Titian's *Risen Christ* at Brescia, see Cat. no. 92.

100. Bieber (1942, p. 7; edition 1967, p. 18) makes the flat statement that Titian acquired a cast of the Laocoön in 1522 but gives no reference or authority. This belief seems to be based on Crowe and Cavalcaselle and on Zanetti (1771, p. 109, note), who remarks that in his youth there was in his school a head and part of the torso of the Laocoön in plaster which people said had come from Titian's house. Such a tradition

after a lapse of two centuries cannot be given serious credence. Nevertheless, those careful scholars, Crowe and Cavalcaselle (1877, I, p. 290), say that Titian owned a cast of Sansovino's copy of the Laocoön, apparently having used Zanetti's allusion as the basis for that belief. Several other writers have repeated the tradition in chain-like succession (Salis, 1947, p. 142, etc.).

The attribution to Titian of the drawing for the *Laocoön Caricature*, a woodcut attributed to Boldrini, is open to serious question, inasmuch as neither Vasari nor Dolce nor any other contemporary of the master ever makes reference to it. Although Ridolfi (1648-Hadeln, I, p. 203) first assigns the caricature to Titian, it has been widely accepted by later critics (Passavant, 1864, VI, p. 243, no. 97; Tietze and Tietze-Conrat, 1938, p. 355; Mauroner, 1941, p. 46, no. 23). Janson (1952, pp. 355–368), proposing an association with the Vesalius controversy, notes the uncertainty of Titian's authorship.

101. Sanuto, XXXIV, 27 August 1523, column 387; XXXIX, 12 September 1525, columns 427–428.

Sansovino's wax copy of the famous Hellenistic group. Vasari adds further that in 1534 the Venetian state presented this cast to Jean de Guise, Cardinal of Lorraine, who held the post of French ambassador to the Holy See.[102] Copies of the Laocoön were much in demand, a fact demonstrated by the one in plaster that Federico Gonzaga ordered in 1525 from Jacopo Sansovino, using Pietro Aretino as intermediary.[103]

Not long after the establishment of the Grimani antiques in the Ducal Palace, a number of important masters came to Venice from Rome, some for brief sojourns, others to stay permanently. During this chaotic period of the fifteen-twenties the Italian peninsula was wracked with wars and intrigues, in which the Spanish-Austrian Hapsburgs and the French were the protagonists. For the most part Venice, thanks to her geographic position and her traditional independence, remained aloof from the most devastating effects of a series of politically suicidal events. The fact that Venetian art could flourish during these years is thus in great part explained. After the sensational defeat of Francis I and his armies at Pavia on 24 February 1525 all Italy seemed doomed to fall to the imperial power of Charles V, then in his twenty-fifth year.[104]

Venice under Doge Andrea Gritti joined briefly in a Holy Alliance with France, Pope Clement VII, and Florence, but luckily the city did not become seriously involved in the tragic events that followed.[105] In September 1526 imperial troops led by Pompeo Colonna came up from Naples and entered Rome. After some relatively limited sacking of the city, the pope capitulated. Much worse lay ahead, however, for a large force of German, Spanish, and Italian mercenaries started south on their long march from north Italy, bypassing Ferrara and Mantua, which were allies of the emperor. Unpaid and half-starved, these professional soldiers sacked every town upon their route, which luckily did not lie through Siena or Florence. On 6 May 1527 the unruly mob of mercenary soldiers entered Rome, descending from the Janiculum, to sack and destroy the city to a degree unprecedented even in the time of the barbarian invasions of the fifth century. For eight days the burning and looting continued, and six thousand people were estimated to have been killed. Luckily the Vatican palace escaped serious damage, but even the papal tombs in St. Peter's were opened and robbed. Meanwhile the pope, whose foolhardiness was so largely responsible for these events, hid with his cardinals within the fortress of the Castel Sant' Angelo. The entire Christian world was shocked by the sacrilege and destruction, and Charles V himself, when

102. Vasari (1568)–Milanesi, VII, p. 489; Temanza, 1778, p. 202, note, in his life of Sansovino, repeats Vasari literally; for the life of Jean de Guise, see Moroni, XXXIX, 1846, pp. 191–192. The ultimate fate of the Sansovino bronze has not been satisfactorily determined (Weihrauch, 1967, p. 139).

A second allotment of antiques from the Grimani Collection is recorded under date of 19 December 1528 by Sanuto (XLIX, column 264). The same items are listed in an inventory of 22 December 1528 (Levi, 1900, II, pp. 3–4). Included in this inventory is a Laocoön without the sons, which were in the possession of the Patriarch. Therefore a second copy of the group may be involved here. However, Paschini (1928, pp. 149–150) believed that only this partial copy was left to the

Venetian state. A small portion of Cardinal Grimani's antiques is still preserved in the Archaeological Museum at Venice; for an important study of the Grimani Collection, see Paschini, 1928, pp. 149–190.

103. Baschet, 1866, pp. 122, 124, 125, 128. This item later appears in a mid-sixteenth-century inventory of Isabella d'Este's collection as 'Laochonte moderno' (D'Arco, 1857, II, p. 135).

104. A vivid if somewhat emotional account of these years by Gregorovius, 1902, VIII, part 2, pp. 461–485.

105. The treaty of alliance was signed 14 February 1526 (loc. cit., p. 498).

the news reached him in Spain at the end of June, ordered public mourning. Secretly he and the enemies of the pope were pleased at the humiliation of Clement VII.[106]

Painters, sculptors, and men of letters fled for their lives, many of them never again to return to Rome, the acknowledged capital of the world. Venice gained thereby, since many great men came to stay. Among them was Jacopo Sansovino, the Florentine architect and sculptor, who left his career in the papal city to become the major figure in the rebuilding of the Piazza of St. Mark's, the library of St. Mark's, as well as palaces and churches. Sansovino had reached the island city before October, as had the Venetian-born Sebastiano del Piombo, who had been resident in Rome since 1511. Reference to their arrival appears in a letter of 6 October 1527, written at Venice by Pietro Aretino, who promised Federico II Gonzaga that Sansovino would carve a statue of Venus for him and that Sebastiano would paint a picture of whatever subject Federico desired.[107] Aretino himself had settled in Venice in March of the same year, but was often in Mantua at the behest of his major patron of the moment.[108] All three men had been friends for many years in Rome, and Aretino's activities in Venice, as intermediary, served both the artists and Federico Gonzaga well. Sebastiano, the Venetian, was the only man among them who chose to return to Rome, where he remained close to the papal court from March 1529 until his death in 1547.[109] Serlio, architect and writer on architecture, also left Rome at the time of the sack for a haven in Venice, where he lived with his numerous family until his departure for Paris in 1541.[110]

The presence of these men in Venice from 1527 explains virtually all indications of central Italian influence upon Venetian masters thereafter. Titian's *Martyrdom of St. Peter Martyr* (Plate 154), which was under way at this time and not completed until 1530, might have differed completely so far as the Michelangelesque figures are concerned, had it not been for the influx of artists from Rome. Sebastiano del Piombo brought the mature Michelangelo's style, as a result of the friendship of the two masters, so close that the Florentine master supplied drawings for certain of Sebastiano's pictures, a fact reported by Vasari and accepted by modern critics.[111] Michelangelo's own sojourn in Venice came slightly later, from 25 September 1529 until 9 November.[112] Then in flight to Venice from besieged Florence, he even thought of taking refuge at the court of Francis I of France. It is unlikely that he engaged in any artistic activity during his six weeks in Venice,

106. *Loc. cit.*, pp. 549–622 and *passim*. For the sack of Rome also see Pastor, 1908, IX, pp. 377–423 and Antonio Rodríguez Villa, *Memorias*, Madrid, 1875.

107. Aretino, *Lettere*, edition 1957, I, p. 17. Aretino promised 'a Venus so true and so alive that she will fill with desire the thoughts of everyone who looks at her'. For a brief but excellent account of Sansovino's career see Mariacher, 1962; also Weihrauch, 1938, pp. 465–470.

108. Aretino, *Lettere*, edition 1957. Aretino's life by Mazzuchelli (1763) with commentary by Camesasca, 1959, III, p. 33.

109. Ludwig (1903, pp. 110–112) publishes documents relating to Sebastiano del Piombo in Venice during 1528. An unfortunate typographical error changed the year to 1526 (Pallucchini, 1944, p. 66). There is some confusion of date in the

theory that Sebastiano visited Orvieto in late March 1528 (Pallucchini, *loc. cit.*; A. Luzio, *Isabella d'Este e il sacco di Roma*, Milan, 1908, pp. 134-135).

110. His will drawn up in Venice on 1 April 1528 and the dangers of life in Rome presuppose his departure the previous year (Ludwig, 1903, p. 42; Dinsmoor, 1942, p. 64).

111. Vasari (1568)–Milanesi, V, pp. 568–571; Freedberg, 1961, pp. 374–396.

112. Tolnay, 1948, III, pp. 10–11; Vasari (1568)–Milanesi, VII, p. 199, states apparently incorrectly that Michelangelo made a design for a new Rialto bridge for Doge Andrea Gritti (1523–1538). Later in 1535 Michelangelo sent Pietro Aretino at Venice some drawings of his Medici tombs at Florence (Aretino, *Lettere*, edition 1957, I, pp. 24–25).

before his return to Florence, but the force of his personality and his fame must have been felt by Titian and other Venetian masters, who met him then for the first time. The following year Rosso Fiorentino also stopped briefly in Venice on his way to France, where he was to become the founder of the school of Fontainebleau.[113]

TITIAN AND CHARLES V

AFTER the sack of Rome in the eventful year of 1527, which brought to Venice so many important artists from central Italy, Titian was to enjoy even more extraordinary experiences as the fourth decade of the century approached. On 29 May 1529 Charles V and the envoys of Pope Clement VII signed a treaty of peace in Barcelona,[114] and by the end of October preparations were under way for the coronation of Charles as Holy Roman Emperor at Bologna. After a fabulous display of pomp and pageantry Clement VII placed the imperial crown upon Charles's head in San Petronio on 24 February 1530.[115] The new emperor's stay in Bologna lasted from his formal entry into the city on 5 November 1529 until his departure for Mantua on 22 March 1530. At some point during this period, presumably in January, Titian was undoubtedly introduced to Charles, whose portrait in full armour he painted then for the first time. Although Vasari[116] attests that Pietro Aretino had arranged with Cardinal Ippolito dei Medici to bring the artist to Bologna in 1530, it appears more likely that Federico Gonzaga was responsible for the meeting, since Charles was then in closer alliance with the Gonzaga at Mantua than with the Medici. In addition, a false rumour was circulated at that time to the effect that Charles gave Titian only one ducat for the painting and that Federico added one hundred and fifty ducats to reward the artist properly. The person who spread this gossip was none other than Benedetto Agnello, agent of Gonzaga, but the story is denied as slanderous in a letter written at Venice on 18 March 1530 by Leonardi, an agent of Francesco Maria della Rovere of Urbino, who reported to his employer that Charles V had been slandered.[117] From these events we can understand that Italy was rife with rumour for and against the triumphant emperor, who at that very time was still in Bologna, whence he departed on 22 March for a stay in Mantua until late in April, when the imperial entourage set forth for Germany.[118]

Leonardi's letter of March 1530 does prove beyond a doubt that Titian painted Charles V's portrait early in 1530, at Bologna.[119] Vasari's account of the affair is confused by the information that the emperor sat at that time for both Titian and Alfonso Lombardi, the Venetian sculptor, and that he awarded them five hundred *scudi* each. These portraits actually came later at Bologna

113. Freedberg, 1966, p. 582.
114. Pastor, x, 1910, p. 56.
115. Pastor, *loc. cit.*, pp. 77–96; an eye-witness account of the events in *Cronica del soggiorno di Carlo V in Italia*, published by G. Romano, Milan, 1892, pp. 245–280.
116. Vasari (1568)–Milanesi, vii, p. 440. Vasari would have

preferred a Florentine to have a major part in these arrangements.
117. Gronau, 1904, p. 13.
118. *Cronica . . . Carlo V.* pp. 236–283.
119. Crowe and Cavalcaselle (1877, I, p. 336) mistakenly doubted that Titian was in Bologna in 1530 because the artist makes no reference to these events in his preserved letters.

in February 1533, as attested by a letter of the last day of the month which specifically records both Titian's and Lombardi's portraits and the emperor's payment for them.[120]

The great problem is to decide which of the lost portraits by Titian should be placed at Bologna in 1530 and which in 1533.[121] Giovanni Britto's woodcut reproduction of a half-length portrait in full armour and with drawn sword resting against the right shoulder shows the emperor as a young man and therefore may possibly reflect one of Titian's earliest portraits.[122]

The knotty problems of these portraits of Charles V, about which considerable literature is available, are deferred until volume II of this work.[123] That they established the artist as the emperor's favourite painter no doubt can be entertained, for immediately on his return to Spain in May 1533 Charles V issued a royal decree conferring upon Titian the titles of Knight of the Golden Spur and Count Palatine with the rank of nobility also granted to his descendants.[124] Titian rose by dint of his own genius to the highest social rank that any artist could hope to attain. Later when, according to Pietro Aretino's letter of 11 July 1539, Charles V invited him to Spain, he wisely chose to remain in Italy.[125] The eminence of the artist in the mind of the emperor has been embellished by the story that, when painting Charles's portrait in 1533, Titian dropped a paint brush, whereupon Charles V picked it up with the remark that Titian deserved to be served by the emperor. Related by various writers, this is one of those myths of popular origin presumably circulated by word of mouth.[126]

120. Braghirolli, 1881, p. 25; letter repeated by Beroqui, 1946, p. 51. Vasari embroidered upon this account with a tale to the effect that Alfonso Lombardi accompanied Titian into the emperor's presence and secretly modelled his portrait, which on completion he showed to Charles, who promptly ordered Titian to give the sculptor half of his payment of one thousand *scudi* (Vasari (1568)–Milanesi, V, pp. 88–89).

121. (Ridolfi (1648)–Hadeln, I, pp. 170–171) seems to have been confused in thinking that the equestrian portrait of Charles, actually commemorative of the battle of Mühlberg of 1547, had been painted in Bologna in 1530. He had never seen this famous work, now in the Prado Museum. Milanesi made the same error (Vasari (1568)–Milanesi, VII, p. 440, note 4). On the contrary, Annie Cloulas (1964, pp. 214–215) proposed that the equestrian Charles V, variously attributed to Rubens or Van Dyck (Salvini, 1961, p. 102), in the Uffizi at Florence does reflect one by Titian of 1530. Nevertheless, Tizianello (1622, edition 1809, p. VI), who first describes the presumed portrait, places it in Bologna in 1533: 'Charles in white armour on a very fierce horse.'

122. Illustrated by Mauroner, 1941, pl. 27.

123. Rubens' copy of the portrait of Charles V with drawn sword (*c.* 1533 or 1536) appears contemporary with the artist's second visit to Spain in 1628 because of the mature style; the original by Titian may have been painted at Asti in 1536; illustrated by Glück, 1937, pp. 169, 171.

A considerable controversy has arisen about the portrait of *Charles V with a Hound* in the Prado Museum. The costume of silver cloth resembles a description of Charles's accoutrement at Bassano on 2 November 1532 (Sanuto, LVII, column 194) and there is mention of a hound accompanying him at Verona (7 November 1532, Sanuto, LVII, column 217,

'Veniva sopra uno caro uno cano grande corso'); consequently the portrait has been dated in 1532–1533 (Beroqui, 1946, pp. 51–52).

German scholars have emphasized the date of 1532 on Jacob Seisenegger's portrait of Charles V at Vienna and have concluded that Titian simply copied the young German painter, who was then twenty-seven (Glück, 1927, pp. 224–242; Löcher, 1962, pp. 32–37). On the other hand, it has been doubted that Charles V would have knighted Titian for having copied a picture by a less-known artist (Cloulas, 1964, pp. 219–220), and the argument of method of composition has been used on both sides of the issue (Löcher, 1962, p. 34; Nordenfalk, 1947–1948, pp. 55–56). Titian undoubtedly painted more than one portrait of Charles V at Bologna in 1533, especially if, as seems likely, his *Charles V with Hound* is a copy after Seisenegger.

124. The original decree of knighthood, dated 10 May 1533 at Barcelona, is now exhibited in the House of Titian at Pieve di Cadore. First published by Ridolfi with a typographical error making the year 1553 (Ridolfi (1648)–Hadeln, I, pp. 180–182), the document was cited with the wrong date by later writers. Palomino (1714, edition 1947, p. 793) thought that Titian had gone to Barcelona to be knighted, and he added a legend to the effect that Titian also became a knight of Santiago, the most exalted of Spanish orders. Cadorin (1833, p. 68), having seen the original decree, corrected the date to 1533, which is known to all modern writers; later full publication by Beltrame (Milan, 1853).

125. Aretino letter of 11 July 1539 to Leone Leoni (*Lettere*, edition 1957, I, p. 130).

126. Ceán Bermúdez, 1800, V, pp. 31–32, an elaborate account; Ticozzi, 1817, p. 101; Cadorin, 1833, p. 66.

TITIAN AND THE GONZAGA OF MANTUA

After the emperor's departure at the end of February 1533, Titian, remaining in Bologna for a few days longer, wrote to Federico Gonzaga on 10 March that he would not stop at Mantua because of the duke's absence. He promised to send Gonzaga a copy of the emperor's portrait, which he was taking with him, undoubtedly to finish it in Venice.[127] At this period (1530–1536) the master was negotiating with the monks of San Benedetto da Polirone in the region of Treviso and those of San Giorgio at Venice for the purchase of lands, a project for which he sought the aid of Duke Federico.[128] He made at least one visit to Mantua, probably in May 1536,[129] a time at which he must have agreed to paint a series of twelve Roman emperors for the Ducal Palace, just as he was in the midst of one of his most important commissions, the large *Presentation of the Virgin* (1534–1538) in the Accademia at Venice (Plates 36–39).

Known today in Aegidius Sadeler's engravings, Jacopo Strada's drawings, and several inferior copies, the *Caesars*, as they were called, drew much admiration from Titian's contemporaries, as is shown by the numerous copies made of the entire series.[130] As a matter of fact Titian delivered only eleven pictures of Roman emperors and Giulio Romano supplied the twelfth.[131] *Augustus*, the first canvas to be finished, arrived in Mantua early in April 1537, and by September three more were ready. In a series of letters between Federico Gonzaga and his agent in Venice, Benedetto Agnelli, the gradual progress of the work can be followed; among them a communication of 23 August 1538 promised the pictures soon, followed by a letter of 3 September in which Agnello wrote in the name of Titian, who having served well with the *Caesars* and the *Portrait of the Turk*, should receive his pension. Federico later expressed his satisfaction by inviting the artist to spend Christmas at Mantua, no doubt in the hope of wheedling further and new works from him.[132]

The importance of the *Caesars* in the evolution of Titian's art has been almost totally overlooked,

127. C. and C., 1877, I, pp. 456–457. This lost replica of the portrait was not dispatched to Mantua from Venice until 30 April 1536 (*loc. cit.*, p. 458). See also Braghirolli, 1881, pp. 29–30; Gaye, 1840, II, p. 262.

128. Braghirolli, 1881, pp. 11–16, 26–27.

129. On 30 April 1536 Agnello wrote to Mantua that Titian would come soon (*loc. cit.*, p. 30).

130. Eight prints are reproduced by Suida, 1935, pls. 124–125. Small reproductions of the series are in Valcanover, 1960, II, pl. 191. Drawings attributed to Jacopo Strada, datable 1567–1568 (Verheyen, 1967, pp. 64–68, illustrations), give a better idea of the quality of these portraits.

The *Roman Emperors* passed to Charles I of England with his purchase of the Mantuan gallery in 1628 (Luzio, 1913, p. 89; van der Doort, 1639, Millar edition, 1960, pp. 226–227). Acquired for Philip IV of Spain at the sale of Charles I's possessions in 1650, they are recorded in the royal palace in Madrid until their destruction in the fire of the palace in 1734 (Bottineau, 1958, p. 151, nos. 219–230). No mention of these pictures occurs in the inventories subsequent to the fire, in which three thousand five hundred paintings were destroyed.

Accounts of the copies: C. and C., 1877, I, pp. 420–424; Wielandt, 1908, pp. 101–108 (mistakenly thought that the copies in the Munich Residenz were the originals); Gronau, 1908, pp. 31–34 (corrects Wielandt).

131. Vasari (1568)–Milanesi, VII, p. 442: 'he made twelve heads, more than half length, of twelve Caesars, very beautiful, under each of which, Giulio made a story of their deeds.' The Inventory of 1627 cites eleven by Titian and one by Giulio Romano (Luzio, 1913, pp. 89–90). In an account of the room, which includes stories of the lives of the emperors by Giulio Romano, Hartt (1958, I, pp. 170–176, fig. 386) states that eleven *Caesars* were placed upon the upper wall and the twelfth in the middle of the ceiling. A reconstruction of the arrangement of the Cabinet of the Caesars using Strada's drawings was made by Verheyen (1966, pp. 170–175), who believes that the twelfth Caesar by Giulio Romano was attached to the door leading to the Camera degli Falconi (Verheyen, 1966, p. 172, note 64).

132. Braghirolli, 1881, pp. 31–87, *passim*; C. and C., 1881, I, pp. 458–459, II, pp. 497–499.

3

and quite naturally, in view of their destruction over two centuries ago. In them the artist revived antiquity by painting images of 'Roman Emperors' as accurately as possible, with something of the same enthusiasm that infused Mantegna in his series of the *Triumph of Caesar*. More fully than at any other time in his life Titian embraced the cult of the antique. In preparation for these canvases he must have studied the *Twelve Caesars* by Suetonius, an historian and friend of Pliny the Younger, as well as chief secretary to the emperor Hadrian. This writer's works included such diverse themes as *Roman Festivals*, *Lives of Famous Whores*, *Offices of State*, and *Grammatical Problems*. Titian's portraits represented the same emperors whose biographies Suetonius reconstructed, with the exception of Domitian, and they were arranged in the same sequence.[133] The rulers, dressed in armour of freely Roman and Renaissance design, carried the baton of authority in most cases, and four of them had a laurel wreath upon the head. Many collections of Roman marbles were available for Titian to study in preparation: Pietro Bembo's at Padua, the ducal collection in Mantua, which was already famous in the time of Mantegna,[134] but above all the Grimani antiques in their palace at Venice and their bequest to the Ducal Palace. This last collection of marbles alone included nine busts, among them Vitellius, Julius Caesar, and Marcus Aurelius,[135] which were obviously well known to Titian. In addition, as late as 1597 statues of Augustus and Marcus Agrippa, which had remained in the court of the Grimani palace, were subject to controversy because the family appeared unwilling to turn them over to the state.[136] Moreover, twelve Roman emperors in marble, also said to have been gifts of Cardinal Domenico Grimani, later set up in the Library of St. Mark's, must have been visible to artists as early as 1523, when the cardinal died.[137] The fact that Titian pored over Roman marbles as well as cameos and coins, the last surely for the heads, is reliably attested by his friend Lodovico Dolce, who also drags in the myth, applied centuries ago to ancient Greek artists, to the effect that people who looked at the portraits thought that they were real people and not pictures.[138]

The *Roman Emperors*, as they appear in Sadeler's prints and other painted copies, look unpleasantly realistic of face and excessively burly and gigantic of body, virtually on the scale of the colossal bronze Hercules of late Roman date in the Capitoline Museum at Rome. Yet the exaggerated hardness of form is surely to be ascribed to the incompetence of the copyists, and we must

133. Verheyen, 1966, p. 173.
134. Although some of Bembo's antiques are listed by Marc-antonio Michiel in 1530 (edition, 1884, pp. 53–58), the collection has never been reconstructed (Dionisotti, 1966, p. 146); in fact knowledge of most of the works owned by these men is slight. The ducal collection at Mantua, which existed in the fifteenth century thanks to the efforts of Andrea Mantegna, was richer. An inventory of the mid-sixteenth century lists the antiques formerly in Isabella d'Este's collection, among which was the Faustina which had belonged to Mantegna (D'Arco, 1857, II, p. 134). Andrea Odoni, the Venetian collector, owned some marbles; see his portrait by Lorenzo Lotto at Hampton Court (Berenson, 1956, pls. 219–221); also his collection in 1532 (Michiel, English edition, 1903, pp. 96–102).
135. Paschini, 1928, p. 155; an inventory in 1586 of the marbles

bequeathed earlier (1523) by Cardinal Domenico Grimani. The great quantity of cameos and medals in the possession of Cardinal Marino Grimani in Rome in the Inventories of 1528 and 1551 provides an insight into the extraordinary richness of such collections (Paschini, pp. 157–159, 183–190).
136. Paschini, 1928, p. 168.
137. Some of these busts must have been among those earlier mentioned. Since the Library of St. Mark's was begun only in 1536, it is certain that the statues were not in place until much later. In fact, they are not mentioned there by Francesco Sansovino in 1581, but in the later edition in 1663 (Sansovino-Martinioni, p. 312). See also notes 101, 102.
138. Dolce, 1557, edition 1960, p. 206. At Mantua there were busts of twelve Caesars in marble, located 'nel salone', according to an inventory of 1627 (Luzio, 1913, p. 149).

assume that the original quality was in no way lower than Titian's normally supreme level, which can be better judged by his *Hannibal*, an unpublished work in a private collection at New York.[139]

During Titian's visits to Mantua in the fifteen-thirties he had ample opportunity to study Giulio Romano's frescoes in the Ducal Palace and in the Palazzo del Te. There can be little doubt that Titian looked at the art of Raphael's pupil and that Giulio Romano's brand of Roman Mannerism in its later development did make an impression upon the much greater Venetian artist. The giant muscular males in whom Giulio imagined to reincarnate the ancients, nude or in armour, do anticipate Titian's *Emperors*. Not they alone, but even Giulio's St. Longinus in his *Nativity* now in the Louvre belongs to the same race of supermen.[140] In the *Roman Emperors* Titian embraced most fully the current and fashionable aspects of Mannerism, and at the same time whole-heartedly adopted the cult of antiquity. The impact of Giulio Romano's frescoes in the Ducal Palace and the Palazzo del Te has frequently been stressed, particularly in Titian's ceiling paintings of Old Testament scenes in the sacristy of S. Maria della Salute at Venice (Plates 157–159). The foreshortening of the compositions to be viewed from below (*di sotto in sù*) is new to the Venetian's work (1543–1544), but ample precedent exists in Giulio's ceiling of the Hall of Psyche (1528) in the Palazzo del Te. Nevertheless, Titian observed the method of design rather than specific figures, and he put his observations to effect in his highly original and much superior pictures in Venice.[141]

TITIAN AND HIS CONTEMPORARIES: 1535–1545

FURTHER central Italian incursions into Venice took place in 1539–1541 with the visit of Francesco Salviati, accompanied by his pupil Giuseppe Porta, known also as Salviati. Their ceiling decorations in the Palazzo Grimani at S. Maria Formosa, as well as those of Giovanni da Udine in the same palace, seem to have had little effect upon Titian, although their influence on Tintoretto was considerable. Francesco's drawing after Michelangelo's still incomplete *Last Judgment*, which he gave to Pietro Aretino, must have been examined with great attention by Titian and his circle.[142]

Vasari also entered the Venetian scene; arriving on 1 December 1541, he remained until September 1542. None other than Titian's close friend, Pietro Aretino, had called the Florentine painter to Venice to design the scenery for his play 'La Talanta', which was performed in February 1542. Vasari's activities during these months included a ceiling of allegorical figures in the Palazzo Corner-Spinelli, a work which has been reconstructed by Dr. Juergen Schulz, who has demonstrated the importance of Vasari's stay in Venice in establishing a model for ceiling painting that

139. Long thought to be lost; dated 1532–1534 (Gronau, 1904, p. 9).

140. Hartt, 1958, I, p. 208, fig. 441; datable *c.* 1531.

141. See Cat. nos. 82–84, 111. Hetzer (1923, pp. 237–248) first discussed Titian's relationship to Giulio Romano at Mantua.

Some writers have exaggerated the dependence here in seeing figure-for-figure repetitions.

142. Cheney, 1963, p. 347; she discounts any influence by the Salviati on Titian at this time. Pallucchini, 1950, pp. 22–24, held a different view.

made an impression upon Titian but even more on Paolo Veronese.[143] As a matter of fact Vasari himself, originally engaged to paint the ceiling of S. Spirito in Isola at Venice, suddenly decided to return to Florence with the result that Titian fell heir to the commission. That the Venetian master must have seen Vasari's sketches is obvious, but that his adoption of the Florentine's methods was limited to the general point of view hardly needs to be stated. Such is the case in the Salute ceiling and that of S. Giovanni Evangelista (Plates 156–159).

During these years Titian created one of his greatest and most original compositions, the *Christ Before Pilate* (1543) in Vienna (Plate 91), a stirring, animated scene in which the clamour of the crowd brings the tragedy of the Passion of Christ to a near-climax. How unlike the tranquil *Presentation of the Virgin* (Plate 36), finished only five years earlier. In both cases the Venetian tradition of pageantry and spectacle, native to the life of that aristocratic state, is maintained. From the grandiose scenes of Jacopo Bellini's 'Sketchbook', through the *Miracles of the Cross* of Gentile Bellini and Carpaccio, and the *Procession on Corpus Christi* of Giovanni Bellini, the Venetian pageant characterizes the pictorial traditions of the city.[144] In both of Titian's compositions a large flight of steps mounts against an imposing architectural setting, but in the earlier picture the crowd is stately and reposeful, producing an effect of serenity and grandeur in the architectonic style of the High Renaissance. The fact that in the *Christ Before Pilate* the mood has so completely altered is explicable, not solely by the cruel nature of the event portrayed, but still more by the deepening of Titian's experience, which led him into new directions. In the undercurrent lies his increased knowledge of central Italian Mannerism, a term that, however, cannot alone explain the profundity of this work.[145] The huge rusticated structure at the left, so like the most advanced architecture of Serlio, Sansovino, and Sanmicheli, is placed obliquely so that the gesticulating figures mount across the diagonal steps with a resultant increase in the tempo of opposed forces. The abstract design of the figures starts at the lower left, rising to an apex in the upraised arms of the shouting men, then falls back to the girl in white, only to rise again toward the mounted horsemen and to come to a halt at the square pier behind them. The brilliancy and the imaginative qualities of this composition have no exact precedent in Titian's art hitherto. On the contrary, *Christ Before Pilate* (Plate 91) points ahead to further new conceptions in such late works as the *Martyrdom of St. Lawrence* (Plate 178) and the great mythological pictures destined for Philip II of Spain.

The fourth decade had been a busy period for Titian, beginning with the portraits of Charles V, followed by the *Roman Emperors* for Mantua, at the very time that he was painting the large processional composition, the *Presentation of the Virgin* (Plate 36), for the Hospital of Charity in Venice. Moreover, he found time to create the handsome and famous *Annunciation* (Plate 59) for the nuns of S. Maria degli Angeli at Murano, which, after they rejected it as too expensive, he presented to the Empress Isabella on the shrewd advice of Pietro Aretino (1537). In spite of his knighthood and other honours conferred on him, Titian had been unsuccessful in extracting payment

143. Schulz, 1961, pp. 501–511; also 1968, pp. 15–21.

144. Jacopo Bellini's 'Sketchbook' in the British Museum, London and in the Louvre, Paris (V. Golubew, *Die Skizzen-* *bücher Jacopo Bellinis*, Brussels, 1912, 2 vols.); the paintings by the Bellini and Carpaccio are in the Accademia at Venice.

145. For Titian and Mannerism, see Frey, 1960, pp. 102–108.

for his pictures from the ever-bankrupt Spanish crown. Aretino foresaw that the gift would touch the emperor's heart, as indeed it did, to the extent that he promptly dispatched two thousand *scudi* to the artist.[146] The previous year, in May 1536, Titian had accompanied the Duke of Mantua to Asti to meet Charles V, then on a triumphal tour from Naples and Rome. It is altogether probable that the artist again painted the emperor's portrait.[147]

As if all of these numerous activities were not enough, Titian was forced to complete the *Battle of Cadore* in 1537, and he carried out several important commissions for the Duke of Urbino and the Duchess, who was Eleanora Gonzaga, sister of the Duke of Mantua. Their two portraits in the Uffizi are among the artist's best-known works (1536–1538). Just at this time too he created the celebrated *Venus of Urbino*, now in the Uffizi, which is by unanimous agreement one of the finest of all Renaissance studies of the female nude.[148]

The fifteen-forties saw Titian at the height of his fame, his services sought constantly by Charles V, by Pope Paul III at Rome, and by the princes of Italy. After his numerous trips to Mantua, Ferrara, and Bologna in the two preceding decades, he now had to travel even more frequently and farther afield. Nevertheless, he managed to produce in the forties the Old Testament Subjects (Plates 157–159) and the *Pentecost* (Plate 104) as well as the *Christ Before Pilate* now in Vienna (Plate 91), the *Christ Crowned with Thorns* in Paris (Plate 132), and numerous other religious compositions in addition to portraits of the Farnese family and members of the Hapsburg court. In August 1541 Titian set out for Milan to see the emperor, according to Aretino's letter of the thirteenth of the month.[149] On this occasion he presumably took with him the finished canvas of the *Allocution of the Marchese del Vasto* for delivery to this general of Charles V who served as governor of Milan.[150] Charles had bestowed a pension of one hundred *scudi* annually for life upon the artist.[151] Even though later at Augsburg, on 10 June 1548, the emperor reconfirmed the award and even increased the sum to two hundred *scudi*, Titian was unable to collect the funds until eleven years later, when he sent his son Orazio to Milan for that specific purpose.[152]

Titian's next meeting with the emperor took place at Busseto, not far from Cremona, a village now better known as the birthplace of Giuseppe Verdi, chosen then as neutral ground on which to discuss matters of dispute between the Farnese pope and the emperor. During the four days of negotiations from 21 to 25 June 1543 no final agreements were reached about problems concerning the Council of Trent or the pope's desire to have the governorship of the duchy of Milan

146. See Cat. no. 10.
147. Perhaps *Charles V in Armour with drawn Sword*, known in Vorsterman's print and Rubens' partial copy (Glück, 1937, pp. 168–171). Letters about the trip to Asti in C. and C., 1877, I, pp. 407, 458.
148. Gronau, 1904, pp. 9–10, for documents. Despite the incredible productivity of the fifteen-thirties Hans Tietze (1936, I, pp. 144–168) entitles this period of Titian's activity a 'creative pause' (*schöpferische Pause*).
149. Aretino, *Lettere*, edition 1957, I, p. 193.
150. Braunfels, 1960, p. 110.

151. In 1541: Voltelini, 1890, nos. 6343 and 6404, the second also in Gaye, 1840, II, pp. 369–370.
152. The original edict of 1548 in the Hispanic Society in New York in *A History of the Hispanic Society of America*, New York, 1954, fig. 289. A study of this manuscript concerning Titian's pension remains unpublished in the Hispanic Society archives (Penney, 1945). On 25 December 1558 Philip II ordered the full sum of two thousand *scudi* to be paid to Titian (Ridolfi (1648)–Hadeln, I, pp. 187–188). Account of Orazio's visit to Milan in 1559 to collect the funds (C. and C., 1877, II, pp. 272–274; 513–514; Cloulas, 1967, pp. 234–235, publishes Titian's letter of 12 July 1559).

transferred to his grandson, Ottavio Farnese, who had married the emperor's natural daughter, Margaret of Parma.[153] Surely Charles V had no time to sit for Titian during these busy days, but he did order a portrait of Isabella, his wife, who had died four years before. This work, now lost and known only in copies and in a print by Peter de Jode, was painted after an earlier model with which Charles supplied the artist.[154]

Titian, then in the train of Cardinal Alessandro Farnese, had met the suite at Ferrara in late April, and after accompanying the papal court to Busseto and travelling on with it to Bologna, he returned to Venice at the end of July.[155] During these three months he had the opportunity to make studies and to begin several portraits of the pope, of Cardinal Alessandro Farnese, and of other members of the same family. One of Paul III was rapidly completed, apparently begun at Bologna and finished before July, a surprising fact in view of Titian's usually slow technical methods.[156] In July 1543 Aretino heaped praise upon the 'miracle made by your brush in the portrait of the pontiff', presumably *Paul III Seated* without beretta, now in the museum at Naples.[157]

TITIAN IN ROME

IN the same letter of July 1543 Aretino praised Titian for rejecting a papal offer to become the keeper of the seals, the point being that his Venetian-born friend Sebastiano del Piombo had held the post since 1531,[158] and Titian would have been most ungracious had he deprived Sebastiano of his income of eighty ducats yearly. On the other hand, Titian did accept an invitation to Rome, and his visit eventually came about in spite of many complications. One of his reasons for making the trip lay in the hope of a benefice for his son Pomponio; that would at least reward the artist for the portraits painted at Busseto and Bologna, for which the Farnese had paid him little or nothing at all.[159] Consequently in September 1545 Titian set out with his son Orazio, then scarcely twenty years old, by way of Ferrara and Pesaro. He was received with virtually royal honours by Duke Guidobaldo della Rovere of Urbino, who sent him, after a brief sojourn at Pesaro, with an escort

153. Pastor, 1914, XII, pp. 169–186.

154. Aretino, *Lettere*, edition 1957, II, pp. 9–10; Glück, 1933, pp. 204–209; Beroqui, 1946, pp. 61–66. This portrait will be catalogued in Volume II.

155. Cittadella, 1868, p. 599: 22 April 1543 in Ferrara. A letter of 26 July 1543 from Venice to Cardinal Alessandro Farnese was written immediately upon Titian's return from Bologna (Ronchini, 1864, pp. 131–132 and in translation by C. and C., 1877, II, p. 85). The Titian-Farnese letters were first published by Ronchini and subsequently in Italian and in English translation by Crowe and Cavalcaselle.

156. Payment of two *scudi* and 20 *bol* for shipping the picture is dated 22 September 1543; fifty gold *scudi*, for expenses of the return to Venice on 8 July 1543 to Titian, seem to be the extent of the remuneration for the portrait (documents in Bertolotti, 1884, p. 18; repeated by Venturi, 1928, p. 145, but he gives the date of shipment as 27 May).

157. Aretino, *Lettere*, edition 1957, II, p. 8. The Farnese portraits will be catalogued in Volume II. The extensive bibliography on the subject includes the standard monographs on Titian; museum catalogues; Clausse, 1905; Rinaldis, 1911; Tietze-Conrat, 'Titian's Portraits of Paul III', 1946, pp. 73–84; Causa, 1960; Pope-Hennessy, 1966; and numerous articles.

158. Vasari (1568)–Milanesi, V, p. 576 and VI, p. 560; Pallucchini, 1944, p. 67, note 144. Titian later was offered and again refused the same benefice, a fact revealed in his letter to Cardinal Farnese, dated 18 June 1547, in which he said that if offered a third time he might accept. The explanation is that Sebastiano had died earlier that month (Ronchini, 1864, p. 137; C. and C., 1877, II, pp. 144–145).

159. Vasari (1568)–Milanesi, V. pp. 627–628, in the life of Perino del Vaga says that Titian was not paid, but see above, note 156.

to the papal court at Rome.[160] There the artist was magnificently established in the Belvedere Palace at the Vatican, provided with a studio, and given every facility to study the antiques in the papal collections as well as the numerous works of the Renaissance period, among them the recent masterpieces of Michelangelo in the Sistine chapel and the frescoes of Raphael in the Vatican halls. Vasari himself, then at work on the murals in the Cancelleria Palace, acted as Titian's guide, reported the residence in the Belvedere, and listed the pictures which the artist painted at this time.[161] By mischance Titian's letters penned at Rome to Aretino and other friends in Venice have been lost, with the result that his own words describing his reactions to the grandeur of Rome are wanting. Aretino in Venice enthusiastically wrote that he could scarcely wait to hear the Venetian's opinions of the antiquities, whether he considered them better than Michelangelo's sculpture, and what he thought of Raphael, Sebastiano del Piombo, and Bramante.[162] We have, nevertheless, Cardinal Bembo's reliable word that Titian, as a true man of the Renaissance, was astonished and delighted by the antiquities of ancient Rome.[163]

The major results of Titian's sojourn were the portraits of Paul III and members of his family, particularly the group of *Paul III and His Grandsons*, the pope with Cardinal Alessandro Farnese and his brother Ottavio, one of the greatest masterpieces in the history of portraiture, although unfinished.[164] Never has portraiture been so dramatically achieved, not alone through movements and attitudes of bodies and characterizations of heads, but also in the incisive contrasts between the restrained and intellectual Cardinal Alessandro, the scheming Ottavio, and the wily, suspicious old pope. No considerations of sources or historical relationship are of any consequence in the presence of such penetrating psychological analysis, compositional mastery, and harmony of colour.

Titian's familiarity with High Renaissance achievements of central Italy are detectable in his own works long before his visit to the Roman capital. The *Assumption* of the Frari, the St. Sebastian of the Brescia altar, and the *Martyrdom of St. Peter Martyr* (Plates 18, 74, 154) demonstrate his knowledge of Michelangelo's achievements through drawings, as previously noted. Raphael, whose composition of the *Madonna of Foligno*, now in the Vatican Museum, was the source of Titian's *Madonna with SS. Francis and Aloysius* in Ancona (Plate 24) as early as 1520, may even have been a partial source of inspiration slightly earlier in the *Assumption* of 1516–1518 (Plates 18–22). Titian's high regard for the Umbrian-born master continued during the stay in Rome, when he surely sketched the group in Raphael's tapestry of the *Miraculous Draught of Fishes*, and subsequently on his return to Venice

160. The itinerary was reconstructed by Crowe and Cavalcaselle (1877, II, pp. 112–113) from the letters of Aretino and Pietro Bembo. Bembo's letter of 10 October 1545, written at Rome to Girolamo Quirini, implies that Quirini had urged Titian to visit the papal court, and it mentions the sojourn at Pesaro and the escort which the Duke of Urbino provided for the rest of the journey to Rome (Bembo, edition Venice, 1830, pp. 238–239). Aretino speaks further of Titian's gratitude for the favours shown by the duke in a letter dated Venice, October 1545 (Aretino, *Lettere*, edition 1957, II, pp. 95–96).

Aretino also records, in passing, Titian's stop at Ferrara (*loc. cit.*, p. 97).

161. Vasari (1568)–Milanesi, VII, pp. 446–448. Writing twenty years later, Vasari placed the year of Titian's arrival in Rome in 1546 instead of 1545.

162. Aretino to Titian at Rome, October 1545 (Aretino, *Lettere*, edition 1957, II, pp. 106–107).

163. Letter of 10 October 1545. See note 160, above.

164. Pope-Hennessy, 1966, p. 148, on the contrary regards it as an unachieved masterpiece.

he placed the same figures in the background of his large altarpiece (Plates 46, 48) at Serravalle, which he seems to have completed during the months immediately after his return from the papal court.

Just how great was the importance of Titian's study of the ancient temples and sculptures which he saw in Rome for the first time in 1545–1546, in relation to the later development of a mature artist, is a question which historians have interpreted variously. Nearly all agree that the *Danae*, painted in Rome and now in the museum at Naples, incorporates a sculpturesque quality which reflects the artist's stay in the Belvedere Palace. Yet the grandiose scale of body and the receptive pose owe more to Michelangelo's *Leda* and the *Night* of the Medici tombs than directly to the antique. Throughout his late career Titian frequently adopted heroic physiques for the female figure to a degree greater than hitherto, for example, in the *Madonna and Child* in Munich (Plate 50), in the legends of Diana, now at Edinburgh and London, and in the later versions of the *Danae* in Madrid and Vienna, to mention only a few.[165]

Specific borrowings or adaptations from the antique throughout Titian's career have been suggested by several writers, the earliest antiquarian detail being the relief on the socle in *St. Peter Enthroned Adored by Pope Alexander VI and Jacopo Pesaro*, c. 1512 (Plates 144–146).[166] That Titian's paintings between 1546 and 1576 show more dependence upon the antique than formerly does not seem really to be borne out in this late phase of his career, so highly personal in nature and so little given to following well-trodden paths.[167] He struck out in new directions which led directly toward Baroque form. Save for sporadic reminiscences of the antique in late compositions and in the great architectural setting of the *Martyrdom of St. Lawrence* (Plate 178), the artist's creative imagination and his originality of composition and technique predominate.

Titian's Roman enchantment lasted about eight months from late September 1545 until early June 1546, when he was made an honorary citizen of Rome.[168] In spite of Vasari's statement that the artist departed homeward laden with gifts, the truth is that he received nothing from the pope but hopes of a benefice for his son Pomponio.[169] His stop of a few days in Florence astonished him no less than his sojourn in Rome, if we are to believe the loyal Florentine, Vasari.[170] By 19 June 1546 Titian had reached his home in Venice, still hopeful of a benefice at Ceneda for his son,[171] as he immediately informed Cardinal Farnese by letter. No direct commissions for the Farnese family were ever again to materialize, and having decided to throw in his lot with Charles V, who called for him to come to Augsburg, Titian wrote to Cardinal Farnese on 24 December 1547 of his impending departure, assuring him at the same time of his undying devotion.[172]

165. These mythological works will be catalogued in Volume III.

166. Curtius, 1938; Brendel, 1955; Kennedy, 1956, pp. 237–243; *idem*, 1963; *idem*, 1964.

167. Saxl, 1957, p. 168, gave his opinion, 'It was indeed a revolution that this Roman stay effected in Titian', a somewhat exaggerated comment.

168. In March 1546 Titian was made a citizen (Gregorovius, 1877, p. 338). Aretino's letter to Cosimo dei Medici, dated in Venice 12 June 1546, speaks of Titian's forthcoming visit to Florence (Gaye, 1840, II, p. 351).

169. Vasari (1568)–Milanesi, VII, p. 448; Milanesi's reference to Aretino's letter of July 1548 written at Verona is a typographical error for 1543 (Aretino, *Lettere*, edition 1957, II, p. 8). See also note 156.

170. Vasari (1568)–Milanesi, VII, p. 448.

171. Letter to Alessandro Farnese: Ronchini, 1864, p. 136; C. and C., 1877, II, p. 132; also pp. 84, 129, 164.

172. Ronchini, 1864, p. 130; C. and C., 1877, II, pp. 164–165. Titian made Cardinal Farnese a gift of a *Magdalen* and a *St. Peter Martyr* and begged for some action on behalf of his son Pomponio twenty years later in 1567 (Ronchini, 1864, pp.

JOURNEYS TO AUGSBURG AND MILAN

IN the depths of winter the painter started his northward journey shortly after Christmas; he stopped at Ceneda, where on 6 January 1548 his host Girolamo della Torre provided him with a letter of introduction to Cardinal Madruzzo at Augsburg.[173] Within two weeks or less he had braved the deep snow and bitter winds of the Alps to reach the imperial court. Having acknowledged Titian's report of safe arrival in February, Aretino remonstrated with him later in April that he had received only one letter.[174] It is no wonder, for Titian's nine months in Augsburg proved to be the busiest of his entire career. There he devoted himself to preparing portraits of several members of the Hapsburg court as well as to finishing the great equestrian *Charles V at Mühlberg* and *Charles V Seated*, now in the Prado and in the Munich Museums respectively. These works alone are enough to make an artist celebrated. Other portraits, many of them now completely lost or known solely in copies, included the emperor's sister, Mary of Hungary, and Ferdinand his brother, king of Bohemia and Hungary, as well as Christina of Denmark, Duchess of Milan, and others of the imperial entourage. A number of them later hung in the long gallery of the palace of El Pardo near Madrid, known in Argote de Molina's description of 1582, which included eleven portraits by Titian. Their destruction in a fire of the palace in March 1604[175] was one of the greatest losses the Spanish royal collection ever suffered, second only to the devastation of the Alcázar at Madrid in 1734.

In late October on his return journey to Venice Titian stopped at Innsbruck, where he wrote a letter[176] to Ferdinand I on 20 October 1548. Soon home again and undoubtedly relieved to be in Venice, he enjoyed rest from travel for only a few weeks before the emperor ordered him to Milan[177] to paint the portrait of his heir and future successor, Prince Philip, aged only twenty-one, already a widower, but on his first trip beyond the borders of Spain. The young prince stayed in Milan from 20 December 1548 until 7 January 1549, during which time Titian was engaged on unspecified portraits of the prince, which are probably to be regarded as lost.[178] The most likely candidate for a preserved work planned at that time is Titian's *Venus and the Organ Player* in Berlin, in which the features of the musician are unmistakably those of the young Philip.

During the remainder of 1549 Titian had the good fortune to stay in Venice, where he kept busy with numerous portraits of courtiers of Charles V and a number of important commissions for the Venetians. In late October 1550, however, Charles V once again demanded the master's presence

142–143; C. and C., 1877, II, p. 376). Aretino in a letter to the Duke of Urbino dated in Venice February 1548 had stated that Titian had obtained everything requested from the Farnese (Aretino, *Lettere*, edition 1957, II, p. 195). Any promise of the benefice at Ceneda at that time obviously was not kept as the letter of 1567 proves.

173. Letter in C. and C., 1877, II, pp. 502–503.

174. Aretino, *Lettere*, edition 1957, II, pp. 198, 211. Other letters were exchanged between the two later in April (*loc. cit.*, pp. 212–214, 219).

175. Calandre, 1953, pp. 43–47, 70.

176. C. and C , 1877, II, pp 189–190

177. Titian's letter of 17 December 1548 written from Venice to Granvelle states that two days later he must go to Milan to see the Prince of Spain (Zarco del Valle, 1886, p. 226).

178. Beer, 1891, item no. 8372. The present number of the document at Simancas is Estado 71, folio 18. Titian was paid one thousand *scudi* for 'ciertos retratos' under date of 29 January 1549.

in Augsburg. Taking with him several pictures, subjects unrecorded, Titian reported to Aretino on
11 November 1550 that the emperor had received him and examined the paintings in the presence
of Prince Philip and the Duke of Alba.[179] Unquestionably the most important work painted in
Augsburg in 1550–1551 is the celebrated full-length portrait of Philip II in armour, now in the
Prado Museum at Madrid,[180] one of Titian's greatest as well as among the masterpieces of all time.
Quite incomprehensibly Philip was not entirely pleased with it, for he apologized on sending the
picture to his aunt Mary of Hungary, regent of the Netherlands in Brussels, in a letter of 16 May
1551, saying: 'It is easy to see the speed with which it has been made, and if there had been more
time I would have had him do it over again.'[181] Presumably Titian had returned to Venice
shortly before mid-May, but letters between the artist and Aretino, usually the source of chrono-
logy of Titian's movements, are curiously wanting at that particular moment.

LATE YEARS IN VENICE

NEVER again was Titian to undertake a long journey, other than the habitual trips to his
native Cadore, with the happy result that the last twenty-five years of his life were
devoted to his art and to creating a series of masterworks. The rumour of the artist's death
in 1553 is a curious occurrence, for which no explanation is forthcoming. Charles V wrote from
Brussels to Venice, worried for fear that some of his pictures had not been finished, only to be
reassured by Francisco de Vargas, his agent, that the rumour was false.[182] These years were not
without further incidents. In 1555 his daughter Lavinia married Cornelio Sarcinelli and moved to
Serravalle, a city now rebaptized Vittorio Veneto, well north of Treviso and Conegliano on the
road to Belluno. In the Duomo there on the high altar stands Titian's *Madonna and Child with Sts.
Peter and Andrew* (Plate 46), a work which has no connection with the marriage, however, as it had
been painted in the previous decade. Lavinia's life was to be short, for she died some six years
after her marriage, apparently on the occasion of the birth of her sixth child.[183] Meantime, Titian's
boon companion Pietro Aretino had died suddenly on 21 October 1556 at the age of sixty-four.[184]

In addition to these sad events, other disappointments and personal misfortunes befell the artist
during the fifteen-fifties. Orazio undertook a fruitless trip to Milan in May-June 1557 in an
attempt to collect the long-unpaid pension awarded by Charles V. Ferrante Gonzaga, governor of
the Spanish-controlled Duchy of Milan, apparently turned a deaf ear, in part no doubt for sheer

179. Marcolini, 1552, I, pp. 146–149; C. and C., 1877, II, p. 212.
 Titian arrived at Augsburg before 4 November 1550 (Aretino,
 Lettere, edition 1957, II, p. 383).
180. Studied by Beroqui, 1946, pp. 112–118.
181. *Loc. cit.*, p. 116, note 3; Cloulas, 1967, p. 213.
182. C. and C., 1877, II, pp. 506–507; Cloulas, 1967, pp. 218,
 220.

183. The biography of Lavinia was reconstructed in a scholarly
 fashion with a few original documents by Abbate Cadorin,
 1833, pp. 56–57, 96–97; the marriage agreement, 20 March
 1555, printed in C. and C., 1877, II, p. 510. See also note 80,
 above.
184. Innamorati, 1962, p. 102.

lack of funds. Titian's letter to Orazio in Milan proposed that he continue thence to Genoa, but the journey did not seem worth the effort.[185] Yet the unexpected occurred when Philip II, grieved over his father's recent death, wrote on Christmas day 1558 to the Duque de Sesa, the new governor of Milan, to pay Titian in full the overdue pension that Charles had awarded him ten years earlier, now accumulated to the amount of two thousand *scudi*.[186] Setting off for Milan in March 1559, Orazio is reported to have carried with him fourteen pictures, which he sold to the Duque de Sesa, whose portrait he was also to paint.[187] After a sojourn of nearly three months Leone Leoni, the celebrated medallist and bronze sculptor, a presumed friend of Titian and Aretino, in whose palace Orazio was lodged, set upon Titian's son in an attempt to kill him. Robbery of the two thousand *scudi* was the motive, but luckily Orazio escaped with severe wounds, from which he recovered.[188]

Angered to the breaking point and determined on revenge, Titian wrote to Philip II on 12 July 1559, setting forth the full particulars of the case. The artist returned to the matter in a letter of September and a third time in March 1560, without the king even so much as making a reference in the various letters exchanged at that time.[189] Finally the painter ceased any further comment on the attempted assassination. Just at that time he was completing some of his most celebrated compositions for Philip II. The religious pictures destined for the church and monastery of the Escorial included the *Entombment*, the *Agony in the Garden*, and the *Adoration of the Kings* (Plates 76, 120, 125, 126). The same letters carry news of the completion and shipment of several of the great mythological compositions: the *Diana and Callisto* and *Diana and Actaeon*, now in Edinburgh, the *Rape of Europa* now in Boston.[190] From these years to the end of his life Titian engaged in ceaseless activity for Philip II, his major patron, yet he still had time for other portraits and other important religious works.

At length Titian died in his spacious and comfortable house in the Biri Grande in the parish of San Canciano on 27 August 1576 during a serious plague.[191] Considerable difference of opinion has arisen as to whether the cause of death was old age or the plague, which carried off thousands, as it did Titian's son Orazio two months later.[192] The fact that a funeral was held the day after the artist's death and his body laid to rest in Santa Maria dei Frari indicates the great esteem in which he was held, and also suggests that the plague had not been the cause of his passing.[193] Elaborate

185. Letter of 17 June 1557 in Cadorin, 1833, pp. 45–46; in English translation in C. and C., 1877, II, p. 256.
186. Ridolfi (1648)-Hadeln, I, p. 187, letter of 25 December 1558; also in Cadorin, 1833, pp. 48–49.
187. Cadorin, 1833, p. 104.
188. A full account of the attempted assassination and the trial of Leone Leoni in Cadorin, 1833, pp. 46–53, 103–105; C. and C., 1877, II, pp. 272–274, 280–281; also see Plon, 1887, pp. 144–150: report to the police on 15 June 1559. Apparently Leone Leoni was banished from Milan by the Milanese court and forced to pay Orazio two thousand ducats.
189. Letters in the archives at Simancas: C. and C., 1877, II, pp. 513–518; Cloulas, 1967, pp. 234–235, 238–240, 243.
190. Letters of 1559 at Simancas: Cloulas, 1967, pp. 233–244;

also C. and C., *loc. cit.* The mythological works will be studied in Volume III of my publication.
191. The entry in the death records of San Canciano states that Titian died of fever, but the obviously erroneous age of 103 does not invite faith in the accuracy of this account. See transcription in note 212.
192. Orazio died in the lazaretto on the 20 October 1576 (Cadorin, 1833, document of death, pp. 95–96), so that no doubt exists that he died of the plague.
193. Cadorin, 1833, document M, p. 95, records the burial. The same author (p. 20) believed that Titian had died of the plague, a view held by Ridolfi (1648)-Hadeln, I, p. 209, but Hadeln in note 2 supported Borghini (1584, edition 1807, III, p. 91) who reported 'morì ultimamente di vecchiezza essendo

exequies in the church of San Luca, protector of artists, were planned by the painters of Venice, whose programme for a large funeral monument with allegorical figures was discovered and published by Ridolfi.[194] Inspired by the lavish ceremonies held in honour of Michelangelo in San Lorenzo at Florence after his death in 1564,[195] the Venetians wished to do equally well by their greatest painter, an intention which had to be abandoned because of the terrible pestilence which then ravaged the city.

TITIAN'S LATE STYLE AND TECHNIQUE

IN the last months of his life Titian was engaged upon the painting of the large *Pietà* (Plates 136–138) that he intended to be placed in the Chapel of the Crucifix in the church of the Frari, the place he had himself selected for his tomb. His powers of invention and the splendour of his brush had in no way diminished here. The work, left not entirely finished, was reverently given the final touches by Palma Giovane.[196]

Titian's late style is conveniently dated after his return from Rome to Venice in 1546, yet the high sense of drama which he created in the *Christ Before Pilate* of 1543, now at Vienna (Plate 91), already forecasts the future. It has previously been noted that the diagonal direction of the building and steps at the left and the struggling, contrasted attitudes of the crowd involve a complete break with the stately Renaissance procession of the *Presentation of the Virgin* (Plate 36). Nevertheless, Titian moved even farther away from previous traditions in the *Martyrdom of St. Lawrence* (1548–1557) in the Jesuit church at Venice (Plate 178), in which he evolved a composition wherein the apotheosis of martyrdom is achieved through light and form of unequalled poetic and emotional evocation. The darkness of night is broken by the great flares which illuminate the monumental temple façade with eerie transcendence. In the foreground a supernaturally created light plays over the figures, while reddish-yellow flames leap beneath the gridiron. The pronounced diagonal direction of the saint and his iron support is counteracted by the wall of figures to the right, but the movement to the left is only deflected and then carried upward to the right background by the great flight of steps rising to the temple. Mood dominates this scene of heroic suffering and saintly triumph. The softness of brush-work marks, like the spatial organization, a bold step in new directions, in which colour and light predominate and the solidity of objects is lessened even more than hitherto. Mere words fail to describe the sheer magic of the colour. The tones of grey and silvery light upon the architectural setting provide a foil to the great rose-coloured flag at the right and to the rose drapery fluttering from the shoulders of the man directly behind St. Lawrence's head. Touches of

la peste in Viniega'. Nevertheless, a legal document concerning Titian's heirs, published nearly a year later on 24 July 1577, states that Titian and his son Orazio had died of the plague.

The huge, ugly monument to Titian in the Frari is a work of the late Neoclassic period of the nineteenth century, fully documented (see Beltrame, 1853).

194. Ridolfi (1648)–Hadeln, I, pp. 211–218.
195. Described by Vasari (1568)–Milanesi, VII, pp. 296–317, and fully discussed by Rudolf and Margot Wittkower (1964).
196. See Cat. no. 86.

warm colour in the group of helmeted men at the right and throughout the foreground create a luminous richness of the most extraordinary subtlety.

On the other hand, a contemporary picture, the *Apparition of Christ to the Madonna* (*c.* 1554) at Medole (Plate 111), retains the heroic structure of the human form just as in the *Christ Crowned with Thorns* at Paris (Plate 132), in the main because of the subject, but this style belongs to the immediate past rather than to the artist's future. The heroic solidity of body and the stance appear to reflect Michelangelo's *Risen Christ*, which Titian surely admired, as he owned a cast or copy.[197] The unusual hardness of contours and surface is also to be ascribed to liberal assistance by the workshop as was indubitably the case in an earlier post-Roman work (1542-1547), the altarpiece at Serravalle (Plate 46).

Otherwise, the direction of Titian's art is unmistakable even in a more conservative theme such as the *Trinity* in the Prado Museum (Plates 105-109), a favourite cult picture of Charles V, which he took with him in his retirement to the Jeronymite monastery of Yuste. Although the basic tradition here is that of a Last Judgment, Titian paid no heed to Michelangelo's enormous mural in the Sistine Chapel which he had seen in Rome. The Venetian's problem in working on a small scale for private devotion had no points in common with the Florentine's. The *Trinity* maintains an essentially Renaissance symmetry, within which considerable variety prevails in the poses and movements of the individual figures. Colours, rich and harmonious, establish balance after the manner of well established Venetian traditions.

The Prado *Entombment* of 1559 (Plate 76), on the contrary, moves boldly onward from the style of the *Martyrdom of St. Lawrence* (Plate 178), the tomb turned into an oblique position as were St. Lawrence and his gridiron. Now in 1559, except for the powerful muscular Christ, the figures are dissolved in colour and darkness, forms merged one into the other into an indissoluble domical structure. The frenzy of grief and irremediable tragedy of death override all other considerations. How unlike the stark humanity of the early *Entombment* (*c.* 1526) in the Louvre (Plate 75), a more structured Renaissance design in parallel planes, though no less tragic in its incorporation of heroic self-control.

At the same period Titian conceived many of his most imaginative and epoch-making compositions of mythological themes, for instance the *Diana and Actaeon* and the *Diana and Callisto*, now in Edinburgh, as well as the *Rape of Europa* in Boston.[198] Here too, as in religious works, Titian introduced the most extraordinary new ideas of composition and design in abandoning both Renaissance and Mannerist conventions by his use of oblique movement into depth and daringly contrasted attitudes, which can best be characterized as proto-Baroque, inasmuch as they

197. A letter dated the 17 June 1554, written by Titian to his son Orazio during the latter's trip to Milan, makes reference to the 'Christ of the Minerva', i.e. Michelangelo's sculpture of the *Risen Christ* in Santa Maria sopra Minerva at Rome. The letter was first published by Cadorin (1833, pp. 45-46) and later by Gualandi (1841, II, p. 102) in Italian. Crowe and Cavalcaselle (1877, II, p. 256) translated into English the first part of the letter but strangely omitted the passage regarding the Christ of the Minerva. Tietze-Conrat (1944, p. 120) first called attention to the significance of this detail.

198. These works will be studied in Volume III of the present publication. The two 'poesies' of Diana were shipped to Spain in 1559. The fable of Europa, begun in 1559 reached Spain in 1562. For illustrations any monograph on Titian; in Tietze, 1936, pls. 231, 232, 233. See also Pope, 1960.

contributed so greatly to the late Renaissance methods of Tintoretto and Jacopo Bassano and to the full Baroque style of the seventeenth century.

Titian's late way of veiling human form to achieve the spiritual clearly applies best to religious works, as already revealed in the *Martyrdom of St. Lawrence* and in the Prado *Entombment*. Many other pictures fall into the same category, for instance, the *Annunciation* (c. 1560–1565) in San Salvatore at Venice (Plate 62), where the statuesque figures of Gabriel and the Madonna retain their structure even within a shadowy setting partially illumined overhead by the glory of angels and the Holy Spirit (the Dove). Similarly he conceived the *Crucifixion* (1558) in San Domenico at Ancona (Plate 114) and the *Christ on the Cross* of the same period in the Escorial (Plate 113), which are, by nature of the theme, tragic in their grandeur, the former in relation to the sorrow of His followers in a scene of night and contemplation, whereas the latter, a single figure, is no less gripping in emotional power as the resigned, handsome Christ is relieved against the darkness, which does not conceal the beauty of the sky and landscape.

Throughout his last phase Titian's conception of the personality of Christ is essentially heroic, as just observed, and equally so in the two canvases of *Christ Carrying the Cross* (c. 1565) in half length, one in the Prado Museum and the other in Leningrad (Plates 127, 128). The colour and the free handling of the fluid brush are masterly in these works as they are in the more deeply felt *Christ Carrying the Cross* (c. 1560) in full length, shown falling to the ground under the weight of the Cross (Plate 129).

No comprehensive scientific study, by means of laboratory examination, has ever been made of Titian's technical methods of painting, an undertaking which would require research of a highly specialized nature with the added difficulty of obtaining access to the paintings for that purpose.[199] The artist's early works were generally painted on panel, not only relatively small pictures such as the *Gipsy Madonna* and the *Tribute Money* in Dresden (Plates 3, 67), but even a huge composition, for instance the *Assumption* in the Frari (Plate 18), while at the same period for the large *Madonna of the Pesaro Family* (Plate 28) the artist chose canvas. Later, although canvas is used more often, panel was never abandoned. The *Christ Crowned with Thorns c.* 1546–1550 in the Louvre (Plate 132) is a large composition of the late period painted on wood, which, because of its destination for a Milanese church, could be moved that distance, even though bulky. Pictures shipped to Charles V or Philip II in Brussels or Madrid were, on the other hand, more readily packed if on canvas. As a matter of fact, canvases sometimes suffered from folding: a famous instance being the *Venus*

199. Doerner, 1949, pp. 343–349, gives all too brief and imprecise accounts of Titian's and El Greco's methods of painting.

Considerable laboratory investigation on painting techniques in general is now in process. Many discoveries have been made in the examination of pictures by X-rays which frequently reveal changes in composition as well as in individual details. They also help immeasurably in the removal of old repaint for the restoration of paintings to the state which the artists themselves had intended. The following laboratories have done notable work: The Istituto Centrale di Restauro in Rome, the Louvre in Paris, the National Museum in Stockholm, the National Gallery and the Courtauld Institute in London, and the German museums, particularly at Munich and Berlin-Dahlem. In the United States among the chief centres of such research are the Intermuseum Laboratories at Oberlin, the Conservation Center at New York University, the Walters Art Gallery in Baltimore, the National Gallery of Art in Washington, the Metropolitan Museum of Art in New York, the Boston Museum of Fine Arts, and the Chicago Art Institute.

and Adonis now in the Prado, which arrived at London so badly creased in 1554, at the time of Philip's marriage to Mary Tudor, that the heir to the Spanish throne wrote a letter of protest.[200] Panel and even marble, by exception, provided the basis for the two small cult pictures of the *Mater Dolorosa* in the Prado (Plates 97, 101), delivered to Charles V. In these instances the master may have considered the more durable but heavier materials on a small scale suitable for works designed to travel with the emperor on his many journeys.[201]

The early pictures of Titian are distinguished by solid technique, large areas of local colour, and relatively detailed drawing. Panel was prepared with white gesso and the drawing of the composition laid over it previous to the application of local colours. Canvas, likewise, was prepared with white gesso, made more flexible by the addition of some starch or sugar according to Cennino Cennini.[202] However, the use of a paste of flour with white lead for priming the canvas seems to have been more general in the sixteenth century.[203] This use of white priming accounts for the glowing quality of the reds and blues in Titian's early works. Brownish or reddish-brown *imprimatura* is found in many of Titian's early works and frequently throughout the artist's career, a technical procedure later followed by his pupil, El Greco.[204]

A study of the development of Titian's technical methods from 1508 to 1576 would produce highly significant results for an understanding of his art and for problems of dating, if conducted by an expert in painters' techniques who was also versed in the scientific methods of laboratory analysis. Titian's late procedures are described by Palma Giovane, who understood the master's technique so well that he was able to add the final glazes to the celebrated *Pietà* (Plates 136–138). Even though Palma Giovane was less precise than might be wished, some ideas can be culled from the famous passage preserved by Boschini.[205] Titian still laid a body colour on the canvas as a foundation, but, although Palma Giovane does not say so, it was no longer red but rather silvery or neutral. He often used a brush loaded with pure colour, but it is obvious, as in the *Christ Crowned with Thorns* in Munich (Plates 133, 135), that the colour was applied in small spots rather than in large areas during his late period beginning with the *Martyrdom of St. Lawrence* in Venice (Plate 178). We know that throughout his life the master turned the canvas to the wall and left it to dry, often returning again and again over long periods to make changes, by modifying colours through the

200. C. and C., 1877, II, p. 509; Cloulas, 1967, p. 227. The horizontal crease across the middle of the picture is still visible in the original, but not in photographs; illustrated by Tietze, 1936, pl. 229; dell'Acqua, 1955, pl. 152; and other monographs.

201. A survey of authentic religious pictures in the present volume reveals that Titian employed panel far more frequently in his early period: seventeen times in the years 1510–1530; four times in the thirties; four times in the forties; four times in the fifties; and once only later, the *St. Nicholas of Bari* in 1563 (Plate 170). Vasari himself (Vasari-Barocchi, 1966, I, pp. 136–137; English edition, 1907, p. 237) says that canvas is more convenient because it can be carried about.

Attention should be drawn to the fact that Vasari and other early writers use the words *tavola* and *quadro* interchangeably,

meaning picture, and therefore the word *tavola* in the sixteenth and seventeenth centuries does not always imply the use of wood, as it does today. In the case of Titian's *Assumption* (Cat. no. 14) in the Frari at Venice, Vasari called it *una tavola* and then said it was made on canvas (*fatta in tela*) (Vasari (1568)–Milanesi, VII, p. 436). Here he was wrong, for the picture is painted on wood.

202. Cennino Cennini, edition 1932, pp. 70–72.

203. Vasari-Barocchi, 1966, I, pp. 136–137.

204. Doerner, 1949. *Imprimatura* may be defined as a body colour, i.e. a uniform layer of colour, applied to the ground as underpaint.

205. Boschini, 1674, edition 1966, pp. 711–712; translated into English by Hume, 1829, pp. 112–114.

addition of transparent glazes and by scumbles, which are opaque. Palma Giovane testified that Titian used his fingers to blend tones or soften edges, as well as to add a bit of colour here and there. It is a well-known fact that Titian in particular and the late-Renaissance Venetians in general adopted an optical approach to painting, which created a revolution in the atmospheric effects of landscape. The illusion of form and structure in objects were established by a very free manipulation of the brush rather than by detailed drawing for the sake of precise representation. Venetian illusionism established a new method of painting, which was adopted and developed by the great Baroque masters, Rubens, Frans Hals, Rembrandt, van Dyck, Velázquez, and numerous others.

During Titian's last period miracles of the brush abound among the pictures of single saints and of the Madonna, for example the *Madonna and Child* (1562) in Munich (Plate 50), where the gigantic size of both figures, rather atypical of the artist's conception of this subject, corresponds exactly to contemporary late Mannerist taste, as seen in Jacopo Sansovino's statues and reliefs of the Madonna and Child.[206] The glowing atmosphere of the sunset landscape, the luxuriant rose and blue robes, all contribute to the aristocratic grandeur of this picture. A series of single saints belonging to the last years of Titian's career includes the *St. Margaret* (c. 1565) in the Prado and another, though restored, version in the Kisters Collection (Plates 173, 174). The superbly manipulated body of the saint sways in *contrapposto*, striding across the monster, the crucifix in hand to indicate her triumph over evil, against a spectacular seascape to the left and a rocky cliff to the right. The Prado canvas having suffered badly by scorching in the fire of 1734, the landscape can best be understood in the second version (Plate 177), where the brilliant green sea and darkened sky are shot through with flashing lights in that indescribable fusion of tone and colour which is uniquely Titian's achievement in his late paintings. Scarcely less brilliant is the landscape of the *St. Jerome* (1575) in the Escorial (Plate 195), in which the rocky setting is pierced by a large central opening to disclose a spectral view of distant sea and mountains, whence a supernatural ray of light shines to illuminate the crucifix. In spite of the general freedom of brushwork in the beard and the rose-coloured drapery, the figure of St. Jerome retains a considerable degree of solidity of form.

The *Stoning of St. Stephen* (c. 1570), a little-known masterpiece at Lille (Plates 198, 199), belongs in the same group by virtue of the extraordinary inventiveness of the composition, which displays draughtsmanship of unsurpassable accomplishment within a highly pictorial concept of painting, notably in the figure of the executioner, whose power of body and movement afford a dramatic contrast to the resignation of the saint. Harmonious colour and mood-invoking landscape combine with the figures to make a truly memorable picture.

One of the artist's very last and unfinished canvases is the large *St. Sebastian* (c. 1575) in Leningrad (Plate 194), which remained in the studio at Titian's death. The final surfaces were never added to the legs from the knees downward nor to the loin-cloth or the landscape, yet the artist's conception of the whole is fulfilled. The sheer physical beauty of colour and workmanship would carry a magic all their own, even if there were no subject matter at all, a fact which explains why the

206. For Sansovino, see Planiscig, 1921, pp. 381–386; also characteristic of the works of Paolo Veronese and Tintoretto.

Leningrad *St. Sebastian* has gained only in the twentieth century the critical recognition that it deserves.

In the past, opinions have varied about the *Christ Crowned with Thorns* (*c.* 1570–1576) in Munich (Plates 133, 135), one of the very latest pictures on which Titian laid his brush, and obviously unfinished.[207] That is not to say that it would ever have had the solid sculptural surfaces of his earlier canvas (*c.* 1546–1550) in the Louvre (Plate 132). The two compositions differ only in minor details so far as the poses of the figures are concerned, yet in the earlier picture the physical power of Christ and the executioners is stressed, while in the late work their very physical existence is veiled in the shadows of night, and the forms exist only to evoke the mood of sacrifice and the resignation to immutable fate. Like so many other great masters, like Rembrandt and El Greco, Titian subordinated the physical existence in order to exalt the spirit. Colour is even more fragmented than the figures themselves, for no large vivid areas are permitted to interrupt the unity of understatement, nor to diminish the spirit of universal tragedy. Titian's *Pietà* (1576), now in the Accademia at Venice (Plates 136–138), projected as his own memorial, incorporates a more solid design both in the great niche of the architectural background and in the long diagonal organization of the principal figures. Even though Palma Giovane added some final touches, his minimal contribution in no way adds to the grandeur of the composition or alters the muted richness of colour in the silvery background highlighted with touches of gold, against which the subdued dark-blue of the Madonna's cloak, the neutralized green dress and plum-coloured draperies of the Magdalen are unified in an all-embracing harmony. Thus to the very end Titian's powers of imagination and skill of brush never faltered, but attained heights beyond which no artist ever passed.

207. Boschini, 1674, edition 1966, p. 712, refers to this picture as 'un abbozzo', meaning that the composition had been laid in but never finished.

APPENDIX
THE DATE OF TITIAN'S BIRTH

SUCH disagreement remains as to the year of Titian's birth that it appears unlikely the issue will ever be conclusively settled. The baptismal records of the parish church in his native village of Pieve di Cadore have been lost, presumably at the time of the Austrian invasions of the early sixteenth century. Wars have a way of destroying historical evidence finally and irreparably.

The traditional date of Titian's birth, 1477, rests mainly upon a letter that he wrote to Philip II of Spain on 1 August 1571, urgently requesting payment for the many pictures he had delivered to the Spanish king. The artist states, 'I do not know how to find a way to live in this my old age which I devote entirely to the service of your Catholic Majesty without serving others, not having had ever in the last eighteen years a farthing in payment for the paintings which from time to time I have sent you'. He then adds, 'your servant of the age of ninety-five'.[208] On the basis of this statement of extreme old age, 1477 has widely been accepted as the year of Titian's birth, but even so it would need to be pushed back to 1476.

Some degree of exaggeration is to be suspected in an appeal for payment to a king notoriously neglectful of such obligations in a period of the declining political fortunes of the Spanish Empire. For one thing Titian's claim that he worked for no other client than Philip is obviously inaccurate; equally exaggerated is the implication that he is impoverished and without resources in his old age. As an artist of international fame, whose works were sought by princes, churchmen, and aristocratic collectors everywhere, Titian's financial status was as a matter of fact affluent. Despite these inconsistencies the master's proverbial longevity was accepted by several early writers, among them Raffaello Borghini, who wrote in 1584.[209] When Tizianello,[210] a distant younger relative of the painter, published his brief tract in 1622, he retained the traditional year 1477, which he passed on to Ridolfi.[211] The ultimate extension was reached in the Book of the Dead (*Liber Mortuorum*) of San Canciano, the parish church within whose boundaries Titian's Casa Grande lies. Only recently a Venetian investigator found an entry there which, in spite of the nearly indecipherable script, appears to say that Titian died on 27 August 1576 at the age of 103 ![212]

Uncertainty about ages and even about the spelling of names is commonplace in earlier centuries, but clearly Titian played the sage and the world-famous master, about whom legends were growing even during his own lifetime. That nobody quite knew the truth can be deduced from

208. The original letter in Italian in Crowe and Cavalcaselle, 1877, II, p. 538; also Cloulas, 1967, p. 276.
209. Borghini, 1584, p. 529; edition 1807, III, p. 91.
210. Tizianello, 1622, edition 1807, p. II.
211. Ridolfi (1648)–Hadeln, I, p. 152.
212. The following entry has been verified by the author:

'Liber Mortuorum Parociae S. Cantiani' (San Canciano), Venice, folio 125: 27 agosto 1576. 'Adi dito ms Tiziã pitor e morto de ani cento e tre amalato de febre Licenzati.' See Lotti, May 1955, who first deciphered the entry; also Borgese, May 30–31, 1955; Valsecchi, June, 1955; Zorzi, 1960–61, p. 487.

various letters of the Spanish ambassadors at Venice. On 11 October 1559 García Hernández writing to Philip II attributes the artist's delay in finishing pictures to his advanced age of over eighty-five.[213] Two years later the same ambassador remarks that Titian is over eighty,[214] thus reducing his age by seven years. After another three years, on 15 October 1564, García Hernández informs the King that Titian still works even though 'people say that he is nearly ninety, but he does not show it'.[215] This uncertainty and casualness in reporting Titian's age first at eighty-five, then eighty, and finally near ninety leaves no doubt that the Spanish ambassador and others relied on gossip and speculation. In an unpedantic way, which often characterizes the Latin mind, they used whatever figure struck the imagination or seemed fitting at a particular moment. This attitude is typical not only of García Hernández, but also of other officials, specifically Thomas de Zornoza, in whose letter of 6 October 1567 Titian is said to be eighty-five.[216]

Most critics and historians of the twentieth century have favoured a date for Titian's birth about 1488–1490, reasons for which will now be considered.[217] The clear-cut statement by Vasari, who visited Titian in Venice in 1566, that the artist was about seventy-six years old ('infino alla sua età di circa settanta-sei anni') cannot be disregarded.[218] However, the accuracy of this information has been greatly vitiated in the minds of many writers by the statement at the beginning of Vasari's life of Titian that he was born in 1480. Surely that date is a misprint for 1489, since Vasari, although frequently inaccurate, can be counted on to have known how to add and subtract.[219] Moreover, he elsewhere states that Titian worked on the frescoes of the Fondaco dei Tedeschi with Giorgione circa 1507–1508 and that, when the young painter began to follow Giorgione's style, he was no more than eighteen. Vasari's account therefore is basically consistent and reliable, since two of his statements imply that Titian was born in 1489–1490.

Exactly the same information is forthcoming from Lodovico Dolce,[220] a personal friend of Titian, who recounts in his *Dialogo della pittura* (1557) that the artist worked with Giorgione on

213. Cloulas, 1967, p. 242; making his birthdate 1474 instead of 1477.
214. C. and C., 1877, II, p. 522; Cloulas, 1967, p. 250; birthdate therefore 1481.
215. C. and C., 1877, II, p. 535; Cloulas, 1967, p. 268: 'va cerca de los noventa aunque no lo muestra.' Birthdate now becomes 1474.
216. Cloulas, 1967, p. 274; Zarco del Valle, 1888, p. 234; therefore born in 1482. Crowe and Cavalcaselle (1871, II, pp. 119–120) expressed doubts about Titian's great age; the same work edited by Borenius, 1912, III, pp. 1–2. Nevertheless, the two authors in their book on Titian (1877, I, pp. 36–38) reversed their position.

The historians who have supported the date of Titian's birth in 1477 as traditional and correct are Georg Gronau, 1901, pp. 457–462, reprinted in English by Cook, 1907, pp. 135–141, and Mather in 1938, pp. 13–25.

Mather in his fiery defence of the date 1477 made the mistake of impugning the motives of those who held opinions contrary to his own. The Titian *Self-portrait*, formerly in the Paolini Collection, now unexhibited in the National Gallery at Washington, is a copy subsequent to the artist's death, a work which has an inscription on the back, 'Aetatis suae 84, 1561'. Neither the inscription nor the picture is a reliable document for consideration in the arguments about Titian's birthdate.

217. Sir Herbert Cook in 1902, reprinted in 1907, pp. 123–134, 141–144; Hourticq, 1919, pp. 64–82; Longhi, 1946, p. 64; Morassi, 1964, p. 11; Pallucchini, 1953, pp. 30–35; 1965, p. 1; Tietze, 1936, I, pp. 43–46; Valcanover, 1960, I, pp. 7–8; Gilbert, 1967, pp. 25–26.
218. Vasari (1568)–Milanesi, VII, p. 459. A letter from Cosimo Bartoli, written at Venice on 15 December 1563 (Frey, 1941, p. 29), tells Vasari that he is sending a note about Titian, but Vasari makes it clear that he himself visited Titian in his studio and collected the data for the artist's life at first hand.
219. Sir Herbert Cook (1907, p. 129) is the only author who has hitherto insisted upon the obvious likelihood of a misprint. Since Vasari's original manuscripts have been lost, no verification in them is possible.
220. Lodovico Dolce, 1557, edition 1960, pp. 164, 201: 'a pena venti anni' and the word 'giovanetto' (very young or youngster).

the Fondaco dei Tedeschi about 1507, when he was barely twenty; and Dolce states elsewhere that Titian was a youngster at the time. The evidence of Vasari and Dolce coincides, and if it had not been for a misprint, there would never have been so much controversy about the whole matter.

Nevertheless, other factors must be taken into account, an important one being the age of Giorgione, whose birth date is generally accepted as 1477.[221] Since Titian was his assistant on the Fondaco dei Tedeschi in 1508, and in his youth was almost completely under Giorgione's spell, it is reasonable to suppose that the latter was the older man rather than Titian's exact contemporary. Furthermore, in 1508 Titian appears for the first time as a painter, his works of that year to be followed three years later by his frescoes in the Confraternity of St. Anthony at Padua.[222] It is reasonable to believe that the young painter was 'barely twenty' (Dolce) in 1508 and twenty-three in 1511, rather than thirty-one and thirty-four.

221. Letter of 7 November 1510 from Taddeo Albano at Venice to Isabella d'Este announces the death of Giorgione from the plague a few days previously (quoted by Richter, 1937, p. 304).

Vasari gives the date of his birth as 1477 and 1478 (Vasari (1568)–Milanesi, IV, p. 92).

222. Cat. nos. 93-95

BIBLIOGRAPHY

The bibliography is in most cases arranged by author. When the same writer has published more than one item, the sequence is by date. Certain publications such as exhibition catalogues are more conveniently arranged by place, i.e. Cleveland, Paris, Stockholm.

Gian Alberto dell'Acqua, *Tiziano*, Milan, 1955.

Gert Adriani, *Van Dycks Italienisches Skizzenbuch*, Vienna, 1940.

Annibale Alberti, 'Pietro Edwards e le opere d'arte tolte da Napoleone a Venezia,' *Nuova Antologia*, CCL, 1926, pp. 325–338.

Giovanni Battista Albrizzi, *Forestiere illuminato intorno le cose più rare della città di Venezia*, Venice, 1772.

Alcázar, Madrid, Inventory of Philip II (1598–1610, but mainly 1600–1602), see:

Sánchez Cantón, *Inventarios reales, bienes muebles que pertenecieron a Felipe II*, Madrid, 1956–1959, 2 vols.

Rudolf Beer, 'Inventare aus dem Archivo del Palacio', *Jahrbuch der Kunsthistorischen Sammlungen des Allerhöchsten Kaiserhauses*, Vienna, XIV, 1893, II Theil, pp. I–LXX.

Alcázar, Madrid, Inventory of 1636, manuscript, Archivo del Palacio, folio number on every fifth page.

Alcázar, Madrid, Inventories of 1666 and 1686, see: Ives Bottineau, 'L'Alcázar de Madrid et l'inventaire de 1686', *Bulletin hispanique*, LVIII, 1956, pp. 421–452; LX, 1958, pp. 30–61, 145–179, 289–326, 451–483.

Alcá, Madrid, Inventories of 1623, 1734 and 1816, manuscripts, Archivo del Palacio.

Aldobrandini Collection, Rome, see:

Onofrio, 1964.

Pergola, 1960, 1962, 1963.

F. Alizeri, *Guida per la città di Genova*, Genoa, 1846.

J. A. Alvarez de Quindós y Baena, *Descripción histórica de la real casa y bosque de Aranjuez*, Madrid, 1804.

Leonce Amaudry, 'The Collection of Dr. Carvalho at Paris', *Burlington Magazine*, VI, 1904–1905, pp. 95–96.

Walther Amelung, *Die Sculpturen des Vaticanischen Museums*, Berlin, 1908, II.

Diego Angulo Iñiguez, 'Ticiano y Lucas Jordán', *Archivo español de arte*, XIV, 1941, pp. 148–154.

The Anonimo: see Marcantonio Michiel.

Anonimo del Tizianello: see Tizianello.

Antwerp: *Catalogue descriptif. Maîtres anciens*, 1958.

APC: *Art Prices Current*, London I (1907–1908)–XLIII (1965–1966)

Apocryphal New Testament: Translation by M. R. James, Oxford, 1924.

Apollo, V, 1927, pp. 8–10: 'A Newly Discovered Masterpiece by Titian' (author not identified).

Aranjuez: 'Inventarios, Real Sitio de Aranjuez', 1700 and also 1800, in Madrid, Archivo del Palacio.

Aretino: *Lettere sull' arte di Pietro Aretino*, edited by Ettore Camesasca and Fidenzio Pertile, Milan, 1957–1960, 4 vols.

Edoardo Arslan, 'Titian's Magdalen', *Burlington Magazine*, XCIV, 1952, p. 325.

——, *I Bassano*, Milan, 1960, 2 vols.

Arundel Collection, see:

Cust, 1911.

Hervey, 1941.

Aschaffenburg: *Galerie Aschaffenburg Katalog*, Munich, 1964.

Augsburg: *Katalog der königlichen Filial-Gemäldegalerie zu Augsburg*, Augsburg, 1912.

Bache: *A Catalogue of the Paintings in the Collection of Jules S. Bache*, New York, 1929; also *Catalogue*, 1937.

L. Bachelin, *Tableaux anciens de la galerie Charles I, roi de Roumanie*, Paris, 1898.

Bailly-Engerand, *Inventaire des tableaux du roi*, rédigé en 1709 y 1710 par Bailly, publié par Fernand Engerand, Paris, 1899.

Ludwig Baldass, 'Tizian im Banne Giorgiones', *Jahrbuch der Kunsthistorischen Sammlungen in Wien*, XVII, 1957, pp. 101–156.

——, and Günther Heinz, *Giorgione*, New York, 1965.

Alessandro Ballarin, 'Profilo di Lamberto d'Amsterdam', *Arte veneta*, XVI, 1962, pp. 61–81.

——, 'I veneti all'esposizione: Le seizième siècle européen au Petit Palais', *Arte veneta*, XIX, 1965, pp. 238–240.

Baltimore Exhibition: *Giorgione and His Circle*, Johns Hopkins University, Baltimore, 1942.

Nino Barbantini, *Scritti d'arte inediti e rari*, Venice, 1953.

Cardinal Francesco Barberini: see Pozzo, Cassiano del.

Angel M. Barcia, *Catálogo de la colección de dibujos originales de la Biblioteca Nacional*, Madrid, 1906.

Adam Bartsch, *Le peintre-graveur*, Leipzig, 1876, XIV.

G. Baruffaldi, *Vite dei pittori e scultori ferraresi*, (1733), Ferrara, 1844–1846, 2 vols.

G. C. Bascapé and Emilia Spinelli, *Le raccolte d'arte dell' Ospedale Maggiore di Milano*, Milan, 1956.

Armand Baschet, 'Documents inédits tirés des archives de Mantoue concernant la personne de messer Pietro Aretino', *Archivio storico italiano*, Florence, 3rd series, part I, 1866, pp. 104–130.

Eugenio Battisti, 'Disegni inediti di Tiziano e lo studio d'Alfonso d'Este', *Commentari*, V, 1954, pp. 191–216.

——, *Rinascimento e barocco*, Rome, 1960.

——, 'Postille documentarie su artisti italiani a Madrid e sulla collezione Maratta', *Arte antica e moderna*, III, 1960, pp. 77–89.

Jacob Bean, *Les dessins italiens de la collection Bonnat*, Paris, 1960.

Rudolf Beer, 'Acten, Regesten und Inventare aus dem Archivo General zu Simancas', *Jahrbuch der Kunsthistorischen Sammlungen des Allerhöchsten Kaiserhauses*, Vienna, XII, 1891, II Theil, pp. XCI–CCIV.

——, 'Inventare aus dem Archivo del Palacio', *Jahrbuch der Kunsthistorischen Sammlungen des Allerhöchsten Kaiserhauses*, Vienna, XIV, 1893, II Theil, pp. I–LXX. See also: Alcázar, Madrid, Inventory of Philip II.

Ernesto Begni, *The Vatican, Its History and Its Treasures*, Rome, 1914.

Pietro Bellori, *Le vite dei pittori, scultori, et architetti moderni*, Rome, 1672.

Francesco Beltrame, *Tiziano Vecellio e il suo monumento*, Milan, 1853.

Pietro Bembo, *Scelta di lettere*, edition Venice, 1830.

Michele de Benedetti, 'Una Sacra Famiglia giovanile di Tiziano', *Emporium*, CXI, 1950, pp. 147–155.

Bernard Berenson, *Study and Criticism of Italian Art* (1901), edition London, 1930.

——, *Venetian Painters of the Renaissance*, New York, 1906.

——, 'While on Tintoretto', *Festschrift für Max J. Friedländer*, Leipzig, 1927, pp. 224–243.

——, 'The Missing Head of the Glasgow Christ and the Adulteress', *Art in America*, XVI, 1928, pp. 147–154.

——, *Italian Pictures of the Renaissance*, Oxford, 1932.

——, *Lorenzo Lotto*, edition London, 1956.

——, *Italian Pictures of the Renaissance, Venetian School*, 2 vols., edition London, 1957.

Adolf Berger, 'Inventar der Kunstsammlung des Erzherzogs Leopold Wilhelm von Österreich', *Jahrbuch der Kunsthistorischen Sammlungen des Allerhöchsten Kaiserhauses*, Vienna, I, 1883, II Theil, pp. LXXIX–CLXXVII.

Padre Damián Bermejo, *Descripción artística . . . del Escorial*, Madrid, 1820.

Berlin catalogue, 1930:
Staatliche Museen Berlin, Die Gemäldegalerie, Die italienischen Meister 16. bis 18. Jahrhundert (by Dr. Irene Kunze), Berlin, 1930.

Pedro Beroqui, 'Adiciones y correcciones al catálogo del Museo del Prado', *Boletín de la Sociedad Castellana de Excursiones*, VI, 1913–1914, pp. 466–473.

——, *El Museo del Prado. Notas para su historia*, Madrid, 1933.

——, *Tiziano en el Museo del Prado*, Madrid, 1946 (first published in a series of articles in the *Boletín de la Sociedad Española de Excursiones*, XXXIII–XXXV, 1925–1927).

Carlo Bertelli, 'Il restauro di un quadro di Tiziano', *Bollettino dell' Istituto Centrale di Restauro*, nos. 31–32, 1957, pp. 129–143.

A. Bertolotti, *Artisti veneti in Roma*, Venice, 1884.

Besançon: *Besançon, le plus ancien musée de France*, Paris, 1957.

W. R. Betcherman, 'Balthazar Gerbier in Seventeenth-Century Italy', *History To-day*, 1961, pp. 325–333.

Gian Carlo Bevilacqua, *Insigne pinacoteca . . . Barbarigo della Terrazza*, Padua, 1845.

Jan Bialostocki and Michal Walicki, *Europäische Malerei in polnischen Sammlungen*, Warsaw, 1957.

Margarete Bieber, *Laocoön. The Influence of the Group since its Rediscovery*, New York, 1942: second edition, Detroit, 1967.

J. C. J. Bierens de Haan, *L'Oeuvre gravé de Cornelis Cort*, The Hague, 1948.

G. Biermann, 'Tizians Judith mit dem Haupt des Holofernes', *Cicerone*, XXI, June 1929, pp. 317–320.

Charles Blanc, *Le trésor de la curiosité tiré des catalogues de vente*, Paris, I, 1857, II, 1858.

Anthony Blunt, *Nicolas Poussin*, Washington, 1967.

Bob Jones University: *Collection of Religious Paintings, Italian and French Paintings*, Greenville (South Carolina), 1962; Supplement, 1968.

Ferdinando Bologna, 'La sacra conversazione di Monaco', *Paragone*, II, no. 17, 1951, pp. 23–29.

Lucien Bonaparte: *Choix de gravures à l'eau forte d'après les peintures . . . de Lucien Bonaparte*, London, 1812.

A Catalogue of the Magnificent Gallery of Paintings, the Property of Lucien Buonaparte, London, 1816.

Bordeaux: *Les trésors des Musées de Bordeaux au Musée de Tel-Aviv*, 1964.

Bordeaux, Musée des Beaux-Arts: *Catalogue des tableaux*, Bordeaux, 1855; Oscar Gué, *Catalogue des tableaux*, Bordeaux, 1862; *Catalogue*, Bordeaux, 1910; *Catalogue*, Bordeaux, 1933.

Tancred Borenius, *Catalogue of the Pictures at Doughty House*, London, 1913.

——, *Catalogue of the Benson Collection*, London, 1914.

——, *Pictures by the Old Masters in the Library of Christ Church, Oxford*, London, 1916.

——, 'Auctions', *Burlington Magazine*, XXXVII, 1920, p. 57.

——, 'Some Reflections on the Last Phase of Titian', *Burlington Magazine*, XLI, 1922, pp. 87–91.

——, 'A Masterpiece by Titian', *Apollo*, VII, 1928, pp. 61–62.

——, 'Von der italienischen Ausstellung in London', *Pantheon*, V, 1930, p. 145.

Tancred Borenius, and L. Cust, *Catalogue . . . Northwick Park*, London, 1921.

L. Borgese, 'Una documentata prova che Tiziano morì all' età di centotrè anni', *Corriere d'informazione*, 30–31 maggio, 1955.

Borghese Collection, see:
Frizzoni, 1910.
Pergola, 1955, 1959, 1964.

Rafael Borghini, *Il riposo*, Florence, 1584, pp. 524–529; edition 1807, III, pp. 86–91.

Cardinal Federico Borromeo, *Il museo del cardinale Federico Borromeo* (1625), edited by Luca Beltrami, Milan, 1909.

Marco Boschini, *La carta del navegar pitoresco*, Venice, 1660; also new annotated edition by Ana Pallucchini, Venice, 1966.

——, *Le minere della pittura . . . di Venezia*, Venice, 1664.

——, *Le ricche minere della pittura*, Venice, 1674; 'Breve instruzione, Premessa a *Le ricche minere*', reprinted in Ana Pallucchini's edition of *La carta del navegar pitoresco*, Venice, 1966, pp. 701–756.

——, *I gioieli pittoreschi, virtuoso ornamento della città di Vicenza*, Venice, 1676.

Giovanni Gaetano Bottari, *Raccolta di lettere*, Rome, 1754–1773, 7 vols.; edition by Stefano Ticozzi, Milan, 1822–1825, 8 vols. See also Gualandi.

Ives Bottineau, 'L'Alcázar de Madrid et l'inventaire de 1686', *Bulletin hispanique*, LVIII, 1956, pp. 421–452; LX, 1958, pp. 30–61, 145–179, 289–326, 451–483.

Willelmo Braghirolli, *Tiziano alla corte dei Gonzaga*, reprint from *Atti e memorie della Real Accademia Virgiliana*, Mantua, 1881.

Pietro Brandolesi, *Pitture, sculture, architteture ed altre cose notabili di Padova*, Padua, 1795.

Wolfgang Braunfels, *Die heilige Dreifaltigkeit*, Düsseldorf, 1954.

——, 'Titian or Orazio Vecellio', *Burlington Magazine*, XCIX, 1957, p. 60.

——, 'Tizians Allocutio des Avalos und Giulio Romano', *Museion, Studien . . . für Otto H. Förster*, Cologne, 1960, pp. 108–112.

Carlo del Bravo, 'G. B. Stefaneschi', *Paragone*, no. 137, 1961, pp. 50–53.

Otto Brendel, 'Borrowings from Ancient Art in Titian', *Art Bulletin*, XXXVII, 1955, pp. 113–126.

G. Briganti, *Pietro da Cortona*, Florence, 1962.

Paolo Brognoli, *Nuova guida per la città di Brescia*, Brescia, editions 1819 and 1826.

Brukenthalisches Museum in Hermannstadt, 1909.

Mario Brunetti, 'Una figlia sconosciuta di Tiziano', *Rivista di Venezia*, XIV, 1935, pp. 175–184.

William Buchanan, *Memoirs of Painting*, London, 1824, 2 vols.

Buckingham Collection, see:
Davies, 1635.
Fairfax, 1758.

Buen Retiro Palace, Madrid, Inventory 1747.

Adolf Buff, 'Rechnungsauszüge, Urkunden und Urkundenregesten aus dem Augsburger Stadtarchiv', *Jahrbuch der Kunsthistorischen Sammlungen des Allerhöchsten Kaiserhauses*, Vienna, XIII, 1892, II Theil, pp. I–XXV.

Lucien Buonaparte; see Lucien Bonaparte.

Jacob Burckhardt, *Beiträge zur Kunstgeschichte von Italien*, Basel, 1898.

W. Bürger (pseudonym of Théophile Thoré, French critic (1807–1869), *Trésors d'art exposés à Manchester en 1857*, Paris, 1857.

Bryson Burroughs, 'Titian's Adoration of the Kings', *Metropolitan Museum Bulletin*, XXV, 1930, pp. 268–270.

Buen Retiro Palace, Madrid, Inventory of 1746 (after the death of Philip V), manuscript, Archivo del Palacio.

Antonio Busacca, *Guida per la città di Messina*, Messina, 1873.

Günter Busch, 'Kopien von Théodore Géricault nach alten Meistern', *Pantheon*, XXV, 1967, pp. 176–184.

J. Byam Shaw, *Paintings of Old Masters at Christ Church, Oxford*, London, 1967.

C. and C., see: Crowe and Cavalcaselle.

Giuseppe Cadorin, *Dello amore ai veneziani di Tiziano Vecellio delle sue case in Cadore e in Venezia*, Venice, 1833.

——, *Nota dei luoghi dove si trovano opere di Tiziano*, San Fior di Conegliano, 1885.

Luis Calandre, *El palacio del Pardo*, Madrid, 1953.

Maurizio Calvesi, 'Il San Giorgio Cini e Paolo Pino', *Venezia e l'Europa*, Venice, 1955, pp. 254–257.

Ettore Camesasca, see Aretino.

Giuseppe Campori, *Raccolta di cataloghi ed inventarii inediti*, Modena, 1870.

——, 'Tiziano e gli Estensi', *Nuova Antologia*, XXVII, 1874, pp. 581–620.

Giordana Canova, *Paris Bordon*, Venice, 1964.

G. Cantalamessa, *R. Gallerie di Venezia*, Le Gallerie Nazionali Italiane. Notizie e documenti, Rome, 1896.

G. B. Carbone and G. B. Rodella, *Le pitture e sculture di Brescia*, Brescia, 1760.

Vicente Carducho, *Diálogos de la pintura*, Madrid, 1633; also in Sánchez Cantón, *Fuentes literarias*, II, Madrid, 1933.

Alessandro Carletti, 'Il Christo della Moneta, quadro replica del Tiziano nel 1514', *Arte e storia*, no. 10, 8 March 1885, pp. 1–3.

Catalogue of European Paintings and Sculpture from 1300–1800, Masterpieces of Art, New York World's Fair, 1939.

Raffaello Causa, *IV Mostra di restauri*, Naples, 1960.

Giovanni Battista Cavalcaselle, 'Spigolature tizianesche', *Archivio storico dell' arte*, IV, 1891.

J. A. Ceán Bermúdez, *Diccionario histórico de los más ilustres profesores de las bellas artes en España*, Madrid, 1800, 6 vols.

Carlo Celano, *Notizie dello bello di Napoli* (1692), editions 1792 and 1870.

Cennino Cennini, *Il libro dell' arte*, Yale, edition by Daniel V. Thompson, 1932.

Philippe de Champaigne, 'Inventaire', *Archives de l'art français*, VIII, 1892, pp. 182–199.

Seigneur de Chantelou (Paul Fréart), *Journal du voyage en France du Cavalier Bernini*, edition Paris, 1930.

L. Charbonneau-Lassay, *Le bestiaire du Christ*, Bruges, 1940.

Charles I of England:

'Pictures Belonging to King Charles I at His Several Palaces, Appraised and Most of Them Sold by the Council of State. Order of March 23, 1649' (n. d., c. 1660), Manuscript no. 79A, Victoria and Albert Museum, London.

'Pictures, Statues, Plate and Effects of King Charles I, 1649–1651', London, Public Records Office, no. LR 2/124.

Harley Manuscript, no. 4898, London, British Museum, 'The Inventory of the Effects of Charles I, 1649–1652'.

See also Appendix in Cosnac, *Les richesses du Palais Mazarin*, Paris, 1885, 'Estat de quelques tableaux exposés en vente à la maison de Somerset May 1650', pp. 413–418.

See also van der Doort, 1639; Vertue, 1757; Ogden, 1947; and Nuttall, 1965.

Iris H. Cheney, 'Francesco Salviati's North Italian Journey', *Art Bulletin*, XLV, 1963, pp. 337–349.

Chicago: *Paintings in the Art Institute*, 1961.

Ciani, *Storia del popolo cadorino*, 1856 and 1862, edition Treviso, 1940.

Emmanuel Antonio Cicogna, *Delle iscrizioni veneziane*, Venice 1824–1853, 6 vols.

——, *Saggio di bibliografia veneziana*, Venice, 1847.

Christina, Queen of Sweden, see:

Granberg, 1896, 1897.

Odescalchi Archives, Rome.

Stockholm, 1966.

Waterhouse, 1966.

Cesare Cittadella, *Catalogo istorico dei pittori, scultori ferraresi*, Ferrara, 1782–1783, 4 vols. in 2.

Luigi Napoleoni Cittadella, *Notizie . . . relative a Ferrara*, Ferrara, 1868.

Gustav Clausse, *Les Farnèses peints par Titien*, Paris, 1905.

Cleveland Museum of Art: *Venetian Tradition*, 1956.

Annie Cloulas, 'Charles Quint et le Titien. Les premiers portraits d'apparat', *L'Information d'histoire de l'art*, IX, no. 5, 1964, pp. 213–221.

——, 'Documents concernant Titien conservés aux archives de Simancas', *Mélanges de la Casa de Velázquez*, III, 1967, pp. 197–288.

Luigi Coletti, 'Intorno ad un nuovo ritratto del vescovo Bernardo dei Rossi', *Rassegna d'arte*, VIII, 1921, pp. 407–420.

——, *Catalogo delle cose d'arte e di antichità d'arte, Treviso*, Rome, 1935.

C. H. Collins Baker, *Catalogue of the Pictures at Hampton Court*, London, 1929.

Rosita Colpi, 'Domenico Campagnola', *Bollettino del Museo Civico di Padova*, XXXI–XLIII, 1942–1954, pp. 81–110.

G. M. Columba, *Terremoto di Messina (1908), Opere d'arte recuperate*, Palermo, 1915.

Columbus (Ohio): *The Age of Titian*, Exhibition, 1946.

Antonio Conca, *Descrizione odeporica della Spagna*, Parma, 1793.

W. G. Constable, 'Italian Painting in the Lee Collection', *International Studio*, CXV, 1930, pp. 23–26.

Herbert Cook, *Giorgione*, London, 1907.

Copenhagen: *Royal Museum of Fine Arts, Catalogue*, 1951.

A. C. Coppier, 'Nos chef-d'oeuvres maquillés', *Les arts*, XII, no. 136, 1913, pp. 26–31.

Gabriel-Jules, Comte de Cosnac, *Les richesses du Palais Mazarin*, Paris, 1885.

Courtauld Files: i.e. Sir Robert Witt Photograph Collection, Courtauld Institute, London.

Luigi Crespi, *Vite dei pittori bolognesi non descritte nella Felsina Pittrice*, Rome, 1769.

Monsignore Lorenzo Crico, *Lettere sulle belle arti Trivigiane*, Treviso, 1833.

Crocker: *Catalogue of the Crocker Gallery*, 1964.

Cronica del soggiorno di Carlo V in Italia, published by G. Romano, Milan, 1892.

Sir Joseph Archer Crowe and Giovanni Battista Cavalcaselle, *History of Painting in North Italy*, London, 1871, 3 vols; edition 1912, with notes by Borenius.

——, *Life and Times of Titian*, 2 vols., London, 1877; edition 1881, same pagination; Italian edition, *Tiziano, La sua vita e i suoi tempi*, Florence, 1877–1878, 2 vols.

Gregorio Cruzada Villaamil, *Anales de la vida y de las obras de Velázquez*, Madrid, 1885.

Richard Cumberland, *Catalogue of the Several Paintings in the King of Spain's Palace at Madrid*, 1787.

L. Curtius, 'Zum Antikenstudium Tizians', *Archiv für Kulturgeschichte*, XXVIII, 1938, pp. 235–238.

Lionel Cust, 'Venetian Art at the New Gallery', *Magazine of Art*, XVIII, 1895, pp. 208–211.

——, 'Notes on the Collections formed by Thomas Howard, Earl of Arundel', *Burlington Magazine*, XIX, 1911, pp. 278–286.

Lionel Cust, 'Titian at Hampton Court', *Apollo*, VII, 1928, pp. 47–52.

Père Pierre Dan, *Le trésor de merveilles de la maison royale de Fontainbleau*, Paris, 1642.

H. Davies, *Hours in Lord Northwick's Picture Gallery*, Cheltenham, 1843.

R. Davies, 'Inventory of the Duke of Buckingham's Pictures at York House in 1635', *Burlington Magazine*, X, 1907, pp. 376–382.

Carlo D'Arco, *Delle arti e degli artifici di Mantova, Notizie raccolte*, Mantua, 1857, 2 vols.

dell'Acqua: see Acqua.

de los Santos, see Santos.

Theodore Demmler, *Kunstwerke aus dem besetzten Nordfrankreich ausgestellt im Museum zu Valenciennes*, Munich, 1918.

de Nolhac, see Nolhac.

de Rinaldis, see Rinaldis.

Detroit, Institute of Arts, *Exhibition of the Paintings of Titian*, 1928.

Detroit: *Paintings in the Detroit Institute of Arts, A Check List*, Detroit, 1965.

Lázaro Díez del Valle, 'Epílogo y nomenclatura de algunos artífices', 1659, in Sánchez Cantón, *Fuentes literarias para la historia del arte español*, Madrid, II, 1933, pp. 345–347.

William B. Dinsmoor, 'The Literary Remains of Sebastiano Serlio', *Art Bulletin*, XXIV, 1942, pp. 55–91.

G. Dionisi, *Sommario di memorie, ossia descrizione succinta delli quadri . . . di San Giovanni Evangelista*, Venice, 1787.

G. Dionisotti, 'Pietro Bembo', *Dizionario biografico degli italiani*, Rome, VIII, 1966, pp. 133–151.

S. Dodsley, 'Chatsworth Inventory', 1761 (manuscript at Chatsworth).

Max Doener, *Materials of the Artist*, New York, 1949 (other editions in German).

Lodovico Dolce, *Dialogo della pittura intitolado l'Aretino* 1557, edition by Paola Barocchi, Bari, 1960, in *Trattati d'arte del Cinquecento*.

Bernardo De Dominici, *Le vite dei pittori, scultori ed architetti napoletani*, Naples, vol. I–III, 1742–1743; also edition 1844 in 4 vols.

Leonardo Donà, *La corrispondenza da Madrid dell' ambasciatore Leonardo Donà*, published by Mario Brunetti and Eligio Vitale, Venice, 1963, 2 vols.

D'Onofrio, see Onofrio.

Doria-Pamphili Collection, see:
Tonci, 1794.
Sestieri, 1942.

R. Langton Douglas, 'The Date of Titian's Birth', *Art Quarterly*, XI, 1948, pp. 136–152.

Dublin: Thomas McGreevy, *Catalogue of Pictures of the Italian Schools*, Dublin, 1956.

Dubois de Saint Gelais: see Orléans Collection.

L. Dussler, 'Tizian-Ausstellung in Venedig', *Zeitschrift für Kunstgeschichte*, 10, 1935, pp. 237–239.

Duveen Pictures in Public Collections in America, New York, 1941.

Dyck: see Van Dyck.

Herbert von Einem, 'Karl V und Tizian', in *Karl V der Kaiser und seine Zeit*, Cologne, 1960.

Raffaele Elia, 'La quadreria della famiglia Storiani', *Studia picena*, XII, 1936, p. 85.

——, 'Elenchi di opere d'arte in Ancona', *Atti e Memorie della Diputazione di storia patria per le Marche*, VI serie, I, 1943.

——, 'La chiesa di San Domenico di Ancona', *Studia picena*, XXIII, 1955, pp. 62–67.

Andrea Emiliani, *La pinacoteca nazionale di Bologna*, Bologna, 1967.

Enciclopedia italiana, Rome, 35 vols., 1929–1939; Appendix, 5 vols., 1938–1961.

Cesare d'Engenio Caracciolo, *Napoli sacra*, Naples, 1624.

Eduard R. V. Engerth, *Gemälde*, Kunsthistorische Sammlungen, I. Band. Italienische, Spanische und Französische Schulen, Vienna, 1884; II. Niederländische Schulen, Vienna, 1892.

Escorial:
Documentos para la historia del monasterio de San Lorenzo el Real de El Escorial.
V (1962). *Verdadero orden de las pinturas del Escorial. Año 1776.*
VIII (1965). *Relaciones de los incendios del Monasterio de El Escorial*, published by Padre Gregorio de Andrés.

Celso Fabbro, 'La casa natale di Tiziano a Pieve di Cadore', *Archivio storico di Belluno, Feltre e Cadore*, XVIII, no. 96, 1946, pp. 1457–1458; XXII, nos. 115–116, 1951, pp. 46–52.

——, 'Documenti su Tiziano e sulla famiglia Vecellio conservati nella casa di Tiziano a Pieve di Cadore', *loc. cit.*, XXVIII, 1957; XXXIII, 1962.

——, 'Notizie . . . sul dipinto conservato nella nuova chiesa', *loc. cit.*, XXIV, 1963, no. 163, pp. 6–13.

——, 'Tre documenti inediti Tizianeschi', *loc. cit.*, XXXV, 1964, pp. 121–129.

Paolo Faccio, *Nuova guida pei forestieri amatori delle belle arti . . . in Padova*, Padua, 1818.

Giorgio T. Faggin, 'Aspetti dell' influsso di Tiziano nei paesi bassi', *Arte veneta*, XVIII, 1964, pp. 46–54.

Brian Fairfax, *Catalogue of the Curious Collection of Pictures of George Villiers, Duke of Buckingham*, London, 1758.

Cesareo Fernández Duro, *El último almirante de Castilla, Don Juan Tomás Enríquez de Cabrera*, Madrid, 1902.

Claude Ferraton, 'La collection du Duc de Richelieu au musée du Louvre', *Gazette des beaux-arts*, 6 période, XXXV, 1949, pp. 437–448.

Ermanno Ferrero and Giuseppe Müller, *Carteggio di Vittoria Colonna*, Turin, 1889.

Giuseppe Fiocco, 'La giovinezza di Giulio Campagnola', *L'Arte*, XVIII, 1915, pp. 138–156.

——, 'A Historical Titian', *Burlington Magazine*, XLV, 1924, p. 199.

——, *Mantegna*, Milan, 1937.

——, 'A Newly Discovered Salome by Titian', *Art in America*, 27, 1939, pp. 125–126.

——, *Pordenone*, Padua, 1943.

——, 'Francesco Vecellio', *Connoisseur*, 136, 1955, pp. 165–169.

——, 'Profilo di Francesco Vecellio', I, *Arte veneta*, VII, 1953, pp. 39–48; II, *Arte veneta*, IX, 1955, pp. 71–79; III, *Arte veneta*, X, 1956, pp. 90–94.

——, 'A Small Portable Panel by Titian for Philip II', *Burlington Magazine*, XCVIII, 1956, pp. 343–344.

——, *Studies in the History of Art Dedicated to William Suida*, New York, 1959, pp. 244–246.

Oskar Fischel, *Tizian*, Klassiker der Kunst, 3rd edition, Stuttgart, 1907; 5th edition, 1924.

Tamara Fomiciova, *Tiziano Vecellio* (in Russian), Moscow, 1960.

——, 'I dipinti di Tiziano nelle raccolte dell' Ermitage', *Arte veneta*, XXI, 1967, pp. 57–70.

Erik Forssman, 'Über Architekturen in der venezianischen Malerei des Cinquecento', *Wallraf-Richartz Jahrbuch*, XXIX, 1967, pp. 108–114.

Lodovico Foscari, *Iconografia di Tiziano*, Venice, 1935.

——, *Affreschi esterni a Venezia*, Milan, 1936.

Fossati, *Notizie sopra gli architetti e pittori della Scuola di San Rocco*, 1814, volume IV.

Anna M. Francini Ciaranfi, *La Galleria Palatina Pitti*, Florence, 1956 and 1964.

Henry Francis, 'Titian's Adoration of the Kings', *Cleveland Museum Bulletin*, 47, 1960, pp. 59–63.

Abbate Gaetano Frascarelli, *Memorie . . . della basilica . . . dei padri minori conventuali in Ascoli Piceno*, Ascoli, 1855.

Burton B. Fredericksen, *A Handbook of the Paintings in the J. Paul Getty Museum*, Malibu, 1965.

Sydney J. Freedberg, 'Il Rosso', *Encyclopedia of World Art*, New York, XII, 1966.

Frank E. Washburn Freund, 'Paintings of Titian in America', *International Studio*, New York, XC, 1928, pp. 35–41.

Dagobert Frey, 'Tizian und Michelangelo, Zum Problem des Manierismus', *Museion, Studien . . . für Otto H. Förster*, Cologne, 1960, pp. 102–108.

Karl Frey, *Il carteggio di Giorgio Vasari dal 1563 al 1565*, Italian edition by Alessandro del Vita, Arezzo, 1941.

Walter Friedländer, 'Titian and Pordenone', *Art Bulletin*, XLVII, 1965, pp. 118–121.

Theodor von Frimmel, *Gemalte Galerien*, Berlin, 1896.

William Frizell Collection: see Brian Reade; H. and M. Ogden.

Gustavo Frizzoni, 'Nuove rivelazioni', *Rassegna d'arte*, VI, 1906.

——, 'Giorgione, Tiziano, e van Dyck', *Rassegna d'arte*, VII, 1907, pp. 154–155.

——, 'Alcuni dipinti della Galleria Borghese', *L'Arte*, X, 1910, pp. 193–194.

Lili Fröhlich-Bum, 'Andrea Meldolla, gennant Schiavone', *Jahrbuch der Kunsthistorischen Sammlungen des Allerhöchsten Kaiserhauses*, Vienna, XXXI, 1913, pp. 137–220.

——, 'Five Drawings for Titian's Altarpiece of St. Peter Martyr', *Burlington Magazine*, XLV, 1924, pp. 280–285.

——, 'Eine Zeichnung Tizians zu dem Paduaner Fresko', *Kunstchronik*, N.F., XXXV, 1925–1926, pp. 221–222.

——, 'Two Unpublished Sketches by Titian', *Burlington Magazine*, LI, 1927, pp. 228–233.

——, 'Die Zeichnungen Tizians', *Jahrbuch der Kunsthistorischen Sammlungen in Wien*, N.F., II, 1928, pp. 194–198.

——, 'Die Landschaftzeichnungen Tizians', *Belvedere*, VIII, 1929, Heft 3, pp. 71–78.

Roger Fry, 'Exhibition of Old Masters at Grafton Galleries', *Burlington Magazine*, XX, 1911, p. 162.

Louis P. Gachard, *Retraite et mort de Charles Quint au monastère de Yuste*, Brussels, 1885.

G. Galbiati, *Itinerario . . . della Biblioteca Ambrosiana, della Pinacoteca*, Milan, 1951.

Gianfrancesco Galeani Napione, *Del quadro di Tiziano rappresentante S. Pietro Martire*, Venice, 1823.

Rodolfo Gallo, 'Per il San Lorenzo martire di Tiziano', *Rivista di Venezia*, XIV, 1935, pp. 155–171.

——, 'Le aggiunte di Davide Farsetti al libro "Della pittura veneziana" . . . a Zanetti', *Ateneo veneto*, serie V, vol. XIII, 1939, pp. 241–266.

P. B. Gams, *Series episcoporum*, Leipzig, 1931.

G. Gamulin, *Zbornik instituta za historijske nauke*, I, 1955.

——, 'Un polittico del Tiziano nella cattedrale di Dubrovnik', *Venezia e l'Europa*, Venice, 1955, pp. 269–271.

——, 'Un quadro di Tiziano troppo dimenticato', *Commentari*, VIII, 1957, pp. 33–38.

Klara Garas, 'The Ludovisi Collection of Pictures in 1633', *Burlington Magazine*, CIX, 1967, pp. 287–289; 339–348.

Antonio Gardin, *Errori di Crowe e Cavalcaselle nella storia critica della pala di Tiziano in Castel Roganzuolo*, Florence, 1883.

Giacomo Gatti, *Descrizione delle cose più rare di Bologna*, Bologna, 1803.

Juan Antonio Gaya Nuño, 'Notas al catálogo del Museo del Prado', *Boletín de la Sociedad Española de Excursiones*, LVIII, 1954, pp. 101–142.

——, *Historia y guía de los museos de España*, Madrid, 1955.

Giovanni Gaye, *Carteggio d'artisti*, Florence, 1839–1840.

Giuseppe Gerola, 'Per la fortuna di un soggetto del Tiziano', *L'Arte*, XII, 1908, pp. 455–456.

Olga von Gerstfeldt, 'Venus und Violante', *Monatshefte für Kunstwissenschaft*, III, 1910, pp. 365–376.

Felton Gibbons, *Dosso and Battista Dossi*, Princeton, 1968.

Creighton Gilbert, 'Sante Zago e la cultura artistica del suo tempo', *Arte veneta*, VI, 1952, pp. 121–129.

——, 'When Did a Man in the Renaissance Grow Old', *Studies in the Renaissance*, XIV, 1967, pp. 7–32.

Josiah Gilbert, *Cadore or Titian's Country*, London, 1869.

G. Giomo, 'San Pietro martire di Tiziano', *Nuovo archivio veneto*, N.S., VI, 1903, pp. 55–69.

Giustiniani Collection, see:
Landon, 1812.
Salerno, 1960.

Glasgow: *Catalogue Descriptive and Historical of the Pictures in the Glasgow Art Galleries and Museum*, Glasgow, editions 1911 and 1935.

Gustav Glück, 'Original und Kopie', *Festschrift für Julius Schlosser*, Vienna, 1927, pp. 224–242.

——, 'Bildnisse aus dem Hause Habsburg', 'I, Kaiserin Isabella', *Jahrbuch der Kunsthistorischen Sammlungen in Wien*, N.F., VII, 1933, pp. 183–210; 'III, Kaiser Karl V', idem, N.F., XI, 1937, pp. 165–178.

——, and August Schaeffer, *Die Gemäldegalerie. Alte Meister*, Vienna, 1907.

V. Golzio, *La galleria e le collezioni della R. Accademia di San Luca*, Rome, 1939.

——, 'Il testamento di Martino Longhi Juniore', *Archivi d'Italia e rassegna internazionale degli archivi*, Serie 2, vol. 5, 1938, pp. 207–208.

Gyorgy Gombosi, *Moretto da Brescia*, Basle, 1943.

Padre Bernardo Gonzati, *La basilica di San Antonio di Padova*, Padua, 1854.

J. W. Goodison and G. H. Robertson, *Catalogue of Paintings, Italian Schools*, Fitzwilliam Museum, Cambridge, 1967.

S. J. Gore, 'An Ecce Homo in Dublin', *Burlington Magazine*, 97, 1955, p. 218.

Cecil Gould, *The Sixteenth-Century Venetian School*, London, National Gallery, 1959.

Olof Granberg, *Drottning Kristinas Tafvelgalleri på Stockholms slott och i Rom*, Stockholm, 1896.

——, *La galerie de tableaux de la Reine Christine de Suède*, Stockholm, 1897.

——, *Inventaire général des trésors d'art en Suède*, Stockholm 1911–1913, 3 vols.

Granvelle: Auguste Castan, 'Monographie du Palais Granvelle à Besançon (with inventory)', *Mémoires de la Société d'Emulation de Doubs*, 4 série, II, 1867 (i.e. 1866), pp. 109–139.

——: see also letters: Zarco del Valle, 1888.

Algernon Graves, *Art Sales*, London, 1921, 3 vols.

Ester Grazzini-Cocco, 'Pittori cinquecenteschi padovani', *Bollettino del Museo Civico di Padova*, III, 1927, no. 3–4, pp. 89–117.

Ferdinand Gregorovius, *History of the City of Rome in the Middle Ages*, translated by Anne Hamilton, London, 1902, VIII, part 2.

——, 'Alcuni cenni storici sulla cittadinanza romana', *Atti della Real Accademia dei Lincei. Memorie della classe di scienze morali, storiche e filologia*, serie III, I, 1877, pp. 314–346.

Andreina Griseri, 'Appunti genovesi', *Studies in the History of Art dedicated to William E. Suida*, London, 1959, pp. 312–324.

Georg Gronau, 'Tizians Geburtsjahr', *Repertorium für Kunstwissenschaft*, XXIV, 1901, pp. 457–462.

——, 'Die Kunstbestrebungen der Herzöge von Urbino', *Jahrbuch der königlich preuszischen Kunstsammlungen*, XXIV, 1904, Beiheft, pp. 1–33; Italian edition: *Documenti artistici urbinati*, Florence, 1936, pp. 1–8, 85–113.

——, *Titian*, English edition, London, 1904.

——, 'Zwei Tizianische Bildnisse der Berliner Galerie', *Jahrbuch der königlich preuszischen Kunstsammlungen*, XXVII, 1906, pp. 3–12.

——, 'Zur Geschichte der Caesarenbilder von Tizian', *Münchner Jahrbuch*, I, 1908, pp. 31–34.

——, 'Ein Bild der Verkündigung von Tizian', *Zeitschrift für bildende Kunst*, N.F. XXXIV, 1924–1925, pp. 158–160.

——, 'Alfonso d'Este und Tizian', *Jahrbuch der Kunsthistorischen Sammlungen in Wien*, N.F., II, 1928, pp. 233–246.

——, 'Alcuni quadri di Tiziano illustrati da documenti', *Bollettino d'arte*, XXX, 1937, pp. 289–296.

Luca Grossato, *Il Museo Civico di Padova*, Venice, 1957.

——, *Affreschi del Cinquecento in Padova*, Milan, 1966.

Giuseppe Grosso Cacopardo, *Guida per la città di Messina*, Messina, 1826.

F. A. Gruyer, *Chantilly, Musée Condé*, Paris, 1899.

A. Guadagnini, *Pinacoteca, catalogo dei quadri*, Bologna, 1899.

Michel Angelo Gualandi, *Memorie originali italiane risguardanti le belle arti*, Bologna, 1840–1845.

Paul Guérin *Les petits Bollandistes*, Paris, 1888, 17 vols.; Paul Piolin. *Supplément*, 3 vols.

Guida sommaria . . . della Biblioteca Ambrosiana, Milan, 1907.

Jules Guiffrey and Vicomte de Gronchy, 'Les peintres Philippe et Jean-Baptiste de Champaigne', *Nouvelles archives de l'art français*, VIII, 1892, pp. 172–218.

Oskar Haagen, 'Das Dürerische in der italienischen Malerei', *Zeitschrift für bildende Kunst*, N.F., XXIX, 1918, pp. 223–242.

Detlev von Hadeln, 'Beiträge zur Tintorettoforschung', *Jahrbuch der königlich preuszischen Kunstsammlungen*, Berlin, XXXII, 1911, pp. 25–58.

Detlev von Hadeln, 'Domenico Campagnola', Thieme-Becker, *Allgemeines Lexikon der bildenden Künstler*, V, 1911, pp. 449–451.

——, 'Damiano Mazza', *Zeitschrift für bildende Kunst*, N.F., XXIV, 1912–1913, pp. 249–254.

——, 'Über Zeichnungen der früheren Zeit Tizians', *Jahrbuch der königlich preuszischen Kunstsammlungen*, Berlin, XXXIV, 1913, pp. 224–250.

——, review of Hetzer's 'Die frühen Gemälde Tizians', in *Kunstchronik*, N.F., 31, 1920, pp. 931–934.

——, *Zeichnungen des Tizian*, Berlin, 1924.

——, 'Some Little-Known Works by Titian', *Burlington Magazine*, 45, 1924, pp. 179–181.

——, *Venezianische Zeichnungen der Hochrenaissance*, Berlin, 1925.

——, *Titian's Drawings*, London, 1927.

——, 'Two Unknown Works by Titian', *Burlington Magazine*, LIII, 1928, pp. 55–56 (both are forgeries).

——, 'Ein Gruppenbildnis von Tizian', *Pantheon*, V, January 1929, pp. 10–12, illustration.

——, 'Dogenbildnisse von Tizian', *Pantheon*, VI, 1930, pp. 489–494.

——, 'Das Problem der Lavinia-Bildnisse', *Pantheon*, VII, 1931, pp. 82–87.

——, and Hermann Voss, *Archiv für Kunstgeschichte*, Leipzig, I, 1913–1915.

Craig S. Harbison, 'Counter-Reformation Iconography in Titian's Gloria', *Art Bulletin*, XLIX, 1967, pp. 244–246.

Harcourt Collection: *Description of Nuneham-Courtenay in the County of Oxford*, Oxford, 1806.

Harley Manuscript, no. 4898, London, British Museum, 'The Inventory of the Effects of Charles I, 1649–1652'.

Count Harrach Collection, see:
Heinz, 1960.
Ritchl, 1926.

Frederick Hartt, *Giulio Romano*, New Haven, 1958, 2 vols.

Francis Haskell, *Patrons and Painters*, New York, 1963.

Louis Hautecoeur, *Ecole italienne et école espagnole*, Musée National du Louvre, Paris, 1926.

Fritz Heinemann, *Tizian*, Munich, dissertation, 1928.

——, *Giovanni Bellini e i Belliniani*, Venice, 1960, 2 vols.

——, 'Tizians zweite Fassung der Grablegung Christi', *Arte veneta*, XVI, 1962, pp. 157–158.

Rudolf Heinemann, *Sammlung Schloss Rohoncz*, Lugano, 1958.

Günther Heinz, *Katalog der Graf Harrachschen Gemäldegalerie*, Vienna, 1960.

Philip Hendy, *Catalogue of the Exhibited Paintings and Drawings*, Isabella Stewart Gardner Museum, Boston, 1931.

——, 'Ein berühmter Tizian wieder aufgetaucht', *Pantheon*, XI, 1933, pp. 52–54.

——, 'More about Giorgione's Daniel and Susannah', *Arte veneta*, VIII, 1954, pp. 167–171.

——, *Some Italian Renaissance Pictures in the Thyssen-Bornemisza Collection*, Lugano, 1964.

Annemarie Henle, *Master Drawings*, San Francisco, Golden Gate International Exhibition, 1940 (1941).

Mary F. S. Hervey, *The Life, Correspondence and Collections of Thomas Howard, Earl of Arundel*, Cambridge, 1941.

Theodor Hetzer, *Die frühen Gemälde Tizians*, Basel, 1920.

——, 'Studien über Tizians Stil', *Jahrbuch für Kunstwissenschaft*, I, 1923, pp. 203–248.

——, 'Über Tizians Gesetzlichkeit', *Jahrbuch für Kunstwissenschaft*, VI, 1928, pp. 1–20.

——, 'Vecellio, Tiziano', Thieme-Becker, *Künstlerlexikon*, XXXIV, 1940, pp. 158–171.

——, *Tizian. Geschichte seiner Farbe*, Frankfurt, 1948.

Hans Hoffmann, *Hochrenaissance, Manierismus, Frühbarock*, Leipzig, 1938.

The Holford Collection, Dorchester House, Oxford, 1927, 2 vols.

Sir Charles Holmes, 'A Preliminary Version of Titian's Trinity', *Burlington Magazine*, L, 1927, pp. 53–62.

——, 'The Inscription on Titian's Portrait of Franceschi', *Burlington Magazine*, LV, 1929, pp. 159–160.

J. Hoogewerff, 'Un bozzetto di Tiziano per la pala dei Pesaro', *Bollettino d'arte*, VII, 1928, pp. 529–537.

Louis Hourticq, *La jeunesse de Titien*, Paris, 1919.

——, *Le problème de Giorgione*, Paris, 1930.

Sir Abraham Hume, *Notices of the Life and Works of Titian*, London, 1829.

A. Hulftegger, 'Notes sur la formation des collections de peintures de Louis XIV', *Bulletin de la Société de l'Histoire de l'Art Français*, 1955 (année 1954), p. 132.

G. Innamorati, 'Pietro Aretino', *Dizionario biografico degli italiani*, IV, 1962, pp. 89–104.

'Inventario general de los objetos artísticos y efectos de todas clases existentes en el Real Museo de pintura y escultura', Prado Library, Madrid, 1857 (manuscript) (pictures without provenance specified came from the Royal Palace).

Teodor Ionescu, 'Un Ecce Homo di Tiziano al Museo Brukenthal', *Paragone*, no. 129, 1960, pp. 38–45.

——, 'Ein Gemälde von Tizian in Sibiu entdeckt', *Kunst in der Rumänischen Volksrepublik*, no. 21, 1961.

——, the same in English in *Arts in the Rumanian People's Republic*, 1961 (colour print).

——, 'Un tablou de Tiziano la Sibiu', *Omagiu lui George Oprescu*, Bucharest, 1961, pp. 275–282.

Emil Jacobs, 'Das Museum Vendramin und die Sammlung Reynst', *Repertorium für Kunstwissenschaft*, 46, 1925, pp. 15–18.

Michael Jaffé, *Van Dyck's Antwerp Sketchbook*, London, 1966, 2 vols.

Mrs. Anna Jameson, *Companion to . . . Celebrated Private Galleries*, London, 1844.

——, *Memoires and Essays* (1846), New York, 1878.

H. W. Janson, *Apes and Ape Lore*, London, 1952.

——, *History of Art*, New York, 1964.

Bob Jones University: see under Bob.

Paulina Junquera, 'Las Descalzas Reales, a la vez convento y museo', *Goya*, no. 42, 1961, pp. 385–388.

Karl Justi, 'Verzeichnis der früher in Spanien befindlichen jetzt verschollenen oder in das Ausland gekommenen Gemälde Tizians', *Jahrbuch der Kunsthistorischen Sammlungen des Allerhöchsten Kaiserhauses*, Vienna, x, 1889, pp. 181–186 (an out-of-date and incomplete account).

——, *Miscellaneen aus drei Jahrhunderten*, Berlin, 1908.

Ludwig Justi, *Giorgione*, editions Berlin, 1908 and 1926.

Madlyn Kahr, 'Titian's Old Testament Cycle', *Journal of the Warburg and Courtauld Institutes*, XXIX, 1966, pp. 193–205.

——, 'Titian and the Hypnerotomachia Poliphili, Woodcuts and Antiquity', *Gazette des Beaux-Arts*, 7 période, LXVII, 1966, pp. 118–127 (unconvincing article).

Hugo Kehrer, *Die heiligen drei Könige*, Strasburg, 1904.

Hayward Keniston, *Francisco de los Cobos, Secretary to the Emperor Charles V*, Pittsburgh, 1959.

Ruth W. Kennedy, review of Arthur M. Hind's, 'Early Italian Engravings', *Art Bulletin*, XXXIII, 1951, pp. 143–148.

——, 'Tiziano in Roma', *Il mondo antico nel Rinascimento*, Florence, 1956 (published 1958), pp. 237–243.

——, *Novelty and Tradition in Titian's Art*, Northampton, 1963.

——, 'Apelles Redivivus', *Essays in Memory of Karl Lehmann*, New York, 1964, pp. 160–170.

Friderike Klauner and Vinzenz Oberhammer, *Katalog der Gemäldegalerie*, Teil I, Vienna, 1960.

Karl Köpl, 'Urkunden, Acten, Regesten, und Inventare aus dem K K Statthalterei-Archiv in Prague', *Jahrbuch der Kunsthistorischen Sammlungen des Allerhöchsten Kaiserhauses*, x, 1889, pp. LXIII–CC: Prague inventory 1718, no. 6232; 1723, no. 6233; 1737, no. 6234; 1763, no. 6235; XII, II Theil, 1891, pp. III–XC: 9433, Letter of Khevenhüller to Rudolf II, Cupid, Ganymede, and 12 Emperors (copies of Titian?) of Antonio Pérez.

Konody: see Rothermere.

Kress Collection, Paintings and Sculpture, Washington, National Gallery, 1959 (illustrations only).

Kress Collection: see also Shapley and Suida.

A. Kronfeld, *Führer durch die fürstlich Liechtensteinsche Gemäldegalerie in Wien*, Vienna, 1927.

Karl Künstle, *Ikonographie der christliche Kunst*, Freiburg, 1928.

Charles P. Landon, *Galerie Giustiniani*, Paris, 1812.

Luigi Lanzi, *Storia pittorica della Italia*, 1789, edition Florence, 1834.

E. Law, *A Historical Catalogue of the Pictures in the Royal Collection at Hampton Court*, London, 1881.

Marqués de Leganés: José López Navio, 'La gran colección de pinturas del Marqués de Leganés', *Analecta calasanctiana*, Madrid, núm. 8, 1962, pp. 261–330.

Legenda aurea sanctorum, by Jacobus de Voragine, Nuremberg, Koberger 1481.

Jules Lenglart, *Musée de Lille*, Lille, 1893.

Leningrad, Hermitage: *Catalogue of Paintings* (in Russian), Leningrad, 1958.

Abbate Antonio Leoni in *Ancona illustrata*, Ancona, 1832, p. 261.

Archduke Leopold Wilhelm: 'Inventar': 1659, published by Adolf Berger, *Jahrbuch der Kunsthistorischen Sammlungen des Allerhöchsten Kaiserhauses*, Vienna, I, 1883, II Theil pp. LXXXVI–CXIV.

François B. Lépicié, *Catalogue raisonné des tableaux du roy*, Paris, 1752–1754, 2 vols.

Cesare A. Levi, *Le collezioni veneziane*, Venice, 1900.

Mirella Levi d'Ancona, *The Iconography of the Immaculate Conception in the Middle Ages and Early Renaissance*, New York, 1957.

V. F. Levinson-Lessing, *The Hermitage, Mediaeval and Renaissance Masters*, London, 1967.

E. de Liphart, 'Les tableaux italiens du XVI siècle au château de Gatchina', *Starye Gody*, January 1915, pp. 3–5.

Liverpool: *Foreign Schools, Catalogue*, Walker Art Gallery, 1963.

M. Llorente Junquera, 'La Santa Margarita de Tiziano en el Escorial', *Archivo español de arte*, XXIV, 1951, pp. 67–72.

Kurt Löcher, *Jacob Seisenegger*, Linz, 1962.

Giovanni Paolo Lomazzo, *Idea del tempio della pittura* (1590), edition Rome, 1947.

London, 1913–1914: Grosvenor Gallery, *Woman and Child in Art*.

London, 1915: *The Venetian School*, by R. H. Benson, Burlington Fine Arts Club.

London, 1930: *Exhibition of Italian Art, 1200–1900*, London, Royal Academy, 1930.

Roberto Longhi, 'Giunte a Tiziano', *L'Arte*, XXVIII, 1925, pp. 40–45; reprinted in *Saggi e ricerche*, 1925–1928, Florence, 1967, pp. 9–18.

——, 'Cartella Tizianesca', *Vita artistica*, II, 1927, pp. 216–226; reprinted in *Saggi e ricerche*, 1925–1928, Florence, 1967, pp. 233–244.

——, *Officina ferrarese* (1934), Florence, edition 1956.

——, *Viatico per cinque secoli di pittura veneziana*, Florence, 1946.

——, 'Calepino veneziano', *Arte veneta*, I, 1947, pp. 191–194.

—— 'Una citazione Tizianesca nel Caravaggio', *Arte veneta*, VIII, 1954, pp. 211–212.

L. Loostrøm, *Konstsamlingarna, På Säfstaholm*, 1882.

Giulio Lorenzetti, 'Per la storia del Cristo Portacroce della chiesa di San Rocco in Venezia', *Venezia, studi di arte e storia*, I, 1920, pp. 181–205.

——, *Venezia e il suo estuario*, Venice, 1926, and edition 1956.

Giovanni Battista Lorenzi, *Monumenti per servire alla storia del Palazzo Ducale di Venezia*, Venice, 1868.

C. Lotti, 'Tiziano morì a 103 anni', *Domenica del Corriere*, May, 1955.

Wolfgang Lotz (editor), *Studien zur toskanischen Kunst, Festschrift Heydenreich*, Munich, 1964.

Ludovisi Collection, see:
Garas, 1967.

Gustav Ludwig, 'Archivalische Beiträge zur Geschichte der venezianischen Malerei', *Jahrbuch der königlich preuszischen Kunstsammlungen*, Berlin, XXIV, 1903, Beiheft, pp. 114–118; XXVI, 1905, Beiheft, pp. 1–157.

——, 'Nachrichten über venezianische Maler', *Italienische Forschungen*, IV, 1911, pp. 85–148.

Alessandro Luzio, *La galleria dei Gonzaga*, Milan, 1913 (Inventory of sale to Charles I of England in 1627).

——, 'Le Maddalene di Tiziano', *La Lettura, Revista mensile del Corriere della Sera*, Milan, anno 40, no. 8, August 1940, pp. 591–598.

Neil MacLaren, 'The Condition of the Picture', *Journal of the Warburg Institute*, III, 1939–1940, pp. 140–141.

Pascual Madoz, *Diccionario histórico-estadístico-geográfico de España*, Madrid, 1847.

Pedro de Madrazo, *Catálogo de los cuadros del Real Museo de Pintura*, Madrid, 1843; editions, 1854, 1873, and 1910.

——, *Viaje artístico de tres siglos por las colecciones de cuadros de los reyes de España*, Barcelona, 1884.

Karl Madsen, 'Köbet af an Tizian', *Samleren*, III, 1926, pp. 133–139.

Madrid, see:
Alcázar.
Buen Retiro Palace.
Madrazo.
Prado Museum.
Sánchez Cantón.

A. Maggiori, *Pitture, sculture ed architetture della città di Ancona*, Ancona, 1821.

Andrea Majer, *Della imitazione pittorica della eccellenza delle opere di Tiziano*, Venice, 1818.

Carlo Malagola, 'La mostra d'arte sacra', *Rassegna d'arte*, IX, 1909, pp. 9–12.

Emile Mâle, *L'art religieux à la fin du moyen âge en France*, Paris, 1925.

——, *L'art religieux après le Concile de Trente*, Paris, 1932.

Carlo Cesare Malvasia, *Felsina pittrice*, Bologna, 1678.

Manchester: *Catalogue of the Art Treasures of the United Kingdom*, Manchester, 1857.
See also Bürger, 1857.

Manfrin: Pinacoteca Manfrin a Venezia, G. Nicoletti, Venice, 1872.

Jacomo Manilli, *Villa Borghese*, Rome, 1650.

Gregorio Marañón, *Antonio Pérez*, Madrid, 1948, 2 vols.

Henri Marceau, 'Titian's Virgin and Child with St. Dorothy', *Philadelphia Museum Bulletin*, LIII, 1957, no. 255, pp. 3–7.

C. F. Marcheselli, *Pitture delle chiese di Rimini*, 1754.

Giuseppe Marchini, *La pinacoteca communale di Ancona*. Ancona, 1960.

Francesco Marcolini, *Lettere scritte al signore Pietro Aretino*, Venice, 1552, 2 vols.

Rudolf Marggraff, *Katalog der königlichen Gemälde-galerie in Augsburg*, Munich, 1869.

Giovanni Mariacher, *Il Sansovino*, Verona, 1962.

——, 'Ein neuer Christus mit dem Zinsgroschen von Tizian', *Die Weltkunst*, XXXIII, 1963, no. 15, pp. 5–6.

P. J. Mariette, 'Abecedario' (1719), published in *Archives de l'art français*, by Chennevières and Montaiglon, Paris, II, 1851–1853, pp. 294–296; V, 1858–1859, pp. 301–340.

Antonio Martinelli, *Quattro discorsi*, Venice, 1783.

Domenico Martinelli, *Il ritratto di Venezia*, Venice, 1684.

Mary of Hungary (sister of Charles V), Inventory 1558:
Rudolf Beer, 'Acten, Regesten und Inventare aus dem Archivo General de Simancas', *Jahrbuch der Kunsthistorischen Sammlungen des Allerhöchsten Kaiserhauses*, Vienna, XII, 1891, II Theil, pp. CLVIII–CLXIV.
See also: Pinchart, 1856.

Frank J. Mather, Jr., *Venetian Painters*, New York, 1936.

——, 'When was Titian Born?', *Art Bulletin*, XX, 1938, pp. 13–25.

Enrico Mauceri, *Il Museo Nazionale di Messina*, Rome, 1929.

——, 'Restauro di una Crocifissione di Tiziano', *Bollettino d'arte*, XXV, 1931–1932, pp. 94–95.

——, *La regia pinacoteca di Bologna*, Bologna, 1935.

Pierre Maurois, *Chef-d'oeuvres de Lille*, Ghent, Musée des Beaux-Arts, 1950.

Fabio Mauroner, *Le incisioni di Tiziano*, Venice, 1941.

A. L. Mayer, 'Tizianstudien', *Münchner Jahrbuch*, N.F. II, 1925, pp. 267–284.

——, *El Greco*, Munich, 1926.

——, 'An Unknown Mater Dolorosa by El Greco', *Burlington Magazine*, 52, 1928, pp. 183–185.

——, 'The Yarborough Magdalen by Titian', *Apollo*, XI, 1930, p. 102.

——, 'Nachrichten', *Pantheon*, V, 1930.

——, *Boletín de la Sociedad Española de Excursiones*, XLII, 1934, p. 298.

——, 'Unknown Ecce Homo by Titian', *Burlington Magazine*, 67, 1935, pp. 52–53.

——, 'Una ignota Mater Dolorosa di Tiziano', *L'Arte*, VI, 1935, pp. 374–375.

A. L. Mayer, 'Two Pictures by Titian in the Escorial', *Burlington Magazine*, LXXI, 1937, pp. 178–183.

——, 'A propos d'un nouveau livre sur le Titien', *Gazette des beaux-arts*, 6 période, XVIII, 1937, pp. 304–311.

——, 'Quelques notes sur l'oeuvre de Titien', *Gazette des beaux-arts*, 6 période, XX, 1938, pp. 289–308.

A. L. Mayer and van Bercken, *Tintoretto*, Munich, 1923.

Christian von Mechel, *Verzeichnis der Gemälde der kaiserlich-königlichen Bilder-Gallerie in Wien*, Vienna, 1783; French edition, 1784.

Memorial to Horace Buttery, London, Colnaghi & Co., June 11–29, 1963, no. 8.

Messina: *Messina e dintorni, Guida*, a cura del Municipio, Messina, 1902.
 See also: G. Grosso Cacopardo, 1826; A. Busacca, 1873.

Julius Meyer and Wilhelm Bode, *Königliche Museen, Gemälde-Galerie*, Berlin, 1878.

Marcantonio Michiel, *Notizie d'opere di disegno* (c. 1532); edition Jacopo Morelli, Bassano, 1800; edition G. Frizzoni, Bologna, 1884; edition G. C. Williamson, London, 1903.

Milan: *Guida Sommaria . . . della Biblioteca Ambrosiana*, 1907.

José Milicua, 'A propósito del pequeño crucifijo Ticianesco del Escorial', *Archivo español de arte*, XXX, 1957, pp. 115–123.

Piero H. de Minerbi, 'Gli affreschi del Fondaco dei Tedeschi a Venezia', *Bollettino d'arte*, XXX, 1936, pp. 170–177.

H. Mireur, *Dictionnaire des ventes d'art*, Paris, 1912, 7 vols.

James V. Mirollo, *The Neapolitan Poet Giovanni Battista Marino*, New York, 1963.

Ettore Modigliani, *La collezione di Luigi Albertini*, Rome, 1942.

——, *Catalogo della pinacoteca di Brera*, Milan, 1950.

P. G. Molmenti, 'Giorgione', *Bollettino di arti, industrie e curiosità veneziane*, II, 1878.

Pompeo Molmenti, *La storia di Venezia nella vita privata*, Bergamo, 1910–1912, 3 vols.

Mond: *The Mond Collection*, J. P. Richter, London, 1910.

Antonio Morassi, 'Il Tiziano di Casa Balbi', *Emporium*, anno LII, vol. CIII, 1946, pp. 207–228.

——, *Capolavori della pittura a Genova*, Milan, 1951.

——, 'Esordi di Tiziano', *Arte veneta*, IV, 1954, pp. 178–198.

——, 'Un disegno e un dipinto sconosciuti di Giorgione', *Emporium*, 121, 1955, pp. 147–159.

——, *Tiziano: gli affreschi della Scuola del Santo*, Milan, 1956.

——, 'Titian', *Encyclopaedia of World Art*, XIV, 1967, pp. 132–158.

——, 'Una Salome di Tiziano riscoperta', *Pantheon*, XVI, 1968, pp. 456–466.

Giovanni Morelli (Lermolieff), *Kunstkritische Studien*, Leipzig, 1890–1893, 3 vols.

——, *Italian Painters*, edition London, 1892, 1893, 2 vols.

——, *Della pittura italiana*, Milan, 1897.

J. Moreno Villa, 'Como son y como eran unos Tizianos del Prado', *Archivo español de arte y arqueología*, IX, 1933, pp. 113–116.

Gaetano Moroni, *Dizionario di erudizione storico-ecclesiastico*, Venice, 1840–1879, 103 vols., plus indices in 6 vols.

Bernardo Morsolin, 'Tiziano a Vicenza', *Arte e storia*, XI, 1892, pp. 89–90.

A. Moschetti, *I danni ai monumenti e alle opere d'arte delle Venezie*, Venice, 1932.

Gianantoni Moschini, *Guida per la città di Venezia*, Venice, 1815, 2 vols.

——, *Guida per la città di Padova*, Padua, 1817.

Sandra Moschini Marconi, *Gallerie dell'Accademia di Venezia, Opere d'arte del secolo XVI*, Rome, 1962.

Mostra di pittura veneziana nelle Marche, Ancona, 1950.

Mostra di Tiziano. Catalogo delle opere, by Gino Fogolari, Venice, 1935.

Mostra dei Vecellio a Belluno: see Valcanover, 1951.

Justus Müller-Hofstede, 'Bildnisse aus Rubens' Italienjahren', *Jahrbuch der Staatlichen Kunstsammlungen in Baden-Württemberg*, II, 1965, pp. 89–153.

——, 'Rubens und Tizian: Das Bild Karl V', *Münchner Jahrbuch*, XVIII, 1967, pp. 33–96.

J. Müller-Rostock, 'Ein Verzeichnis von Bildern aus dem Besitze des van Dyck', *Zeitschrift für bildende Kunst*, N.F. XXXIII, 1922, pp. 22–24.

Munich: *Alte Pinakothek*, 1957.

Hugh A. J. Munro, *A Complete Catalogue of Paintings*, London, 1865.

Michelangelo Muraro, *Pitture murali nel Veneto e tecnica dell' affresco*, Venice, 1960.

——, 'Studiosi collezionisti e opere d'arte veneta dalle lettere al Cardinale Leopoldo de' Medici', *Saggi e memorie di storia dell' arte*, Venice, Fondazione Cini, IV, 1965.

Peter Murray, *Catalogue of the Lee Collection*, London, 1962.

Napoli sacra: see Engenio Caracciolo.

Janomír Neumann, 'Titian's Apollo and Marsyas at Kremser' (in Russian), *Umeni*, IX, 1961, pp. 325–371.

——, *Guide to the Picture Gallery of Prague Castle*, Prague, 1966.

New York Historical Society, Catalogue of Paintings, 1915.

Marcel Nicolle, *Musée Municipal de Nantes, Catalogue*, Nantes, 1913.

Giorgio Nicodemi, *Città di Brescia, La pinacoteca Tosio e Martinengo*, Bologna, 1927.

Benedict Nicolson, 'Venetian Art in Stockholm', *Burlington Magazine*, CV, 1963, p. 32.

——, 'Current and Forthcoming Exhibitions', *Burlington Magazine*, CIX, 1967, p. 321.

Pierre de Nolhac, 'Les collections de Fulvio Orsini', *Gazette des beaux-arts*, 2 période, XXIX, 1884, pp. 427–436.

Carl Nordenfalk, *National museum, Arsbok*, Stockholm, 1947–1948.

——, 'Titian's Allegories on the Fondaco dei Tedeschi', *Gazette des beaux-arts*, 6 période, XL, 1952, pp. 101–108.

——, see also Stockholm National Museum, 1966.

C. Norris, 'Notes on the Venice Exhibition', *Burlington Magazine*, LVII, 1935, pp. 127–131.

Northbrook: *A Descriptive Catalogue of the Collection of Pictures Belonging to the Earl of Northbrook*, W. H. James Weale and J. P. Richter, London, 1889.

James Northcote, *Life of Titian*, London, 1830, 2 vols.

Northwick:

Hours in Lord Northwick's Picture Gallery, H. Davies, Cheltenham, 1843.

Catalogue of the Late Lord Northwick's . . . Pictures, Cheltenham, 26 July 1859.

Catalogue of the Pictures . . . at Northwick Park, 1864.

Catalogue of the Collection of Pictures at Northwick Park, T. Borenius, London, 1921.

W. L. F. Nuttall, 'King Charles I's Pictures and the Commonwealth Sale', *Apollo*, 85, October 1965, pp. 302–309.

V. Oberhammer, 'Christus und die Ehebrecherin, ein Frühwerk Tizians', *Jahrbuch der Kunsthistorischen Sammlungen in Wien*, Vienna, N.F., XXIV, 1964, pp. 101–136.

Edward D. O'Connor, *The Dogma of the Immaculate Conception*, Notre Dame, 1958.

Odescalchi Archives, Palazzo Odescalchi, Rome:

'Contratto fatta fra l'Illustrissimo Signore Principe Livio Odescalchi ed il Signore Marchese Pompeo Azzolino con l'inventario de' mobili esistenti nel Palazzo del Marchese Ottavio Riario alla Lungara, 1692' (inventory of Queen Christina's possessions), vol. II, M2, folios 465ᵛ–471.

'Nota dei quadri della Regina Christina di Svezia divisi in ogni classe d'autori' (no date, probably before her death in 1689), vol. V, B1, no. 16.

'Inventari Bonarum Heredita Clare Memoriae Ducis D. Liviis Odescalchi', November 1713, vol. V, D 2.

'La compra dei quadri da noi fatta a nome della serenissima A. R. del Duca d'Orleans, Regente di Francia dall Eccmo. Signore Don Baltasar Odescalchi Duca di Bracciano, 2 settembre 1721.' vol. B 1, no. 18.

Karl Oettinger, 'Tizians Verkündigung', *Münchner Jahrbuch*, N.F., VII, 1930, pp. 319–337.

Henry and Margaret Ogden, 'Van der Doort's List of the Frizell and Nonesuch Palace Pictures in the Royal Collection', *Burlington Magazine*, LXXXIX, 1947, p. 248.

Ugo Ojetti, *Tiziano e il Cadore, discorso tenuto a Pieve di Cadore il 7 agosto 1932 per inaugurare la casa di Tiziano restaurata*, Rome, 1932.

Harald Olsen, *Italian Paintings and Sculpture in Denmark*, Copenhagen, 1961.

Omagiu liu George Oprescu, 1961.

Cesare d'Onofrio, 'Inventario dei dipinti del Cardinal Pietro Aldobrandini, compilato da G. B. Agucchi nel 1603', *Palatino*, VIII, 1964, pp. 15–20, 158–162, 202–211.

Johannes A. F. Orbaan, *Documenti sul barocco in Roma*, Rome, 1920.

Orléans Collection:

Dubois de Saint Gelais, *Description des tableaux du Palais Royal*, Paris. 1727.

J. Couché, *Galerie des tableaux du Palais Royal*, Paris, 1786–1788.

Champier and Sandoz, *Le Palais Royal*, Paris, 1900.

Casimir Stryienski, *La galerie du Regent*, Paris, 1913.

Sergio Ortolani, 'Le origini della critica d'arte a Venezia', *L'Arte*, XXVI, 1923, pp. 1–17.

A. Ottino della Chiesa, *Accademia Carrara*, Bergamo, 1955.

Leandro Ozzola, 'Il S. Pietro di Tiziano al museo di Anversa e la sua data', *Bollettino d'arte*, XXVI, 1932, pp. 128–130.

Francisco Pacheco, *Arte de la pintura* (1638), edition Madrid, 1956, 2 vols.

Vincenzo Pacifici, *Ippolito II d'Este*, Tivoli, 1923.

Rodolfo Pallucchini, *Sebastian Viniziano*, Venice, 1944.

——, *I dipinti della Galleria Estense di Modena*, Rome, 1945.

——, *La giovinezza di Tintoretto*, Milan, 1950.

——, *Tiziano, Conferenze*, Bologna, 1953-1954, 2 vols.

——, 'Il Cristo Morto Vendramin', *Arte veneta*, XIII–XIV, 1959–1960, pp. 39–45.

——, 'Un altra redazione della Santa Margherita di Tiziano', *Arte veneta*, XIII–XIV, 1959–1960, pp. 47–50.

——, 'Studi Tizianeschi', *Arte veneta*, XV, 1961, pp. 286–295.

——, *Tiziano*, Milan, 1965, I maestri del colore, no. 66.

Antonio Palomino, *El parnaso español pintoresco laureado con las vidas de los pintores y estatuarios eminentes españoles*, Madrid, 1724; modern edition, Madrid, 1947.

Erwin Panofsky, *Studies in Iconology*, New York, 1939.

——, 'Classical Reminiscences in Titian's Portraits', *Festschrift für Herbert von Einem zum 16 Februar 1965* Berlin, 1965.

——, *Problems in Titian Mostly Iconographic*, New York, 1969 (in press and unavailable).

Pier Alessandro Paravia, 'Sopra la palla di Tiziano detta della Concezione', *Giornale sulle Scienze e Lettere delle Provincie Venete*, XVIII, 1822; also in reprint, Treviso, 1822.

Pier Alessandro Paravia, *Del quadro di Tiziano rappresentante S. Pietro Martire. Lettera di P. A. Paravia a S. E. il Sigr. Conte Gianfrancesco Galeani Napione*, Venezia, 1825.

El Pardo Palace, 'Inventario, 1614–1617', Madrid, Royal Palace Archives.

Paris, 1954: *Chefs d'oeuvre vénitiens*, Musée de l'Orangerie.

Paris, 1966: Germaine Bernaud, *Le seizième siècle européen*, Paris, Petit Palais.

Kenneth J. Parker, 'La cena di Emmaus di Tiziano a Brocklesby Park', *Arte veneta*, VI, 1952, pp. 19–26.

Pio Paschini, 'Le collezioni archeologiche dei prelati Grimani del Cinquecento', *Pontificia Accademia Romana di Archeologia, Rendiconti*, VI, 1927, pp. 149–190.

L. Pascoli, *Vite dei pittori, scultori ed architetti*, Rome, 1736.

J. D. Passavant, *Le peintre graveur*, Leipzig, 1864, VI.

Ludwig Pastor, *History of the Popes*, St. Louis, 1891–1953.

Carola Caterina Patina, *Tabellae selectae et explicatae (Pitture scelte)*, Venice, 1691.

Carl Peez, *Tizians Schmerzenreiche Madonnen*, Vienna, 1910.

César Pemán, *Catálogo de las pinturas*, Cádiz, 1952.

Pembroke, 16th Earl of, *A Catalogue of the Paintings and Drawings in the Collection at Wilton House*, London, 1968.

Clara L. Penney, 'Titian's Pension from Charles the Fifth', unpublished article, 1945, in the Hispanic Society archives, New York.

J. Pérez de Guzmán, 'Las colecciones de cuadros del Príncipe de la Paz', *La España moderna*, año 12, tomo 140, 1900, p. 123.

Alfonso E. Pérez Sánchez, *Inventario de las pinturas*, Madrid, Real Academia de Bellas Artes de San Fernando, 1964.

—— *La pintura italiana del siglo XVII en España*, Madrid, 1965.

A. Ritter von Perger, 'Studien zur Geschichte d. K. K. Gemäldegalerie im Belvedere zu Wien', *Berichte und Mittheilungen des Altertums-Vereins zu Wien*, Vienna, VII, 1864, pp. 101–168.

Paola della Pergola, *Galleria Borghese, I dipinti*, 1955.

——, *Galleria Borghese, II dipinti*, 1959.

——, *Giorgione*, Milan, 1955.

——, 'L'Inventario del 1592 di Lucrezia d'Este', *Arte antica e moderna*, II, 1959, pp. 342–351.

——, 'Gli inventari Salviati', *Arte antica e moderna*, III, 1960, pp. 193–200.

——, 'Gli inventari Aldobrandini' (Inventario del 1611; Inventario del 1626), *Arte antica e moderna*, III, 1960, pp. 425–444.

——, 'Gli inventari Aldobrandini del 1682', *Arte antica e moderna*, V, 1962, pp. 316–322; VI, 1963, pp. 61–87, 175–191.

——, 'L'Inventario Borghese del 1693', *Arte antica e moderna*, VII, 1964, pp. 219–230, 451–467; VIII, 1965, pp. 202–217.

Giovambatista da Persico, *Descrizione di Verona*, Verona, 1820, 2 vols.

Fidenzio Pertile: see Aretino.

Philip II, Inventory of, see: Alcázar, Madrid.

André Philippe, *Catalogue de la section des beaux-arts*, Epinal, 1929.

Sir Claude Phillips, *The Picture Gallery of Charles I*, London, 1896.

——, *The Later Works of Titian*, London, 1897.

——, *The Earlier Work of Titian*, London, 1906.

Duncan Phillips, *The Leadership of Giorgione*, Washington, 1937.

Carlo Pietrangeli, 'Nuovi lavori nella più antica pinacoteca di Roma', *Capitolium*, nos. 3–4, 1951, pp. 59–63.

Francesco de Pietri, *Dell' historia napoletana*, Naples, 1634.

Nicolas de Pigage, *Catalogue raisonné et figuré des tableaux de la galerie electorale de Düsseldorf*, Basle, 1778.

Alexandre Pinchart, 'Tableaux et sculptures de Marie d'Autriche, reine douairière de Hongrie', *Revue universelle des arts*, III, 1856, pp. 127–146.

Paolo Pino, *Dialogo della pittura*, 1548, edition Bari, 1960.

Mary Pittaluga, 'Eugène Fromentin e le origini della moderna critica d'arte', *L'Arte*, XX, 1917, pp. 1–18, 115–139, 240–258, 337–349; XXI, 1918, pp. 5–25, 66–83, 145–189.

——, 'Un Tiziano di meno', *Dedalo*, XIII, 1933, pp. 297–304.

Leo Planiscig, *Venezianische Bildhauer*, Vienna, 1921.

Eugène Plon, *Les maîtres italiens au service de la maison d'Autriche, Leone Leoni et Pompeo Leoni*, Paris, 1887.

Stephen Poglayen-Neuwall, 'Tizianstudien', *Münchner Jahrbuch*, IV, 1927, pp. 59–66.

Vicente Poleró y Toledo, *Catálogo de los cuadros del real monasterio de San Lorenzo llamado del Escorial*, Madrid, 1857.

Antonio Ponz, *Viage de España*, Madrid, 1772–1794, 18 vols.; edition Madrid, 1947, in 1 vol.

Arthur Pope, *Titian's Rape of Europa*, Cambridge (Mass.), 1960.

John Pope Hennessy, *The Portrait in the Renaissance*, New York, 1966.

A. E. Popham, *Italian Drawings Exhibited at the Royal Academy*, London, 1931.

——, *Correggio's Drawings*, London, 1957.

Portland: *Catalogue of Pictures Belonging to his Grace the Duke of Portland at Welbeck Abbey and in London*, C. Fairfax Murray, London, 1894. Same catalogue by Richard W. Goulding and C. K. Adams, Cambridge, 1936.

Hans Posse, *Die staatliche Gemäldegalerie zu Dresden, Katalog der alten Meister*, Dresden, 1930.

Chandler R. Post, *A History of Spanish Painting*, Cambridge (Mass.), VI, 1935.

Cassiano del Pozzo, 'Legatione del Signore Cardinale [Francesco] Barberino in Francia', 1625, Vatican Library, MS. Barberini latino 5688.

——, 'Legatione del Signore Cardinale [Francesco] Barberino in Spagna', 1626, Vatican Library, MS. Barberini latino 5689.

Prado Museum, Madrid:
 Catálogo de las pinturas, Madrid, 1963, and numerous earlier editions.
 See also:
 'Inventario general', 1857.
 Madrazo.
 Sánchez Cantón.

Prague Castle, see:
 Rudolf II.
 Zimmermann, 1905.
 Neumann, 1966.

Prodomus zum Theatrum Artis Pictoriae (1735), see: Stampart and Prenners, 1888.

Frédéric Quilliet, *Le arti in Ispagna*, Rome, 1825.

F. von Ramdohr, *Über Mahlerei und Bildhauerarbeit in Rom*, Leipzig, 1787.

Carlo G. Ratti, *Instruzione di quanto può vedersi di più bello in Genova*, Genoa, 1780.

Aldo Ravà, 'Il camerino delle antigaglie di Gabriele Vendramin', *Nuovo archivio veneto*, N.S. XXXIX, 1920, pp. 155–181.

Serafino Razzi, *La storia di Ragusa*, Ragusa, 1595.

Brian Reade, 'William Frizell and the Royal Collection', *Burlington Magazine*, LXXXIX, 1947, pp. 70–75.

W. R. Rearick, 'Jacopo Bassano's Later Genre Paintings', *Burlington Magazine*, CX, 1968, pp. 241–249.

Louis Réau, *Iconographie de l'art chrétien*, Paris, 1955–1959, 3 vols. in 5 parts.

Franz von Reber, *Katalog der Gemäldegalerie*, Munich, 1895.

George Redford, *Art Sales*, London, 1888, 2 vols.

Karl Reinhardt, 'Rätsel um ein Fragment', *Beiträge für Georg Swarzenski*, Berlin, 1951, pp. 156–164.

Repertorio delle opere d'arte trafugate in Italia, I, 1957–1964.

Sir Joshua Reynolds, *The Literary Works of Sir Joshua Reynolds*, London, 1835, 2 vols.

Corrado Ricci, *La R. Galleria di Parma*, Parma, 1896.

Seymour de Ricci, *Description raisonnée des peintures du Louvre*, Paris, 1913.

George M. Richter, 'The Problem of the Noli Me Tangere', *Burlington Magazine*, LXV, 1934, pp. 4–16.

——, 'Unfinished Pictures by Giorgione', *Art Bulletin*, XVI, 1934, pp. 272–290.

——, *Giorgio da Castelfranco*, Chicago, 1937.

J. P. Richter: see Mond.

J. P. Richter and Giovanni Morelli, *Italienische Malerei der Renaissance im Briefwechsel* (*1876–1891*), editor, Gisela Richter, Baden Baden, 1960.

Charles Ricketts, *Titian*, London, 1910.

Ridolfi (1648)–Hadeln: Carlo Ridolfi, *Le meraviglie dell' arte* (Venice, 1648), edition by von Hadeln, Berlin, 1914–1924.

Riedel and Wenzel, *Catalogue des tableaux de la galerie electorale à Dresde*, Dresden, 1765.

E. Rigoni, 'Appunti e documenti sul pittore Gerolamo (Sordo) del Santo', *Memorie della R. Accademia di Scienze, Lettere ed Arti di Padova*, LVII, 1940–1941; also a reprint.

Aldo de Rinaldis, *Guida del Museo Nazionale di Napoli*, II, Pinacoteca, Naples, 1911; second edition, 1927–1928.

——, 'Una inedita nota settecentesca delle opere pittoriche nel Palazzo Borghese in Campo Marzio', *Archivi d'Italia e rassegna internazionale degli archivi*, serie 2, vol. III, 1936, pp. 194–206.

Hermann Ritschl, *Katalog der erlaucht Gräflich Harrachschen Gemälde-Galerie*, Vienna, 1926.

Francesco Rivola, *Vita di Federico Borromeo* (*1564–1631*), Milan, 1656.

Giles Robertson, *Vincenzo Catena*, Edinburgh, 1954.

Amadio Ronchini, 'Delle relazioni di Tiziano coi Farnesi', *Deputazioni di storia patria per le provincie modanesi e parmesi, Atti e Memorie*, Modena, II, 1864, pp. 129–146.

Alan Rosenbaum, 'Titian and Giotto in Padua', *Marsyas*, XIII, 1966–1967, pp. 1–7.

Jakob Rosenberg, *On Quality in Art*, Princeton, 1967.

G. M. Rossi, *Nuova guida di Verona*, Verona, 1854.

Rothermere: *Works of Art in the Collection of Viscount Rothermere*, by P. G. Konody, London, 1932.

Eugene von Rothschild, 'Tizians Darstellungen der Laurentiusmarter', *Belvedere*, X, 1931, Heft 6, pp. 202–209, Heft 7–8, pp. 11–17.

——, 'Tizians Kirschenmadonna', *Belvedere*, XI, 1932, pp. 107–114.

Pasquale Rotondi, *La Madonna nell' arte di Liguria, Catalogo della mostra*, Genoa, 1952.

Rovigo: *Guida della pinacoteca dei Concordi di Rovigo*, Rovigo, 1931.

Benjamin Rowland, *The Classical Tradition in Western Art*, Cambridge (Mass.), 1963.

Rubens' Inventory: Paul Lacroix, 'Catalogue de tableaux et d'objets d'art qui faisaient partie du cabinet de Rubens', *Revue universelle des arts*, I, 1855, pp. 170–275.

Rudolf II, collection of, see:
 Ludwig Urlichs, 'Beiträge zur Geschichte der Kunstbestrebungen und Sammlungen Kaiser Rudolf II', *Zeitschrift für bildende Kunst*, V, 1870, pp. 47–53, 136–142.

Köpl, 1889.

Perger, 1864.

Zimmermann, 1888.

Helmut Ruhemann, 'The Adulteress Brought Before Christ, The Story of Its Restoration', *Scottish Art Review*, v, 1954, pp. 13–21.

——, 'The Cleaning and the Restoration of the Glasgow Giorgione', *Burlington Magazine*, 97, 1955, pp. 278–282.

John Ruskin, *The Works of John Ruskin*, New York, about 1910 (undated).

William N. Sainsbury, *Original Unpublished Papers Illustrative of the Life of Sir Peter Paul Rubens*, London, 1859.

Saint Gelais: see Dubois.

A. Sala, *Pitture ed altri oggetti di belle arti di Brescia*, Brescia, 1834.

Xavier de Salas, 'Inventario de las pinturas de la colección de don Valentín Carderera', *Archivo español de arte*, XXXVIII, 1965, pp. 207–227.

Luigi Salerno, 'The Picture Gallery of Vincenzo Giustiniani', *Burlington Magazine*, 102, 1960, pp. 21–27, 93–104, 135–148.

Arnold von Salis, *Antike und Renaissance*, Erlenbach-Zürich, 1947.

Larissa Salmina, *Disegni veneti del Museo di Leningrado*, Venice, 1964.

Marqués de Saltillo (Lasso de la Vega), *M. Frédéric Quilliet*, Madrid, 1935.

Roberto Salvini, *La galleria degli Uffizi, Catalogo dei dipinti*, Florence, 1961 and 1964.

Francisco J. Sánchez Cantón, *Fuentes literarias para la historia del arte español*, I–V, Madrid, 1923–1941.

——, *Inventarios reales, bienes muebles que pertenecieron a Felipe II*, Madrid, 1946–1949, 2 vols.

——, *Catálogo de las pinturas*, Museo del Prado, Madrid, 1963 (and earlier editions).

Domingo Sánchez Loro, *La inquietud postrimera de Carlos V*, Caceres, 1958, 3 vols.

San Diego: *Fine Arts Gallery, Catalogue*, San Diego, 1960.

Francisco de Borja de San Román, *Alonso Sánchez Coello*, Toledo, 1941.

Francesco Sansovino, *Delle cose notabili che sono in Venetia*, Venice, 1561.

——, *Venetia*, Venice, 1581; edition Venice, 1604, with additions by Stringa; edition Venice, 1663, with additions by G. Martinioni.

Padre Francisco de los Santos, 'Descripción de San Lorenzo del Escorial, 1657 y 1698', in Sánchez Cantón, *Fuentes literarias para la historia del arte español*, II, Madrid, 1933, pp. 225–319.

Marino Sanuto, *Diarii*, 1496–1533, published Venice, 1879–1903, 58 vols.

A. Sartori, *Le pitture, sculture ed architettura della città di Ancona*, Ancona, 1821.

Antonio Sartori, *L'arciconfraternita del Santo*, Padua, 1955.

Simona Savini-Branca, *Il collezionismo veneziano nel '600*, Padua, 1964.

Fritz Saxl, *Lectures*, London, 1957.

F. Scanelli, *Il microcosmo della pittura*, Cesena, 1657.

Ercole Scatassa, 'Chiesa del Corpus Domini in Urbino', *Repertorium für Kunstwissenschaft*, XXV, 1902, p. 443.

L. Scaramuccia, *Le finezze dei pennelli italiani*, Pavia, 1674.

Emil Schaeffer, 'Bildnisse der Caterina Cornaro', *Monatshefte für Kunstwissenschaft*, IV, 1911, pp. 12–19.

George Scharf, *Catalogue raisonné or List of the Pictures at Blenheim Palace*, London, 1862.

Juergen Schulz, 'Vasari at Venice', *Burlington Magazine*, 103, 1961, pp. 500–511.

——, 'Titian's Ceiling in the Scuola di San Giovanni Evangelista', *Art Bulletin*, XLVIII, 1966, pp. 88–94.

——, *Venetian Painted Ceilings of the Renaissance*, Berkeley, 1968.

Kurt Schwarzweller, *Giovanni Antonio da Pordenone*, Göttingen (dissertation), 1935.

Charles Sedelmeyer, *Catalogue des tableaux, troisième vente*, Paris, 1907.

Count A. Seilern, *Flemish Paintings and Drawings at 56 Princes Gate*, London, 1955.

Luigi Serra, 'Elenco delle opere d'arte mobili delle Marche', *Rassegna marchigiana*, III, 1924–1925, pp. 367–429.

——, *Le galerie comunali delle Marche*, Rome, 1925.

——, 'Giuseppe Pallavicini', Thieme-Becker, *Künstlerlexikon*, Berlin, XXVI, 1932, pp. 166–167.

——, 'La mostra di Tiziano a Venezia', *Bollettino d'arte*, 1934–1935, pp. 549–563.

Ettore Sestieri, *Catalogo della galleria exfidecommissaria Doria-Pamphilij*, Rome, 1942.

Charles Seymour, *Art Treasures for America* (Kress Collection), New York, 1961.

Fern R. Shapley, *The Samuel H. Kress Collection*, El Paso Museum of Art, 1961.

——, *North Carolina Museum of Art*, 1965.

——, *Paintings from the Samuel H. Kress Collection, Italian Schools XV–XVI Century*, London, 1968.

J. Byam Shaw, see under Byam.

John Shearman, 'Titian's Portrait of Giulio Romano', *Burlington Magazine*, 107, 1965, pp. 172–177.

G. Sigismondo, *Descrizione della città di Napoli*, Naples, 1788.

Padre Joseph de Sigüenza, 'Historia de la orden de San Gerónimo', 1599, in Sánchez Cantón, *Fuentes literarias para la historia del arte español*, I, 1923, pp. 325–448.

S. Sinding-Larsen, 'Titian's Madonna di Ca Pesaro and its Historical Significance', *Acta et archaeologiam et artium historiam pertinentia*, Institutum Romanum Norwegiae, I, 1962, pp. 139–169.

Oswald Sirèn, *Dessins et tableaux de la renaissance italienne dans les collections de Suède*, Stockholm, 1902.

Oswald Sirèn, 'Pictures of the Venetian School in Sweden', *Burlington Magazine*, VI, 1904–1905.

——, *Descriptive Catalogue of the Pictures in the Jarves Collection Belonging to Yale University*, New Haven, 1916.

——, *Italienska tavlor och teckningar i Nationalmuseum och andra svenska och finska Samlingar*, Stockholm, 1933.

A. Somoff, *Catalogue de la galerie des tableaux*, St. Petersbourg, 1899.

R. Soprani and Carlo G. Ratti, *Delle vite de' pittori, scultori ed architetti genovesi*, Genoa, 1768–1769.

Giambattista Soravia, *Le chiese di Venezia*, 1823, 3 vols.

Ernesto Spadolini, 'Dalmatica dall' archivio storico di Ancona, documenti inediti', *Bullettino di archeologia e storia dalmata*, Spalato, 24, 1901, p. 119.

A. Spahn, *Palma Vecchio*, Leipzig, 1932.

Marquess of Stafford:

 William Y. Ottley and P. W. Tomkins, *Engravings of the Most Noble Marquis of Stafford's Collection of Pictures in London*, London, 1818.

 Catalogue of the Collection of Pictures . . . Marquess of Stafford at Cleveland House, London 1825.

Franz von Stampart and Anton von Prenners 'Prodomus zum Theatrum Artis Pictoriae', (1735), edited by Heinrich Zimmermann, *Jahrbuch der Kunsthistorischen Sammlungen des Allerhöchsten Kaiserhauses*, Vienna, VII, II Theil, 1888, pls. 1–30.

Wolfgang Stechow, 'Joseph of Arimathea or Nicodemus', *Festschrift Heydenreich*, Munich, 1964, pp. 289–302.

Alfred Stix and Erich von Strohmer, *Die fürstlich Liechtensteinsche Gemäldegalerie in Wien*, Vienna, 1938.

Stockholm:

 Notices descriptives des tableaux du Musée National de Stockholm, Stockholm, 1910.

 Konstens Venedigs, Stockholm, National Museum, 1962–1963.

 Christina Queen of Sweden, Exhibition, Stockholm, National Museum, 1966.

 Documents and Studies, Stockholm, 1966.

Storffer, *Gemaltes Inventarium der Aufstellung der Gemäldegalerie in der Stallburg*, Vienna, 1720–1733.

Erich von Strohmer: see Alfred Stix.

Stryienski, see: Orléans Collection.

Margret Stuffman, 'Les tableaux de la collection de Pierre Crozat', *Gazette des beaux-arts*, VI période, LXXII, 1968, pp. 13–135.

Stuttgart: *Katalog der Staatsgalerie Stuttgart, Alte Meister*, Stuttgart, 1962.

William Suida in Anton Hall, *Das Steiermärkische Landesmuseum*, Graz, 1911.

——, 'Rivendicazioni a Tiziano', *Vita artistica*, II, 1927, pp. 206–215.

——, 'Die Ausstellung italienischer Kunst in London', *Belvedere*, IX, part 2, 1930, pp. 35–45.

——, 'Alcune opere sconosciute di Tiziano', *Dedalo*, XI, part 4, 1931, pp. 894–901.

——, 'Tizians Darstellungen des heiligen Hieronymus', *Kirchenkunst*, Vienna, V, 1933, pp. 158–161.

——, *Titien*, French edition, Paris, 1935.

——, 'Correggio e Tiziano', in *Manifestazioni nel IV centenario della morte del Correggio*, Parma, 1936.

——, 'New Light on Titian's portraits', *Burlington Magazine*, LXVIII, 1936, pp. 281–282.

——, 'Forgotten Splendor in Titian's Treasury', *Art in America*, XXIX, 1941, pp. 3–13.

——, 'Addenda to Titian's Religious Oeuvre', *Gazette des beaux-arts*, 6th series, XXIV, 1943, pp. 355–362.

——, *Catalogue of Paintings*, The John and Mable Ringling Museum of Art, Sarasota, 1949.

——, *Paintings and Sculpture from the Kress Collection* (acquired 1945–1951), Washington, National Gallery of Art, 1951.

——, 'Miscellanea Tizianesca, I', *Arte veneta*, VI, 1952, pp. 27–41.

——, 'Spigolature Giorgionesche', *Arte veneta*, VIII, 1954, pp. 153–171.

——, and Fern R. Shapley, *Paintings and Sculpture from the Kress Collection* (acquired 1951–1956), Washington, National Gallery of Art, 1956.

——, 'Miscellanea Tizianesca, II', *Arte veneta*, X, 1956, pp. 71–81.

——, 'Miscellanea Tizianesca, IV', *Arte veneta*, XIII–XIV, 1959–1960, pp. 62–67.

——, 'Titian Portraits, Originals and Reconstructions', *Gazette des beaux-arts*, 6th series, XXIX, 1946, pp. 139–150.

Eva Tea, 'La pala Pesaro e la Immacolata', *Ecclesia, Rivista mensile*, Vatican City, XVII, 1958, nos. 11–12, pp. 605–609.

Tommaso Temanza, *Vite dei più celebri architetti e scultori veneziani*, Venice, 1778.

David Teniers II, *Theatrum pictorium*, Brussels, 1660.

Stefano Ticozzi, *Vite dei pittori Vecelli*, Milan, 1817.

Hans Tietze, *Der Cicerone*, I, 1909, pp. 313–315.

——, *Tizian*, Vienna, 1936, 2 vols.

——, *Venetian Painting in America*, Toledo, 1940.

——, *Titian*, London, 1950.

——, and Erica Tietze, 'Tizian Studien', *Jahrbuch der Kunsthistorischen Sammlungen in Wien*, Vienna, N.F., X, 1936, pp. 137–192.

——, and Erica Tietze-Conrat, 'Titian's Woodcuts', *Print Collectors Quarterly*, XXV, 1938, pp. 333–360.

——, and Erica Tietze-Conrat, *The Drawings of the Venetian Painters in the 15th and 16th Centuries*, New York, 1944.

——, and Erica Tietze-Conrat, 'The Allendale Nativity in the National Gallery', *Art Bulletin*, XXX, 1949, pp. 11–20.

Erica Tietze-Conrat, 'Decorative Paintings of the Venetian Renaissance Reconstructed from Drawings', *Art Quarterly*, III, 1940, pp. 15–39.

——, 'A Rediscovered Early Masterpiece by Titian', *Art in America*, XXIX, 1941, pp. 144–151.

——, 'Titian as a Letter Writer', *Art Bulletin*, XXVI, 1944, pp. 117–123.

——, 'The So-called Adulteress by Giorgione', *Gazette des beaux-arts*, 6 période, XXVII, 1945, pp. 189–190.

——, 'Titian's Battle of Cadore', *Art Bulletin*, XXVII, 1945, pp. 205–208.

——, 'Titian's Portraits of Paul III', *Gazette des beaux-arts*, 6 période, XXIX, 1946, pp. 73–84.

——, 'Titian's Workshop in his Late Years', *Art Bulletin*, XXVIII, 1946, pp. 76–88.

——, 'Titian's Design for the Battle of Cadore', *Gazette des beaux-arts*, 6 période, XXIV, 1948, pp. 237–242.

——, 'Titian's Allegory of Religion', *Journal of the Warburg Institute*, XIV, 1951, pp. 127–132.

——, 'The Pesaro Madonna, a Footnote', *Gazette des beaux-arts*, 6 période, XLII, 1953, pp. 177–182.

——, 'L'Adorazione dei Magi di Tiziano dipinta per il Cardinale di Ferrara', *Emporium*, CXIX, 1954, pp. 3–8.

——, 'Titian's St. Catherine', *Gazette des beaux-arts*, 6 période, XLIII, 1954, pp. 257–261.

——, *Mantegna*, London, 1955.

Tizianello, *Vita del insigne Tiziano Vecellio*, 1622, edition Venice, 1809.

Charles de Tolnay, *Michelangelo. III. The Medici Chapel*, Princeton, 1948.

——, *Michelangelo. IV. The Tomb of Julius II*, Princeton, 1954.

S. Tonci, *Descrizione ragionata della Galleria Doria*, Rome, 1794.

Elias Tormo, *Las viejas iglesias de Madrid*, Madrid, 1927, 2 vols.

Piero Torriti, *La galleria del Palazzo Durazzo Pallavicini a Genova*, Genoa, 1967.

Joseph Townsend in *Viages de extranjeros por España*, edition Madrid, 1962.

Elizabeth du Gué Trapier, 'Sir Arthur Hopton', Part 1, *Connoisseur*, 164, 1967, April, pp. 239–243; Part 2, *ibidem*, 165, 1967, May, pp. 60–63.

Hugo von Tschudi, *Katalog der königlichen Alten Pinacothek*, Munich, 1911.

Uffizi:

Catalogue of the Royal Uffizi Gallery, by Eugenio Pieraccini, Florence, 1910.

Real Galleria degli Uffizi, Florence, 1926.

Catalogo tipografico illustrato, Florence, 1930.

Giovanni Urbani, 'Schede di restauro', *Bollettino dell' Istituto Centrale di Restauro*, nos. 1–4, 1950, pp. 95–111.

——, 'Recupero di un Tiziano', *Bolletino dell' Istituto Centrale di Restauro*, nos. 7–8, 1951, pp. 17–24.

——, 'Schede di restauro', *Bollettino dell' Istituto Centrale di Restauro*, nos. 9–10, 1952, pp. 61–79.

——, 'Schede di restauro: Tiziano, le stimmate di San Francesco, Trapani', *Bollettino dell' Istituto Centrale di Restauro*, nos. 17–18, 1954, pp. 41–45.

Ludwig Urlichs, 'Beiträge zur Geschichte der Kunstbestrebungen und Sammlungen Kaiser Rudolf II', *Zeitschrift für bildende Kunst*, V, 1870, pp. 47–53, 136–142.

Francesco Valcanover, *Mostra dei Vecellio*, Belluno, 1951.

——, 'La mostra dei Vecellio a Belluno', *Arte veneta*, V, 1951, pp. 201–208.

——, *Tutta la pittura di Tiziano*, Milan, 1960, 2 vols.

——, 'Il restauro del S. Giorgio Cini di Tiziano', *Arte veneta*, XIX, 1965, pp. 199–200.

——, 'Gli affreschi di Tiziano al Fondaco dei Tedeschi', *Arte veneta*, XXI, 1967, pp. 266–268.

Wilhelm Valentiner, *The Henry Goldman Collection*, New York, 1922.

——, *Das unbekannte Meisterwerk*, Berlin, 1930.

——, 'A Late Work by Titian', *Pantheon*, XVI, 1935, September, p. 33.

——, 'Judith with the Head of Holofernes', *Bulletin*, Detroit Institute of Arts, XIV, no. 8, 1935, pp. 102–104.

M. Valsecchi, 'Forse sono troppi i 103 anni di Tiziano', *Tempo*, 16 giugno, 1955.

——, *Tiziano*, Novara, 1960.

Abraham van der Doort, *Catalogue of the Collections of Charles I (1639)*, edited by Oliver Millar, Glasgow, The Walpole Society, XXXVII, 1958–1960.

Sir Anthony Van Dyck, 'Antwerp Sketchbook': Michael Jaffé, *Van Dyck's Antwerp Sketchbook*, London, 1966, 2 vols.

——, Inventory: see Müller-Rostock.

——, 'Italian Sketchbook': Gert Adriani, *Van Dycks Italienisches Skizzenbuch*, Vienna, 1940.

Giorgio Vasari, *Le vite dei più eccellenti pittori, scultori, ed architetti (1568)*, edition by Gaetano Milanesi, Florence (first published 1875–1885), 1907; edition by Paola Barocchi, vols. 1–2, 1966, 1967.

——, *Vasari on Technique*, London, 1907, translated from Volume I by Louisa S. Maclehose.

Velázquez, 'Memorial de las pinturas de Velázquez' (1658), *Varia Velazqueña*, Madrid, 1960.

Venetian School: see Cleveland, Gould, London.

Venetian Tradition, 1956: see Cleveland.

Venezia e le sue lagune, Venice, 1847.

Adolfo Venturi, 'Tiziano nel Cadore', *Vita artistica*, II, 1927, pp. 185–187.

——, *Storia dell'arte*, Milan, 1928, IX, part 3.

——, *Storia dell'arte*, Milan, 1929, IX, part 4.

——, *Storia dell'arte*, Milan, 1934, IX, part 7.

——, 'Un Ecce Homo di Tiziano a Budapest', *L'Arte*, XI, 1940, pp. 26–28.

Lionello Venturi, 'Saggio sulle opere d'arte italiana a Pietroburgo', *L'Arte*, xv, 1912, pp. 121–146.

——, *Giorgione e il Giorgionismo*, Milan, 1913.

——, *Pitture italiane in America*, Milan, 1931; English edition, 1933.

——, 'Contributi a Tiziano', *L'Arte*, N.S., iii, anno xxxv, 1932, pp. 481–497.

——, 'Giorgione', *Encyclopedia of World Art*, Vol. vi, New York, 1962.

Ridolfino Venuti, *Roma moderna*, Rome, 1767, 2 vols.

Egon Verheyen, 'Correggio's Amori di Giove', *Journal of the Warburg and Courtauld Institutes*, xxix, 1966, pp. 160–192.

——, 'Jacopo Strada's Mantuan Drawings', *Art Bulletin*, xlix, 1967, pp. 62–70.

Cornelius Vermeule, *European Art and the Classical Past*, Cambridge (Mass.), 1964.

George Vertue, *Catalogue of the Collection of Charles I*, London, Bathoe, 1757.

Vienna, Kunsthistorisches Museum, see:
Engerth, 1884.
Glück and Schaeffer, 1907.
Klauner and Oberhammer, 1960.

Fédéric Villot, *Notices des tableaux du Musée du Louvre*, Paris, 1874.

Vita Christi (1497), Isabel Llibre anomenat, Barcelona, edition 1916.

Scipione Volpicella, *Descrizione storica di alcuni principali edifici della città di Napoli*, Naples, 1850.

von: Names with von, see: the major patronymic.

von Engerth: see Engerth.

Theodor von Frimmel: see Frimmel.

von Hadeln: see Hadeln.

F. von Ramdohr: see Ramdohr.

Franz von Stampart and Anton von Prenners: see Stampart

Hans von Voltelini, 'Urkunden und Regesten', *Jahrbuch der Kunsthistorischen Sammlungen des Allerhöchsten Kaiserhauses, Vienna*, xi, ii Thiel, 1890, pp. i–lxxxiii; xiii, ii Theil, 1892, pp. xxvi–clxxiv.

G. F. Waagen, *Treasures of Art in Great Britain*, London, 1854, 3 vols.

——, *Galleries and Cabinets of Art in Great Britain*, London, 1857, 1 vol.

John Walker, *Bellini and Titian at Ferrara*, New York, 1956.

Wallace Collection Catalogue. Pictures and Drawings, London, editions 1928 and 1968.

Washington: National Gallery of Art, *Preliminary Catalogue of Paintings and Sculpture*, 1941.
Summary Catalogue of European Paintings and Sculpture, 1965.

Ellis K. Waterhouse, 'Paintings from Venice for Seventeenth-century England', *Italian Studies*, vii, 1952, pp. 1–23.

——, *Italian Art and Britain*, London, 1960.

——, 'Queen Christina's Italian Pictures in England', *Documents and Studies*, Stockholm, 1966, pp. 372–375.

H. B. Wehle, *Catalogue of Italian, Spanish and Byzantine Paintings*, New York, Metropolitan Museum, 1940.

Hans R. Weihrauch, 'Jacopo Tatti', Thieme-Becker, *Künstlerlexikon*, xxii, 1938.

——, *Europäische Bronzestatuetten*, Brunswick, 1967.

Dorothee Westphal, 'Wenig bekannte Werke der Malerei des xiv–xviii Jahrhunderts in Dalmatien', *Bulletin International*, Zagreb, ix, 1937; also reprint, pp. 1–30.

Harold E. Wethey, 'The Early Works of Bartolomé Ordóñez and Diego de Siloe', *Art Bulletin*, xxv, 1943, pp. 226–238; 325–345.

——, *El Greco and His School*, Princeton, 1962, 2 vols.

——, 'The Spanish Viceroy, Luca Giordano, and Andrea Vaccaro', *Burlington Magazine*, cix, 1967, pp. 678–686.

Manuel Wielandt, 'Die verschollenen Imperator-Bilder Tizians in der königlichen Residenz zu München', *Zeitschrift für bildende Kunst*, N.F., xix, 1907–1908, pp. 101–108.

Karl Wilczek, 'Tizians Emmauswunder im Louvre', *Jahrbuch der preuszischen Kunstsammlungen*, xlix, 1928, pp. 159–166.

Johannes Wilde, 'Wiedergefundene Gemälde aus der Sammlung des Erzherzogs Leopold Wilhelm', *Jahrbuch der Kunsthistorischen Sammlungen in Wien*, N.F., iv, 1930, pp. 245–266.

——, 'Röntgenaufnahmen der drei Philosophen Giorgiones und der Zigeuner-Madonna Tizians', *Jahrbuch der Kunsthistorischen Sammlungen in Wien*, N.F., vi, 1932, pp. 141–154.

——, 'Die Probleme von Domenico Mancini', *Jahrbuch der Kunsthistorischen Sammlungen in Wien*, N.F., vii, 1933, pp. 97–135.

Edgar Wind, *Bellini's Feast of the Gods*, Cambridge, 1948.

——, *Pagan Mysteries in the Renaissance*, New Haven, 1958.

Fernanda Wittgens, 'The Contributions of Italian Private Collections to the Exhibition at Burlington House', *Apollo*, xi, 1930, pp. 73–90.

Rudolf Wittkower, 'Transformations of Minerva in Renaissance Imagery', *Journal of the Warburg Institute*, ii, 1938–1939, pp. 194–205.

——, 'Titian's Allegory of Religion Succoured by Spain', *Journal of the Warburg Institute*, iii, 1939–1940, pp. 138–141.

Rudolf and Margot Wittkower, *The Divine Michelangelo. The Florentine Academy's Homage on his Death in 1564*, London, 1964.

Karl Woermann, *Katalog der königlichen Gemälde-Galerie zu Dresden*, Dresden, 1892 and also 1902.

A. Wolf, 'Tizian's Madonna der Familie Pesaro', *Zeitschrift für bildende Kunst*, XII, 1877, pp. 9–14.

Sir Richard Worsley, *Catalogue Raisonné of the Principal Paintings, Sculptures, and Drawings at Eppuldurcombe House*, London, 1804.

Padre Andrés Ximénez, *Descripción del real monasterio de San Lorenzo del Escorial*, Madrid, 1764; also in Sánchez Cantón, *Fuentes literarias para la historia del arte español*, V, Madrid, 1941, pp. 61–104.

Yuste, Inventories, see:

Gachard, 1885.

Sánchez Loro, 1958.

Pietro Zampetti, *Mostra della pittura veneta nelle Marche*, Ancona, 1950.

——, *Giorgione e i Giorgioneschi*, Venice, 1955.

——, and Virgilio Lilli, *Giorgione*, Milan, 1968.

Antonio Maria Zanetti, *Descrizione di tutte le pubbliche pitture*, Venice, 1733.

——, *Varie pitture a fresco dei principali maestri veneziani*, edition Venice, 1760.

——, *Della pittura veneziana*, edition Venice, 1771.

——, *Della pittura veneziana*, edition Venice, 1797.

F. Zanotto, *Pinacoteca . . . veneta*, Venice, 1834.

Julián Zarco Cuevas, 'Inventario . . . donados por el rey don Felipe II, Años de 1571 a 1758', *Boletín de la Real Academia de la Historia*, XCVI, 1930, pp. 545–668; XCVII, 1930, pp. 35–95, 134–144.

——, *Pintores españoles en San Lorenzo el Real de el Escorial*, Madrid, 1931.

Manuel R. Zarco del Valle, 'Unveröffentlichte Beiträge zur Geschichte der Kunstbestrebungen Karl V und Philipp II', *Jahrbuch der kunsthistorischen Sammlungen des Allerhöchsten Kaiserhauses*, VII, 1888, pp. 221–237.

Federico Zeri, *La Galleria Spada in Roma*, Rome, 1951 and 1952.

Heinrich Zimmermann, 'Urkunden, Acten, und Regesten', *Jahrbuch der Kunsthistorischen Sammlungen des Allerhöchsten Kaiserhauses*, VII, 1888, pp. XV–LXXXIV.

——, 'Das Inventar der Prager Schatz und Kunstkammer von 6 Dezember 1621', *loc. cit.*, XXV, II Theil, 1905, pp. XIII–LXXV.

Giangiorgio Zorzi, 'Notizie di arte e di artisti nei diarii di Marino Sanudo', *Atti dell' Istituto Veneto di Scienze, Lettere ed Arte*, CXIX, 1960–1961, pp. 471–604.

CATALOGUE RAISONNÉ

Arranged alphabetically by subject; pictures of the same subject appear chronologically.
Dimensions are cited in all cases height × width.

Abraham, Sacrifice of, see: Old Testament Subjects, Cat. no. 83

1. Adam and Eve, Temptation of Plate 162

Canvas. 2·40 × 1·86 m.

Madrid, Prado Museum.

Signed on the rock at the lower left in large black capitals (badly restored): TITIANVS F.

About 1550.

Adam's gesture with his left hand, suggestive of a mild impulse to restrain Eve, is the principal motivation which differentiates this scene from Raphael's in the Stanza della Segnatura of the Vatican, where Adam is also seated while the standing Eve assumes a more active role. The handsome interrelation of the figures with the landscape and the sensuous fullness of Eve's body must have been the elements which inspired Rubens to copy the picture on his visit to Madrid in 1628.

Condition: In spite of the fire of 1734, the colour retains considerable freshness, and the canvas escaped the general blackness of other Titian masterpieces which underwent the same disaster.

History: Probably from the collection of Philip II's disgraced minister, Antonio Pérez, Inventory, 1585 (Marañón, 1948, I, p. 58); Sacristy of the Alcázar, Madrid, in 1600 (Inventory of Philip II, I, p. 26, no. 62; also Rudolf Beer, 1893, p. XI, no. 62); recorded in the Inventory of the Alcázar, 1636, in the 'pieca última de las bóvedas que tiene la ventana al levante'; Alcázar Inventories 1666, 1686, 1700 (Bottineau, LX, 1958, p. 324, no. 882); Inventory 1734, no. 28, as 'algo maltratado de retoques antiguos'.

Bibliography: Not in Vasari; Madrazo, 1843, p. 177, no. 812; 'Inventario general', 1857, p. 169, no. 812; C. and C., 1877, II, p. 406; Beroqui, 1913–1914, p. 471; Suida, 1935, pp. 139–140; Tietze, 1936, I, p. 295, II, p. 238; Valcanover, 1960, II, pl. 129; Prado catalogue, 1963, no. 429.

VARIANT:

An imaginary picture described by Boschini as having an Eve by Titian, an Adam by Tintoretto, and a landscape with animals by Bassano (Boschini, 1660, p. 336).

COPIES:

1. Madrid, Prado Museum, no. 1692, canvas, 2·37 × 1·84 m., painted by Rubens in 1628; purchased from his estate (Rubens' Inventory, p. 271, no. 42).

2. Palma in Mallorca, Marqués de la Cernia, 2·00 × 1·80 m., careful but mediocre copy; sold to the Marqués in 1916 by Iriarte (Mas photo C 12450; Tomás de Veri, *Cuadros notables de Palma*, Madrid, 1920, p. 71, pl. 2).

LOST ITEM:

Madrid, Alcázar, small version, $\frac{1}{2} \times \frac{1}{3}$ *varas* (0·42 × 0·28 m.); must have been a copy; untraceable today (Alcázar Inventory 1747, no. 117).

Adoration of the Kings

The composition and colour of all four versions of Titian's *Adoration of the Kings* differ only in certain minor details, the Ambrosiana canvas offering the most variations. The four examples, in the museums at Milan, the Escorial, Madrid, and Cleveland, are listed in chronological order. The Madonna at the left is entirely in blue with a white veil (the Ambrosiana picture excepted); the first king wears a deep purplish-red robe with gold sleeves; the second king a blue mantle; and the third, Negro king a green jacket and a large shaggy cap in red. At the right the attendant on a white horse is dressed in light rose, his companion in lavender. The silhouettes of three camels appear through the shed in the Escorial, Cleveland, and Prado pictures. These three works are in general much alike, while the Ambrosiana variant omits the camels and the kneeling man at the extreme right, and it differs in the costumes worn by the Madonna and first two kings. The man at the right has been interpreted as a donor, but his presence in three versions and particularly in Philip II's would seem to eliminate that possibility. The curious monogram ⅌ on the bundle on the extreme

right, which appears in the same three pictures (Escorial, Cleveland, and Prado), eludes explanation.

The Ambrosiana canvas varies most in the two horsemen at the upper right. The farther of them, who lifts his hat, certainly resembles Titian and must be considered a self-portrait. The distant landscape of trees and the setting show a like independence of the exact formulae of the other paintings of the series. The sky and the distant mountains are a lovely deep blue in three cases: the Prado and Escorial versions differing from the example at Cleveland in the introduction of the sunset.

Vasari saw in Titian's studio in 1566 a picture of the subject which he characterizes as 'molto vaga' (very beautiful), size 3×4 *braccia* (about 1·74×2·32 m.). Since the Escorial example had been delivered to Philip II in 1559, Vasari could not have seen it, but instead either the Prado or Cleveland example, most probably the latter. The Florentine also states in the past tense that Titian had sent a painting of the subject by himself to the old Cardinal from Ferrara (Ippolito d'Este, 1509–1572). It will be seen later that the Cardinal intended it as a gift to King Henry II of France. This is confirmed by the tiny golden crescents on the harness of the principal white horse, and in addition, on the frame, the crescents and bows and arrows, emblems of Diane de Poitiers, mistress of King Henry II, as well as the celebrated monogram D and H intertwined. Extraordinarily enough, all four versions

Intertwined monograms of Diane de Poiters and Henry II

Emblems of Diane de Poitiers

of the painting include the crescents and sometimes the fleur-de-lys. Consequently it seems obvious that the Ambrosiana canvas, which was ordered as a gift for Henry II, must have been painted first, since it served as a prototype for the Escorial, Prado, and Cleveland pictures,

in which the insignia of Diane were repeated. Burroughs, who saw these details on the Cleveland picture, did not know that they are also present on the Ambrosiana composition, and mistakenly concluded that the Cleveland painting had been first destined for Henry II but instead shipped to Philip II. The devices of the king and his mistress on the carved frame also serve unequivocally to identify the Ambrosiana picture.

Iconography: The Bible speaks only of 'wise men' (Matthew 2: 7–11) who went to adore the Child, but mediaeval tradition, beginning with Tertullian in the second century, turned them into kings. Belief in the dogma of the Trinity is responsible for setting the number at three, apparently an innovation of Cesare of Arles *c.* 502 (Künstle, I, pp. 354–355; Kehrer, 1904, pp. 12–16; Réau, II, part 2, pp. 336–338). The white horse bows in reverence toward the Christ Child in a pose that has been shown to resemble the horse on a Roman gem (Curtius, 1938) and another on the Rospigliosi sarcophagus of Roman date (J. Held, *Art Bulletin*, XL, 1958, p. 146, fig. 7). The copy of the horse in Van Dyck's 'Italian Sketchbook' (1622–1628) suggests that he had seen the Ambrosiana *Adoration* or the Cleveland picture, then in Genoa. The head of the first king in the Fleming's 'Antwerp Sketchbook' confirms this supposition, but the identification of the figure as Philip II is doubtful (Jaffé, 1966, II, p. 222).

Bibliography: Vasari (1568)-Milanesi, VII, p. 452; further references under each item below.

2. Adoration of the Kings (Type I) Plate 119

Canvas. 1·18×2·22 m.

Milan, Ambrosiana Gallery.

Titian and workshop.

Datable 1557.

The high quality of this picture eliminates the possibility that it is a later copy. The splendid landscape with rosy sky differs from the other three major versions, notably in the lack of deep-blue hills, particularly at the right side. The Madonna, here wearing the usual rose dress, blue cloak, and white veil, is rather charming despite retouching of the face by a later hand. St. Joseph and the kneeling king are decidedly mediocre because of either a student's assistance or, more probably, poor restoration. The first king is dressed in solid red with white fur trimming, unlike those of the other three compositions. On the other hand, the splendid figure of the Oriental in a white turban and rose jacket, seated upon a white

horse, varies little from the other versions, but the two horsemen at the right in the second plane reveal Titian's self-portrait in the one doffing his hat.

Condition: The faces of the Madonna and the first king have been repainted; otherwise only X-rays would reveal the extent of the various retouchings. The peculiar marks ⅝ do not appear on the bundle at the lower right, whereas they are present in the three other major pictures.

History: After his visit to Titian's studio in 1566 Vasari reported that the master had painted an *Adoration of the Kings* for the old Cardinal of Ferrara. In 1564 Titian had actually sent the picture to Cardinal Ippolito II d'Este, as is proved by a payment on 7 October: 'a Rainaldo coriero per tante che lui a pagate in Venetia a M. Thizziano pitore per la spesa fatta ad incassare una pittura in tela de' re maggi' (Pacifici, 1923, p. 393). It was thereafter placed in a small chapel in the palace which the cardinal had leased from the Orsini in Monte Giordano at Rome, where payment was made in 1565 for an intarsia frame for the picture (Pacifici, pp. 146, 409–410). On the cardinal's death in 1572 it does not appear in the inventory of the 'cappellina' in the Palace of Monte Giordano, so we must conclude that it had been moved elsewhere (Pacifici, pp. 146–147).

Titian's painting was next purchased by San Carlo Borromeo, who bequeathed it to the Ospedale Maggiore in Milan on his death in 1584. Later Cardinal Federico Borromeo bought the canvas from the hospital and donated it to the Ambrosiana on 28 April 1618. In the act of donation Cardinal Borromeo wrote: '. . . l'Adorationo dei Magi di Titiano, nella qualle se veggono dodeci figure humane, e quattro cavalli in circa lunga braccia tre e alta due con cornicioni dorati. Questo quadro fu fatto dal Cardinale di Ferrara per donarlo al re Francesco. Ultimamente essendo stato di S. Carlo fu comprato da me Federico Cardinale Borromeo Arcivescovo di Milano dall' Hospitale maggiore che fu di lui erede' (Pacifici, p. 393).

The king for whom Cardinal Ippolito d'Este had commissioned the *Adoration of the Kings* was Henry II of France (not Francis). That fact is demonstrated by the original frame, which still encloses the painting in the Ambrosiana Gallery. This carved frame is adorned with crescents and also with bows and arrows, the emblems of Diane de Poitiers, celebrated mistress of Henry II. Moreover, tiny crescents hang upon the harness of the white horse in the painting. In addition, the monogram of Henry II and Diane, the intertwined D and H, is

included on the frame, just as it appears upon the walls of the Louvre and on other monuments of the period of Henry II, Fontainebleau and Diane's own Château d'Anet. Finally on each side of the frame is a large Roman numeral X which must refer to the tenth year of Henry II's reign, i.e. 1557. The king died not long after, in 1559, thus explaining why the cardinal's gift was never presented to him. Cardinal Ippolito d'Este (1509–1572), archbishop of Lyons, Narbonne, Arles, and other cities, was a close friend and adviser of Henry II of France, who in 1550 and again in 1555 unsuccessfully supported the cardinal's candidacy to the papal throne (Pacifici, pp. 108–117, 261–267). Therefore the projected gift of the picture to the French king is easily explained. A special devotion of Henry II to the cult of the Three Kings is indicated by the fact that a military banner used by his forces in Italy is embroidered with these three figures and the star (*Storia di Milano*, IX, 1961, pp. 242–243).

Bibliography: See also History; Vasari (1568)-Milanesi, VII, p. 452; Cardinal Borromeo, 1625, edition 1909, pp. 45–47 (Titian); C. and C., 1877, II, p. 310 (old copy); *Guida sommaria*, 1907, pp. 68–69 (Titian); Burroughs, 1930, pp. 268–270 (Titian); Suida, 1935, pp. 141–142 (Titian); Tietze, 1936, II, p. 300 (workshop); Galbiati, 1951, p. 188, colour print; dell'Acqua, 1955, pl. 172 (Titian); Berenson, 1957, p. 188 (great part by Titian); Valcanover, 1960, II, pl. 77 (mainly autograph); *loc. cit.* p. 58 (lost).

3. **Adoration of the Kings** (Type II) Plate 120

Canvas. 1·385×2·19 m.

Escorial, Nuevos Museos.

Signed: TITIANVS F (barely visible and probably restored) 1559–1560.

The presence of the French fleur-de-lys on the saddle and of the crescents of Diane de Poitiers on the harness proves that this picture is a variant of the composition intended for the French King, Henry II.

This canvas is a documented work by Titian, which was always in the Escorial in its original location in the large chapel within the monastery, not in the main church, from the time Philip II sent it there in 1574 until the establishment of the New Museum in 1963. Apparently never restored or cleaned until 1963, it was barely visible in the poor light of the Iglesia Vieja, a fact which led Crowe and Cavalcaselle quite incorrectly to call it a Spanish copy of Titian's original. They mistakenly

thought that the version in the Prado Museum was the work sent to the Escorial in 1574. Pedro Beroqui clarified the situation, and Mayer at one point (1937) declared the Escorial canvas to be the major version. Earlier (1930) he had suggested that the Escorial picture had been replaced by a copy in the Napoleonic period and had proposed that the one now in Cleveland came from the Spanish monastery. Unfortunately Tietze (1936) not only accepted this theory, which Mayer himself later abandoned, but also repeated Crowe and Cavalcaselle's statement that the picture in the Escorial was a Spanish copy.

Condition: Now badly blistered by fire (probably in 1671), darkened throughout and the sky inexpertly restored; the heads are barely visible, in fact the picture is almost a total wreck.

History: Not mentioned by Vasari; shipped to Philip II in 1559 (Cloulas, 1967, p. 242); listed in Titian's letter of 2 April 1561 (C. and C., 1877, II, p. 519; Cloulas, 1967, p. 245); sent to the Escorial in 1574 (Zarco Cuevas, 'Inventario', 1931, p. 44, no. 997); Padre Sigüenza in 1599 (edition 1923, p. 380) says it was located in the lateral altar on the gospel side of the Iglesia Vieja, just as it was until 1963; all subsequent writers on the Escorial confirm him: Padre de los Santos in 1657 (edition 1933, p. 243) and 1698; Padre Ximénez, 1764 (pp. 109–110); Ponz, 1773 (tomo II, carta IV, 55); Inventory 1776 (see Escorial, *Documentos*, V, p. 260); Conca, 1793 (II, p. 101); Padre Bermejo, 1820 (p. 207); Poleró, 1857 (p. 115, no. 470).

Bibliography: See also History; C. and C., 1877, II, pp. 305–309, 519 (a Spanish copy!); Beroqui, XXXV, 1927, pp. 184–185 (Titian's original); *idem*, 1946, pp. 157–158; Mayer, 1930, pp. 60–61 (copy); *idem*, 1937, pp. 178–183 (Titian's original); Berenson, 1932 and 1957 (omitted); Tietze, 1936, I, 234 (as a Spanish copy, following Crowe and Cavalcaselle); Valcanover, 1960, II, pl. 76 (Titian's original).

4. Adoration of the Kings (Type II)　　　Plate 121

Canvas. 1·41 × 2·19 m.
Madrid, Prado Museum.
Titian and workshop.
About 1560.

The picture is unsigned, but as in the Escorial and Cleveland examples there is a strange monogram 兀 on the bundle at the right: Crowe and Cavalcaselle wrongly thought that this canvas was the one shipped by Titian in 1559, on the theory that the picture still at the Escorial was a Spanish copy. Many subsequent writers including Madrazo, Berenson, Mayer (in 1930) and Suida followed them. A. L. Mayer in 1930 called the Prado example second best to the Cleveland version and termed the Escorial original a copy. In 1937 he made the most improbable suggestion of all, that the Prado picture was a copy by Luca Giordano because of the rising sun (or sunset).

Condition: The picture is dirty throughout and heavily varnished.

History: Antonio Pérez's Collection (?) (see Lost Pictures); first mentioned *c.* 1785, collection of Charles IV, Casita del Príncipe, Escorial ('Cuadros reunidos por Carlos IV . . . Escorial', *Religión y Cultura*, XXV, 1934, pp. 382–491); Inventory of the palace at Aranjuez, 1818, no. 139 (Beroqui, 1946, p. 158).

Bibliography: Madrazo, 1843, p. 194, no. 882 (no provenance given); 'Inventario general', 1857, p. 184, no. 882; C. and C., 1877, II, pp. 308–309 (Titian's original); Beroqui, XXXV, 1927, pp. 184–185 (Titian); *idem*, Madrid, 1946, pp. 157–159; Berenson, 1932, p. 572 (Titian); *idem*, 1957, p. 188 (studio); Tietze, 1936, II, pp. 295–296 (workshop); Mayer, 1930, pp. 60–61; *idem*, 1937, pp. 178–183 (Luca Giordano); Burroughs, 1930, pp. 268–270 (copy by Polidoro); Valcanover, 1960, II, pp. 70–71 (uncertain); Prado catalogue, 1963, no. 433 (old no. 882).

5. Adoration of the Kings (Type II)　　　Plates 122, 123

Canvas. 1·36 × 2·29 m.
Cleveland (Ohio), Museum of Art.
About 1566.

Condition: The central group and the horseman wearing a turban are faded and scrubbed down to the canvas. Particularly brilliant in technique is the kneeling first king, whose costume sparkles with white high-lights. The Madonna's head has been retouched, but in general this version has survived the centuries much better than the two in Spain and the fourth canvas in the Ambrosiana. The curious monogram 兀, which is clearly seen on the bundle in the Escorial and Prado compositions, has been almost cleaned off the Cleveland picture, but it still can be discerned.

History: Most probably the picture that Vasari saw in Titian's studio in 1566 (Vasari (1568)–Milanesi, VII, p. 452). The history of the picture is complicated by the fact that the Walsh Porter sales catalogues state that the work

came from the collection of Charles I of England, who had received it as a gift from Philip IV. That story is an invention for sales purposes, since no such item was among the Spanish gifts to Charles I, and, moreover, no such item was in his collection. Mayer at one time (1930) added further confusion by proposing the hypothesis that this canvas had been carried off from the Escorial by the French, but he later (1937) returned to the obviously correct belief that the picture datable 1559 in the Escorial is still *in situ*. The original Italian provenance of the work in Cleveland is most probably the Balbi Palace in Genoa (see below, Unknown and Lost Versions, no. 1).

The Cleveland version appears in all three Walsh Porter sales (London, Christie's, 14 April 1810, no. 38; 21 June 1811, no. 40; 6 May 1826, no. 7); never in Benjamin West's collection (as wrongly stated in the Munro catalogue; also by Waagen); Samuel Rogers (sold privately, not in public sale, 2 May 1856); Hugh A. J. Munro of Novar (*Catalogue*, 1865, p. 15, no. 23; sale, London, Christie's, 18 May 1867, no. 183; also Novar sale, Christie's, 1 June 1878, no. 121); William Graham (sale, London, Christie's, 10 April 1886, no. 472); Ralph Brocklebank, *c.* 1886–1904 (sale, London, Christie's, 7 July 1922, no. 112; the catalogue states that the picture was formerly Novar collection, William Graham, Benjamin West, Rogers, and Orléans (!); also with wrong dates); Durlacher Gallery, New York; Arthur Sachs, New York, 1928–1955; long exhibited at the Fogg Art Museum, Harvard University; purchased by the Cleveland Museum, 1957.

Bibliography: See also History; Waagen, 1854, II, p. 267 (Francesco Bassano); C. and C., 1877, II, pp. 309–310 (copy by Schiavone or Bassano); Venturi, 1931, pl. 386 (Titian); Burroughs, 1930, pp. 268–270 (Titian); Mayer, 1930, pp. 60–61 (Titian); *idem*, 1937, pp. 178–183 (Titian); Suida, 1935, p. 141 (not Titian!); Tietze, 1936, II, pp. 295–296 (Titian, as the original from the Escorial, following Mayer's erroneous theory of 1930); *idem*, 1940, no. 60, fig. 60 (Titian); Berenson, 1957, p. 184 (Titian); *Cleveland*, 1956, no. 51 (Titian); Francis, 1960, pp. 59–63 (Titian); Valcanover, 1960, II, p. 70 (doubtful attribution!)

COPIES:

1. Bologna, private collection, canvas, 0·59 × 1·21 m., Venetian School. A mediocre Venetian picture, influenced by Titian, from whom the white horse is borrowed, it is far removed from the master to whom Suida assigns it (Suida, 1935, p. 142, pl. 256).

2. London, Netherlands Gallery (*c.* 1935), partial copy with the Madonna and the first king only, no dimensions (photo, Witt Library, Courtauld Institute, London).

3. Paris, Atri Gallery (formerly), canvas, 1·49 × 2·17 m., sixteenth century. This copy of the Ambrosiana picture has, nevertheless, many variations in landscape and elsewhere. A. L. Mayer published it as a product of Titian and his pupils (Mayer, 1937, pp. 179–180; Valcanover, 1960, II, p. 71, doubtful attribution).

UNKNOWN AND LOST VERSIONS:

1. Genoa, Palazzo Balbi (Ratti, 1780, I, p. 186, large picture); imported to London from Genoa by Mr. Andrew Wilson, who sold it on 6 May 1807 for 315 guineas (Peter Coxe, London, no. 28; also Buchanan, 1924, II, pp. 196, 200); no purchaser is recorded but he must have been Walsh Porter. This picture is almost certainly the version now in Cleveland (see above, Cat. no. 5).

2. Madrid, Antonio Pérez, picture given by him to a bishop (Marañón, 1948, I, p. 58). Possibly the version now in the Prado Museum (Cat. no. 4).

3. Madrid, Royal Palace, Inventory 1814, 'Adoración de los Reyes de Ticiano, una vara escasa de alto' (0·835 m. high).

4. South Queensferry, Scotland, Earl of Hopetoun (Hume, 1829, p. 67). Hume was undoubtedly mistaken in believing that Lord Hopetoun bought an *Adoration of the Kings* by Titian from the Balbi Palace in Genoa. The Marquess of Linlithgow, the present owner of Hopetoun House, informs me that there exists no record of such a picture by Titian, but that they still possess an *Adoration of the Shepherds* by Rubens, which, according to Waagen (1854, III, p. 310), was purchased in Genoa, about 1823 according to the Hopetoun archives.

WRONG ATTRIBUTIONS:

1. Kreuzlingen (Switzerland), Heinz Kisters, canvas, 1·10 × 1·32 m., Venetian School, late sixteenth century; in 1954 in the W. Lüthy Collection, Aarburg, Switzerland. Tietze-Conrat, usually a careful scholar, attempted to demonstrate that this picture was Titian's original, rather than the one in the Ambrosiana Gallery at Milan, painted for Cardinal Ippolito d'Este who planned to send it as a gift to Henry II of France. The mediocrity of the painting excludes any immediate connection with Titian's school (Tietze-Conrat, 1954, pp. 3–8; Valcanover, 1960, II, p. 70, pl. 170, not by Titian).

2. Lucerne (formerly), very doubtful work (Fischer sale, Lucerne 19–21 March 1942, no. 1044, supposedly dated

1551; photo, Witt Library, Courtauld Institute, London).
3. Madrid, San Isidro (formerly), canvas. The painting, destroyed by fire in 1936–1938, was wrongly attributed to Titian by Ceán Bermúdez (1800, v, p. 40). Tormo (1927, II, p. 166) suggested Bonifacio dei Pitati.
4. Venice, Manfrin Collection (formerly), panel, 1·05 × 0·62 m. (Manfrin catalogue, 1872, no. 80, as Titian).
5. Vienna, Kunsthistorisches Museum, panel, 0·58 × 0·51 m., Venetian School (Plate 233). Berenson considered this indifferent panel to be an early work by Titian, but it is difficult to see any immediate connection with the master. The composition is clearly a sketch for the *Epiphany* (panel, 0·58 × 0·49 m.) by a follower of Titian in the church of Santo Stefano at Belluno (Valcanover, 1951, pp. 72–73, fig. 47). *History:* Bartolomeo della Nave, Venice, before 1638 (Waterhouse, 1952, p. 15, no. 35); Archduke Leopold Wilhelm, Vienna (not in Inventory of 1659, although included by Teniers, 1660, pl. 77); 1809 taken by the Napoleonic officials to Paris, but returned to Vienna in 1815 (Engerth, 1884, I, p. 344, no. 492; Berenson, 1957, p. 192, no. 183). *Related item:* A horizontal version similar to No. 5 in Graz, Landesmuseum (Suida, 1911, p. 365).

Adoration of the Shepherds, see: Nativity, Cat. no. 79.

6. Agony in the Garden Plate 125
Canvas. 1·76 × 1·36 m.
Madrid, Prado Museum.
1562.

This canvas is an original, now so ruined that the figures are barely visible. The extraordinarily large man with the lantern in the foreground caused Palomino to characterize the work as 'caprichosa'. Opinions vary widely, Berenson and Pallucchini considering the composition highly imaginative, while Tietze suggested that the Spaniard, El Mudo, might have painted it, an opinion that must be ruled out by anyone who has studied El Mudo's works at the Escorial. As a matter of fact the prominent lantern may well refer to Easter night processions (see Dorothea Forstner O.S.B., *Die Welt der Symbole*, Innsbruck, 1961, p. 570, under the section entitled 'Lampe').

Condition: Very darkened as early as the eighteenth century (Ponz); excessively rubbed, but the removal of thick varnish would improve its visibility.

History: A letter from Philip II, dated in Brussels 13 July 1558, urged Titian to finish the *Agony in the Garden*

(quoted by Díez del Valle (1656–1659), p. 345). Titian promised to complete it in 1559 (Cloulas, 1967, p. 233); a picture of the same subject was shipped from Genoa in April 1562 according to letters of García Hernández and Titian (Cloulas, 1967, pp. 252–253; C. and C., 1877, II, p. 524). Although the matter is problematical, both the Prado and Escorial pictures may be involved in these letters. On the other hand, Bonasone's engraving of 1563 might be construed as placing the second version later (Cat. no. 7). Titian's name is again mentioned in connection with the Prado canvas in 1574, when Philip II sent it to the Escorial; size recorded as eight by seven feet (Zarco Cuevas, 'Inventario', 1930, p. 45, no. 1006). Philip II sent two paintings of the subject to the Escorial in 1574, but Padre Sigüenza in 1599 places the one with the lantern by Titian in the 'zaguán [entrance hall] de la sacristía' (edition 1923, p. 417); Padre de los Santos in 1657 (edition 1933, p. 237) repeats the former almost word for word, although he calls the room the 'antesacristía', obviously the same location. Palomino's account (1724) conforms with the above and he adds that the picture is 'extremadamente caprichosa', referring of course to the large man with the lantern in the foreground (edition 1947, p. 796). It had been moved and placed near the door of the sacristy in the time of Ponz, who remarks that the canvas had darkened ('ennegrecido'), adding 'en que figuró su autor, Ticiano, las tinieblas de la noche con tal cual accidente de luz' (1773, tomo II, carta III, 43); in 1800 it hung in the sacristy (Ceán Bermúdez, v, p. 41); transferred to the Prado Museum in 1837.

Bibliography: See also History; Madrazo, 1843, no. 428 (from Escorial); 'Inventario general', 1857, p. 84, no. 428 (from Escorial); Poleró, 1857, no. 428 (as in the Prado); C. and C., 1877, II, pp. 320–322 (Venetian copy); Suida, 1935, pp. 144, 179, pl. 255 (Titian); Tietze, 1936, I, p. 232, II, p. 296 (implausible suggestion that it might be Spanish, by El Mudo); Beroqui, 1946, pp. 159–160 (Titian); Berenson, 1957, p. 188 (studio); Valcanover, 1960, II, pl. 104B (Titian); Prado catalogue, 1963, no. 436 (old no. 428).

7. Agony in the Garden Plate 126
Canvas. 1·85 × 1·72 m.
Escorial, Nuevos Museos.
About 1563.

Titian's authorship of the work has been accepted since 1599, and it is substantiated even earlier by Bonasone's

engraving dated 1563. The picture is so darkened, almost to the point of invisibility in the lower part, that little can be said about its quality. Christ in the usual pale rose and blue, the white-clad angel, and the large grey sprawling man at the right constitute the major elements, supplemented by the foreshortened Apostles at the left. Crowe and Cavalcaselle rightly suggested that Correggio's *Agony in the Garden* now in Apsley House, London, influenced Titian in this subject.

Condition: The size of the canvas has been reduced on all sides, as indicated by the original dimensions (9 ×7½ feet, i.e. 2·52×2·10 m.), given in 1574; much darkened.

History: Also see previous picture; it was hung in the Chapter House of the Escorial in 1574 (Zarco Cuevas, 'Inventario', 1930, p. 60, no. 1305, artist unspecified), where it remained until after 1857. Padre Sigüenza gives an accurate description of it, as by Titian, on the altar in the Sala Capitular in 1599 (edition 1923, pp. 395–396); in the same place when Padre de los Santos wrote in 1657 (edition 1933, p. 248); in the same location in 1773 'casi destruída' (Ponz, 1773, tomo II, carta IV, 45); also in 1800 (Ceán Bermúdez, V, p. 42); still in the Sala Capitular in 1857 (Poleró, p. 103, no. 411); sometime later moved to the Sacristy, where it remained until 1963.

Bibliography: See also History; Palomino, 1724 (edition 1947, p. 797, Titian); Ticozzi, 1817, pp. 212–213 (describes the two pictures of the subject at the Escorial as though one picture); C. and C., 1877, II, pp. 320–322 (Titian); Suida, 1935, p. 144, pl. 254 (the Escorial example better than the Prado version); Tietze, 1936, II, p. 296 (partly workshop); Beroqui, 1946, pp. 159–160 (Titian); Berenson, 1957, p. 185 (great part Titian); Valcanover, 1960, II, pl. 104A (Titian).

DRAWING:
Florence, Uffizi, *Christ in Gethsemane*, proposed as Titian's study for either the Escorial or the Prado version (Hadeln, 1924, pl. 36; Popham, 1931, no. 268). The figure does not correspond closely, and moreover the attribution to Titian is doubtful; given more reasonably to Paris Bordone (Tietze and Tietze-Conrat, 1944, p. 119, no. 393).

WRONG ATTRIBUTION:
Longniddry (East Lothian), Gosford House, canvas, 30 × 12 inches (0·762×0·305 m.), late imitation, unlike Titian's compositions; exhibited at the Royal Academy, 1886.

8. Annunciation Plates 56, 57

Panel. 1·79×2·07 m.

Treviso Cathedral, Broccardi Chapel.

About 1519. Titian and assistant.

The deep space in this composition has struck many writers as abnormal in the work of Titian, although such space is common enough throughout Italian painting in the late fifteenth and early sixteenth centuries. There is no reason why the artist should not have tried the scheme, for it appears even later in a workshop piece, the *St. Catherine* (Plate 188) as well as in the third quarter of the century in youthful pictures by his pupil, El Greco, for example the *Annunciation* in the Prado Museum. Details which are unthinkable as Titian's own are the awkward angel and the small kneeling figure of the donor. The latter appears to have been repainted, and both must have been left to an assistant in the first place, unless the donor was a later clumsy addition. The resemblance of the amply draped Madonna to that in the contemporary *Assumption* of the Frari (Plate 18) has often been remarked.

The red-and-yellow rectangles of the marble pavement separated by grey strips, so characteristic of Venetian churches as well as of other pictures by Titian (*St. Peter Enthroned*, Plate 144) are somewhat overpowering in a black-and-white photograph. The long wall, light tan in colour and decorated by an indecipherable frieze, converges toward the landscape with low horizon and abundant white clouds against a deep blue sky. Within this setting the Madonna's full red tunic harmonizes with the pavement, while her blue mantle and beige veil provide needed contrast. The pinkish-white tunic of the grey-winged angel plays a small role in the ensemble and the donor in red and black is extraordinarily inconspicuous.

A horizontal crack runs through the middle of the panel, revealing the joining of the wood, but there is no possible suggestion of enlargement of the composition subsequent to Titian's day. Nevertheless, Oettinger put forward an elaborate theory to the effect that Titian painted the Madonna about 1515 and that the entire setting and the other figures were added by his pupil, Paris Bordone, a native of Treviso, later in 1525–1529. Acceptance of this proposal has not been forthcoming for a variety of reasons, among them the improbability that Titian would have painted the picture for Broccardi before the latter built the chapel. Moreover, the panel shows unmistakably that it was prepared all at one time, there being no additional

pieces of wood discernible. Broccardi's escutcheon appears not only on the wall to the left of the Madonna's head in the painting, but also upon the handsome original white-marble frame, which is inlaid with roundels of *rosso antico* and diamond-shaped pieces of *verde antico*. However, Oettinger does make interesting stylistic comparisons between the Treviso *Annunciation* and Paris Bordone's work. Since this pupil of Titian was only nineteen in 1519, he would probably have served in a subordinate capacity.

Condition: In addition to restorations in the figures of the donor and angel, the left side of the Madonna's face has suffered somewhat and a few spots upon the drapery have been retouched. For a picture of this period still in a church, the condition as a whole is satisfactory.

History: The chapel of the Annunciation was erected by the canon Malchiostro Broccardi in 1519, according to the documents published by Coletti and confirmed by that date on a plaque in the chapel and by the long Latin inscription of dedication. Broccardi's escutcheon appears repeatedly in the chapel, on the walls, on the choir stalls, in the frescoes of Pordenone (dated 1520), on the altar frame, and even in Titian's picture of the *Annunciation*. The entire chapel seems to have been completed with its decoration by January 1523.

Other dating: Crowe and Cavalcaselle, and Suida, 1517 (because Titian visited Treviso in that year); Berenson, 1519–1523.

Bibliography: Ridolfi (1648)–Hadeln, I, pp. 112–113, 176; C. and C., 1877, I, pp. 221–224; C. and C., 1871, edition 1912, III, pp. 146–148; Gronau, *Titian*, 1904, pp. 46–47; Coletti, 1921, pp. 407–420; *idem*. 1935, pp. 162–165; Oettinger, 1930, pp. 319–337; Suida, 1935, p. 50; Tietze, 1936, I, pp. 117–119; II, p. 309; Valcanover, 1960, I, pls. 98–99 (donor's portrait repainted).

9. Annunciation Plate 58

Canvas. 1·66×2·66 m.

Venice, Scuola di San Rocco.

About 1530.

The emphasis in this picture upon the splendid palace architecture gives primary importance to the setting and to the space within which the Annunciation takes place. The horizontal balustrade cuts across the centre, establishing the stage space where the angel and Madonna are located and separating the distant landscape from the figures. Upon this kind of architectural environment later artists were to build, particularly Paolo Veronese, Rubens, and Van Dyck. The conception in Titian's career precedes stylistically the composition which he presented to the Empress Isabella in 1537, a lost work (Cat. no. 10) known only in Caraglio's engraving, where the setting is subordinated to the divine rays, which stress the miraculous aspect of the event.

The Madonna's white veil and her slender hand enframe her head, while her figure is enveloped by the blue cape, the pale rose of her tunic being visible only at the neck and wrists. Gabriel wears a rose costume and a white scarf, which blows from his shoulders. The rose colour is repeated in the cloth placed in the centre upon the grey balustrade. The yellow and pink rectangles of the marble floor, divided by wide grey bands, contribute to the establishment of space in depth. The landscape, now considerably darkened, furnishes a discreet backdrop. The quail in the foreground represents, among other things, maternal devotion and conjugal concord (Charbonneau-Lassay, 1940, pp. 503–504).

The new canvas, with which the picture is now relined, covers numerous drawings which were formerly visible on the reverse of the original canvas. They included a study for the Madonna of the Annunciation and nude figures certainly not by Titian's hand. A photograph of the drawings exists in the Witt Library, Courtauld Institute, London.

Condition: The Madonna's blue mantle has been repainted and retouched; in general the canvas has darkened greatly and the surface has deteriorated.

History: Bequeathed to the Scuola di San Rocco in the testament of 31 October 1555 of a member of the Confraternity, Amelio da Cortona (Fossati, VI, 1814, p. 30; Cicogna, IV, 1834, p. 141); Milanesi's suggestion that it is the 'tavoletta' which Vasari records in Santa Maria Nuova in Venice is wrong (Vasari (1568)–Milanesi, VII, pp. 448–449); Van Dyck, 'Italian Sketchbook', folio 7.

Other dating: Crowe and Cavalcaselle, *c.* 1526; Suida, 1530; Berenson, Gronau, Tietze, and Valcanover, 1540.

Bibliography: See also History; Moschini, 1815, II, pp. 216–217; C. and C., 1877, I, pp. 304–305; Gronau, *Titian*, 1904, pp. 119–120; Suida, 1935, p. 65; Tietze, 1936, I, p. 151, II, p. 314; Berenson, 1957, p. 191; Valcanover, 1960, I, pl. 157.

10. **Annunciation** (lost) Plate 59

Canvas. 5·43 ×3·34 m.

Aranjuez, Palace chapel (formerly).

1536.

The extraordinarily large dimensions suggest that they included the frame, otherwise the picture would have approached the size of Titian's *Assumption* in the Frari at Venice. Aretino (1537) praises the beauty of the *Annunciation* at some length and mentions the yellow draperies of the angel, which conformed in colour to the late *Annunciation* in San Salvatore (Cat. no. 11). A fuller description occurs in Cassiano del Pozzo's journal of Cardinal Francesco Barberini's visit to Spain (1626, folio 34ᵛ): 'che guarda nella cappella che è nell' apartamento à terreno di dove ambidue i Cardinali col corte udirono la messa in detta cappela la tavola è famosissima di Titiano et è un Annontiata con l'Angelo che in atto di genuflessione. Da un angolo della tavola s'inclina, e la santissima Vergine da Inginocchiotoio che è formato da un Aquilone che si svolge ascoltando l' messagio divino. L'aria si della Vergine come dell' Angelo e i panni non si può dire altro se che non di Titiano, (folio 35) non si può vedere tinta di carne più bella né l' colorito più fresco che a questo quadro patito alquanto dalla freschezza della stanza. . . . La cornice è stretta e pò degna di si bel quadro essendo senza lavoro nessuno di puro abbruccio tinta di nero profilata d'oro.'

Caraglio's print, preserving the composition of the lost canvas of 1536, shows an entirely different conception from that of the *Annunciation* in San Rocco. The supernatural aspects of the mystery are emphasized in the total subordination of the architecture to the dove of the Holy Spirit surrounded by rays of divine light and the groups of angels that fill the upper part of the picture.

History: The *Annunciation* was originally intended for the nuns of Santa Maria degli Angeli, Murano, who protested at the high price of 500 ducats. According to Vasari, at Aretino's suggestion Titian presented the work as a gift to the Empress Isabella in 1537, with the result that Charles V rewarded the artist handsomely to the extent of 2000 *scudi*. In a letter dated 9 November 1537 (Aretino, *Lettere*, edition 1957, I, pp. 78–79), Aretino congratulates Titian on his shrewdness without saying that he himself had suggested the gift, a fact which is usually assumed. In the print by Caraglio, which preserves the composition, the angels hold the emblem of Charles V: two pillars with the inscribed motto: PLVS VLTRA.

Luca Giordano retouched the painting in 1698 because it had deteriorated (Palomino, 1724, edition 1947, p. 793). The Inventory of the palace at Aranjuez, dated 1700, places the *Annunciation* in the high altar of the chapel, the measurements given as six and one-half *varas* high by four *varas* wide (5·43 ×3·34 m.). Its continued presence there later in the century is confirmed by Ponz (1772, tomo I, carta v, 54) and Ceán Bermúdez (1800, v, p. 39). Beroqui discovered that the picture was in Bayeu's studio in 1794, presumably for restoration. In 1804 Alvárez de Quindós y Baena (pp. 2–6, 208) says that it has been taken to Madrid and replaced by a copy. Later in 1814 during the French occupation it was purchased from the invaders by Pablo Recio y Tello and placed by the painter Carnicero (died 1814) in the Casa de Rebeque (Beroqui, 1946), but it must have been destroyed during the chaos of the French retreat from Spain. No further notice has been found. The French painter, who had charge of the works of art in Spanish royal palaces under Joseph Bonaparte, gives no hint in 1825 (Quilliet, p. 17) of the fate of any of the objects which were looted or sold.

Bibliography: See also History; Vasari (1568)–Milanesi, VII, p. 441; Ridolfi (1648)–Hadeln, I, pp. 171–172; C. and C., 1877, I, pp. 425–426; Tietze, 1936, I, p. 151; Beroqui, 1946, p. 53, note 1, pp. 187–189 (note by Tormo); Cloulas, 1967, p. 201 (letter, Venice, 26 November 1536, Gaztelu to Cobos: Titian is finishing the *Annunciation*).

COPIES:

1. Cheltenham, Lord Northwick's collection (formerly), a picture attributed to Michael Coxie which seems to have had this composition (sale Cheltenham, 26 July 1859, p. 59, no. 582).

2. London, Viscount Rothermere, canvas, 0·787 ×1·04 m. variant, sixteenth century, after the Caraglio print (Rothermere, 1932, pl. 32); published as Titian *c.* 1520 (Rome, Galleria Addes: Gronau, 1924–1925, pp. 158–160).

3. Unknown location, fragment of the head of the large angel in the upper left, apparently a copy of the Caraglio version (Reinhardt, 1951, pp. 156–164).

4. A copy, now lost, was made by Michael Gross at Aranjuez in 1634 (Trapier, 1967, p. 60).

11. **Annunciation** Plates 61, 62

Canvas. 4·03 ×2·35 m.

Signed in capitals on the lower centre step: TITIANVS FECIT FECIT

Venice, S. Salvatore.

About 1560–1565.

Ridolfi(1648) quotes the signature as it is today and relates the tradition that Titian wrote FECIT twice to prove that despite his advanced age he really painted the picture. For that reason Tietze's suggestion that the second FECIT was added by a restorer and that it covers an illegible date is not convincing.

The picture stands in Jacopo Sansovino's original frame of grey stone in a lateral altar on the right side of the church. The architectural setting within the painting itself comprises only tall channelled columns behind the angel and the floor of rose and yellow tiles.

Vasari, who saw this composition, did not entirely approve of Titian's late works because of their advanced illusionistic style, which made them appear unfinished to the Florentine. The tone throughout is neutral with rosy and yellowish tints against a faint blue sky in the upper regions. The yellow drapery and white sleeves of the angel and the Madonna's rose tunic and blue mantle emerge in their full richness when seen in proper light. Within the setting shrouded in clouds and the small area of distant landscape, the figures are heroic, both those on earth and the robust angels in the sky, some nude and others draped in rose.

In the lower right-hand corner are the Latin words, IGNIS ARDENS NON COMBVRENS (Fire that burns but does not consume). The chastity of the Virgin is thus symbolized by the Burning Bush of Moses (Quod rubus arderet et non combureretur. Exodus 3:2). This idea originates at least as early as the seventh century in the writings of St. Andrew of Crete, deacon of Hagia Sophia in Constantinople (O'Connor, 1958, pp. 114–115). In the *Speculum Humanae Salvationis* of the early fourteenth century the Annunciation is accompanied by the Burning Bush (Mâle, 1925, p. 234). Later Titian's pupil, El Greco, was to place the bush, burning with white flames, in the centre foreground of his *Annunciation* now in the Prado (Wethey, 1962, fig. 129).

Condition: Considerably darkened and somewhat dirty.

History: Engraved by Cornelius Cort, *c.* 1566. The picture still remains in the altar for which it was first intended.

Bibliography: Vasari (1568)–Milanesi, VII, p. 449; Ridolfi (1648)–Hadeln, I, p. 205; Boschini, 1664, p. 134; C. and C., 1877, II, pp. 352–354; *Mostra di Tiziano*, 1935, no. 87; Tietze, 1936, I, pp. 237, 240, II, p. 313; Valcanover, 1960, II, pls. 108–109.

DRAWING:
Florence, Uffizi, no. 12, 903. Study of an angel, probably preparatory for the *Annunciation* in S. Salvatore (Hadeln,

1924, pl. 35; Tietze and Tietze-Conrat, 1944, p. 316, no. 1905).

COPY:
Venice, San Giacomo di Rialto, on the right lateral altar, *c.* 3.00×1.50 m., signed: MARCVS TITIANI (signature partly covered by the frame). The picture, well preserved, but lacking the atmosphere of Titian's work, is a tame repetition of the painting in San Salvatore; the angel wears yellow and the Madonna a rose blouse and white sleeves (Boschini, 1664, p. 263).

12. Annunciation Plate 60

Canvas. 2·80×2·10 m.

Naples, San Domenico Maggiore.

Titian and workshop. Signed in capitals on the base of the prayer-desk: TITIANVS F.

About 1557.

The quality of the picture is not first rate on comparison with the *Annunciation* in San Rocco or that in San Salvatore at Venice. The workshop had a predominant share in the Naples variant, which constitutes a development of the composition preserved in Caraglio's print. The grey tunic of the angel is unusual in Titian's work, and even more peculiar as costume is the rose drapery. Here a pavement of pink and dark-blue marble replaces Titian's normal rose and yellow, which correspond to the actual tradition of Venetian churches.

Condition: Restored in 1959, the canvas is in bad condition with several holes about the Madonna's head, and even one in her right eye, although now repaired. The surface has darkened considerably throughout. Sigismondo (II, 1788, p. 13) says 'si vuole di Tiziano'. He relates that the picture, being in bad condition ('molto patito'), was retouched in 1788 at the order of the Principe di Belmonte; old varnish and repaint removed in 1957–1960 (Causa, 1960, pp. 58–61).

History: Dominici in 1743 in his life of Giacomo di Castro was the first to declare this picture a copy by Luca Giordano, claiming that the original had been sent to Spain by Pedro de Aragón, the Spanish Viceroy in 1666–1671, who shipped off a number of pictures (Dominici, first edition 1743, II, p. 290; edition 1844, III, p. 67, in the life of Giacomo di Castro: 'la Nunziata di Tiziano anche in San Domenico Maggiore si suppone fatta copiare da Luca Giordano e portato via l'originale'). However, Dominici's story is full of errors, among them

the name of the Viceroy, who was probably the Count of Peñaranda, Viceroy in 1659–1664, since Giacomo di Castro was his art adviser. Celano, a contemporary of both viceroys, makes no reference to such an affair, and he includes Titian's picture in his book in 1692 (Celano, edition 1792, III, p. 98). Volpicella in 1850 rejected Dominici's account and substantiated his belief with full references to Titian's picture in Neapolitan literary sources (Scipione Volpicella, 1850, pp. 157, 354–355). In 1925 Longhi in repeating Volpicella's account re-claimed the work as Titian's, and he added a reference to the picture by de Rogissart, *Les délices de l'Italie*, Leyden, 1706, II, p. 527 (Longhi, 1925, pp. 40–45).

The inscription in the chapel records its dedication by the donor 'Cosmus Pinellus' in 1557, about which time the picture may be dated. Cesare d'Engenio Caracciolo, the early historian (1624, p. 287), quotes the inscription and identifies the picture as Titian's, but he incorrectly gives the date 1546 (misprint for 1564?) and names the Duke d'Acerenza (i.e. Pinelli) as the patron of the chapel. The escutcheons on the picture are those of the Pinelli and the Pignatelli, and therefore were probably added after a marriage between the two families in 1721 (Causa, 1960, pp. 60–61). Cesare d'Engenio Caracciolo writes: 'Nella cappella del Duca d'Acerenza. D. Mariae Dei Matri sacellum hoc in quo per singulos dies sacrum fiat Cosmus Pinellus dicavit Anno 1557. Nell' Altar di questa cappella è la tavola in cui la Vergine dall' Angiolo Annunciata fatta da Titiano da Vecellio da Cador celebre pittore, il qual fu chiaro al mondo nel 1546' (=1564?).

Bibliography: See also History; Pietri, 1634, p. 203; Angulo, 1941, pp. 148–154; Tietze, 1936, I, p. 240; II, p. 302; Causa, 1960, pp. 58–61, no. 17.

COPIES:

1. Madrid, San Ginés, Capilla del Santo Cristo, canvas, 2·90×2·12 m., Luca Giordano's copy of Titian. In his important and thorough publication of this picture, Professor Diego Angulo also studies the *Annunciation* in Naples by Titian, which at one time was thought to be Luca Giordano's copy on the theory that the original had been taken to Spain. The Madrid canvas is now in a neglected state, ripped and dirty, much in need of new framing and proper conservation. The colours differ somewhat from Titian's picture in Naples. There the angel's grey-brown wings sustain the grey of the tunic, which is partially concealed by a rose outer garment of curiously nondescript nature. In Madrid the white tunic and yellow draperies of the angel of Giordano's picture

are the same colours that Titian used in the *Annunciation* in San Salvatore at Venice and in the lost picture known in Caraglio's print. The Madonna appears in both instances in the customary rose tunic, blue mantle, and white veil.

Bibliography: Palomino 1724, edition 1947, p. 1114; Ponz, 1776, tomo v, quinta división, 6; Ceán Bermúdez, 1800, II, p. 347; Diego Angulo, 1940, pp. 148–154; Wethey, 1967, pp. 678–686.

2. Peñaranda de Bracamonte (Salamanca), Carmelite Convent, canvas, c. 2·10×1·63 m., Neapolitan School, c. 1660. The *Annunciation* occupies the high altar of the church (Plate 231) at Peñaranda de Bracamonte, a donation of Gaspar de Bracamonte y Guzmán, Conde de Peñaranda. In the chapel behind the sanctuary the foundation in the year 1669 is recorded in a long inscription placed in the frieze of the chamber. Another inscription gives the epitaph of Don Gaspar (1596–1676). He had been Spanish viceroy to Naples in the last years of Philip IV's reign (1659–1664), and the traditions of the convent hold that he brought many works of art from Naples to decorate the church and nunnery.

In the case of the *Annunciation* that tradition is confirmed, since the composition represents an adaptation of Titian's picture of the same subject in San Domenico Maggiore at Naples. The attitudes of the Madonna and Gabriel are repeated at Peñaranda but with an increased sense of movement in both cases. The major changes occur in the figure of Gabriel, who combines elements drawn from the Naples picture and from the Caraglio print after Titian's lost *Annunciation*. At Peñaranda the positions of the right arm and the upper part of the body repeat the Naples canvas whereas the placing of the legs, the shorter draperies, and the effect of a lunge forward suggest the Caraglio print. The platform upon which the event takes place as well as the wicker basket with the Virgin's sewing are also adaptations from the same source. At Peñaranda the landscape background and the few cherubs' heads in the sky do not conform precisely to either proto-type, since the setting here is much simplified. On the other hand, the yellow drapery and white sleeves of the angel, the Madonna's blue drapery over a rose tunic, as well as the pink and yellow pavement adhere to Titian's normal colour scheme. Here the Virgin's long beige veil is draped over her head and descends across her right arm and across her blue cloak. In the early *Annunciation* in the Scuola di San Rocco at Venice the angel wears white over rose and at Naples the colours are rose over grey. All this discussion of colour, an element often disregarded by critics, demonstrates that the *Annunciation* at Peñaranda

differs in many details from the Naples picture and yet corresponds in the same respects to others of Titian's versions of the same subject, particularly the original in San Salvatore at Venice. The *Annunciation* at Peñaranda appears to be an adaptation of the Naples picture, either commissioned by Gaspar de Bracamonte when he held the office of Viceroy in that city, or bought by him in the belief that it was an original by Titian. Trade in forged works passing as by Titian is confirmed by Giacomo di Castro in 1664 and later by Dominici (Wethey, 1967, p. 685).

The entire effect of the angel at Peñaranda in the swift flow of drapery and blowing hair, is unquestionably Baroque and Neapolitan. The Madonna's head, likewise, is Neapolitan of the seventeenth century in its long shape, comparable with figures by Stanzione, Vaccaro, Pacecco de Rosa, and Francesco Guarino.

Condition: The canvas at Peñaranda is in ruinous condition, torn and dirty with numerous paint losses. The horizontal crease above Gabriel's head and another upon the platform reveal where the canvas was sewn together. The floor in the foreground, representing tiles, has been daubed over by a local sacristan or nun.

Bibliography: The existence of the work was generously called to my attention by Doña María Luisa Caturla. Wethey, 1967, pp. 685–686.

13. **Apparition of Christ to the Madonna** Plate III

Canvas. 2·77×1·78 m.

Medole (Mantua), Santa Maria.

Titian and workshop.

About 1554.

The collaboration of the workshop in this picture is generally agreed, even discounting the restorations of 1862, which help to explain the strong accents in the heads of the cherubs and the hard outlines of the major figures.

The arch of cherubs' heads and the yellow-to-brown background provide the setting for Christ in Limbo accompanied by the youthful Adam, and the patriarchs of the Old Testament, who appear to His kneeling mother. The athletic figure of Christ, draped in white, is reminiscent of that in the Louvre *Christ Crowned with Thorns*, and clearly Michelangelesque (Plate 132). Various critics have associated the male figures specifically with Michelangelo's *Risen Christ* in Santa Maria sopra Minerva, Rome, although the poses at Medole are not identical.

Iconography: In the unusual iconography of this canvas Titian seems to combine the apocryphal accounts of the Descent of Christ into Hell and the Descent of the Virgin into Hell. In Part II of the Gospel of Nicodemus(*Apocryphal New Testament*, pp. 117–145) is the description of the setting up of the Cross in Hell as a sign of victory, and the leading forth of Adam, Eve, and various other Old Testament figures. According to the Apocalypse of the Virgin (*loc. cit.*, p. 563) the Madonna also descends into Hell and is shown all its torments. She makes an appeal, entreating all of the saints to intercede, with her, for the Christians, whereupon her Son appears. Isabel de Villena's account of the Madonna in Hell (published in 1497, pp. 160–173) and St. Vincent Ferrer's sermon on the Resurrection (1413) appear to have influenced Valencian painters of the late fifteenth century (Post, VI, 1935, p. 270). The theme is also found in the reliefs of the Barcelona choir stalls (1518), the work of the Italianate sculptor Bartolomé Ordóñez (Wethey, 1943, p. 236). The concentration of the subject in Spain suggests the possibility that Titian originally painted the work for a Spanish client, one of the numerous envoys of Charles V, and that, being left with an unwanted picture, the artist decided to donate it to the church at Medole.

Condition: Damaged during the Napoleonic invasion, but restored in Venice in 1862, the picture was in a lamentable state, all very dirty and the paint in a dry and crackled condition; under restoration in 1968–1969 after being cut from the frame and stolen.

History: The benefice of Medole was presented to Titian's son Pomponio at the age of six in 1530 (Braghirolli, 1881, pp. 10–11), but he behaved so disgracefully that Titian asked the Duke of Mantua in a letter of 26 April 1554 to replace him with his nephew (C. and C., 1877, I, p. 507). At that time Titian seems to have presented the *Apparition of Christ to the Madonna* to the church. The painting was stolen in April, 1968 (*New York Times*, 27 April 1968), but returned a short time later.

Bibliography: See also History; C. and C., 1877, II, pp. 240–242, 507; Suida, 1935, pp. 98, 128, 178; *Mostra di Tiziano*, 1935, no. 76 (colour largely destroyed); Tietze, 1936, II, p. 301; Valcanover, 1960, II, pl. 64 (assisted by the workshop).

14. **Assumption of the Virgin** Plates 17–19, 21, 22

Panel. 6·90×3·60 m.

Venice, Santa Maria dei Frari.

Signed in capitals on the end of the tomb: TICIANVS

Dated 1516–1518.

The inscription of 1516 on the lower right pilaster of the grey-stone frame reads as follows: FRATER GERMANVS HANC ARAM ERIGI CVRAVIT MDXVI. On the left pilaster is the dedication to the Virgin: ASSVMPTAE IN COELVM VIRGINI AETERNI OPIFICIS MATRI. Within the picture a cherub in the clouds at the extreme left holds an oval shield inscribed with the restored letters BEVI (?), i.e. Beata Virgo, while opposite at the extreme right another cherub holds a circular object with the hypothetical letters GLO, i.e. Gloria.

The colour composition is dominated by the triangle of figures in red, comprising the Madonna in her red tunic and the two Apostles below, St. John the Evangelist facing the spectator at the left and the principal Apostle at the right with back turned and arms outstretched (identified by Crowe and Cavalcaselle as St. Andrew, although he is without attribute). The green and the white costumes of the Apostles beside and between them complement the reds. The pale-blue sky above the Apostles' heads is changed to a yellow light in the upper section behind the figure of the Madonna. Although not all of the Apostles can be identified, the man in the centre, seated upon the tomb, is clearly St. Peter; the Apostle at the left front probably St. Paul because of the long beard; the profile at the extreme right, with his pilgrim's hat and the shell upon his cloak, can only be St. James Major. Since St. Mark, the patron of Venice, ought to have a prominent position, he may be the bearded man in profile with upraised arm in the centre just behind St. Peter.

Raphael's *Disputa* (1509) may be reflected here not only in the semicircular composition above, but equally so below in the vigorous gestures of the Apostles and their variety of pose. Rosso Fiorentino's *Assumption* (1517) in Florence, which has a scheme somewhat similar to Titian's, is not, however, a likely source of inspiration since Raphael's works must have been known to Titian through drawings and sketches by others who had visited Rome.

That the germ of the idea for Titian's *Assumption* lies in Mantegna's fresco formerly in the Ovetari chapel in the church of the Eremitani at Padua was reasonably proposed by Fiocco (1937, p. 199), but flatly rejected by Tietze-Conrat (1955, p. 193). The standing figure of the Madonna, her arms outstretched, and the group of astonished Apostles below do surprisingly forecast Titian's work. Just at this time the vigorous pose with upraised arms similar to that of Titian's Madonna appears in other compositions, for example, the fresco of the *Transfiguration* by Sebastiano del Piombo in the Borgherini chapel of San Pietro in Montorio at Rome. Begun in 1516, the design is said to have been supplied by Michelangelo (Vasari (1568)–Milanesi, V, p. 569). Basically the spirit is also Michelangelesque in Raphael's *Transfiguration* (1518–1522) in the Vatican Museum, where the Christ, transfigured above the mount, lifts his arms in a similar attitude of beseeching. The medieval *orant* figure seems unrelated. Although Lodovico Dolce in 1557 saw in the *Assumption* 'la grandezza e la terribilità' of Michelangelo, his remark strikes one as more literary than stylistic, yet the use of *contrapposto* and the energetic movements throughout do reflect the High Renaissance in Florence and Rome, where the personality of Michelangelo was already dominant.

The old-fashioned composition of Giovanni Bellini's *Assumption* in San Pietro Martire at Murano and Perugino's (1506) in the SS. Annunziata at Florence are a measure of the brilliance and inventiveness of Titian's great work. Titian's originality in insisting upon the dramatic ascent of the Virgin, in contrast to the symbolic and static treatment of earlier artists, has been noted by Réau (II, part II, p. 617) and Künstle (p. 581).

Numerous other influences have been proposed: Tietze compares the attitudes of the Apostles to those on a relief from the Barbarigo tomb (1515), but the relationship is not very significant (Planiscig, 1921, p. 210, fig. 219). The poses of certain of the nude angels were undoubtedly suggested by antique sculpture (Plate 20; see also Tietze, 1936, I, p. 81). Nevertheless, all of these contributions are no more than subconscious remembrances on the part of a great master such as Titian.

Condition: In better condition than should be expected, although it has been cleaned on several occasions, the one of 1817 being recorded. St. Peter's costume, which Crowe and Cavalcaselle considered largely restoration, has suffered most. In 1965 the panel was treated with insecticide gas to kill termites, which had begun to attack the wood.

History: Commissioned about 1516, the picture was installed in the altar on 20 May 1518, the feast of St. Bernardino (not in March as often stated), according to the contemporary diarist Sanuto (XXV, col. 418: 'Et eri fu messo la palla granda di l'altar di Santa Maria di Frati Menori suso, depenta per Ticiano'). Exhibited in the Accademia in Venice 1817–1918; in the latter year it was returned to the Frari.

Bibliography: See also above; Dolce, 1557, edition 1960, p. 202; Vasari (1568)–Milanesi, VII, p. 436 (mistakenly says it is on canvas and in bad condition); Van Dyck's

'Italian Sketchbook', folio 10 (Apostles); Ridolfi (1648)–Hadeln, I, p. 163; Boschini, 1664, p. 297; C. and C., 1877, I, pp. 211–221; Tietze, 1936, I, pp. 109–112, II, p. 311 (wrongly said to be on canvas); Valcanover, 1960, I, pls. 72–76.

DRAWINGS:

1. London, British Museum, study for St. Peter of the *Assumption* (Hadeln, 1924, pl. 20; Tietze and Tietze-Conrat, 1944, p. 320, no. 1929).
2. Paris, Louvre, Study of Apostles. Although the attitudes clearly indicate an *Assumption*, the drawing does not conform closely to the Frari picture. Hadeln (1924, pl. 5), however, considered it specifically preparatory for that work. Tietze (1936, pl. 38) seemed at first to agree, yet he later (Tietze and Tietze-Conrat, 1944, p. 323, no. 152) classified the sheet as a study for a *Pentecost*. Fröhlich-Bum (1928, p. 198, no. 41) proposed a most unlikely connection with the *Pentecost* in S. Maria della Salute at Venice, with which none of the figures corresponds.
A copy of the Louvre drawing is in the Buendía collection at Pamplona, Spain.

COPY:

Venice, S. Maria del Carmine, high altar, copy of the Madonna and angels of the upper section, by Lattanzio Querena, early nineteenth century (Lorenzetti, 1956, p. 552).

15. Assumption of the Virgin Plates 43, 44, 45

Canvas. 3·94 × 2·22 m.

Verona, Cathedral.

About 1535.

The simplicity of this composition, with the Madonna kneeling in a prayerful attitude as she looks at the Apostles below, could scarcely provide a greater contrast to the magnificent drama of the Frari *Assumption*. The Apostles, terminated by a profile head at each side, suggest also more intimate and personal reactions to the miracle. Here the blue mantle almost completely envelops the Madonna's figure, her white tunic being visible only in the right sleeve and at the waist. The red drapery of the two men at the extreme left and of the young St. John at the right, in salmon-red over dark green, are the major warm colours in a generally subdued tonality. The bearded Apostle in black, kneeling to the extreme right, was identified by Ridolfi (1648) as a portrait of the Veronese architect, Michele Sanmicheli. St. Peter with

white beard, leaning backwards in the centre, wears his traditional yellow cloak over a dark costume. The girdle in the outstretched hand of another Apostle identifies him as St. Thomas. The rest of the eleven (*sic*) Apostles are difficult to determine, although the long white beard (fourth from the left) suggests St. Paul.

Condition: Good; heavily varnished.

History: Placed in an altar once belonging to the Cartolari family (Persico, 1820, I, p. 41; Rossi, 1854, p. 25); the altar redesigned by Sansovino for the Nichisola family (Ridolfi (1648)–Hadeln, I, p. 176); taken to France by the Napoleonic invaders, but later returned (1797–1815).

Other dating: Suida and Pallucchini, *c.* 1535; Crowe and Cavalcaselle, and Tietze, *c.* 1543.

Bibliography: See also History; Vasari (1568)–Milanesi, VII, p. 445; C. and C., 1877, II, pp. 96–97; *Mostra di Tiziano*, 1935, no. 22; Suida, 1935, pp. 67, 165; Tietze, 1936, II, p. 148; Pallucchini, 1953, I, p. 168; Valcanover, 1960, I, pl. 137.

COPIES:

1. By Carlo Ridolfi for Giovanni Azzolino's altar in Rovere di Trento (Ridolfi (1648)–Hadeln, I, p. 176).
2. By Théodore Géricault, now in Bremen Kunsthalle (G. Busch, 1967, p. 177, illustration).

16. Baptism Plates 65, 66

Canvas. 1·15 × 0·89 m.

Rome, Capitoline Museum.

About 1515.

Among the best preserved of Titian's early pictures, this *Baptism* has a deep ultramarine sky and exceptionally lovely Giorgionesque landscape. The high quality should leave no doubt of Titian's authorship, which is attested by Marcantonio Michiel's reference of 1531. The half-length figure in the right foreground represents Giovanni Ram, the Venetian collector, to whom the picture belonged at that time. Nevertheless, Crowe and Cavalcaselle attributed it to Paris Bordone, while Hetzer likewise excluded it from Titian's work. Hadeln rightly insisted that the documentation is unchallengeable.
The kneeling St. John and Christ in the water up to his knees Hadeln regarded as Flemish iconography, because the kneeling St. John occurs in Gerard David's picture of the same subject in the Bruges Museum. He stated that in Venetian art Christ's body is visible to the feet and St.

John stands upright (Giovanni Bellini, Santa Corona, Vicenza). That theory is not justified, inasmuch as Christ's body is covered by water to the waist and the Baptist appears to genuflect as early as the mosaic in the Baptistry of the Arians at Ravenna (van Marle, I, 1923, p. 14); both Veronese's and Tintoretto's iconography is similar to Titian's and the same features later become widespread in the seventeenth century (Mâle, 1932, pp. 260–262).

Condition: Extensive blistering of paint throughout, but the main sections are well preserved.

History: Venice, Giovanni Ram, in 1531, seen by Marcantonio Michiel (English edition, 1903, p. 122); Venice, Inventory of Alessandro Ram in 1592 (Ludwig, IV, 1911, p. 76). Without any doubt the picture was purchased in Venice about 1660 by the young painter Giovanni Bonati, acting as agent for Cardinal Carlo Pio, Bishop of Ferrara. In 1662 the cardinal moved to a palace in the Campo dei Fiori at Rome, bringing his collection with him. Titian's *Baptism* was included in the one hundred and twenty-six pictures that a later member of the family, Prince Giberto Pio di Savoia, sold to Pope Benedict XIV in 1750. The pope purchased the collection specifically for the Capitoline Museum (Pietrangeli, 1951, pp. 59–60).

Bibliography: See also History; C. and C., 1877, I, pp. 297–298 (Paris Bordone); Morelli, 1892, pp. 289–290 (Titian, not Bordone); Hetzer, 1920, pp. 104–107 (contemporary of Titian); Hadeln, 1920, pp. 931–933 (Titian); *Mostra di Tiziano*, 1935, no. 6 (Titian); Suida, 1935, pp. 22–23 (Titian); Tietze, 1936, I, p. 95 (Titian); dell'Acqua, 1955, pl. 15 (Titian); Berenson, 1957, p. 190 (Titian); Valcanover, 1960, I, pl. 47 (Titian); Canova, 1964 (not mentioned).

Cain Slaying Abel, see: Old Testament Subjects, Cat. no. 82.

Christ, see: Ecce Homo, Cat. nos. 32, 33, 34, 35, and Man of Sorrows, Cat. no. 75.

17. **Christ and the Adulteress** (unfinished) Plate 70

Canvas. 0·91 × 1·36 m.

Vienna, Kunsthistorisches Museum.

About 1511.

In his exhaustive monograph on this picture Dr. Oberhammer published X-rays which demonstrated that

Titian made changes in the positions of figures, a fact which proves that the work cannot be a copy. The high quality of this unfinished painting should leave no doubt of Titian's authorship at the period when he was engaged on the frescoes at Padua (1511), where stylistic analogies are impressive.

Condition: Unfinished; well preserved.

History: Collection of Bartolomeo della Nave, Venice (?) (Ridolfi (1648)–Hadeln, I, p. 201); Archduke Leopold Wilhelm, Vienna, in 1659 (Inventory, p. XCIV, no. 131; Teniers, 1660, pl. 67; Titian).

Bibliography: Storffer, 1720, no. 227; Mechel, 1783, p. 17, no. 1; C. and C., 1877, II, pp. 453–455 (ascribed to their favourite grab-bag, Padovanino); Engerth, 1884, I, p. 348 (Titian); Suida, 1928, p. 208 (Titian); *idem*, 1935, pp. 67, 68, 165 (Titian); Tietze, 1936 (omitted); Berenson, 1957, p. 191 (Titian); Valcanover, 1960, I, p. 99, pl. 210 (doubtful attribution); Klauner and Oberhammer, 1960, p. 138, no. 713 (Titian); Oberhammer, 1964, pp. 101–136 (Titian).

COPIES:

1. Budapest, National Museum, canvas, 0·534 × 0·61 m., partial copy with changes (Oberhammer, p. 135, illustration; Fischel, 1930, p. 264; *Guide du Musée George Roth*, Budapest, 1906, p. 49).
2. London, Wallace Collection, panel, 0·17 × 0·23 m., copy by Teniers (*Wallace Collection*, no. 637).
3. Padua, Museo Civico, canvas, 0·98 × 1·48 m., hard copy attributed to Varotari il Padovanino (Oberhammer, 1964, p. 119, illustration; Grossato, 1957, p. 169).

WRONG ATTRIBUTION:
Bordeaux, Musée des Beaux-Arts, canvas, 1·30 × 1·98 m., Venetian School, *c.* 1560 (Bordeaux, 1964, p. 17, no. 5).

Christ Appears to the Madonna, see: Apparition of Christ to the Madonna, Cat. no. 13.

Christ at the Column, see: Flagellation, Cat. no. 41.

18. **Christ Blessing** Plate 93

Canvas. 0·96 × 0·80 m.

Leningrad, Hermitage Museum.

About 1570.

There can be no doubt that this late picture came in part

at least from Titian's own hand. The quality is innately splendid in pictorial beauty and majesty of interpretation.

Condition: Somewhat restored, especially in the highlights and in the halo.

History: Titian's house at his death; Barbarigo Collection, 1581–1850 (Bevilacqua, 1845, no. 79; Levi, 1900, p. 288, no. 79).

Bibliography: C. and C., 1877, II, p. 422 (as authentic but much repainted); L. Venturi, 1912, p. 146 (copy); Suida, 1935, pp. 131, 180, pl. 265 (Titian); not listed by Tietze or Berenson; Leningrad, 1958, no. 114 (Titian); Valcanover, 1960, II, p. 72, pl. 178 (as workshop); Fomiciova, 1960, pl. 52 (Titian); *idem,* 1967, pp. 66–67 (Titian, after 1566).

RELATED WORKS:

1. Cobham Hall, Earl of Darnley, *Christ Blessing* (Plate 216), panel, 0·737×0·75 m., Venetian, *c.* 1520–1530. A minor follower of Giovanni Bellini or Titian must be credited with this unimportant work, which had, nevertheless, been accepted by several critics. *History:* Domenico Ruzzini Collection, Venice; an inscription on the back confirms its provenance from the Ruzzini Collection (Ridolfi (1648)–Hadeln, I, p. 200, as Titian); Vitturi Collection, Venice (?); T. M. Slade, London, 1777; Lord Darnley, acquired 1777 (Darnley sale, London, Christie's, 1 May 1927, no. 80, bought in). *Bibliography:* Buchanan, 1824, I, p. 328; Waagen, 1854, III, p. 19 (Titian); C. and C., 1877, II, p. 429 (authentic but damaged); Suida, 1935 (omitted); Tietze, 1936 (omitted); Berenson, 1957 (omitted); Waterhouse, 1960, no. 87 (Titian).

2. Greenville (South Carolina), Bob Jones University, since 1954, panel, 0·203 ×0·140 m. (8×5½ inches), *Bust of Christ with a Book,* follower of Titian; formerly New York, E. D. Levinson (Suida, 1943, pp. 358–359, Titian; Bob Jones University, *Catalogue,* 1962, pp. 88–89, Titian).

3. Venice, Chiesa Evangelista Tedesca, *Christ Blessing,* canvas, 1·23×0·91 m., school of Titian, sixteenth century. Christ blesses with His right hand and holds the globe in the left hand. The mediocrity of the picture eliminates any possibility of the attribution to Titian, which rests upon eighteenth-century writers. *Condition:* Considerable crackle and some repaint. *History:* Fondaco dei Tedeschi (Zanetti, 1733, p. 193, in the Fondaco: 'evvi una mezza figura del Salvatore, opera di Tiziano;' Zanetti, 1771, p. 127, Saviour by Titian); since 1812 in the present location, a German Protestant church formerly the Scuola dell' Angelo Custode. *Bibliography: Venezia,* 1847, I, p. 10 (gives the date 1551 for the picture); C. and C., 1877, I, pp. 87–88 (by a follower of Titian); Richter, 1960, p. 467 (doubts the attribution); *Mostra di Tiziano,* 1935, no. 85 (Titian); Suida, 1935, p. 10, pl. 306 (Titian, *c.* 1508); Berenson, 1957 (omitted); Valcanover, 1960 (omitted).

LOST PICTURES (*Christ Blessing*):

1. Escorial, Atrium of the Chapter House; from Rubens' estate (?) (Rubens' Inventory, p. 270, no. 2); first mention in the Escorial in 1657, 'Otra de mano del Ticiano . . . Salvador con el Mundo en la mano, y echando la bendición . . .' (Padre de los Santos, edition 1933, p. 247); cited by Ceán Bermúdez in 1800 (V, p. 42).

2. Paris, Philippe de Champaigne, Inventory of 1674, no. 75, 'coppie d'un Christ d'après le Titien;' Inventory, 1681, no. 59; probably made by that artist (Philippe de Champaigne, 'Inventaire', p. 199).

3. Parma, Palazzo del Giardino, 1680, 'Salvatore, 1 braccia, on. 5×1 braccia, 1½ on' (Campori, 1870, pp. 283–284). Possibly Cardinal Farnese inherited the picture from Giulio Clovio, part of whose collection passed to him; Giulio Clovio, Inventory 1578 (Bertolotti, 1882, p. 274).

19. **Christ, Bust of** Plate 92

Panel. 0·77×0·57 m.

Florence, Pitti Gallery.

About 1532–1534.

The strong outlines and firm modelling, along with the hard blue sky and the vivid reds of both tunic and mantle, do not seem particularly characteristic of the artist. Yet, if restoration is taken into consideration, the *Bust of Christ* is consistent with the contemporary *Presentation of the Virgin* (Plate 36).

Condition: Paint surfaces somewhat blistered; old varnish; numerous repairs in the sky, drapery, and the right eye.

History: Undoubtedly the work recorded in the Urbino documents in 1532–1534 (Gronau, 1904, pp. 9, 14–17); 1631 to Florence on the marriage of Vittoria della Rovere to Ferdinand II dei Medici; taken to Paris 1799–1815.

Bibliography: C. and C., 1877, II, pp. 417–418 (Titian); Gronau, *Titian,* 1904, pp. 92–93 (badly restored); Wilczek, 1928, p. 162 (workshop); Francini Ciaranfi, 1956, p. 105, no. 228 (Titian); Berenson, 1957, p. 185 (Titian); Valcanover, 1960, I, pl. 135 (Titian).

COPY:

Oxford, Christ Church Gallery, canvas, 0·76×0·57 m.; Guise Bequest in 1765. (C. and C., 1877, II, p. 417, copy; Borenius, 1916, no. 189; Byam Shaw, 1967, p. 69, no. 81, bad copy in poor condition.)

20. Christ, Bust of

Canvas. 0·825×0·605 m.

Vienna, Kunsthistorisches Museum (in storage).

Titian's workshop.

About 1520–1530.

The picture, somewhat superior in quality to Lord Darnley's, has been accepted as Titian's by some modern critics. However, it is no longer exhibited at Vienna, nor included in the recent catalogue. The medium rose tunic and blue drapery and the dark chestnut hair are placed against a deep green background.

Condition: The general condition of the picture, having unusually little crackle, is excellent, but it needs restoration to fill in a few minor spots where the paint has flaked off.

History: Bartolomeo della Nave, Venice; sold to Lord Feilding for the Marquess of Hamilton 1638–1639 (Waterhouse, 1952, pp. 6, 15); Archduke Leopold Wilhelm, Vienna, Inventory 1659 (probably p. CIV, no. 301).

Bibliography: See also History; Mechel, 1784, p. 17, no. 3; C. and C., 1877, II, p. 456 (near Padovanino); Engerth, 1884, I, pp. 344–345, no. 493 (Titian); Glück and Schaeffer, 1907, p. 40, no. 164 (school of Titian); Wilczek, 1928, p. 162 (workshop); Suida, 1935, pp. 61, 185, pl. 307 (Titian, *c.* 1532); Berenson, 1957, p. 191 (Titian).

21. Christ before Pilate Plates 90, 91

Canvas. 2·42×3·61 m.

Vienna, Kunsthistorisches Museum.

Signed and dated on a scroll upon the steps: TITIANVS EQVES CES. F 1543

The Biblical sources of this subject are Luke 23:13–22 and John 19:13–15. Ridolfi (1648–Hadeln, I, p. 172) correctly called the figure of Pilate a portrait of Partenio, using that as a nickname for Pietro Aretino. Contrary to Ridolfi the man in armour on horseback resembles Alfonso d'Avalos rather than Charles V. D'Avalos, forty-one years of age in 1543, had led the victorious expedition against the Turks at Tunis in 1535. As the emperor's governor of Milan, a post he held from 1538 to his death in 1546, he attended the coronation of Doge Pietro Lando at Venice in 1539 (Braunfels, 1960, pp. 109, 111; Aretino, *Lettere*, edition 1957, I, p. 143). The portly elderly nobleman in a red robe wearing the wide ceremonial ermine collar of a Venetian doge can only be the octogenarian Pietro Lando, Doge of Venice from January 1539 to November 1545, who in 1540 concluded a peace treaty between Venice and Soliman the Great. Thus Ridolfi's identification of the turbaned horseman is sustained, and the recent proposal that the other cavalier is d'Avalos is strengthened.

Lando's close connection with the d'Anna family is demonstrated by the fact that during his term of office Martino d'Anna, father of Giovanni who commissioned the picture, was made a citizen of Venice in June 1545 (for a biography of Lando: Cicogna, II, 1824, pp. 167–169; for the doge's ceremonial costume of the mid-sixteenth century: Molmenti, II, 1911, pl. IV). The prominent Hapsburg shield clearly alludes to another important political connection of the d'Anna family, for in 1529 Ferdinand of Austria, brother of Emperor Charles V, had ennobled this same Martino d'Anna by conferring on him the privilege of bearing a coat-of-arms (Cicogna, IV, 1834, p. 198). In romantic vein the girl in white in the centre has been associated with Lavinia, Titian's daughter, who was thirteen or fourteen in 1543. To her right, the full-bearded man deep in conversation with the doge, sometimes doubtfully called Titian himself, is in all likelihood Giovanni d'Anna, who commissioned the picture, at that time thirty-four years of age.

The new complexity of design, with the flight of grey steps obliquely placed and creating an angle with the rusticated stone wall (reminiscent of Serlio), was misunderstood as chaotic by Crowe and Cavalcaselle. On the contrary, Titian's dramatic imagination is demonstrated here in a major work, which contains ideas that were developed later in the Baroque style in the hands of Rubens as well as of Italian masters. Particularly effective are the gestures of arms both in their dramatic expressiveness and their compositional purpose in interrelating and co-ordinating the design, in which the girl in white serves as an anchor from which two opposed diagonals rise. The picture has stir and excitement that go beyond Renaissance balance and repose, and it builds up to a climax at the pathetic figure of Christ.

Condition: Slightly blistered, but in generally satisfactory condition.

History: Painted in 1543 for the Flemish merchant, resident in Venice, Giovanni d'Anna, i.e. van Haanen or van der Hanna (Cicogna, IV, 1834, pp. 198–199); surely the picture seen in 1575 in Venice in the house of Giovanni's son, Paolo d'Anna, for which Henry III of France is said to have offered 800 ducats (Michiel, English edition, 1903, p. 133); undoubtedly still in the d'Anna family in 1621, when Balthazar Gerbier purchased it at Venice for the Duke of Buckingham (Betcherman, 1961, p. 331; Buckingham Inventory, 1635, p. 376; Fairfax, 1758, p. 2, no. 10); in 1648, at the Buckingham auction, bought by Canon Hillewerve of Antwerp; shortly thereafter Archduke Leopold Wilhelm of Austria acquired it for his brother Emperor Ferdinand III at Prague; Prague Inventory, 1718, no. 425; taken to Stallburg Castle, 1723, no. 425; in Belvedere Palace, Vienna, 1783, cat. no. 17.

Bibliography: See also above; Vasari (1568)–Milanesi, VII, p. 457; Ridolfi (1648)–Hadeln, I, p. 172 (portraits of Partenio, Charles V, Soliman); Waagen, 1854, I, p. 14; C. and C., 1877, II, pp. 92–95; Engerth, 1884, I, pp. 345–347; Suida, 1935, pp. 63, 164; Tietze, 1936, I, pp. 194–196, II, p. 315; Klauner and Oberhammer, 1960, p. 140, no. 717; Valcanover, 1960, I, pls. 174–175.

COPIES:
1. Padua, San Gaetano, sacristy, copy, full size, with the same inscription as the Vienna picture but dated 1574; in bad condition in 1968 (cited by C. and C., 1877, II, p. 96, and by Engerth, 1884, I, p. 347).
2. Turnhout, Palais de Justice, on loan from the Musée des Beaux-Arts, Antwerp, canvas, 2·44×3·70 m. (Antwerp: *Catalogue*, 1958, p. 218, no. 623).

SAME SUBJECT, type of composition unknown:
Venice, Palazzo Correr, near Santa Fosca (Boschini, 1674, preface, folio 7; C. and C., 1877, II, p. 96).

22. Christ Carrying the Cross Plate 64

Canvas. 0·70×1·00 m.

Venice, Scuola di San Rocco.

About 1510.

Vasari in the first edition of his *Vite* (1550) assigns the picture to Giorgione, whereas in the second edition of 1568 he corrects the attribution and names Titian as the painter. Vasari wrote: 'Per la chiesa di Santo Rocco fece, dopo le dette opere, in un quadro Cristo con la croce in

spalla e con una corda al collo tirata da un Ebreo: la qual figura che hanno molti creduto sia di mano di Giorgione.' Sansovino in 1581, Tizianello in 1622, Ridolfi in 1648, and Boschini in 1674 all confirm Titian's authorship. In spite of this evidence the opinions of critics today are widely divided between Titian and Giorgione.

Van Dyck's 'Italian Sketchbook' (fol. 20ᵛ) includes the composition in reverse, suggesting that he followed a print, although he must have seen the picture when in Venice. He labels it Giorgione, thus reflecting the continued confusion in people's minds. The book *Modus celebrandi officium*, published in Vicenza in 1539, which has a woodcut of the picture but unreversed on the cover, contains no indication of the author of the composition or of the engraver or of the location of the original. Richter (p. 247) reproduces a similar woodcut which is dated 1520.

Condition: The wretched state of the canvas provides very little ground for judgment of the work itself or for attribution which must rest on historical evidence. Christ's right eye is redrawn and the grey-bearded man at the left is much repainted. The only remaining colours consist of the pale blue of Christ's robe and the partially white garment at the left. The lunette formerly above the picture was attributed to Francesco Vecellio, Titian's brother, a small bit of evidence in favour of the Vecellio.

History: Until recently in the church of San Rocco.

Bibliography: Vasari (1568)–Milanesi, IV, p. 96, VII, p. 437; Sansovino, 1581, p. 102, also edition of 1663, p. 195; Borghini, 1584, p. 525 (Titian); Ridolfi (1648)–Hadeln, I, p. 158 (Titian); Boschini, 1664, p. 308 (opera famosissima di Tiziano); Boschini, 1674, p. 49 (Titian); C. and C. 1877, I, pp. 61–62 (Titian); Lorenzetti, 1928, pp. 181–205 (exhaustive historical account); Tietze, 1936, I, pp. 60–61 (undecided); G. M. Richter, 1937, pp. 246–249 (Giorgione); Suida, 1935, pp. 35, 159, pl. 42 (Titian); Zampetti, 1955, no. 48 (Giorgione); Berenson, 1957, p. 84 (Giorgione); Valcanover, 1960, I, pl. 44 (Titian); L. Venturi, 1961, p. 331 (Giorgione).

COPIES:
Mediocre painted copies in the Parma Gallery, the villa of Poggio Imperiale near Florence, marble reliefs in San Rocco and the Museo Correr at Venice, and several prints (listed by Lorenzetti, 1928, pp. 190–196).

23. Christ Carrying the Cross (full length) Plate 129

Canvas. 0·98×1·16 m.

Madrid, Prado Museum.

Signed in capitals on the rock at the lower left: TITIANVS with the initials added above it: I B

About 1560.

The I. B. was formerly thought to refer to Giovanni Bellini on the ground that the two artists collaborated here, a theory which is stylistically impossible. Could it mean Julio Bonasone with reference to the engraver? This great work has been doubted by various critics because of the peculiar inscription. The emotional power of the figures, the Mannerist concentration, and the technical mastery of every detail combine to produce a masterpiece. Christ in a beautiful dark-red robe falls to the ground while St. Simon in mauve assists Him.

Condition: Some coarse retouching of the folds of Christ's dark-red robe and repaired slits in the canvas in the area of Simon's sleeve are the chief flaws of condition.

History: Sent to the Escorial as by Titian in 1574 (Zarco Cuevas, 'Inventario', 1930, p. 45, no. 1008); Padre Sigüenza locates it in the Oratory of Philip II in 1599 (edition 1923, p. 418), where it still remained in 1657 (Padre de los Santos, edition 1933, p. 265); likewise in Palomino's day, 1724 (edition 1947, p. 797); taken to the Prado in 1845.

Bibliography: See also History; Madrazo, 1854, no. 1998 (first listing in catalogue, no provenance given); C. and C., 1877, omitted; Beroqui, 1946, pp. 166–168 (as *c.* 1530); Suida, 1935, pp. 144, 181 (Titian, *c.* 1560); Tietze, 1936, I, pp. 232–233, II, p. 296 (as a Spanish copy!); Berenson, 1957, p. 188 (studio); Valcanover, 1960, II, p. 69, pl. 168 (workshop); Prado catalogue, 1963, no. 439 (old nos. 488 and 1998).

COPIES:
1. Burgo de Osma, Museo de la Catedral, Spanish copy of Prado no. 439; canvas, 0·98 × 1·16 m.
2. Escorial, Oratorio de Felipe II, no. 361, canvas, 0·98 × 1·22 m., Spanish copy of *c.* 1845, of Prado no. 439.
3. Salamanca Cathedral, Sala Capitular, competent Spanish copy of Prado no. 439; canvas, 0·98 × 1·16 m.

24. **Christ Carrying the Cross** (half length) Plate 127
Canvas. 0·67 × 0·77 m.

Madrid, Prado Museum.

Signed in red capitals on the Cross at the left: TITIANVS AEQ. CAES. F

About 1565.

Christ's pale-blue tunic has many white highlights and the eyes are very red. In a version in the Hermitage (Cat. no. 25), almost equally good though unsigned, Simon of Cyrene is identified as Francesco Zuccato (dal Mosaico). In both pictures he wears a garnet ring on his right thumb.

Condition: Even though somewhat darkened in colour, the canvas is among the better preserved of Titian's masterpieces in Madrid.

History: First mentioned in the Alcázar Inventory 1666, Alcoba de la galería de mediodía, no. 614; Inventory 1700, no. 101 (Bottineau, 1958, p. 160); Buen Retiro Palace, Madrid, Inventory 1746, no. 367, ¾×1 *vara* (0·63 × 0·84 m., approximate dimensions).

Bibliography: See also History; Madrazo, 1843, p. 155, no. 725; 'Inventario general', 1857, p. 146, no. 725 (no provenance given); C. and C., 1877, II, pp. 405–406 (fine work, Titian); Suida, 1935, pp. 144, 180 (Titian, *c.* 1570); Tietze, 1936, II, p. 296 (no opinion); Beroqui, 1946, pp. 167–168 (Titian); Berenson, 1957, p. 188 (studio); Valcanover, 1960, II, pl. 127 (authentic Titian); Prado catalogue, 1963, no. 438.

COPY:
New York, Dr. A. F. Mondschein, canvas, 0·61 × 0·483 m. (24 × 19 inches), coarse copy of the figure of Christ alone (Baltimore Exhibition, 1942, no. 40).

25. **Christ Carrying the Cross** (half length) Plate 128
Canvas. 0·895 × 0·77 m.

Leningrad, Hermitage Museum.

About 1565.

This picture seems to be of very high quality, equal to the signed version in the Prado. The slight variations in the positions of the head and hand of Simon in the Leningrad canvas are scarcely worth the mention. Ridolfi (1648) records the tradition that Simon of Cyrene is a portrait of Francesco dal Mosaico, an early instance of unlikely romantic identification.

Condition: X-rays reveal a picture of Christ Blessing on this re-used canvas. Pieces were added to enlarge the canvas on all four sides, including the parapet at the bottom and the back of the head of Joseph of Arimathea at the left. It has been proposed that the additions were made in the seventeenth century, but this theory is not entirely convincing (Fomiciova, 1967, pp. 67–68).

History: In Titian's house at his death; Barbarigo Collection, 1581–1850; sale 1850, no. 79 (Bevilacqua, 1845, p. 15, no. 15; Levi, 1900, p. 283; Savini-Branca, 1964, p. 186).

Bibliography: See also History and Condition; Ridolfi (1648)–Hadeln, I, p. 200 (Titian); C. and C., 1877, I, p. 144, II, pp. 405–406 (Titian but much repainted); Berenson, 1957 (not listed); Leningrad, 1958, no. 115 (Titian); Fomiciova, 1960, no. 56, colour reproduction (Titian); Valcanover, 1960, II, p. 73, pl. 181 (attributed to Titian); Pallucchini, 1961, pp. 288–289 (Titian); Levinson-Lessing, 1967, pl. 37.

LOST PICTURES

1. Venice, Sant' Andrea alla Certosa, Chapel of Federigo Vallaresso (died 1485), 'un Christo che porta la croce' (Sansovino, 1581, p. 79; edition 1663, p. 215; Boschini, Venice, 1664, p. 557, no mention of the picture in the church; Cicogna, 1827, II, fasciculo 5, p. 70, no mention; C. and C., 1877, II, p. 470, as missing in 1664). The mediocre Venetian picture in possession of a New York dealer cannot possibly be the lost work by Titian, notwithstanding numerous certificates by now deceased but well-known distributors of expertises.

2. Genoa, Palazzo Marcello Balbi (now Royal Palace) (Ratti, 1780, I, p. 213).

3. A picture related to Cat. no. 25 is recorded in Van Dyck's 'Italian Sketchbook', folio 22.

26. Christ Crowned with Thorns Plates 132, 134

Panel. 3·03 × 1·80 m.

Paris, Louvre.

Signed in the centre on the third step: TITIANVS F

About 1546–1550.

The violently dramatic nature of this picture has impressed all writers. Crowe and Cavalcaselle saw a reflection of the Laocoön, and Fogolari believed that Titian's contact with Giulio Romano and this artist's works in Mantua had profoundly affected the master. The bust of Tiberius (A.D. 14–37), emperor in Christ's time, displays an obvious knowledge of the antique, even though the head is mistakenly based on a classical portrait of Nero (Kennedy, 1956, p. 239). The same features were used in Titian's earlier lost portrait of Nero, preserved in Sadeler's engraving (illustration, Suida, 1935, pl. 124). The Venetian master had seen the antiquities in the collections at Mantua, and in the extensive Grimani Collection at Venice, long before his visit to Rome in 1545–1546, as demonstrated by the lost series of paintings representing twelve Roman Emperors, which Titian delivered to Mantua in 1537–1538. The architecture, which purports to be ancient Roman, is clearly inspired by Serlio's publication of 1537, the contemporary architecture of Sanmicheli, and the ideas of Titian's friend Jacopo Sansovino (Forssman, 1967, pp. 108–111). Nevertheless, I am inclined to agree with historians who place the Louvre composition after Titian's Roman sojourn. The earlier date *c.* 1543 is based upon a statement by Vasari that Titian painted the *Christ Crowned with Thorns* in competition with Gaudenzio Ferrari. His mediocre *St. Jerome*, originally in the same Milanese church, but now in the Lyons Museum on permanent loan from the Louvre, has a signature and the date 1543. It is such a poor thing that the artist could never have been considered Titian's competitor.

Against the roughly rusticated building of dark-brown stone the powerful figure of Christ in rose drapery and a dark beard is relieved, an extraordinarily athletic conception of the Saviour. The tormentor at the left in white trousers and bright-yellow drapery with rose-coloured shadows is balanced against the darker and more neutral costumes of the men at the right. The soldier in dark-grey chain-mail and a figure above him in neutral brown-and-grey rise up compositionally to the bald-headed person in dark red and the uppermost figure in a light-blue shirt.

The Biblical sources for the Crowning with Thorns are Matthew 27:29 and Mark 15:17–19.

Condition: Darkened and crackled; transferred from panel to canvas in 1967–1968.

Other dating: Tietze and Pallucchini, *c.* 1542; Crowe and Cavalcaselle, 1559 (on the basis that Orazio Vecellio made a trip to Milan in that year; however, Titian himself visited Milan briefly in December 1548); Berenson, late.

History: Cappella Corona, Santa Maria delle Grazie, Milan; 1797 taken to Paris; Musée Napoléon, Paris (no. 464).

Bibliography: See also above; Louvre catalogue, no. 1583, inv. no. 748; Vasari (1568)–Milanesi, VI, p. 519, VII, p. 543; Ridolfi (1648)–Hadeln, I, p. 177; Villot, 1874, p. 284, no. 464; C. and C., 1877, II, pp. 264–266; *Mostra di Tiziano*, 1935, no. 45; Tietze, 1936, I, pp. 197–198, 237, II, p. 305; Pallucchini, I, 1953, p. 194; Valcanover, 1960, II, pls. 170–171.

COPIES:

1. Basle, private collection, nineteenth-century copy by Théodore Géricault (Busch, 1967, p. 178, illustration).
2. Hartford, Wadsworth Atheneum, canvas, 45¾×28½ inches (1·166×0·724 m.); formerly attributed to John Trumbull.
3. Milan, Ospedale Maggiore (Bascape and Spinelli, 1956, pp. 43–44).
4. Unknown location, copy by Giovanni Bonati for Cardinal Carlo Pio, bishop of Ferrara, c. 1655 (Baruffaldi, 1733, edition 1846, II, p. 241).

27. Christ Crowned with Thorns Plates 133, 135

Canvas. 2·80×1·81 m.

Munich, Alte Pinakothek.

About 1570–1576.

This late work is so large that it could not possibly be a preparatory sketch, as some writers (Ridolfi, Boschini) have suggested, nor is it essentially unfinished, but instead representative of Titian's latest style. Although the composition follows the same general scheme as the earlier picture in the Louvre, the broken colour and highly illusionistic technique here show Titian in his maturest vein. Despite the generally dark tonality, there is considerable colour; for instance, the youth in the foreground wears a deep-blue jacket, yellow sleeves, and rose velvet breeches. The tormentor at the left wears rose drapery over white, while Christ Himself appears in neutral white. Other figures to the right are in rose, greenish-black, and white, and all of them are contrasted to the greenish-black architecture. The great chandelier above, lighted by pink-white flares, suggests an eerie and unnatural illumination. Emotionally this composition is one of the most stirring episodes in the Passion of Christ that Titian ever painted.

Matthew 27: 29 and Mark 15: 17–19 are the Biblical sources of the theme.

Condition: Darkened and somewhat retouched but generally satisfactory.

History: Sold to Tintoretto after Titian's death (Ridolfi (1648)–Hadeln, I, p. 207); sold by Domenico Tintoretto to a northerner, i.e. the Prince Elector of Bavaria (Boschini, 1674, preface, edition 1966, p. 712).

Bibliography: See also History; C. and C., 1877, II, pp. 399–401 (unfinished); Reber, 1895, p. 221, no. 1114; Tschudi, 1911, p. 166, no. 1114; Suida, 1935, pp. 147–148; Tietze, 1936, I, pp. 237–238, II, pp. 300–301; Tietze-Conrat, 1946, pp. 84–85; Berenson, 1957, p. 188; Valcanover, 1960, II, pl. 134.

28. Christ Mocked (Ecce Homo) (three figures)
Plate 102

Canvas. 1·10×0·93 m.

St. Louis, City Art Museum.

Titian and assistants.

About 1575.

This unfinished picture has been classified by Tietze-Conrat as a sketch (*modello*) which was kept in Titian's shop to serve for the production of replicas. Indeed, the number of variants based upon this composition lends support to the theory, yet the picture is largely unfinished. At the origin or perhaps at a later time another hand intervened in the painting of the hard surfaces of the boy's head at the left and in details of Pilate's costume. The obviously unfinished section at the upper left which is difficult to decipher suggests a large candle with flame enclosed by arch and sky.

That the high quality of the conception in composition and in the two principal figures is worthy of Titian himself has been agreed by most critics. The existence of numerous replicas and variants adds lustre to the prototype.

History: Bishop Coccapani at Reggio in 1640 (suggestion of Tietze-Conrat, 1946, p. 86, no. 83; Campori, 1870, p. 174); Heinemann and Levy, Venice and London (1935); Robert Frank, London (1935).

Bibliography: Mayer, 1935, pp. 52–53; *Mostra di Tiziano*, 1935, no. 96; Serra, 1934–35, p. 561 (doubtful); Tietze, 1936, II, p. 292 (Titian); Tietze-Conrat, 1946, p. 86 (Titian); Dussler, 1935, p. 238 (not Titian); Berenson, 1957, p. 190 (partly Titian); Valcanover, 1960, II, pl. 135 Titian).

COPIES:

1. Aschaffenburg, Gemäldegalerie, canvas, 1·18×1·10 m., weak replica of the St. Louis type; from the Mannheim Gallery; lent by the Alte Pinakothek, Munich (Aschaffenburg, 1964, pp. 156–157, follower of Titian; in 1933 catalogue attributed to Bartolomeo Schedoni).
2. Burgos Cathedral, copy (Beroqui, 1946, p. 166).
3. Dresden, Gemäldegalerie, canvas, 0·84×0·765 m. The disposition of the hard, coarsely painted figures is based upon the St. Louis model with the addition of arch and

pier in the background. In the Guarienti Inventory, 1753, it was given to Francesco Vecellio, Titian's brother (Hans Posse, 1929, pp. 91–92, no. 184, illustration).
4. Hampton Court Palace (in storage), no. 802, canvas, 39¾×37 inches, very hard and poor copy (Law, 1881, no. 437).
5. Madrid, Urzáiz Collection, stolen in 1926 (Beroqui, 1946, p. 166).
6. New York, New York Historical Society, canvas, 1·44 ×1·015 m. (45×40 inches), mechanical copy with added architectural background; gift of Thomas J. Bryan in 1867; bought in Rome (Tietze-Conrat, 1946, p. 86, fig. 7).
7. New York, Wildenstein Gallery, variant attributed to Pietro della Vecchia by Valcanover (1960, II, p. 51).

RELATED WORKS:
1. Leningrad, Hermitage, *Christ Mocked* (Ecce Homo) (three figures in three-quarter length), canvas, 0.95 × 0·79 m., workshop of Titian, *c.* 1565. Although limited to three figures the symmetrical composition differs completely from the one in St. Louis, but it is clearly a study (*bozzetto*). Just how much Titian himself was involved, if at all, in this picture is problematical. Unlike the St. Louis painting this version had very few imitators. *History:* Barbarigo Collection, Venice, 1581–1850 (Levi, 1900, p. 288, no. 77). *Bibliography:* Fischel, 1907, p. 172; 1924, pl. 179; C. and C., 1877, II, p. 423 (late work, poor condition); Somoff, 1899, no. 94; Tietze-Conrat, 1946, p. 86 (Titian *modello*); Valcanover, 1960, II, p. 73 (doubtful attribution). *Variant* of Leningrad picture: Munich, Bayerische Staatsgemäldesammlungen (in storage, no. 5189), canvas, 1·00×0·98 m.; by a follower of Titian, late sixteenth century; exhibited in the Augsburg Museum 1946–1962; original lender the Düsseldorf Gallery. Numerous variations from the Leningrad prototype are evident in the more erect body of Christ and in the different poses of the heads at the sides. *Bibliography:* Pigage, 1778, no. 32, pl. IV, as Palma Vecchio; Augsburg, 1912, p. 77, no. 2305.
2. Madrid, Prado, *Christ Mocked* (Ecce Homo) (four figures) (Plate 223), canvas, 0·99×0·98 m., workshop of Titian, *c.* 1560. Christ stands in a cell with a barred window at the left, while three men taunt Him, the one at the right in a red cap. The tonality is dark, but the extremely dirty condition makes a judgment difficult although the quality seems fairly good. The composition is closely related to the much later sketch in St. Louis, where only three figures appear instead of four as here. *History:* Sent to the Escorial in 1574 as an original (Zarco Cuevas, 'Inventario', 1930, p. 45, no. 1005); 1599 in the chapel of

the Infirmary, as Titian (Padre Sigüenza, edition 1923, p. 418); 1657 in the Sacristy over a doorway, as Titian (Padre de los Santos, edition 1933, p. 239); 1773 over the lavabo in the Sacristy (Ponz, tomo II, carta III, 47); 1800 in the Sacristy (Ceán Bermúdez, V, p. 42); 1847 brought to the Prado Museum. *Bibliography:* See also History; Madrazo, 1843, p. 91, no. 435 (from Escorial); 'Inventario general', 1857, p. 86, no. 435; C. and C., 1877, II, pp. 420–421 (damaged original); Madrazo, 1910, no. 42 (Leandro Bassano); Suida, 1927, pp. 206–207 (Titian); Suida, 1935, p. 131, pl. 271b (Titian); Beroqui, 1946, pp. 165–166 (Titian); Berenson, 1957, p. 187 (partly Titian); Valcanover, 1960, II, pp. 73–74, pl. 183 (workshop); Prado catalogue, 1963, no. 42 (questionable attribution).
3. Paris, Louvre (in storage), *Christ Mocked* (Ecce Homo) (three figures, half length) (Plate 222), panel, 1·14 m. diameter (round); by a follower of Titian, late sixteenth century. The wretched quality, even discounting the poor state of preservation, justifies the classification as a copy in which the single figure of the *Ecce Homo* in the Prado served as model. *Condition:* Scratched; dry pigment; in a darkened and dirty state. *History:* Fontainebleau, undoubtedly the picture mentioned by Cassiano del Pozzo in 1625 and said to be by Pordenone (Pozzo, 1625, folio 195); again cited in 1642 and attributed to Paris Bordone, 'un Christ avec Pilate et un juif' (Dan, 1642, p. 137); Versailles, Louis XIV, Le Brun Inventory, 1683, no. 255 ('un tableau rond'; no attribution); Louvre, Paris, in 1690; Inventories of 1709, 1722, 1752 (Lépicié, II, pp. 23–24, manner of Titian); Hotel de la Surintendence, Paris, in 1784 and 1788 (Bailly-Engerand, 1899, p. 81, fullest history). *Bibliography:* See also History; Villot, 1874, p. 284, no. 463; C. and C., 1877, II, pp. 458–459 (Schiavone); Ricci, 1913, p. 159; Gronau, 1937, pp. 289–290 (Titian); Suida, 1935, pp. 131, 180 (Titian); Tietze, 1936 (omitted); Berenson, 1957, p. 189 (studio); Valcanover, 1960, II, p. 67, pl. 158 (copy).

COPIES OF LOUVRE VERSION:
a. Como, private collection, canvas, 1·00×1·20 m., copied from the Louvre picture but not a tondo (photo, Florence, Kunsthistorisches Institut; Suida, 1935, p. 180).
b. St. Denis, Maison de la Légion d'Honneur, canvas, 2·70×1·57 m., copy by Ghiraldi in 1830; from the collection of Charles X (data in Louvre archives).

LOST VERSIONS:
1. Venice, Gabriel Vendramin, Inventory 1568, 'un Christo con due figure una per banda . . . de man de

missier Titian con fornimento in tondo' (Ravà, 1920, p. 178); wrongly identified as the Louvre picture by Gronau (1937, pp. 289–290).

2. Venice, Michele Pietra (or Spietra), 26 April 1656, another circular composition (Levi, 1900, p. 21; Savini-Branca, 1964, p. 136).

29. Christ on the Cross
Plate 113

Canvas. 2·14 × 1·09 m.

Escorial, Sacristy.

About 1555.

The Escorial Crucifix is one of Titian's masterpieces both in the stirring emotional quality of the handsome Christ's resignation and in the splendour of the landscape with its very rich blue mountains and grey clouds. To the right of the Cross lightning flashes, and at the left the crescent moon rises, while rose-and-yellow lights break across the horizon. The horsemen in the landscape at the left side show El Greco's source for the same details.

Condition: Excellent, although the surfaces are dry.

History: Sent to the Escorial in 1574 (Zarco Cuevas, 'Inventario', 1930, p. 44, no. 998, Titian); Padre Sigüenza in 1599 locates it in the passageway between the Sacristy and the high altar (edition 1923, p. 418); in the Sacristy in 1657 (Padre de los Santos, edition 1933, p. 240); still there.

Bibliography: Poleró, 1857, no. 88 (Titian); C. and C., 1877, II, p. 445 (too high to see and a feeble work!); Tietze, 1936, I, pp. 234, 241, II, p. 288 (Titian); Valcanover, 1960, II, pls. 110–111 (Titian); Berenson, 1957, p. 185 (late Titian).

VARIANT:

Toledo, Cathedral, Vestry, canvas, *c.* 0·76 × 0·56 m., poor, very black copy after Titian, based on the large Escorial Crucifix (photo, Mas Se C 77489).

30. Christ on the Cross and the Good Thief
Plate 112

Canvas. 1·37 × 1·49 m.

Bologna, Pinacoteca Nazionale.

About 1566.

No agreement is forthcoming on the authorship of this work, which has been considered the fragment of a picture that Vasari saw in Titian's shop in preparation for Giovanni d'Anna. Mayer and Tietze ascribe it to Tintoretto. The canvas is very coarse, painted *alla prima* and apparently unfinished.

Condition: Rubbed, badly preserved; probably unfinished.

History: Zambeccari Collection, Bologna, eighteenth century; donated to the museum in 1882 (Guadagnini, 1899, no. 584).

Bibliography: Vasari (1568)–Milanesi, VII, p. 457; Mayer-van Bercken, 1923, p. 216 (Tintoretto); Suida, 1931, p. 899 (Titian); Mauceri, 1931–1932, pp. 894–895; *idem*, 1935, p. 57 (Titian); Suida, 1935, p. 146; *Mostra di Tiziano*, 1935, no. 89; Tietze and Tietze-Conrat, 1936, pp. 145–146 (Tintoretto); Paris, 1954, no. 54 (Titian); Berenson, 1957, p. 184 (late Titian); Valcanover, 1960, II, p. 73, pl. 182 (near Palma Giovane); Emiliani, 1967, p. 166 (Titian attributed).

31. Crucifixion
Plates 114, 115

Canvas. 3·713 × 1·972 m.

Ancona, San Domenico.

Signed on the foot of the Cross: TITIANVS F. (Plate 202).

Datable 1558.

This late masterpiece, admired by Vasari in 1566, is slightly earlier in date than had been believed before the discovery of the document of 1558. Against the very dark sky with traces of blue the figures emerge, in great part because of the strong white highlights, but also because the sky glows a bit around the figure of the Madonna, who wears a nun's black robe and a dark-blue mantle relieved by the white veil and neckerchief. St. John's rose-brown tunic and rose mantle are subtly played against the bluish background. His right hand is brought forward by the outlines of white light, which also give three-dimensional existence to his body. The figure of St. Dominic, illusionistically rendered in his black-and-white habit, is the most moving of all, as he embraces the Cross in anguish and prayer.

In spite of the darkened condition of the pigment and past restorations, the profundity of Titian's interpretation and his technical maturity have survived. The figure of Christ bears a stylistical relationship to the better-preserved *Christ on the Cross* (Plate 113) in the Escorial. The lunette-shaped section above the Cross is modern.

Condition: Somewhat darkened; restored and cleaned in 1925 and 1940.

History: On 22 July 1558 the picture was placed in the high altar of the sanctuary, which was then under the patronage of the Venetian family, Cornovi della Vecchia, who were living in Ancona (documents first published in 1936 by Elia, see below); placed in the choir in 1715; 1884–1925 in the museum; rehung in the sanctuary of San Domenico in 1925.

Bibliography: Vasari (1568)–Milanesi, VII, p. 453; Scanelli, 1657, p. 218; Scaramuccia, 1675, p. 87; Sartori, 1821, p. 12; C. and C., 1877, II, p. 328; Serra, 1925, p. 77; Elia, 1936, pp. 85, 87 (document of 1558); *Mostra . . . Marche,* 1950, p. 34, no. 52; Elia, 1955, pp. 62–67; Tietze, I, pp. 240–241, II, p. 283; Paris, 1954, no. 53; dell'Acqua, 1955, pl. 160; Valcanover, 1960, II, pl. 74.

David Slaying Goliath, see: Old Testament Subjects, Cat. no. 84.

Death of Abel, see: Old Testament Subjects, Cat. no. 82.

Ecce Homo, see also: Christ Before Pilate, Cat. no. 21; Christ Crowned with Thorns, Cat. nos. 26, 27; Christ Mocked, Cat. no. 28; Dead Christ, Cat. nos. X–9, X–10, X–11; and Man of Sorrows, Cat. no. 75.

32. **Ecce Homo** (single figure) Plate 96
Slate. 0·69 × 0·56 m.
Madrid, Prado Museum.
Signed at the left: TITIANVS
1547.

The burly anatomy of Christ belongs to the post-Roman period of Titian, but stylistically little else remains since the picture has suffered so severely that it retains no more than iconographical value today. The omission of the rod is unusual and in fact unique in Titian's pictures of the subject, while the body turns more than in others excepting the Chantilly repetition. On the other hand, Titian consistently adopted the downward cast of the head, excepting the erect *Ecce Homo* at Sibiu (Cat. no 33). The Prado *Ecce Homo* on slate appears with the *Mater Dolorosa* on marble in several inventories, as both on stone and sometimes cited incorrectly as both on slate.

The Alcázar Inventory of 1636 also adds the identifying statement that the Madonna's hands are open ('abiertas las manos') (Cat. no. 77, Plate 97).

Condition: The picture, in a ruinous state, is hard and dark and the paint badly blistered, undoubtedly the victim of the fire of the Alcázar in 1734. The rose colour of the drapery survives better than the vitreous flesh.

History: Generally conceded to be the picture taken to Charles V at Augsburg in 1548. On 1 September 1548 Titian wrote from Augsburg to Granvelle that the Christ had been delivered and that Charles V had taken it with him (Zarco del Valle, 1888, p. 222).
Charles V took to Yuste on his retirement the *Christ* on stone paired with a *Madonna* on wood (Inventory, 1556: see Gachard, 1855, III, p. 91). The same two items are repeated, Yuste Inventory, 1558, no. 404, after Charles V's death, where it is explained that the *Mater Dolorosa* is by Maestre Miguel [Coxie] (Sánchez Loro, 1958, III, p. 506). The *Ecce Homo* from Yuste and the *Mater Dolorosa,* both on stone, were given to the Escorial in 1574, both cited as by Titian (Zarco Cuevas, 'Inventario', 1930, p. 44, no. 1000). In the same year a *Christ Carrying the Cross* paired with a *Mater Dolorosa,* both by Maestre Miguel, were sent to the Escorial from Yuste (Zarco Cuevas, 'Inventario', 1930, p. 662, no. 881). Therefore Philip II had had Coxie's two pictures joined together while Titian's *Ecce Homo* on slate and his *Mater Dolorosa* on marble (Prado, nos. 437 and 444) were made into a diptych just as Titian had originally intended. (Cat. nos. 32, 77).
The famous pair were shortly transferred to the Alcázar (royal palace) in Madrid where they appear in July 1600, both said to be on slate ('pizarra'), serving as a small altar in the 'Oratorio del quarto bajo' (Inventory, 1600, p. 21); possibly at El Pardo (Inv. 1621, leg. 27, folio 10); 1636 in His Majesty's Library, Alcázar, 'one *vara* high more or less', both on stone, 'nuestra señora con toca y manto azul y la saya morada llorando abiertas las manos' (open hands) (Alcázar Inventory, 1636, folio 23 ff.). 1666, 1686 in the Alcoba de la Galería del Mediodía, *Ecce Homo* on slate and *Dolorosa* $\frac{3}{4} \times \frac{1}{2}$ *vara* (Inventory 1666, nos. 625, 626, Inventory 1686, nos. 302, 303, Bottineau, 1956, pp. 161–162); 1700 (Inventory, nos. 112, 113); 1772 and 1794, Palacio Real, Antecamera de Su Magestad (Beroqui, 1946, p. 122); 1776, Prince's Dressing Room (Ponz, 1776, tomo VI, Del Alcázar, 52); 1821, taken to the Prado Museum.

Bibliography: See also History; Madrazo, 1843, p. 202, no. 914; 'Inventario general', 1857, p. 191, no. 914 (no

provenance); C. and C., 1877, II, pp. 160–161, 270–271 (Titian); Tietze, 1936, I, p. 197, II, p. 292 (Titian); Beroqui, 1946, pp. 121–122 (Titian); Berenson, 1957, p. 188 (studio!); Valcanover, 1960, II, pl. 20 (Titian); Prado catalogue, 1963, no. 437.

COPIES (of Prado *Ecce Homo*):
1. Amsterdam, Dr. H. Wetzlar, free copy of Titian's Prado picture, attributed to Willem Key. Copied from Titian or from Vermeyen (see item no. 2, below; Faggin, 1964, p. 50).
2. Brussels; in 1555 Jan Vermeyen made a copy of Charles V's *Ecce Homo* before it went to Spain in 1556 (Pinchart, 1856, p. 138); no longer traceable.

REPLICA (of Prado picture):
Chantilly, Château, *Ecce Homo* (single figure). Canvas, 0·72 × 0·58 m. (Plate 214), workshop of Titian, 1547. A rather mediocre work, it repeats the Prado composition with the addition of a cane. The dark-brown hair and matted beard are placed against a brown background that allows for little contrast. The red drapery is customary, whereas the bluish flesh and the darkened face are less so. Tietze-Conrat called attention to Aretino's letter of 1548 in which it is said that Domenico Molino painted a copy of his picture. *Condition:* Fairly well preserved; retouchings on nose and elsewhere. *History:* Titian gave Aretino a copy of Charles V's *Ecce Homo*, according to a letter of January 1548 (Aretino, *Lettere*, edition 1957–1960, II, p. 191); it is presumed to be the item once in the Averoldi Collection at Brescia (Brognoli, 1826, p. 201, as done for Altobello, *c.* 1522); later purchased in 1858 by the Duc d'Aumale, who exhibited the picture at Leeds in 1868 and left his collection at Chantilly to the French state (C. and C., 1877, II, pp. 160–161). *Bibliography:* See also History; Gruyer, 1899, p. 51, no. 32; Gronau, *Titian*, 1904, pp. 146–147; Fischel, 1907, pl. 116 (Titian); Suida, 1935, p. 130 (close to Prado version); Tietze, 1936 (omitted); Tietze-Conrat, 1946, p. 86, note 75; Berenson, 1957 (omitted); Valcanover, 1960, II, p. 53 (Aretino's replica is lost). *Copy:* Bath (England), Victoria Art Gallery, panel, 15 × 11 inches (0·38 × 0·28 m.); from the Hall Standish Collection, from Madrid; poor quality; by Domenico Molino (?) (Courtauld Institute, London, photograph).

33. Ecce Homo (single figure) Plate 98
Canvas. 0·665 × 0·53 m.
Sibiu (Roumania), Muzeul Brukenthal
About 1560.

The proud, erect position of Christ's head distinguishes this picture from other examples of the *Ecce Homo* (single figure), in which the head is usually inclined in an attitude of resignation. The purplish-red mantle and late style of painting correspond more closely to the *Ecce Homo* in Dublin than to the earlier example in Madrid. In Teniers' picture at Vienna reproducing the chief works in Archduke Leopold Wilhelm's collection, this *Ecce Homo* is shown paired with a *Mater Dolorosa* who bends her head and wrings her hands, a type for which no original is known today (see Plate 99).

Condition: Apparently satisfactory.

History: Bartolomeo della Nave, Venice; probably seen there by Van Dyck ('Italian Sketchbook', pl. 21ᵛ); Duke of Hamilton, Glasgow, 1639 (Waterhouse, 1952, p. 15); Archduke Leopold Wilhelm, Vienna (Inventory, no. 199, Titian); Teniers, 1660, pl. 78, reversed (Titian); Prodomus, 1735, pl. 24 (Titian).

Bibliography: See also History; Frimmel, 1896, pp. 21–22 (as lost); *Baron Brukenthalisches Museum*, 1909, p. 358, no. 1196 (school of Titian); Ionescu, 1960, pp. 38–45 (Titian); *idem*, 1961, no. 21 (Titian); *idem*, 1961, pp. 275–282.

34. Ecce Homo (single figure) Plate 100
Canvas. 0·72 × 0·55 m.
Dublin, National Gallery of Ireland.
About 1560.

The frontal position of the shoulders, the downward cast of the head to the left, the presence of the cane as well as the arrangement of the drapery are considerable divergencies from the earlier composition (1547) in the Prado Museum (Plate 96).

Richter in 1885 accepted the attribution to Titian; later in 1914 it was assigned by Armstrong to the Spanish artist of the seventeenth century, Mateo Cerezo, but returned to Titian in 1955 by Gore.

The very soft brush is consistent with a late date in Titian's career, yet the colour is unusually rich, in particular the purplish-rose draperies against the background of dark brown to the left turning greyish-tan to the right. The head with chestnut-coloured hair, luxuriant beard, and swarthy complexion is given dramatic impact against the neutral-yellow radiance, in which the brilliance of tone and the points of white light have perhaps been somewhat exaggerated by the hand of a

restorer. Nevertheless, this picture is a highly original and moving work.

Condition: Cleaned in 1955; well preserved.

History: Engraved by Lucas Vorsterman; therefore it might be from Van Dyck's collection (Müller-Rostock, 1922, p.22, no. 17); Sir William Knighton (sale, London, Christie's, 21 May 1885, lot 520); purchased by the Dublin Museum.

Bibliography: Richter, 1885, edition 1960, p. 409; Dublin Catalogue, 1928, no. 75 (Cerezo); Gore, 1955, p. 218; Dublin, 1956, no. 75 (Titian); Berenson, 1957, p. 185 (Titian); Suida, 1959–1960, p. 67 (Titian); Ionescu, 1960, pp. 41–42 (Titian); Valcanover, 1960, II, p. 69, pl. 167 (doubtful attribution).

COPIES:

1. Rome, Lucien Bonaparte (formerly), canvas, no dimensions. The chief variation is the reversal and modification of the drapery in the print. Otherwise the composition is not reversed in this case nor in most of the other prints in the Bonaparte catalogue (Bonaparte, 1812, no. 86; *idem*, 1816, lot 72, as life size).

2. Sarasota, Ringling Museum, canvas, 0·73 × 0·59 m., weak but exact copy, ascribed by Suida to Peterzano (Suida, *Catalogue*, 1949, p. 61; Suida, 1959–1960, p. 67, fig. 82); formerly Prince Lichnowsky.

LOST PICTURES (single figure, exact type unknown):

1. Escorial, Aula de Escritura, an *Ecce Homo*, unidentifiable (Padre de los Santos, 1657, edition 1933, p. 257, 'del Ticiano maravilloso').

2. Escorial, Capilla del Colegio, *Ecce Homo* and *Mater Dolorosa*, copies of Titian (Padre de los Santos, 1698, edition 1933, p. 314); the same in 1764 (?) (Padre Ximénez, edition 1941, p. 82). Mediocre pictures now kept in storage at the Prado or on loan and eliminated from recent catalogues are surely some of the copies whose provenance is given as the Escorial: no. 449, 0·73 × 0·48 m. (Madrazo, 1910, p. 86); no. 456, Christ and the Madonna, half length, 0·72 × 0·48 m., lent to Las Palmas, Museo del Cabildo Insular (Gaya Nuño, 1954, p. 116, no. 456).

3. Escorial, Upper Cloister, vaults beside the main stairway, *Ecce Homo* and *Mater Dolorosa*, two pictures both by Titian (Padre Ximénez, 1764, edition 1941, p. 70); in the same location in 1800 they are described as painted on slate (Ceán Bermúdez, V, p. 42). The only examples of these subjects on stone are the famous works in the Prado

(Cat. nos. 32, 77). Since these are traceable in the Alcázar since 1600 and in the new Royal Palace in the eighteenth century, they could scarcely have been in the Escorial in 1764–1800. The pair of the Upper Cloister may be identical with the *Dolorosa* said to be on slate and by Titian that was paired with El Mudo's copy of the *Ecce Homo* both located in the Sala del Prior when Poleró wrote in 1857 (pp. 108–109, nos. 438, 439). The whereabouts of neither is known to me today, although they may be in a cell somewhere in the vast Escorial, but in that case works of no particular significance.

4. Madrid, Alcázar, Alcoba de la Galería de Mediodía, *Ecce Homo* by Titian, 1¼ × 1 *vara*: Alcázar Inventory, 1666, no. 619; 1686, no. 292; 1700, no. 106 (Bottineau, 1958, p. 160). This item, which first appears in 1666 and disappears after 1700, may have been a copy; probably lost in the fire of 1734 (Beroqui, 1946, p. 165).

5. Madrid, Alcázar, Oratory beneath the Choir, *Ecce Homo* and *Dolorosa*, two pictures, copies of Titian, made by Juan Bautista del Mazo, son-in-law of Velázquez and compiler of the Inventory of 1666; Alcázar Inventory, 1686 (Bottineau, 1956, p. 452); undoubtedly destroyed by fire in 1734.

6. Madrid, Alcázar, Sacristy, two panels, 1 × ⅔ *vara*, copies of Titian; Alcázar Inventory, 1686 (Bottineau, 1956, p. 447, nos. 5, 6).

7. Rome, Aldobrandini Inventory of 1626, 'Un quadro con Christo Ecce Homo che tiene in mano una Canna di mano di Titiano' (Pergola, 1960, p. 434, no. 181).

8. Rome, Paul III, *Ecce Homo*, painted 1545–1546 (Vasari (1568)–Milanesi, VII, p. 447; Vasari qualified it as not a good work compared with Michelangelo, Raphael, and Polidoro da Caravaggio (!); Ridolfi (1648)–Hadeln, I, p. 178).

9. Unknown location, Cardinal Antoine Perrenot, Seigneur de Granvelle, minister of Charles V, an *Ecce Homo* by Titian. Correspondence between Granvelle and Titian, October 1548–July 1549; shipped 2 March 1549, but possibly lost in transit (Zarco del Valle, 1888, pp. 224–229; this item does not appear in the Granvelle Inventories).

35. Ecce Homo and Mater Dolorosa Plates 218, 219
Bertelli prints.

1564.

The inscription on Bertelli's print, 'Philippo regi Catholico hispanarum Titianus pictor clarissimus D D', makes it clear that these two canvases were later than the works

which Charles V carried with him to retirement at Yuste. A reference of 1564 appears to refer to the arrival of Philip's two pictures (Beroqui, 1946, p. 122).

The prints are, of course, reversals of the original painted compositions on canvas. Our illustrations have been again reversed to achieve the relationships of the lost pictures. That Philip's *Ecce Homo* and *Mater Dolorosa* were much admired is proved by the numerous copies, which are listed below. However, any reconstruction of the history of Philip's *Ecce Homo* and *Dolorosa* may only be regarded as hypothetical.

In 1599 Padre Sigüenza (edition 1923, p. 418) describes a pair of these subjects in the sacristy of the Escorial, of which, he states, there are prints and many copies. Neither Padre de los Santos (1657) nor the so-called Velázquez 'Memoria' records them, so that Palomino (1724) may have erred in his list of pictures in the sacristy where he does place them. It is most probable that, shortly after Padre Sigüenza wrote, Titian's *Ecce Homo* and *Dolorosa* were transferred to the royal palace. At any event the two canvases in His Majesty's Apartment of the Alcázar at Madrid in July of the following year must have been Philip's, known in Bertelli's prints, inasmuch as the Madonna had clasped hands (Alcázar Inventory, 1600, pp. 26–27, 1 *vara* 2 *dedos* 5 *sesmas*). In 1623 and 1636, described in this fashion as in the King's Oratory: two canvases, 1 × 1 *varas*, Christ holding a cane, his hands tied, the Madonna with clasped hands (Alcázar Inventory, 1623, legajo 26; Inventory 1636, folio 22 ff.).

These two pictures later disappear from the Alcázar, a fact explained by Philip IV's gift of Titian's *Ecce Homo* and *Dolorosa* to the Escorial, where they were placed over the same artist's *Adoration of the Shepherds* and *Entombment* respectively in the Iglesia Vieja (Padre de los Santos, 1657, edition 1933, pp. 243–244). Thereafter the same pictures are recorded in the same place throughout the following century (Padre Ximénez, 1764, p. 260); also in 1776 (Escorial, *Documentos*, V, 1962, p. 260); in 1800 (Ceán Bermúdez, V, p. 43). Their disappearance during the occupation of the Escorial by the French Napoleonic troops marks the end of the story.

PRESERVED COPIES (Titian-Bertelli composition):
1. Avila, Cathedral, Museum, *Ecce Homo*, canvas, 0·84 × 0·65 m.; *Mater Dolorosa*, canvas, 0·842 × 0·65 m., original sizes, now enlarged to 0·935 × 0·71 m., wretched copies, eighteenth century, made from the original pictures, not from the prints since the compositions are not reversed.
2. Corella (Navarre), church of San Miguel, *Ecce Homo*, canvas, 0·715 × 0·575 m., an old copy of no. 3 below;

recently cleaned and varnished (José Luis de Arrese, *Arte religioso en un pueblo de España*, Madrid, 1963, pp. 126–127, pl. 126).
3. Escorial, Nuevos Museos, *Ecce Homo* (Plate 220), canvas, 0·76 × 0·58 m., as by Titian; until 1963 over Titian's *Adoration of the Kings* in the Iglesia Vieja (Poleró, 1857, no. 473, number still seen on the lower left.) It is either a ruined original (now dark and badly damaged) sent here by Philip IV (Padre de los Santos, 1657, edition 1933, pp. 243–244) or an old copy which replaced the original either before or after the French occupation of 1808–1814.
4. Milan, Ambrosiana Gallery, *Ecce Homo* (Plate 221) Bertelli type, canvas, 0·52 × 0·44 m., mediocre copy in extremely damaged, dirty state; gift of Cardinal Federico Borromeo in 1618 (*Guida sommaria*, 1907, p. 132 and no. 22; Valcanover, 1960, II, pl. 20, replica).

Ecce Homo and Mater Dolorosa, see also: Mater Dolorosa, Cat. nos. 76, 77, 78.

36. Entombment Plate 75

Canvas. 1·48 × 2·05 m.

Paris, Louvre.

About 1526–1532.

Nineteenth-century critics declared Titian's *Entombment* much inferior to Raphael's, but today the verdict would almost unanimously be reversed. The man on the left, sometimes thought to be a self-portrait of Titian, kneels upon a stone, thus arresting the suggestion of movement, which is also halted by the group composed of the Madonna and the Magdalen. Against the stone rests the crown of thorns, an idea repeated much later by El Greco in the Niarchos *Pietà*. The colours are distributed as follows: at the left the Madonna in blue and the Magdalen in rose-and-gold brocade; in the centre St. John wearing red is flanked by the man in dark green at the left and the one in a rose cloak with a brown lining at the right. This beautifully balanced, dome-like composition enfolds the limp but muscular body of Christ, who is carried upon a white winding-sheet. Details in the right background, including a landscape with the tomb, a skull, and two tiny figures, are now almost invisible.

Condition: The picture is much darkened and has doubtless suffered from several restorations, three of which are recorded: 1698, 1753, 1786 (when Godefroy retouched it 'avoir repointillé quelques endroits mastiqués dans les

draperies.') (see below: Bailly). For example, the free
'impressionistic' brushwork on the lower part of the
brown draperies of the man at the right is obviously
modern.

History: Ducal Palace, Mantua; sale of 1627 (Luzio, 1913,
p. 92, no. 11); Charles I of England in 1628–1649 (van der
Doort, 1639, Millar edition, 1960, p. 15, no. 7; Charles I:
LR 2/124, folio 9; Harley MS., no. 4898, 1649–1652,
British Museum, folio 151, no. 32, 'The Buriall of Christ
by Tytsian', £120, sold to Webb, October 25, 1649);
Jabach, Paris, 1649; Louis XIV; Versailles, Le Brun
Inventory, 1683, no. 46; Versailles Inventories of 1696,
1698; listed by Lépicié, 1752, p. 24; at the Luxembourg
Palace in 1764; at the Louvre in 1785 (Bailly-Engerand
(1709), 1899, pp. 68–69; complete history).

Bibliography: See also History; Vasari (1568)–Milanesi,
VII, p. 458; not in Ridolfi; C. and C., 1877, I, pp. 283–288;
Villot, 1874, p. 285, no. 465; Louvre catalogue, no. 1584,
inventory no. 749; Tietze, 1936, I, p. 142, II, p. 305;
Berenson, 1957, p. 189; Valcanover, 1960, I, pl. 125.

Drawing: London, Agnew and Sons (formerly), proposed
as a study for the Louvre *Entombment* (Fröhlich-Bum,
1927, pp. 228–233), with which there seems to be no
connection. The attribution to Titian has not been
accepted by other critics.

REPLICA:
Vercelli, Museo Borgogna, canvas, 1·32×2·18 m., copy,
sixteenth century. This hard duplication (Plate 79) does
not seem worthy of Titian's own studio. The colours
approximate those in the Louvre picture except that the
Magdalen's costume approaches a violet rose and the
man's garment at the right has a smooth tan lining, which
doubtless reflects that detail as Titian originally painted it,
whereas in the restored Louvre canvas this lining now has
a puckered effect. *History:* Manfrin Collection, Venice
(sale, Milan, 1897, no. 23, pl. 3); probably bought by
Antonio Borgogna; bequeathed with his house and
collection to the city of Vercelli. *Bibliography:* Vasari
(1568)–Milanesi, VII, p. 458, note; *Manfrin,* 1872, pp.
17–18; C. and C., 1877, I, p. 287 (follower); Berenson,
1957, p. 191 (studio).

COPIES:
1. Amiens, Cathedral, small, very dark, probably nine-
teenth century.
2. Bayonne, Musée Bonnat, 0·24×0·32 m.
3. Detroit, Institute of Arts, canvas, 54×82½ inches

(1·372×2·095 m.), poor copy (Detroit, 1965, p. 108;
copy).
4. London, Koetser Gallery, free copy by Rubens (Nicol-
son, 1967, p. 321; illustration in *Art News*, 66, September
1967, p. 19).
5. London, Serby Hall, bad copy; sale, 24 October 1948,
no. 135 (Courtauld Institute London, photograph).
6. Lyon, Musée des Beaux-Arts, small version by Dela-
croix, subsequent to the 'impressionistic' restoration of
the lower part of the draperies of the man at the right.
7. Paris, Philippe de Champaigne, Inventory 1674, large
copy, now lost (Guiffrey and Gronchy, 1892, p. 185, no.
75).
8. Seville, Hospital de la Caridad, antecabildo, canvas,
c. 1·37×2·17 m., competent, exact copy, sixteenth-
seventeenth century (Plate 81).
9. Tours, Musée des Beaux-Arts, no. 289, mediocre copy.

LOST COPIES:
Four copies in Charles I's Collection, one by 'Crosso',
i.e. Michael Cross; pre-sale inventory of 1649 (Charles I:
LR 2/124, folios 119, 171, 185ᵛ, 186).

37. Entombment Plates 76–78
Canvas. 1·37×1·75 m.
Madrid, Prado Museum.
Signed on the tablet in the centre with gold letters:
TITIANVS VECELLIVS OPVS AEQVES CAES.
1559.

One of Titian's great works, this *Entombment* is an import-
ant milestone in the development of his late style of compo-
sition and in the freedom of his illusionistic brushwork.
The scenes in grisaille upon the sarcophagus representing
the 'Sacrifice of Isaac' and 'Cain Slaying Abel' are pre-
figurations of the death of Christ. The antique inspiration
has long been recognized in this and other works. Brendel
also gives the source of the Magdalen's pose in a Roman
relief of the death of Meleager (Brendel, 1955, p. 124).

Condition: The signature seems to have been somewhat
restored, but the condition of the picture was relatively
good. A long crease over the lower edge implies that this
section was once folded over a smaller frame. On the
other hand, a lighter-coloured band three inches wide
(7·5 cm.) at the top appears to be an addition. Newly
restored in 1968.

History: Ordered by Philip II on 13 July 1558 to replace

another *Entombment* lost in transit (Díez del Valle, 1659, p. 345; shipped from Venice on 22 September 1559 (C. and C., 1877, II, pp. 278–281, 515; Cloulas, 1967, p. 238); sent to the Escorial in 1574 (Zarco Cuevas, 'Inventario', 1930, p. 43, no. 996); Crowe and Cavalcaselle (1877, II, p. 291) are mistaken in locating the *Entombment* in the chapel at Aranjuez during Philip II's lifetime (see next item); in the altar on the Epistle side of the Iglesia Vieja in 1599 (Padre Sigüenza, edition 1923, p. 381); the same location, 1657 (Padre de los Santos, edition 1933, p. 243); likewise in 1773 (Ponz, tomo II, carta LV, 55); brought to the Prado in 1837.

Bibliography: See also History; Palomino, 1724, edition 1947, p. 797; Ceán Bermúdez, 1800, V, p. 43; Madrazo, 1843, p. 177, no. 813; 'Inventario general', 1857, p. 169, no. 813 (from the Escorial); C. and C., 1877, II, pp. 278, 289–292 (confused histories); Ricketts, 1910, pp. 148–149 (arbitrarily rejects date of 1559); Tietze, 1936, II, p. 296; Beroqui, 1946, pp. 155–156; Berenson, 1957, p. 188; Valcanover, 1960, II, pl. 79; Prado catalogue, 1963, no. 440.

COPIES:

1. Escorial, Nuevos Museos, poor copy, labelled Titian; made in 1837 to replace the original; in the lateral altar of the Iglesia Vieja, 1837–1963 (Poleró, 1857, no. 469).
2. Munich, private collection, weak variant, perhaps nineteenth century (Heinemann, 1962, pp. 157–158, Titian and workshop).
3. Palencia, Cathedral, damaged copy.
4. Toledo, Museo de Santa Cruz, canvas, 1·12×1·68 m., probably nineteenth century; from S. Nicolás, Toledo.

VARIANT:

Milan, Ambrosiana Gallery, canvas, 1·80×2·08 m., school of Titian, *c.* 1580 (Peterzano?) (Plate 84). The composition, related to the Prado *Entombment* of 1559, includes additional figures, particularly a standing man in reddish brown at the extreme left. In the background have now been added an open archway at the right and a masonry wall at the left. The hard drawing and general crude ineptness rule out the possibility that it came from Titian's studio. *Condition:* Ruinous, cracked, and patched; the canvas has several bad creases where it was once folded, both vertically and horizontally. *History:* St. Charles Borromeo's collection; gift to the Ambrosiana of Cardinal Federico Borromeo, 1618. *Bibliography:* Cardinal Borromeo, 1625, edition 1909, p. 48 (Titian); *Guida sommaria*, 1907, no. 29 (Titian); C. and C., 1877,

II, p. 292 (seventeenth-century imitation); Suida, 1943, pp. 360–362 (Titian); Valcanover, 1960, II, p. 49 (under Madrid *Deposition*, late replica). *Variant:* Torrigiano Collection, Florence, mediocre variant (C. and C., 1877, II, p. 292, seventeenth-century adaptation; Suida, 1943, pp. 360–362, illustration, Titian).

38. Entombment

Plate 80

Canvas. 1·30×1·68 m.

Madrid, Prado Museum.

Inscribed on the upper edge of the tomb: TITIANVS F

Workshop of Titian.

About 1570.

The quality of this picture is so far below the main version, which Titian delivered to Philip II in 1559, that the classification as workshop is mandatory. The brown tunic with large blue spots, worn by the man to the right, is especially distressing. Christ's head has been badly restored, but the same ugly face persists in other versions of the picture.

The figures in Bonasone's print dated 1563 correspond to this painting in the inclusion of the youth drying his tears at the extreme left. That the canvas has been cut down considerably on all sides is demonstrated by the copy at Salamanca, which includes more, at the left particularly.

Recent critics have tended to accept the picture as by the master himself. Crowe and Cavalcaselle were surely mistaken in considering it the copy by Mazo that was in the Oratory below the choir of the Alcázar chapel in 1686 (Bottineau, 1956, p. 452, no. 53).

Condition: The canvas was so dirty and thickly varnished as to conceal the features of the Madonna and the two men at the left. Newly restored in 1968.

Probable history: Almost surely this *Entombment* was presented by the Venetian state to Philip II's secretary, Antonio Pérez, in 1572. Several letters, but without ever mentioning the subjects of the works, are published in the correspondence of Leonardo Donà, Venetian ambassador to Madrid, who requested the gifts to Pérez of pictures of good quality by Titian (Donà, 1570–1573, edition 1963, see Titian in index; for another picture in Antonio Pérez's collection, see *Adam and Eve*, Cat. no. 1). The probability that the *Entombment* from Antonio Pérez's estate was purchased or confiscated by Philip II lies in its description as 'like the Escorial picture' in a

letter of 14 December 1585 from Khevenhüller to Rudolf II at the time of the Pérez sale (Urlichs, 1870, p. 81). An *Entombment* by Titian in the chapel at Aranjuez is characterized by Cassiano del Pozzo as like the engraving (by Bonasone), as indeed the version under discussion is. Its first appearance in the royal inventories in 1600 helps to support the belief in its acquisition from Antonio Pérez's estate fifteen years earlier; then recorded as on canvas, 2×2⅛ *varas* or 1·67×1·945 m., value 30 ducats, and by Titian (Alcázar Inventory, 1600, I, p. 117). Cassiano del Pozzo's statement in 1626 that it measured about three by five *braccia* (i.e. 1·75×2·92 m. if he used the Florentine *braccia* of 58·4 cm.), demonstrates how casual and approximate were these estimates.

Cassiano del Pozzo, secretary to Cardinal Francesco Barberini, writes in 1626, folio 33ᵛ, during the Spanish visit while at Aranjuez: 'Si vidde in un stanzino che serve d'Oratorietto un quadro alto da tre braccia in circa e Largo cinque in circa d'un Pietà ò sia Christo morto con la gloriosa Vergine e le Marie, opera bellissima di Titiano della quale si vede la stampa.'

Certain history: In the Aula de Escritura at the Escorial in 1657, said to be the gift of Philip IV and very much like the *Entombment* in the Iglesia Vieja (Padre de los Santos, 1657, edition 1933, pp. 255, 257); brought to the Prado in 1839.

Bibliography: See also History; Madrazo, 1843, p. 179, no. 822 (from the Escorial); 'Inventario general', 1857, p. 171, no. 822 (from the Escorial); Madrazo, 1873, p. 91, no. 491 (of doubtful authenticity); C. and C., 1877, II, p. 292 (mistaken as a copy by Mazo!); Rothschild, 1931, p. 202 (the picture Vasari saw in 1566); Longhi, 1925, pp. 45–48 (Titian); Suida, 1935, p. 145 (Titian); Tietze, I, p. 232, II, p. 297 (Titian, new version); Beroqui, 1946, pp. 156–157 (Titian); Valcanover, 1960, II, pl. 124 (Titian, 1566); Prado Catalogue, 1963, no. 441 (Titian).

COPIES:

1. Escorial, Infirmary, copy of Titian (Padre Ximénez, 1764, edition 1933, p. 80), lost.
2. Lerma, Colegiata (unverified).
3. Salamanca, Old Cathedral (Plate 82), given to El Mudo by Ponz (1783, XII, carta IV, 28) and Ceán Bermúdez (1800, II, p. 111).
4. Segovia Cathedral, chapel of Saints Cosmas and Damian, a poor late copy.
5. Soria, San Pedro, copy wrongly attributed in the *Guide Bleu*, edition 1954, p. 464, to El Greco (there called a 'Descent from the Cross').

LOST PICTURES:

1. *Entombment* shipped to Philip II by Titian but lost in transit; letters of 1558 and 1559 (C. and C., 1877, II, pp. 512–515; Cloulas, 1967, pp. 232–233, 236).
2. *Entombment* on panel in the Oratory at the Encomienda of Aceca, mentioned 1591, 1614, and 1646 (Alvarez de Quindós y Baena, 1804, p. 133).
3. *Christ in the Tomb with the Madonna and Two Angels* (probably a devotional *Man of Sorrows*), Alcázar, Madrid, Sacristy, copy on panel (Inventory, 1686: Bottineau, 1956, p. 448, no. 29; probably not related to Titian).

39. Entombment Plate 83

Canvas. 1·00×1·16 m.

Vienna, Kunsthistorisches Museum (storage).

Blurred inscription on the tomb: TITIANV (not a signature).

Workshop or copy, late sixteenth century.

The workshop of Titian would be the most optimistic classification possible for this picture, even discounting its deteriorated condition. The Madonna's ultramarine cloak is the best colour; the Magdalen, in white, stands behind Joseph of Arimathea, in deep green with a grey fur collar, while Nicodemus at the left wears a dark purplish-red coat, a grey turban and a striped grey scarf. St. John the Evangelist appears in a dusty rose-brown, and Christ's draperies are, of course, white, against a light brown tomb.

Condition: Relining and restoration are recorded on the back of the frame: 'G. J. 1919.' The number 086 appears on a paper.

History: The suggestion that this picture originally belonged to Antonio Pérez in Madrid and that it passed into and remained in the royal collection until Philip IV presented it to Charles I of England, who in turn gave it to the first duke of Buckingham, is certainly erroneous (Ludwig Urlichs, 1870, pp. 81–83). For a more logical history of Antonio Pérez's *Entombment*, see Cat. no. 38, the preceding item in this book, which is much larger (1·30×1·68 m.).

An *Entombment* (40×48 inches or 1·015×1·22 m.) in the Buckingham collection is the Vienna picture, Inventory, York House, 1635 (Davies, 1907, p. 380); also Brian Fairfax, 1758, p. 2, no. 14, lists pictures sold at Antwerp in 1649; this *Entombment*, 5 figures, 40×48 inches, purchased by Archduke Leopold Wilhelm in 1649 for Emperor Ferdinand III at Prague; 1723 to Vienna.

Bibliography: See also History; C. and C., 1877, II, pp. 292–294 (Titian and workshop); Engerth, 1884, I, pp. 347–348, no. 495 (Titian); Glück and Schaeffer, 1907, p. 44, no. 179 (Titian); Suida, 1935, pp. 145, 181, pl. 273b (Titian); Berenson, 1957, p. 192 (studio).

COPIES:

1. Unknown location, canvas, 1·02 × 1·16 m., exactly like the one in Vienna, but poorer. *History:* Sir J. C. Robinson, London (sale, Lepke, Berlin, 31 March 1914, no. 24, illustration; said to have come from Prince Borghese's collection); Sedelmeyer, Paris; Marczell von Nemes sale, 2–3 November, 1933 (no illustration, called 'attributed'); Burlington House Exhibition, 1912, no. 32; Fischel, 5th edition, p. 204.

2. Unknown location, canvas, 0·77 × 0·64 m., similar to the Vienna picture, but the old man at the left is bareheaded instead of turbaned; Crosses visible on the hill at the left. Silbermann Gallery, Vienna and New York, in 1936; formerly Különféle sale, Budapest, 2–6 December 1935, no. 2105, illustration, 0·76 × 0·64 m.

3. Unknown location, canvas, 28 × 21 *pouces* (0·714 × 0·535 m.), Paris, Dufourny sale, November 1819, no. 131. The line engraving at the Courtauld Institute shows a high background, resembling the Padua frescoes, and three Crosses on the hill at the left, as in Bonasone's engraving of 1563. *History:* Gonzaga Collection, Mantua; Charles I at Whitehall Palace (van der Doort, 1639, Millar edition, 1960, p. 37, 45 × 63 in., i.e. 1·09 × 1·60 m.); it cannot be Prado no. 441, as Oliver Millar suggests (see above, Cat. no. 38).

Epiphany, see: Adoration of the Kings, Cat. nos. 2–5.

40. Faith Adored by Doge Antonio Grimani Plate 201

Canvas. 3·65 × 5·00 m.

Venice, Ducal Palace, Sala delle quattro porte.

Titian and workshop, 1555–1576.

St. Mark in a red tunic and dark-blue drapery is nearest to Titian's style and quality. The figure of the Doge is fair, but Faith and the men at the right are mediocre. Marco Vecellio, according to Boschini, added a prophet at the left and Alfieri one at the right; his statement is credible as this work, commissioned in 1555, remained unfinished at Titian's death.

Condition: Darkened and much restored.

History: Unfinished in 1566 at the time of Vasari's visit; completed after Titian's death.

Bibliography: Vasari (1568)–Milanesi, VII, p. 457; Boschini, 1664, p. 13; Ridolfi (1648)–Hadeln, I, p. 206; C. and C., 1877, II, pp. 244–248 (great praises for the picture); Zanetti, 1777, p. 164; *Mostra di Tiziano*, 1935, no. 77; Tietze, 1936, I, pp. 131, 134, 207, 235, II, p. 310 (workshop); Pallucchini, 1954, II, pp. 120–121 (workshop); Berenson, 1957, p. 191 (Titian in great part); Valcanover, 1960, II, pl. 102 (Titian and workshop).

41. Flagellation Plate 217

Canvas. 0·86 × 0·58 m.

Rome, Villa Borghese.

Titian (?). Mid-sixteenth century.

Even discounting the fact that the brown background has turned very dark and that the paint upon the body is worn down to the canvas, the weave of which is plainly visible, this forced and uninspired composition is difficult to accept as a work of Titian. The position of the figure in the picture is partially explicable by the reduction of the size of the canvas in past generations.

Condition: Extremely rubbed and in a generally bad state.

Other dating: Pergola, *c.* 1560.

History: Probably from the collection of Paolo Emilio Cardinal Sfondrato of Milan (1561–1618), who in 1595 owned 'a Christ at the Column half length by Titian' (Urlichs, 1879, p. 49; C. and C., 1877, II, p. 475); in 1608 Cardinal Scipione Borghese purchased seventy-one 'most beautiful paintings' from Cardinal Sfondrato (Pergola, *Galleria*, 1959, p. 215, item 48); in the Villa Borghese in 1650 (Manilli, 1650, p. 97); inventory of the Palazzo Borghese in 1693; '171. a picture about four *palmi* Christ bound with hands behind him canvas . . .' (Pergola, 1964, p. 451); still in the palace inventory about 1700 (Rinaldis, 1936, p. 199).

Bibliography: See also History; C. and C., 1877 (no such subject mentioned as in the Borghese collection); Gronau, *Titian*, 1904 (omitted); Frizzoni, 1910, p. 143 (school); Suida, 1935, p. 185 (Titian); Pergola, 1955, I, p. 132, no. 236 (Titian); Berenson, 1957, p. 190 (Titian); Valcanover, 1960, II, pl. 119 (partly workshop).

LOST WORKS:

1. A *Flagellation* by Titian with six figures, which is known today only in Martin Rota's print (Tietze, 1936,

I, pp. 227, 232), is thought to be the composition of a lost work which Vasari says was painted for the Queen of Portugal, 'Christo, poco minore del vivo, battuto da Giudei alla colonna' (Vasari (1568)–Milanesi, VII, p. 453).

2. Florence, Cardinal Leopoldo dei Medici in the second half of the seventeenth century had a drawing of 'Christo alla Colonna, uno studio in matita nera' attributed to Titian (Muraro, 1965, p. 83).

3. Genoa, Palazzo Balbi, *Flagellation* (Ratti, 1780, I, p. 187).

4. Rome, Aldobrandini Collection, 1598–1682. Inventory of Lucrezia d'Este, Duchess of Urbino, of 1592, no. 47 'Our Lord beaten at the Column' (Pergola, 1959, p. 345); passed by inheritance to the Aldobrandini at her death in 1596 or 1597, for the Duchess willed her property to Cardinal Pietro Aldobrandini (1571–1621); in the cardinal's Inventory of 1603; '165. Half-length Christ at the column . . .' (D'Onofrio, 1964, p. 202); Inventory of Donna Olimpia Aldobrandini of 1626, no. 77, the same item (Pergola, 1960, p. 431); Inventory of Donna Olimpia Aldobrandini–Pamphili, before 1665, no. 165, height about three *palmi* (D'Onofrio, 1964, p. 202); Inventory of Donna Olimpia Aldobrandini-Pamphili after her death in 1682, no. 412, the same item, height about three *palmi* (Pergola, 1963, p. 80). Paola della Pergola's suggestion that the Aldobrandini *Flagellation* is now in the Villa Borghese cannot be sustained, since the Borghese picture was already cited by Manilli in 1650, thirty-two years before the Aldobrandini Inventory of 1682 (Pergola, *Galeria*, 1955, I, p. 132).

5. Venice, Casa Orsetti, 'Salvatore alla colonna' (Ridolfi (1648)–Hadeln, I, p. 201).

PRESERVED COMPOSITION:
Venice, S. Trovaso, sacristy, canvas, 0·63×0·57 m., free copy of the Borghese picture (Cat. no. 41) by Bernardino Prudenti, seventeenth century (Boschini, 1664, p. 365; Lorenzetti, 1956, p. 540).

Gloria, see: Trinity, Cat. no. 149.

Holy Family, see also: Madonna and Child, Cat. nos. 47–73; Rest on the Flight into Egypt, Cat. nos. 90, 91.

42. Holy Family with St. John the Baptist and a Donor
Plate 6

Canvas. 0·90×1·20 m.

Edinburgh, National Gallery of Scotland (Duke of Sutherland's loan).

Titian, about 1510.

In spite of the over-elaboration of the folds of the drapery the quality of the painting is high, superior to the puzzling *Holy Family with a Shepherd* in the National Gallery in London. As a matter of fact, similar excesses do appear in Titian's early works such as the frescoes in Padua. The splendid rose and blue of the Madonna's costume combine with St. John's grey drapery and the donor's violet suit and red mantle to effect a superb colour composition, while the landscape leaves nothing to be desired. The attribution in the gallery is now to Palma Vecchio.

History: Prince de Condé, Paris, who gave it to the Duc d'Orléans (Orléans Collection, see Dubois de St. Gelais, 1727, p. 209, called Palma Vecchio; not in Couché, 1786–1788; Stryienski, 1913, p. 152, no. 46, attributed to Palma Vecchio); Duke of Bridgewater, purchased 1798 (Buchanan, 1824, I, p. 126, called Giorgione); Marquess of Stafford, London (by inheritance), 1818 (no. 18, as Palma Vecchio; 1825, I, p. 40, no. 68, as Palma Vecchio); Lord Ellesmere (by inheritance); Bridgewater House, London, until 1939; Duke of Sutherland (by inheritance).

Bibliography: See also History; Hetzer, 1920, pp. 112–114 (not Titian); Suida, 1935, p. 25 (Titian); Tietze, 1936 (omitted) and 1950, p. 375 (doubtful); Mayer, 1937, p. 305 (Titian); Berenson, 1957, p. 185 (early Titian); Suida, 1959–1960, pp. 62–64 (Titian); Valcanover, 1960, I, pl. 50 (early Titian).

COPY:
Unknown location, panel, 0·58×0·90 m., inferior copy; Helbing sale Munich, 17–18 March 1921, no. 723; formerly Archbishop Caspar von der Leyen of Trier (died 1676).

43. Holy Family with a Shepherd in a Landscape
Plate 8

Canvas. 0·99×1·37 m.

London, National Gallery.

Titian (?), about 1510.

The poor drawing and miscalculated proportions of the Madonna have led to doubts about the correctness of the attribution, yet the Child is very lovely and the landscape superior. An attribution to Paris Bordone on comparison with his signed canvas in the Galleria Tadini at Lovere (Canova, 1964, pl. 15) has received little acceptance. Gould considers the picture by Titian and contemporary with the altar of St. Mark.

Condition: Cut down on all four sides; generally good state; cleaned 1954. A drawing, published by Frizzoni (1907, pp. 154–155), wrongly labelled as by Van Dyck and at Chatsworth (really in Moscow, Dolgoroukoff Collection in 1907) shows the full original composition. Tietze's erroneous statement that the work is recorded in Van Dyck's 'Italian Sketchbook' must be based on this article.

History: Borghese Palace, Rome, Inventory 1693: '379. . . . un quadro grande in tela la Madonna il Bambino e San Gioseppe un Pastore in ginocchioni . . . di Titiano, (Pergola, 1964, p. 461); W. Y. Ottley, purchased in Italy in 1799 (Buchanan, 1824, II, pp. 21, 27); Ottley sale, London, Christie's, 16 May 1801, no. 45; W. Champion, London (sale, 23–24 March, 1810); Rev. Holwell Carr, who left the picture to the National Gallery in 1831 (Redford, 1888, II, p. 256).

Bibliography: See also above; Ramdohr, 1787, I, p. 299 (in the Borghese Palace, Rome); C. and C., 1877, II, p. 428 (uncertain attribution); Gronau, *Titian*, 1904, pp. 30–33, 279 (Titian, early and Palmesque); Ricketts, 1910, p. 43 (Titian aided by Francesco Vecellio); Hetzer, 1920, pp. 110–112 (not Titian); Suida, 1935, pl. 78 (Titian); Tietze, 1936, II, pp. 292–294 and 1950, p. 377 (perhaps Paris Bordone); Berenson, 1957, p. 187 (early Titian); Gould, 1959, pp. 97–98 (with full history; Titian); Valcanover, 1960, I, pl. 51 (early Titian).

COPIES:

1. Moscow, Dolgoroukoff Collection, in 1907, sketch (Gould, 1959, p. 98).
2. Unknown location, canvas, 0·94×1·232 m., a poor copy of the National Gallery canvas (sale, London, Christie's, 31 October 1958, no. 9).
3. Unknown location, copy (sale, London, Christie's, 30 April 1954, no. 157).

44. Judith Plate 193

Canvas. 1·13×0·953 m.

Detroit, Institute of Arts.

About 1570.

The free technique and broken colour place the picture late in Titian's career. The superficial elegance of the head at first misleads as to the quality, but it is probable that an early restorer has tampered with that part of the composition to make the canvas saleable. The relationship of the composition to a somewhat similar *Judith* once in the

Archduke Leopold Wilhelm's Collection and illustrated by Teniers (1660, pl. 51) has been noted by Borenius.

History: Marchese Andrea Gerini, Florence (*Raccolta di ottanta stampe . . . i quadri . . . Marchese Gerini*, Florence, 1786, pl. 22); Marchese Giovanni Gerini, Florence (sales catalogue, Florence, December 1, 1835, no. 272); John Rodwell, London, 1829; Colonel W. Cornwallis-West, London (London, 1915, p. 57, no. 47); Dealer: A. L. Nicholson, London, 1923 (*International Studio*, 77, April 1923, p. 17); gift of Edsel Ford to the Institute in 1935.

Bibliography: See also History; Borenius, 1922, pp. 88–91 (Titian); Venturi, 1928, p. 367 (Titian); Bierman, 1929, pp. 317–320 (Titian); Valentiner, 1935, pp. 102–104 (Titian); Valentiner, *Pantheon*, XVI, September 1935, p. 33; Suida, 1935, pp. 137, 177, pl. 233 (Titian); Tietze, 1936, II, p. 286 (Titian, late); Berenson, 1957, p. 184 (Titian); Valcanover, 1960, II, pl. 117 (Titian, late).

WRONG ATTRIBUTION:

London, University of London, Courtauld Institute, canvas, 0·972×0·755 m., most surely by Padovanino; a false signature at upper right: TITIANVS. The attribution of this mediocre non-Titianesque work to Titian by Fry and Borenius is over-optimistic. *History:* Lord Walsingham, London, bought in Italy about 1848, sold London, Sotheby's, 7 December 1927, no. 42; Lord Lee of Fareham, 1927–1958; bequest to the University of London. *Bibliography:* Fry, 1911, p. 162 (Titian); Borenius, 1928, pp. 61–62 (Titian); Constable, 1930, p. 68 (Titian); Suida, 1935, pl. 226b (Titian); Murray, 1962, no. 56 (attributed to Titian).

VERSIONS:

1. Switzerland, private collection, *Judith* or *Salome*, canvas, 1·14×0·96 m., variant of Titianesque original, published as by Titian and identical with version 2 below (Morassi, 1968, pp. 456–466).
2. Vienna, Archduke Leopold Wilhelm, 'Judith with a Moorish page' (Inventory, 1659, p. XCV, no. 157; Teniers, 1660, pl. 51); earlier, Venice, Bartolomeo della Nave, c. 1638 (Waterhouse, 1952, p. 15, no. 15); the print suggests that the picture was a *Judith* and not a *Salome*

45. Last Supper and Resurrection
(Processional Banner) Plates 94, 95

Canvas. Each 1·45×0·88 m.

Urbino, Ducal Palace.

Documented 1542–1544.

LAST SUPPER: The composition, placing the table on a diagonal, may be the first of a type that was to have a long history in Venetian art, especially in the hands of Tintoretto. It makes a break with the older tradition, that of the horizontal position of the table adopted by Leonardo and by Titian himself in the *Supper at Emmaus* (Plate 88). The iconography differs from that of Leonardo and most painters who chose the moment when Christ said, 'One of you shall betray me'. Here Christ holds the wafer between His fingers, thus symbolizing the origin of the Eucharist, an early case of which is the well-known fresco by Fra Angelico in San Marco at Florence, where, however, Christ stands in the foreground. In the Cinquecento the dogmatic aspect of the event was to become more and more prevalent subsequent to Titian, as the Counter-Reformation advanced. Paintings of the subject by Barocci at Urbino and by Tintoretto at Venice are the logical aftermath of Titian (Mâle, 1932, pp. 72–76). The young St. John the Evangelist, who usually sleeps at Christ's side, is shifted here to the opposite side of the table, i.e. the youth at the left with back turned, dressed in a green tunic and rose mantle, his proper colours. If Judas is present at all, he does not occupy a conspicuous place. The Near Eastern environment of the event explains the round church, which is the Holy Sepulchre, and the Egyptian pyramid (or possibly the pyramid of Cestius in Rome) in the background.

The white tablecloth provides a strong central accent, with the tan floor and greenish-grey walls contributing a relatively neutral setting for the colours of the Apostles' garments. St. Peter in uncanonical red sits at the right of Christ, who as usual wears rose and blue. A handsome dark-bearded Apostle in grey tunic and rose drapery occupies a prominent position at the lower right. In general the colour scheme of soft rose, green, and an occasional blue adds immeasurably to the calm and peaceful mood of the work.

Condition: Satisfactory, not excessively restored; considerably cut down at both sides, partially eliminating the lateral Apostles.

RESURRECTION: The crouching soldier with the Hapsburg shield of gold and black (explainable by the alliance of Urbino with the Hapsburgs) closely repeats the figure at the left in Titian's *Christ Before Pilate* (Plate 91) in Vienna, a rare phenomenon of such repetition in the artist's work. On the other hand, Christ, blessing in this instance, diverges from the *Risen Christ* (Plate 72) at Brescia (1522), the two figures resembling each other

only in the colours, that is, the white loincloth and the Resurrection banner of rose and white. Behind Him the sky of neutral blue turning to the rose and yellow of sunset has faded somewhat, but the effectiveness of the composition as a whole is not greatly impaired by minor points of deterioration.

Condition: Pigment is dry and the heads of the soldiers at the right have suffered from crude old retouching; cut down on all sides.

History: Painted for the confraternity of Corpus Domini located in San Francesco di Paola at Urbino; payments were made to Titian for the banner in 1542–1544 and to Pietro Viti for the frame (1544–1545); the two sides of the banner were separated and framed shortly after their completion; transferred to the Istituto di Belle Arti in 1866 and to the museum in the Ducal Palace at Urbino in 1911 (information in the museum archives).

Bibliography: Scatassa, 1902, p. 443; C. and C., 1877, II, pp. 373–374; Gronau, 1904, pp. 121, 297; Suida, 1935, pp. 65–66; *Mostra di Tiziano*, 1935, nos. 60, 61; Tietze, 1936, I, p. 197, II, p. 309; Valcanover, 1960, I, pls. 176–177.

COPY OF LAST SUPPER:
Florence, Contini-Bonacossi Collection, canvas, 0·94 × 0·625 m., reputedly the preparatory sketch for the Urbino *Last Supper*, the colours of which are the same; much of the paint has fallen away from the sky, but less so elsewhere; in general the condition is dirty although the canvas is heavily varnished (Berenson, 1957, p. 186, studio of Titian).

46. Last Supper Plates 116–118

Canvas. 2·07 × 4·64 m.

Escorial, Nuevos Museos.

Signed in capitals on the copper basin just below the quail: TITIANVS F

Titian and workshop, 1557–1564.

The barbarous reduction in size of the canvas, perpetrated by the monks in the sixteenth century, and various restorations have left the picture only a shadow of its original self. Nevertheless, the participation of Titian with the workshop in the preparation of the huge canvas is indubitably in evidence. Today the finest parts, closest to Titian's own hand, include the grey-bearded man in golden brown who leans over the table at the extreme

right and beside him Judas, his back turned, in a pink tunic and pale-blue drapery, holding the bag of money. The third and fourth Apostles from the left also appear to have been at least retouched by the master. The figure of Christ, the central groups, and St. James Major with hand upon his chest at the far left strike one as stilted in design and mediocre in technique. On the other hand, a strong bent for still life, beautifully painted by some expert assistant, is demonstrated by the basket and the copper basin with the quail (an Old Testament prefiguration of the Eucharist; see Charbonneau-Lassay, 1940, pp. 502–503). Amusing details include the green cushion, on Judas' stool, with red tassel and embroidered with a figure of a rabbit.

Titian's *Last Supper* in Santi Giovanni e Paolo in Venice, a canvas destroyed by fire in 1571, has been proposed as the prototype for the Escorial picture, but no contemporary suggestion of that possibility is found in letters or in literary sources. The account of the fire on 17 July 1571, which burned the refectory and Titian's picture, is found in a manuscript 'Emortuale del convento' upon which Cicogna drew for his explanation (1853, VI, p. 825; C. and C., 1877, II, pp. 337–338). It states that drunken Germans started the fire, which became uncontrolled, in a room beneath the refectory.

Condition: St. John's head is now very dark from poor repainting, and the creases in the canvas bulge through his hair. The large canvas, too big for its location in the refectory of the Escorial, was cut down, particularly at the top, but also somewhat at the lower edge and at the sides. Palomino reports that the Spanish painter, Fernández de Navarrete, el Mudo, protested vigorously but in vain, and was allowed only to copy the picture before its mutilation.

History: Documented by a series of Titian's letters and by others written by Philip II and by García Hernández, his ambassador at Venice. Titian stated that he had begun the picture in 1557, but it is clear that he delayed finishing it and shipping it until his pensions from Milan and Naples, for years overdue, had been paid. Letters of July and August 1564 state that the picture is ready (Zarco del Valle, 1888, p. 233; Cloulas, 1967, pp. 261–264); sent to the Escorial in 1574 (Zarco Cuevas, 'Inventario', 1930, p. 45, no. 1011). A fragment of the architecture found its way into the collection of Charles I of England, but later disappeared (van der Doort, 1639, Millar edition, 1960, p. 175, no. 19a). The *Last Supper* is mentioned as in the refectory in 1599 (Padre Sigüenza, edition 1923, p. 380); by Padre de los Santos in 1657 (edition 1933, p. 242); and

by all other writers on the Escorial. It was transferred to the Chapter House in the mid-nineteenth century, where it remained until 1963.

Bibliography: See also History; Vasari (1568)–Milanesi, VII, pp. 456–457; Ridolfi (1648)–Hadeln, I, pp. 190–191; Palomino, 1724, edition 1947, p. 796; Padre Ximénez, 1764, edition 1941, p. 80; Ceán Bermúdez, 1800, V, p. 43; Poleró, 1857, p. 110, no. 446 (the number still visible in lower right corner); C. and C., 1877, II, pp. 325–327, 338–350, 527–535; Suida, 1943, p. 360; Tietze, 1936, I, p. 234, II, p. 287 (largely workshop); Valcanover, 1960, II, pl. 105. For iconography, see Réau, II, part 2, pp. 409–411.

COPIES:

1. Florence, Contini Bonacossi Collection, *Last Supper*, canvas, 1·31×2·12 m., a remote adaptation of the Escorial composition, of late date and weak quality; partial composition.
2. Gerona (Spain), Museum, reduced as the original is today; possibly formerly in the palace at Boadilla del Monte (Ponz, 1776, tomo VI, Boadilla, 1).
3. London, Bridgewater Collection (formerly); not the complete original composition; attributed to Andrea Schiavone (C. and C., 1877, II, p. 349).
4. Milan, Brera, storage, *Last Supper* (Plate 229), canvas, 1·70×2·16 m., large copy showing complete original composition (Suida, 1935, pl. 229). Tietze (1936, II, p. 287) suggests that this version may have been painted from Jan Muller's engraving. The picture belonged to Cardinal Cesare Monti in 1650; transferred to the Brera in 1896.
5. Pavia, Certosa, *Last Supper* by Ottavio Semino, dated 1567, based on the Escorial picture (Suida, 1943, pp. 360–361).
6. Wantage (Berkshire), Lockinge House, C. L. Loyd, small copy, 30×40¾ inches, arch above, no ceiling; eighteenth century (?); from the collections of Benjamin West and his son Raphael West; sale 24 June 1820, no. 77 (Graves, 1921, III, p. 211), bought in; again 16 July 1831, no. 34; Lord Overstone (Waagen, 1857, p. 142; C. and C., 1877, II, p. 350, wrongly attribute it to El Mudo); passed by inheritance to A. T. Loyd at Wantage in 1920; shown at the Royal Academy, 1888 and 1902, and at the Burlington Fine Arts Club, 1914 (*Wantage Catalogue*, 1905, p. 163; *Loyd Collection*, London, 1967, cat. no. 57).

LOST COPIES:

1. London, Charles I, Inventory of sale, 1649, copy of Titian (Charles I: LR, 2/124, folio 117ᵛ, no. 6).

2. Venice, Antonio Pasqualino, an unfinished 'Cena' attributed to Titian and Stefano (Michiel, c. 1532, edition Bassano, 1800, p. 56; English edition, London, 1903, p. 93).

3. Venice, Sant'Angelo, a 'Cena' said to be by the school of Titian (Boschini, 1664, p. 129; Martinelli, 1684, p. 33; Zanetti, 1733, p. 176; references by courtesy of Dr. Maurice Cope).

WRONG ATTRIBUTION:
Greenville (South Carolina), Bob Jones University, canvas, 2·216×3·595 m. (Bob Jones University: *Supplement*, 1968, cat. no. 217: Titian and assistant).

Madonna and Child, see also: Holy Family, Cat. nos. 42, 43.

47. **Madonna and Child** ('Gipsy Madonna') Plates 1, 3
Panel. 0·658×0·835 m.
Vienna, Kunsthistorisches Museum.
About 1510.

The name 'Gipsy Madonna', traditionally attached to the picture, is explained by the dark hair and dark eyes of the Madonna. One of the most Bellinesque among Titian's early works compositionally, it is also so Giorgionesque in mood that some critics formerly attributed it to Giorgione, but Titian's authorship is almost universally agreed today. The fact that the picture was originally signed is proved by the copy at Rovigo (see below) and the inscription TITIANVS PINXIT on the print by Jan Meyssen (1612–1670). The similarity of the landscape to Titian's background in the Dresden Venus has also been generally recognized. Nevertheless, the pale blue of the cape and the white veil over the dark-red tunic and the general delicacy of colour relations recall Giorgione's tonal effects in a work such as the *Adoration of the Shepherds* in the National Gallery at Washington.

Condition: Surface damage on hands, feet, and abdomen of the Child.

Other dating: Crowe and Cavalcaselle, 1508; Tietze, 1510; Rothschild, 1510.

History: Archduke Leopold Wilhelm, Vienna, Inventory 1659 (p. C, no. 235); Leopold I; Charles VI.

Bibliography: See also History; C. and C., 1877, I, pp. 54–56 (Titian); Cook, 1907, p. 97 (Giorgione); Hetzer, 1920, pp. 37–39 (Titian); Wilde, 1932, pp. 151–154 (Titian);

Rothschild, 1932, pp. 114–116 (Titian); Richter, 1934, pp. 278–281 (composition by Giorgione, finished by Titian); Tietze, 1936, I, pp. 87–88, II, p. 315 (Titian); Richter, 1937, pp. 92–93, 252–253 (Giorgione and Titian); Phillips, 1937, pp. 24, 55–56, 77 (Giorgione and Titian); Berenson, 1957, p. 191 (early Titian); Valcanover, 1960, I, pl. 43 (Titian); Klauner and Oberhammer, 1960, p. 132, no. 704 (Titian).

COPIES:
1. Rovigo, Museo Civico, canvas, 0·643×0·82 m., copy preserving the *cartello* with the signature, TITIANVS F, a detail lost in the original at Vienna. The mechanical nature of the work leaves no doubt that this is a later copy. The curtain behind the Madonna is red with black stripes (unlike the original in Vienna), while the Madonna wears the usual red tunic, blue mantle, and white headdress. *History:* Donation Casilini 1838 to the museum (C. and C., 1877, I, p. 56, copy; Rovigo, 1931, p. 36, no. 69).

2. Windsor Castle, copy by Teniers (C. and C., 1877, I, p. 56).

48. **Madonna and Child** Plate 5
Panel. 0·457×0·559 m.
New York, Metropolitan Museum of Art, Bache Collection.
Titian (?), about 1511.

The physical types suggest Titian at the time of the murals in Padua, but the poor condition makes judgment difficult.

Condition: The head of the Child is badly damaged and almost completely restored; much retouched throughout.

History: Purchased in Italy by the Earl of Exeter, c. 1690–1700; at Burghley House, Stamford, Northamptonshire; Benson Collection, London, 1895–1927; Lord Duveen, London, 1927–1929; Jules S. Bache, New York, 1929–1944; bequeathed to the Metropolitan Museum, 1944.

Bibliography: C. and C., 1877, I, p. 111 (Titian); Phillips, 1906, p. 25 (anonymous painter, between Giorgione and Titian); Berenson, 1906, p. 98 (Domenico Caprioli); Cook, 1907, p. 101 (Giorgione); Ricketts, 1910, p. 29 (Titian); Borenius, 1914, pp. 181–182 (Titian); Berenson, 1928, p. 153 (Titian); *Bache Collection*, 1929 (unpaged; Titian) and 1937, p. 16 (Titian); Valentiner, 1930, pl. 22 (Titian); Suida, 1935, pp. 25, 162 (Titian); Tietze, 1936

and 1950 (not listed); Berenson, 1957, p. 189 (early Titian); Valcanover, 1960, I, pl. 13 (early Titian).

49. Madonna of the Cherries — Plates 2, 4

Panel, transferred from canvas. 0·81 ×0·995 m.

Vienna, Kunsthistorisches Museum.

About 1515.

Among the most admired of Titian's early religious works, this picture is clearly later than the *Gipsy Madonna* in the breadth and maturity of the figures and the more pronounced modelling toward white.

In this still Bellinesque composition in half length, with a ledge in the foreground and a damask panel behind the Madonna, St. Joseph appears at the left and Zacharias, the father of the Infant Baptist, at the right. The Madonna's rose tunic and medium-blue mantle do not correspond at all to the pale colours of the *Gipsy Madonna*, nor does the dark-red brocaded cloth behind her. On the Baptist's banderole are inscribed the words ECCE AGNVS DEI, referring to his symbol the lamb. The motive of the Infant St. John bringing cherries has given rise to much discussion, since the same action takes place in Dürer's *Madonna*, dated 1506, in which the Infant Baptist presents lilies of the valley (painted in Venice, now in the Staatliche Gemäldegalerie, Berlin-Dahlem). As Dürer visited Venice that year, Titian may have seen his picture, or both may have derived the idea from an earlier Italian source, as suggested by Tietze and Panofsky.

Condition: Originally on canvas prepared with gesso; somewhat retouched (Wilde, 1932, pp. 151–154); transferred to panel in 1853, when examined and measures for conservation taken; small losses repaired (Rothschild, 1932, pp. 107–116); a copy of the underpaint shows slight variations in the first design (Tietze, 1936, II, pl. 29).

Other dating: Hetzer, 1506–1508; Crowe and Cavalcaselle, 1508; Gronau, 1512–1513; Tietze, 1515; Heinemann, 1511–1516.

History: Leopold Wilhelm's collection, Vienna, 1659 (Inventory, p. XCV, no. 161; erroneous statement that it was on canvas mounted on wood: see Rothschild, 1932, p. 115; Teniers, 1660, pl. 62).

Bibliography: Storffer, 1733, II, no. 245; Mechel, 1783, p. 22, no. 21; C. and C., 1877, I, pp. 105–107; Gronau, *Titian*, 1904, p. 277; Hetzer, 1920, pp. 39–42 (Titian); Rothschild, 1932, pp. 107–116 (Titian); Tietze, 1936, I, pp. 119–120, II, 315 (Titian); Berenson, 1957, p. 191

(early Titian); Klauner and Oberhammer, 1960, p. 133, no. 707 (Titian); Valcanover, 1960, I, pl. 77 (Titian).

COPIES:

1. Cologne, Feschenbach sale, 1889, no. 83, probably the same as the one formerly in the Widener Collection, Philadelphia (photos, Courtauld Institute, London).
2. Florence, formerly, Prince Corsini (Rothschild, 1932, fig. 122).
3. London, Wallace Collection, canvas on panel, 0·14 × 0·17 m., by Teniers; formerly Blenheim Palace (Wallace Catalogue, no. 636; Rothschild, 1932, fig. 121).
4. Padua, formerly, Via del Busanello, Portico (C. and C., 1877, I, p. 107).
5. Prague, Hradschin Palace in 1718 (C. and C., 1877, I, p. 107; Rothschild, 1932, p. 108).
6. Unknown location, canvas, 30 ×39½ inches (0·762 × 1·03 m.), sale, London, Christie's, 27 May 1960, £136; resold 25 November 1960, £420 (APC, XXXVII, 1959–1960, no. 4806; XXXVIII, 1960–1961, no. 1134).
7. Venice, Signore Cadorin (C. and C., 1877, I, p. 107).

50. Madonna and Child — Plate 12

Panel transferred to canvas. 0·375 ×0·31 m.

Lugano, Thyssen-Bornemisza Collection.

Inscribed in gold letters on the dais at the left: TITIANVS

Titian (?), about 1515.

Judgment of this picture is extremely difficult because of the extensive repainting, most noticeably in the hard nature of the heads. The pose is related to Titian's *Rest on the Flight* at Longleat (Plate 7), the Madonna at Bergamo (Cat. no. X-18) and works by Lorenzo Lotto. The Madonna in a rose tunic, blue drapery, and a beige veil, sits in front of a green curtain.

Condition: Many losses, particularly on the Child's foot and the heads; much retouched.

History: Sciarra Collection, Rome, before 1874; Francis, Lord Cowper, purchased it in Rome in 1874; Lord Desborough, Panshanger (Hertfordshire) (sale Christie's, London, 16 October 1953, no. 130); Agnew and Co., London, 1953; purchased by Thyssen, 1956.

Bibliography: C. and C., 1877, II, p. 420 (Titian; then in Rome); Tietze, 1936 and 1950 (omitted); Suida, 1956, pp. 76–77 (Titian); Berenson, 1957 (not listed); Heinemann, 1958, p. 108, no. 420A (Titian); Valcanover, 1960, I, p. 99, pl. 208 (attributed): Hendy, 1964, p. 101 (Titian).

COPY:

Palazzo Spada, Rome, no. 44, canvas, 0·36×0·285 m., (Plate 210), late sixteenth century (Zeri, 1952, p. 13, no. 44; anonymous, Titianesque, seventeenth-century).

51. Madonna and Child with Angels Plate 26

Fresco. 1·60×3·50 m. (lunette)

Venice, Ducal Palace, Sala della Quarantia Criminale.

1523.

Wretched as the condition of the detached fresco is, with its only surviving colour the pale blue on part of the Madonna's drapery, the composition is one of great beauty, leaving no doubt of Titian's authorship, which is fully documented. Other parts of the fresco, which included St. Nicholas, the four Evangelists, and the Doge Andrea Gritti (1523–1538) kneeling at the left as donor, are lost.

Condition: Transferred to canvas in 1899 previous to the use of modern techniques for this operation; ruinous and much retouched.

History: Originally in the chapel of S. Niccolò (destroyed) near the stairway called the Scala dei Giganti of the Ducal Palace (Ridolfi). The following reference was formerly thought erroneously to refer to the picture in S. Niccolò dei Frari (Cat. no. 63, Vatican Gallery): Sanuto, XXXV, column 254, under December 6, 1523: 'in la chiexia nuova di San Nicolò, dove questo Doxe l'ha fata compir quasi et è dipento esso Doxe, che stà ben, di man di Tiziano, fin col suo cagnol sutin drio, et altre figure, San Nicolò e li 4 evangelisti che scriveno li evanzelii.'

Bibliography: Vasari (1568)–Milanesi, VII, p. 439 (second mention 1568); Van Dyck's 'Italian Sketchbook', fol. 9ᵛ; Ridolfi (1648)–Hadeln, I, p. 166 (Titian); Boschini, 1664, p. 71 (Titian); C. and C., 1877, II, p. 296 (Titian); Suida, 1935, pp. 55–56, 163; Tietze, 1936, II, p. 310 (workshop, after 1530); Berenson, 1957 (omitted); Valcanover, 1960, I, pl. 92 (Titian, *c.* 1523).

52. Madonna and Child Plate 54

Canvas. 1·24×0·96 m.

Rome, Luigi Albertini.

About 1560.

The style and quality of this work as well as the Madonna's aristocratic bearing compare favourably with the *Annun-ciation* in San Salvatore at Venice (Plate 62). Neutral tonality prevails in both canvases, although the Albertini Madonna's tunic retains a distinctly rose hue, while the red curtain behind her is subdued. Her veil and mantle are grey with a slightly bluish tinge.

Condition: The Child's feet have been badly restored; otherwise in a satisfactory state.

History: Marchese Mazenta, Milan, 1616–1879 (catalogue of this collection of 1616 in the archives of the Castello Sforzesco, Milan), as by Titian; also Inventory, 1628; Pinetti Collection, Martinego, until 1916, when purchased by Albertini.

Bibliography: London, 1930, p. 117, no. 176; Suida, 1930, p. 43 and 1935, pp. 138, 181 (Titian); Wittgens, 1930, XI, pp. 73, 88 (Titian); Modigliani, 1942, no. v (Titian); Longhi, 1946, p. 65 (Jacopo Bassano); Berenson, 1957, p. 190 (Titian); Valcanover, 1960, II, p. 71 (doubtful attribution).

COPIES:

1. Bologna, private collection, unverifiable (Suida, 1935, p. 138).
2. Burghley House, Marquess of Exeter, cat. no. 421, 36½×33½ inches (0·927×0·838 m.), free, hard variant of the nineteenth century; said to have come from the Barberini collection (photo, Frick Library, New York).
3. New York Historical Society, oval, 43×36 inches (1·092×0·914 m.), free copy, seventeenth century; Thomas J. Bryan bequest 1867 (*New York Historical Society*, 1915, p. 62).
4. Padua, Duomo, Museum, canvas, *c.* 1·20×1·00 m., free variant doubtfully attributed to Padovanino (Faccio, 1819, p. 72; Venturi, 1934, p. 309).

53. Madonna and Child in an Evening Landscape
 Plates 49, 50

Canvas. 1·74×1·33 m.

Munich, Alte Pinakothek.

Signed on the marble block at the lower left: TITIANVS FECIT

About 1562–1565.

In this late masterpiece, the large powerful figures of both the Madonna and the Child are in Titian's most Mannerist vein, when the sculpture of Jacopo Sansovino and the general Michelangelesque taste of the period were vividly in his mind. The big physiques puzzled both Crowe

and Cavalcaselle and Phillips, who were inclined to doubt Titian's signature for that reason. Even Palomino called the picture a 'cosa extremada'. The sunset landscape has extraordinary beauty, as do the colours throughout, particularly the broad expanse of the rose of the Madonna's tunic against her blue mantle, golden-white veil, and the neutral brown curtain behind her.

Condition: Signature repaired, but unquestionably authentic; condition satisfactory despite extensive damage inflicted when the picture was brought from Spain to France in General Sebastiani's luggage. The largest holes in the canvas, now repaired, occur to the right of the Madonna's knee; others are visible over the Child's head and beneath His foot. Unimportant rips horizontally across the top of the picture; vertical crease coinciding with the tree suggests that the picture was folded when packed for General Sebastiani.

History: Undoubtedly the Madonna and Child on which Titian was working on 26 April 1562 (letter; C. and C., 1877, II, p. 524; Cloulas, 1967, p. 253); sent to the Escorial in 1574 (Zarco Cuevas, 'Inventario', 1930, p. 44, no. 1003; note in the manuscript 'en la sacristia'); in the Sacristy of the Escorial when Padre Sigüenza wrote in 1599 (edition 1923, p. 418); in the Chapter House in 1657 according to Padre de los Santos (edition 1933, p. 237); in the Sacristy in the eighteenth century (Palomino; Ponz, 1773, tomo II, carta III, 44; Ceán Bermúdez, 1800, V, p. 41); General François H. S. Sebastiani took it to Paris during the Napoleonic occupation of Spain; in 1815 privately purchased in Paris for Ludwig I of the House of Wittelsbach; 1836 to the Alte Pinakothek.

Bibliography: See also History; Palomino, 1724; C. and C., 1877, II, p. 425 (dubious signature); Reber, 1895, p. 220, no. 1113 (late Titian); Suida, 1935, pp. 138, 181, pl. 274 (Titian, *c.* 1560); Tietze, 1936, II, p. 301 (Titian); Berenson, 1957, p. 188 (late Titian); Valcanover, II, pl. 99 (important late work).

COPIES:

1. Escorial, Claustros Menores (Poleró, 1857, no. 179), a mediocre copy, now ruined, which looks as though one of the monks had painted it previous to the Napoleonic invasion.
2. Rome, dealer (in 1964), copy. Is this the Stockholm picture?
3. Säfstaholm, Sweden, Count Frederic Bonde, copy with remains of a signature: TI; formerly Christian Aspelin (Sirèn, 1902, pp. 93–94, illustrated). An item cited as in

the collection of the King of Sweden is probably the same picture (Gronau, *Titian*, 1904, p. 288).

54. Madonna Nursing the Child Plate 55

Canvas. 0·756×0·632 m.

London, National Gallery.

About 1570.

The general effect of this somewhat Donatellesque composition is very appealing, as well as unusual in the pale blue of the dress and the dark brown of the headdress and curtain. To the free, sketchy technique of Titian's late style is added the faded condition of the canvas, yet the tenderness of feeling and the essential strength of the design come through.

Condition: Abraded and with numerous retouchings.

History: Bisenzio Collection, Rome (Mond Catalogue); Earl of Dudley (Waagen, 1854, II, p. 235; sale, 25 June 1892, no. 89); purchased by Dr. Ludwig Mond; bequeathed to the National Gallery in 1924; engraved by Pieter de Jode.

Bibliography: C. and C., 1877, II, p. 428 (Titian; overcleaned); Gronau, *Titian*, 1904, p. 282 (late Titian); Mond, 1910, pp. 134–144 (Titian); Suida, 1935, pp. 138, 181 (late Titian); Tietze, 1950, p. 377 (Titian); Berenson, 1957, p. 187 (Titian); Gould, 1959, pp. 116–117 (Titian).

COPIES:

1. Lucerne, Fischer Gallery (sale, 25–29 June 1957, no. 2223, illustration, 1·13×0·845 m.), hard, weak copy, nineteenth century (?).
2. London, Henniker-Heaton, canvas, 0·616×0·851 m., modern adaptation (Hadeln, 1928, p. 56, as Titian).
3. Other copies and versions (see Gould, 1959, p. 117).

55. Madonna of the Pesaro Family Plates 28–31

Canvas. 4·85×2·70 m.

Venice, Santa Maria dei Frari.

Dated 1519–1526.

The Pesaro Madonna inaugurates the High-Renaissance Venetian composition of crossed diagonals with the Madonna placed high to the side, an arrangement that other Venetian masters adopted and varied and that passed much later into the basic repertory of Baroque art. The glowing colours stand out against the columns of grey marble: St. Peter in a dark-blue tunic and yellow drapery,

the Madonna in a rose tunic, blue mantle, and a white headdress. The rose banner with its escutcheon of gold and black is a major element in the balance of the colour composition. In the broad robe of red brocade on the figure of Benedetto Pesaro, kneeling in the right foreground, is created both contrast and balance for Jacopo Pesaro at the left, who is in a reddish-black mantle of watered silk.

The banner with the Borgia escutcheon and the laurel sprig above it refer to the victory over the Turks at Santa Maura in 1502 under the leadership of Jacopo Pesaro, bishop of Paphos, whose escutcheon is also included in the lower part of the flag. Behind him a knight in gleaming armour (Dolce calls him a knight, Vasari St. George) holds the banner, as a bound Turk with white turban bends his head in submission, and beside him stands a Negro slave. Set in the wall to the right of the painting is the tomb of Jacopo Pesaro (1466–1547). Benedetto Pesaro (1433–1503) opposite Jacopo in the picture is accompanied by other members of the family: Vittorio, Antonio, Fantino, and Giovanni. St. Francis and St. Anthony stand behind them in the rear, while St. Peter, so prominently situated in the centre of the picture, represents the church of Rome.

Long ago it was demonstrated by Wolf that Titian had originally planned the setting within a church and that he subsequently changed his mind in favour of the exterior portico. Such a modification must have been made before the painting was far advanced. The theory proposed by Sinding-Larsen that the columns 'are not Titianesque' and were added in the mid-seventeenth century is a subjective opinion devoid of historical or other reasonable basis. A recent study of architectural settings in Venetian painting also rejects this proposal (Forssman, 1967, p. 138, note 5a).

Iconography: The subject of the Pesaro altar is the Madonna and Child accompanied by saints and donors, who are members of the Pesaro family. The exact connection of the altar with the Confraternity of the Immaculate Conception is not clear until 1582, when Gregory XIII conceded special indulgences which are recorded in an inscription on the round pier opposite the altar (transcribed by Soravia, 1823, II, p. 133). A statuette of the Madonna and Child (Pisan School, fourteenth century), located on the same pier below the inscription, has also been associated with this cult, as pointed out by Paravia in 1822 (p. 7). The word GREGORIANO in large letters upon the frieze of the Pesaro altar also refers to the privileges of 1582. Great confusion has arisen in the minds of Eva Tea (1958)

and Erica Tietze-Conrat (1953), both of whom claimed that Titian's picture illustrates the doctrine of the Immaculate Conception. The festival of the Conception was celebrated in this church from 1517 onward and in other churches in Venice (Sanuto, XXV, column 125). The Pesaro altar was not consecrated on the feast of the Immaculate Conception, on 8 December 1526, as has been stated; the festival was merely celebrated there (Sanuto, XLIII, column 396).

The iconography of the Immaculate Conception in the earlier periods has been the subject of extensive research by Mirella Levi d'Ancona (1957). The fully developed iconography of the standing figure of the Madonna accompanied by symbols of her purity, borrowed from the litanies of the Virgin, is a phenomenon of the later sixteenth and seventeenth centuries (Mâle, 1932, pp. 41–48; Réau, 1957, II, pp. 80–83) and best known in the works of Ribera, Murillo, Cano, and other Spanish masters. Titian's Pesaro Madonna has no part in this tradition.

Condition: The colours remain surprisingly fresh despite considerable varnish, and the fine crackle of the paint is not visible to the naked eye at the distance at which one views the composition.

History: Contract in the Pesaro archives, dated 28 April 1519; final payment made 27 May 1526 (documents: Paravia, 1822; C. and C., 1877, I, p. 441; Ludwig, 1911, p. 133; Venturi, IX, 1928, part 3, pp. 121–122).

Bibliography: See also above; Dolce, 1557, edition 1960, p. 203; Vasari (1568)–Milanesi, VII, p. 436; Sansovino, 1581, p. 66; Ridolfi (1648)–Hadeln, I, pp. 163–164; Sansovino-Martinioni, 1663, p. 189; Boschini, 1664, p. 295; D. Martinelli, 1684, p. 345; Wolf, 1877, pp. 9–14; C. and C., 1877, I, pp. 305–310, 441; Tietze, 1936, I, pp. 112–113, II, p. 311; Tietze-Conrat, 1953, pp. 177–182; Tea, 1958, pp. 602–605; Valcanover, 1960, I, pl. 122; Sinding-Larsen, 1962, pp. 139–169 (Sinding-Larsen's theory unfortunately accepted by Janson, 1964, p. 372).

COPIES:

1. Florence, Uffizi, a copy of the Madonna alone, 0·71 × 0·585 m., was purchased in 1863 (no. 938) as an original sketch.
2. Oxford, Christ Church Gallery, unimportant copy, 0·85 × 0·504 m., Guise bequest, 1765. (Borenius, 1916, cat. no. 190; Byam Shaw, 1967, cat. no. 82).
3. Princeton University Museum of Art, late copy, once proposed as Titian's *bozzetto*; formerly D. Hermsen,

The Hague; later Frank J. Mather, Princeton, New Jersey (Hoogewerff, 1928, p. 532, reproduction).

56. Madonna and Child with St. Agnes and the Infant Baptist Plate 42

Canvas. 1·56×1·59 m. (originally 1·11×1·49 m.)

Dijon, Musée des Beaux-Arts.

About 1535.

The general mood of the picture, the splendid figures, and the lovely landscape give this work an importance which has been widely overlooked. Even though darkened and dirty and considerably repainted (notably the Child and his post-Titian shirt), the composition is memorable. Any doubts about the attribution are explainable by the numerous restorations and the fact that many writers have never seen the picture.

A lizard points to the marble block, where a signature may once have existed. The lamb appears to serve as attribute of both St. Agnes and the Infant Baptist.

Condition: Dirty and much repainted; X-rays show damage to the Madonna's head and arm. The canvas was cut down at the left and at the top some time in the seventeenth century. With the original canvas extending just above the Madonna's head, the whole sky above is an enlargement of a subsequent period (Coppier, 1913, p. 30, illustration); relined 1698; restored by Colins, 1749; again by Godefroy, 1785 (Bailly-Engerand, 1899, p. 70; also see Paris, 1966, p. 234).

History: Possibly Bevilacqua Collection, Ferrara (Ridolfi (1648)–Hadeln, I, p. 190: the description corresponds exactly except that St. Agnes is called St. Catherine); Thomas Howard, Earl of Arundel, 1655 (both sources are proposed by Germaine Barnaud and Pierre Rosenberg, see Paris, 1966, p. 233; also Hervey, 1921, p. 489, no. 376, in the Arundel Inventory, 1655); Jabach's collection; Louis XIV's collection; Le Brun's Inventory of Versailles, 1683, no. 251; Hôtel d'Antin, Paris, 1715; Luxembourg Palace, 1750; Lépicié Inventory, 1752, p. 20; Louvre, 1785 (Bailly-Engerand, 1899, p. 70); lent to the Dijon Museum since 1946.

Bibliography: See also History; Villot, 1874, p. 283, no. 460 (Titian); C. and C., 1877, II, pp. 421–422 (Titian, assisted by Cesare Vecellio); Gronau, *Titian,* 1904 (not listed); Ricketts, 1910, p. 178 (Francesco Vecellio); Suida, 1935, pp. 57, 163 (Titian; St. Agnes wrongly called St. Catherine); Tietze, 1936 (not listed); Berenson, 1957,

p. 184 (Titian); Valcanover, 1960 (omitted); Paris, 1966, p. 233, no. 284 (detailed study).

57. Madonna and Nursing Child with SS. Andrew and Tiziano, and Titian as Donor Plate 47

Canvas. 1·015×1·375 m.

Pieve di Cadore, Parish church.

Titian and workshop, about 1560.

This well-documented picture is, nevertheless, too weak to owe more to Titian than the composition, for which he must have prepared a sketch.

The Madonna wears a rose tunic and a greenish-white cloak, which was undoubtedly bluish originally. Against the dark-green curtain with gold fringe as background kneels St. Andrew in a brown tunic and red drapery, according to tradition a portrait of Francesco Vecellio, the artist's brother. He is contrasted to St. Tiziano in a white robe with gold borders and the artist as donor entirely in black.

Condition: The canvas, faded and retouched, now makes a feeble impression.

History: Vasari (1568–Milanesi, VII, p. 432) mentions the picture as at Cadore; at the destruction of the parish church in 1764 the canvas was given into the care of Dr. Taddeo Jacobi; in 1847 another Dr. Jacobi and Alessandro Vecellio, descendants of Titian, returned it to the church, the restitution being recorded on a stone plaque near the lateral altar in which the painting is placed. Documents record the earlier history (Fabbro, 1963, no. 162, pp. 6–13).

Bibliography: See also History; Tizianello, 1622, (unpaged) p. 12; Ridolfi (1648)–Hadeln, I, p. 203 (Titian); C. and C., 1877, II, pp. 297–299 (Orazio Vecellio); A. Venturi, 1927, II, pp. 185–187 (Titian); Foscari, 1935, p. 20, pl. 5; Suida, 1935, p. 138 (Titian; the Madonna based on Dürer's print of 1503); Tietze, 1936, II, p. 307 (workshop); *Mostra di Tiziano,* 1935, no. 81 (Titian and the workshop); Valcanover, 1951, pp. 63–65 (Titian and workshop); Berenson, 1957 (not listed); Valcanover, 1960, II, pl. 125 (Titian).

58. Madonna and Child with St. Anthony Abbot and the Infant Baptist Plate 10

Panel. 0·69×0·965 m.

Florence, Uffizi (not exhibited).

Signed on the jacket of the Baptist: TITIANVS

About 1520.

The beauty of this work carries forcibly even in photographs, the only medium through which it can be judged.

Condition: For several years under restoration and not exhibited.

History: Archduke Leopold Wilhelm, Vienna, 1659 (Inventory, p. XC, no. 68; Teniers, 1660, pl. 71); sent to Florence in 1793 in exchange for another picture (Uffizi, 1926, pp. 84–85).

Bibliography: C. and C., 1877, I, pp. 108–109 (early Titian); Hetzer, 1920, p. 88 (not Titian); Tietze, 1936, II, p. 289 (Titian); Berenson, 1957, p. 186 (early Titian); dell'Acqua, 1955, pl. 75 (Titian); Valcanover, 1960, I, pl. 129 (Titian).

COPY:

Utrecht, Huffel sale, 22–26 March, 1934, no. 436, 0·66 × 0·92 m., very weak (photograph, London, Courtauld Institute).

59. **Madonna and Child with St. Catherine and the Infant Baptist in a Landscape** Plate 35

Canvas. 1·01 × 1·42 m.

London, National Gallery.

About 1530.

This work of extraordinary beauty is one of Titian's finest creations of the middle period. The vivid blue of the Madonna's garb is repeated in the sky and brilliantly painted distant hills. The colours throughout, excepting St. Catherine's yellow-green costume and pale-tan veil, are undoubtedly brighter than originally because of the loss of the final glazes.

The London catalogues of 1861 and 1862 quoted an inscription TICIANVS 1533, yet subsequent editions omitted the date, and it is now believed that the letters were not of Titian's period. The drawing of St. John the Baptist in Van Dyck's 'Italian Sketchbook', folio 12, may be after the figure in this picture, then in Rome.

Condition: Unusually well preserved despite loss of final glazes; cleaned in 1955.

History: Collection of Alfonso I d'Este, Ferrara; undoubtedly brought to Rome by Cardinal Pietro Aldobrandini, heir of Lucrezia d'Este, in 1598; Inventory of Pietro Aldobrandini, 1603, no. 78 (D'Onofrio, 1964, p. 159); given in 1621 to Cardinal Ludovisi, nephew of

Gregory XV (1621–1623) by Olimpia Aldobrandini at the request of her sons (D'Onofrio, *loc. cit.*); Inventory of Cardinal Ludovico Ludovisi (d. 1632) after his death, 1633, no. 44 (Garas, 1967, p. 288; cf. Ridolfi (1648)–Hadeln, I, p. 197, 'nelle habitationi del Signor Principe Ludovisi in Roma si veggono più imagini della Vergine'; Hadeln notes they are lost); presented as a gift to Philip IV by the Cardinal's heir, his brother Niccolò Ludovisi, Prince of Piombino, consequently probably sent to Naples in 1637 and taken to Madrid in 1638 by the retiring viceroy, Manuel de Guzmán, Conde de Monterrey (1631–1637), along with the celebrated mythological pictures by Titian from Ferrara, the *Worship of Venus* and the *Andrians*, which passed at the same time and in the same way from the Aldobrandini to the Ludovisi and which are recorded as having arrived in Madrid in July 1638 by Sir Arthur Hopton, the British Secretary in Madrid (Garas, 1967, p. 288; Sainsbury, 1859, p. 353).

Sent to the Escorial by Philip IV in 1656 (Cruzada Villaamil, 1885, p. 206); at first located over a doorway at the lower end of the Sacristy in 1657 (Padre de los Santos, edition 1933, p. 239); moved to a place beside the door of the main entrance within the Sacristy in 1658 (Velázquez, 'Memoria', in Cruzada Villaamil, 1885, p. 212); still in the same position in 1764 (Padre Ximénez, 1764, p. 305) and in 1773 (Ponz, II, carta III, 43) and in 1800 (Ceán Bermúdez, 1800, I, p. 41).

Taken as French booty from Spain in the time of Napoleon; W. G. Coesvelt, London (Cat. 1836, no. 16, illus.; sales catalogues Christie's, 2 June 1837, no. 15, and 13 June 1840, no. 47, pl. 16, there identified as coming from the Escorial; the Coesvelt catalogue illustrates the picture which is now in the National Gallery); later purchased by the National Gallery from the Beaucousin Collection, Paris, in 1860 (Gould, 1959, p. 113).

Phillips (1897, pp. 10–11) wrongly believed it was the Gonzaga picture of 1530, which is certainly the *Madonna and St. Catherine* now in Paris (Cat. no. 60); Crowe and Cavalcaselle (1877, I, p. 208) incorrectly identified the picture as the one in the collection of the Duc de Noailles, Paris, in 1720; their source is Mariette, 1858–59, p. 307.

Bibliography: See also History; C. and C., 1877, I, pp. 206–208; Suida, 1935, pp. 59, 162 (influence of Leonardo); Tietze, 1936, II, p. 294 (Titian; gives wrong provenance); dell'Acqua, 1955, pl. 74; Berenson, 1957, p. 187 (Titian; 1530); Cecil Gould, 1959, pp. 111–114 (thorough account); Valcanover, 1960, I, pl. 126.

COPIES:

1. Rome, Palazzo Senatori, Mayor's Office, Waiting Room, canvas, 1·40×2·05 m., by Pietro da Cortona, *c.* 1622 (Briganti, 1962, p. 160, pl. 285, no. 2); much larger than the original and the colours darker in value, particularly the blues, while St. Catherine's costume has been changed to brown and white. The quality in no way compares with Titian's original.

2. Copy by Teniers with variations, panel, 8¼×12¾ inches (*Connoisseur*, 155, no. 126, 1964, p. xxxi, colour reproduction; *Burlington Magazine*, CVI, 1964, p. liii).

VARIANT (Pitti type):

Florence, Pitti Gallery (Plate 33), canvas, 0·93×1·30 m., late sixteenth century. This copy, based on the London picture, is changed by placing the Baptist on the right side and by some variations in the landscape setting in the right distance. The dull colour and general darkness make it inferior to Pietro da Cortona's copy in Rome, which would also seem to be the likely place for this canvas to have been painted. *History:* Ducal Palace, Urbino, Inventory of 1624 (as Tintoretto); Vittoria della Rovere in 1631 brought it to Florence on her marriage to Ferdinand II dei Medici; Cardinal Leopoldo dei Medici, 1675 (then identified as school of Mantua); Inventory of 1723. *Bibliography:* C. and C., 1877, II, p. 441 (attributed to Cesare Vecellio); Suida, 1935, p. 192 (school of Titian); Valcanover, 1960, I, p. 66, under pl. 126 (school); Francini Ciaranfi, 1964, p. 17 (school).

VARIANTS OF THE PITTI TYPE:

a. Dowdeswell, Great Britain, Humphrey Ward, hard, poor copy after the composition in the Pitti Gallery (photo, Courtauld Institute, London).
b. Padua, private collection, moderate copy of Pitti type (photo, Padua Museum, no. 2187).
c. Venice, Francesco Pospisil, panel, 1·04×1·448 m., based on the Pitti version; purchased at the Fuller sale (London, Christie's, 29 May 1952, no. 129).

OTHER VARIANTS:

1. Hampton Court Palace, panel, 0·812×1·43 m.; arms of the La Tour family; formerly Reinst collection, Venice (Ridolfi (1648)–Hadeln, I, p. 201); collections of Charles II and James II. The Madonna is based on the London figure. The source of the floating Child is Jacopo Bassano's *Adoration of the Shepherds* in the Ambrosiana Gallery, Milan. Tobias with the Angel appears in the landscape in the right distance. *Bibliography:* See also above; Mariette, 1858–1859, V, p. 307; C. and C., 1877,

II, p. 464 (Sante Zago); Jacobs, 1925, p. 30; Cust, 1928, p. 48 (Titian); Collins Baker, 1929, p. 146 (school).
2. Vienna, Kunsthistorisches Museum, copy with variations by Andrea Schiavone (Berenson, 1932, p. 520; *idem.*, 1957, p. 162, illustration).

60. Madonna and Child with St. Catherine and a Rabbit Plate 34

Canvas. 0·74×0·84 m.

Paris, Louvre.

Signed on St. Catherine's wheel: TICIANVS F.

Datable 1530.

One of Titian's most beloved works, it has a captivating charm pervading both the landscape and the figures, which include a shepherd in the right middle ground, a flock of sheep, and the appealing Madonna, who holds an enchanting white rabbit. The rose of the Madonna's dress is the predominant colour against her blue cape, and St. Catherine's white dress is relieved by a pale-green scarf and rose drapery over the skirt. Here more than usual the Child's entire body is flushed with a ruddy tone.

Condition: Much reduced in size, cutting through the figures of St. Catherine and the shepherd (see item 3 under copies); relined and restored in 1749; damaged by early restorations; a judicious cleaning might produce a miracle, the picture would gain most in the landscape and sky.

History: The identification of this canvas with a picture destined in 1530 for Federico Gonzaga of Mantua can now be proved to be correct. It is mentioned in a letter from the duke's agent Giacomo Malatesta to Federico: '5 febbraio 1530. Tuciano m'ha fatto vedere gli quadri che 'l fa per V. S. Quello di Nostra donna con Sta Catherina . . .' (C. and C., 1877, I, p. 446). The other picture of the same subject from the d'Este collection at Ferrara, once thought to be identical with the Louvre canvas, is the work now in the National Gallery at London (Cat. no. 59). The *Madonna with the Rabbit* subsequently belonged to Cardinal Richelieu, who must have received it as a gift from Vincenzo Gonzaga *c.* 1624–1627, at the time that the Duke presented to the French minister the pictures by Mantegna, Lorenzo Costa, and Perugino, in hope of receiving a title (Luzio, 1913, pp. 300–302).
Cardinal Richelieu (died 1642); his collection sold to Louis XIV in 1665 (Ferraton, 1949, pp. 439, 444); Le Brun's Inventory, Versailles, 1683, no. 157 ('Un tableau

du Titien représentant Notre Seigneur, la Vierge, et Ste Catherine où il y a un lapin blanc, haut de 2 pieds 2 pouces sur 2 pieds 9 pouces de large. Peint sur toile avec sa bordure dorée'); Versailles, 1695; Inventory of Bailly, 1709; Hotel d'Antin, Paris, 1715; Louvre, 1737; Luxembourg Palace, 1757; Louvre, 1785 (Bailly-Engerand, 1899, p. 73).

Bibliography: See also History; Lépicié, 1752, p. 19 (thought the shepherd was St. Joseph); Villot, 1874, p. 282, no. 459; C. and C., 1877, I, pp. 336–341, 446; Louvre cat., no. 1578, inv. no. 743; Gronau, *Titian*, 1904, pp. 86, 283; Morelli, 1907, II, p. 61; Hautecoeur, 1926, p. 132 (erroneous history); Suida, 1935, pp. 44, 162; Tietze, 1936, I, pp. 152–153, II, p. 305; Hulftegger, 1955 (année 1954), p. 132 (incorrectly states that it was not in Le Brun's Inventory); Berenson, 1957, p. 189 (Titian, 1530); Valcanover, 1960, I, pl. 127 (Titian, 1530).

COPIES:

1. Biel, East Lothian, Scotland, collection of B. C. Barrington Brooke, canvas, 21 ×26 inches (0·533 ×0·66 m.), hard copy (photo, Frick Library, New York, and Kunsthistorisches Institut, Florence).
2. Unknown location, formerly Detroit, collection of Edsel Ford, canvas, 1·31 ×0·973 m., free copy in vertical format, nineteenth century (Freund, 1928, colour plate, pp. 35–39); formerly Dr. S. Aram of Erhardt Gallery, Berlin (certified by Dr. Bode); D. Speck, Bridgend, Glamorgan, Wales; comparable item formerly Duncombe Park, Lord Feversham (Waagen, 1857, p. 493).
3. Unknown location, formerly New York, Lewisohn collection, drawing, pen and ink and gouache, 228 ×280 mm., seventeenth century (Henle, 1941, no. 103, illustration, Titian). The drawing includes complete figures of St. Catherine at the left and the shepherd at the right, a fact which implies that the original painting in the Louvre has been much reduced in size.

61. **Madonna and Child with SS. Catherine and Dominic, and Donor** Plates 9, 11

Canvas. 1·38 ×1·85 m.

La Gaida (Reggio d'Emilia), Professor Luigi Magnani.

About 1515–1520.

This extraordinarily well-preserved work of Titian's early period has been seen by very few people, having been shown publicly just once, in 1951 at an exhibition in Genoa. The possibility that it was painted to commemo-rate a wedding is based upon the presence of a male donor and the inclusion of St. Catherine, whose mystical marriage to the Infant Christ would be a suitable subject for such an occasion. Nevertheless, since the absence of a bride as donor is an undeniable omission of consequence for the proper fulfilment of the occasion, the marriage theory must be abandoned. In any event the portrait of the male donor and his patron saint are interpreted in an intensely romantic vein, which one usually characterizes in Titian's work as the Giorgionesque survival. The lovely Madonna at the left in the broad rose tunic, medium-blue drapery, and grey veil, is seated against a red curtain and accompanied by St. Catherine in a delicate lavender-grey tunic, white sleeves, and medium-green drapery. The black-robed donor and the Dominican saint in black-and-white against a darkened landscape balance the group to the left.

In Van Dyck's drawings of the figures in his 'Italian Sketchbook' (folios 10ᵛ–11) the composition is reversed, thus indicating that he copied Wyngaerde's engraving. He could, nevertheless, have seen the original painting either in Genoa or Venice.

Condition: Generally in excellent condition; some tiny spots, now filled with white to prevent further losses. The Infant's face seems to have been repainted long ago, but otherwise retouchings are negligible.

History: Morassi suggests that the Venetian branch of the Balbi family might have ordered the picture from Titian. Thus far a Domenico in the Balbi family has not been discovered, yet he could have been in a collateral branch. The assumption is, of course, that the saint should be identified as Dominic rather than some other Dominican.

Until about 1952 this picture remained in the Balbi Palace in Genoa, but because of a division of the estate among three heirs it was sold at that time.

Bibliography: Ratti, 1780, p. 187; Alizeri, 1846, II, p. 75; C. and C., 1877, II, p. 417 (noted abrasion and repaint); Morassi, 1946, pp. 207–228; idem, 1951, pp. 64–65, pls. 114–119; Rotondi, 1952, no. 37; Berenson, 1957, p. 186 (early Titian); Valcanover, 1960, I, pl. 53.

COPIES:

1. Hale (England), Mrs. Riddle, canvas, 1·50 ×2·007 m., perhaps nineteenth-century copy (photo at Courtauld Institute, London).
2. Genoa, Palazzo Rosso (in storage), copy, seventeenth century.

62. Madonna and Child with SS. Catherine and Luke
Plate 53

Canvas. 1·245×1·675 m.

Kreuzlingen, Heinz Kisters.

About 1560.

The fact that this handsome and impressive late work of Titian belongs to the period of the *Annunciation* (Plate 62) in San Salvatore at Venice and of the *Madonna and Child* (Plate 54) in the Albertini Collection in Rome is unmistakable in the massive figures of aristocratic bearing and in their strong features. Nevertheless, the playful attitude of the Child and the loving solicitude of both Madonna and saints contribute a warmly human note. A dark-green curtain to the right and the blue sky, now turned greenish, provide the setting for the Madonna in rose and blue and St. Catherine in a pink-rose tunic and pale-blue drapery, while darker tones distinguish St. Luke's mauve tunic and golden-brown drapery.

Condition: Earlier neglect and resultant darkening of colours have left their mark.

History: Said to have been painted for Cavaliere Orologio, Padua (Buchanan, 1824, II, p. 278, no. 113, p. 291, no. 219); recorded by Van Dyck in his 'Italian Sketchbook', folio 12; Lucien Bonaparte, Rome (1812, pl. 115, no. 70); sale, London, 1816 (cat. no. 123); Sir J. Rae Reid (British Institution, 1829, cat. no. 129); C. P. Grenfell, Taplow Court, Maidenhead (exhibited at Manchester, 1857, no. 278); Royal Academy Exhibition, 1878, no. 141; Lord Desborough, Panshanger (sale, London, Christie's, 9 April, 1954, no. 77); Rosenberg and Stiebel, New York, 1956.

Bibliography: See also History; C. and C., 1877, II, p. 466 (near Polidoro Lanzani); Cleveland, 1956, no. 53 (Titian); Berenson, 1957, p. 187 (great part Titian); Suida, 1959–1960, pp. 65–66 (Titian); Stockholm, 1962–1963, p. 93, no. 91 (Titian).

VARIANT:
Hampton Court, Madonna and Child with St. Luke and Donor, 48¼×68 inches (1·231×1·727 m.), perhaps by a pupil of Titian; very dull in colour, damaged and in poor condition; in the collection of Charles I, bought from Frizell in 1637 (Reade, 1947, p. 71). *Bibliography:* van der Doort, 1639, Millar edition, 1960, p. 21, no. 8; Harley MS., no. 4898, 1649–52, folio 199, no. 29 (probably); 'Tableaux exposés en vente à la maison de Somerset May 1650,' Lettre E, no. 21, 'Une Vierge et saint Luc, après le mesme [Tissian] . . . £80' (Cosnac, 1885, p. 415); Collins Baker, 1929, p. 147 (school); Berenson, 1957, p. 186 Titian's studio); Suida, 1959–1960, p. 66 (Titian).

COPIES:
1. Brentford, Syon House, Duke of Northumberland, and Mr. Hope's Collection (Collins Baker, 1929, p. 147).
2. Unknown location, 1·244×1·676 m., inferior copy of Hampton Court version; formerly owned by Miss Young, Grange-over-Sands (sale, London, Christie's, 3 July 1953, no. 26, bought by Hallsborough; 100 guineas).

63. Madonna and Child with SS. Catherine, Nicholas, Peter, Sebastian, Francis, and Anthony of Padua
Plate 23

Panel, transferred to canvas. 4·23×2·90 m.

Rome, Pinacoteca Vaticana.

Signed on a plaque in the centre above the saints' heads:
TITIANVS FACIEBAT

1520–1525.

The composition of this altar with the Madonna seated in the clouds, accompanied by angels, is related to the *Madonna and Saints* at Ancona (Plate 24) but the latter is far more successful in the balance and the scale of the figures. The Vatican altar seems overweighted in the lower section, where the massive St. Nicholas dominates unnecessarily within the contrapuntal grouping of the six saints. The destruction of the curved top of the panel, which contained the dove of the Holy Spirit, resulted in the unintentional crowding of the Madonna and angels, and thus the original scale relations are lost. This event took place in the eighteenth century when the panel was placed in the Quirinal Palace and cut down to be a pendant to Raphael's *Transfiguration*.

One of the most curious features of the Vatican composition is the shallow semicircular background, which is cut through as though ruined at the right side. Perhaps this setting is in part a survival of Titian's first composition, which X-rays show was similar to Giovanni Bellini's San Zaccaria altar. The Madonna, enthroned within an apse, was accompanied by three saints at each side. Changes occurred in the final design too, although limited to minor variations in the position of the heads of the Madonna and St. Sebastian.

The most beautiful single figure is the St. Catherine in a brilliant green skirt, pale rose blouse, and transparent white veil. St. Sebastian, because of the Renaissance cult of the nude, was much admired and occasionally copied.

He is a somewhat gentler variation of the same saint in the altar of St. Mark (Plates 147, 148).

Condition: Enormously brightened and improved after the transfer to canvas in 1960–1964 and the removal of old repaint. Dr. Deoclecio Redig de Campos and Luigi Brandi were most kind and helpful in allowing me to see the picture during restoration and to examine the numerous X-rays and the photographs taken at all stages of the work. The cherub at the left of the Madonna is almost entirely intact, while the companion at the right has been so damaged that only the right leg survives from Titian's day. So far as the Madonna is concerned, her head and right hand retain essentially the original surface, but the draperies are extensively retouched. The head of the Christ Child appeared riddled after it had been freed of repaint, yet the left arm and left leg survive. Among the saints the two Franciscans have suffered most from fading, while losses of paint occur in the heads of the other figures.

Dating: Crowe and Cavalcaselle, 1523; Mayer, 1530–1535; Tietze, *c.* 1542. Although the style of the Vatican altar is closest to that of the *Madonna and Saints* (dated 1520) in Ancona, particularly in the physiques and the poses of the figures, the general effect is deceptively different, primarily because of the lack of landscape setting, a fact which seems to have misled some people to propose a date in the thirties or forties. Crowe and Cavalcaselle were mistaken in confusing S. Niccolò dei Frari with Sanuto's reference to the chapel of S. Niccolò in the Ducal Palace, which is datable 1523 (see *Madonna and Child with Angels*, Ducal Palace, Venice, Cat. no. 51). Nevertheless the nineteenth-century biographers were correct in recognizing the early character of the Vatican altar.

The discovery in the X-rays that the first composition resembled that of Giovanni Bellini's San Zaccaria altar is further evidence of the early date, inasmuch as it is unlikely that Titian would have had space in his studio to let a huge panel of this scale remain unused for a period of twenty to twenty-five years. That would have to be the supposition if Tietze's date in the 1540's were accepted.

History: Originally in San Niccolò dei Frari, Venice; sold in 1770 to Udini, the British consul, who had it restored and backed by new wood; Clement XIV (1769–1774) purchased it and brought it to Rome, placing it in the Quirinal Palace (R. Gallo, 1939, p. 261); Pius VII transferred it to the Vatican.

Bibliography: See also History; Dolce, 1557, edition 1960, p. 203; Vasari (1568)–Milanesi, VII, p. 436; Sansovino,

1581, p. 70; Borghini, 1584, p. 525; Ridolfi (1648)–Hadeln, I, p. 172; Sansovino-Martinioni, 1663, p. 194; Boschini, 1664, p. 314 (on the high altar); C. and C., 1877, I, pp. 288–292; Begni, 1914, p. 221; Suida, 1935, pp. 51, 159, pl. 49; Tietze, 1936, I, p. 189, II, p. 308; Mayer, 1937, p. 305; Berenson, 1957, p. 190 (early Titian); Valcanover, 1960, I, pl. 136 (*c.* 1545).

COPIES OF ST. SEBASTIAN, Vatican type:
Florence, Contini-Bonacossi Collection, canvas, 1·88 × 0·72 m. The figure, transfixed by two arrows, is set between gray pilasters. Its position in the niche resembles the Escorial-Harrach type (Plate 237), but the saint looks downward and the body is more slender in physique. A mediocre drawing in the Uffizi at Florence, no. 1714 F, 270×135 mm., repeats the Contini-Bonacossi model, both of which are copied from the Vatican altarpiece.

64. **Madonna and Child with St. Dorothy** Plate 32
Canvas. 1·143 × 1·492 m.
Philadelphia, Museum of Art.
Workshop of Titian or copy, about 1530–1540.

The technique of the Philadelphia version is so mechanical as to exclude the possibility that it is by Titian's own hand. A picture of this composition was engraved by Lisebetius for Teniers' *Theatrum Pictorium* (1660, pl. 65). It exists also in Van Dyck's 'Italian Sketchbook' (folio 6ᵛ) and in a painting by the same artist, now owned by Count Seilern in London (see below).

Condition: A few paint losses; the edges of the canvas slightly cut down.

History: The assumption that the Philadelphia canvas is the same item formerly owned by Archduke Leopold Wilhelm of Vienna in 1659 (Inventory, p. CII, no. 279, Titian) is not at all certain, although the description is exact; Russia, private collection; F. A. Szarvasy, London (sale, Christie's, London, 10 December, 1948, no. 53; APC, XXVI, 1947–1949, no. 5539); G. W. Elkins, Philadelphia; F. Drey, London, 1951; bought by the Philadelphia Museum, February 1957.

Bibliography: See also History; Suida, 1935, pl. 80 (print); Hendy, 1933, pp. 52–54 (Titian); Marceau, 1957, no. 255, pp. 3–7 (Titian); Berenson, 1957, p. 190 (Titian in great part); Valcanover, 1960, I, pp. 99–100, pl. 211 (workshop).

COPIES:

1. London, Count Antoine Seilern, canvas, 1·03 ×1·34 m., Van Dyck's copy (J. Wilde, 1930, pp. 262–265; Seilern, 1955, p. 74).
2. Paris, Louvre, copy by Teniers (Lacaze, no. 2190; Wilde, 1930, p. 263).
3. Seebarn Castle, Austria, mechanical copy (Wilde, 1930, p. 261).

VARIANT:

Dresden, Gemäldegalerie, canvas, 1·18 ×1·61 m., Madonna and Child with St. Joseph and three donors, school of Titian; Madonna of the Philadelphia type (C. and C., 1877, I, p. 188, note, II, p. 449, Marco or Orazio Vecellio; Posse, 1929, p. 89, no. 175, illustration, school of Titian; Berenson, 1957, p. 185, Madonna only by Titian; Valcanover, 1960, II, p. 67, workshop).

65. Madonna and Child with SS. Dorothy and George Plate 13

Panel. 0·86 ×1·30 m.

Madrid, Prado Museum.

About 1515.

The fresh colour of Titian's early period survives well in the Madonna's brilliant red dress and ultramarine cloak, but slightly less so in St. Dorothy's grey dress and light-brown mantle. Most impressive of all is the handsome dark-haired St. George, who retains the Giorgionesque mood to a greater extent than the other figures.

The Prado catalogue identifies the knight in armour as St. George, so named in 1593. The woman has been called St. Catherine by Padre Sigüenza and others, but she holds as attribute the basket of roses, which identifies her as St. Dorothy.

Doubts about Titian's authorship may in part be understood because of old restorations on the Madonna's right cheek and lips, on the Child's face, on St. Dorothy's arm, and in various spots of minor importance.

Condition: Horizontal cracks in the panel and long crackles in the paint; panel enlarged about 5 cm. at each side and about 2·5 cm. at the upper and lower edges; numerous retouchings, although not seriously damaged.

Other dating: Gronau, 1512; Berenson, 1510–1515; Pallucchini, 1516–1518.

History: In 1593 Philip II sent the picture (Madonna and Child with St. George and 'una santa veneciana') to the Escorial as the work of Titian (Zarco Cuevas, 'Inventario', 1930, p. 46, no. 1017); in the Chapter House when Padre Sigüenza wrote in 1599 (edition 1923, p. 418); in the Sacristy in 1657 (Padre de los Santos, edition 1933, p. 239); Palomino, 1724, as Titian; taken to the Prado in 1839.

Bibliography: See also History; Madrazo, 1843, p. 172, no. 792 (Giorgione; calls the saints Brigida and Ulfo); 'Inventario general', 1857, no. 792 (Giorgione); Madrazo, 1873, p. 42, no. 236 (Giorgione); C. and C., 1877, I, pp. 110–112 (young Titian); Gronau, *Titian*, 1904, p. 302 (early Titian); Madrazo, 1910, p. 83, no. 434 (Titian); Hetzer, 1920, pp. 83–86 (unknown Venetian); Suida, 1935, pp. 24, 159, pl. 41 (Titian); Tietze, 1936 and 1950 (not listed); Beroqui, 1946, pp. 8–9 (Titian); dell'Acqua, 1955, pl. 35 (Titian); Berenson, 1957, p. 188 (early Titian); Valcanover, 1960, I, pl. 70 (Titian); Prado catalogue, 1963, no. 434 (Titian).

COPY:

Hampton Court Palace (in storage), no. 216 or 632, panel 0·825 ×1·203 m., accurate but hard copy (Plate 213); from the collection of Charles I (Phillips, 1896, p. 89, illustration; Cust, VII, 1928, p. 47, illustration; Collins Baker, 1929, no. 79, copy). Michael Cross, who copied the Titians in Madrid and in the Escorial for Charles I, may be the painter of this item. Presumably an Englishman, he was engaged in this project when Vicente Carducho wrote in 1633 (Carducho, edition 1933, p. 81); he was mistakenly thought to be Spanish (Ceán Bermúdez, 1800, II, p. 379).

66. Madonna and Child with SS. Francis and Aloysius and Alvise Gozzi as Donor Plates 24, 25, 27

Panel. 3·20 ×2·06 m.

Ancona, Museo Civico.

Inscription and signature on a paper in the lower centre:

ALOYXIVS GOTIVS RAGVSINVS FECIT FIERI MDXX
TITIANVS CADORINVS PINXIT

Dated 1520.

The Giorgionesque mood still prevails in this lovely work (1520) even after Titian's first great dramatic composition, the Frari *Assumption* (Plate 18). Particularly charming are the youthful Madonna and the exquisitely painted cherubs who offer her wreaths. The figures have clarity of design, beauty of form, and the

emotional tenderness of the artist's early works. Never-
theless, the portrait of the donor is endowed with an
earthy vigour as he kneels to adore the heavenly vision.
The Ducal palace and the church of St. Mark's appear in
the distance against the low horizon and beneath the deep-
blue sky with its handsomely decorative white clouds.
Adding to the poetic quality of the setting is the large
branch of fig leaves in the left foreground. The intention is
also symbolic, since the fig tree stands for redemption.
Dr. Klauner has pointed out its repeated occurrence in
that sense, most notably in the case of the *Madonna and
Saints* by Moretto in the Episcopal Palace at Brescia,
where the Madonna is seated upon the branches of the
tree.

At the left stands St. Francis in slate-grey, while the donor,
Alvise Gozzi of Ragusa (Dalmatia), in black robes kneels
at the right, accompanied by his patron St. Aloysius in a
red-and-gold cope with a blue lining. The Madonna's
rose tunic, blue drapery, and beige veil are relieved against
a yellow light and the deep-blue sky.

Titian's composition must have been inspired by Raphael's
Madonna of Foligno (1511), painted only nine years
earlier, which then still adorned the high altar of S. Maria
in Aracoeli at Rome (Vasari (1568)–Milanesi, VIII, pp.
23–24), until it was transferred to S. Anna at Foligno much
later in 1565. Although Titian had not seen the original,
he was well aware of developments in Florence and
Rome. However he came to know Raphael's composition,
it was surely not through Marcantonio Raimondi's
engraving (Bartsch, XIV, no. 47) of the upper part of the
Madonna of Foligno, since only the Madonna in a different
pose is included.

Condition: Restored in Rome in 1948–1951, but nonethe-
less much darkened in colour, seriously damaged by old
restorations, and with numerous flecks of lost paint now
filled in (Urbani, 1952, pp. 61–79). During the restorations
it was revealed that the wood on the back of the picture
has many crayon sketches of heads upon it. The head of a
child in full face might possibly be the artist's study for the
Christ Child of this composition. Most of the others
seem to be scribblings, many of them caricatures, by
students in the artist's shop.

History: High altar, San Francesco ad Alto, Ancona;
transferred to San Domenico, Ancona, 1862–1864; ceded
to the museum of Ancona in 1864, but not in the catalogue
of 1925. It was painted for Alvise Gozzi, who died in
1538 at the age of 80 and was buried in the church of San
Francesco. His epitaph (Spadolini, 1901, p. 119), which
has disappeared along with the church, read as follows:

D. O. M.
ALOYSIO GOTHIO PATRITIO RAGUSINO
FIDE RELIGIONE AC REBUS NEGOTIISQUE AGENDIS
MORUM PRESENTIA INSIGNI
STEPHANUS ET JOANNES NEPOTES PATRUO
ET AVUNCULO
PIETISSIMI POSUERE
VIXIT ANNOS LXXX MENSES VII DIES XIX
MDXXXVIII. XII MAII.

Bibliography: Scannelli, 1657, p. 218; Scaramuccia, 1674,
p. 87; Sartori, 1821, pp. 14–15; C. and C., 1877, I, pp.
233–235; Tietze, 1936, I, pp. 115–116, II, p. 283; Paris
1954, no. 50; dell'Acqua, 1955, pls. 51–54; Klauner, 1955,
p. 155; Marchini, 1960, pp. 36–38; Valcanover, 1960,
I, pl. 94.

DRAWING:

Perhaps a first idea for the Madonna on the same sheet as
the sketches for St. Sebastian, Berlin, Kupferstich-
kabinett (Hadeln, 1924, pl. 6; Tietze and Tietze-Conrat,
1944, p. 313, no. 1880).

COPIES, *unknown locations:*

1. In the collection of paintings of Carlo Maratta, sold
to Spain in 1722 by Faostina Maratti Zappi, is listed 'Una
Madonna e due Santi, e Paese di Tiziano copiato dal Cav.
Maratti in Ancona' (Battisti, 1960, p. 88; also *Revista de
archivos*, VI, 1876, p. 129). It recurs in the Inventory of
La Granja of 1746, no. 297, size ¾ *vara* 3 *dedos* × ½ *vara*
2 *dedos*, but thereafter disappears.

2. Paris, Dufourny sale, November, 1819 (print in the
Courtauld Institute, London).

3. New York, American Art Gallery, a poor copy sold
for $100.00, 21–22 March 1922, there attributed to
Moretto da Brescia (photograph in the Frick Library,
New York).

67. Madonna and Child with SS. John the Baptist, Mary Magdalen, Paul, and Jerome Plate 14

Panel. 1·38 × 1·915 m.

Dresden, Staatliche Gemäldegalerie.

Titian and workshop.

About 1520.

This composition in three-quarter length is contempo-
rary but not at all like the Paris-Vienna *Madonna and
Child with Three Saints* (Plates 15, 16). The design and

awkward poses do not seem possible as a work entirely from Titian's own hand.

History: Casa Grimani dei Servi, Venice (Boschini, 1660, p. 307); purchased from them by the museum in 1747 through Zanetti and Guarienti (Woermann, 1892, p. 88; early Titian).

Bibliography: Riedel and Wenzel, 1765, p. 212, no. 234 (Titian); C. and C., 1877, II, pp. 447–448 (Andrea Schiavone); Morelli, 1893, II, p. 229 (Titian, *c.* 1514–1520); Hetzer, 1920, pp. 91–94 (not Titian); Posse, 1930, p. 212, no. 168 (early Titian); Suida, 1935, pp. 25, 163, pl. 83 (Titian); Tietze, 1936 (not listed); Berenson, 1957, p. 184 (early Titian); Valcanover, 1960, I, pl. 71 (early Titian).

68. Madonna and Child with the Magdalen Plate 52

Canvas. 0·98 × 0·82 m.
Leningrad, Hermitage Museum.
Titian and workshop.
About 1555.

Although this picture is good in quality and its history leaves nothing to be desired, many writers have neglected even to mention it. Crowe and Cavalcaselle regarded it as authentic, but suggested that Titian was assisted by Marco Vecellio. The soft light and generally delicate handling are evidence of a late work of importance.

History: In Titian's house at his death, Venice; Barbarigo Collection, Venice 'la Vergine col bambino al seno e la Maddalena che le porge il vase d'alabastro' (Ridolfi (1648)–Hadeln, I, p. 200; Bevilacqua, 1845, no. 76; Savini Branca, 1964, p. 186); sold to Russia in 1850 (Levi, 1900, p. 287, no. 76).

Bibliography: See also History; C. and C., 1877, II, p. 423; Fischel, 1907, p. 209 (school); Suida, 1935, pp. 138, 181, pl. 276a (Titian); Tietze, 1936 and 1950 (not listed); Berenson, 1957 (not listed); Leningrad, 1958, no. 118 (Titian); Valcanover, 1960, I, p. 104, pl. 222 (workshop); Fomiciova, 1960, no. 32, colour print (Titian); Pallucchini, 1961, p. 288 (Titian): Fomiciova, 1967, pp. 63–64 (Titian).

COPIES:

1. Florence, Uffizi, in storage, no. 949, *Madonna and Child with the Magdalen*, canvas, 0·72 × 0·605 m. *Bibliography:* C. and C., 1877, II, pp. 440–441 (school; their description is reversed because they used a print); Uffizi catalogue, 1926, p. 84, no. 949 (school of Titian; wrongly

identifies the saint as Catherine); Suida, 1952, p. 29 (incorrectly calls it a 'Madonna with St. Catherine').

2. Naples, Galleria Nazionale, Capodimonte, in storage, canvas, 1·10 × 0·76 m., mediocre copy. The item in the Farnese inventory of 1680 at Parma may be a lost original or this copy (Campori, 1870, p. 224). *Bibliography:* C. and C., 1877, II, p. 445 (copy of the Leningrad picture); Rinaldis, 1911, II, pp. 157–158, no. 81; *idem*, 1927, p. 341 (copy); photo Anderson, no. 5618.

3. New York, private collection, canvas, 1·04 × 0·925 m., later replica of the Leningrad picture with slight variations in the draperies; probably workshop of Titian; apparently restored. *Bibliography:* Suida, 1952, pp. 28–30 (Titian's original); Valcanover, 1960, I, p. 103 (uncertain attribution).

4. Unknown location, weak copy, 38½ × 30¾ inches, said to come from the Borghese Collection, Rome (not among the first 410 pictures of the Borghese Inventory of 1693 published by Pergola, 1964); purchased from Buchanan by Lord Radstock (Buchanan, 1824, II, p. 179), sale, London, Christie's, 12 May 1826, no. 53, 39 × 31 inches; Captain Gillam; Sir John Pringle; Mr. Charles Geel; Sedelmeyer, Paris (sale 1913, no. 65); exhibited at Detroit Institute of Arts, February 1928, cat. no. 12, 1·00 × 0·80 m. lent by Norbert Fischmann, Munich.

5. Other poor copies, too bad to be considered: J. B. Renier, Copenhagen; Stewart sale, New York, 23–31 May 1887, no. 181; E. Bührle, Zurich, canvas, 1·00 × 0·80 m. (photographs in the Frick Library, New York, and the Courtauld Institute, London).

69. Madonna and Child accompanied by SS. Mark, Alvise, Bernardino, and Marina with Andrea Gritti as donor (destroyed)

Venice, Ducal Palace, Sala del Collegio.
Dated 1531.

Marino Sanuto first saw the picture on 6 October 1531, and he records a legend to the effect that St. Mark presented the three other saints to the Madonna in order to resolve an argument as to which one aided in the election of Andrea Gritti as doge of Venice ('Io vidi in Colegio il quadro nuovo posto con la persona et effigie di questo Serenissimo, qual se inzenochia davanti una Nostra Donna col putin in brazo, et San Marco lo apresenta, e dadrio la Nostra Donna è tre santi, San Bernardin, Sant' Alvise et Santa Marina; et è stà comentado che tra questi tre santi vene diferentia chi lhoro l'havea fatto doxe. San Bernardin diceva: "Fo electo nel mio zorno"; Santa Marina diceva: "É stà electo per haver recuperà Padoa nel

mio zorno a di 7 di luio"; Santo Alvise diceva: "Et io son il nome di sier Alvise Pisani procurator suo consolo qual erra nel XLI, et lui fo causa di farlo doxe." Unde San Marco, visto questa diferentia tra li tre santi per lo apresenti a la Nostra Donna e il Fiol, per terminar qual di lhoro è stà causa di la electione al ducato di Soa Serenità. È bel quadro fatto per Ticiano pitor et è stà bello il commento fato, dil qual ne ho voluto far memoria.'

Destroyed in the fire of 1574 (Sansovino, 1581, p. 117ᵛ.), this important lost work is known in an anonymous print (Tietze, 1936, I, Taf. 18) where Doge Francesco Donato's features are substituted for those of the original donor Andrea Gritti. Van Dyck's drawing in the 'Italian Sketchbook' (folio 93ᵛ) is derived from this print. The composition was one of major significance inasmuch as it served as a prototype for other votive pictures such as Tintoretto's large picture of *Madonna and Saints with Andrea Gritti*, which replaced the destroyed work. The series of steps provided a monumental platform for the Madonna and accompanying saints with the kneeling donor at the left.

Bibliography: See text above; Sanuto, LV, column 19; Vasari (1568)–Milanesi, VII, p. 437; Ridolfi (1648)–Hadeln, I, p. 164; C. and C., 1877, I, pp. 356–357, 454; Hadeln, 1913, pp. 234–238; Hadeln, 1930, p. 489; Tietze, 1936, I, p. 134, Taf. 18, II, p. 311; Valcanover, 1960, I, p. 84.

Drawing: Florence, Uffizi, study for St. Bernardino, and on the reverse two studies for the drapery of the doge (Hadeln, 1913, p. 237, 1924, pl. 23; Hans and Erica Tietze, 1936, p. 191, notes 23, 24).

70. Madonna and Child Appearing to SS. Peter and Andrew　　　　Plates 46, 48

Canvas. 4·56×2·70 m.

Serravalle (Vittorio Veneto), Santa Maria Nuova.

Signed on the stone in the centre: TITIAN [VS]

Titian and workshop.

Documented 1542–1547.

This gigantic composition is calculated to be seen at a distance in the high altar of the church, where it still stands as originally intended. The large scale and breadth of effect forecast the altar at Medole, painted a few years later, in 1554. The colours have inevitably darkened with time, the yellowish light behind the Madonna being deeper and the blue of the sky turning to grey. St. Andrew at the left (who carries a Latin cross rather than his normally X-shaped one), in a neutral green tunic and broad orange-rose drapery, is balanced by St. Peter at the right, in a light-grey tunic with yellow drapery turning to rose in the shadows.

Here as in the early *Madonna and Saints* (Plate 24) at Ancona the general form of the composition is derived from Raphael's *Madonna of Foligno*, but even more striking is the literal quotation in the seascape from Raphael's tapestry design for the *Miraculous Draught of Fishes*.

History: Although ordered in 1542 the picture was not finished until 1547, a fact which is obvious because of the pronounced influence of Raphael's pictures in Rome, which Titian saw in 1545. Final payments were not concluded until 1553.

Bibliography: Ridolfi (1648)–Hadeln, I, pp. 203–204 (with ode to the picture by Guido Casoni); C. and C., 1877, II, pp. 145–149, 499–502; Gronau, *Titian*, 1904, pp. 163–164, 296; Monsignore Crico, 1833, pp. 266–272 (description of the picture and the date 1542); Suida, 1935, pp. 128, 178; *Mostra di Tiziano*, 1935, no. 70; Tietze, 1936, I, pp. 189, 197, II, p. 309 (mainly workshop); Berenson, 1957, p. 192 (under Vittorio Veneto; partly Titian); Valcanover, 1960, II, pl. 12 (workshop).

71. Madonna and Child with SS. Peter and Paul, triptych　　　　Plate 51

Canvas. Centre: 2·22×0·80 m.; Sides each: 1·98×0·61 m.; Lunette, Dead Christ Supported by an Angel: 0·80×0·80 m.

Castello di Roganzuolo (Veneto), San Fior.

Workshop of Titian.

Documented 1543–1550.

Photographs of the triptych published after World War I show that the Madonna and St. Peter were almost totally defaced while buried during the Austrian occupation and that what remains today is modern restoration. The Madonna's long brown cloak, which was blue over a red dress according to descriptions by Monsignore Crico (1833) and Crowe and Cavalcaselle (1877), can only be explained as a misunderstanding on the part of the restorer. Nevertheless, he retained the proper colours for her rose tunic and for St. Peter's yellow cloak over a blue-grey robe. Even the figure of St. Paul is extensively retouched, and one can be confident only that the general plan of the triptych is Titian's. Notwithstanding the Titianesque physical types and poses, modern restorers

must have been responsible for the hard, tubular folds of the drapery throughout. In general the broad vigorous style of the figures corresponds to the altarpiece at Serravalle (Plate 46), with which the Roganzuolo triptych is contemporary.

History: The contract with Titian in 1543 (documents first published by Crowe and Cavalcaselle, but Gardin corrected them and added more) for a triptych and the agreement of the church to pay for it with wine, wheat, and building materials for a small house as well as manual labour, leaves no doubt that Titian supplied the altar, even though it was painted by assistants. In 1557 payments had not yet been completed. The fact that Orazio Vecellio agreed in 1575 to supply a standard (*gonfalone*) representing St. Peter and St. Paul led Crowe and Cavalcaselle to propose that the pictures of the two saints might be by Orazio. However, the style corresponds to that of Titian's workshop in the fifteen-forties rather than to Orazio's thirty years later.

Bibliography: Crico, 1833, pp. 234–238 (includes the date of 1544); C. and C., 1877, II, pp. 100–101, 500–501; Antonio Gardin, 1883 (new correct data and violent rejection of the opinions expressed by Crowe and Cavalcaselle); Gronau, *Titian*, 1904, pp. 164–165 (Titian); Moschetti, 1932, pp. 321–327; Tietze, 1936, II, p. 286, and 1950, p. 368 (ruined); Valcanover, 1960, II, p. 67, pl. 159 (workshop).

72. Madonna and Child with SS. Stephen, Jerome and Maurice Plate 15

Canvas. 1·08 × 1·32 m.

Paris, Louvre.

About 1520.

Except for the peculiar face of the Child and His ugly feet, which can be explained by extensive and faulty restoration, this picture is very handsome, one of the two major versions, the other being in Vienna. The Madonna in a red tunic, blue-green mantle, and pale-tan veil is very lovely. The long-bearded St. Jerome, dressed in the cardinal's red, and the two youthful saints express the contemplative Giorgionesque mood of Titian's early works. In Van Dyck's 'Antwerp Sketchbook' (Jaffé, 1966, II, 63ᵛL) his copy of the Louvre picture, which he saw in the Aldobrandini collection in Rome, contains an additional head of St. Joseph against the curtain at the left.

Condition: Badly damaged in 1665 (see History); numerous losses, extensive old repaint and old discoloured varnish; in a generally lamentable state. The head of St. Joseph (see above) must be overpainted.

History: Certainly from the d'Este Collection, Ferrara, which Cardinal Pietro Aldobrandini brought to Rome in 1598; Inventory of Pietro Aldobrandini, 1603, no. 16, 'Una Madonna con S. Girolamo et altri santi, del sudetto Titiano' (D'Onofrio, 1964, p. 18); Inventory ordered by Olimpia Aldobrandini Aldobrandini, 1626, no. 16, 'Una Madonna con S. Girolamo et altri Santi di mano di Titiano . . .' (Pergola, 1960, p. 428); a Madonna with SS. Jerome and Lawrence by Titian cited by Ridolfi in the collection of Cardinal Aldobrandini (Ridolfi (1648)–Hadeln, I, p. 197); inherited from Cardinal Ippolito Aldobrandini (d. 1638) by his niece Olimpia Aldobrandini Borghese Pamphili; gift of Prince Pamphili to Louis XIV in 1665, brought to Paris by Bernini; the picture is described as badly damaged by water on the journey: 'le tableau de Titien qui est une Vierge avec un petit Christ et quelques autres saints à demi corps. Ils se sont trouvés tous si gâtés qu'on n'y connaissait presque plus rien' (Chantelou, edition 1930, p. 213); Le Brun Inventory of Versailles, 1683, no. 188 ('Notre Seigneur, la Vierge, St. Etienne et St. Hiérosme'); 1695 and 1696 still at Versailles; at Meudon, 1706; Louvre, 1737; Versailles, 1752 and 1760 (Bailly-Engerand, 1899, p. 80, full history).

Bibliography: See also History; Lépicié, 1752, pp. 21–22 (identified St. Jerome as St. Ambrose); Villot, 1874, p. 282, no. 458; C. and C., 1877, I, pp. 107–108 (early Titian); Louvre catalogue, no. 1577, inventory no. 742; Gronau, *Titian*, 1904, pp. 282–283 (Titian); Seymour de Ricci, 1913, p. 157 (Titian); Hetzer, 1920, pp. 86–88 (unknown Venetian); Suida, 1935, pl. 84b (replica); Tietze, 1936, II, p. 305 (workshop repetition of a lost original); Berenson, 1957, p. 189 (Titian); Valcanover, 1960, I, p. 99 (incorrect provenance; workshop replica).

COPY:

Florence, Casa Bicchierai, late careful copy (photo, London, Courtauld Institute).

VARIANTS:

1. Cracow, State Museum, 'Madonna and Child (after Louvre picture) with SS. Catherine and John the Baptist', canvas, 0·74 × 1·15 m., from the Pininski Collection (Bialostocki and Walicki, 1957, fig. 83).

2. Milan, Ambrosiana Gallery, canvas, 0·71 × 1·04 m., version by a follower of Titian, 'Madonna and Child with SS. John the Baptist and Cecilia'; the Madonna and Child are weakly copied from the Paris original; very

dirty, patched and heavily varnished; gift of Cardinal Federico Borromeo in 1618 as Titian (*Guida sommaria*, 1907, p. 132 and no. 14).

3. Unknown location, formerly Ancona, Storiani Collection, 'Madonna and Child with St. Cecilia and St. John the Baptist', 1 *braccia* × 1⅓ *braccia*, Inventory 1749 (Elia, 1936, p. 82; 1943, p. 7).

73. **Madonna and Child with SS. Stephen, Jerome, and Maurice** Plate 16

Panel. 0·925 × 1·38 m.

Vienna, Kunsthistorisches Museum.

Titian and workshop.

About 1520.

The quality seems at least equal to that of the Louvre version, from which it differs in colour in the extensive yellow lining of the Madonna's blue cape. The hardness of the painting of the Madonna's face (retouched) accounts for the usually low estimate of the picture, but Titian's share certainly predominates.

Condition: Blistered paint and numerous cracks; the figure of the Child much damaged and retouched, particularly the face and right arm; the Madonna's hand also repaired.

History: Venice, Bartolomeo della Nave until 1636 (Waterhouse, 1952, p. 15, no. 16); Vienna, Archduke Leopold Wilhelm, 1659 (Inventory, p. XCIV, no. 129; Teniers, 1660, pl. 68); taken to Paris in 1809; returned to Vienna in 1815.

Bibliography: See also History; Boschini, 1660, p. 40 (Titian); Storffer, 1730, II, no. 266; Mechel, 1783, p. 30, no. 59; C. and C., 1877, I, pp. 107–108 (superior to the Louvre version); Engerth, 1884, p. 343 (Titian); Ricketts, 1910, pp. 50, 175 (better than Louvre picture); Hetzer, 1920, pp. 86–87 (not Titian); Suida, 1935, pp. 25, 163, pl. 84a (Titian); Tietze, 1936, II, p. 315 (workshop replica of a lost original); Berenson, 1957, I, p. 191 (replica of Louvre picture, partly by Titian); Valcanover, 1960, I, p. 99 (workshop replica); Klauner and Oberhammer, 1960, p. 136, no. 710 (Titian).

LOST VERSION:

The small panel listed as no. 496 in the Aldobrandini collection in Rome in 1682: 'Un quadro in tavola in forma mezzana con la Madonna a sedere, che tiene il Bambino sopra il Ginocchio con tre altri Santi, uno de

quali ha un libro in mano alto pmi due e mezzo . . . di Titiano' (Pergola, 1963, p. 176). Pergola wrongly identifies this panel with the 'Madonna con S. Girolamo et altri Santi, del sudetto Titiano', no. 16 in the Inventory of 1603, which reappears with identical title under the same number in the Inventory of 1626. Titles characteristically do not change from inventory to inventory of the Aldobrandini collection. No. 16 is the Paris version (see above) which left the Aldobrandini collection in 1665.

WRONG ATTRIBUTIONS, Variants:

1. Middlebury (Vermont), A. Richard Turner, canvas, 0·762 × 1·168 m., inherited from F. J. Mather, Princeton; attributed to Pordenone (Berenson, 1957, p. 145).

2. Unknown location, Madonna and Child with SS. Barbara, Zaccharius and a Donor, all half to three-quarters length, a potpourri of figures adapted from Titian; probably a Baroque forgery by Pietro della Vecchia (Suida, 1943, pp. 355–356, illustrated as Titian). Suida (1959–1960, p. 66) insisted that it was the picture cited by Boschini as in the Scuola dei Sarti. However, the description does not correspond closely enough to justify such a theory (Boschini, 1674, Canareggio, pp. 15–16, as by Giorgione, the Madonna with SS. Joseph, Barbara and a donor; Zanetti, 1733, p. 368, repeats Boschini; Zanetti, 1792, p. 122).

74. **Madonna of Mercy** Plate 200

Canvas. 1·54 × 1·44 m.

Florence, Pitti Gallery.

Workshop of Titian.

About 1573.

The adorers beneath the Virgin's cloak include Titian and his family, most of the men being in black except for a youth in a red jerkin, while one lady wears a white mantle and brown veil. In 1573 the Duke of Urbino ordered a picture of this subject which his letter describes as 'una Madonna in piedi che sotto il manto habbi numero di gente . . .'. Although most critics have considered the quality to be too mediocre for Titian, the documents clearly indicate that the artist must have supplied the design, as Gronau and Tietze-Conrat have insisted. Formerly under Marco Vecellio in the Pitti Gallery, it is now labelled Titian and school.

History: Duke of Urbino, letter of 1573 (Gronau, 1936, pp. 66, 107) brought to Florence in 1631 by Vittoria della Rovere on her marriage to Duke Ferdinand II dei Medici.

Bibliography: See also above; Tietze-Conrat, 1946, pp. 87–88 (Titian and workshop); Francini Ciaranfi, 1956, p. 43, no. 484; Berenson, 1957, p. 185 (partly Titian); Valcanover, 1960, II, p. 74, pl. 184 (workshop).

75. Man of Sorrows
Plate 63

Canvas. 0·56×0·81 m.

Venice, Scuola di San Rocco.

About 1510.

Very Giorgionesque and unlike the *Christ Carrying the Cross* (Plate 64) in the same room, but in slightly better condition, this canvas is also faded and most difficult to judge.

The iconography maintains the mediaeval type of the *Man of Sorrows* in half length, which was especially favoured in Germany and northern lands (see Panofsky, 'Imago Pietatis', *Festschrift für Max J. Friedländer*, Leipzig, 1927, pp. 261–308). At the upper left are the letters YHS and at the upper right xƒs.

Condition: Darkened and poorly preserved; difficult of attribution.

History: Marcantonio Michiel in 1532, referring to the house of Antonio Pasqualino, records a portrait of Christ in S. Rocco by some pupil of Giorgione ('La testa del S. Jacomo cun el bordon fu de man de Zorzi da Castelfranco, over de qualche suo discipulo ritratto del Cristo de S. Rocho'; Michiel, edition 1888, p. 80). It is also possible that Marcantonio had in mind another picture, *Christ Carrying the Cross* (Cat. no. 22).

Bibliography: C. and C., 1877, I, pp. 58–60 (Titian); *Mostra di Tiziano*, 1935, no. 1 (early Titian); Suida, 1935, p. 21, pl. 299a (early Titian); Tietze, 1936, II, p. 314 (undecided); Berenson, 1957, p. 191 (early, with interrogation); Valcanover, 1960 (omitted); Heinemann, 1960, no. 168m (Titian after a composition by Giovanni Bellini).

76. Mater Dolorosa with Clasped Hands
(half length)
Plate 101

Panel. 0·68×0·61 m.

Madrid, Prado Museum.

Not signed.

About 1555.

Although the *Mater Dolorosa* with the clasped hands is related iconographically to the lost Titian which is known only in Bertelli's print (Plate 219) and in copies, the pose differs notably in that the Madonna looks upward rather than down. The costumes vary markedly also in that the Prado figure wears an open-throated rose tunic, an abundant blue cloak, and a brown headdress over a white veil, which acts as a wide frill around the face. On the other hand, the costume of the lost *Mater Dolorosa* with its high-throated wimple is suggestive of a nun's garb.

Condition: Much better preserved than the *Mater Dolorosa with Raised Hands* (Cat. no. 77), although various small losses of paint have been repaired.

History: Probably the work mentioned 7 March 1555 (Beer, 1891, no. 8430; Cloulas, 1967, p. 228), not at Augsburg in 1550; sent from Brussels to Yuste in 1556 as 'Notre Dame de Pitié faict desus bois par Tisiane' (Gachard, 1885, II, p. 91); Yuste Inventory, 1558, no. 406, a single item, annotated in margin as taken away by Philip II (Sánchez Loro, 1958, III, p. 507); sent to the Escorial in 1571 as by Raphael, formerly Charles V's (who had no Dolorosa by Raphael) 'belo leonado y un manto azul', panel 2¾×2¼ *pies* (Zarco Cuevas, 'Inventario', 1930, p. 41, no. 973); the later history of this picture at the Escorial is confused, since this *Dolorosa* by Titian may have been paired with a copy of Titian's *Ecce Homo* (see Cat. no. 34, Lost Pictures). This picture, Prado no. 443, is most probably the *Dolorosa* that hung unpaired in the Iglesia Vieja of the Escorial in 1776 (Escorial, *Documentos*, V, 1962, p. 262, no. 31) and is called 'María' in 1800 (Ceán Bermúdez, V, p. 43); finally taken to the Prado in 1839.

Bibliography: Mater Dolorosa on wood: Madrazo, 1843, p. 97, no. 465 (from the Escorial); 'Inventario general', 1857, p. 92, no. 465 ('N. Sra. de los Dolores... con manos cruzadas'; from the Escorial); C. and C., 1877, II, pp. 270–271 (Titian); Gronau, *Titian*, 1904, p. 306 (studio!); Tietze, 1936, I, p. 197, II, p. 297 (Titian, 1550); Beroqui, 1946, pp. 121–122 (incorrectly said to be prototype of Uffizi copy; see Cat. no. 78, copy 2); Berenson, 1957, p. 188 (Titian); Valcanover, 1960, II, pl. 37 (datable 1550); Prado catalogue, 1963, no. 443 (old no. 475).

77. Mater Dolorosa with Raised Hands
(half length)
Plate 97

Marble. 0·68×0·53 m.

Madrid, Prado Museum.

1554.

The inscription in small block capitals in the lower left corner is not a signature, despite the statement in the

Prado catalogue: TITIAN (fragmentary). The extraordinary pictorial beauty of this panel and its depth of emotional expression place it among Titian's finest religious pictures. The neutral plum-coloured tunic and blue mantle glow resplendently in contrast to the soft white wimple and veil.

Condition: The paint has suffered greatly from scratches and blisters. Even the eyes, nose, and mouth of the Madonna, damaged long ago, have been retouched.

History: This work was expressly intended by Titian to be a companion piece to the *Ecce Homo* on slate (Plate 96), which he had delivered to Charles V in 1548. Francisco Vargas, the ambassador of Spain to the Venetian state, in a letter from Venice 30 June 1553 remarks that Titian will paint a *Dolorosa* to match the *Ecce Homo* but that the artist does not know the size of the latter (C. and C., 1877, II, pp. 506–507; Cloulas, 1967, p. 220); sent to Charles V at Brussels 15 October 1554 (C. and C., 1877, II, p. 508; Cloulas, 1967, p. 225); Titian's undated letter to Charles V mentions his satisfaction that the *Dolorosa* pleased the Emperor (Ridolfi (1648)-Hadeln, I, p. 185; Ticozzi, 1817, p. 310); this picture was shipped from Brussels to Yuste in 1556 as 'Notre Dame de Pitié desus pierre' attached in a diptych to a 'Notre Seigneur sur bois' (Gachard, 1885, p. 91); the Yuste Inventory 1558, no. 405, clarifies the situation by explaining that the companion panel was a *Christ Carrying the Cross* by Maestre Miguel [Coxie] (Sánchez Loro, 1958, III, no. 507 L); in 1574 at the Escorial Titian's *Ecce Homo* and *Mater Dolorosa* were joined together in a diptych (Zarco Cuevas, 'Inventario', 1930, p. 44, no. 1000). In 1600 they appear in the Oratory of the Alcázar at Madrid. For their joint history thereafter see *Ecce Homo*, Prado, no. 437 (see above, Cat. no. 32). Both were transferred to the Prado Museum in 1821.

Bibliography: Madrazo, 1843, p. 204, no. 922 (pizarra!); no provenance given; 'Inventario general', 1857, p. 193, no. 922, companion of no. 914 (no provenance given); C. and C., 1877, II, pp. 232–233, 270–271, 507–508 (Titian); Gronau, *Titian*, 1904, p. 305 (Titian); Tietze, 1936, I, p. 197, II, p. 297 (Titian); Beroqui, 1946, pp. 121–123 (history confused); Berenson, 1957, p. 188 (studio!!); Valcanover, 1960, II, pl. 55 (Titian); Prado catalogue, 1963, no. 444.

COPY:

Villandry, Carvalho Collection (formerly) panel (Plate 215), inscribed at the left: TITIANVS F. From the collection of Señor de Alava, Seville (Amaudry, 1904–1905, pp. 95–96). Amaudry claims that the Carvalho picture is the original and the Prado example a copy. Although such a theory is untenable, the really handsome Carvalho panel may well be one of the various replicas recorded in the seventeenth and eighteenth centuries at the Escorial, possibly the item on slate (*sic*) above the principal stairway in 1764 and 1800 (see above, Cat. no. 34, lost picture 3).

78. **Mater Dolorosa** (Teniers type) (lost)

This lost item may have been the original of which so many copies survive. The type (Plate 99) differs from the *Mater Dolorosa* recorded in Bertelli's print (Plate 219) in the arrangement of the headdress. *History:* Bartolomeo della Nave, Venice; Duke of Hamilton, Glasgow, 1639 (Waterhouse, 1952, p. 20, no. 205); Archduke Leopold Wilhelm, Vienna, Inventory 1659 (p. XCVIII, no. 200, as a copy of Titian, 4 Spann × 3 Spann 3 Finger (0·832 × 0·686 m.), paired with the *Ecce Homo*, no. 199, which is now in Sibiu, Roumania; see Cat. no. 33); engraved by Stampart and Prenners (1735), edition 1888, pl. 24, as Titian; also known as a detail in Teniers' painting, *Leopold Wilhelm's Gallery*, in the Kunsthistorisches Museum at Vienna (Engerth, II, 1892, p. 474, no. 1290).

COPIES:

1. Cracow, University Art Institute, canvas, 0·82 × 0·68 m.; the grey mantle over the red tunic replaces the canonical blue. *History:* Duchesse de Berry, Palazzo Vendramin, Venice (sale, Paris, Hôtel Drouot, 19 April 1865, no. 171); F. J. Gesell, Vienna, until 1872; Frederick Schwarz, Vienna, 1872; Rogawski Collection, Cracow; donated to the University (Peez, 1910, pp. 26–27).
2. Florence, Uffizi, canvas, 0·63 × 0·57 m. (Fischel, fifth edition, 1924, pl. 266, studio; Peez, 1910, pp. 24–25).
3. Genoa, private collection, canvas, 0·85 × 0·69 m., attributed to Luca Cambiaso, *c.* 1583 (Griseri, 1959, pp. 313–315, reproduction).
4. Hampton Court Palace, in storage, no. 149, panel, 0·775 × 0·615 m. The inscription in capitals at the upper right, 'LA SCONSOLATA', suggests that this wretched copy was done in Italy rather than in England. An escutcheon on a red seal is preserved on the back of the panel (Law, 1881, p. 25, no. 76).
5. Padua, San Gaetano, Oratory, panel, 0·49 × 0·385 m., weak copy; gift of Catarina Vicentina Scarella, 1650 (Moschini, 1817, p. 115; C. and C., 1877, II, p. 271, school; Peez, 1910, pp. 28–29, school).

6. Tarnobrzeg, Prince Tarnowski, canvas, 0·475×0·315 m.; purchased in Rome in 1803–1804 (Peez, 1910, pp. 31–32).

7. Unknown location, panel, 0·735×0·585 m., follower of Titian, sixteenth century, inscribed: TITIANVS. This picture (Plate 99) appears to be the best extant example of the type once owned by Archduke Leopold Wilhelm. *History*: Prince Borghese, Rome (?) (Buchanan, 1824, II, p. 123; not in the Borghese Inventories published by Rinaldis, 1936, and Pergola, 1964 and 1965); Walsh Porter (sale, London, Christie's, 21 June 1811, no. 26); Jacob Fletcher, Allerton, near Liverpool (Waagen, 1857, p. 420, Titian); Sir Lionel Fletcher, London; A. L. Nicolson, London, 1924; P. Jackson Higgs, New York, 1924 (Hadeln, 1924, p. 179, Titian; exhibited Detroit Institute of Arts, February 1928, no. 18, Titian; Suida, 1935, pp. 131, 180, Titian).

8. Venice, Monsignore Luigi Vason, canvas, 0·60×0·50 m., academic copy, Teniers type (Malagola, 1909, p. 11, illustration; Peez, 1910, pp. 25–26).

9. Venice, San Zaccaria, canvas, 0·81×0·63 m. (C. and C., 1877, II, p. 271, school; Peez, 1910, p. 25; illustration in *Archivo español de arte*, XXVIII, 1955, p. 357, pl. VI).

10. Vienna, Dr. A. von Peez, canvas, 0·63×0·53 m., German or Dutch copy. Peez claimed that his picture was Titian's original, which is recorded in Bertelli's print. That theory is totally unacceptable, since the original went to Spain (Gerola, 1908, pp. 455–456; Tietze, 1909, pp. 313–315, workshop or school; Peez, 1910, pp. 32–37).

11. Zara, Santa Maria, panel, 0·45×0·35 m., copy, paired with a copy of the same size of the *Ecce Homo* also on panel (Peez, 1910, p. 30).

WRONG ATTRIBUTIONS: (non-Titianesque)

1. Madrid, Museo Cerralbo, *Mater Dolorosa*, canvas, 0·84×0·685 m., as Titian; Venetian school, *c.* 1580. This figure bends backward, eyes heavenward, hands clasped; unrelated to Titian's compositions of the theme. Formerly Principe di Fondi, Naples (Mayer, *L'Arte*, 1935, pp. 374–375, Titian; Valcanover, 1960, II, p. 69, doubtful).

2. Unknown location, formerly Berlin, Benedict and Co. A picture of exactly the same type as no. 1 above attributed by Mayer on this occasion to Palma Giovane (1928, pp. 183–185).

Mater Dolorosa, see also: Ecce Homo and Mater Dolorosa, Cat. no. 34, lost pictures and Cat. no. 35.

Nativity (Adoration of the Shepherds)

A picture of this subject by Titian was placed temporarily on the high altar of St. Mark's in Venice for the wedding festivities of the duke of Ferrara, Alfonso II d'Este, and his third wife, Margherita Gonzaga; fire destroyed it the following day, 19 January 1578 (Cicogna says 1579/80). Not even a contemporary description survives to clarify its relationship to other compositions of the same subject. The document reads as follows: 'Il giorno seguente vennero in Chiesa di San Marco a Messa e videvo il Vescovo; finita la Messa s'accero il fuoco nel feston che era all'altar grande e s'abbruccio il quadro che era sopra il Volto che era di Titiano bellissima pittura che rappresentava il nascimento del Signor Nostro' (see below, Bibliography).

The frescoes painted in the principal church of Cadore by Titian's pupils after the master's designs in 1566–1567 included a *Nativity*. Destroyed in 1813, when the church was demolished, the pictures were seen and described by Ticozzi (1817, pp. 238–241) and perhaps seen by Northcote (1830, II, pp. 301–304), who almost literally translates passages in the Italian's book. The vagueness of these descriptions does not definitively establish Crowe and Cavalcaselle's assumption (1877, II, p. 379) that the *Nativity* had much the same composition as Master I. B.'s and also Bertelli's print, which corresponds to the panels in the Pitti Gallery and in Christ Church at Oxford. In addition, the Cadore description includes angels above in the clouds which do not appear in the preserved works.

Bibliography: Cicogna, 1834, IV, p. 333, note 220; also VI, 1853, p. 825 (Cicogna gives the source of the document as 'Annali veneti', MSS. Codice mio, no. 1007. The item, now in the catalogue of the Biblioteca Correr, Venice, reads as follows: 'Diarii delle cose pubblici di Venezia, 1578–1583', Codex 2555 (old number 1007), folio 26 (unnumbered). The codex is an eighteenth-century compilation of sixteenth-century diaries, the originals of which might still exist. The section cited above is called 'Relatione del Contarini 1578').

79. Nativity (Adoration of the Shepherds)

Panel. 0·93×1·13 m.

Florence, Pitti Gallery.

Ruined original by Titian, 1532–1533.

In 1532–1533 Titian sent a *Nativity* to the Duke of Urbino at Pesaro. When the Urbino Collection came to Florence in 1631 it included the panel (no. 44) which is

now in the Pitti Gallery. Gronau drew attention to the citation of it in the Inventory of Vittoria della Rovere's possessions in 1646 (no. 58) and later in an inventory at Poggio Imperiale in 1694 (no. 623). There is every historical reason to believe that the panel in the Pitti Gallery is the ruined original by Titian.

In spite of the print by Master I. B. and of all the evidence, Mary Pittaluga concluded that the composition was an invention of Jacopo Bassano, primarily because the shepherd doffing his hat appears in Jacopo Bassano's *Adoration of the Shepherds* at Hampton Court, which is, however, later, *c*. 1550. Tietze pointed out that a similar figure appears earlier in 1528 in the mural by Giovanni da Asolo in the Scuola del Santo at Padua (illustrated by Fiocco, *Bollettino d'arte*, VI, 1926–1927, p. 313). Hence the shepherd must be derived from a still earlier composition by Titian or some other Venetian.

Condition: The picture, in a totally ruinous state, has been under restoration for several years; not exhibited.

History: 1532–1533, Duke of Urbino, Pesaro and Urbino; brought to Florence by Vittoria della Rovere in 1631 on her marriage to Ferdinand II dei Medici. See also above.

Bibliography: Not in Vasari; C. and C., 1877, II, p. 379 (copy); documents in Gronau, 1904, pp. 4, 9; Berenson, 1932, p. 570, and 1957, p. 185 (ruined); Pittaluga, 1933, pp. 297–304 (copy); Gronau, 1937, pp. 289–290 (Titian); Hans and Erica Tietze, 1936, pp. 142–144 (copy); Suida, 1935, p. 61 (Titian); Tietze, 1936, I, pp. 155–156; II, p. 288 (copy); Valcanover, 1960, I, p. 100, pl. 213b (attributed).

PRINTS:

Woodcuts by Boldrini and Master I B (Plate 85). *Bibliography:* C. and C., Italian edition, 1878, II, p. 571; Pittaluga, 1933, pp. 298–299, illustration; Mauroner, 1941, no. 16, pl. 28.

COPY:

Oxford, Christ Church, panel, 0·937×1·12 m. (Plate 86). In spite of its provenance from the Gonzaga Collection and from that of Charles I (his initials 'C R' on the back), the small panel could never have been of high quality, even discounting its present lamentable condition. *History:* Gonzaga Collection, Mantua, Inventory 1627 (Luzio, 1913, p. 114, no. 302); Charles I, London (Ridolfi (1648)–Hadeln, I, p. 196); said to have belonged to Crozat, sale 1751 (Blanc, 1857, I, p. 63; Stuffmann, 1968,

p. 76, no. 153); John Guise, bequest to Christ Church in 1765. *Bibliography:* C. and C., 1877, I, pp. 379–380 (repainted copy); Borenius, 1916, no. 188 (copy); Berenson, 1957, p. 189 (studio); Byam Shaw, 1967, p. 67, no. 79, pl. 70; see also bibliography of the Pitti version above.

DERIVATIONS:

1. Florence, Corsini Gallery. A late copy of the print or of the Pitti version; once in the Corsini Gallery, it was no longer there in 1964 (Pittaluga, 1933, p. 304).

2. Florence, Pitti Gallery, a reproduction in miniature, datable *c*. 1631–1632, painted by G. B. Stefaneschi (1582–1659) (del Bravo, 1961, p. 52, figs. 42a and 42b).

DOUBTFUL ATTRIBUTIONS:

1. Leningrad, Hermitage, *Nativity*, panel, 0·489×0·40 m., school of Giorgione. *History:* Imperial Palace, Gatchina. *Bibliography:* Liphart, 1915, p. 7 (Cariani); Berenson, 1932, p. 571 (Titian, early); *idem*, 1957, p. 86 (Giorgionesque); Tietze and Tietze-Conrat, 1949, p. 12, illustration (possibly the picture by Giorgione mentioned in Giovanni Grimani's Inventory of 1563); Heinemann, 1960, no. 98e, fig. 604 (Domenico Mancini?).

2. Raleigh (North Carolina), North Carolina Museum of Art, *Nativity*, panel, 0·191×0·162 m., school of Giorgione. The composition repeats that of the larger version in the Hermitage at Leningrad, which is there attributed to the school of Giorgione. The Raleigh picture has barely survived in fragmentary condition so that any judgment is hazardous, particularly the attribution to Titian held at the museum. *History:* Contini Bonacossi, Florence; Kress Collection, 1952. *Bibliography:* Suida, 1954, p. 155, fig. 166 (Titian); Zampetti, 1955, no. 75 (Titian); Morassi, 1955, p. 151, fig. 7 (Giorgione); Fiocco, 1955, p. 136 (Giorgionesque); Berenson, 1957, I, p. 86 (Giorgionesque copy of the Leningrad picture); Shapley, 1965, p. 84 (Titian); Shapley, 1968, pp. 185–186 (ascribed to Titian).

3. Stuttgart, Staatsgalerie, *Nativity*, canvas, 1·305×1·785 m., Venetian school, sixteenth century. The composition does not repeat that of Titian, preserved in Master I B's print (see Plate 85). *Bibliography:* Berenson, 1932, p. 575; *idem*, 1957, p. 190 (Titian's studio); *Stuttgart*, 1962, pp. 235–236 (follower of Tintoretto; formerly Barbini Breganza collection; acquired by Stuttgart in 1852).

LOST ITEMS:

1. Brescia, *Nativity* by Titian for sale in Brescia in 1687 (Campori, 1870, p. 335).

2. Venice, *Nativity* by Titian owned by the painter Gamberato at Venice in 1648 (Ridolfi (1648)–Hadeln, I, p. 153).

3. Venice, *Nativity* by Titian offered to Pope Clement IX by Paolo del Sera of Venice in 1667 (Muraro, pp. 73, 83).

4. Vienna, Archduke Leopold Wilhelm (Teniers, 1660, print by Boll, pl. 70; same composition as Plate 85).

80. Noli Me Tangere Plate 71
Canvas. 1·09 ×0·91 m.
London, National Gallery.
About 1512.

Formerly the theory was widely held that Giorgione began the picture and that Titian completed it. After a study of X-rays and in view of recent cleaning, Gould came to the conclusion that Giorgione must be ruled out altogether. The landscape is no more Giorgionesque than in Titian's *Three Ages of Man* in Edinburgh or his *Baptism* (Plate 65). The X-rays reveal that Christ's pose differed in the first scheme by crossing of the legs in the direction opposite to that finally adopted. Overpainting *c.* 1742 changed the silhouette of the Magdalen's dress, which has now been returned to Titian's design. The buildings at the right in the incomplete landscape are an almost exact repetition of those in the background of Giorgione's Dresden *Venus*, the landscape of which was painted by Titian after Giorgione's death.

Condition: Cleaned in 1957; state of preservation satisfactory.

History: Compiled by Gould, 1959, p. 110: Muselli Collection at Verona (Ridolfi (1648)–Hadeln, I, p. 198; Campori, 1870, p. 178); Marquis de Seignelay (died 1690); Pierre Vincent Bertin (died 1711); Orléans Collection, Paris (1727–1792) (see Orléans, 1727, pp. 477–478); Lord Gower (1798–1802), sale London, 12–13 May 1802, no. 91; Champernowne (1802–1820) (Buchanan, 1824, I, p. 114), sale, 30 June 1820 (Redford, II, p. 257); Samuel Rogers bought it in 1820 and left it to the National Gallery in 1856.

Bibliography: See also History; Waagen, 1854, II, pp. 76–77 (Titian); C. and C., 1877, I, pp. 208–210 (Titian); Hourticq, 1919, pp. 110–111 (Titian); Hetzer, 1920, p. 107 (not Titian); Richter, 1934, pp. 4–16 (Giorgione, finished by Titian); Tietze, 1936, I, pp. 84–85, II, p. 292 (begun by Giorgione); Richter, 1937, p. 225 (Giorgione, finished by Titian); Gould, 1958, pp. 44–48 (Titian);

idem, 1959, pp. 109–111 (Titian); Valcanover, 1960, I, pls. 39, 40 (Titian).

OTHER VERSIONS:
1. Cracow, Czartoryski Museum, copy (Richter, 1937, p. 225).
2. London, Christie's, Hugh A. J. Munro sale, 1 June 1878, no. 128, a small replica; Munro catalogue, 1865, p. 16, no. 47.
3. Valladolid, Colegio de los Ingleses, rector's study, mediocre copy in reverse (Gould, 1959, p. 110; photo in London, National Gallery; reversed copy, i.e., after a print).

DRAWING:
Leningrad, Hermitage, 285 ×145 mm., pen and bistre; suggested as a study for the *Noli Me Tangere* (Salmina, 1964, no. 6); if so, it does not relate to any preserved painting.

81. Noli Me Tangere Plate 103
Canvas. 0·68 ×0·62 m. (fragment)
Madrid, Prado Museum.
1553.

Only the fragment of Christ's head and shoulders remains, but the composition exists in a badly preserved copy by Sánchez Coello (Plate 230). Christ's dark hair and beard appear against a light-blue sky with white clouds, the two colours being repeated in the white tunic and the ultramarine mantle.

Condition: The paint on this fragment is blistered, undoubtedly by the fire in the Escorial in 1671.

History: Painted for Mary of Hungary, a fact stated by Francisco de Vargas, Spanish ambassador, who saw it in Titian's studio in 1553 (letter 30 June 1553; C. and C., 1877, II, p. 506; Cloulas, 1967, p. 220); in the Brussels Inventory of pictures that Mary of Hungary took to Spain in 1556 (Pinchart, 1856, p. 141, no. 36); sent to the Escorial in 1574, already cut down (Zarco Cuevas, 'Inventario', 1930, p. 45, no. 1012); the elder Madrazo discovered it in a storeroom of the Escorial under a storage jar; brought to the Prado in 1839.

Bibliography: See also History; Madrazo, 1843, p. 97, no. 462 (from the Escorial); Poleró, 1857, p. 181, no. 462; 'Inventario general', 1857, p. 91, no. 462; C. and C., 1877, II, pp. 227, 232–233 (Titian); Richter, 1934, pp. 15–

16 (Titian); Suida, 1935, pp. 129, 179, pl. 252 (Titian); Tietze, 1936, II, p. 297 (Titian); Beroqui, 1946, pp. 126–127 (Titian); Berenson, 1957, p. 188 (Titian); Valcanover, 1960, II, pl. 54 (Titian); Prado catalogue, 1963, no. 442.

COPIES:

1. Escorial, canvas, $8\frac{1}{4} \times 8$ feet (2·31 × 2·24 m.), by Sánchez Coello before 1574; sent to the Escorial in 1574 as the Spanish painter's copy of Titian (Zarco Cuevas, 'Inventario', 1930, p. 41, no. 978); Padre de los Santos in 1598 locates it in the Capilla del Vicario (edition 1933, p. 289); Padre Ximénez in 1764 calls it school of Titian (edition 1941, p. 79); Zarco Cuevas, 1931, p. 156, illustration. Plate 230; present dimensions 1·90 × 1·90 m.
2. Schloss Seuslitz, von Harck, canvas, 0·91 × 0·71 m., very poor variant (Hadeln and Voss, 1914–1915, pl. 143; Richter, 1934, p. 15, illustration).

LOST VERSION:

Another version, unfinished, seen by Vasari in Titian's studio in 1566 (Vasari (1568)–Milanesi, VII, p. 458). Milanesi mistakenly identified this item with the picture now in the National Gallery in London. It is probably the version seen by Van Dyck, since he never went to Spain; recorded fully in the 'Italian Sketchbook', folio 23.

Old Testament Subjects, Ceiling Paintings:

82. Cain Slaying Abel Plate 157
Canvas. 2·92 × 2·80 m.

83. Sacrifice of Abraham Plate 158
Canvas. 3·28 × 2·82 m.

84. David Slaying Goliath Plate 159
Canvas. 2·92 × 2·82 m.

(MEDALLIONS):

Evangelists and Fathers of the Church
Canvas. Diameter 0·71 m.

Venice, Santa Maria della Salute, Sacristy.

1543–1544.

All three Old Testament compositions, laid out in long diagonals, are to be seen as a unit and are planned with foreshortened figures intended to be viewed from below (*di sotto in sù*) at a single point. The major picture, the 'Sacrifice of Abraham', which occupies the central position must always have been so located with the smaller scenes above and below. Any attempt to settle the positions of the last two by reference to the order of mention by early writers proves fruitless (Kahr, 1966). When the pictures were transferred from the nave of S. Spirito in Isola to the sacristy of S. Maria della Salute, their original sequence was undoubtedly maintained, in the same order listed above. The long diagonals of the three compositions were clearly intended by the artist to be interrelated. Professor Schulz's suggestion (1968, p. 78, pl. 11) that *Cain Slaying Abel* was hung upside down so as to be viewed from the entrance had precedents in sixteenth-century painting, but such an arrangement destroys the unified design of the three pictures. Critics in general have agreed that Titian's new enthusiasm for spatial illusionism in ceiling decoration was inspired by Giulio Romano's work, which he had seen in both the Ducal Palace and the Palazzo del Te at Mantua (Hetzer, 1923, pp. 237–248).

The possibility that Vasari had made drawings for these pictures which might have influenced Titian has also been proposed (Tietze and Tietze-Conrat, 1944, see below). Vasari's example in his ceiling painted at Venice may well be responsible in major degree for Titian's adoption of central Italian ideas (Schulz, 1961, p. 506, note 29; p. 511). On the other hand, Walter Friedländer recently proposed that Pordenone's frescoes (1532), now totally ruined, in the cloister of S. Stefano at Venice were the direct prototype for Titian's (illustrations in Foscari, 1936, figs. 26–37). In the latter's *David and Goliath* David raises his hands in prayer to God after the giant's head has been severed, while Pordenone's David lifts his sword about to sever the head. The similarity between the two compositions lies in the foreshortened position of Goliath's body. The unusual attitude of David has been explained as the dedication of his sword to God after slaying Goliath, as described by Josephus in *Jewish Antiquities*, c. A.D. 93 (Kahr, 1966, pp. 196–197). Dr. Friedländer also saw dependence upon Correggio's treatment of the same theme, but in the three cases the explanation for relationships may lie in the widespread interest in foreshortening at that period and in common elements of tradition, from which Titian actually diverges in presenting David in prayer rather than wielding either a club or a sword. In the scene of *Cain and Abel* both Titian and Pordenone present Cain swinging his club above the prostrate Abel, but the poses are not similar. Dr. Kahr in her recent study (1966) is also sceptical of Pordenone's influence in these compositions.

All three scenes of the Salute ceiling are Old Testament prototypes for the death and sacrifice of Christ. The colours are predominantly grey and the atmosphere stormy. The powerful, athletic Abraham in abundant rose drapery occupies the centre of the entire scheme.

The eight roundels representing the four Evangelists and the four Fathers of the Latin Church were originally located in the ceiling of the church of S. Spirito in Isola along the sides and perhaps between the three Old Testament scenes (Sansovino-Stringa, 1604, p. 170). They are now hung without order on the walls of the sacristy of S. Maria della Salute. Their mediocre and undeniably workshop quality is explained by their subordinate purpose, just as in the case of the decorative sections of the ceiling in the Scuola di San Giovanni Evangelista (Cat. no. 112). Attempts to identify St. Gregory or one of the other venerable bearded saints as Titian's Self-portrait do not carry conviction nor would such an identification be reasonable at this early date (1543–1544).

Schulz interprets the three scenes iconographically as the *Fall of Man* (Cain and Abel), the *Sacrifice of Christ* (Sacrifice of Abraham), and *Man's Redemption* (David Slaying Goliath) (letter of 16 October 1968; also Schulz, 1968, p. 78).

Condition: The curiously irregular sizes of the three ceiling canvases indicate that they must have been cut down when they were transferred to the present location in 1656. All are badly darkened and apparently covered with varnish; the sky in each case is almost black. The roundels are in ruinous condition.

History: Transferred from S. Spirito in Isola, Venice, in 1656 (Sansovino-Martinioni, 1663, pp. 230, 280), although the church was not demolished until the Napoleonic period. Vasari states that he himself was first engaged to paint these pictures, but that since he had to leave Venice the commission was transferred to Titian. Therefore they are subsequent to Vasari's visit of 1542–1543. In a letter to Cardinal Alessandro Farnese in December 1544 (C. and C., 1877, I, p. 73), Titian asked for aid in obtaining payment from the monks, and thus it may be assumed that the pictures had then been finished.

Bibliography: See also above; Vasari (1568)–Milanesi, VII, p. 446; Sansovino, 1581, p. 83ᵛ; Ridolfi (1648)–Hadeln, I, p. 175; Boschini, 1660, pp. 164–166; *idem*, 1664, p. 351; C. and C., 1877, II, pp. 68–73, 416; Frölich-Bum, 1913, p. 204; Venturi, IX, part 3, 1928, p. 310; Hetzer, 1948, pp. 127–129; *Mostra di Tiziano*, 1935, nos. 46–48; Tietze, 1936, I, pp. 187–189, II, p.313; Valcanover, 1960, I, pls.179–182;

Walter Friedländer, 1965, pp. 118–121; Kahr, 1966, pp. 193–205; Schulz, 1968, pp. 14, 17–18, 77, pls. 11–15.

Drawing: Paris, Ecole des Beaux-Arts. Titian's study for the *Sacrifice of Abraham* (Frölich-Bum, 1928, no. 36; Tietze and Tietze-Conrat, 1944, p. 325, no. 1962, pl. xx; Paris, 1966, pp. 237–239). Fig. 3 (opp. p. 7).

VARIANTS:

1. Longleat, Marquess of Bath, *Cain and Abel*, canvas, *c.* 1·525 × 1·525 m. attributed to Palma Giovane; perhaps general influence of Titian; Abel is prostrate, foreshortened, his head toward the spectator, while Cain at our left bends over and raises his club; probably bought *c.* 1860–1880 by the 4th Marquess.

2. Unknown location, *Cain and Abel*, canvas, 43 × 33 inches (1·092 × 0·838 m.). Although said to be inscribed TITIANVS in capitals on the altar, the picture appears in the poor illustration of the catalogue to be a work of the late sixteenth or seventeenth century. The composition, showing Abel lying on his back as Cain stands above with lifted club, does not resemble Titian's picture in S. Maria della Salute (anonymous sale, Sotheby's, London, 16 July 1930, no. 82; APC, IX A, 1929–30, no. 10,833, £1,850).

Old Testament Subjects, see also: Adam and Eve, Cat. no. 1; Judith, Cat. no. 44; Tobias and the Angel, Cat. nos. 145 and X-39.

85. Pentecost Plate 104

Canvas. 5·70 × 2·60 m.

Venice, Santa Maria della Salute.

About 1550.

The work, first painted for the monks of Santo Spirito in Isola, was the object of a dispute between artist and patrons, of which Titian speaks in a letter of 1544 to Cardinal Alessandro Farnese. Nevertheless, no documentation survives to establish the exact date of this, the second version. However, the style of the picture, which fits the post-Roman period of the master, is close to that of the *Christ Crowned with Thorns* in the Louvre (Plate 132). The centralized design, to be seen from below, converges upon the Madonna in light rose and blue and perhaps even more upon the dove of the Holy Spirit, which sheds abundant whitish rays from the spacious vault. The major Apostles in the foreground space are the enormous St. Peter at the right, in a blue-grey tunic and dark

golden-yellow mantle, and at the left the one standing figure, the Venetian patron, the dark-bearded St. Mark, who is given even more prominence by his red drapery over the light-pink tunic. The white-headed St. Paul, in a blue tunic and red drapery, kneels at the right of the Madonna. On the whole, the colour lacks the richness of Titian at his best, although the dirty condition must be taken into consideration. The centralized composition for the Pentecost is so well established that it seems unnecessary to seek prototypes, as Tietze did, in Raphael's *Logge* or Signorelli's painting (1494) of the same subject in Santo Spirito at Urbino.

Condition: Very dirty and darkened by varnish but essentially intact.

Other dating: Crowe and Cavalcaselle, after 1545; Tietze, 1555.

History: Originally the high altar of Santo Spirito in Isola, transferred to its present location in 1656 (Sansovino-Stringa, 1604, p. 170; Sansovino-Martinioni, 1663, p. 230).

Bibliography: Vasari (1568)–Milanesi, VII, p. 444; Van Dyck's 'Italian Sketchbook', folios 96ᵛ–97; Ridolfi (1648)–Hadeln, I, p. 175; Boschini, 1664, p. 348; C. and C., 1877, II, pp. 68–73; Suida, 1935, pp. 134, 178; Tietze, 1936, I, pp. 208–209, II, p. 313; Berenson, 1957, p. 191; Valcanover, 1960, II, pl. 70.

DRAWINGS:
1. London, Lord Harewood, kneeling figure (Hadeln, 1927, pl. 37, 257×183 mm.; Popham, 1930, no. 267; Tietze and Tietze-Conrat, 1944, p. 320, no. 1935; proposed as study for St. Peter right: possible but poses are not identical).
2. See *Assumption*, Venice (Cat. no. 14, drawing 2).

86. Pietà Plates 136–138
Canvas. 3·53×3·48 m.
Venice, Accademia.
1576.

The inscription on the pedestal in the centre of the picture, placed there by Palma Giovane, records the fact that he completed the work left unfinished by Titian and that he dedicated it to God: QVOD TITIANVS INCHOATVM RELIQVIT / PALMA REVERENTER ABSOLVIT / DEOQ. DICAVIT OPVS. Many critics have attributed to Palma Giovane the small angel with the torch, but that figure seems too integral a part of the composition to have been an addition to Titian's design. The fact that Palma repeated the angel in his altar in San Zaccaria does not prove that he originated the type. If any part is due to him alone, the small cherub at the lower left is the best candidate. The unity of the pictorial organization is so flawless that I cannot imagine that any part of the invention is attributable to anyone other than Titian, and none of the figures reveals notable changes in handling.

Titian himself is unquestionably represented as St. Jerome, the kneeling elderly man at the right who is draped in rose and presented as the penitent saint rather than as cardinal. The costume eliminates any possibility that the figure represents Joseph of Arimathea. Titian and his son Orazio are repeated as adorers of a Pietà on the tiny votive tablet beneath the Hellespontic sibyl. An inscription, now illegible, appeared beneath their figures, and nearby at the left stands the Vecellio escutcheon.

The sibyl, identified by her name upon the base at her feet, was thought to have prophesied the death of Christ; hence her attributes are the Cross and the crown of thorns. At the left stands Moses with the table of laws, beneath his feet his name in Latin (MOYSES). Above him appear the Greek letters *MOYΣHΣ IEPON* ('Sacred Place of the Muse'); above the sibyl, *ΘEOS ANOS ENEΣTIKH* ('Christ is risen') (transcribed by Zanotto, 1831, I, engraving; no longer legible). A well-known symbol of Christ's crucifixion, the pelican feeding her young with her own blood, occupies the semi-dome of the large niche. The sacramental nature of the theme is re-stated by the torch in the hands of the angel as well as by the rows of short candles along the raking cornices.

The whole architectural setting reflects the designs of Serlio and Sanmicheli (Forssman, 1967, pp. 110–111). The great rusticated niche as well as Moses and the Hellespontic sibyl are painted in silvery tones touched with golden highlights. Because of their muted values the Magdalen's green robe and dark plum-coloured cloak, St. Jerome's rose drapery, and the Madonna's rose-and-blue garments and her beige veil produce a soft harmony in this crepuscular interpretation of tragedy resolved. The composition rises from lower right to upper left in a long diagonal terminating in the upraised arm of the Magdalen. Her dramatic pose has been shown to resemble closely a figure of a mourning Venus on an antique sarcophagus (Saxl, 1957, pl. 114).

Condition: Covered with a heavy crackle and thick varnish; much darkened and dirty; considerable old

repaint upon the figures of Christ and St. Jerome; restored 1953.

History: The *Pietà* was painted by Titian with the intention of having it placed over his own tomb in the Cappella del Crocifisso of Santa Maria dei Frari. Left incomplete at the artist's death, it somehow, probably through Palma Giovane, was located instead in the now destroyed church of Sant' Angelo until taken to the Accademia in 1814. At that time Sebastiano Santi restored it.

Bibliography: Ridolfi (1648)–Hadeln, I, p. 206; Boschini, 1664, p. 119 (then in Sant' Angelo); Zanetti, 1773, Sestiere di S. Marco, pp. 176–177; C. and C., 1877, II, pp. 411–414; Suida, 1935, pp. 148–149, 183; Tietze, 1936, I, pp. 248–249, II, p. 309; Berenson, 1957, p. 191; Valcanover, 1960, II, pl. 144; Moschini Marconi, 1962, pp. 260–261, no. 453.

87. Presentation of the Virgin — Plates 36–39

Canvas. 3·35 × 7·75 m.

Venice, Accademia.

Documented 1534–1538.

This picture, a traditional processional composition, represents the culmination of its type in the Venetian High Renaissance, in the creation of a monumental formal work, constructed in great geometric planes with insistence upon the horizontal, both in the architecture and in the isocephalism of the figures. Suggestions that this work should be considered Mannerist (Hoffmann, 1938, p. 52) seem to be as far removed as possible from the truth of the situation. The deep space at one side contrasted with a shallow space at the other is characteristically Venetian and not Mannerist as Hoffmann believes.

Leading members of the Confraternity of Charity appear in the crowd. The senator in a red gown, who stands with arm outstretched at the right corner of the intruding doorway, has generally been identified as Andrea dei Franceschi (1472–1551). Between the other notables wearing black intervenes a begging gipsy mother in light grey to afford tonal contrast. To the right of Andrea is a senator traditionally said to be Lazzaro Crasso (Ridolfi). Lighter colours distinguish the grey-haired Joseph, who turns his back to reveal handsomely designed yellow drapery as he places his hand upon St. Anne's shoulder. Two elegantly gowned ladies stand at the foot of the steps, the one in pale yellow-green and a white veil, the other in rose pointing to the young Virgin. Van Dyck recorded this group of spectators in his 'Italian Sketchbook'

(folio 53ᵛ). The huge peasant woman seated in the right foreground has always been greatly admired. She not only fulfils the function of clarifying the spatial organization, but she also, with her basket of eggs, the chickens, and a black pig for sale, adds contrast to the elegance of the scene. It has often been observed that Carpaccio employed a similar figure for the same purpose in *St. Ursula's Announcement to her Father* (Accademia, Venice). Upon the steps above, the small figure of the Virgin, in pale blue, is received by the tall high priest, in blue-and-gold vestments, while the dignified black-bearded priest, in full rose robes, brings the procession to a solemn conclusion.

The imposing architectural setting is partially constructed in light-grey marble, notably the massive steps and the tall columns behind them. In contrast, the next building displays a revetment of pink-and-white marble that obviously recalls the polychromatic walls of the Ducal Palace. At the left the tomb of Cestius is intended to suggest a Near-Eastern setting, while the mountain crags, indubitably those of Titian's native Cadore, loom handsomely against the rich blue-and-white sky.

Ancient Roman quotations stand out in the partial view of a statue of an archaistic maiden (*kore*) in the niche above the steps and in the fragment of a male statue at the lower right. It has been suggested that the latter is Greek (Vermeule, 1964, p. 88) and that the grand stairway itself is inspired by the Forum of Augustus and the Temple of Antoninus Pius in Rome (*loc. cit.*, p. 89). The source of the architecture, however, lies far more reasonably in the work of Serlio and Sansovino (Forssman, 1967, pp. 108–111).

Condition: In spite of varnish and retouching the state of the canvas is superior for a work of the period.

History: First ordered from a painter named Pasqualinus Venetus in 1504, the picture still occupies the position for which Titian originally painted it. The door cutting into the composition at the left must be subsequent. Even though Boschini in 1664 mentioned two doors, the design itself proves that only the door to the right was there in Titian's day. Sebastiano Santi, in restoring the canvas in 1838, reconstructed the section which the inserted left door had eliminated because the work was then placed elsewhere in the museum. In 1895 his additions were removed, when the picture was reinstalled in its present and original location.

Bibliography: Vasari (1568)–Milanesi, VII, p. 440; Sansovino, 1581, p. 95; Ridolfi (1648)–Hadeln, I, p. 153;

Boschini, 1664, p. 361; C. and C., 1877, II, pp. 31–35; Cantalamessa, 1896, II, pp. 37–43; Gronau, *Titian*, 1904, pp. 115–117; Ludwig, 1905, pp. 52–53, 143–144, 146 (documents); Suida, 1935, pp. 62–63, 164; Tietze, 1936, II, p. 309; Berenson, 1957, p. 191; Valcanover, 1960, I, pls. 148–152; Moschini Marconi, 1962, pp. 258–259, no. 451.

COPY:
Grantham, Belton House, Lord Brownlow, small copy; Brownlow sale, 4 May 1923, no. 59, bought in; formerly Pelluziole Palace, Venice, and Sir Abraham Hume, London.

88. **Religion Succoured by Spain** Plate 196

Canvas. 1·68 × 1·68 m.

Madrid, Prado Museum.

Signed in black capitals at the lower right upon the stone near the Cross: TITIANVS F

1572–1575.

The kneeling woman, nude except for the blue drapery, represents Religion, as indicated by the chalice and Cross at the right and by numerous snakes, which are symbols of heresy; the red-plumed helmet and other military accoutrements in the centre refer to Spain's military prowess. The allegorical figure of Spain, in rose over a neutral-green skirt, holds a shield emblazoned with the arms of Philip II in her right hand and a tall pike in her left. The small turbaned man, spear in hand, drawn by sea horses over the water in the distant middle-ground, alludes to the victory over the Turks at Lepanto. A series of stylized white sails is visible to the left of him.

Condition: Faded but relatively well preserved; proper cleaning and varnish would restore much of the former brilliance of colour. Restored by Vicente Carducho in 1625 (Moreno Villa, 1933, p. 113).

Date: Begun for Alfonso I d'Este (died 1534); finished after 1571.

History: Intended as a mythological work for Alfonso I d'Este of Ferrara, representing Minerva, a nude female, and Neptune in his chariot in the middle distance; seen by Vasari in Titian's house in 1566, still in its original state (Vasari (1568)–Milanesi, VII, p. 458); after the battle of Lepanto (1571) Titian transformed Minerva into Spain; in 1575, according to a letter from the Spanish ambassador at Venice, Guzmán de Silva, it was shipped to Philip II

(Beroqui, 1946, p. 164; Cloulas, 1967, p. 281); Alcázar, Madrid, in the Oratory, Inventory of 1600 (Alcázar, *Inventarios*, 1956, II, p. 397, no. 452, wrongly called 'St. Margaret'); 1614 in the palace of El Pardo, sent after the fire of 1604 ('Pardo, Inventario', 1614–1617, folio 3ᵛ); 1633 again in the Alcázar (Carducho, 1933, p. 108); 1636, Alcázar, Pieza en que duerme su magd en el cuarto bajo de verano (Alcázar, 'Inventario', 1636, folio 37); 1661 in Alcázar, Velazquez's studio (Beroqui); 1662, sent to the Escorial (Padre de los Santos, edition 1667, folio 83ᵛ); Escorial, Chapter House, 1698 (Padre de los Santos, edition 1933, pp. 305–306); 1839 brought to the Prado Museum.

Bibliography: See also History; Ridolfi (1648)–Hadeln, I, p. 197; Madrazo, 1843, p. 175, no. 805 (no provenance given); C. and C., 1877, II, pp. 360–362 (disliked the picture); Moreno Villa, 1933, pp. 115–116 (says it was repaired by Carducho but not enlarged); Suida, 1935, pp. 73, 124, 182; Tietze, 1936, II, p. 297; Wittkower, 1939–1940, pp. 138–141; MacLaren, 1939–1940, pp. 140–141; Beroqui, 1946, pp. 161–162 (full history); Wind, 1948, p. 38; Tietze-Conrat, 1951, pp. 127–132; Berenson, 1957, p. 188 (extensively restored); Valcanover, 1960, II, pl. 130 (Titian); Battisti, 1960, pp. 112–119; Prado catalogue, 1963, no. 430.

DRAWING:
Madrid, Biblioteca Nacional, no. 7640, 174 × 123 mm. Extremely mediocre copy after the picture, published as Titian's original study (Battisti, 1954, p. 193; *idem*, 1960, p. 112).

LOST VERSION:
Maximilian II of Austria, delivered before 1568; engraved by Giulio Fontana (Voltelini, 1892, p. XLVII, no. 8804; Tietze-Conrat, 1951, pp. 130–132).

COPY:
London, dealer, in 1950's, copy (Bertelli, 1957, p. 133, note).

89. **Religion Succoured by Spain** Plate 197

Canvas. 1·66 × 1·74 m.

Rome, Doria-Pamphili Gallery.

Workshop replica.

About 1575.

Spain, the standing figure, appears in a greenish skirt and a red blouse, the latter colour being repeated in the plumes

of her helmet, while Religion wears light grey against the pale yellow sky. The composition here lacks the details of the Prado version (see Plate 196).

The main problem here is whether this version is Titian's own oil study (*modello*), as Tietze-Conrat believed, or a workshop replica, the more generally held opinion. The X-rays seem to settle the argument in favour of a copy since no change in composition is revealed. We know from Vasari that such was the case in the first picture of the subject (Cat. no. 88).

Condition: Numerous holes in the canvas, one in the face of the woman at extreme left; badly scratched in various sections prior to the restoration of 1956.

History: Aldobrandini Collection, Rome (Ridolfi (1648)–Hadeln, I, p. 197); not in the Inventories published by Pergola and D'Onofrio.

Bibliography: C. and C., 1877, II, pp. 361–362 (unfinished; disapproving, they identified this picture as the one intended for Alfonso I d'Este); Tietze, 1936, II, 298 (copy); Sestieri, 1942, p. 266, no. 383 (copy); Tietze-Conrat, 1951, pp. 127–132 (Titian's *modello*); Bertelli, 1957, pp. 129–143 (Titian; numerous illustrations before and after restoration); Valcanover, 1960, II, p. 74 (doubtful attribution).

90. Rest on the Flight into Egypt Plate 7
Panel. 0·463 × 0·615 m.

Longleat (Wiltshire), Marquess of Bath.

About 1515.

This exquisite little panel shows every indication of being an early work by Titian, characteristic in mood and also in the landscape setting, which is brownish except for the dark-green tree. The yellow of Joseph's drapery over his neutral blue tunic has a glistening clarity, which is complemented by the soft rose of the Madonna's tunic.
The attributions to Giorgione, Schiavone, and Beccaruzzi do not appear reasonable.

Condition: Well preserved.

History: Perhaps Emperor Rudolf II, Prague; Archduke Leopold Wilhelm, Vienna, 1659 (Inventory, p. XCII, no. 96; Teniers, 1660, pl. 63); H. A. J. Munro of Novar, before 1851 (Catalogue, 1865, no. 48; sale, Christie's, London, 1 June 1878, no. 124).

Bibliography: Waagen, 1854, II, p. 133 (Giorgione); C. and C., 1871, edition 1912, III, p. 52 (Beccaruzzi); London,

1915, p. 42 (Titian); Suida, 1935, p. 14, pl. 17 (Titian, *c.* 1511); Tietze, 1936 (omitted); Berenson, 1957, p. 189 (Titian); Valcanover, 1960, I, pl. 42 (Titian).

COPY:

Florence, Contini-Bonacossi Collection, canvas, 0·91 × 1·60 m., copy, sixteenth century. The mediocre quality of the painting, with its blurred uncertain brushwork, leaves no question as to the impossibility of the picture having issued from Titian's own hand. Even though an enlarged replica of Titian's early panel at Longleat, it does not bear comparison with the original. *History:* Unknown; proposed identification with a picture in the collection of Charles I of England (van der Doort, 1639, Millar edition, 1960, p. 17, no. 3, 35 × 66 inches, i.e. 0·889 × 1·677 m.) by Suida (1935, p. 14). *Bibliography:* See also History; Longhi, 1927 and 1967, p. 237 (Titian); Tietze, 1936 (not included); Suida, 1941, pp. 4–5 (incorrectly states that it was originally in Andrea Loredan's collection in Venice before it went to Charles I; on the contrary see the *Flight into Egypt* now in the Hermitage, discussed in the Appendix, Cat. no. X–12); Berenson, 1957, p. 186 (Titian); Valcanover, 1960, I, pp. 79, 93, pl. 200 (attributed to Titian).

91. Rest on the Flight into Egypt Plate 40
Canvas. 1·55 × 3·23 m.

Escorial, Nuevos Museos.

Titian and workshop.

About 1535.

This charming picture may nevertheless be a workshop replica. The principal colours against the beautiful but flat landscape are the rose curtain behind the Madonna, her customary rose tunic, blue mantle, and white veil, and the pale-rose tunic and yellow drapery of St. Joseph. The pink costume of the angel at the left restates in a different key the colours worn by the Holy Family. Most delightful are the details of the landscape, which opens at the right into a mountain valley populated by tiny figures of peasants and two munching rabbits in the foreground. At the left the grazing donkey, the ducks in the pond, and the Infant St John the Baptist's lamb add delicate touches of humour to the poetic scene.
Crowe and Cavalcaselle classified this picture as a school work, a judgment which was repeated by Pedro Beroqui on historical grounds (see below). Even Suida with his well-known liberality in the matter of attributions considered it a product of the atelier.

Condition: The paint has been badly rubbed, particularly the flesh areas, leaving the weave in the canvas visible. Other parts, such as the landscape and the animals, especially the rabbits, still retain an adequate amount of pigment. The Child's left hand shows gashes in the canvas, ineffectively restored, and a long horizontal crease extends across the middle of the picture.

Engravings: Of the two engravings of the subject in the Accademia dei Lincei at Rome, the one by Giulio Bonasone follows the Escorial picture more closely. The second version, inscribed 'Ticianus Inventor 1569' by Martin Rota (Plate 41; signature cut off in this example), is considerably higher in format, including more of the trees as well as a group of three angels above the Holy Family, not present in the painting.

History: Van Dyck's 'Italian Sketchbook' (folio 8ᵛ) (*c.* 1622–1627) unmistakably contains the main figures which he identified as 'Titian'. The Fleming must have seen this canvas or another version in the house of Francesco Assonica at Padua, where Vasari recorded it in 1566 and where Ridolfi later repeated it.

One thing is certain, that the Duke of Medina de las Torres presented the *Rest on the Flight* to Philip IV after his return from Italy in 1644. It has been doubted (Beroqui, 1946) that the Escorial version came from Assonica's collection because Ridolfi still locates it in Padua in his book, the preface of which is dated 1646. However, any book of this type takes years in the writing, and the picture may well have been sold to the Duke of Medina de las Torres about 1644 without Ridolfi's knowledge.

Padre de los Santos records the *Rest on the Flight* in the Antesacristía of the Escorial in 1657; in the second edition, 1698, he adds the erroneous statement that it 'is said' to have been bequeathed to Philip IV in the testament of Luis Méndez de Haro (edition 1933, pp. 232, 311). Because of this last statement Waagen (1854, II, p. 479) believed that the Escorial *Rest on the Flight* had been in Charles I's collection (van der Doort, 1639, Millar edition, 1960, p. 17, no. 3). That theory is erroneous, however, since that composition was much smaller in size, i.e. 35 ×66 inches (0·89 × 1·677 m.).

Another complication arises because the Paduan Carola Caterina Patina (1691, p. 179) writes that Titian's famous picture was sent to Spain but was lost in a shipwreck. N. R. Cochin's engraving, which is copied from Rota's print, including the angels in the clouds above the Madonna, is the illustration used in that book. On the Cochin print the legend reads 'Opus Titiani in Hispaniam deportaretur, naufragio peryt'. We cannot be completely sure that this late information is correct, since it is not corroborated by any Spanish source. Moreover, the Escorial version does not have the angels in the clouds, a fact which means either that the Assonica picture was cut down or that it is another picture.

Crowe and Cavalcaselle further complicated the situation with the theory that Velázquez had purchased the *Rest on the Flight* in Italy in 1649–1651, a suggestion without foundation and in contradiction to Velázquez's own report.

Exhibited at the Prado Museum 1839–1943; 1943–1963 in the Chapter House at the Escorial; 1963 in the Nuevos Museos.

Bibliography: Vasari (1568)–Milanesi, I, p. 456 (Assonica's picture); Ridolfi (1648)–Hadeln, I, p. 190; Madrazo, 1843, p. 191, no. 868; 'Inventario general', 1857, p. 180, no. 868 (from the Escorial); Poleró, 1857, no. 868; C. and C., 1877, II, pp. 445–446 (follower); Suida, 1935 p. 140 (studio); Tietze, 1936, I, pp. 157–158, II, p. 296 (Titian); Beroqui, 1946, p. 169–171 (copy); Berenson, 1957, p. 188 (great part by Titian; wrongly located in the Prado Museum); Valcanover, 1960, I, p. 100, pl. 212 (doubtful).

COPIES:

1. Madrid, Academia de San Fernando, storage, canvas, 1·20×2·50 m. (Mas photo C94955; Pérez Sánchez, 1964, no. 532).

2. Switzerland, private collection (in 1935), canvas, 1·585×2·504 m., workshop or copy, sixteenth century. A smaller version of the Escorial picture with the landscape partially eliminated, but apparently of good quality, it is assigned by Suida to the workshop, while Tietze reasonably suggests that it is the copy by Padovanino mentioned by Patina (1691, pp. 49–50; Suida, 1935, p. 140, pl. 258, Titian; Tietze, 1936, II, p. 296, copy).

92. Resurrection Altarpiece Plates 72, 74

Panel. 2·78 × 1·22 m.

Brescia, SS. Nazaro e Celso, High Altar.

Signed on the column at St. Sebastian's feet: TITIANVS FACIEBAT MDXXII.

Against a blue background the two dedicatory saints of the church accompany the donor, Bishop Altobello Averoldo, St. Celso arrayed in armour with a rose scarf at his neck and long white hose. The panel of St. Sebastian, already completed in 1520, so impressed Tebaldi, the agent of Alfonso d'Este of Ferrara, that he attempted to

buy it for his master. Letters of 1520 between Tebaldi and Alfonso show that the latter finally decided it unwise to risk offending Averoldo, who was the papal legate.

The drawings for the St. Sebastian, preserved in Berlin (Plate 73) and Frankfurt (Tietze, 1936, pl. 57), demonstrate Titian's experiments with *contrapposto* which appear to reflect some knowledge of Michelangelo's *Slave* now in the Louvre, then still in the sculptor's studio at Rome (Tolnay, 1954, p. 97). The nude saint, silhouetted against a medium-blue sky, rests his right foot upon a white marble column, presumably an antique fragment. St. Sebastian's presence in the altar may be in remembrance of the plague of 1510 at Venice. Tietze suggests also that both Christ and St. Sebastian may owe something to the study on Titian's part of the recently discovered *Laocoön*. This theory in regard to the Risen Christ is shared by Brendel and others.

The extraordinarily beautiful landscape in the *Resurrection* is much like the setting of the *Madonna and Saints* at Ancona (Plates 24, 27). Though darkened, the blue of the sky and the pink-and-yellow sunset in a measure survive. The banner of rose and white and Christ's white loincloth contribute to the dominant force of this principal figure. Above, the angel appears in luminous white as he salutes the Madonna, who, in rose and blue, kneels before her prayer desk aand against a green curtain.

Condition: The condition of the Brescia altar, in spite of darkening, is fairly good; a restoration by Girolamo Romani is recorded in 1819 (Brognoli, 1826, p. 277, note 4). A new altar of marble was built and dedicated in 1820, a probable time for the renewal of the picture frame also. The gilded wooden frame, nevertheless, follows the original disposition of the five panels in an arrangement familiar in Venetian altars of the late fifteenth and early sixteenth centuries.

History: Altobello Averoldo, born in Brescia, titular bishop of Pola, 1497–1531 (Gams, 1931, p. 802), ordered the picture in 1520. Leo X, in an attempt to start a crusade against the Turks, sent him as papal legate to Venice to enlist the aid of that state (Pastor, 1908, VII, pp. 221–222). Two large panels, now lost, attributed to Moretto (the 'Coronation' and a picture with three saints, Michael, Francis, and Nicholas), formerly served as wings which could be closed to cover Titian's altar (Carboni, 1760, p. 58).

Bibliography: See also above; Vasari (1568)–Milanesi, VII, pp. 444–445; Sala, 1834, pp. 87–88; C. and C., 1877, I, pp. 235–239; Campori, 1874, pp. 591–594; *Mostra di Tiziano*, 1935, p. 53 (letter of Tebaldi); Suida, 1935, pp. 51–52, 159; Tietze, 1936, I, pp. 116–117, II, p. 285; dell'Acqua, 1955, p. 22, colour reproduction; Berenson, 1957, p. 184; Valcanover, 1960, I, pls. 101–105.

DRAWINGS:

1. Berlin, Kupferstichkabinett, six sketches (Plate 73) for St. Sebastian on one sheet (Hadeln, 1924, p. 6; Tietze and Tietze-Conrat, 1944, no. 1880).
2. Frankfurt, Städelsches Institut, two sketches on one sheet (Hadeln, 1924, pls. 7, 8; Tietze and Tietze-Conrat, 1944, no. 1915).

COPIES OF THE ST. SEBASTIAN:

1. Epinal (Vosges), Musée des Beaux-Arts (Plate 238), canvas, 1·32×0.84 m., academic copy, seventeenth century (Giraudon, photo no. 23,886); from Prince de Salm, 1788, no. 134. Here the saint is attached to a column, the landscape is considerably changed, and Titian's signature has been omitted (Philippe, *Catalogue*, 1929, no. 23).
2. Longniddry, East Lothian, Gosford House, Earl of Wemyss and March (formerly Lord Elcho), a *St. Sebastian*, canvas, 1·625×1·067 m. (C. and C., 1877, I, p. 252); the inscription, TICIANVS FACIEBAT 1522, indicates clearly that this item is based on the Brescia *St. Sebastian*. The statement by Waagen (1854, II, p. 83) that this picture formerly belonged to Charles I is not confirmed by any document, according to the Earl of Wemyss (letter of 11 December 1967).
3. Longniddry, East Lothian, Gosford House, Earl of Wemyss and March, another smaller sketch of the Brescia *St. Sebastian*, measuring 0·762×0·305 m.(Waagen, 1857, p. 63; C. and C., 1877, I, p. 252).
4. Rome, Villa Madama (on loan since 1954 from the Pinacoteca of Bologna, no. 920), canvas, 1·82×1·14 m.; apparently from the Zambeccari Collection, Bologna (Gatti, 1803, p. 100).
5. Troyes, Musée des Beaux-Arts (Philippe, 1929, p. 11).

LOST COPIES OF THE ST. SEBASTIAN:

1. Blenheim, Duke of Marlborough (formerly), canvas, 1·65×1·143 m.; type not clearly specified; from the Michieli Collection; Blenheim sale, London, Christie's, 7 August 1866, no. 684 (Waagen, 1854, III, p. 122; Scharf, 1862, p. 52; C. and C., 1877, II, p. 466; remote from Titian).
2. Brescia, Lechi Collection (formerly); version attributed to Pietro Rosa by Crowe and Cavalcaselle (1877, I, p. 253), with variations in the landscape (Lechi catalogue,

1837, no. 90, attributed to Titian); perhaps passed to the Maggi family (letter of Count Fausto Lechi, 11 November 1967).

3. Brescia, Tosi Collection (formerly), item attributed to Moretto (C. and C., 1877, I, p. 253; not listed in the modern catalogue, Nicodemi, 1927).

4. Liechstenstein Collection (formerly), 1·71×0·70 m., probably from the Fenaroli Collection, Brescia (C. and C,. 1877, I, p. 253); not mentioned in recent catalogues of the Liechtenstein Collection (A. Kronfeld, 1927, or Stix and von Strohmer, 1938).

5. London, Whitehall Palace, Collection of Charles I, a *St. Sebastian*, 75×39 inches (1·905×0·99 m.), sold to Webb, 30 October 1649, for £6 (Harley MS. 4898, British Museum, 1649–1652, folio 226, no. 250); the small sum indicates that it must have been an unimportant copy, and the catalogue description shows that it differed in minor details from the Brescia original (van der Doort, 1639, Millar edition, 1960, p. 9, no. 4). Neither van der Doort in 1639 nor Ridolfi in 1648 (Ridolfi-Hadeln, I, p. 196) says that it came from Mantua, an assumption which is due to Crowe and Cavalcaselle (1877, I, p. 253). Waagen (1854, II, p. 83) wrongly thought that this item passed to Lord Elcho (see above under Copies, no. 2).

Resurrection, see also: Last Supper and Resurrection, Processional Banner, Cat. no. 45

Sacrifice of Abraham, see: Old Testament Subjects, Cat. no. 83.

St. Anthony, Miracles of

93. **Miracle of the Speaking Infant** Plates 139, 140
Fresco. *c.* 3·40×3·55 m.

94. **Miracle of the Irascible Son** Plates 142, 143
Fresco. *c.* 3·40×2·07 m.

95. **The Jealous Husband** Plate 141
Fresco. *c.* 3·40×1·85 m.

Padua, Scuola del Santo.

Documented 1510–1511.

The importance of these frescoes, as the earliest surviving dated works by Titian, has been recognized by all critics. Since the frescoes (1508) of the Fondaco dei Tedeschi in Venice are known mainly in eighteenth-century prints,

the work at Padua is the point of departure for all considerations of Titian's early chronology.

The finest picture, the *Miracle of the Speaking Infant* (Plate 139) reveals a well-constructed composition with all heads upon the same level (isocephalism), a characteristic scheme of Renaissance masters and one to which Titian returned in his large canvas of the *Presentation of the Virgin* (Plate 36) in the Accademia at Venice. The grouping and action are successfully integrated both to tell the story and to provide a handsome decorative organization, in which the stage space is established by the wall behind and by the familiar Venetian device of an opening into a landscape at one side. In this scene St. Anthony causes the infant to speak to assure his father that his mother is innocent of adultery.

A similar treatment of space with figures set against a rocky cliff and a landscape corridor into the distance characterizes *The Jealous Husband* (Plate 141). Here Titian experimented with foreshortened figures and created the excitement of violent action as the jealous husband attempts to murder his wife, who is later restored to life after the repentant husband implores the intercession of St. Anthony (detail in the background).

The least successful of the Paduan frescoes, the *Miracle of the Irascible Son* (Plate 142), is notable for its splendid landscape distance, which is separated from the foreground by a tall tree. The figures are, on the other hand, awkwardly grouped, the contrasted positions of heads and bodies arranged in forced positions, which recall the methods of earlier artists such as Carpaccio and Gentile Bellini. They do not achieve dramatic conviction. Clearly Titian had not yet struck his stride in this composition, a fact which accounts for the disparaging evaluation of the entire series at Padua by critics such as Crowe and Cavalcaselle. The preposterous story itself relates that St. Anthony replaced the foot which the son himself had severed in remorse after having kicked his mother.

Titian's skill in handling the fresco technique is, nevertheless, not to be denied. The recent analysis of his medium (Morassi, 1956, p. 27) demonstrates that the young artist employed a liquid brush with the utmost freedom and rapidity as he sketched his compositions and reinforced details upon the moist plaster.

Numerous suggestions have been forthcoming in regard to the influences of Donatello, Giotto, and Mantegna in the frescoes at Padua. The isocephalism of the *Miracle of the Speaking Infant* does recall the frieze-like disposition of figures, in Giotto's murals in the Arena Chapel (1305) and Donatello's bronze reliefs in the church of San

Antonio at Padua, but further than that similarities are not remarkably close. The recent analysis of Alan Rosenbaum, proposing direct dependence on Giotto's *Marriage of the Virgin* in this scene, and even closer reliance on Giotto's *Lamentation* in Titian's *Miracle of the Irascible Son*, seems overdrawn. Hourticq saw a relationship between the Christ in Giotto's *Raising of Lazarus* and the St. Anthony in Titian's *Miracle of the Irascible Son*, an unconvincing suggestion, although he admitted that an artist of the early sixteenth century would have found Giotto too archaic to be regarded as a suitable model.

The statue of a Roman Emperor in the *Miracle of the Speaking Infant* is indubitably dependent on an ancient source at a period when Roman culture held a magical attraction to all men of imagination. The choice of Curtius (1923, p. 220) and Brendel (1955, p. 116) for Titian's model is an Augustan relief at Ravenna, which is identical in pose and costume, whereas Morassi (1956, p. 18) preferred a statue of Trajan in the triumphal arch at Ancona. The classical pose and armour are indeed common to numerous works of the Imperial age which Titian must have seen.

History: The full documentation for the frescoes by Titian, Francesco Vecellio, Gianantonio Corona, Filippo Corona, Girolamo Tessari (del Santo), Bartolomeo Montagna and others has recently been published (Sartori, 1955); for Girolamo del Santo see also Rigoni, 1940–1941; first payment to Titian made 1 December, 1510; other payments 23 April, 9 and 21 May, 11 July, all in 1511 (Sartori, 1955, pp. 63–64); documents of final payment 2 December 1511:

'Ricevi io Ticiano ducati quatro d'oro de la fraja [confraternita] de mis Sto Antonio de Padova li quali me contò ser Antonio suo fator per resto de compido [compiuto] pagamento de li tre quadri io ho dpicta [dipinto] sudita schuola. Val 1 24
Et io Tician da Cadore depetore' (Gonzati, 1854, I, p. CXLIII).

In the agreement of 1 December 1510 Titian was to have painted the scene of the *Recognition of St. Anthony's Corpse*, but this was later executed by Bartolomeo Montagna (Rigoni, 1940–1941, p. VII; Morassi, 1956, p. 18).

Condition: Restored by Francesco Zanoni in 1748 (Gonzati, 1854, p. 281): in 1968–1969 in the process of cleaning and of possible transfer to canvas.

Bibliography: See also History; Vasari (1568)–Milanesi, VII, p. 431; Van Dyck, 'Italian Sketchbook', folios 106ᵛ, 107 (studies of heads); Ridolfi (1648)–Hadeln, I, p. 156; C. and C., 1877, I, pp. 126–127, 133–140 (unfavourable account); Hourticq, 1919, pp. 107–108; Hetzer, 1920, pp. 13–21 (Titian); Suida, 1935, pp. 10, 11, 16; Tietze, 1936, I, pp. 65–69, II, p. 304 (sees influence of Dürer, Donatello, and Carpaccio); Morassi, monograph, 1956; Muraro, 1960, pp. 27, 102–103; Valcanover, 1960, I, pp. 23–31; Grossato, 1966, pp. 67–73, with colour reproductions; Rosenbaum, 1966–1967, pp. 1–7.

AUTHENTIC DRAWING:
Paris, Ecole des Beaux-Arts, *Jealous Husband Attacks Wife* (Hadeln, 1924, pl. 1; Tietze, 1936, pl. 10; Tietze and Tietze-Conrat, 1944, p. 325, no. 1961, possibly by Domenico Campagnola); Paris, 1966, pp. 233–237).
Fig. 2 (opp. p. 7)

DRAWINGS, *uncertain attributions*:
1. The Hague, *Miracle of the Speaking Infant*, sale Paris, Drouot, 23 February 1924, no. 32, 145×370 mm.
2. Manchester (formerly), *Miracle of the Speaking Infant* (mentioned by C. and C., 1877, I, p. 135, now lost and unverifiable): perhaps the same as No. 1.

COPIES:
1. London, Thomas Agnew & Sons, *The Jealous Husband*, copy by Edgar Degas, canvas, 0·81×0·47 m. (illustrated *Burlington Magazine*, CIX, May 1967, fig. 66).
2. London, Hockliffe, *Miracle of the Speaking Infant*, nineteenth-century copy, 35½×51⅞ inches (0·90×1·317 m.).
3. Unknown location, oil on paper, 19½×14½ inches, *Miracle of the Irascible Son*; formerly Lord Brownlow (Brownlow sale, 4 May 1923, no. 62); Sir Abraham Hume purchased it from Giovanni Sasso in Venice.

96. **St. Catherine of Alexandria in Prayer** Plate 188

Canvas. 1·17×0·77 m.

Boston, Museum of Fine Arts.

Partial signature: [TI] TIANVS F

Workshop of Titian.

About 1568.

Both Fischel and Gronau noted that the composition of the picture with its deep space is characteristic of Titian's work in his early career, but assumed that he painted the picture at the time he sold it in 1568. It should be mentioned also that the plinth with the simulated relief of the Entombment recalls a work such as the early *St. Peter Enthroned* (Plate 144). Tietze-Conrat, pointing out the

fact that the iconography corresponds in reality to St. Catherine of Siena receiving the Stigmata, proposed that Titian reworked an early picture (c. 1520) and transformed the subject into a St. Catherine of Alexandria. The date of the Boston painting still remains a puzzle since there is relatively little to suggest a date c. 1568. Nevertheless, El Greco used a similar type of composition for his early *Annunciations* (Madrid, Barcelona, Florence) during his Italian period (c. 1560–1577) (Wethey, 1962, cat. nos. 37–39). Thus, when all is considered, Tietze-Conrat's solution appears to be the most reasonable.

The rather mediocre head of the St. Catherine is the weakest part of the Boston canvas. Dressed in a brown brocaded tunic and blue drapery, the saint kneels before the Crucifix. To the left the red curtain is the chief touch of warm colour against the grey architecture and the pavement of grey and brown squares. The landscape, now much faded, and the touch of blue sky complete the background.

Condition: Somewhat darkened.

History: Titian's letter to Cardinal Alessandro Farnese, dated 10 December 1568, states that he had delivered a picture of St. Catherine to Cardinal Alessandrino several months before but that no payment for it has ever been made (Ticozzi, 1817, pp. 315–316). The Boston picture appears in the inventory of Cardinal Alessandrino (Michele di Bonelli) dated Rome, 28 April 1598: 'una Santa Caterina della ruota inginocchiata, con un crocifisso, fatto di mano di Titiano, stimata scudi 40' (Orbaan, 1920, p. 490; Gronau, 1937, p. 294). Lord Radstock (sale, London, Christie's, 12 May, 1826, no. 39); Charles Dixon, Stanstead Park, Sussex (c. 1850; not seen by Waagen in 1857); Dixon sale, London, Christie's, 19 May, 1911, no. 27, 46×39 inches; George Wilder; Koppel Collection, Berlin and Toronto (1913–1927?); A. L. Nicolson, London (1927); purchase by the museum in 1948.

Bibliography: Hadeln and Voss, 1913, no. 2, pl. 2 (Titian, c. 1540); Fischel, 1924, pl. 246 (Titian); Gronau, 1937, pp. 294–296 (Titian); Tietze, 1936 and 1950 (not listed); Tietze-Conrat, *Gazette*, 1954, pp. 257–261 (partially workshop); Cleveland, 1956, no. 56 (Titian); Berenson, 1957, p. 184 (Titian); Valcanover, 1960, II, pp. 72–73, pl. 180 (uncertain attribution).

VARIANT:

Unknown location, poor copy, canvas, 0·97×0·69 m.; in Gluckselig sale, Vienna, 1–2 December 1926, no. 300, illustration.

LOST EXAMPLES:

1. London, Earl of Arundel. A *St. Catherine*, inventory 1664 (Cust, 1911, p. 284).
2. London, Charles I. A 'saint kneeling before a Cross by Titian' might be the Boston picture (Charles I: Inventory of sale 1649, LR, 2/124, folio 118ᵛ).

ATTRIBUTION:

Vienna, Kunsthistorisches Museum, canvas (0·99×0·75 m.), Venetian School, seventeenth century. The costume and attitude suggest a picture of Diana with St. Catherine's wheel of martyrdom added. It is difficult to see any relation to Titian in spite of Berenson's opinion to the contrary. *Condition:* Relined and reframed by 'G. T.' in 1919. *History:* Archduke Leopold Wilhelm, Vienna, 1659 (Inventory, p. LXXXVIII, no. 39; Teniers, 1660, pl. 58). *Bibliography:* C. and C., 1877, II, pp. 377–378 (suggest Padovanino); Engerth, 1884, p. 349, no. 497 (possibly the picture which Titian painted for Cardinal Alessandro Farnese in 1568); Tietze (not listed); Berenson, 1957, p. 192 (copy of Titian).

97. St. Catherine of Alexandria Plate 168

Canvas. 0·98×0·74 m.

Florence, Uffizi.

Copy.

Sixteenth Century.

An inscription on the back of the canvas, TITIANI OPVS ANNO 1542, may refer to the original composition. The tradition that Caterina Cornaro is represented here is difficult to accept, since that lady had died long before in 1510. Nevertheless, many critics accept the theory and consider this work an ideal portrait of the former Queen of Cyprus, although positive evidence is slight indeed.

Critical opinion is virtually unanimous in the belief that the hard dull quality suggests a copy, although elegance of pose and bearing reflect a splendid original, as does the bejewelled costume sewn with pearls, plum-coloured with green overdress brocaded in gold, and a golden-and-grey crown.

Crowe and Cavalcaselle misquoted Ridolfi as saying that the Uffizi canvas had been frequently copied, whereas Ridolfi referred to a portrait of Caterina Cornaro in widow's garb (Ridolfi (1648)–Hadeln, I, p. 153), which could not have been the costume worn by St. Catherine. This error was earlier noted by Emil Schaeffer (1911, pp. 17–18).

Condition: Much darkened and retouched.

History: Bequest of Antonio de' Medici in 1632.

Bibliography: C. and C., 1877, II, pp. 57–58 (Marco di Tiziano); Uffizi catalogue, 1926, no. 909; Suida, 1935, pp. 83, 171, pl. 171b (Titian); Tietze, 1936, II, p. 291 (copy); Salvini, 1952, no. 909 (copy); Berenson, 1957, p. 185 (head and hands by Titian); Valcanover, 1960 (omitted).

COPY:

Unknown location, canvas, 40×32 inches, free copy; A. L. Nicolson, London, 1953; Earl of Rosebery (sale, London, Christie's, 5 May 1939, no. 139; from Venice, Manfrin Collection, according to the Rosebery catalogue but not in the Manfrin sale, 1872.

98. St. Christopher Plates 151, 152

Fresco. 3·00×1·79 m.

Venice, Ducal Palace.

About 1523.

This fresco portrays a swarthy-complexioned saint in a dark-green tunic, white shirt, and deep-red drapery, while the small Christ Child, His body simply covered with a white shirt, flourishes a cloth of rose and gold brocade above His head. Below the ultramarine sky the campanile of St. Mark's is discernible on the low horizon. The face of the saint, enframed in soft curly hair and beard, is mild and affectionate.

Condition: Slightly restored but well preserved.

History: Painted for Andrea Gritti soon after his election as doge (1523–1538).

Bibliography: Ridolfi (1648)–Hadeln, I, p. 166; Boschini, 1674, Sestiere di S. Marco, p. 57; C. and C., 1877, I, pp. 294–296; Hetzer, 1935, pp. 127–128; Suida, 1935, p. 55; Tietze, 1936, I, p. 132, II, p. 310; Berenson, 1957, p. 191; Valcanover, 1960, I, pl. 120.

DRAWING:

Florence, Uffizi. Regarded by Popham as a possible study for the legs of St. Christopher (Popham, 1930, no. 263); demonstrated by Tietze and Tietze-Conrat (1944, p. 316, no. 1906) to be a study for the legs of the executioner in the *Martyrdom of St. Lawrence* in the Gesuiti at Venice (Cat. no. 114).

99. St. Dominic (or St. Vincent Ferrer) Plate 187

Canvas. 0·92×0·78 m.

Rome, Villa Borghese.

Inscribed in lower left-hand corner: TICIANV
S
F

About 1565.

An imposing figure with a sense of grandeur, it carries conviction also in the splendid features of a profoundly sympathetic religious leader. The superbly designed black-and-white habit is relieved against a reddish brown background. The peculiar size and the shapes of the letters of the inscription raise some doubts that it is an original signature by Titian.

Condition: In the restorations of 1950 by the Istituto Centrale di Restauro, the picture was freed of repaint, leaving the surface somewhat abraded; red ground is visible in the background. The canvas must also have been cut at the left and at the bottom in centuries past.

Other dating: Pergola, c. 1565.

History: Possibly acquired from Cardinal Sfondrato's estate in 1608; Borghese Inventories 1693, 1700; Morelli identified this picture with the one Ridolfi saw in the house of the painter Gamberato at Venice: 'suo Confessore dell' Ordine dei Predicatori' (Ridolfi (1648)–Hadeln, I, p. 169), but this highly speculative suggestion is rightly rejected by Paola della Pergola.

Bibliography: C. and C., 1877, II, p. 419; Morelli, 1892, p. 238; *Mostra di Tiziano*, 1935, no. 93; Tietze, 1936, I, pp. 247–248, II, p. 307; Urbani, 1950, p. 98; Pergola, 1955, I, p. 131, no. 234 (full account); Berenson, 1957, p. 190; Valcanover, 1960, II, pl. 118.

100. St. Francis Receiving the Stigmata Plate 163

Canvas. 2·81×1·95 m.

Trapani (Sicily), Museo Pepoli.

About 1545–1550.

Despite the ruinous condition of the picture, the excellent quality of the original design and the dramatic interpretation remain. The former attribution to a minor painter, Vincenzo da Pavia, was consigned to oblivion in 1946, when Longhi recognized the hand of Titian.
The general conception of the composition and even the poses of the two Franciscan saints are related to Boldrini's woodcut (c. 1566) after a lost drawing by Titian. In the

print the landscape provides the major interest, while the small figures are seen in back view. The free illusionistic brushwork of the picture at Trapani suggests a date *circa* 1545–1550, although the rubbed surface of the canvas does not permit absolute certainty in such judgments. Today the most beautiful part of the composition is the landscape, a scene of twilight in which the blue sky and blue hills have lost some of their original freshness, but they still furnish a pleasing background to the brownish trees, so lovely in their decorative silhouettes and in their suggestion of the poetic aspects of nature. Nevertheless, the two Franciscans dominate, and through their gestures of wonder convey the significance of the miracle of the stigmatization. Their attitudes are paralleled not only in the Boldrini woodcut (Tietze, 1936, I, p. 209, illustration) but also in Titian's painting at Ascoli Piceno (Plate 164).

Condition: Relined, cleaned, and restored in 1953, the canvas had been deprived of much of its painted surface in an earlier incompetent restoration, when the painting was cut down on the left side. Numerous slashes (repaired) on the right side can still be detected; the large ill-shaped hands are to be explained to a great extent by old restorations.

Other dating: Longhi, c. 1525.

History: In San Francesco, Trapani, until 1928, when it passed to the museum.

Bibliography: Longhi, 1946, p. 64, pl. 118 (Titian); Urbani, 1954, pp. 41–45; Valcanover, 1960, I, pl. 121 (Titian).

101. St. Francis Receiving the Stigmata Plate 164

Canvas. 2·95 × 1·78 m.

Ascoli Piceno, Pinacoteca Comunale.

About 1561.

The inscription in capitals at the lower left, TITIANVS VECELLIVS CADVR (*sic*), is in very irregular letters which have undoubtedly been restored in times past; nevertheless, this peculiar form cannot be regarded as a signature. An archaeological ruin, the picture was saved from further deterioration by expert preservation and relining at Rome in 1950. Very little of the original paint survives, but it is certain that the landscape in Titian's late style was once a luminous evocation of the mountains of Cadore. The athletic physique of Christ also reveals an advanced period in Titian's career, more distinctly than the other figures.

The escutcheon and the large books with red bindings in the lower centre refer to the donor, who kneels at the lower right. Most unusual is the iconography showing in the clouds the Risen Christ, from Whom the wounds descend in rays, rather than the crucifix, as the 'Little Flowers of St. Francis' tell the story. Brother Leo, here shown pausing as he reads his book, is more frequently depicted as amazed at the miracle—in many pictures by other masters, as well as by Titian in his design for Boldrini's woodcut and also in the work at Trapani (Cat. no. 100).

Condition: Ruinous; restored in 1950.

History: Abbate Frascarelli recorded both the inscription with the name of the donor, Desiderio Guidone, in the chapel founded by this man, and the date 1561 upon the altar in which the picture stood. The canvas, transferred to the museum c. 1861, was studied in detail by Crowe and Cavalcaselle, who noted that Ridolfi mentioned a picture of the subject in the Franciscan church at Ancona, and that he must have intended to write Ascoli Piceno. Hadeln agreed with this reasonable assumption inasmuch as no painting of the subject by Titian is traceable in San Francesco at Ancona, whence, on the contrary, came the celebrated *Madonna and Saints* (Plate 24), now in the Ancona museum.

Bibliography: Ridolfi (1648)–Hadeln, I, p. 204; Frascarelli, 1855, pp. 63, 210; C. and C., 1877, II, p. 328 (Titian); Luigi Serra, 1925, p. 77; Berenson, 1932, p. 568, and 1957, p. 183 (ruined); Suida, 1935, p. 135 (Titian); Tietze, 1936, II, p. 283 (Titian); Urbani, 1951, pp. 17–24 (with photographs during restoration); Valcanover, 1960, II, pls. 100–101 (Titian and workshop).

102. St. George Plate 150

Panel. 1·246 × 0·657 m.

Venice, Cini Collection.

About 1516.

The traditional attribution to Giorgione has been largely abandoned in favour of Titian, particularly since the eighteenth-century repaint was removed in 1965. The head, formerly turned downward, had already been recognized as modern by Berenson. In the recent cleaning the original head in profile with the glance directed forward suggests an entirely different character of considerable force, which appears to support an attribution to Titian.

Condition: Cut down from a larger composition, which included St. Michael, St. George, and St. Theodore; restored 1965 (Valcanover, 1965, pp. 199–200).

History: Described as one of several gifts of the Venetian state to Lautrec, French governor of Milan, on 27 May 1517 (Sanuto, XXIV, col. 303; discovery of Tietze, 1950, see below). Calvesi advanced another, less likely identification with a picture of St. George, described by Paolo Pino in 1548, as demonstrating Giorgione's use of mirrors to reflect the figure (Pino, edition, 1960, I, p. 131). Mr. Neeld, 1854 (Waagen, 1854, II, p. 244, Giorgione); Sir Audrey Neeld, 1915; L. W. Neeld, Grittleton House, Chippenham (sale Christie's, London, 9 June 1944, no. 10, as Giorgione); Agnew & Co., London, 1944; Cini, 1950.

Bibliography: London, 1915, p. 33 (Giorgione); Spahn, 1932, p. 177 (rejected attribution to Palma); Longhi, 1934, edition 1956, p. 88, fig. 287 (Titian, *c.* 1511); Tietze, 1950, p. 375 (Titian); Zampetti, 1955, no. 49 (Titian, *c.* 1522); Calvesi, 1955, pp. 254–257 (Giorgione); Berenson, 1957, p. 84 (Giorgione, a fragment, the head modern); Valcanover, 1960, I, pl. 83 (Titian); Valcanover, 1965, pp. 199–200 (Titian).

103. St. James Major Plate 160

Canvas. 2·92×1·40 m.

Venice, San Lio.

Fragmentary signature in the foreground.

About 1550.

The mature style of this ruined picture is clearly distinguishable in all of its aspects: largeness of physique, breadth of expressiveness, and freedom of movement. St. James strides forward vigorously, his head turned heavenward and his right hand upon his chest in a gesture of piety, a pose later adopted by El Greco in his *Espolio* in Toledo Cathedral. Strange iconographic details are the presence of St. John the Baptist, a tiny figure in the right background, and of a seated warrior in the left distance.

Condition: So dirty and darkened as to be nearly invisible, the canvas originally showed a sunset sky behind the saint, who wears a yellow tunic and red drapery over the right arm and left shoulder. Canvas has been added on all sides to fit the much larger frame of a seventeenth-century altar.

Other dating: Gronau, 1565–1570; Valcanover, *c.* 1540–1550.

Bibliography: Not in Sansovino (1581) or Vasari; Van Dyck's 'Italian Sketchbook', folio 40ᵛ (labelled Titian); Ridolfi (1648)–Hadeln, I, p. 205; Sansovino-Martinioni, 1663, p. 42; Boschini, 1664, p. 150; Boschini, 1674, p. 130; Zanetti, 1771, p. 124; C. and C., 1877, II, pp. 352–355; Gronau, *Titian*, 1904, p. 299; *Mostra di Tiziano*, 1935, no. 71; Tietze, 1936, II, p. 312; Berenson, 1957, p. 191; Valcanover, 1960, II, pl. 13.

LOST PICTURE:

Rome, Palazzo Farnese, Fulvio Orsini's collection, in 1600, head of St. James (Nolhac, 1884, p. 433, no. 47).

104. St. Jerome in Penitence (Type I) Plate 155

Canvas. 0·80×1·02 m.

Paris, Louvre.

About 1531.

In this work of extraordinary poetic beauty the landscape predominates, as the moon shines from behind the trees with an eerie light. Giorgione had earlier painted a *St. Jerome in Moonlight*, which Marcantonio Michiel saw in Andrea Odoni's house in 1532 (Michiel, 1884, p. 162). This work may reasonably be assumed to have been Titian's source of inspiration. Wretched as the preservation of Titian's small canvas is, its highly imaginative spirit survives. The muscular figure of St. Jerome in blue drapery kneels before the crucifix, with his red cardinal's hat and his books nearby, while the lion, his attribute, stands at the left near the front.

Condition: The generally smudged state of the canvas, the large gash (repaired) in the centre, and the poor light in the museum render the picture nearly invisible; restored and relined in 1750.

History: An inventory of pictures dated 1637, said to have been bought from Frizell, includes a 'St Hierom in a darke painted landscept (*sic*) being a little figuere' (Ogden, 1947, p. 248; van der Doort, 1639, Millar edition, 1960, p. 183, no. 21). It hung in Charles I's dressing-room at Hampton Court. Because Mantua is not given as the provenance, it has been assumed that Charles I's *St. Jerome*, now in the Louvre, was bought through Frizell from another source. Nevertheless, there was a *St. Jerome* at Mantua, ordered by Isabella d'Este in 1523 but delivered only in 1531 (D'Arco, 1857, I, p. 112). Therefore the probability seems strong that the Louvre *St. Jerome* is the same item that Titian painted for Mantua and

that it was purchased along with Charles' acquisition of the great Gonzaga art collection. Such minor errors in catalogues and inventories are easily made.

The Louvre *St. Jerome* was sold with Charles I's collection after his execution: Harley MS. no. 4898 (1649–1652), British Museum, folio 287, no. 65, 'A Saint kneeling before Ye Cross by Tytsian'; Jabach, Paris; Louis XIV; inventoried at Versailles by Le Brun in 1683, no. 307; still at Versailles in 1695; Luxembourg Palace in 1762; Louvre in 1785 (complete French history, Bailly-Engerand, 1899, p. 76).

Bibliography: See History; Lépicié, 1752, p. 27, no. 10; F. Villot, 1874, p. 285, no. 466; C. and C., 1877, I, p. 351; Louvre, cat. no. 1585, inv. no. 750; Suida, 1935, pp. 60, 164; Tietze, 1936, I, p. 155, II, p. 305; Berenson, 1957, p. 189; Valcanover, 1960, I, pl. 130.

VARIANTS:

1. Chatsworth, Duke of Devonshire, panel, 0·343 × 0·254 m., follower of Titian, sixteenth century. This composition differs considerably from other versions, for the crucifix is placed on a tree near the centre, with St. Jerome in purplish-rose drapery at the left and the lion in the background. The small scale of the panel is the reason for placing it under the Louvre version. Although it is a pleasant little picture, the quality does not approach Titian's own work. The handling of the trees is solid and strong but lacking in atmosphere. *Condition:* Well preserved; cleaned by Horace Buttery *c.* 1960. *History:* Chatsworth Inventory, 1761, first mention (S. Dodsley, II, p. 228). *Bibliography:* Waagen, 1854, III, p. 350 (Titian); C. and C., 1877, I, p. 352 (workshop); Chatsworth, 'Catalogue' (manuscript) 1933, no. 620 (Titian); *Memorial*, 1963, no. 8 (Titian).

2. Stockholm, National Museum (in storage), canvas transferred from panel, 0·53 × 0·63 m., follower of Titian, *c.* 1560. With the major emphasis on landscape, very blue in the sky and the sea, the painting includes a small kneeling St. Jerome, grey-bearded and in rose drapery. The precision in the outlines has led to the suggestion of a Flemish painter, who could have been an assistant in Titian's shop. It is in any event a work of considerable charm. *History:* Lord Northwick, Northwick Park (Northwick catalogue, 1859, no. 280; C. and C., 1877, I, p. 258, 20 × 24 inches, as Romanino); Holford Collection, Dorchester House, 1927, called Domenico Campagnola after Titian (cat. no. 49, pl. XLV; sale Christie's, London, 15 July 1927, no. 32, 20¼ × 24½ inches). *Bibliography:* See also History; Sirén, 1933, pl. 102 (Venetian School);

Richter, 1937, p. 238, no. 74, pl. 64 (copy of a lost Giorgione); Stockholm, 1962–1963, no. 99 (Titian school).

DERIVATIONS:

1. Bucharest, former Royal Collection, 0·53 × 0·34 m. (Bachelin, 1898, no. 66, illustration; called a replica of the Balbi picture (Lost Versions, no. 2) and related to the Louvre canvas, which it does not really resemble; apparently seventeenth century).

2. Glasgow, Garscube House (formerly), Louvre type, 0·749 × 0·508 m. Sir A. Campbell (Waagen, 1854, III, p. 292; C. and C., 1877, I, p. 352); just possibly, Andrew Wilson sale, London, Peter Coxe, 6 May 1807, lot 4, as Orazio Vecellio, from the Doria Palace, Rome (suggestion of Ellis K. Waterhouse); Sir George Campbell until 1946 (sale, London, Christie's, 19 July 1946, lot 75, purchased by Hartveld for 17 guineas. Later history of this picture supplied by Ellis K. Waterhouse.

3. Nantes, Musée des Beaux-Arts, canvas, 0·82 × 0·665 m., from the Cacault Collection, 1810 (Nicolle, 1913, p. 76, no. 174, called a reduced copy of the Louvre picture).

4. Sacramento (California), E. B. Crocker Art Gallery (since 1938), canvas, 0·571 × 0·445 m., remote school of Titian. Generally given to Bonifazio Veronese. *History:* Formerly Contini-Bonacossi, Florence; Kress Collection, 1936. *Bibliography:* Crocker, 1964, p. 53 (as Bonifazio).

5. Unknown location, canvas, 0·54 × 0·42 m., sixteenth century. The kneeling St. Jerome and the crucifix are copied from the Louvre picture, although the lion and the whole landscape setting, except for the rock in front of the saint, have been eliminated. *History:* Imperial Castle of Gatchina, Russia, listed in pen-and-ink catalogue of 1783; sold by Lepke's, Berlin, 4–5 June 1929, no. 90. *Bibliography:* Liphart, 1915, p. 3 (then at Castle Gatchina; called workshop of Titian).

6. Venice, Dal Zotto Collection, variant based on the Louvre picture (photo, Böhm, 882N, in Cini Foundation, Venice).

LOST VERSIONS:

1. A *St. Jerome*, sold to Russia in 1850, formerly Venice, Barbarigo Collection, 0·90 × 0·68 m. (Bevilacqua, 1845, p. 37, no. 41). St. Jerome kneels with stone in hand, lion at the left (Inventory of sale to Russia in 1850; Levi, 1900, p. 287, no. 41).

2. *St. Jerome* (see Cat. no. 107), from the Balbi Palace, Genoa (Buchanan, 1824, p. 200, no. 19); Andrew Wilson, bought from the Balbi Palace on 13 November 1805; Wilson sale (London, Peter Coxe, 6 May 1807, lot 19,

bought in); Lord Rendlesham (sale, 25 May 1810, lot 8). All of this data by courtesy of Ellis K. Waterhouse.

3. A *St. Jerome* in the testament of Martino Longhi Juniore, Rome, 1 July 1656, 'un quadretto in tavola di un S. Girolamo meditante la morte, pittura di Titiano' (Golzio, 1938, p. 208).

105. St. Jerome in Penitence (Type II) Plate 171

Panel. 2·35 × 1·25 m.

Milan, Brera Gallery

Signed in capitals on the rock below the saint's knee:
TITIANVS F

About 1555.

A general brownish tonality is maintained throughout the picture with contrasts in the slightly greenish trees and the red drapery around the lower part of the saint's body. The muscular, Michelangelesque old man with grey beard holds the rock of self-mortification in his right hand as he addresses his prayer toward the crucifix.
A tiny lizard is directed toward the signature, the poor restoration of which with shadows gives a relief-like effect rarely used by Titian himself. At the lower right the head and paws of the sleeping lion, St. Jerome's attribute, are discernible, and above on the rocks grows the ivy plant, symbol of eternal life. At the left stand the symbols of penitence: the death's head and the hour-glass. The two large volumes obviously refer to the saint's scholarly work, but the indecipherable letters in capitals on the vertical book cannot be explained.

Condition: Tietze suggested that the semicircular top constituted a later addition, because Titian's other versions are rectangular. Nevertheless, the physical condition indicates a uniform panel from the start. A vertical split at the right side which passes through the saint's elbow reveals where the panel was originally joined. The general state of preservation of the work is superior, although the colours have faded throughout, especially the blue of the sky and the greens of foliage. Chief restorations are in the loin cloth, where the paint is blistered.

Other dating: Crowe and Cavalcaselle, 1560; Gronau, 1550.

History: Santa Maria Nuova, Venice, which was rebuilt in 1555 and closed in 1808 during the Napoleonic occupation; the picture went to the Brera thereafter (Cicogna, 1830, III, fascicolo II, p. 283).

Bibliography: Sansovino, 1581, folio 56ᵛ. (Titian); Ridolfi (1648)–Hadeln, I, p. 205 (Titian); Boschini, 1664, p. 412 (Titian); Albrizzi, 1740, p. 157; Zanetti, 1797, Canareggio, p. 71; not mentioned by Moschini in 1815; C. and C., 1877, II, pp. 333–334; Gronau, *Titian*, 1904, p. 293; Suida, 1935, pp. 129, 179; Tietze, 1936, I, p. 199, II, p. 300; Modigliani, 1950, p. 50, no. 182; Berenson, 1957, p. 188; Valcanover, 1960, II, pl. 65.

COPY:
Vienna, private collection, head and shoulders only (Suida, 1933, p. 161).

DRAWINGS of St. Jerome, not specifically preparatory for this picture:
1. London, British Museum (Hadeln, 1924, pl. 13).
2. Vienna, Albertina (Hadeln, 1924, pl. 14).
3. Unknown location, formerly Dresden Gemäldegalerie, sepia sketch, no longer traceable (cited by C. and C., II, 1877, p. 133, from a Braun photo, probably an error).

106. St. Jerome in Penitence (Type II) Plate 169

Canvas. 1·04 × 0·79 m.

Rome, Accademia di San Luca.

Titian and workshop.

About 1555.

At the left, on the edge of the pages of the book, are the red letters T V, which, however, do not correspond to Titian's usual signature and must be a late addition. The quality is rather good in this picture, in which all major details follow the version in the Brera, the differences consisting in a simplification of the landscape. The grey rocks and other details are much the same in both cases: the rose drapery, hour-glass, books, skull, and even the ivy on the rocks and the tiny lizard in the foreground.

Condition: Somewhat crackled and dirty.

Bibliography: C. and C., 1877, II, p. 334 (seventeenth-century copy); Golzio, 1939, no. 309 (Titian); Berenson, 1957 (omitted); Valcanover, 1960 (omitted).

107. St. Jerome in Penitence (Type II) Plate 172

Canvas. 1·375 × 0·97 m.

Lugano, Thyssen-Bornemisza Collection.

About 1570.

The background, entirely in tones of brown, seems to be the underpaint, and the trees above likewise remain

unfinished. Nevertheless, this version is a late and simplified rendering of the better-known composition in the Brera (Plate 171). Although the attributes of the saint at the left in the Brera canvas have been eliminated here, the rose drapery is retained, somewhat repaired vertically on the right side. The saint's features resemble Titian's late portraits of himself, especially the St. Jerome of the *Pietà* in the Accademia at Venice.

Condition: Somewhat rubbed; slight repairs in the drapery.

History: The lost *St. Jerome* once in the Balbi Collection in Genoa, which passed to England in 1805 (see Cat. no. 104, Lost Versions, no. 2), might possibly be the Lugano picture, since the latter has no early history. This suggestion is pure speculation. S. E. W. Browne, London, expertise by Léon Bonnat (1833–1922); Mordasewicz, Paris, 1920 (?); Julius Böhler, Munich, 1931; Steinmayer, New York, 1932; purchased by Thyssen in 1934.

Bibliography: Lionello Venturi, 1932, pp. 490, 497 (Titian); *idem*, 1933, pl. 530 (Titian); Suida, 1933, pp. 159–160 (Titian); Suida, 1935, pp. 129–130, pl. 249a (Titian); Tietze, 1936 (omitted); Berenson, 1957, p. 187 (Titian, late); Heinemann, 1958, p. 109, no. 423 (Titian); Valcanover, 1960, II, p. 72, pl. 177 (doubtful); Hendy, 1964, p. 119 (Titian).

108. St. Jerome in Penitence (Type III)　　Plate 195

Canvas. 1·84 × 1·77 m.

Escorial, Nuevos Museos.

Signed in capitals on the rock beneath the saint's knee: TITIANVS F

1575.

Information published about this picture since the time of Crowe and Cavalcaselle has been mostly erroneous. Their statement that the *St. Jerome in Penitence* had been so extensively repainted that the master's hand can be seen only in the saint's head is totally incorrect, for the canvas is in good condition. Tietze repeated their account, and this misconception of a great work has been passed on by many people who have never seen it.

There can be no doubt about this magnificent picture, which ranks among the best of the artist's late works, done with brilliantly free strokes of the brush. A rich blue sky is visible through the opening in the cave, into which a white light enters, directed to the crucifix at the right. The only warm colour is supplied by St. Jerome's rose

drapery. Accompanied by a snarling lion at the lower left, the saint kneels before the crucifix, as usual, while just above him the hour-glass stands upon a large bound volume. On the rock lie papers on which the letters appear to be TUIJO VASO, the meaning of which eludes explanation.

Condition: Some crackle on the saint's body; repairs in the drapery over the leg and under the right arm.

History: Shipped to Philip II in 1575, according to a letter dated 24 September 1575 from the Spanish ambassador at Venice, Guzmán de Silva (San Román, 1931, Apéndice I, nota 10; Beroqui, 1946, p. 164; Cloulas, 1967, p. 281); sent by Philip II to the Escorial in 1584 (Zarco Cuevas, 'Inventario', 1930, p. 46, no. 1013; on an altar in the Chapter House when Padre Sigüenza wrote in 1599 (edition 1923, p. 395), and there it remained in 1657 and 1698, in the latter year with a long description by Padre de los Santos (edition 1933, pp. 248, 302); exhibited in the Prado Museum *c.* 1843–1860 (Prado catalogues, 1843–1858); in the past century again in the Escorial; in the Nuevos Museos of the Escorial since 1963.

Bibliography: See also History; Palomino, 1724 (edition 1947, p. 797); Ponz, 1773, tomo II, carta IV, 35; Ceán Bermúdez, 1800, V, p. 42; Poleró, 1857, no. 399; C. and C., 1877, II, pp. 333–334; Suida, 1935, p. 179; Tietze, 1936, II, p. 288; Berenson, 1957, p. 185; Valcanover, 1960, II, pl. 75.

COPY:
A weak copy in the Claustros Menores of the Escorial was probably painted by one of the monks.

109. St. John the Baptist　　Plate 165

Canvas. 2·01 × 1·34 m.

Venice, Accademia.

Signed upon the stone under the left foot: TICIANVS

About 1545–1550.

The fine blue sky and brown-green landscape occupy most of the background, which is completed by the rocky setting at the left. The powerful, dark-bearded saint, clad in his traditional fur, lined in grey, assumes a bold pose, which carries such force and conviction that various proposals of influences by other masters seem inconsequential. Tietze saw a reflection of Mantegna's print of the Baptist, and he also suggested a relationship to Jacopo Sansovino's early sculpture, but the attitude of Titian's

saint is more authoritative than either. The quality of the picture far surpasses the effect achieved in the unsatisfactory photographs.

Condition: Well preserved, although trees and earth have darkened under thick varnish.

Other dating: Mayer, *c.* 1530–1532 (*Gazette des beaux-arts*, 1937, p. 178); Tietze, *c.* 1545–1550; Valcanover, 1540–1550.

History: Santa Maria Maggiore, Venice; removed from the church in 1807, destined for the Accademia.

Bibliography: Vasari (1568)–Milanesi, VII, p. 437; Dolce, 1557, edition 1960, p. 203 (wrongly says on panel); Sansovino, 1581, p. 96; Ridolfi (1648)–Hadeln, I, p. 167; Sansovino-Martinioni, 1663, p. 269; Boschini, 1664, p. 388; Tietze, 1936, I, p. 198, II, p. 310; Berenson, 1957, p. 191; Valcanover, 1960, I, pl. 172; Moschini Marconi, 1962, p. 259, no. 452.

LOST VERSIONS:

1. Venice, Niccolò Cornaro, version cited in 1663 (Sansovino-Martinioni, 1663, p. 375; C. and C., 1877, II, p. 253).
2. Venice, Galeazzo Galeazzi, replica cited as passing to him in the nineteenth century from the Casa Jacobi at Cadore (C. and C., 1877, II, p. 253).

110. St. John the Baptist Plate 167

Canvas. 1·85 × 1·14 m.

Escorial, Nuevos Museos.

Signed on the stone under his foot: TITIANVS FACIEBAT (entirely repainted).

About 1560.

A banderole in his right hand has an inscription in red letters: ECCE AGNVS DEI. The saint in full length holds a wooden cross, placed diagonally in his left hand, as he looks heavenward. The superb quality of technique and the fresh colour of the picture are evident despite its lamentable condition. Moreover, the beautiful conception of the spiritually moving figure is memorable. The work has been overlooked by most writers because of its former location in a dark corner of the Antesacristía.

Condition: In a ruinous state with scaling paint; superficially cleaned and varnished in 1963. The wretched photograph here reproduced (no other could be obtained) shows scratches which are not on the canvas.

History: Sent to the Escorial in 1574 (Zarco Cuevas, 'Inventario', 1930, p. 47, no. 1019, grouped with pictures by Titian, but no author given); Padre Sigüenza said in 1599 that it then hung in the passageway to the high altar (edition 1923, p. 418); in 1657 Padre de los Santos locates it in the Sacristy (edition 1933, p. 240); in the Antesacristía in the twentieth century until 1963.

Bibliography: See also History; Poleró, 1857, no. 98 (Titian); C. and C., 1877, II, p. 253 (replica); Suida, 1935, p. 139 (Titian); Mayer, 1937, pp. 178–183 (Titian); Berenson, 1957 (omitted); Valcanover, 1960, II, p. 70 (doubtful attribution).

111. St. John the Evangelist on Patmos, Vision of
Plate 156

Canvas. 2·375 × 2·639 m.

Washington, National Gallery of Art, Samuel H. Kress Collection.

1544–1547.

An exhaustive study of Titian's ceiling for the Scuola di San Giovanni Evangelista has been made by Dr. Juergen Schulz, who shows that Correggio's dome and decorative frescoes below it in S. Giovanni Evangelista at Parma are the direct source for Titian's scheme. This idea was advanced by Suida and by Tietze (1936) and further developed by A. E. Popham in his study of Correggio's drawings. Dr. Schulz in his reconstruction of the ceiling demonstrates that, although Titian foreshortened the main figure of St. John, now in Washington, he painted the lateral decorative panels without foreshortening, that is, like easel pictures. New documents, published by the same scholar, make it clear that the ceiling is datable *c.* 1544–1547, considerably later than formerly believed.

The engraving by Andrea Zucchi of the early eighteenth century establishes without question the identity of the canvas now in Washington, in which God the Father and angels appear at the upper left as St. John raises his arms in prayer and exaltation. The light-rose tunic and red drapery are highlighted with white pigment, while the medium-blue sky provides a pleasing setting against which the black eagle and God the Father in dark green are major accents.

Condition: In damaged condition in 1789 (Schulz); ruinous when exchanged with Barbini in 1818; present state of preservation, much disintegrated and heavily retouched.

History: Scuola di San Giovanni Evangelista, Venice, until 1806, located in the ceiling of a new *albergo* (council room) which was rebuilt in 1540–1545 (Schulz, 1966, pp. 89–90); Accademia, Venice (1812–1818); passed by exchange to the Barbini Collection, Turin, in 1818 (Zanotto, 1834, p. 18); Conte Bertalazione d'Arache, Turin, in 1885 (Cadorin, 1885, p. 19); rediscovered by Suida; Contini-Bonacossi, Florence; purchased for the Kress Foundation, New York, in 1954.

Bibliography: See also History; Sansovino, 1581, p. 101a; Ridolfi (1648)–Hadeln, I, p. 205; Sansovino-Martinioni, 1663, p. 284; Boschini, 1664, p. 295; Zanetti, 1733, p. 294; G. Dionisi, 1787, p. 22; C. and C., 1877, II, p. 416 (Titian); Suida, 1935, pp. 69, 165, pl. 108b; Suida, 1936, p. 111; Tietze, 1936, I, pp. 188, 232, Taf. 24, II, p. 312; Suida and Shapley, 1956, p. 186, no. 73; Popham, 1957, pp. 38–40; National Gallery Booklet no. 6, 1960, p. 28; Valcanover, 1960, I, p. 103, pl. 178; Seymour, 1961, pp. 121, 203; Moschini Marconi, 1962, pp. 262–263; Washington, 1965, p. 130, no. 1484 (Titian); Schulz, 1966, pp. 89–95; Shapley, 1968, pp. 183–184; Schulz, 1968, pp. 84–85, pls. 16, 17.

112. Decorative panels

Panel. Average sizes: 0·56 × 0·53 and 0·41 × 0·45 m.

Venice, Accademia.

Workshop of Titian, 1544–1547.

These twenty-one panels from the ceiling of the council room (*albergo*) of San Giovanni Evangelista at Venice were primarily decorative in purpose. Among the panels the symbols of the Evangelists (*c.* 0·45 × 2·40 m.) provide the major interest, although some of the *putti* have charming poses. Indeed Dr. Schulz believes that the nude figures, but not the symbols of the Evangelists, were painted by Titian himself. The central canvas of *The Vision of St. John the Evangelist* is now in the National Gallery at Washington (see Cat. no. 111).

Condition: Darkened and dirty; Numerous restorations, those recorded in 1817, 1903–1904, and 1935, have left little more than archaeological interest in the paintings.

History: See Cat. no. 111. At the suppression of the Scuola by the Napoleonic government the panels were taken to the Accademia.

Bibliography: See Cat. no. 111. Moschini Marconi, 1962, pp. 262–263 (as by the workshop).

113. St. John the Hospitaler Plate 166

Canvas. 2·64 × 1·56 m.

Venice, San Giovanni Elemosinario, High Altar.

About 1550.

The large figure of the saint in white surplice and a rose velvet hood is presented as he makes a broad gesture to bestow charity upon the beggar. He sits against a background of deep-blue-and-white sky, as though revealed through the lifting of the dark-green curtain. The muscular beggar, swarthy of skin and partially covered by red and white drapery, sprawls upon mottled marble steps while he receives alms from the venerable, white-bearded Saint. To the right a youth in black holds aloft the golden episcopal cross, which marks the apex of a long diagonal movement. The cross refers to the office of Patriarch of Alexandria (*c.* 608–619) held by this patrician saint, who was celebrated for his charitable deeds.

The grandeur of spirit conveyed in this work has the mark of the artist's richness of experience as a man and as an artist. The various proposals of dependence on other painters in this mature masterpiece carry little conviction. Friedländer's suggestion that Titian borrowed the beggar from Bonifacio's *Madonna and Saints* now in the Accademia in Venice does not seem justified, since the figures do not resemble each other in physique or in pose. The same scholar theorized that Titian used the third-rate Pordenone as a model for St. John on the basis of a drawing of St. Augustine at Windsor Castle and because of the fact that the latter had painted frescoes representing the four Evangelists and the four Fathers of the Latin Church in the cupola of the same building in which Titian's picture serves as high altar. Even though these works are earlier (*c.* 1527–1528) than Titian's, it is difficult to discern any direct interdependence in style between Pordenone's drawing at Windsor and Titian's painting. Because of the presence of works by both painters in this same church, rivalry between the two was proposed as early as the time of Ridolfi (1648).

Condition: The picture has darkened considerably through time and the addition of varnish. It appears most probable that the painting has been cut down considerably at both sides and that more canvas was added at the foot of the picture at the time the present architectural setting was installed; restored in 1935.

Other dating: Vasari and Ridolfi date the picture after Titian's return from Bologna in 1533; Tietze, 1540–1545; Longhi, 1545; Friedländer, *c.* 1535–1537.

Bibliography: Vasari (1568)–Milanesi, VII, p. 441; Ridolfi (1648)–Hadeln, I, pp. 123, 171, 417; Boschini, 1664, p. 260 (on high altar); C. and C., 1877, I, p. 381; *Mostra di Tiziano*, 1935, no. 24; Suida, 1935, pp. 55–56, 66–67; Tietze, 1936, I, p. 149, II, p. 312; Longhi, 1946, p. 24; Paris, 1954, no. 78; Valcanover, 1960, I, pp. 187–189; Friedländer, 1965, pp. 120–121.

114. St. Lawrence, Martyrdom of Plates 178, 179

Canvas. 5·00 × 2·80 m.

Venice, Gesuiti.

Signed on the gridiron: TITIANVS VECELIVS AEQVES F.

Ordered in 1548, completed about 1557.

The beauty of Titian's *Martyrdom of St. Lawrence* is overwhelming in its richness of colour within an eerie effect of night and in the sheer virtuosity of the brushwork. Yet perhaps the grandeur of the drama portrayed is even more memorable. Only in recent times, since the installation of strong electric lights, has it been possible to see and evaluate the work properly. Although the general setting is rather dark, the architecture is painted in tones of grey and white and the opening in the clouds has a yellowish cast against the blue-black sky. In the darkness the reddish-yellow flares throw light upon the statue, perhaps Minerva, at the left and upon the great structure at the right, which must be the temple of Jupiter before which Valerius brought the saint to trial (Guérin, 1888, IX, pp. 434–436). Under the gridiron the coals glow red, while further richness of colour is added by the rose banner at the upper right, the rose over the shoulders of the man with the helmet at the lower right, and the rose drapery behind St. Lawrence.

The muscular youths at the left in contorted positions are in postures strikingly like Tintoretto's in a contemporary work (*c.* 1550), the *Cain Slaying Abel* in the Accademia at Venice. In the *Martyrdom of St. Lawrence* most critics see the result of Titian's study of the antique monuments on his visit to Rome, his enthusiasm for which Pietro Bembo notes in a letter to Girolamo Querini, 10 October 1545 (Bembo, edition 1830, p. 238). Comparison of the architectural setting with the remains of the temple of Hadrian in the Piazza di Pietra at Rome, first made by Crowe and Cavalcaselle, is still valid. An ingenious idea is Mrs. Kennedy's that Titian was inspired by the church of San Lorenzo in Miranda, whose façade is the temple of Antoninus and Faustina in the Roman Forum, yet the architectural relationships are remote (Kennedy, 1956, p. 242). Brendel sees the pose of St. Lawrence as suggested by the *Gaul* in the Archaeological Museum at Venice, while Rothschild derived the composition as a whole from Michelangelo's *Sacrifice of Noah* in the Sistine Chapel, the figure of St. Lawrence from Michelangelo's *Jonah* and the *Day* of the Medici tombs. Surely the shadow of Michelangelo looms mightily here, but it is absorbed in Titian's incomparable sense of colour and light, and the theory that Titian consciously copied this or that figure seems of secondary significance in the creative process of such a great master.

Condition: Early restorations in 1834–1835, 1877, and relining in 1877; cleaned for the exhibition of 1935 and more thoroughly in 1959; the condition of the canvas could never have been as bad as Crowe and Cavalcaselle in the darkness of the church supposed. In general the picture is still somewhat dirty and heavily varnished.

History: On 18 November 1548 Titian was already at work upon the picture: 'La palla del qual altar voglio che si abbia a finir' (testament of Lorenzo Massolo, 1548); in 1557 it still remained unfinished: 'Voglio et ordino che se l'arca et pala di crosechieri non sarà finita la facci finir con quella più prestezza sera possibile' (testament of Elisabetta Querini, 15 March 1557).

The canvas occupied the second altar to the right in the church of Santa Maria dei Crociferi. On the suppression of the order in 1656 the church passed to the Jesuits, who subsequently rebuilt it in 1715–1730. Lorenzo Pezzana took Titian's picture for his own chapel, the first on the left in the new church. Although the suppression of the Jesuits in 1773 left the canvas untouched, the French transported it to Paris in 1793, but were obliged to return it to the church in 1815.

Bibliography: See also above; documents in Gallo, 1935, pp. 155–171; Vasari (1568)–Milanesi, VII, p. 453; Sansovino, 1581, p. 160; Ridolfi (1648)–Hadeln, I, p. 204; Sansovino-Martinioni, 1663, p. 169; Boschini, 1664, p. 422; Scanelli, 1657, p. 215; C. and C., 1877, II, pp. 259–264; Rothschild, 1931, Heft 6, pp. 202–209; Suida, 1935, pp. 133–134; Tietze, 1936, I, pp. 199–202, II, pp. 311–312; Tietze and Tietze-Conrat, 1944, pp. 306, 316; Brendel, 1955, p. 122; Berenson, 1957, p. 191; Valcanover, 1960, II, pls. 66-69.

DRAWING:

Florence, Uffizi, study for the legs of the executioner of St. Lawrence, charcoal heightened with white, on blue paper, 403 × 253 mm. (Hadeln, 1924, pl. 31; Frölich-Bum, 1928, p. 198, no. 38; Tietze and Tietze-Conrat, 1944, p. 316, no. 1906). The last-mentioned authors'

identification of the drawing with the *Martyrdom of St. Lawrence* is reinforced by reference to a study of legs for this picture in the correspondence of Cardinal Leopoldo dei Medici in the mid-seventeenth century (Muraro, 1965, p. 83). For the unconvincing association of the study with St. Christopher, see Cat. no. 98, drawing.

115. St. Lawrence, Martyrdom of

Plate 181

Canvas. 4·40×3·20 m.

Escorial, Iglesia Vieja.

Signed in capitals on the gridiron: TITIANVS F.

Titian and workshop.

Documented 1564–1567.

The great open archway, or city gateway, which replaces the temple façade of the version in Venice, forces into the foreground the compact group of figures, now also much changed, not the least of whom is St. Lawrence in his twisted position. Against the generally blackened background, the crescent moon seen through the arch, the two flares at the left, and the whitish coals beneath the gridiron, along with flesh tints, supply the chief contrasts in colour values. The ugly old men as torturers are the most villainous ever in Titian's work. The new figure of a man at the right on a white horse adds colour by virtue of the dark red of his jacket and the blue of his sleeve and hat, the last topped by a white plume. The introduction of two beautiful cherubs within an aura of radiant light in the upper part of the composition is also an innovation, whereas the pedestal with the statue (Minerva?) remains virtually unaltered. The sculptured relief on the rectangular plinth beneath this statue shows two figures, one standing who holds a baton and the other seated with back turned. Probably the judgment by Emperor Valerius and the condemnation of St. Lawrence to martyrdom is intended here.

The high quality of the picture in Venice is attained here neither in composition nor in execution, in which the work of an assistant, probably Girolamo di Tiziano, is much in evidence.

Condition: Very darkened; apparently never thoroughly cleaned or restored; varnished and slightly restored in 1963.

History: Begun in 1564, it was seen in Titian's studio by Vasari in 1566 and shipped to Spain in December 1567. (Zarco del Valle, 1888, pp. 233–234). On 31 August 1564 Philip II had written to García Hernández, the Spanish

ambassador at Venice, that he wanted a picture of the Martyrdom of St. Lawrence for the Escorial. On 8 October 1564 the latter informed Gonzalo Pérez that for fifty *scudi* Titian's pupil Girolamo di Tiziano would paint a copy of the composition that was then in the Chiesa dei Crociferi. Various letters of 1565, 1566, and 1567 refer to the progress on the picture by Titian himself until its shipment from Venice via Genoa on 3 December 1567 (C. and C., 1877, II, pp. 533–537; Cloulas, 1967, pp. 265–272, 274). The canvas was included among those sent to the Escorial in 1574 (Zarco Cuevas, 'Inventario', 1930, p. 43, no. 995). Padre Sigüenza gives a description of it on the high altar of the Iglesia Vieja of the Escorial in 1599 (edition 1923, p. 380); likewise on the high altar when Padre de los Santos wrote in 1657 (edition 1933, p. 234); still in the same location in 1969.

Bibliography: Vasari (1568)–Milanesi, VII, p. 457; Ridolfi (1648)–Hadeln, I, p. 204; C. and C., 1877, II, pp. 259–264, 343–344, 380–383, 533–534; Rothschild, 1931, pp. 11–17; Gallo, 1935, pp. 155–171; Tietze, 1936, I, p. 238, II, p. 288; Valcanover, 1960, II, pl. 121.

ENGRAVING:

Cornelius Cort's signed engraving, dated 1541 (Plate 180), is dedicated to Philip II by an inscription on the pedestal of the statue at the upper right: 'Invictis Philippo Hispaniarum Regi.' The principal figures in the foreground follow in the main the composition of the *Martyrdom of St. Lawrence* in Venice, while the cherubs at the upper left are related to the Escorial version. However, the simplified background of swirling clouds, resembling neither, suggests that Titian prepared a drawing especially for the print. The variants and copies of this sheet are catalogued by Bierens de Haan (1948, pp. 144–147).

COPY:

Madrid, Prado, canvas, 1·44×0·36 m., poor copy after Cort's print (Madrazo, 1910, p. 86, no. 455, no provenance given; Mas photograph, no. P 455).

LOST COPIES (exact type unknown):

1. La Granja, Inventory 1746 and also 1814 (Archivo del Palacio, Madrid, no. 20136 (264), 2¼×1½ *pies* (0·686× 0·457 m.), bought from the heirs of Carlo Maratta in 1722 and attributed to Scarsellino (Battisti, 'Postille', 1960, p. 89; Pérez Sánchez, 1965, p. 208).

2. London, Charles I, Inventory of sale, 1649 (Charles I: LR, 2/124, folio 117ᵛ, no. 12).

3. Madrid, 1647, Inventory of Juan Alfonso Enríquez de Cabrera, Admiral of Castille, 'Un Sant Lorenzo, en

lienzo, del Ticiano 5·500 reales' (Fernández Duro, 1902, p. 190).

St. Lawrence, Life of (Escorial)

In his letter of 2 December 1567 Titian offered to paint a series of eleven pictures of the saint's life, in which he would be assisted by his son Orazio and another very able young pupil, 'un altro molto valente giovine, mio discepolo' (C. and C., 1877, II, p. 536; Cloulas, 1967, p. 272). Karl Justi suggested that this anonymous pupil must have been El Greco, but such an identification is hazardous when one considers the number of young painters in the artist's studio (Justi, 1908, II, p. 206; Wethey, 1962, I, p. 6).

The series of canvases of the life of St. Lawrence, located in ruinous condition in the upper cloister of the Escorial, was completed in 1598 by the Florentine artist Bartolomé Carducho, who accompanied Federico Zuccaro to Spain in 1585 and remained there until his death in 1606 (Zarco Cuevas, 1932, pp. 271–298).

116. St. Margaret
Plate 175

Canvas. 2·10 × 1·70 m.

Escorial, Apartment of Philip II.

Workshop of Titian.

1552.

Against a very black background and an enormous over-sized dragon, the saint in a pale-blue tunic turns in an exaggerated *contrapposto*. The coarseness of drawing and generally mediocre quality may be due to restoration of a work which was almost a total ruin until 1949. Nevertheless the original design itself is far inferior, especially the setting, to the later *St. Margaret* now in the Prado Museum.

Condition: Much reduced in size; completely ruined after more than a century of neglect in the upper cloister; restored 1949 by Seisdedos; previous to restoration remains of the false drapery on the leg were clearly visible (illustration, Beroqui, 1946, p. 134).

History: The famous picture of *St. Margaret* at the Escorial, whose bare leg was covered with false drapery in the late sixteenth century, is mentioned by all the major Spanish sources. It seems to be the work shipped to Prince Philip (later Philip II) in 1552, according to Titian's letter to the young prince dated 11 October 1552, in which he mentions 'il paessaggio et il ritratto di Santa Margherita' (C. and C., 1877, II, p. 505). A letter of 3 June 1552 speaks of two pictures which may be these same items (Cloulas, 1967, pp. 213, 215). The *Landscape* was lost in the fire of the Alcázar in 1734 (Bottineau, 1958, p. 154, no. 261). The *St. Margaret* sent to the Escorial in 1574 measured 9½ × 7½ *pies* (2·67 × 2·10 m.), dimensions which, even though inexact, establish it as a large canvas (Zarco Cuevas, 'Inventario', 1930, p. 44, no. 1001); in the 'zaguán de la sacristía' in 1599, when Padre Sigüenza wrote 'echáronle una ropa falsa en un desnudo de una pierna' (edition 1923, pp. 417–418); Padre de los Santos in 1657 notes it in the Aula de Escritura (edition 1933, p. 255); Palomino in 1724 reports that the leg is disfigured by false drapery (edition 1947, p. 796); same place in 1764 (Padre Ximenez, p. 118); still in the Aulilla del Moral (i.e. de Escritura) in 1773 (Ponz, tomo II, carta IV, 70); still there in 1800 (Ceán Bermúdez, V, p. 43); also in 1820 (Padre Bermúdez, p. 237); the drapery was removed some time in the nineteenth century and the picture consigned to the upper cloister (Poleró, 1857, no. 332.)

Bibliography: See also History; C. and C., 1877, II, p. 223 (they confuse *St. Margaret*, Cat. no. 117, with the Escorial picture); Beroqui, 1946, pp. 132–134 (established correct history); Llorente Junquera, 1951, pp. 67–72; Pallucchini, 1959–1960, p. 47 (as Titian's picture of 1552); Berenson, 1957, p. 185 (repainted); Valcanover, 1960, II, pl. 52 (Titian).

117. St. Margaret
Plate 173

Canvas. 2·42 × 1·82 m.

Madrid, Prado Museum.

Signed at the right near the head of the dragon: TITIANVS

About 1565.

This picture, one of Titian's masterpieces, presents an heroic St. Margaret in *contrapposto* as she lifts the cross to subdue the monster. Her pale-green tunic and brown veil have faded and the once glorious rocky landscape at the right and the distant seascape behind her are barely distinguishable. Francisco Pacheco objected to the striding pose on the ground that the saint seems to be riding the monster, an observation he had copied from Lodovico Dolce (1557, edition 1960, p. 170), and a curiously close parallel to Mrs. Jameson's Victorian comment that the bare leg is immodest. Various writers have seen the influence of Giulio Romano's *St. Margaret* in the Louvre.

Condition: In 1666 the picture measured 2½ × 2 *varas*; in 1734 it is reported as 3 × 2 *varas* (2·58 × 1·72 m.). Although dimensions in inventories are always approximations, there is every reason to believe that canvas was added at the top after the fire of 1734. The line of joining is

clearly visible above the rocks at the right. The picture is blackened and badly damaged by the same fire in the Alcázar. The former Harcourt version demonstrates how the Prado landscape must have looked originally (Cat. no. 118).

Other dating: Crowe and Cavalcaselle, 1552; Gronau, *c.* 1567; Tietze, late.

History: If this version of *St. Margaret* first belonged to Mary of Hungary (died 1558), it would have to be dated *c.* 1554, since she left Brussels for Spain in 1556. None of her inventories lists it, however. The proposal that it belonged to Mary, sister of Charles V, is based on a print by Luca Bertelli which has the following inscription: 'Titiani Vecelei aequitis Cae Reginae Mariae Imp. Caroli V. Sororis Opus' (Glück, 1934, p. 193, note 72). The Prado *St. Margaret* was previously identified incorrectly with the picture sent to Spain in 1552 (C. and C., 1877, II, pp. 218, 222–223; see Cat. no. 116, History). The suggestion that it came from Charles I's collection (Mayer, *Gazette*, 1937, p. 309) is mistaken since that picture, formerly in the Harcourt collection, is now owned by Heinz Kisters at Kreuzlingen (Cat. no. 118).

The correct history of the Prado *St. Margaret* was established by Beroqui (1946, pp. 131–135): Pacheco (1638) saw the picture in the church of San Jerónimo at Madrid (edition 1956, I, p. 286); Palomino in 1724 (edition 1947, p. 795) says that the *St. Margaret*, formerly in San Jerónimo, is now in the Alcázar; Alcázar Inventories, Galería del Mediodía, 1666, no. 589; 1686, no. 266; 1700, no. 77 (Bottineau, 1958, pp. 154–155); saved from the Alcázar fire in 1734, no. 59; Buen Retiro Palace, 1746, no. 59; Royal Palace, Madrid, 1772–1821 (Ponz, 1776, tomo VI, Del Alcázar, 44); Prado Museum (catalogue of 1821, no. 410).

Bibliography: See also History; Ceán Bermúdez, 1800, V, p. 40; Madrazo, 1843, p. 186, no. 851 (no provenance given); 'Inventario general', 1857, p. 177, no. 851 (no provenance); C. and C., 1877, II, pp. 222–223 (incorrect history of the picture); Gronau, *Titian*, 1904, p. 306 (*c.* 1567); Tietze, 1936, I, p. 241, II, p. 297 (late Titian; incorrect history); Beroqui, 1946, pp. 131–135; Suida, 1935, pp. 139, 180 (wrong data and history); Berenson, 1957, p. 188 (late); Valcanover 1960, II, pl. 113 (Titian); Prado catalogue, 1963, no. 445.

COPIES:

1. Escorial, Aula del Moral, canvas, 2·44 × 1·70 m., copy of Prado picture (Poleró, 1857, no. 106, copy of Prado

picture: '7 pies 8 pulg. 3 lin alto, ancho 6 pies 10 lin.'; illustration, Beroqui, 1946, p. 136).

2. Calahorra (Logroño), Cathedral, museum, canvas, 1·85 × 1·86 m. (Plate 176), *c.* 1600, after Prado original. The landscape has turned black and numerous holes and rips in the canvas are crudely repaired. In the upper right corner barely visible are capital letters purporting to be a signature: TIT . . . S.

118. **St. Margaret** Plates 174, 177
Canvas. 1·98 × 1·676
Kreuzlingen, Heinz Kisters.
Signed in capitals at the lower right near the skull:
TITIANV(S)
About 1565–1570.

Most extraordinarily beautiful is the seascape, dark green in the lashing stormy waves and dramatically lighted in the sky by a fiery sunset, in which the campanile of St. Mark's is recognizable. The saint's brilliant light-green tunic and white sleeves are contrasted to thin rose drapery worn over the shoulders like a stole, upon which her long brown hair falls loosely. The great dragon is very black except for the brownish belly and the red spots on the right claws. The rocks, brown at the lower left, which merge into grey at the upper right, are brilliantly highlighted with white pigment.

Condition: The state of preservation is far superior to that of the Prado canvas, which was damaged by fire in 1734. It has suffered primarily from retouching of the face with resultant hard surfaces, which produce a harsh strained expression. On the other hand, the rest of the figure and the superb landscape have survived intact.

History: Collection of Charles I, 74 × 63 inches or 1·88 × 1·60 m. (van der Doort, 1639, Millar edition, 1960, p. 14, no. 3); exhibited at Somerset House, May 1650; appraised and sold for £100 (Charles I MS., *c.* 1650, p. 4, no. 19: Cosnac, 1885, p. 415; also Public Records Office, LR 2/124, folio 192ᵛ); Viscount Harcourt, Nuneham Park (Harcourt collection, 1806, p. 22), located then in the Great Drawing Room, it is described as follows: 'On one side of the chimney is a most capital picture by Titian of St. Margaret. It was in the collection of Charles I and has been engraved by Hugh Howard the painter.'; Harcourt sale, London, Christie's, 11 June 1948, no. 184, 500 guineas (*APC*, XXVI, 1947–1949, no. 3548); purchased by Frank Sabin, London, 1948; anonymous sale, London,

Christie's, 27 June 1958 (*APC*, xxxv, 1957–1958, no. 4585); bought by Kisters.

The suggestion that this picture was sent to Spain in 1552 and that Philip IV later gave it to Charles I is completely erroneous (*Connoisseur*, 1953, p. 48); see Cat. no. 116.

Bibliography: See also History; Waagen, 1857, p. 350 (Harcourt Collection; copy of the Prado picture); C. and C., 1877, II, p. 223, note (lost); unknown to Suida, Tietze, Berenson, and Valcanover; Pallucchini, 1959–1960, pp. 47–50 (Titian).

LOST PICTURE:

Padua, Cardinal Pietro Bembo, *St. Margaret Standing* (Ridolfi (1648)–Hadeln, I, p. 192).

119. **St. Mark Enthroned** Plates 147, 148

Panel. 2·30 × 1·49 m.

Venice, Santa Maria della Salute.

About 1511–1512.

The chief argument over this picture is whether to date it about 1504 (Fischel and Gronau) after the plague of that year or subsequent to Titian's return from Padua in 1511 and thus make it a memorial to the cessation of the plague of 1510, as first suggested by Crowe and Caval-caselle. The early style, still somewhat Bellinesque in its clarity and in the statuesque isolation of the figures, has been noted by all writers. There has also been general agreement that a relationship in style to Giorgione's *Judgment of Solomon* at Kingston Lacy is to be assumed and that Titian may also have been impressed by Florentine monumentality as a result of the visit of Fra Bartolommeo to Venice in 1508.

St. Mark, in a rose tunic and blue mantle, is enthroned upon a pedestal covered with dark grey-green drapery and silhouetted against a sky with large white clouds. The characteristic Venetian floor of rose and yellow marble tiles separated by grey bands establishes a stage space below. At the left are the two physicians Saints Cosmas and Damian, one in a red cloak and the other in light golden-brown mantle over blue, balanced by the two protectors against the plague, St. Roch in green-black with rose sleeves and the nude St. Sebastian. The most advanced technically is this youth, where Titian's soft handling of light and the brilliant design of the ample white loin cloth are especially notable.

Condition: Colours are fresh because of the solid early technique on panel; somewhat dirty in the centre.

History: In Santo Spirito in Isola, Venice (Sansovino-Stringa, 1604, p. 170), until 1656, when it was transferred to the church of Santa Maria della Salute (Sansovino-Martinioni, 1663, p. 229; Boschini, 1664, p. 350, as from Santo Spirito).

Bibliography: Vasari (1568)–Milanesi, VII, p. 432; Ridolfi (1648)–Hadeln, I, p. 153; C. and C., 1877, I, pp. 144–148 (Titian); Gronau, *Titian*, 1904, p. 299; Fischel, 1924, pl. 4; Hourticq, 1919, p. 79 (dated after 1510); Suida, 1935, pp. 19–20; Tietze, 1936, I, pp. 46, 77–78, II, p. 313; Zam-petti, 1955, pp. 164–167; Berenson, 1957, p. 191 (early); Valcanover, 1960, I, pls. 35–37 (c. 1511).

COPY:

A picture of St. Mark and other saints formerly located in San Francesco ad Alto in Ancona may have been a variant of this picture. It was assigned to the school of Titian, perhaps Girolamo di Tiziano (Sartori, 1821, p. 16).

120. **St. Mary Magdalen in Penitence** Plate 182
(Pitti type)

Panel. 0·84 × 0·69 m.

Florence, Pitti Gallery.

Signed on the vase at the left: TITIANVS

About 1530–1535.

The sensual appeal of the female nude was the artist's unmistakable intention in this luxuriant work. That the pose is based upon an antique statute of Venus has been convincingly proposed by Rothschild and others. Ridolfi regarded the antique as the source of all of Titian's Magdalens, whether clothed or unclothed. On the other hand, Suida was right in that the nude physical aspect had prevailed earlier in Leonardo's *Magdalen* and those of his school, but whether Titian consciously admired them is another matter.

A long poem by Giovanni Battista Marino dedicated to Titian's *Magdalen* suggests inspiration from a replica or copy of the Pitti type (Mirollo, 1963, pp. 286–293, with English translation; also Marino, *Poesie varie*, edition Bari, 1913, pp. 242–245).

Condition: Essentially well preserved, but no scientific data are available.

History: Duke of Urbino (Vasari); brought to Florence in 1631 (Inventory, no. 6; Gronau, 1904, p. 12) as the inheritance of Vittoria della Rovere on her marriage with

Ferdinand II dei Medici; Inventory 1654–1656 (Gronau, *loc. cit.*).

Bibliography: See also History; Vasari (1568)–Milanesi, VII, p. 444; Ridolfi (1648)–Hadeln, I, pp. 174, 188; C. and C., 1877, I, pp. 350–351; Rothschild, 1931, Heft 6, p. 207; Suida, 1935, pp. 61, 165; Tietze, 1936, II, p. 288; Francini Ciaranfi, 1956, p. 43, no. 67; Berenson, 1957, p. 185; Valcanover, 1960, I, pl. 138.

121. St. Mary Magdalen in Penitence Plate 189
(Pitti type)

Canvas. 0·98 × 0·75 m.

Milan, Ambrosiana Gallery.

Workshop of Titian.

About 1540.

The quality of this replica is much superior to the others, placing it next to the Pitti example, and the possibility remains that it should be identified with one of the pictures cited in sixteenth-century documents. The Magdalen is placed against a rocky wall with a touch of blue sky above. The major variation from the Pitti version is in the hair, which has less sense of texture in general and is less wavy here. In his own discussion of this work Cardinal Federico Borromeo defended the nude by stating that Titian knew how to maintain its honesty ('seppe mantenere nel nudo l'onesta': Borromeo, 1625, edition 1909, p. 64).

Condition: The canvas is warped and much in need of re-stretching; heavily covered with old varnish.

History: Gift of Cardinal Federico Borromeo to the Ambrosiana in 1618 (*Guida sommaria*, 1907, 132, deed of gift. 1¾ × 1¼ *braccia*, i.e. 1.12 × 0.80 m.)

Bibliography: See above.

COPIES (Pitti type):
1. Bordeaux, Musée des Beaux-Arts, panel, 0·865 × 0·642 m., an extremely provincial copy in ruinous condition. *History:* At Fontainebleau, 1625 and 1642; Versailles, 1764; Louvre; sent to Bordeaux in 1803. *Bibliography:* Cassiano del Pozzo, 1625, folio 194ᵛ (at Fontainebleau); Dan, 1642, p. 137 (Titian, nude, half length); Lépicié, 1752, p. 26; C. and C., 1877, II, p. 316; Bailly-Engerand, 1899, p. 75 (school); see Bordeaux, *Catalogue*, 1855, no. 424; Gué, *Catalogue*, 1862, no. 489; *Catalogue*, 1910, no. 489; *Catalogue*, 1933, no. 22.

2. Cádiz, Museo de Bellas Artes, canvas, 0·60 × 0·50 m., copy with drapery added to cover the nudity (Pemán, 1952, p. 25, no. 45).

3. Hampton Court Palace, canvases, two very bad copies, located by Crowe and Cavalcaselle in the Prince of Wales' room and Queen Mary's closet, both now in storage (C. and C., 1877, I, p. 351; Law, 1881, p. 50, no. 161); these two are probably among the *Magdalens* of uncertain types mentioned in the collection of Charles I:
(*a*) Charles I purchased from Mantua a *Magdalen* there listed as a copy, evaluated at £24 in the Inventory of 1627 at Mantua (Luzio, 1913, p. 96, no. 106); perhaps the work recorded in Daniel Nys' letter of 1631 (Sainsbury, 1859, p. 336).
(*b*) Hampton Court, a *Magdalen* 'with hanging hair', half length, life size, bought from Frizell in 1637 (Ogden, 1947, p. 248, no. 22).
(*c*) Whitehall Palace, a *Magdalen* 'with foulding hands turning her head over her right shoulder', 39 × 33 inches (0·99 × 0·838 m.), but this composition does not conform to any known work by Titian (van der Doort, 1639, Millar edition, 1960, p. 19, no. 14). Waagen incorrectly states that this item came from Mantua (1854, II, p. 479).
(*d*) A *Magdalen* sold to Mr. Jasper, 21 May 1650, sale of Charles I's estate, £25 (Harley MS. 4898, British Museum, folio 288, no. 77; same item: Charles I: LR 2/124, folio 118ʳ, no. 77).
(*e*) A *Magdalen* after Titian, copy by 'Crosso', i.e. Michael Cross, valued at £4 (Charles I: LR 2/124, folio 118, no. 33); since Cross copied the Titians in Spain, this item may have been the Escorial type.

4. Nottingham, Welbeck Abbey, Duke of Portland, paper, mounted on canvas over panel, 0·473 × 0·36 m., head only of the *Magdalen* (Pitti type). Rubens' Inventory contains a head of the *Magdalen* which might be this item (edition 1855, p. 270). The Inventory of the Marqués de Leganés, 1655, also includes a similar picture, one-third *vara* square, i.e. 0·275 m. (edition 1962, no. 11). *History:* Collection of Giovanni Battista Roeta, maestro di cappella in Venice. A print by Arnoldo van Westerhout (Courtauld Library) has an inscription recording Roeta's former ownership. Subsequently in the collection of Don Gaspar de Haro y Guzmán, Marqués de Heliche, Marchese del Carpio, Spanish ambassador to Rome. His monogram 'DGH' with a coronet is on the back of the picture exactly as it appears on El Greco's small 'Espolio' at Upton Downs (Wethey, 1962, II, p. 55, no. 80). After Don Gaspar's death in 1687 it was purchased by the first Duke of Portland (1649–1709) (see Portland, 1894, p. 14, no. 48; Portland, 1936, no. 48).

5-6. Rome, Doria-Pamphili Gallery (in storage), two canvases, No. 162, 0·88×0·69 m.; No. 566, 0·99×0·76 m.; both very poor copies (C. and C., 1877, I, p. 351; Sestieri, 1942, pp. 162, 368, copies). *History:* Probably from the Aldobrandini inheritance. A *Magdalen,* copy of Titian, appeared as No. 23 in the Inventory of Lucrezia d'Este, 1592 (Pergola, 1959, p. 344). A *Magdalen* listed as No. 197 in the Aldobrandini Inventory of 1626 (Pergola, 1960, p. 435) can be traced as No. 294 in the Aldobrandini Inventory of 1682, a canvas said there to be by Titian, four *palmi* in height (0·89 m.) (Pergola, 1963, p. 73). A second *Magdalen,* copy of Titian, is given the number 205 in the Aldobrandini Inventory before 1665 (D'Onofrio, 1964, p. 205), and reappears as No. 68 in the Inventory of 1682, 1¼ *palmi* in height (0·279 m.) (Pergola, 1962, p. 321). Two other *Magdalens,* both called copies of Titian, appear as Nos. 43 and 209 in the Inventory of 1682, both three and a half *palmi* in height (0·78 m.).

7. Salisbury, Wilton House, Earl of Pembroke, canvas, 35½×27 inches (0·92×0·686 m.); gift of Cosimo III dei Medici to the fifth Earl of Pembroke in 1669 (Pembroke, 1968, p. 85, no. 230).

8. Other bad copies include one in the Senyi Collection, Budapest, and another in the Nathaniel Mason sale, Gamston Hall, Nottinghamshire, 1818.

LOST EXAMPLES (Pitti type):

1. Escorial, monastery, canvas, 5×4 feet (1·524×1·219 m.), like the famous picture in the Pitti Gallery at Florence; cited at the Escorial in 1574 as follows: 'Un lienzo en que está pintada la Magdalena desnuda, en contemplación con una calavera en la mano; de mano de Tiziano; que tiene de alto cinco pies y de ancho quarto' (Zarco Cuevas, 'Inventario', 1930, p. 45, no. 1009). Since no further reference to the picture occurs anywhere, it may be concluded that the monks, celebrated for their puritanism, destroyed it as improper.

2. Padua, Giustiniani Collection, a *Magdalen,* three-quarter length, nude, hands and drapery over the breast; sold in Paris, 1812 (Landon, 1812, p. 139, pl. 66).

REMOTE IMITATION:

Milan, private collection, nude *Magdalen,* canvas, 0·705 × 0·535 m., somewhat recalls Forabosco, 1604–1679 (*Burlington Magazine,* CX, 1968, July, p. xxxv).

122. St. Mary Magdalen in Penitence Plate 183
(Naples type)

Canvas. 1·28×1·03 m.

Naples, Museo di Capodimonte.

Signed in capitals at the left above the vase in gold letters:
TITIANVS P

About 1550.

The quality of the Naples *Magdalen* is considerably higher than most critics concede, especially if one takes into consideration the damage inflicted by old restorations. The picture differs from the Hermitage composition only in minor details of landscape, among them the rather thin tree (Plate 185). The vase of ointment, of opaque alabaster in Naples, is of transparent glass, touched with highlights of white, in the example in Russia. Neither the blond hair nor the white blouse nor the drapery of black and white stripes with occasional red bands vary notably. On the other hand, a transparent veil around the shoulders constitutes an additional bit of costume in Naples. The rocky background extends to the right beyond the saint's body, as it does in Cort's engraving (Plate 191). The late style of the landscape, sketched illusionistically to the right, reveals clear blue sky and autumn-brown earth. Nevertheless, the technique seems somewhat earlier than that of the Leningrad *Magdalen,* particularly in the more solid figure and in the handling of the alabaster vase.

Condition: The signature, much enlarged and entirely repainted, is placed over the original letters, which are, nevertheless, visible in a fragmentary condition. The hands are obviously repainted, the retouching of the knuckles giving a strange effect. However, the surface of the canvas has escaped the excessive rubbing by past restorers which damaged other works by the master in Naples. Recently restored in 1957–1960, removing old varnish and old repaint and found to be permanently damaged by early cleaning, which had removed original glazes (Causa, 1960, pp. 64–65).

History: Titian presented this *Magdalen* to Cardinal Alessandro Farnese in 1567 (letters in Ronchini, 1864, pp. 142–143; C. and C., 1877, II, pp. 375–377); Farnese Collection, Palazzo del Giardino, Parma, in 1680, signed TITIANVS (Campori, 1870, p. 227); shipped to Naples in the mid-eighteenth century; in 1799 taken from Capodimonte by the French but recovered in Rome in 1800; placed that same year in the Palazzo Francavilla, Naples (today called the Palazzo Cellamare); in 1806 taken to Palermo; brought back to Naples after the fall of Napoleon in 1815 (Filangieri di Candida, *Gallerie italiane,* 1902, p. 300, no. 30; p. 305, no. 79; p. 321, no. 29). Crowe and Cavalcaselle say that the Naples picture is not

the one that Titian gave to Alessandro Farnese, but was bought from the Colonna collection by Ferdinand I of Naples (C. and C., 1877, I, pp. 348–349, 450–452); Alessandro Luzio also held that the Naples picture first belonged to Vittoria Colonna (1531; see Cat. no. 129, Lost Magdalens, known by literary reference, No. 4) and that later Ferdinand I of Naples bought it (Luzio, 1940, pp. 591–598). The date 1531, unacceptable for this late picture at Naples, invalidates that theory.

Bibliography: See also History; C. and C., 1877, II, p. 315 (workshop); Gronau, *Titian*, 1904, p. 196 (Titian's Farnese picture of 1567); Rinaldis, 1911, pp. 154–156; 1928, pp. 338–341, no. 136 (Titian); Tietze, 1936 and 1950 (not listed); Berenson, 1957, p. 189 (great part by Titian); Causa, 1960, pp. 64–65 (Titian and workshop); Valcanover, 1960, II, p. 72, pl. 179 (before cleaning; mediocre workshop replica).

123. St. Mary Magdalen in Penitence Plate 185
(Hermitage type)

Canvas. 1·18 × 0·97 m.

Leningrad, Hermitage Museum.

Signed in capitals above the vase: TITIANVS P.

About 1560.

All writers agree that the Leningrad *Magdalen* surpasses all other extant pictures of this subject by Titian and that the hand of the master is identifiable throughout. The design is similar to the Naples picture (Plate 183), but there are variations in details, for instance: the vase of ointment is of transparent glass in Leningrad, the tree in the right background is fully leaved, and above all the Magdalen's head has a more moving and grieved expression. The rocky background is reduced in size and in details so that the Magdalen's body dominates, with the edge of the rock carried only to the middle of her head.

Condition: Satisfactory.

History: In Titian's house at his death; Barbarigo Collection, 1581–1850 (Bevilacqua, 1845, no. 16); sold to Russia, 1850 (Levi, 1900, p. 286, no. 16; Savini-Branca, 1965, p. 184). Alessandro Luzio attempted to identify the Leningrad picture with the destroyed canvas, formerly in Escorial, a proposal which is completely contrary to known facts (1940, pp. 596–598). See Cat. no. 127.

Bibliography: Ridolfi (1648)–Hadeln, I, p. 200; Sansovino-Martinioni, 1663, p. 274; C. and C., 1877, II, pp. 314–315

(Titian); Suida, 1935, p. 137 (Titian); Tietze, 1936, II, p. 291 (as the best extant); Berenson, 1957, p. 186 (Titian); Leningrad, 1958, no. 118 (Titian); Valcanover, 1960, II, pl. 112 (best version); Fomiciova, 1960, pls. 50–51 (Titian); *idem*, 1967, pp. 64–66 (Titian after 1566); Levinson-Lessing, 1967, pls. 34–35.

124. St. Mary Magdalen in Penitence Plates 184, 186
(Hermitage variant)

Canvas. 1·05 × 0·95 m.

Busto Arsizio (Varese), Collection of Paolo Candiani.

About 1560.

Although unsigned, this picture is of extraordinarily high quality, painted in Titian's late free style. In general, the composition is closest to the Leningrad version, varying most notably in the sky and the landscape with the mountain peaks at Cadore in ultramarine blue against a dramatic sky; even the shape of the large tree in the right background is highly original and unlike the Leningrad canvas. These facts and the more youthful face of the Magdalen constitute variations from other versions such as the master himself rather than a copyist would have made. The white scarf with red and grey stripes is present as in nearly all variants of this subject.

Condition: Cleaned by Raffaldini about 1940; very few losses and little repaint.

Other dating: Arslan, 1560.

History: Early history unidentified; Professor Porgiluppi at Mantua until 1943, when purchased by Paolo Candiani.

Bibliography: Luzio, 1940, pp. 591–598 (Titian); Arslan, 1952, p. 325 (Titian); unknown to Suida, Tietze, Berenson; *Sele arte*, 35, 1958, p. 42 (Titian); Valcanover, 1960, II, p. 72 (good replica of the Leningrad picture).

125. St. Mary Magdalen in Penitence Plate 235
(Hermitage Type)

Canvas. 1·44 × 0·99 m.

Stuttgart, Staatsgalerie.

Workshop of Titian.

Signed in capitals at the left above the vase: TITIANVS P (or F?)

About 1560–1570.

The quality of this version is much finer than is generally conceded, a fact which raises the question how many writers have seen it. The entire composition adheres to the Hermitage model (Plate 185), with slight differences in the clouds and details of landscape: the tree at the right, which here is thick with leaves, approximates the one in the Hermitage instead of the thin and bare branches of the landscape in Naples. The ointment jar of transparent glass also distinguishes the prototype in Russia. As for flaws, a certain hardness in the modelling of the face in the Stuttgart version is the element to be cited. Against the very deep-blue sky the tree and landscape have a predominantly green and brown tone. The saint's blonde hair lies upon her white shift, whereas the drapery of grey and white stripes with occasional broader bands of red is pulled together at the waist. Flesh tones, particularly on the cheeks, have a ruddy cast.

History: Antonio Canova, Venice; Barbini Breganza, Turin, no. 236; bought by Stuttgart in 1852.

Bibliography: C. and C., 1877, II, p. 316, note (Venetian copy); Gombosi, by letter (Flemish copy); Valcanover, 1960, II, p. 72 (workshop); Stuttgart: 1962, p. 223, no. 113 (studio).

COPIES (Hermitage type):

1. Stockholm, heirs of Dr. Emil Hultmark, *Magdalen*, canvas, 1·10×0·95 m., mediocre copy. *History:* Joseph Sanders, Taplow House, Maidenhead (Waagen, 1857, p. 292; one of the best of its type); Sanders sale, London, Christie's, 9 March 1839, no. 79 (Graves, 1921, III, p. 212, not sold); shown at Manchester, 1857, no. 261 (C. and C., 1877, II, p. 316, late copy); Sir Stuart Samuel (sale, London, Christie's, 25 March 1927, no. 111, bought by Ackermann, 22 guineas; photo, Courtauld Institute, London).

2. Location unknown, formerly London, Sir Abraham Hume and descendants, Lord Brownlow, *Magdalen*, canvas, 0·647×0·584 m., copy. A line engraving in the Courtauld Library shows a glass vase as in the Hermitage version, drapery with no stripes, and a large tree to the right. This picture was wrongly said by Waagen to be from the Orléans Collection, and Crowe and Cavalcaselle repeated the same story. Sir Abraham Hume does not mention his own picture, which, to be sure, he may have bought later. However, he does speak of a *Magdalen* from the Muselli Collection in Verona, then in a private collection in London. Perhaps he meant his own collection, which he does not specify by name in his book. Moreover, Hume gives the dimensions of the picture (25½ × 23

inches), a very rare instance for him, and praises it as the most beautiful in existence, all of which suggests that he himself possessed it. Crowe and Cavalcaselle list the Muselli picture as missing (1877, II, p. 472). *History:* Sir Abraham Hume bought it from Giovanni Sasso in Venice in 1792; exhibited London, Venetian Art, 1895; Lord Brownlow's sale in London, Christie's, 4 May 1923, does not contain a *Magdalen*. Since Lord Brownlow no longer owns it, the picture must have been sold privately after 1946. *Bibliography:* Hume, 1829, pp. 46–47; Waagen, 1854, II, p. 313; C. and C., 1877, II, p. 316 (wrongly as formerly Queen Christina and Duke of Orléans).

3. Location unknown, formerly London, Lord Lansdowne, *Magdalen*, canvas, 1·12×0·965 m., copy. The photograph in the Courtauld Library reveals a work of poor quality based on the Hermitage type and very similar to Lord Brownlow's picture. *History:* Shown at the British Institute, 1829, no. 168. *Bibliography:* Jameson, 1844, p. 311, no. 54 (as formerly Queen Christina, i.e. Orléans Collection, and James Maitland; a wrong identification); Lansdowne sale, Christie's, London, 7 March 1930, no. 76, bought by the Saville Gallery, London (*APC*, IX, Part A, 1930, no. 5484, 44×38 inches (1·117×0·965 m.), £1575); photos in Washington, National Gallery, Frick Library, New York (wrongly labelled Lord Brownlow), and Courtauld Institute, London (as Lord Lansdowne's).

4. Unknown location, formerly Rome, studio of John R. Tilton (an American painter, died 1888). J. P. Richter in 1888 thought it an original (Letters, edition 1960, p. 576); Cavalcaselle called it the Naples-Hermitage type and said it had been sent to America (1891, pp. 5–6).

5. Unknown location, formerly Saragossa, *Magdalen*, canvas, 1·22×0·93 m. Offered for sale by Victor Oliver in 1924 (*New York Times*, 17 October 1948, a lost Titian; photos, Washington, National Gallery and New York, Frick Library, by Coyne, Calle Alfonso I, 12, Saragossa).

126. **St. Mary Magdalen in Penitence** (Hermitage type) (lost)

Canvas. 1·042×0·915 m.

Location unknown (formerly Queen Christina, Orléans Collection, and Lord Northwick).

The print of the picture formerly in the Orléans Gallery identifies a *Magdalen* similar to the one in Leningrad in which a tree appears in the middle distance of the landscape and the rocky background reaches only to the

middle of the saint's head. Exceptional in this version is the position of the skull, which is shown in profile.

History: Rudolf II, Inventory *c.* 1600, Prague Castle, a Mary Magdalen by Titian (Ritter von Perger, 1864, p. 105); Prague Inventory, 1621, no. 859 (Zimmermann, 1905, p. 891); Queen Christina of Sweden (died in Rome 1689) (Granberg, 1896, p. 15; 1897, p. 35, no. 33; 1689 Inventory, p. LVIII, no. 32); Cardinal Azzolino, 1689; Pompeo Azzolino, 1689–1692; Prince Odescalchi, 1692–1721 (Odescalchi Archives, 'Nota', folio 57; 'Inventario', 1692, folio 466ᵛ, no. 32; sale to Dule of Orléans, 1721, folio 1, no. 8); Orléans Collection, Paris (see Orléans: Du Bois de Saint Gelais, 1727, pp. 476–477; Couché, 1786–1808, pl. 14; Stryienski, 1913, p. 151, no. 37); sold at Christie's in 1798 from Orléans to T. Maitland for 350 guineas (Buchanan, 1824, p. 114); Maitland sale, 30 July 1831, no. 101, bought by Lord Northwick; Northwick sale, Thirlestane House (26 July 1859, p. 134, no. 1506); bought by David Marks.

Bibliography: See also History; Campori, 1870, p. 343: Queen Christina's Inventory of 1689 had two *Magdalens*, the present one described as of the Hermitage or Naples type, 4¾×3¾ *palmi* (1·06×0·868 m.) and the other said to be different except for the face, 4×3¾ *palmi* (0·89×0·868 m.); Davies, 1843, no. VI (Lord Northwick's *Magdalen* from the Orléans Collection); C. and C., 1877, II, p. 316 (copy, much damaged); Waterhouse, 1966, p. 374, no. 64 (lost).

For other *Magdalens* incorrectly claimed to have come from the Orléans Collection, see Cat. no. 125, copy 2, Sir Abraham Hume and descendants, including Lord Brownlow, and Cat. no. 125, copy 3, Lord Lansdowne.

127. St. Mary Magdalen in Penitence (Escorial type) (destroyed in London in 1873)

Canvas. 1·17×0·98 m.

Escorial, Monastery of San Lorenzo (formerly).

1561.

The numerous references to the picture as representing the saint in half-length looking heavenward, and that it was known in prints and copies, leave us no doubt that the composition was similar to that preserved in Cornelius Cort's print dated 1566 (Plate 191). It is certain, however, that the painting, shipped in 1561, did not exactly resemble the print in details of setting and landscape.

The best evidence of the composition of Titian's lost *Magdalen*, which was long thought to have been destroyed at the time of the Napoleonic invasion, is the copy now located in the Iglesia Vieja of the Escorial (see below).

History: On 20 November 1561 García Hernández in Venice wrote to Philip II that Titian was still engaged on the *Magdalen*, which good judges had said would be his best work; on 1 December he announced to the king that the picture had been finished and would shortly be shipped; on 12 December it had been delivered in Venice (Beer, 1891, part 2, no. 8459; Cloulas, 1967, pp. 250, 251). Vasari tells an anecdote to the effect that Titian sold the *Magdalen* to Silvio Badoaro, who liked the picture, and made a copy of it for Philip II, but this may not be true. Padre Sigüenza in 1599 says that the *Magdalen* is in the Sacristy and there are prints and many copies of it (edition 1923, p. 418); Cassiano del Pozzo, 1626, folio 100 ('una Maddalena simile alla del Giardino dei Medici a Roma che tiene la mano sopra una tetta . . . un drappo rigato di variati colori'); in 1657 it remained in the same location and there it stayed until the Napoleonic invasion (Padre de los Santos, edition 1933, p. 238); the *Magdalen* sent to the palace of San Ildefonso at La Granja under Joseph Bonaparte in 1810 must have been this picture (Beroqui, 1933, p. 154); later in London in the collection of Lord Ashburton, who purchased it from Bonaparte (*Art Union*, 1847, p. 127); destroyed by fire at Bath House in 1873 (*Times*, 3 February 1873, p. 12, column C).

Bibliography: See also History; Vasari (1568)–Milanesi, VII, p. 454; Ridolfi (1648)–Hadeln, I, pp. 188–189; Velázquez, 1658, edition 1960, II, p. 297; Palomino, edition 1947, p. 796 ('medio cuerpo de que hay muchas copias'); Ponz, 1773, tomo II, carta III, 42; Padre Ximénez, 1764, p. 307; Ceán Bermúdez, 1800, V, p. 41; Padre Bermejo, 1820, p. 228, no. 11; C. and C., 1877, II, pp. 312–315 (Lord Ashburton's picture: masterly landscape, head restored; provenance unknown to the authors); Valcanover, 1960, II, pp. 58–59 (lost).

COPY:
Escorial, Iglesia Vieja, *St. Mary Magdalen in Penitence* (Escorial type) (Plate 190), canvas. 1·015×0·80 m., copy of Titian, *c.* 1695, Luca Giordano. This canvas is now placed at the right of the high altar where Titian's *Entombment* originally stood. On a paper label the number is 2286. The ruinous state of the canvas makes it difficult to verify an attribution to Luca Giordano, although the face does resemble his female types. The landscape at the right has very blue mountains in the distance, and only a cluster of small trees near the right frame. Although the composition somewhat resembles Cort's print, this version is

simplified, omitting the rocks and trees and pendant roots, etc., on the cave, which reaches only to the centre of the saint's head. The figure in general repeats the print with slight variations in that the left breast is naked. The position of the skull, face forward, should be noted.

Bibliography: Ponz, 1773, tomo II, carta IV, 24; see also Escorial original above; Padre Ximénez, 1764, edition 1941, p. 70 (mentions the Jordán 'copia de la Magdalena de Ticiano'); Ceán Bermúdez, 1800, II, p. 342 (Giordano); Poleró, 1857, no. 348; Justi, 1889, p. 184, no. 31 (Giordano).

128. St. Mary Magdalen in Penitence
(Escorial variant)

Canvas. 1·11 × 0·78 m.

Genoa, Palazzo Durazzo-Pallavicini.

Signed at the left side: [TI]TIANVS

Titian and workshop.

About 1560–1565.

The fact that this canvas has received virtually no attention since the time of Crowe and Cavalcaselle is explained by the reluctance of the owners to allow it to be seen or to be photographed. A recent book (Torriti, see below), dedicated to the palace, again allows some judgment of Titian's picture, although Torriti is totally mistaken in his theory that this version came to Genoa from the Escorial, inasmuch as that famous example from Spain was destroyed in London in 1873 (Cat. no. 127). Photographs in the recent publication do show, however, that the landscape lacks a tree as did the Escorial *Magdalen*.

Condition: Somewhat retouched (Alizeri, 1846, II, p. 63); cut down, eliminating the first two letters of the signature.

History: Mentioned in the Durazzo Pallavicini Palace on Via Balbi, Genoa, in 1780 (Ratti, I, p. 180).

Bibliography: See also above; Alizeri, 1846, II, p. 63 (perhaps a replica); C. and C., 1877, II, pp. 315–316 (partly Titian, but much restored); Suida, 1906, p. 143 (workshop replica of the Pitti version!!); Suida, 1935 (omitted); Tietze, 1936 (omitted); Berenson, 1957 (omitted); Torriti, 1967, pp. 201–204, colour prints (Titian).

129. St. Mary Magdalen in Penitence Plate 236
(Escorial variant)

Canvas. 1·04 × 0·91 m.

Malibu (California), J. Paul Getty Museum.

Workshop or Venetian copy.

About 1560–1570.

The general effect is that of a work of high quality, yet the extensive restorations have contributed much to that illusion. Only in this version of the *Magdalen* does the book lie upon a cloth rather than upon the skull, symbol of death. The vase, made of alabaster as in the Naples picture, is shown by X-rays to be unchanged. The composition differs from both the Naples and the Leningrad compositions notably in the landscape, which in the other cases contains a large tree at the right. However, in Cornelius Cort's print and in the lost Escorial version the tree was also omitted. The rocky background at the left extends farther over in the Naples picture as well as in the print, while the silhouette of the Magdalen's body is relieved against the sky in the Getty version as in those in Leningrad and Busto Arsizio (Plates 183, 184, 185, 191).

Condition: The figure of the Magdalen retains the original surface of the paint, yet even here the eyes and forehead were extensively repaired long ago. The X-rays reveal these facts and the fragmentary condition of the landscape, the right side of which is totally repainted and the left side almost as completely. The white streaks in the left background are products of the restorer's imagination.

History: Purchased presumably in Venice by Sir Richard Worsley, who lived there in 1793–1797 (Worsley, 1804, no. 76); inherited by the Earls of Yarborough (Waagen, 1854, II, p. 87; 1857, p. 65, as Titian); Lord Yarborough Brocklesby Park (sale, London, Christie's, 12 July 1929, no. 102; purchased by Colnaghi for 4000 guineas); Gutekunst Gallery, London, 1930; sold to Paul Getty, 1955, as Titian.

Bibliography: See also History; C. and C., 1877, II, p. 316 (later Venetian copy); Mayer, 1930, p. 102, colour illustration (Titian); Borenius, 1930, p. 145 (Titian); Suida, 1935, p. 137 (one of Titian's best); Arslan, 1952, p. 325 (school piece); Berenson, 1957, p. 190 (Titian); Valcanover, 1960, II, p. 72 (workshop; but he splits this one picture into two separate items); Stockholm: 1962–1963, no. 98 (Titian); Nicolson, 1963, p. 32 (studio); Fredericksen, 1965, pp. 13–14 (Titian).

COPY (Escorial variant):
Munich, Bayerische Staatsgemälde-Sammlungen (depot). Canvas, 1·247 × 0·93 m. This mediocre copy of the later sixteenth or seventeenth century does not repeat exactly any extant original by Titian. In general it

follows the Escorial version in the face of the skull, in the simplified landscape, and in the elimination of the large tree of the Hermitage type (Plates 185, 190). This last omission also occurs in Cort's print (Plate 191), but other details differ. *History:* From the Kurfürstliche Galerie, Munich; lent by the Munich Gallery to Augsburg, where it was exhibited for many years in the City Art Gallery (1850 (?)–1962). *Bibliography:* Marggraff, 1869, p. 75, no. 255 (copy of Hermitage picture); Augsburg, 1912, p. 76, no. 2302 (old copy of the Hermitage picture).

LOST PICTURE (Escorial type):
Venice, Silvio Badoaro. Both Vasari and Ridolfi mention the anecdote of the *Magdalen*, sold to Badoaro for one hundred *scudi*, which had been intended for Philip II. Later in 1601 Francesco di Pietro Morosini, Duke of Candia, wrote that he had bought the famous *Magdalen* by Titian, which the painter had sold for 2000 *scudi* (Cicogna, v, 1842, p. 46). *Bibliography:* Vasari (1568)–Milanesi, VII, p. 454; Ridolfi (1648)–Hadeln, I, p. 190; Ticozzi, 1817, p. 231 (repeats the former writers).

LOST MAGDALENS, known by literary references:
1. Antwerp, Rubens' Collection, two *Magdalens*, one of the head only (Rubens Inventory, edition 1855, p. 270, no. 1 and no. 9 (head only); C. and C., 1877, II, p. 316).
2. Fano, Ippolito Capilupi, Bishop of Fano, in 1580 (D'Arco, 1857, II, p. 112; C. and C., 1877, II, p. 316).
3. Florence, Bianca Cappello, Grand Duchess of Tuscany, in a letter of 1 August 1587 thanks Francesco Bembo, a Venetian patrician, for the gift of Titian's *Magdalen* (Cicogna, v, 1842, p. 565).
4. Ischia, Vittoria Colonna. Duke Federico Gonzaga of Mantua gave Titian's *Magdalen* to Vittoria Colonna, Marchesa di Pescara, then a widow living at Ischia. Letters between Titian and Gonzaga show that it was ordered 5 March 1531, for the Marchese del Vasto to present to Vittoria, but apparently Gonzaga gave it himself. Isabella d'Este Gonzaga wrote to Agnello at Venice on 19 March 1531 that she was gratified that Titian had begun the *Magdalen* (Gaye, 1840, II, p. 224). Federico Gonzaga thanked the artist for the picture in a letter of 19 April 1531 and Titian replied 29 April 1531 (Gaye, 1840, II, pp. 223–226). It has been thought that Vittoria's first letter of thanks for the picture is lost, inasmuch as in a letter of 25 May 1531 from the Castello di Ischia she makes casual reference without the customary effusive language ('de la Magdalena la rengratio infinite volte') and she does not even praise the picture (Ferrero and Müller, 1889, p. 71). On 28 July 1531

Federico Gonzaga acknowledged her presumably earlier lost letter of thanks, delighted at her enthusiasm for his *Magdalen*, and stating that he has informed the painter of her satisfaction (*loc. cit.* pp. 71–72).

Writing from Parma on 4 March 1533, the Marchese del Vasto remarks that he had received the *Magdalen*. Another letter dated some time in March 1533, written by Isabella d'Este Gonzaga to Tomaso Tucca of Naples, states that she has a *Magdalen* of which the Marchese del Vasto wanted to obtain a copy to present to Vittoria Colonna, and that she has had the painter do a replica of it (Ferrero and Müller, 1889, p. 66). Luzio (1940, p. 594) believed that this picture was also by Titian, although he admits that there is no proof, since no artist's name is mentioned in either letter. He speculated that the Marchese del Vasto himself wanted the work and that he used Vittoria Colonna's name as a shield. The whole affair is puzzling in view of the fact that del Vasto and Federico Gonzaga had been involved only two years earlier in presenting Titian's *Magdalen* to the famous Colonna poetess. The *Magdalen* of 1533 almost surely was not by Titian.

The possibility that Vittoria Colonna gave her *Magdalen* by Titian to Eleanora Gonzaga, Duchess of Urbino, is well worth considering. Relatives by marriage, they corresponded frequently in these years 1532–1536 (Ferrero and Müller, 1889, pp. 74–106). If that hypothesis is true, Vittoria Colonna's picture is the famous nude *Magdalen* in the Pitti Gallery (Cat. no. 120). *Bibliography:* See also above; letters of Titian and Federico Gonzaga in Gaye, 1840, II, pp. 223–226; D'Arco, 1857, II, p. 12; Braghirolli, 1881, pp. 52, 77–80; C. and C., 1877, I, pp. 348–350 (confused account); Tietze, 1936, II, p. 288 (suggested that it was the Pitti type); Luzio, 1940, pp. 591–596 (wrongly assumed it to be the picture now in Naples); Valcanover, 1960, I, p. 84 (lost).
5. London, Duke of Buckingham, sale 1648, a *Magdalen*, 12×10 inches (Hume, 1829, p. 161; Brian Fairfax, 1758, p. 1, no. 3).
6. London, Grinling Gibbons, sale 15 November 1722, no. 37 (information courtesy of Frank A. Simpson, Esq.).
7. London, Walsh Porter, size 43×36 inches (1·092× 0·914 m.) says Hume (1829, p. 97). *History:* Borghese Palace, Rome; Sir William Hamilton, sale 1801; purchased by Walsh Porter (Buchanan, 1824, II, p. 175, no. 5); Walsh Porter sales, Christie's, London, 14 April 1810, no. 7; 21 June 1811; 6 May 1826. Paola della Pergola confirms that a *Magdalen* attributed to Titian was acquired from the Palazzo Borghese by Buchanan (Pergola, 1962, p. 322). Lord Radstock's *Magdalen* also claimed Borghese

source (London, Christie's, 12 May 1826, no. 53, 39×31 inches).

8. London, Benjamin West, 47×37 inches (1·194×0·94 m.); sale 1820 to Thomson Martyn (Graves, 1921, III, p. 211).

9. Padua, Monsignore Buonfio (Ridolfi (1648)–Hadeln, I, p. 199; C. and C., 1877, II, p. 471, as lost).

10. Paris, Charles Coypel, sale 1752 (Blanc, 1857, I, p. 68).

11. Paris, Philippe de Champaigne, Inventory 1674, copy of Titian (Guiffrey and Gronchy, 1892, p. 186, no. 82).

12. Parma, Palazzo del Giardino, Farnese Collection, a copy, in addition to the original (now Cat. no. 122), registered in the Inventory of 1680, 2 *braccia* 5½ *on.*×1 *braccia* 10 *on.* (Campori, 1870, p. 294).

13. Rome, Palazzo Barberini, a *Magdalen* by Titian (Venuti, 1767, I, p. 226); possibly a wrong attribution.

14. Rome, Giulio Clovio. In his Inventory of 1578 appears a *Magdalen* by Titian (Bertolotti, 1882, p. 274); his heirs were Cardinal Alessandro Farnese, who received the drawings, and the churches of San Pietro in Vincoli and San Luca. This *Magdalen* may have gone to the Farnese Collection, since we know that El Greco's portrait of Giulio Clovio passed to the Farnese (now in Naples, Galleria Nazionale, Capodimonte; Wethey, 1962, cat. no. 134).

15. Venice, Niccolò Crasso (Ridolfi (1648)–Hadeln, I, p. 194; Hadeln suggests that it is in the Kilény Collection, Budapest, published in 1908 (wrong reference); C. and C., 1877, II, p. 316).

16. Venice, Casa Ruzzini (Sansovino, 1581, p. 374; Ridolfi (1648)–Hadeln, I, p. 200; Buchanan, 1824, I, p. 325; C. and C., 1877, II, p. 316).

17. Venice, S. Maria dei Miracoli (Boschini, 1664, Castello, p. 51; C. and C., 1877, II, p. 316).

18. Verona, Casa Muselli (Ridolfi (1648)–Hadeln, I, p. 198, 'piccolo modello', described as 'stringe qualche cosa'; also Campori, 1870, p. 184; C. and C., 1877, II, pp. 316, 472, lost); probably later Sir Abraham Hume and Lord Brownlow (Hume, 1829, pp. 46–47; see above, Cat. no. 125, copy 2).

19. Vienna, Archduke Leopold Wilhelm, 1659 (Inventory, p. CIV, no. 337), canvas, 6½ *Span*×5½ *Span* (1·352×1·144 m.). The description relates to the Naples-Leningrad-Escorial types.

20. Unknown location, Antoine Perrenot, Seigneur de Granvelle, Cardinal. Titian's letter of 10 September 1554 apparently refers to shipping him a *Magdalen*: 'Et vostra signoria riverendissima pregata della Sua devota Maddalena, che io le mando per mia interceditrice' (Zarco del Valle, 1888, p. 232).

II

130. St. Mary Magdalen with St. Blaise, Tobias and the Angel, and Donor

Canvas. 2·08×1·63 m.

Dubrovnik (Ragusa), San Domenico.

Workshop or school of Titian.

About 1550.

Although Crowe and Cavalcaselle identify the donor as Count Gozzi and local tradition favours the Pucić-Pozza family, no historical data has come to light to confirm either. The quality of this work is so inferior as to discredit any participation by Titian himself. The same physical type of Magdalen recurs in the altar at Lentiai, a work by followers of Titian (Valcanover, 1951, p. 68, no. 41).

Bibliography: Razzi, 1595, p. 142 (the *Magdalen* by Titian in San Domenico); C. and C., 1877, II, pp. 416–417 (Titian, late); Westphal, 1937, p. 15 (studio); Pallucchini, 1953, II, pp. 49–50 (studio); Berenson, 1957, p. 185, pl. 1004 (Titian and assistant); Gamulin, 1955, pp. 269–271 (Titian); idem., 1957, pp. 33–39 (Titian); Valcanover, 1960, II, p. 67 (attributed).

COPY:

Unknown location, variant of Ragusa picture, canvas, 0·85×0·70 m. A hard copy based on the Ragusa type, with long tresses added to cover her shoulders and bosom. *History:* Cardinal Filomarino, Naples, so stated in Paolini sale, New York, 10–11 December 1924, no. 36, 34×28½ inches (0·863×0·714 m.) (photo: Washington, National Gallery); Lucerne Fine Art Co., 1927 (photograph, Courtauld Institute, London); Ferrari Collection, Novara, catalogue of sale, 1964.

131. St. Nicholas of Bari Plate 170

Panel. 1·71×0·91 m.

Venice, San Sebastiano.

Signed on the step: TITIANVS P

Titian and workshop.

1563.

The rose hood over the saint's white surplice and the red tunic of the angel are the chief colours in this dull painting, which is largely a workshop production. The date usually given, 1563, is the year in which the Venetian lawyer Niccolò Crasso purchased his chapel, where the picture stands.

Condition: Restored and revarnished in 1834 (Cicogna, 1834, IV, p. 149).

History: Still in Niccolò Crasso's chapel.

Bibliography: Vasari (1568)–Milanesi, VII, pp. 453–454; Ridolfi (1648)–Hadeln, I, p. 193; Cicogna, 1834, IV, p. 162; C. and C., 1877, II, pp. 331–332 (Orazio and workshop); Suida, 1935, pp. 114, 135, 179 (Titian); Tietze, 1936, II, p. 314 (workshop); Berenson, 1957, p. 191 (Titian in great part); Valcanover, 1960, II, pl. 107 (partly workshop).

132. St. Peter Enthroned, Adored by Alexander VI and Jacopo Pesaro Plates 144–146

Panel. 1·455 × 1·835 m.

Antwerp, Musée Royal des Beaux-Arts.

About 1512.

An inscription in the lower centre reads: RITRATTO DI VNO DI CASA PESARO IN VENEZIA CHE FV FATTO GENERALE DI SANTA CHIESA. TITIANO F. These words leave no doubt that they were added much later than the time of Jacopo Pesaro, the donor.

The picture presents St. Peter enthroned as the head of the Christian Church, as he is given thanks by the pope Alexander VI (died 18 August 1503) and by Jacopo Pesaro, leader of the papal armada, for the victory over the Turks at Santa Maura in Cyprus on 30 August 1502 (Sanuto, IV, cols. 313–314). The helmet, a symbol of victory (see Wittkower), refers to Jacopo's naval conquest and, likewise, the papal banner which he carries. As donor he wears black ecclesiastical robes, not the Dominican habit, as Crowe and Cavalcaselle stated incorrectly, an error repeated by most later writers.

The classical relief on the base of St. Peter's throne has been much discussed. According to Curtius and Wittkower, the Venus Genetrix at the right side of the socle, with the cuirass just to the left of her is in this fashion identified as the patroness of Victory, Peace, and Virtue. Cupid on the altar is the symbol of divine love; therefore St. Peter's keys are placed intentionally just above him. At the left erotic love and passion are contrasted to divine love. It should also be recalled that Venus, as goddess of the sea, was the protectress of mariners. The symbolism of the picture affirms the triumph of the Christian Church over paganism as St. Peter replaces Aphrodite, who was once revered at Paphos in Cyprus, i.e. Cytherea (see Brendel). Since

Jacopo Pesaro held the title of Bishop of Paphos, he was involved in both the naval and the ecclesiastical victory. Nearly all writers agree that the composition of Titian's picture is somewhat archaistic. Hetzer suggested the influence of Carpaccio, Mather proposed Jacopo Bellini as the source, and Langton Douglas believed that both Palma Vecchio and Giorgione were vividly in the young artist's mind. To some extent elements of these styles are present in this youthful work, which involves the same isolation of figures found in Titian's altar of St. Mark in S. Maria della Salute (Plate 147). The seascape with its hard dark green water and the rather linear galleys disappoints and does not reveal the mastery of landscape that Titian commanded in the picture of the *Baptism* (Cat. no. 16, Plate 65.) The light-blue sky with some touches of pink and yellow fails to convey a sense of atmosphere. On the other hand, the floor of rose and light yellow marble tiles is canonical at this time because of its constant use in Venetian churches.

Nevertheless, the colour is fuller and more glowing than one might expect: St. Peter, in a rose tunic and brown drapery, holds a red book and is enthroned upon a light-grey marble dais and in front of a dark-green panel. The mild mood of his countenance is the most Giorgionesque element. Jacopo Pesaro, in black robes, has white sleeves, grey gloves and a collar edged in red and white. The rose flag of the Borgias and the pope's light-green-and-gold cope are magnificent, notably the latter, the border of which is sewn with pearls. Equally sumptuous is his gold tiara adorned with rubies and sapphires. The white surplice and golden pallium afford a proper contrast in colour values in this area of the composition.

Condition: The condition of the panel is good on the whole, better than in many of Titian's paintings on canvas. Slight retouchings, as on the bishop's cheek, do not affect the totality of the composition. Some darkening of colour is inevitable, St. Peter's drapery having been originally more yellow and less brown. That accords with Van Dyck's notes in his 'Italian Sketchbook' in which he describes the drapery as 'giallo'.

Other dating: Crowe and Cavalcaselle held that it must be dated 1503, before the death of Alexander VI, since he was later too hated to be represented. Such a theory is untenable since his coat-of-arms appears much later on the Pesaro Madonna (1519–1526). Mather quotes Crowe and Cavalcaselle and claims that the picture commemorates the appointment of Pesaro as admiral in 1502 previous to the battle because no battle is represented in the background (Mather, 1938, pp. 18–19). On the

contrary, a votive work is done after, not before a victory. Tietze, *c.* 1506; Langton Douglas and Hourticq, 1512; Ozzola, 1510, arguing that the helmet is datable that year, but rarely is the chronology of costume so specific; Suida, begun 1512, portraits finished *c.* 1520. Jacopo Pesaro (1460–1547) was forty-two in 1502 and fifty-two in 1512, but the portrait does not enable one to determine his exact age, although he looks definitely middle-aged in the jowl.

History: The later inscription in Italian indicates its addition to the panel in Italy. That it originally belonged to the Pesaro family can be assumed, although it might have been in a church rather than in one of their palaces at Venice. Sir Anthony Van Dyck's drawing of the composition in the 'Italian Sketchbook' (folio 19) proves that he saw the work in Venice during his stay there, presumably in 1623. Unfortunately the young Flemish master failed to note its location, but the *Holy Family with St. Catherine* which precedes it (folio 18ᵛ) apparently hung in Count Widman's Venetian palace.
Titian's *St. Peter Enthroned* shortly thereafter passed into the collection of Charles I of England, where it decorated the first 'private lodging' of the king in Whitehall Palace, as recorded in the catalogue of 1639 (van der Doort, Millar edition, 1960, p. 14). It is described as follows: 'A Picture where the Pope is preferring the generall of his Navie to St. Peeter three intire figures Somewhat less than the life In a painted all over guilded frame'; Height 6–3 inches, Breadth 5–11 inches. After Charles I's execution in 1649 it was exhibited at Somerset House in May 1650 (Cosnac, 1885, p. 414) and sold for £100 on 23 October 1651, to a Mr. Buggley. It is described as follows: 'Pope Alexander and Burgeo and Ceaser Burgeo his son by Tytsian' (Charles I: LR, 2/124, folio 9; Harley MS., no. 4898, folio 151). Buggley was really Thomas Bagley, a glazier, whose account with the king was thus paid (Nuttall, 1965, p. 307).
At that time it must have been acquired by a Spanish agent of Don Juan Gaspar Henríquez de Cabrera, Duque de Medina de Rioseco, Admiral of Castile (died 1691), who endowed the nuns of San Pascual in Madrid with many works of art (Madoz, 1847, X, p. 730; the convent was suppressed in 1835). The picture is cited in San Pascual by Ponz (1776, tomo v, primera división, 38), who not only describes the subject but also quotes the inscription. Townsend, 1786–1787, refers to it (1962, III, p. 1403); Ceán Bermúdez in 1800 (v, p. 41) still lists the canvas in San Pascual; in Godoy's collection, Madrid, 1808, inventory made by F. Quilliet (J. Pérez de Guzmán,

1900, p. 123); apparently sold after Godoy's death with the aid of Quilliet (Saltillo, 1933, p. 35). The subsequent purchaser in Paris was William of Holland, who presented the work to the museum at Antwerp in 1823, where it will doubtless remain.
[Waagen, 1854, II, pp. 479–480, quoted Mengs as saying that the picture had been in the royal palaces at Madrid and Villaviciosa before it went to San Pascual. This error is traceable to misreading a passage in Conca (1792, I, p. 168) as earlier pointed out by Beroqui (1946, p. 175).]

Bibliography: See also above for sources; C. and C., 1877, I, pp. 73–78; Hourticq, 1919, pp. 23–24, 79–81; Ozzola, 1932, pp. 128–130; Suida, 1935, pp. 23–24; Tietze, 1936, I, pp. 58–60, II, p. 283; Curtius, 1938, pp. 235–238; Wittkower, 1938–1939, pp. 202–203; Beroqui, 1946, p. 175; Douglas, 1948, pp. 144–152; Brendel, 1955, pp. 115–116; Saxl, 1957, pp. 163–164; Berenson, 1957, p. 183; Antwerp, 1958, p. 218; Valcanover, 1960, I, pls. 10–12.

133. **St. Peter Martyr, Martyrdom of** (destroyed)
Canvas. 5·15×3·08 m.
Venice, SS. Giovanni e Paolo (formerly).
Documented 1526–1530.

The copy by Niccolò Cassana (1659–1713) on the original altar of SS. Giovanni e Paolo undoubtedly preserves the colour scheme of Titian's lost masterpiece. The deep-blue mountains and sky, the monks' habits of white with black cloaks, as well as the assassin's white shirt and red breeches, and even the greenish-brown of the trees and earth are completely in Titian's style. The Dominican Peter Martyr, a mediaeval Inquisitor (1203–1252), was assassinated on the road between Milan and Como, as revenge for the severity of his actions against those accused of heretical views. See Plates 153, 154, for the composition. Universally regarded as a major landmark in Titian's career, this picture shows an important turn toward highly dramatic interpretation, which had been first revealed in the *Assumption* (Plate 18). Michelangelo's influence in the muscular figures and violent action has generally been conceded by all historians. The Libyan sibyl of the Sistine Chapel seems reflected here in the pose of the murderer. Further discussion of this picture occurs in the text, pp. 17 and 20.

History: From 30 November 1525 to 26 January 1526 the Confraternity of St. Peter Martyr carried on negotiations with the Council of Ten of Venice for permission to

order the painting. The work was completed by 27 April 1530 (C. and C., 1877, I, p. 445), and later in 1531 Titian petitioned for payment of one-hundred ducats (Giomo, 1903, pp. 57–68). The new altar-piece may well have been inaugurated on St. Peter Martyr's day, 29 April 1530, but Sanuto fails to mention the fact.

The first writer to say that Palma Vecchio (a member of the Confraternity of St. Peter Martyr) competed with Titian for the contract was Paolo Pino in 1548 (edition 1960, p. 137); Ridolfi exactly one hundred years later added Pordenone as the third competitor (Ridolfi (1648)–Hadeln, I, p. 167). Reference to drawings by the three masters is the only other early support for Pordenone's part in the affair (Scanelli, 1657, p. 217).

A date of 1528 for Titian's contract, commonly cited by various writers, does not appear in the documents. It was proposed by Crowe and Cavalcaselle previous to the discovery of the documents of 1525–1526, but many writers continue to give their date.

The picture was taken to Paris by the French in 1797, then returned to the church in 1816 (Alberti, 1926, pp. 325–328); while temporarily stored in the chapel of the Rosario of SS. Giovanni e Paolo, it was destroyed by fire on 16 August 1867.

Bibliography: See also History; Aretino's letter of 29 October 1537 (*Lettere*, edition 1957, I, p. 73); Paolo Pino, 1548, edition 1960, p. 137; Dolce, 1557, edition 1960, pp. 145, 204; Vasari (1568)–Milanesi, VII, pp. 438–439; Sansovino, 1581, p. 23ᵛ (Titian's picture replaces one by Jacobello del Fiore); Ridolfi (1648)–Hadeln, I, pp. 34, 167–168; Boschini, 1664, p. 217; Galeani Napione, 1823 (with early bibliography and list of thirteen engravings); Paravia, 1825, pp. 1–33; C. and C., 1877, I, pp. 326–335, 445–446; Giomo, 1903, pp. 55–69 (documents); A. Venturi, 1928, pp. 124–125; Suida, 1935, pp. 39, 54–55; Tietze, 1936, I, pp. 113–115, II, p. 312; Valcanover, 1960, I, p. 82.

DRAWINGS:

In the seventeenth century, competition drawings by Titian, Palma Vecchio, and Pordenone were said to belong to a private collector of Bologna (Scanelli, 1657, p. 217). At the same period (1648) there was a reference to a *modello*, apparently by Palma Vecchio, in the Casa Contarini at Venice (Ridolfi (1648)–Hadeln, I, p. 167). Today two drawings of the subject by Pordenone are preserved at Chatsworth (Hadeln, 1925, pls. 37, 38). Rubens owned a large drawing, now lost, which was inventoried as Titian's preparatory study (Rubens

Inventory, 1855, p. 270, no. 3; also Sainsbury, 1859, p. 236). As for Titian's drawings, considerable disagreement prevails as to which of the following are by his own hand because so many artists made sketches after his famous composition. Only the sheets at Lille are accepted by all critics.

1. Lille, Musée Wicar, sketch for angels (Hadeln, 1924, pl. 9), two sketches of the main figures (Hadeln, 1924, pl. 10; Tietze, 1936, II, pl. 85; Tietze and Tietze-Conrat, 1944, p. 318, nos. 1923, 1924, 1925), unanimous agreement as by Titian.

2. Bayonne, Musée Bonnat, copies of figures in landscape (Fröhlich-Bum, 1924, pp. 281–285, Titian; *idem*, 1927, pp. 228–233, Titian); regarded as copies of Carracci circle by Tietze and Tietze-Conrat (1936, pp. 150–152; *idem*, 1944, p. 312, no. A 1873); regarded as copies by Bean (1960, no. 174).

3. Chantilly, Musée Condé, sketch (Fröhlich-Bum, 1929, p. 74, Titian; Tietze and Tietze-Conrat, 1936, pp. 150–155; *idem*, 1944, p. 314, no. A 1888, copy).

4. Florence, Uffizi, two sketches (Fröhlich-Bum, 1924, pp. 280–285, Titian; Tietze and Tietze-Conrat, 1936, p. 154, follower; *idem*, 1944, p. 203, no. 901, Palma Giovane).

5. London, British Museum, copy of the two main figures (C. and C., I, p. 333; Fröhlich-Bum, 1927, p. 228, Titian; Tietze and Tietze-Conrat, 1936, p. 154, not Titian); attributed to Pomponio Amalteo (1505–1588), a follower of Pordenone (Tietze and Tietze-Conrat, 1944, p. 35, no. 22).

6. Paris, Louvre, two sketches (Fröhlich-Bum, 1924, p. 285, Titian); second item (Tietze and Tietze-Conrat, 1936, p. 154, circle of Titian; Fröhlich-Bum, 1925, p. 22, erroneous identification as Titian's study for the *Jealous Husband*, Padua; Tietze and Tietze-Conrat, 1944, nos. 1997 and 1998, copies by the circle of Titian).

EXTANT REPLICAS:

1. Martin Rota's woodcut (Plate 154), *c.* 1558–1586, inscribed 'Ticianus inventor, Martinus Rotus Sibesis F.' The original composition is presented unreversed. Numerous other prints (C. and C., 1878, Italian edition, II, p. 594).

2. Venice, SS. Giovanni e Paolo, copy by Niccolò Cassana, formerly in the Medici Collection at Florence, was brought here in 1868 to replace Titian's picture, which had been destroyed the year before (Lorenzetti, 1926, p. 337; Soprani-Ratti, 1768–1769, II, p. 15). Since Crowe and Cavalcaselle mistakenly attributed this copy to Cigoli, a number of later writers have repeated their error.

OTHER COPIES OR VERSIONS:

1. Ancona, San Domenico Maggiore, second chapel at the right, copy by Giuseppe Pallavicini (1736–1812) (Sartori, 1821, pp. 11–12; Serra, 1932, p. 167).

2. Bologna, Museum, free adaptation by Domenichino. The composition is the reverse of Rota's print and also of the original picture.

3. Cambridge (England), Fitzwilliam Museum (Plate 153), canvas, 1·238×0·842 m., gift of J. W. Clark in 1891 (Goodison and Robertson, 1967, no. 621, pp. 175–176).

4. Colinsburgh, Fife, Scotland, Earl of Crawford and Balcarres (formerly); previously London, Lady Wantage, until 1920; canvas, 67¼×39¼ inches (1·709×0·997 m.) (*Wantage Catalogue*, 1905, no. 165).

5. Huesca, Museo Provincial, copy, probably from the Carderera Collection (Salas, 1965, p. 220, no. 212; Gudiol photo 24677).

6. Leningrad, Academy of Arts, copy by P. T. Borispolets, 1850–1851 (Fomiciova, 1960, no. 19).

7. Madrid, Mora Collection, canvas, 2·00×1·15 m., copy (Angulo, 1940–1941, p. 154).

8. Vienna, Akademie, canvas, 0·78×0·46 m., copy (Eigenberger, 1927, pp. 411–412, no. 303).

9. Unknown location, Lord Northwick's copy, 64×37½ inches (1·625×0·952 m.) (Northwick sale, London, Christie's, 5 November 1965, no. 130; Borenius and Cust, 1921, p. 36, no. 72; Northwick sale, Cheltenham, 1864, no. 107, bought in; Lord Northwick bought it from the Stanley sale, 12 June 1832, no. 113).

10. Unknown location, canvas, 36×23 inches, copy exhibited at the Royal Academy in 1875 by Mr. Pigott and apparently by J. Smith Pringle at Manchester in 1857, no. 249 (C. and C., 1877, I, p. 334, note).

COPIES NOTED IN THE COURTAULD FILES, LONDON, AND THE FRICK ART LIBRARY, NEW YORK:

1. London, Robinson sale, Christie's, 13 April 1927, no. 96, 52½×32½ inches (1·33×0·825 m.), 6½ guineas.

2. London, P. Tubbs Collection, 67×36 inches (1·72×0·914 m.) (Frick Library photo).

3. Rome, San Giorgi sale, 8–11 April 1895, no. 78, 1·58×0·95 m.

4. Numerous other bad copies.

WRONG ATTRIBUTION:

Unknown location, canvas, 0·99×1·17 m., a fragment of a larger composition, published as Titian's work *c.* 1520, which also has been attributed to Cariani; formerly Henry Labouchere, Lord Taunton, Stoke Park, England; by inheritance to P. Stanley (sale Sotheby, London, 14–15

July 1920, no. 41, 39×46 inches (0·991×1·168 m.), illustrated); Scandinavia, private collection (Borenius, 1920, p. 57, Cariani; Suida, 1935, pp. 31, 54, 183, pl. 299, Titian).

LOST EXAMPLES, known from literary references:

1. Bologna, Casa Ghisilieri, copy by Annibale Carracci; Casa Bolognetti, another by Lodovico Carracci (Malvasia, 1678, I, pp. 367–368; Crespi, 1769, p. 77).

2. Escorial, copy, 7⅓×4 *varas* (5·12×3·34 m.), undoubtedly the one made by Jerónimo Sánchez in 1575 for Philip II (Zarco del Valle, 1888, p. 235; Cloulas, 1967, p. 281; Palomino, 1724, edition 1947, p. 797, wrongly says that Titian himself painted this replica). The picture was displayed in the chapel of the infirmary when Padre Sigüenza (1599) criticized it as improper and unsaintly and not inspirational for prayer (edition 1933, p. 419); it hung in the sacristy of the choir in 1657 (Padre de los Santos, edition 1933, p. 257); Padre de los Santos in 1680 says this picture was destroyed in the fire at the Escorial which occurred in 1671 (*loc. cit.*, p. 314; Palomino, 1724, edition 1947, p. 797, states that it still exists in his day, but he must have read Padre de los Santos of 1657).

3. Paris, copy by Jean Baptiste de Champaigne, Inventory of 1681 (Guiffrey and Gronchy, 1892, p. 182, no. 5, pp. 195–196).

4. Rome, Pope Pius V, 1567, sent by Titian as a gift through Cardinal Alessandro Farnese (Ronchini, 1864, p. 142; C. and C., 1877, II, pp. 375–376); engraved by Bertelli (Tietze, 1936, I, pp. 375–376, pl. XXIII).

5. Rome, Cardinal Pio di Savoia, copy done at Venice by Giovanni Bonatti for the cardinal (Cittadella, 1783, III, p. 294; also L. Pascoli, 1736, II, p. 213), which Pietro da Cortona said would one day pass for an original (Baruffaldi, 1733, edition 1846, II, p. 241).

6. Rome, Lucien Bonaparte, small copy (1812, no. 71, pl. 107; Buchanan, 1824, II, p. 278, no. 114).

7. Venice, Alvise Mocenigo IV, Inventory 1759, large copy (Levi, 1900, II, p. 230).

8. Venice, Michele Pietra (or Spietra) in 1656 (Levi, 1900, II, p. 22; Savini-Branca, 1964, p. 138).

134. St. Sebastian Plate 194

Canvas. 2·10×1·15 m.

Leningrad, Hermitage Museum.

About 1575.

Kept in storage at the Hermitage in the later nineteenth century as an inferior work, the *St. Sebastian* has now been

elevated to the rank of Titian's finest creations. The extreme freedom of the brush finds comparison only in other of the master's last works, such as the *Shepherd and Nymph* in Vienna and the *Christ Crowned with Thorns* in Munich (Plate 133). Even those masterpieces are surpassed here in the misty, iridescent tones of the landscape.

Condition: Unfinished; in a relatively good state after restoration.

History: In Titian's house at his death; Barbarigo Collection, 1581–1850 (Bevilacqua, 1845, no. 40; Levi, 1900, II, p. 287, no. 40; Savini-Branca, 1964, p. 186).

Bibliography: Ridolfi (1648)–Hadeln, I, p. 200; C. and C., 1877, II, p. 423 (authentic but badly damaged); Suida, 1935, p. 137 (Titian); Tietze, 1936, II, p. 291 (Titian); Berenson, 1957, p. 187; Leningrad, 1958, no. 191 (Titian); Valcanover, 1960, II, pls. 132–133 (Titian); Fomiciova, 1960, no. 59, colour illustration; Neumann, 1961, pp. 350–371; Fomiciova, 1967, pp. 68–70; Levinson-Lessing, 1967, pl. 38.

VARIANT:

Unknown location, *St. Sebastian*, life size, Earl of Arundel, Inventory of 1655 (Hervey, 1921, p. 488, no. 360).

135. St. Sebastian (Escorial type) (lost)

No dimensions, said to be life-sized.

Escorial, Sacristy (formerly).

This lost picture was described by Padre de los Santos in 1657 as a nude single-figure in a niche, his hands placed behind him, two arrows in his body and his face lifted toward heaven. Ponz in the eighteenth century verified the type of composition by an even fuller description: '. . . un San Sebastián, figura del natural, en pie, de Ticiano; está con las manos atadas atrás, y atravesado de algunas flechas; es divina la expresión de su cabeza mirando al cielo, y parece verdadera carne la de todo su cuerpo.'
The suggestion was made by Crowe and Cavalcaselle that the work in the Harrach Collection in Vienna might be Titian's lost original, but that version is no better than a copy (see below).

History: Gift of the Conde de Benavente to Philip IV; in the Escorial in 1657 (Padre de los Santos, edition 1923, p. 240); still there in the next century (Ponz, 1773, tomo II, carta III, 49); the picture was last recorded as sent to the palace of San Ildefonso at La Granja in 1810 under Joseph Bonaparte (Beroqui, 1933, p. 154).

Bibliography: See also History; Palomino, 1724, edition 1947, p. 39; Ceán Bermúdez, 1800, V, p. 42; C. and C., 1877, II, p. 427.

COPY (Escorial type) (Plate 237)
Vienna, Harrach Collection, canvas, 1·85 × 0·90 m., copy possibly by Pordenone. St. Sebastian's pose only partially resembles the same saint in Titian's *Madonna and Saints* in the Vatican (Plate 23), who in this case looks downward and is much slenderer in physique. The Harrach saint, powerful in body, bends his head back and gazes heavenward. He corresponds precisely to the description of the lost Escorial picture, of which the Harrach version may be a copy. This painted example, rather wooden in quality, consists of a neutral figure and an archaistic setting within a niche covered by a semi-dome of gold mosaics, none of which admit of Titian's own authorship. *Condition:* Restored; the right leg and foot are badly redrawn. *History:* Count von Harrach, who was ambassador to Spain for various periods between 1661 and 1698, is thought to have purchased the picture. Nevertheless, Crowe and Cavalcaselle's suggestion that he acquired the Escorial picture must be rejected, since that work remained in the monastery throughout the eighteenth century and until the Napoleonic disaster. A Spanish provenance for the picture is not assured. *Bibliography:* C. and C., 1877, II, p. 427 (as Titian's Escorial picture); Ritschl, 1926, p. 128, no. 330; Venturi, 1928, IX, part 3, p. 676 (Pordenone); Schwarzweller, 1935, p. 144 (Pordenone); Fiocco, 1943, pp. 143, 151, pls. 214, 215 (attribution to Pordenone rejected; suggests Nadalino da Murano); Heinz, 1960, p. 59, no. 138 (Pordenone).

DRAWING:
Bayonne, Musée Bonnat, 300 × 148 mm., Venetian School, sixteenth century. The drawing corresponds exactly to the *St. Sebastian* in the Harrach Collection (see above), for which it is probably the study. Tietze and Tietze-Conrat (1944, p. 235, no. A 1291) considered the sheet a copy of the picture rather than a study for it. The quality is high but not Titian's own work (see also Bean, 1960, no. 219).

LOST PICTURE:
Venice, Renieri lottery, 4 December 1666, half-length St. Sebastian, attached to a column, no further description, called Titian (Savini-Branca, 1965, p. 99).

One of this type in the Steiner sale, 11 April 1899, no. 242, half length, 1·21 ×0·93 m., seventeenth century.

St. Sebastian, see also: Madonna and Child with Sts. Catherine, Nicholas, Peter, Sebastian, Francis, and Anthony of Padua, Cat. no. 63, and copies. Resurrection altarpiece, Brescia, Cat. no. 92, and copies.

136. **St. Stephen, Stoning of** Plates 198, 199

Canvas. 1·94×1·27 m.

Lille, Musée des Beaux-Arts.

About 1570–1575.

Formerly attributed to Tintoretto in the museum, this work represents Titian at his best and in his most original late style. The vivacity of the brushwork is notable throughout the composition. The modelling of the saint's body in rose, blue and grey as well as the rose drapery with its rich impasto and white highlights constitute a virtuoso performance. St. Stephen's dalmatic is painted in golden brown against a greyish-white background, while blue buskins complete his costume. The stormy landscape in the middle ground, of which the large dark grey tree stands against a neutral-blue sky, mirrors the agony of the saint, above all in the vibrant illusionistic silhouettes of branches and foliage. The sweeping movement through the muscular body of the executioner as well as the spirited brushwork have the same verve as the Judas of the *Last Supper* in the Escorial (Plate 116).

Demmler first attributed the picture to Titian in 1918, while Hadeln orally suggested Damiano Mazza, a follower of the master. Not until Longhi published the work as Titian's in 1946 did recognition of its extraordinary quality become more general. Nevertheless, neither Tietze nor Berenson gave it any recognition or even comment.

Condition: Generally well preserved; the red underpaint comes through in the upper left of the sky and in St. Stephen's head and left hand, areas on which the artist may have intended further glazes.

History: Acquired by Lille in 1888 from a dealer, Morhange.

Bibliography: Lenglart, 1893, no. 653 (Tintoretto); Demmler, 1918, p. 72, no. 345 (Titian); Longhi, 1946, pp. 64–65, pl. 119 (Titian); not listed by Mayer-Bercken in 1923 or by Tietze in either *Titian* or *Tintoretto*; Maurois, 1950, cat. no. 31 (as Tintoretto); Pallucchini, 1954, p. 111

(Titian, *c.* 1560); Valcanover, 1960, II, pl. 83 (Titian); Stockholm, 1962–1963, no. 96 (Titian, *c.* 1560); Ballarin, 1965 (i.e., 1966), p. 238 (Spanish school, early seventeenth century!!); Paris, 1966, pp. 234–235 (Titian, 1570–1576).

137. **Salome** (Doria-Pamphili type) Plate 149

Canvas. 0·90×0·72 m.

Rome, Doria-Pamphili Gallery.

About 1515.

Salome ranks with the Celestial Venus of *Sacred and Profane Love* as one of Titian's most beautiful and poetic conceptions. Her lovely red drapery over the white blouse forms a handsome complement to the green costume of the maidservant. The greenish-black background with the faint blue and white of the sky visible through the archway combines with the figures to make an extraordinarily ingenious composition.

The attribution to Titian is firmly established by the early inventories, and it has been accepted by all critics except G. M. Richter ever since Morelli in 1892 definitely declared Titian and not Giorgione the painter. The composition is recorded in Van Dyck's 'Antwerp Sketchbook' (Jaffé, 1966, II, pl. 63ᵛ), on the same page with the *Madonna and Child with SS. Stephen, Jerome, and Maurice* (Cat. no. 72), both of which the artist must have seen in the Aldobrandini Palace at Rome during his sojourn in that city in 1622–1623.

Condition: Unusually well preserved.

History: A *Salome* appears in the Inventory of Lucrezia d'Este, Duchess of Urbino, in 1592: '56. Uno di una Herodiade, N. 1.', but without identification as to the artist (Pergola, 1959, pp. 345, 349). Since many d'Este pictures passed to the Aldobrandini family, they can be traced in the successive Aldobrandini Inventories of the seventeenth century.

Two pictures of this subject are included in the Inventory of 1603 of Cardinal Pietro Aldobrandini, nos. 19 and 295 (D'Onofrio, 1964, pp. 18, 209). The same two paintings by Titian reappear in the Inventory of 1626 ordered by Olimpia Aldobrandini, nos. 19 and 150 (Pergola, 1960, pp. 428, 433). They recur in the Inventory 'before 1665' of Olimpia Aldobrandini-Pamphili, granddaughter of the first Olimpia, although the name of Titian has been omitted on one item, nos. 213 and 295 (D'Onofrio, 1964, pp. 205, 209). In a fourth Aldobrandini Inventory, made in 1682 after the death of Donna Olimpia Aldobrandini-

Pamphili, the two paintings are again listed and are said to have come from the cardinal, nos. 357 and 379 (Pergola, 1963, pp. 77, 78).

Part of Donna Olimpia's pictures passed by inheritance to her son Giovanni Battista Pamphili and thus into the present Doria-Pamphili Gallery (Pergola, 1963, p. 78, note 379). In the eighteenth century two works of the subject still remained in the collection (Tonci, 1794, p. 225), but Tonci ascribed one of them to the school of Guercino and the other to Titian. They are probably identical with the two owned in 1603 by Cardinal Pietro Aldobrandini. The Doria family sold their second-best *Salome* in 1798–1799 to the Englishman, William Young Ottley (see Cat. no. 138 in the Norton Simon Foundation). See also Lost Copies, no. 1, below.

The history of the Doria picture as coming from the Salviati collection and later Queen Christina's, given by Sestieri and accepted by Tietze, is clearly mistaken, since the Salviati inventories (Pergola, 1960, pp. 193–200) do not contain a *Salome* and Queen Christina's paintings went to France (see Cat. no. 140). This false theory was advanced before the publication of the inventories by Pergola and D'Onofrio. Ludwig Justi (1925, I, pl. 32) first suggested this provenance with a question mark and he included Tonci in his bibliography. Neither Tonci (1794, p. 225) nor Justi stated that the Doria *Salome* first entered the collection in 1794. Moreover, Van Dyck's drawing, mentioned above, proves the fact that in 1622–1623 he saw the Doria-Pamphili *Salome*, then in the Aldobrandini Palace at Rome.

It remained for Sestieri to introduce the mistaken date of 1794 in his catalogue (1942, pp. 341–342, no. 517) and to give Tonci as his source. Unfortunately the incorrect thesis that the Doria *Salome* is identical with Queen Christina's was accepted by the organizers of the Stockholm exhibition of 1966, in the catalogue of which the erroneous history of the two works is repeated (Stockholm, 1966, p. 480).

Bibliography: See also History; C. and C., 1871, edition 1912, III, p. 178 (Pordenone); Morelli, 1892, p. 307 (Titian, early); Morelli, 1897, pp. 312–313 (Titian, early); Hourticq, 1919, pp. 138, 276 (Titian; John's head a self-portrait); Hetzer, 1920, pp. 52–54 (Titian); London, 1930, p. 112, no. 165 (Titian; with wrong history); Foscari, 1935, p. 32 (St. John as Titian's portrait); Richter, 1937, p. 228 (as a replica of a picture he assigned to Giorgione, Cat. no. 139); Suida, 1935, pp. 30–31 (Titian); Tietze, 1936, I, pp. 88–89, II, p. 308 (Titian); Berenson, 1957, p. 190 (early Titian); Valcanover, 1960, I, pl. 61 (Titian).

COPIES (Doria-Pamphili type):
1. Huesca, Museo Provincial (Gaya Nuño, 1955, p. 287); this museum has been under reconstruction and inaccessible for ten years.
2. Naples, Galleria Nazionale, Capodimonte, in storage, poor copy (not catalogued by Rinaldis, 1911 and 1927).
3. Nîmes, Musée des Beaux-Arts, Head of the Baptist (Richter, 1937, p. 228).
4. Unknown location; Venice, Stroiffi Collection, 1683; perhaps passed to the Duchesse de Berry, Grimani-Calergi Palace, Venice, sold 1865 (C. and C., 1871, edition 1912, III, p. 178, modern copy of Pordenone; Borenius, 1914, p. 184; Richter, 1937, p. 228).

LOST COPIES (uncertain type):
1. London, Bath House, Alexander Baring, i.e. Lord Ashburton, canvas, 27½×24 inches (0·698×0·61 m.); Waagen assigned it to Giorgione, although the attribution was to Titian (Waagen, 1854, II, p. 100); Lord Ashburton's picture had the maidservant but C. and C. say that she was replaced by an old man (C. and C., 1877, II, p. 463, as Licinio or Beccaruzzi); in the *Art Union*, 1847, p. 126, wrongly said to have come from the Aldobrandini Palace in Rome (see below); destroyed by fire in Bath House in 1873 (*Times*, 3 February 1873, p. 12, col. C; C. and C., 1871, edition 1912, III, p. 54). *Earlier history:* Bought from the Colonna (?) in Rome by Mr. Day, who sold it in 1800–1801 to Lord Northwick; later Lord Radstock (Buchanan, 1824, II, p. 5); Radstock sale, 13 May 1826, no. 50, bought by Lord Ashburton.
2. Marseilles, Château de Borély, 1860 (Richter, 1937, p. 228).

138. **Salome** (Doria-Pamphili type)
Canvas. 0·838×0·712 m.
Fullerton (California), Norton Simon Foundation.
Workshop of Titian, sixteenth century.

Richter insisted on Giorgione's authorship of this version, but today it is generally regarded as a repetition by Titian's assistants.

History: Traceable in Rome from 1603; for the early history of this picture see item in the Doria-Pamphili Gallery (Cat. no. 137); bought from the Doria in 1798–1799 by William Young Ottley, who sold it at Christie's in 1801 (Buchanan, 1824, II, p. 23); Sir Richard Sullivan (sale, Christie's, London, 9 April 1808, no. 14, as from the Doria Palace); Sir Richard Sullivan (sale, Christie's, London, 18 June 1859, no. 17); George Cavendish

Bentinck (sale, Christie's, London, 11 July 1891, no. 779); Charles Murray; Charles Butler, 1891; Robert Benson, London, 1894–1930 (Borenius, 1914, pp. 183–184); Duveen Brothers, New York (until 1965).

Bibliography: C. and C., 1871, edition 1912, III, p. 178 (note 2 by Borenius calls it a version of Doria-Pamphili picture); London, 1915, pp. 33–34 (Giorgione); Suida, 1935, p. 158, included under pl. XXXVI (Titian replica); Tietze, 1936, II, p. 308 (Titian workshop); Richter, 1937, p. 228 (Giorgione; incorrect history); Cleveland, 1956, no. 57 (Titian; wrong history); Valcanover, 1960, I, included under pl. 61 (Titian, workshop); Stockholm, 1962–1963, no. 80 (Giorgione).

139. **Salome** (Doria-Pamphili type)

Canvas. 0·889×0·724 m.

Vienna, Private Collection (?).

Copy.

Sixteenth century.

Condition: Cleaned in 1934; considerable restoration in Salome's head.

History: Sir Thomas Baring, Stratton; Thomas Baring, London (Waagen, 1854, II, p. 179, attributes the picture to Catena, although Baring gives it to Giorgione); Manchester Exhibition, 1857, no. 252 (as Titian, lent by Thomas Baring); Lord Northbrook, nephew of Baring (catalogue 1889, no. 186, Giorgione); Anonymous sale, London, Sotheby, 16 July 1930, no. 94, 35×28½ inches (*APC*, IXA, 1929–1930, no. 10,836, £320, as Giorgione); Frank T. Sabin, London, 1930–1945 (?); Baltimore Exhibition, 1942, no. 11 (lent by Frank T. Sabin); in the catalogue the identification of this version of the *Salome* with the picture that once belonged to Queen Christina and to the Orléans Collection is incorrect.

Bibliography: See also History; C. and C., 1877 (not mentioned); Morelli, 1897, p. 313 (copy of the Doria-Pamphili picture); C. and C., 1871, edition 1912, III, p. 178, note 2 by Borenius (Pordenone); Suida, 1935, p. 158, mention under pl. XXXVI (Titian, replica); Richter, 1937, pp. 227–228, pls. 38, 40 (insisted on Giorgione's authorship and on an incorrect provenance from Queen Christina's collection); not listed by Tietze, Berenson, or Valcanover.

140. **Salome** (lost)

Canvas. 3½×3 *palmi* (0·78×0·67 m.)

Formerly Rome, Queen Christina and Prince Odescalchi.

Queen Christina's picture was attributed to Giorgione, but it was probably of the Doria-Pamphili type, in reality by Titian or his workshop.

History: Rudolf II, Prague; Prague Inventory 1648, no. 516; Queen Christina, Inventory 1689, no. 112, 3½ *palmi* high ×3 *palmi* wide (Granberg, 1897, no. 38); Cardinal Azzolino, 1689; Pompeo Azzolino, 1689–1692; Prince Odescalchi, Rome, 1692–1721, as Giorgione (Odescalchi Archives, purchase 1692, folio 468ᵛ, no. 112; 'Nota', no. 108; sale to Orléans, 1721, folio 2, no. 30). Since this item does not appear in the Orléans catalogues, some people have doubted it ever reached France. It is more probable that the Duc d'Orléans presented it to a favourite, as the picture was unquestionably among those purchased by him in 1721.

Bibliography: See also History; Campori, 1870, p. 354; Granberg, 1896, no. 53 (Giorgione), wrongly placed Queen Christina's picture in England and thought that it was destroyed in a fire at Bath House in 1873 (i.e. Lord Ashburton; Cat. no. 137, Lost Copies, no. 1). Other theories are: Richter (1937, pp. 237–238), the picture now in Vienna (Cat. no. 139); Sestieri's (1942, pp. 341–342) incorrect belief that the Doria-Pamphili canvas is identical with Queen Christina's (see Cat. no. 137, History); Waterhouse (1966, p. 374) believes that Queen Christina's *Salome* is the picture now attributed to Pordenone in the Ringling Museum at Sarasota. See next paragraph.

SALOME, PORDENONE VERSION:
Sarasota, Ringling Museum, canvas, 0·92×0·813 m. (35½×32 inches). Salome facing left holds the salver with the Baptist's head; the executioner with sword hilt stands at the left side and the young maidservant at the right. *History:* Padua, Giustiniani Collection: the composition as shown in Landon's publication is in every detail identical with the Sarasota picture (Landon, 1812, p. 125, pl. 59, 32×29 *pouces*, as Giorgione); later in the Holford Collection, London (Waagen, 1854, II, p. 196, vague description; C. and C., 1871, edition 1912, III, p. 54, very feeble, describe the three figures); Holford sale, London, Christie's, 15 July 1927 (*APC*, VI, 1926–1927, no. 9776, as Pordenone); purchased by Ringling. *Bibliography:* Berenson, 1932, p. 470 and 1957, p. 146 (Pordenone); Fiocco, 1943, pl. 193 (Pordenone); Suida, 1949, no. 66 (as Pordenone; wrongly assumed that this work came from Queen Christina's collection, there attributed to Giorgione); Salerno, 1960, p. 137, no. 49 (accepted Suida's theory).

141. Salome (Madrid type) Plate 192
Canvas. 0·87×0·80 m.
Madrid, Prado Museum.
About 1550.

Even the wretched condition and the paint blistered by
fire cannot destroy the extraordinary beauty of design and
the exquisite quality of this handsome picture. The girl,
fashionably garbed in a rose costume, is generally identi-
fied as Titian's daughter Lavinia. Another version in
Berlin, in which she is transformed into a young woman
with a basket of fruit, does not equal the high standard of
this work in Madrid.

Condition: Badly damaged by fire; much darkened.

History: The English Inventories of Charles I of England
cite no painting of this subject by Titian, but in a French
list of pictures on sale at Somerset House in May 1650 is
'Hérodes avec la teste de saint Jean, par Tissian' (Cosnac,
1885, p. 416, Lettre H, no. 78). Waagen (1854, II, p. 480)
proposed that Charles' picture went to Spain; Marqués de
Leganés, Inventory 1665 (Leganés, edition 1962, no. 25);
bought by Philip IV; Alcázar, 'pasillo que llaman de la
Madonna', Inventory 1666, no. 646, and Inventory 1686,
no. 198, as Titian; in 1700, no. 47, called a copy (Alcázar:
Bottineau, 1958, p. 148); Inventory 1747, probably one
of the items identified simply as 'muger' (woman)
(Alcázar, Madrid, Archivo del Palacio); Buen Retiro
Palace; Royal Palace, Madrid, 1814.

Bibliography: See also History; Madrazo, 1843, p. 167,
no. 776; 'Inventario general', 1857, p. 159, no. 776;
C. and C., 1877, II, pp. 136, 141 (Lavinia's portrait);
Suida, 1935, pp. 112, 176 (Titian); Tietze, 1936, II, p. 295
(workshop); Beroqui, 1946, p. 169 (Titian); Berenson,
1957, p. 188 (Titian); Valcanover, 1960, II, pl. 82 (Titian);
Prado catalogue, 1963, no. 428.

VARIANTS:
1. Berlin, Staatliche Gemäldegalerie, *Lavinia with a
Basket of Fruit*, canvas, 1·02×0·82 m., the same composi-
tion as Salome (C. and C., 1877, II, pp. 139–141, Titian;
Berlin catalogue, 1930, fig., 166, Titian; Tietze, 1936, II,
pl. 284, Titian; Berenson, 1957, p. 184, Titian; Valcanover
1960, II, pl. 63, Titian).
2. London, Abbott, *Lavinia with a Casket*, a variant
of the Madrid *Salome* and the Berlin *Lavinia with a Basket
of Fruit*; Orléans collection (Orléans, 1727, p. 472;
Couché, 1786–1788, II, pl. 12); later in the collections of

Lady Lucas, Lady de Grey (Buchanan, 1824, I, p. 113;
Waagen, 1854, II, p. 497), and Lord Cowper (C. and C.,
1877, II, pp. 140–141, Titian's workshop).

COPY (Prado type):
Lisbon, Senhora Margarida Eisen, canvas. 1·23×0·875 m.
(Fiocco, 1939, pp. 125–126, as Titian, restored).

LOST COPIES (Prado type):
1. London, Coesvelt Collection (formerly), 36×30
inches or 0·914×0·76 m.; same type as Prado item
(Coesvelt cat., 1836, no. 18, illus.).
2. Padua, Museo, Civico (C. and C., 1877, II, p. 141, as
Varotari); an error, they confused it with Varotari's
Judith (Grossato, 1957, p. 68).

Saviour, see: Christ, Blessing, Cat. no. 18; Christ, Bust
of, Cat. no. 19.

Spain and Religion, see: Religion Succoured by Spain,
Cat. nos. 88, 89.

142. Supper at Emmaus Plate 87
Panel. 1·69×2·11 m.
Brocklesby Park (Lincolnshire), Earl of Yarborough.
Signed in large capitals beneath the dog: TITIANVS F.
Datable 1531.

No one should doubt the signature or Titian's authorship
of this impressive work, which has, however, suffered
from the effects of time, particularly through darkening
of colours. Although the three figures at the left repeat
those of the Louvre version (Plate 88), both Christ and
the pilgrim at the right differ in facial type and in
details of costume. Here the shell on the left side of
Christ's collar is clearly the badge of a pilgrim, associated
with travellers to the shrine of St. James at Santiago de
Compostela. The crossed daggers on the opposite side are
less easy to explain. On the other hand, the olive leaves
upon the table refer without any doubt to His sacrifice
on the Mount of Olives.

The thinly painted long beard of the Apostle at the right
in Lord Yarborough's picture is hardly discernible in the
photograph. Quality and state of preservation in this
case, nevertheless, make it the finest figure in the compo-
sition. No major alterations appear throughout the
painting, although A. L. Mayer asserted that the
architecture and sky were modified by a later hand.

Condition: Restored 1952; some damage to the face of the page and to the dog; somewhat darkened in general.

Other dating: C. and C., 1547; Mayer, 1536.

History: Preparations for the installation of the picture in the Ducal Palace in Venice are mentioned by Sanuto on 27 September 1531 (vol. LIV, column 615), thus supplying the date. It had been given by the Contarini family to the Venetian state (Vasari (1568)–Milanesi, VII, pp. 439–440). In 1566 Vasari saw the painting in the palace: 'nella salotta d'oro dinanzi alla sala del Consiglio dei Dieci sopra la porta'; still in the Ducal Palace in the 'chiesa a canto al Pregadi' in the time of Ridolfi (1648) and Boschini (1664, p. 23); in the room near the 'Cappella del Collegio' in 1771 (Zanetti, 1771, p. 20); in the 'Chiesetta' in 1797 (Zanetti, pp. 39–40); Sir Richard Worsley, ancestor of the Earls of Yarborough, who lived in Venice in 1793–1797, reported that the provincial French government during the Napoleonic period received it as a 'gift'; the *Supper at Emmaus* does not appear in the list of works of art sent to Paris in 1797 (Alberti, 1926, pp. 325–338); Worsley apparently purchased it from the French in Venice; the picture passed by inheritance to the Earls of Yarborough; lent to the Ashmolean Museum, Oxford (1952–1956?).

Bibliography: See also History: Ridolfi (1648)–Hadeln, I, p. 166; Boschini, 1674, Sestier di S. Marco, p. 18; Zanetti, 1733, p. 109; Worsley, 1804, p. 28; Waagen, 1857, p. 66 (workshop); C. and C., 1877, II, pp. 152–155 (Orazio or Cesare Vecellio); Wilczek, 1928, p. 159 (Cesare Vecellio); Suida, 1935, p. 165 (variant); Tietze, 1936, II, p. 305 (under Paris, Louvre, wrong data about the date); Mayer, 1938, pp. 301–305 (Titian); Gallo, 1939, p. 244 (Titian); Parker, 1952, pp. 19–26 (Titian); Berenson, 1957, p. 184 (Titian); Valcanover, 1960, I, pl. 124 (Titian).

DRAWING:
London, British Museum. The pencil drawing is an amateurish copy after the picture and not Titian's preparatory study as Mayer suggested (1938, p. 294).

143. **Supper at Emmaus** Plates 88, 89

Canvas. 1·69×2·44 m.

Paris, Louvre.

Signature on leg of table at left near the head of the cat:
TICIAN [VS]

About 1535.

Titian's best-known version of the subject is also the finest in quality, despite darkening of colours, and various past restorations. A second column to the right of the reverent pilgrim, which was painted out at a later period, is present in the earlier panel at Brocklesby Park (see reconstruction in Wilczek, 1928, p. 165). The eagle, dimly discernible in a circle in the left background, must refer to the Hapsburg Emperor Charles V.

The Christ of the Louvre picture appears, by exception, in a pale-blue tunic with pink highlights, over which is draped a dark-blue mantle. To the right sits in an attitude of adoration the black-bearded man, whose rose drapery falls over his dark-brown costume, which, being that of a pilgrim, resembles a monastic habit. His companion, seated at the left in a dark-green costume and a green-checkered muffler, draws back in a gesture reminiscent of St. Luke in Leonardo's *Last Supper*, a fact that nearly all writers have observed. Rather gay by contrast is the serving boy's orange-yellow jacket and his blue hat with white plume. The innkeeper in rolled-up sleeves has the mien of a peasant in his red cap, white shirt, and black jacket. Under the table, as in comic relief, the tiger cat and the white-and-tan dog seem about to spring at each other. Nevertheless, an all-pervading stillness establishes a highly contemplative mood, to which the deep blue hills and magnificent landscape, although faded, add greatly.

Condition: Darkened by varnish and old repaint; in generally faded state; signature badly restored.

Date: By general agreement later than the version at Brocklesby Park, which is datable 1531 (see Cat. no. 142).

History: Mayer claims that X-rays of the Louvre picture reveal the escutcheon of the Maffei family of Verona, located over the head of the pilgrim at the right and that the same coat-of-arms appears in the identical position in a copy belonging to a Milanese private collection. He therefore proposes that the Gonzaga bought it from the Maffei. In the Louvre catalogues this picture has been confused with the other version, formerly in the Ducal Palace, now at Brocklesby Park (see Cat. no. 142).

Gonzaga Collection, Mantua (until 1627); Charles I of England, Whitehall Palace, London, as Titian from Mantua (van der Doort, 1639, Millar edition, 1960, p. 16, no. 9, size 63×96 inches); exhibited at Somerset House, May 1650 (Cosnac, 1885, p. 416); bought by Colonel Webb on 25 October 1649 for £120 (Harley MS. no. 4898, folio 151, no. 32); Jabach, Paris (1649–1671); Louis XIV; Le Brun's Inventory of Versailles, 1683, no. 45; Paillet Inventory, 1695; others of Versailles, 1690, 1696, 1698; Hôtel d'Antin, Paris, 1715; Louvre, Paris, 1737;

Inventories of Versailles, 1752 (Lépicié, pp. 25–26), 1760, 1762, 1788 (Bailly-Engerand, 1899, pp. 67–68; complete history).

Bibliography: See also History; Villot, 1874, p. 283, no. 462; C. and C., 1877, II, pp. 153–155; Louvre catalogue, no. 1581, inv. no. 746; Wilczek, 1928, pp. 159–166; Suida, 1935, p. 67; Tietze, 1936, I, p. 142, II, p. 305 (dated 1525–1545); Mayer, 1938, pp. 302–303; Berenson, 1957, p. 189; Valcanover, 1960, I, pl. 147; Nuttall, 1965, p. 306.

COPIES:

1. Bergamo, collection of Marisa Madaschi, weak copy, lost in World War II (*Repertorio*, I, 1957–1964, no. 146).
2. Clermont-Ferrand, cathedral, copy of size of the original.
3. Dresden, Gemäldegalerie, canvas, 1·697×2·375 m. (C. and C., 1877, II, p. 154, suggest Sassoferrato; Posse, 1929, p. 91, no. 181, copy).
4. The Hague, formerly collection of William III, sold to Mr. Roos in 1850 (C. and C., 1877, II, p. 154).
5. Milan, private collection, copy said to come from the Martinengo Palace, Brescia (Mayer, 1938, p. 303, Titian).
6. Naples, Capodimonte Museum, in storage, small hard copy from the d'Avalos Collection (Rinaldis, 1927, p. 341).
7. Unknown location, canvas, 61¼×91½ inches (1·53×2·325 m., sale, Sotheby's, London, 15 April 1959, £60 (*APC*, XXXVI, 1958–1959, no. 3316).
8. Unknown location, panel, 9×14 inches (0·229×0·356 m.), anonymous sale, Christie's, London, 18 March 1960, £63 (*APC*, XXXVII, 1959–1960, no. 3005).
9. Versailles, chapel, large copy.

Temptation, see: Adam and Eve: Cat. no. 1.

144. **Temptation of Christ** Plate 110

Panel. 0·91×0·73 m.

Minneapolis, Institute of Arts.

About 1540–1545.

Restoration has given the picture a generally bland look and accounts for the softness of the hand, yet the attribution to Titian is undoubtedly correct.

Condition: Cut down at the bottom and slightly at the left; much restored.

History: M. le Grand; Orléans Collection (Dubois de Saint Gelais, 1727, p. 471, Titian; Orléans, Couché, 1786, pl. 8, Titian); Walukers, Brussels, in 1793; exhibited in London by Bryan, 1798–1799; sold to Mr. H. T. Hope (Buchanan, 1824, I, p. 112, no. 8); Hope Family Sale (Christie's, London, 20 July 1917, no. 123; sold to Robertson); G. Neumans, Brussels (1922); A. Reinhardt, New York (1925); sold to the Minneapolis Institute of Art in 1925.

Bibliography: See also History; Waagen, 1854, II, pp. 113, 497 (not Titian); C. and C., 1877 (not cited); Suida, 1935, p. 61 (Titian, *c.* 1540); Tietze, 1936, II, p. 301 (Titian, *c.* 1540); Berenson, 1957, p. 188 (Titian); Valcanover, 1960, I, pl. 185 (Titian, *c.* 1540–1545).

145. **Tobias and the Angel** Plate 161

Canvas. 1·93×1·30 m.

Venice, San Marziale, Sacristy.

About 1550.

Confusion about this picture has existed because of Vasari's statement that Titian himself said that he painted it in 1507. Even the kneeling figure of St. John the Baptist corresponds to Vasari's detailed description, yet the painting cannot be as early as 1507. Vasari may have seen an earlier version, or his memory was inexact. Suida and others have held unconvincingly that the Florentine writer meant to refer to the picture of the same subject now in the Accademia at Venice (Cat. no. X–39), but the discrepancies are too numerous.

The superior quality of the work, even in the blue of the sky and its white clouds, survives despite neglect. The angel Raphael in rose, with brown buskins and grey wings, strides forward, a jar of gall in hand (*Tobit* 6, 4) while the dark-haired Tobias' brown costume is relieved by rose buskins and a rose-coloured belt. The painting technique, still rather solid with white highlights, fits with a date *c.* 1550.

Condition: Darkened and dirty, in need of conservation.

Other dating: Mostra di Tiziano, c. 1534; Gronau, *c.* 1540–1543; Suida and Valcanover, 1550.

Bibliography: Vasari (1568)–Milanesi, VII, p. 430 (Titian, 1507); Ridolfi (1648)–Hadeln, I, p. 158; Sansovino, 1581, p. 54 (Titian); Boschini, 1664, p. 473 (Titian); Boschini, 1674, Canareggio, p. 53 (Titian); C. and C., 1877, II, pp. 29–31 (Titian); Gronau, *Titian,* 1904, p. 299; Frölich-Bum, 1912, pp. 198–199 (Andrea Schiavone); *Mostra di Tiziano,* 1935, no. 33; Suida, 1935, p. 65 (Titian); Tietze, 1936, I, p. 194, II, p. 312 (follower); Berenson, 1957, p. 191 (Titian); Valcanover, 1960, I, pl. 186 (Titian).

COPIES:

1. Variant in van Dyck's 'Italian Sketchbook', pl. 88ᵛ.
2. Dresden, Gemäldegalerie, 1·695×1·16 m. copy (C. and C., 1877, II, p. 31; Posse, 1929, p. 91, no. 180).
3. Unknown location, 0·884×0·80 m., free partial copy, sixteenth-seventeenth century; thought to be the one formerly in the collection of Barbarigo della Terrazza, Venice (Bevilacqua, 1845, no. 17; Levi, 1900, p. 286, no. 17); Russian Imperial Collection (?); Count Tyszkiewicz, St. Petersburg (London, Grosvenor, 1913–1914); Gains-borough Galleries, New York, 1927; Petre sale (Sotheby's, London, 17 December 1947, no. 51, 34¾×31½ inches).

146. Transfiguration Plate 124

Canvas. 2·45×2·95 m.

Venice, San Salvatore, high altar.

About 1560–1565.

Titian's very late style is fully in evidence in this large, almost monochromatic composition, bold in conception and free in brush. Against the light-yellow background Christ emerges in yellow and white draperies, while Moses appears in grey at the left and Elijah floats in mono-chrome at the right. The Apostles in the lower part of the composition assume eccentric attitudes, especially the sprawling St. James in red, who raises his right arm as a shield against the miraculous light. The young St. John the Evangelist extends his hands in adoration at the extreme right and St. Peter falls to the ground in astonishment at the lower left.

Condition: In a ruinous state, blistered, dirty, and badly in need of conservation.

Bibliography: Vasari (1568)–Milanesi, VII, p. 449; Ridolfi (1648)–Hadeln, I, p. 205; Boschini, 1664, p. 133; Sanso-vino-Martinioni, 1663, p. 123 (omitted in first edition of 1581); C. and C., 1877, II, p. 352; Suida, 1935, p. 134 (date *c.* 1550); Tietze, 1936, I, p. 240, II, p. 313; Berenson, 1957, p. 191; Valcanover, 1960, II, pl. 103.

COPY:

London, Leger and Sons, formerly, 1·57×1·06 m., a free copy of Titian's *Transfiguration*, then wrongly attributed to El Greco's youthful period (Wethey, 1962, no. X-136).

147. Tribute Money (Dresden type) Plates 67, 68

Panel. 0·75×0·56 m.

Dresden, Staatliche Gemäldegalerie.

Signed: TICIANVS F

About 1516.

The Pharisee shows a coin bearing the portrait of Caesar to Christ, Who replies with the celebrated words, 'Render unto Caesar the things which are Caesar's and unto God the things which are God's' (Matthew, 22: 15–16, 21). In the inexpressible tenderness of mood, notable in the humility and spiritual beauty of Christ, this picture would be difficult to surpass. The colour, too, has subtlety of tone and delicacy of nuance that none of the replicas approaches.

Ridolfi (1648) reports that the Spanish ambassador compared this picture to a work by Dürer then in the palace chapel at Modena. The tradition that Titian con-sciously wanted to compete with Dürer is repeated by Scanelli (1657), yet it is difficult to see any objective reason for accepting such a theory. More reasonable is the suggestion that a Leonardo drawing might possibly have influenced Titian in his conception of the Pharisee.

Condition: Generally well preserved; probably not mutil-ated, as Valcanover suggested, since the Madrid replica is identical in size and details.

Other dating: Crowe and Cavalcaselle, 1508–1514; Haagen, 1507–1508; Gronau, Hetzer, and Suida, 1516: at the time of the first visit to Ferrara.

History: Originally in the door of an armoire in Alfonso I d'Este's studio in the castle at Ferrara (Vasari); taken to Modena in 1598 by Cesare d'Este after the death of Alfonso II; purchased from Modena by the Dresden Gemäldegalerie in 1746.

Bibliography: Vasari (1568)–Milanesi, VII, pp. 434–435; Ridolfi (1648)–Hadeln, I, pp. 161–162; Scanelli, 1657, pp. 228–231; Riedel and Wenzel, 1765, p. 207, no. 208; C. and C., 1877, I, pp. 116–121; Woermann, 1902, p. 86; Haagen, 1918, p. 238; Hetzer, 1920, pp. 59–62; Gronau, 1928, pp. 235–236; Suida, 1935, pp. 35, 159; Tietze, 1936, I, p. 120, II, p. 287; Mayer, 1938, pp. 303–308; Berenson, 1957, p. 184; Valcanover, 1960, I, pl. 76 (says it is mutilated at the right side and cites the copy in Rome as proof).

REPLICA:

Madrid, Descalzas Reales, Museum (Plate 69); panel, 0·745×0·56 m., *c.* 1516–1520, inscribed on the gold neck-band of the Pharisee's tunic: TICIANVS F. Against the dark-brown background Christ's brown hair, His light-rose tunic, and His blue mantle predominate. The

swarthy-skinned burly Pharisee in a white tunic is closer in quality to the original in Dresden than the figure of Christ. In general, the drawing, the modelling, and the contrasts are much harder than in the original, but the Madrid example is one of the better of the replicas. *History:* First known to the public in 1961 upon the opening of the museum in the convent, it may have been in the nunnery since the late sixteenth century when the Empress Maria, widow of Emperor Maximilian II, retired there. *Bibliography:* Junquera, 1961, pp. 385–388 (Titian).

COPIES AND VERSIONS:
1. Baltimore, Walters Gallery (in storage), poor copy of Christ alone, nineteenth century; formerly Massarenti Collection, Rome; purchased by Henry Walters in 1902.
2. Florence, Uffizi (in storage), panel, 0·202 × 0·219 m., an adaptation of Titian's composition attributed to Garofalo (Uffizi, Inventory of 1735, no. 1586; Uffizi, 1930, p. 22, illustration; Salvini, 1964, p. 74).
3. Rome, Accademia di San Luca, canvas, a very bad copy which has only archaeological interest: the copyist enlarged the composition of the Dresden original (C. and C., 1877, I, p. 121; Mayer, 1938, p. 304).
4. Rome, Soprintendenza alle Gallerie, amateurish copy (photo E 32063, Gabinetto Fotografico Nazionale, Rome).
5. Unknown location, formerly London, Duke of Westminster at Grosvenor House, 1821, no. 26, engraving; Westminster sale, Christie's, London, 4 July 1924, no. 54, 29½ × 23½ inches; formerly Agar Ellis Collection.
6. Unknown location, formerly Venice. Giovannelli Collection, Christ alone.

LOST EXAMPLES:
1. Ancona, Ferretti Collection, panel, signed on the collar-band of the Pharisee. *History:* originally in the Jesuit church, San Francesco Saverio, at Rimini (mentioned by Marcheselli, 1754, p. 53; Lanzi, 1824, III, p. 88); given to Vincenzo Ferretti, Bishop of Ancona in the nineteenth century; inherited by Carlo Ricotti; later confiscated by the Italian government (Sartori, 1821, pp. 63–64; Maggiori, 1821, p. 64; Cavalcaselle, 1891, p. 5 (uncertain attribution); Carletti, 1885, pp. 1–3; Elia, 1936, p. 86).
2. Bologna, Palazzo Sampieri in 1803, copy by Lodovico Carracci (Gatti, 1803, p. 171).
3. Dresden, Gemäldegalerie, panel, 0·813 × 0·61 m., by Flaminio Torre (Riedel and Wenzel, 1765, p. 208.
4. Piacenza, Marchese Annibale Scotti (died 1732). His

collection, brought from Spain, included a replica (Campori, 1870, p. 521).

148. **Tribute Money** (Escorial type) Plate 131

Canvas. 1·09 × 1·015 m.

London, National Gallery.

Signed in large capitals on the stone wall at the right:
TITIANVS F
1568.

If the workshop had any part in this picture it must have been of a very minor nature. The low opinion expressed by Crowe and Cavalcaselle, as well as by later writers, is due in great part to lack of understanding of Titian's late, heroic style. The deep-blue sky and the rusticated stone wall provide the setting for Christ in a broad blue mantle over a red tunic. The Pharisee, in golden brown and a darker red-brown scarf, with his intense expression and menacing gesture, advances toward the Saviour. Gould, reports that X-rays show that the head of Christ was at first slightly inclined to the left.

Condition: Some hard lines in the beard of the Pharisee could well be due to a restorer, and the same man's right arm has been damaged considerably. Otherwise, the condition of the paint is as good as can reasonably be expected. Now cut down on all sides; the original size was about 1·245 × 1·118 m.

History: Letter of Titian to Philip II on 26 October 1568 saying that he has finished the picture and has shipped it (C. and C., 1877, II, p. 537; Cloulas, 1967, p. 275); sent to the Escorial in 1574 (Zarco Cuevas, 'Inventario', 1930, p. 45, no. 1010, 4½ × 4 ft); in 1599 in the Sacristy (Padre Sigüenza, edition 1923, p. 418); in the Chapter House in 1657 (Padre de los Santos, edition 1933, p. 238); in the Sacristy in the eighteenth century (Padre Ximénez, 1764, p. 307; Ponz, 1773, tomo II, carta III, 42; Ceán Bermúdez, 1800, V, p. 41); taken to France by Maréchal Soult (sale, 19–22 May 1852, no. 132, purchased by Woodburn for the National Gallery; Waagen, 1857, p. 59).

Bibliography: See also History; engraved by Cornelius Galle and Martin Rota; Palomino, 1724, edition 1947, p. 796; C. and C., 1877, II pp. 386–389 (workshop); Suida, 1935, pp. 131, 180 (Titian); Tietze, 1936, II, p. 293 (workshop); Berenson, 1957, p. 187 (studio); Gould, 1959, pp. 107–109 (suggests the intervention of an assistant in the head of the Pharisee and in Christ's mantle); Valcanover, 1960, II, pl. 126 (Titian).

COPIES:

1. London, Christie's, anonymous sale, 6 May 1938, lot 129, canvas, 48×40 inches (Gould, 1959, p. 108).
2. Paris, Sedelmeyer (formerly), canvas, 1·17×0·93 m., poor quality throughout. Differs greatly from the composition in London: St. Peter at the right; a small frieze on the wall behind. An extra figure is also present in the print by Cornelius Galle. *History:* Chevalier Erard, Paris, 1832; Baron Doazan, Paris; Baron de Bully, Paris; Charles Sedelmeyer (sale, 1907, III, p. 208, no. 188).
3. Seville, Duque del Infantado (Plate 130), canvas, 1·01×1·073 m., sixteenth century. This copy, or at best workshop piece, is a close repetition of the composition now in the National Gallery in London. *Condition:* Very bad restoration in jerky meaningless strokes on the right arm of the Pharisee, while Christ's right arm has also been repainted and the hand weakly drawn. The canvas has been enlarged by five centimetres at the lower edge. *History:* Purchased about 1910–1920 by the late duke (unpublished).
4. Wentworth Woodhouse (Gould, 1959, p. 108).

VARIANTS:

1. Rome, Villa Borghese, canvas, 0·82×0·60 m., partial copy of Galle's print. *History:* Borghese Inventory of 1693 as Giorgione; Inventory of 1790 as Titian (Pergola, 1955, I, p. 134, no. 240, illustration; Photo GFN, E 33265).
2. Venice, private collection, canvas, 0·70×1·02 m. Giovanni Mariacher compares this weak composition with the print by Cornelius Galle the Elder, which is related to the Sedelmeyer version (see above, copy 2). He suggests that Titian may have been aided here by Damiano Mazza. The figure of Christ recalls Veronese's work more than that of Titian, from whom the composition is remote. *History:* Prince Giovanelli, Venice (Mariacher, 1963, as Titian).

149. **Trinity** (Gloria) Plates 105–109
Canvas. 3·46×2·40 m.
Madrid, Prado Museum.

Signed at the lower left on the scroll in the hand of Ezekiel: TITIANVS P. The signature in black letters is obviously restored.

About 1551–1554.

The stylistic elements of this picture in relation to Titian's late works are considered in the text on p. 35.

Iconography: The 'Trinity' as the title of this picture appears in the earliest extant letters of 1553–1554 regarding the progress of the work, as well as in Charles V's Inventories of 1556 and 1558 (see History). The codicil of his will in 1558 concerning the construction of a high altar at Yuste refers to the picture as a 'Last Judgment' (Einem, 1960, p. 85). Likewise the later Inventory of pictures which Philip II sent to the Escorial in 1574 specifically describes it as the 'Judgment with portraits of the Emperor Charles V who is in glory' (heaven) ('el Juycio con los retratos del Emperador Carlos quinto que está en gloria'). To speak of a deceased person as 'está en gloria' is common Spanish usage and therefore does not imply any esoteric iconographical significance. Padre Sigüenza, confessor to Philip II, writing in 1599, is the first author to call the subject 'la gloria de Ticiano', which he further characterizes as the 'Trinity' accompanied by the royal family (Sigüenza, edition 1923, p. 417).

Since then, the name 'Gloria', obviously implying Heaven, has clung to this work, in which the attitudes of the figures unmistakably reveal that the judgment day is at hand. Further documentation of the meaning of the composition is forthcoming in a letter of 22 January 1566 to the Venetian Doge and the Council of Ten, in which Titian wrote that he had recently had engraved 'un disegno del paradiso' (Bierens de Haan, 1948, p. 9).

The blue-robed figures of the Trinity and the Madonna appear at the top against the yellowish clouds, while to the upper right are Charles V and the Empress Isabella draped in white shrouds suitable for the judgment day, the head of Philip II, and just below presumably Mary of Hungary and the profile of the Princess Juana, all of whom assume prominent positions below the groups of blue-winged angels. Other recognizable figures in addition to the royal family are Adam and Eve and the profile of Titian at the right side just above David with a zither. The dark-haired man may be Francisco de Vargas, the Spanish ambassador at Venice, who was included at his own specific request (Titian's letter of 1 September 1554). In the left centre Noah holds up the ark, on which perches the dove with the olive branch. Moses, below in rose, displays the table of laws and Ezekiel reclines upon the eagle, while the Magdalen (?), richly dressed in green, her back turned, points upward. The other attendants defy identification, although the shaggy-haired man in back view at the top left must be St. John the Baptist and the bearded man, seen full face, may be Vargas instead of the other person, previously suggested.

Recently Harbison (1967, pp. 244–246) has proposed with finely spun arguments that Charles V ordered the picture to demonstrate his own orthodox views of the Trinity and thus to remove any suspicion of heretical thinking on his part, because of the publication of Cochlaeus'

Commentaria (Mainz, 1549), in which the author attacked the anti-Trinitarian opinions of the Spaniard Servetus published in 1531. Servetus had been at Bologna as assistant to Charles' confessor Quintana at the time of the coronation of the Hapsburg ruler as Holy Roman Emperor. Furthermore, Harbison regards the tiny figures in the landscape below, which have been tentatively interpreted as the martyrdom of St. Peter Martyr, as supporting evidence of the propagandistic nature of this painting. Actually this tiny scene (Plate 107) bears no resemblance whatever to the *Martyrdom of St. Peter Martyr* (Plate 154), the lost masterpiece by Titian painted twenty-five years earlier, and it cannot easily be construed as a scene of violence. At the left seems to be a group of monks, arms lifted in amazement, who gaze awestruck at the heavenly vision above, while at the right a figure in lay attire, also with raised arms, appears to fall back on the ground in a paroxysm of excitement. The fact that these minuscule figures do not appear in Cornelius Cort's engraving of the picture suggests that Titian did not consider them of primary significance.

The theme of Arianism is used throughout Harbison's argument as the unifying element. Following Caxton's translation (1483) of the *Golden Legend* (ed. 1900, III, pp. 147–155), Harbison characterizes the murderers of the Dominican St. Peter Martyr (died 1252) as Arians, although that heretical sect had died out half a millennium earlier. The original Latin of Jacobus de Voragine's thirteenth-century work refers only to 'infidels' and 'heretics' without specifying any particular group (*Legenda aurea*, 1481, folios LVᵛ–LVIII). In actual fact the heresy combated by the mediaeval Inquisitor St. Peter Martyr was Catharism, a late form of Manichaeanism (Guérin, 1888, V, pp. 79–84; Gustav Krüger, 'Arius', *Encyclopaedia Britannica*, 11th ed., 1910, II, pp. 542–544; F. C. Conybeare, 'Cathars', *loc. cit.*, V, pp. 515–517). Harbison's characterization of Servetus as an Arian seems likewise unwarranted, for that sixteenth-century theologian denounced Arius in his own writings. Servetus' anti-Trinitarian views were equally abhorrent to Catholics and Protestants, and it was Calvinist Geneva where he was convicted of heresy and executed in 1553 (A. Gordon, 'Servetus', *loc. cit.*, XXIV, pp. 684–686).

Notwithstanding Harbison's arguments, no documentary or other contemporary evidence exists to suggest that Charles V ordered the subject with the intention of establishing himself as a defender of the orthodox view. Nor is it essential that he selected the particular saints and Old Testament figures, although he surely specified the inclusion of the portraits of the royal family. Charles was a man of action and normally supported the ruthless policies of the Inquisition, yet in the case of Alonso de Virués, his favourite preacher, he secured an annulment from Rome when the Inquisition found Virués guilty of Lutheranism in 1538 (J. Longhurst, *The Case of Juan de Valdés*, Albuquerque, 1950, p. 76). Charles V's challenge to Clement VII had resulted in the sack of Rome in 1527, though not specifically ordered by him, and his political struggles with the papacy continued well into the pontificate of Paul III (1534–1549). Charles surely ordered the 'Trinity' or 'Last Judgment' for his personal devotion, not in the defence of dogma.

Condition: Inasmuch as the canvas has never suffered from fire, the colours could be brightened by judicious cleaning.

History: Presumably commissioned during Titian's visit to Augsburg in 1550–1551; first mentioned in Francisco de Vargas' letter to Charles V from Venice 30 June 1553 that the *Trinity* will be finished by September (C. and C., 1877, II, p. 506; Cloulas, 1967, p. 220); letter from Vargas to Charles V, 11 March 1554, saying Titian promised to complete the *Trinity* that month (Cloulas, 1967, p. 222); finished 10 September 1554, according to Titian's letter, and shipped to Brussels by Vargas before 15 October 1554 (C. and C., 1877, II, p. 508; Cloulas, 1967, pp. 224–225); taken to the monastery of Yuste by Charles V on his retirement in 1556 (Gachard, 1855, II, p. 90) and listed in the Inventory of 1558 after his death (Sánchez Loro, II, p. 506, no. 401); Philip II sent it to the Escorial in 1574 (Zarco Cuevas, 'Inventario', 1930, p. 44, no. 1002); Padre Sigüenza in 1599 discusses it as in the 'aula del convento' (edition 1923, p. 417); in 1657 Padre de los Santos includes it in the 'aula de escritura', which is the same location (edition 1933, p. 254); transferred to the Prado in 1837 or 1839.

Bibliography: See also Iconography and History; Vasari (1568)–Milanesi, VII, p. 451; Madrazo, 1843, p. 161, no. 752; 'Inventario general', 1857, p. 153, no. 752 (from the Escorial); C. and C., 1877, II, pp. 231–236, 269; Tietze, 1936, I, pp. 210–212, II, p. 297; Beroqui, 1946, pp. 123–126; Berenson, 1957, p. 188; Valcanover, 1960, II, pl. 53; Einem, 1960, pp. 82–93 (proposes Titian's dependence on Dürer's *Trinity* in the Vienna museum); Prado catalogue, 1963, no. 432 (old no. 752).

COPIES:

1. Engraving by Cornelius Cort, dated 1566, doubtless based on Titian's original study (*modello*) for the picture in Madrid.

2. Escorial, Aula del Moral, copy (hanging there in 1964), probably dates from 1837 when the original was removed to the Prado Museum.

3. London, National Gallery, canvas, 1·31 × 0·985 m., Venetian copy, sixteenth century. Charles Holmes considered it to be Titian's original sketch, although Crowe and Cavalcaselle had earlier called it a copy, an opinion confirmed by Gould and recent critics. Mayer rashly proposed Francisco Rizi or some other Spanish master of the seventeenth century as the copyist.

The blue sky opens below while the upper part has a yellowish background. The quality of the picture throughout is miserably poor and much redone besides, so that all details are blurred. Changes include the head of the man at the lower right and the position of the man with both hands raised. The woman who kneels with back turned is in green with strong yellow highlights. Gould analysed the work detail by detail in comparison with the Prado original and Cort's engraving. *History:* Could it be the Duke of Buckingham's picture at York House in 1635? (see Buckingham, Inventory, 1907, p. 379); De Bourke, Madrid, 1808; Samuel Rogers, before 1833 (sale, 3 May 1856, no. 725); Lord Harry G. Vane, Duke of Cleveland, 1857–1902 (sale, 8 March 1902, no. 37); Sir William Corry (sale, 25–28 October 1926, no. 285); Colnaghi, London, 1926; bought by the National Gallery in December, 1926. *Bibliography:* Jameson, 1844, pp. 401–402 (Titian's sketch; said to have been found in a gambling establishment in Madrid in 1808); Waagen, 1854, II, p. 77 (Titian); C. and C., 1877, II, p. 237 (copy); Holmes, 1927, pp. 53–62 (Titian's study); Mayer, 1934, p. 298; Gould, 1959, pp. 125–129 (copy; a very thorough account).

4. Yuste, high altar, copy made by Antonio Segura in 1580 (Beroqui, 1946, p. 126); from 1823 to 1958 it was in San Pedro ad Vincula, Casatejada (Cáceres).

LOST EXAMPLE:

London, collection of Charles I of England, a copy by Michael Cross; exhibited at Somerset House in May 1650, listed as 'Un paradis, par Crosso, £25' (Cosnac, 1885, p. 416, Lettre H, no. 339); van der Doort, 1639, describes it merely as 'a high square peece being Coppied after Titian's peece, wch is called Titians Glory beeing the graven' (Millar edition, 1960, p. 100, no. 8).

Via Dolorosa, see: Christ Carrying the Cross, Cat. Nos. 22–25.

APPENDIX

WRONG ATTRIBUTIONS AND SCHOOL PIECES

The Appendix includes works sometimes attributed to Titian, but which are in the author's opinion by Giorgione, Giovanni Bellini, Polidoro Lanzani, Palma Giovane, or unknown followers.

X–1. Adoration of the Shepherds

Panel. 0·91 × 1·15 m.

Vienna, Kunsthistorisches Museum.

Giorgionesque painter, about 1510.

This unfinished picture repeats Giorgione's composition known as the *Allendale Nativity* in the National Gallery at Washington.

History: Venice, Bartolomeo della Nave, no. 45, until 1636; Duke of Hamilton, London, 1638–1649 (Waterhouse, 1952, p. 16); Archduke Leopold Wilhelm, Vienna, 1659, no. 27.

Bibliography: Tietze and Tietze-Conrat, 1949, p. 12 (Venetian School); Klauner and Oberhammer, 1960, p. 60, no. 552 (Giorgione); Baldass, 1957, pp. 111–113 (Titian); Berenson, 1957, p. 85 (Flemish copy of Giorgione); Baldass, 1965, no. 39 (Titian).

X–2. Animals Entering Noah's Ark

Canvas. 2·07 × 2·65 m.

Madrid, Prado Museum.

Jacopo and Francesco Bassano, about 1570.

Accepting the theory that Titian bought this picture and shipped it to Spain, Rearick attributes to Titian a retouching of the sky and landscape, the heads of the horses and their groom at the right, and the addition of the Hapsburg eagle, which precedes the two lions on the ramp. The origin of the dubious theory that Titian once owned the Prado canvas rests upon Ridolfi's statement that the artist bought a picture of this subject by Jacopo Bassano for twenty-five scudi (Ridolfi (1648)–Hadeln, I, p. 391). With this allusion as a point of departure, Madrazo in 1843 seems to have been the first to expand the narrative and to include a statement that Titian sold the picture to Charles V. All of Madrazo's later catalogues of the Prado

Museum contain the same information, and the current catalogues have continued to retain it. Rearick suggests that Philip II bought the picture from Titian, since Charles V's death in 1558 obviously eliminates him.

No evidence exists to show that Titian ever shipped a picture by Jacopo Bassano, or by any hand other than his own, to Spain. That the aged artist would have taken the time in the years before his death to repaint a work by Bassano is improbable. Moreover, the stylistic evidence advanced is not conclusive.

History: Alcázar Inventory 1636, Pieza en que su Majestad come en el cuarto baxo, folio 33: 'Arca de Noe, otro lienzo original del Basan . . . quando . . . entrando en ella los animales'; Inventory 1686, Pieza donde Su Magestad comía, no. 472: '. . . la entrada . . . en la Arca de Noe . . . de mano de Bassan el mozo [the Younger] . . .' (Bottineau, 1958, p. 294); New Royal Palace, Cuarto del Rey (Ponz, 1776, tomo VI, Del Alcázar, 32; Bassano, no mention of Titian).

Bibliography: See also History; Madrazo, 1843, pp. 148–149, no. 703 (says Titian bought it and sent it to Charles V); *idem*, 1873, p. 7, no. 23 [*sic*] (same statement); *idem*, 1910, p. 7, no. 22 (same statement); Berenson, 1957, I, p. 23 (Leandro Bassano); Arslan, 1960, I, p. 170 (repeats Madrazo; Jacopo and Leandro Bassano); Prado catalogue 1963, no. 22 (repeats Madrazo); Rearick, 1968, pp. 244–245 (Jacopo and Francesco Bassano, retouched by Titian.)

X–3. Assumption (polyptych)

Canvas. 3·44 × 1·72 m.

Dubrovnik (Ragusa), Cathedral.

Follower of Titian, about 1550.

The quality of the polyptych is so inferior and so archaistic that it is difficult to see Titian's hand in the design, but rather that of a weak follower. The position of the four saints (at the left Lazarus and Blaise; at the right

Nicholas of Bari and Anthony) is explained by the use as model of Giovanni Bellini's altar in the sacristy of the Frari, dated 1488. This *Assumption* itself is a poor reflection of Titian's high altar of the same church in Venice. On the outside of the lateral panels appear Gabriel and the Virgin of the Annunciation, the latter derived from the Madonna in Titian's Brescia altar of 1522 (Plate 72).

Condition: Badly damaged and much restored.

History: From the church of San Lazzaro extra muros, Ragusa; copied by a local master in 1552 (Gamulin).

Bibliography: Pallucchini, 1954, II, p. 50 (Titian and workshop); Gamulin, 1955, I, pp. 93–115 (Titian and workshop); Gamulin, *Venezia*, 1955, pp. 269–271 (Titian and workshop); Berenson, 1957, p. 185 (Titian and workshop); Valcanover, 1960, II, p. 67, pl. 160 (mainly workshop).

X–4. Christ and the Adulteress Plate 204

Canvas. 1·392×1·817 m.

Glasgow, Art Gallery

Giorgione, about 1505.

The authorship of this picture has been a matter of controversy for nearly a century, since the original attribution to Giorgione has been accepted and rejected by such a critic as Berenson at various periods of his career. Although Titian is favoured by a variety of writers, the angular poses of the figures in the Glasgow canvas are not characteristic of him, whereas they do appear in Giorgione's *Judgment of Solomon* at Kingston Lacy, as well as in the celebrated frescoes of the Fondaco dei Tedeschi, known in Zanetti's prints (1760, pls. 1–4; Pergola, 1955, pls. 83, 84). The adulteress in a white skirt, rose blouse, and green drapery is strangely placed, and her legs, arms and head awkwardly related to the body. The colours, with their rather vivid tonalities of yellow, red, green, and white, do not appear in Titian's normally more harmonious compositions.

At the extreme right stood a man (still included in the Bergamo copy) in striped hose, with his back turned and his left knee raised at an angle. The eccentric nature of this figure or perhaps a bad state of preservation led to its elimination at some time in the past. The head, rediscovered and published by Berenson in 1928 when in the collection of Arthur Sachs at New York, has now found its way back to England (1968: on loan to the National Gallery in London).

A recent controversy has raged over the subject of the picture subsequent to E. Tietze-Conrat's and Philip Hendy's identification of it as representing *Susannah Brought Before Daniel*. Much can be said in favour of this proposal because the presentation differs greatly from the usual iconography of *Christ and the Adulteress*, even disregarding the fact that the seated man does not resemble the usual figure of Christ either in pose or in physical type. Nevertheless, the cross-shaped halo, always reserved for Christ and worn by this figure in the copy at Bergamo assigned to Cariani, is a strong argument in support of the traditional explanation of the subject. Recent X-rays of the Glasgow picture prove, moreover, that a cross-shaped halo, now almost invisible, is part of the original painting. Equally inconclusive is the theory that the Glasgow canvas is one of the four pictures of the life of Daniel which Giorgione was engaged to paint, by contract of 13 February 1508, for Alvise de Sesti. Both Tietze-Conrat and Philip Hendy strongly support this possibility.

Condition: Despite the careful restoration of the Glasgow picture in 1952, the condition of the paint leaves much to be desired as a result of negligence in centuries past. The surface shows many losses and the whole painting was cut down long ago eliminating a figure at the right. The landscape at the upper right is fresh and clean, while the foreground has suffered greatly and appears to consist mainly of restoration. Among the figures the Christ-Daniel is the least visible. The best-preserved include the youth at the right in red tights, yellow jacket and black cap, and a soldier in armour at the left, who with back turned assumes an exaggerated angular bend of leg.

History: Presumably: Vincenzo Imperiale, Genoa, sale 1661, 5½×7 *palmi* (1·228×1·56 m.), as Giorgione (Luzio, 1913, p. 306); Queen Christina purchased a large part of this collection (Stockholm, 1966, p. 417); Queen Christina, Inventory, 1689, no. 69, Giorgione (Campori, 1870, p. 348); Odescalchi Inventories: 1692, folio 467, as Titian; 1713, folio 75, no. 136, as Titian; 'Nota', undated, vol. V, B I, no. 16, folio 123, 4½×7½ *palmi* (1·005 × 1·675 m.) as Bordone; Odescalchi sale to Orléans 1721, folio 4, no. 47, as Bordinon 'mezza figura' (half life size?); not in the Orléans catalogues; McLellan Collection, Glasgow (Waagen, 1857, pp. 459–460, Giorgione); 1856 Glasgow Gallery (Glasgow, 1935, p. 116).

Bibliography: See also History; C. and C., 1871, II, pp. 159, 548 (Cariani); Molmenti, 1878, p. 17; Cook, 1907, p. 26 (Giorgione); L. Venturi, 1913, p. 164 (Sebastiano del Piombo); Justi, 1908 and 1926, I, p. 173, pl. 33

(Giorgione); A. Venturi, 1928, IX, part 3, p. 812 (Romanino); Longhi, 1927, pp. 206–207 (Titian); Berenson, 1928, pp. 147–154 (Titian); *idem*, 1932, p. 570 (Giorgione); Richter, 1934, pp. 287–289 (Giorgione, finished by Titian); Glasgow, 1935, pp. 116–117 (Giorgione); Suida, 1935, pp. 15, 155 (Titian); Richter, 1937, pp. 219–220 (Giorgione); Tietze-Conrat, 1945, pp. 189–190 (Giorgione); Hendy, 1954, pp. 167–171 (Giorgione); Ruhemann, 1954, pp. 13–21 (Giorgione); *idem*, 1955, pp. 278–282 (Giorgione); Acqua, 1955, pl. 7 (Titian); Pergola, *Giorgione*, 1955, pl. 108 (Sebastiano del Piombo); Berenson, 1957, p. 84 (Giorgione); Zampetti, 1955, pp. 110–113 (possibly Domenico Mancini); Valcanover, 1960, I, pl. 15 (Titian); Baldass, 1965, no. 41 (Titian).

COPIES:

1. Bergamo, Accademia Carrara, canvas, 1·49×2·09 m., attributed to Cariani, shows the composition before it was mutilated at the right (Berenson, 1957, pl. 661).
2. Berlin, Friedeburg Collection, canvas, 1·01×1·37 m., it comprises only half-length figures of the right half of the composition including the Sachs head (illustration, Berenson, 1928, p. 148); formerly Lord Northwick (Waagen, 1854, III, p. 202; Cheltenham sale, 26 July 1859, no. 1577); later, London, Sir Charles Turner.

LOST COPIES:

Rome, Inventory of Duke Livio Odescalchi, 1713, two copies of the *Adulteress* by Titian (folio 46, no. 125; folio 51v, 186); copies probably painted *c.* 1700.

LOST PICTURES:

1. Florence, 1672, Livio Meo to Cirro Ferri described an *Adulteress* by Giorgione or Titian for sale (Bottari, 1822, II, pp. 61–64).
2. Venice, Michele Pietra (or Spietra) in 1656 owned the same subject by Giorgione; possibly the same as no. 4, below (Richter, 1937, p. 219; Levi, 1900, p. 20; Savini-Branca, 1964, p. 136).
3. Venice, Girolamo and Barbon Piso, on Campo di S. Benedetto, owned an *Adulteress* by Giorgione (Sansovino-Martinioni, 1663, p. 376).
4. Venice, Camillo Sordi, 10 November 1612, offered in a letter to Duke Francesco Gonzaga of Mantua an *Adulteress* by Giorgione (Luzio, 1913, p. 110).

X–5. Christ Carrying the Cross (single figure, half length)

Panel. 0·50×0·39 m.

Boston, Isabella Stewart Gardner Museum.

Giorgionesque.

The composition is generally agreed to be based on Giovanni Bellini, whereas the attribution has wandered among Bellini's pupils.

Bibliography: Philip Hendy, 1931, pp. 163–164 (Palma Vecchio); Berenson, 1932, p. 323, and 1957, p. 83 (Giorgione); Heinemann, 1960, no. 151e (Titian after Bellini).

X–6. Christ Mocked (Ecce Homo) (four figures, half length) Plate 227

Canvas. 0·84×1·12 m.

Escorial, Nuevos Museos.

Follower of Titian, about 1580.

The picture, now labelled Tintoretto, has more elements in the style of Titian, yet the attribution to the master himself is over-ambitious despite the impressive figure of Pilate at the right.

Condition: Darkened, dirty, and in need of conservation.

History: Possibly to be identified with a picture of the 'Crowning with Thorns', classified in 1657 as a copy after Titian, then hanging in the Chapter House of the Prior (Padre de los Santos, edition 1933, p. 248); repeated in the edition of 1698 (*loc. cit.*, p. 291); Sacristy of the Choir in 1764 (Padre Ximénez, edition 1941, p. 79); Chapter House, *c.* 1815–1963.

Bibliography: Poleró, 1857, no. 333 (Tintoretto); Longhi, 1954, pp. 211–212 (Titian); Milicua, 1957, p. 122 (Titian); Valcanover, 1960, II, p. 69, pl. 169 (doubtful).

X–7. Christ on the Cross Plate 225

Panel. 0·233×0·17 m.

Escorial, Nuevos Museos.

Orazio Vecellio, 1559.

The quality of this portable crucifix is so far below Titian's standard that there seems to be no reason to doubt Titian's own statement that his son painted it. In 1956 Fiocco published the work as a 'discovery' made on a visit to the Escorial. He attributed the panel to Titian on the basis of a corresponding print (Plate 224) by Bonasone which is inscribed 'Ticianus inventor' but not dated.

Braunfels (1957) drew attention to Titian's letter and Orazio's authorship, and Milicua (1957) in an excellent article gave an account of the extensive bibliography on the subject. The Spanish scholar suggested that Titian might have lied in order to promote his son's interests with Philip II. Fiocco in his reply (1959) sustains this view, insisting that Titian himself painted the portable crucifix. The large ugly hands, the poor draughtsmanship, and the generally muddy colour of the work do not sustain that opinion. It is more likely that both the panel and Bonasone's print are based on a drawing by Titian himself.

History: Titian mentions, in his letter of 22 September 1559, a small picture of *Christ on the Cross* by his son Orazio, which he had sent to Philip II as a gift; a second reference to it occurs in García Hernández's dispatches to Philip a few days later (C. and C., 1877, II, pp. 280–281, 517; Cloulas, 1967, pp. 240, 242). The crucifix has been known in Spanish bibliography since its inclusion in gifts of Philip II to the Escorial in 1574 as Titian (Zarco Cuevas, 'Inventario', 1930, p. 96, no. 1516). Later writers also ascribe it to Titian (Padre Ximénez, 1764, p. 122, edition 1941, p. 73; Ponz, 1773, tomo II, carta IV, 76); later in the *camarín* (Ceán Bermúdez, 1800, V, p. 43); still there in 1857 (Poleró, 1857, no. 905); deposited in the Royal Palace, Madrid, 1956–1963; then to the Escorial Museum. A *St. John the Baptist* painted on a cover of the crucifix has been lost (Zarco Cuevas, 'Inventario', 1930, p. 96, no. 1516).

Bibliography: See also History; Fiocco, 1956, pp. 343–344 (Titian); *idem*, 1959, pp. 244–246 (Titian); Braunfels, 1957, p. 60 (Orazio Vecellio); Milicua, 1957, pp. 115–123 (full documentation); Valcanover, 1960, II, pp. 67–68 (possibly partly by Titian).

X–8. Circumcision

Panel. 0·355 × 0·781 m.

New Haven (Connecticut), Yale University Art Gallery.

Giorgionesque painter, about 1510.

The little panel, formerly almost totally repainted, is now nearly a complete wreck subsequent to the cleaning of 1927–1928. Attributions to Giorgione, Cariani, and Titian have been suggested; most recently Titian is widely accepted, yet Berenson's arguments were based on *Christ and the Adulteress* in Glasgow, itself a work of much debated attribution (Cat. no. X-4).

History: Purchased by Yale University in 1871 from Jarves.

Bibliography: Sirèn, 1916, pp. 231–232 (Cariani); *Bull. Associates Fine Arts*, Yale, III, December 1928, pp. 37–39 (Titian); Berenson, 1932, p. 573 (Titian); L. Venturi, 1933, pl. 504 (Titian); Berenson, 1957, p. 84 (Giorgione); Valcanover, 1960, I, pl. 14 (Titian); Heinemann, 1960, p. 25, no. 98e (Domenico Mancini).

X–9. Dead Christ (half length)

Canvas. 0·575 × 0·385 m.

Unknown location.

School of Titian, sixteenth century.

Published by Venturi as an *Ecce Homo*, it is a fragment of a *Dead Christ* in the burly style of Titian's *Christ Crowned with Thorns* in the Louvre (Plate 132).

Bibliography: A. Venturi, 1940, pp. 26–28.

X–10. Dead Christ Supported by one Angel

Canvas. 0·763 × 0·632 m.

New York, Private Collection.

Venetian School, about 1530.

Pallucchini identifies the picture with a Christ by Titian with the Angel by Giorgione that Marcantonio Michiel saw in 1530 in the Vendramin Collection in Venice (Michiel, English edition, 1903, p. 123).

Condition: Recently cleaned and relined by Modestini.

Bibliography: Pallucchini, 1959–1960, pp. 39–45; *Goya*, no. 40, 1961, p. 309.

X–11. Dead Christ Supported by two Angels

Plate 226

Canvas. 0·75 × 1·05 m.

Lentiai, Parish Church.

School of Titian, about 1550–1570.

Bibliography: C. and C., 1877, II, p. 434 (Cesare Vecellio); Valcanover, 1951, pp. 66–70 (studio of Titian); *idem*, 1960, II, pl. 36 (studio); omitted by Berenson, Suida, and Tietze; Pallucchini, 1954, II, p. 49 (perhaps Cesare).

X–12. Flight into Egypt

Canvas. 2·06 × 3·36 m.

Leningrad, Hermitage Museum.

Follower of Giovanni Bellini, about 1510.

Although completely in the style of Giovanni Bellini, this picture has, nevertheless, been attributed unconvincingly to Titian by Tietze-Conrat and Fomiciova, whereas Liphart suggested Cariani and Berenson Paris Bordone.

History: From the castle of Gatchina.

Presumed history: Andrea Loredan, San Marcuola, in 1568 (Vasari-Milanesi, VII, p. 429, called Titian); Grimani Collection in 1648 (Sansovino-Martinioni, 1663, p. 375; Ridolfi-Hadeln, I, p. 155, called Titian; Tietze-Conrat, 1941, p. 145).

Bibliography: Liphart, 1915, p. 10 (Cariani); Tietze-Conrat, 1941, pp. 144–151 (Titian); Tietze, 1950, p. 374 (Titian); Berenson, 1957, p. 46 (Paris Bordone); Valcanover, 1960, I, p. 92, pl. 199 (uncertain attribution); Fomiciova, 1960, nos. 2, 3 (Titian); Canova, 1964, p. 126 (not Paris Bordone): Fomiciova, 1967, pp. 57–60 (Titian, *c.* 1503–1508).

X–13. **Flight into Egypt**
No dimensions.

Ancona, Annunziata (formerly).

Described as showing Mary riding on the donkey, the picture is recorded in 1821 by Sartori, who stated that it was a copy after Titian by Giuseppe Pallavicini (1736–1812) and that the original had been sold to England in 1800. Abbate Leoni in 1832 repeated the story of the sale. Later in 1936 Raffaele Elia claimed that the original by Titian went to England for the sum of 2000 *scudi*. Nevertheless, neither Ridolfi nor any other early writer mentions the work. Luigi Serra in his article on Giuseppe Pallavicini in Thieme-Becker (XXVI, 1932, p. 167) lists the *Flight into Egypt* as still in the church, but in his guide to the works of art at Ancona he does not mention it (Serra, 1924–1925, pp. 371–372). No modern guidebook makes reference to the picture.

Could the painting sold in 1800, attributed to Titian, be the work now in Leningrad (Cat. no. X–12)?

Bibliography: Sartori, 1821, p. 4; Abbate Leoni, 1832, p. 261, note 2; Elia, 1936, p. 85.

X–14. **Holy Family with the Infant Baptist** Plate 208
Canvas. 0·81 × 1·08 m.

Paris, Louvre.

Polidoro Lanzani, about 1530.

This work, often incorrectly titled 'Rest on the Flight into Egypt', falls well below Titian's level in quality.

Condition: Reported badly preserved in 1789, when restored and cleaned. As exhibited with the reserves in 1960–1964 the present condition of the canvas seemed satisfactory.

History: Charles I of England, possibly the item called the Egyptian Madonna, i.e. Flight into Egypt, Inventory of sale, 1649 (Charles I: LR, 2/124, folio 161ᵛ, no. 16, as after Titian); purchased by Mazarin's agent in London in 1653 (Cosnac, 1885, pp. 198, 203, 243: incorrectly said to be the *Madonna with the Rabbit* (Cat. no. 60), a different history); Mazarin Inventory 1661 (Cosnac, p. 316); Louis XIV; Le Brun Inventory of Versailles, 1683, no. 40; at Versailles in 1695, 1706, 1722, 1752 (Lépicié, p. 22), 1760, 1788 (Bailly-Engerand, 1899, pp. 75–76).

Bibliography: See also History; Villot, 1874, p. 283; no. 461 (Titian); C. and C., 1877, I, pp. 341–342 (Titian); Ricketts, 1910, pl. 178 (Francesco Vecellio); Fischel, 1907, pl. 255 (school); Suida, 1935, p. 59 (workshop); Berenson, 1957, p. 143 (Polidoro Lanzani after Titian).

COPIES:

1. Escorial, Spain; a mistake; this composition never existed there (C. and C., 1877, I, p. 341).
2. Halle, Museum, no. 205, copy, canvas, 0·95 × 1·56 m.; lent by Berlin Gemäldegalerie (C. and C., 1877, I, p. 342, note, copy; Meyer and Bode, 1878, p. 404, no. 203, copy).
3. Liverpool, Walker Art Gallery, canvas, 0·92 × 1·27 m., there attributed to Francesco Vecellio; purchased by Liverpool Royal Institute, 1842, as Titian (see Liverpool, 1963, pp. 196–197).
4. London, Holford Collection (formerly, *c.* 1867–1927), 31 × 45 inches (0·787 × 1·143 m.), sale Christie's, London, 15 July 1927, no. 115, pl. XVI; formerly Orléans Collection until 1798 (Orléans, 1737, p. 468, as from M. de Senelay; Couché, 1786, pl. 19); Mr. Walton, London (Buchanan, 1824, I, p. 114); Wilkins, London (Waagen, 1854, II, p. 497); Coningham, London; Holford, purchased from Contessa Maisio, Milan in 1867. *Bibliography:* Waagen, 1854, II, p. 497 (Titian); C. and C., 1877, I, p. 341 (replica); Fischel, 1907, pl. 225 (school); *Holford Collection*, 1927, I, p. 30 (Titian).
5. London, Viscount Lee of Fareham (formerly) (photo, Courtauld Institute); dealer, London, 1960.
6. Modena, Galleria Estense, no. 418, canvas, 1·02 × 1·42 m. (C. and C., 1877, I, p. 341, note, copy; Pallucchini, 1945, p. 182, no. 418, Flemish copy).

7. Stockholm, National Museum, no. 1060, late copy (photo, Frick Library, New York; C. and C., 1877, I, p. 342, note, late copy); probably Stockholm, 1910, p. 169, no. 236, canvas, 1·35 × 1·15 m., octagonal, Italian school.

X-15. Holy Family with St. George

Panel. 0·79 × 1·16 m.

Messina, Museo Civico.

Follower of Giovanni Bellini, about 1500.

Formerly in the monastery of Santa Maria di Montalto at Messina, this picture was attributed to Titian for at least a century and identified as a 'Rest on the Flight into Egypt'. It is so described in 1826 (Grosso Cacopardo, 1826, p. 22; also edition of 1841, p. 19, 'fuga in Egitto mezze figure opera celebre di Tiziano'). Busacca (1873, p. 37) refers to 'il magnifico ed imprezzabile quadro della fuga in Egitto del celebre Tiziano'. About the time of the exclaustration of 1876 it probably went to the museum, where it definitely appears in 1902 (Messina e dintorni, 1902, pp. 335, 338–339, as attributed to Titian). Finally the incorrectness of the ascription to Titian was made clear: 'Sacra Famiglia o La fuga in Egitto . . . mezze figure' (Columba, 1915, p. 42).
Hans Tietze, relying on the Messina guide-book of 1826 and overlooking the description of half-length figures, thought that the picture was lost and speculated that it might have been another version of the Rest on the Flight into Egypt in the Escorial (Cat. no. 91). I am indebted to Professor Sante Luigi Agnello, director of the Messina Museum, for assistance in straightening out this tangle.

Bibliography: See above; Berenson, 1932, p. 138; 1957, p. 62 (Catena); Mauceri, 1929, p. 36 (Bellini School); Tietze, 1936, II, p. 296; Valcanover, 1960, I, p. 100 (follows Tietze); Heinemann, 1963, p. 25, no. 99b (Giovanni Buonconsiglio).

X-16. Infant Christ between SS. Andrew and Catherine Plate 211

Panel. 1·06 × 1·48 m.

Venice, San Marcuola (Ermagora).

Francesco Vecellio.

The mediocrity of this work, uncertain condition of the panel notwithstanding, has caused widespread doubt of Titian's authorship. The St. Andrew by far surpasses the other figures, which are rigid and uninspired.

Condition: Considerably damaged by neglect and early restorations; described by Boschini in 1664 as 'opera singolare e mal tenuta'.

History: First mention in San Marcuola by Boschini in 1664 (p. 481, Titian), and again in 1674 (Canareggio, p. 58, Titian).

Bibliography: Martinelli, 1684, p. 269 (repeats Boschini's words); C. and C., 1877, II, p. 484 (Sante Zago or Francesco Vecellio); Morelli, 1893, pp. 39, 57 (early Titian); Gronau, Titian, 1904, p. 299 (Titian, 1508); Ricketts, 1910, p. 185 (Francesco Vecellio); Hetzer, 1920, pp. 100–102 (not Titian); Fischel, 1924, pl. 34 (Titian c. 1508); Mostra di Tiziano, 1935, no. 8 (Titian); Suida, 1935, pp. 58, 189 (workshop); Berenson, 1957, p. 191 (Titian); Valcanover, 1960, I, p. 95 (Francesco Vecellio).

X-17. Life of Christ and the Virgin

Frescoes.

Padua, Scuola del Carmine.

Domenico Campagnola and members of the school of Padua, about 1530.

Titian had no part in the design or execution of these murals, the attribution of which first appeared in the book of Brandolesi (1795, p. 190), who gave Titian the Meeting of Joachim and Anna at the Golden Gate and also a Madonna and Child upon the high altar. Crowe and Cavalcaselle (1877, I, pp. 127–128, 132–133) and Gronau accepted the first-mentioned as by Titian and other frescoes as by Domenico Campagnola. They cited a drawing formerly in Crozat's collection in Paris (Mariette (1719), edition 1851–1853, p. 294) on which there was an inscription stating that Domenico Campagnola had assisted Titian in the Scuola del Carmine in 1511. Another drawing of an Omnia Vanitas at Düsseldorf, also recorded by Crowe and Cavalcaselle, had a memorandum to the effect that Titian owed Domenico Campagnola salary for his assistance with other frescoes on the façade of the Palazzo Cornaro in Padua. Hadeln correctly declared both inscriptions to be forgeries (Hadeln, 1911, p. 449). The discovery of the dates of birth and death (1500–1564) of Domenico Campagnola (Colpi, 1942–1954, p. 81) finally and completely excluded any possibility of his collaboration with Titian in 1511 at the age of eleven. The frescoes in the Scuola del Carmine are now dated about 1530 (Colpi, pp. 88–89). Another minor Paduan artist, Giovanni Antonio Corona (1481–1528), also painted a

fresco there, but on the outside of the building over the portal (Grazzini-Cocco, 1927, p. 102).

The study of the frescoes in the Scuola del Carmine lies outside the scope of this book, but suffice it to say that certain scenes have been attributed also to Giulio Campagnola (Fiocco, 1915, pp. 138–148).

Bibliography: See also above; Gronau, *Titian*, 1904, p. 294 (Titian); Hourticq, 1919, p. 108 (Titian); *idem*, 1930, pp. 154–159 (three frescoes by Titian); Suida, 1935, p. 11, pl. VII (Titian); Tietze, 1936, II, p. 304 (Paduan School); Berenson, 1957, p. 52 (three frescoes by Domenico Campagnola); Valcanover, 1960, I, p. 94 (not Titian); Grossato, 1966, pp. 126–130, 155–156 (Domenico Campagnola and Girolamo del Santo).

X–18. Madonna and Child

Panel. 0·38 × 0·47 m.

Bergamo, Accademia Carrara.

Giorgionesque painter, about 1510.

No agreement can be reached on the attribution of this work, which is so damaged as to permit no firm opinions.

Condition: Scrubbed, over-cleaned, and generally blurred.

History: Conte Guglielmo Lochis, Bergamo; bequeathed to the museum in 1900.

Bibliography: C. and C., 1877, II, p. 438 (Sante Zago; apparently this item); Berenson, 1932, p. 127 (Cariani; copy of early Titian); Suida, 1935, pp. 57, 163 (Titian); Tietze, 1936 (not listed); Phillips, 1937, pp. 44, 59 (Cariani); Richter, 1937, p. 230 (Giorgione); Ottino della Chiesa, 1955, pp. 126–127 (early Titian); Fiocco, 1955, p. 88 (Francesco Vecellio); Berenson, 1957, p. 193 (Francesco Vecellio); Valcanover, 1960, I, p. 91 (uncertain attribution).

X–19. Madonna and Child with SS. Anthony of Padua and Roch
Plate 203

Canvas. 0·92 × 1·33 m.

Madrid, Prado Museum.

Giorgione, about 1505.

The soft rose and yellows as well as the general style clearly place this work among Giorgione's productions rather than those of the youthful Titian.

Condition: Generally well preserved.

History: Padre de los Santos in 1657 first cites it in the sacristy of the Escorial as 'Bordonon' (meaning Giorgion or Pordenon (Santos, edition 1933, p. 239); same location 1773 (Ponz, tomo II, carta 3, 47 (Bordonon); brought to the Prado from the Escorial in 1839.

Bibliography: See also History; Morelli, 1893, p. 216 (Giorgione); Hetzer, 1920, pp. 94–96 (Venetian School); Longhi, 1927, p. 218 (Titian); Wilde, 1933, p. 99 (Giorgione, unfinished); Suida, 1935, pp. 21–22, 155 (early Titian); Beroqui, 1946, pp. 6–8 (Giorgione); Berenson, 1957, p. 84 (Giorgione); Valcanover, 1960, I, p, pl. 22 (Titian); Prado catalogue, 1963, no. 288 (Giorgione); Morassi, 1964, fig. 2 (Titian); Baldass, 1965, no. 24 (Giorgione).

X–20. Madonna and Child with St. Catherine and the Infant Baptist
Plate 212

Canvas. 0·756 × 0·978 m.

Hampton Court Palace, Audience Chamber.

Francesco Vecellio.

Although the quality is rather good, the picture does not measure up to Titian. Curiously enough, the Madonna wears a brown cloak over her rose tunic while the headdress is the usual beige colour. The red curtain at the left adds richness of tone, which is augmented also by St. Catherine's green mantle over her brown dress. The landscape background at the right is repeated with some variation in the other versions.

Condition: Cleaned in 1927.

History: Perhaps from the Gonzaga Collection, Mantua: 'Un quadro dipintovi la Madonna con il bambino in braccio et S. Catterina . . . opera di Titiano. £240' (Luzio, 1913, p. 115, no. 315). Cust, 1928, p. 50 assumed that this item is identical with the picture at Hampton Court. The picture in the van der Doort Inventory of 1639, then at Nonesuch House, and described as 'Our Lady with Christ St. John and St. Katherine', no artist mentioned, dimensions 1·245 × 1·092 m., might possibly be the Hampton Court version, but it cannot be proved (van der Doort, 1639, edition Millar, 1960, p. 185, a 'Mantua peece').

Bibliography: C. and C., 1877, II, p. 464 (manner of Palma Vecchio); Cust, VII, 1928, p. 50, colour print (Titian); Collins Baker, 1929, no. 133 (school); Suida, 1935, p. 181, pl. 276b (Titian); Berenson, 1957, p. 193 (Francesco Vecellio).

COPIES AND VARIANTS:

1. Audley End (England), copper 13 ×17½ inches (photograph Courtauld Institute, London).

2. Milan, Ambrosiana Gallery, storage, canvas, about 0·76×1·20 m., school of Titian, there called Francesco Vecellio; in this late variant the St. Catherine holds a cross, changing her identity to St. Helena; the Colosseum occupies the right; gift of Cardinal Federico Borromeo in 1618 (*Guida sommaria*, 1907, p. 132).

3. Richmond, Cook Collection (formerly), canvas, 0·713 ×0·963 m. (28⅛×38 inches), Francesco Vecellio; this version differs from the canvas at Hampton Court in the omission of a landscape background at the right; the attribution to Francesco Vecellio is widely accepted; from Casa Muselli, Verona (Campori, 1870, p. 178, as Titian; C. and C., 1877, II, p. 472, lost). *Bibliography:* Borenius, 1913, I, p. 174; A. Venturi, 1934, IX, part 7, p. 72 (Francesco Vecellio); Berenson, 1957, p. 193, pl. 937 (Francesco Vecellio).

4. Riga, German Legation (lent by Munich, Alte Pinakothek), canvas, 0·80×0·98 m., no landscape (Munich, photo 5234).

5. Unknown location, canvas, 0·745×0·97 m., sold as a copy, Lepke, Berlin, 4 June 1912, no. 55 (photo, London, Courtauld Institute).

6. Unknown location, canvas, 0·65×0·95 m., mediocre copy; not, as claimed, from the Muselli Collection, Verona (see no. 3 above); sale at Frankfurt-am-Main, Schneider and Hanau, 20–22 May 1913, no. 478; formerly Berlin, Reimer Collection, canvas, 0·65×0·98 m. (photo, Fischel, 1907, pl. 204).

7. Unknown location, canvas, 0·78×0·72 m., remote variant with sleeping Child; formerly Guhl Collection, Zurich (Suida, 1935, pp. 138, 181, pl. 277; Titian).

X–21. Madonna and Child with SS. Dorothy and Jerome

Canvas. 0·585×0·865 m.

Glasgow, Art Gallery.

Polidoro Lanzani.

Formerly attributed to Titian, the picture has been assigned in recent years to Lanzani by the gallery and by nearly all critics, with the exception of Suida, who continued to cling to Titian. He considered it the same work illustrated in *Opera selectiora quae Titianus . . . et Paulus Caliari*, 1680. An undoubtedly handsome picture, the Titianesque style predominates.

History: M'Lellan Collection, Glasgow, 1854 (as Titian); purchased by the museum, 1856.

Bibliography: C. and C., 1877 (not listed); Berenson, 1894, p. 122 and 1957, p. 142 (Lanzani); Glasgow Catalogue, 1911, no. 1005 (Titian); Suida, 1935, p. 25, pl. 330 (partly by pupils of Titian); Tietze, 1936 (omitted); Valcanover, 1951, p. XVIII (Francesco Vecellio); Morassi, 1954, p. 182 (Titian); Suida, 1959–1960, pp. 62–65 (early Titian); Valcanover, 1960, I, p. 96 (doubtful attribution).

X–22. Madonna and Child with SS. Dorothy and Jerome

Canvas. 0·75×1·04 m.

Vicenza, Private Collection (formerly).

School of Titian.

A weak school piece related to the *Madonna and St. Jerome* in the Fogg Museum, Cambridge (Massachusetts), which is attributed to Polidoro Lanzani.

History: Vicenza, Private Collection (formerly).

Bibliography: Benedetti, 1950, pp. 147–155 (Titian).

X–23. Madonna and Child with SS. Francis, Jerome, and Anthony Abbot Plate 206

Canvas. 1·03×1·38 m.

Munich, Alte Pinakothek (in storage, no. 500).

School of Titian (Francesco Vecellio).

The attribution of this picture to Titian has been made on the basis of photographs, which are highly deceptive in this case. The beauty of the figures both in spirit and body seems close to Titian himself, but it must be agreed that Crowe and Cavalcaselle were correct in assigning the picture to Francesco Vecellio (or to the school). The faulty proportions and incorrect draughtsmanship of all the saints are decidedly inferior when seen in the original. The fact that the work is kept in storage reflects the opinions of the curators at Munich.

Condition: Excessively rubbed and over-cleaned in the past.

History: Perhaps Van Uffel Collection, Antwerp (Ridolfi (1648)–Hadeln, I, p. 259); lent to Ansbach Museum 1946–1962.

Bibliography: C. and C., 1877, II, p. 452 (Francesco Vecellio); Reber, 1898, p. 222, no. 1117 (Francesco Vecellio); Bologna, 1951, no. 17, pp. 23–29 (Titian); Fiocco, 1955, p. 79 (Titian aided by Francesco Vecellio); Berenson, 1957, p. 193 (Francesco Vecellio); Valcanover, 1960, I, pl. 93 (Titian).

VERSIONS:

Madonna and Child (repeated in the following pictures), probably by Francesco Vecellio:

1. Milan, Dealer, canvas (Bologna, 1951, pp. 27–28, fig. 16, as Titian).

2. San Diego (California), Timken Gallery, canvas, 0·698 × 0·559 m.; (Plate 209) attributed to Titian; ex-collection Count Carlo Foresti Carpi, Italy; loan of Anne and Amy Putnam, 1942–1968 to Fine Arts Gallery, San Diego (Berenson, 1957, p. 193, Francesco Vecellio; Valcanover, 1960, I, p. 97, attributed; Fine Arts Society of San Diego, 1960, p. 65).

3. Verona, Museo Civico (Plate 205) as Polidoro Lanzani (Fiocco, 1955, p. 79, Francesco Vecellio; Berenson, 1957, p. 194, Francesco Vecellio).

X–24. Madonna and Child with the Infant Baptist

Panel. 0·375 × 0·31 m.

Prague, Castle Museum.

Follower of Titian (Francesco Vecellio?), about 1550.

Related in composition to the same subject in the Uffizi at Florence (see Cat. no. X–26), but superior in quality.

History: Inventory of Prague Castle 1685 and later.

Bibliography: J. Neumann, 1966, p. 61, no. 54 (follower of Titian).

X–25. Madonna and Child with the Infant Baptist

Canvas. 0·28 × 0·58 m.

Washington, National Gallery of Art, Mellon Collection.

Follower of Titian (Polidoro Lanzani).

This pleasing little work reflects the style of early Titian but is too precise and mechanical for his own hand. The style and physical types are identical in Lanzani's *Holy Family* in the De Young Memorial Museum in San Francisco; formerly given to Bonifazio Veronese by Tietze (1940, no. 14).

Condition: Well preserved; slightly darkened.

History: Colonel Henry Edward Burney (sale, Christie's, London, 29 June 1928, no. 126); Max Rothschild, Sackville Gallery, London; Mellon Collection, Washington (c. 1934); gift to the National Gallery in 1937.

Bibliography: See also above; Berenson, 1932, p. 577; 1957, p. 192 (Titian); L. Venturi, 1933, pl. 507 (Titian, dated 1516–1523); Suida, 1935, pp. 38, 163, pl. 87 (Titian); G. M. Richter's letter of 8 July 1940, in the National Gallery, Washington (Polidoro Lanzani); Washington, 1941, p. 196, no. 36 (Titian): Valcanover, 1960, I, p. 98 (not Titian); Washington, 1965, p. 129, no. 36 (Titian).

COPY:

Unknown location; Spiridon Collection, Paris; sale Knight, Frank, and Rutley, London, 26 November 1958, no. 72; 50½ × 31 inches (1·283 × 0·788 m.); crude variant with St. Joseph added at extreme right.

X–26. Madonna and Child with the Infant Baptist

Canvas. 1·02 × 0·85 m.

Florence, Uffizi (in storage)

School of Titian, about 1570.

The banderole with the words ECCE AGNVS DEI appears upon the scroll upon the Baptist's arm. The picture is related to an original by Tintoretto now in the National Gallery of Art at Washington (Washington, 1965, p. 128, no. 901).

A similar composition is suggested by the description of a lost picture in 1631 once belonging to Urban VIII's collection and later in the Palazzo Barberini at Rome: 'un quadro di Titian con la Madonna e Nostro Signore in braccio con San Giovannino . . . pieno di cherubini; donò già Nostro Signore Papa Urbano VIII' (Orbaan, 1920, pp. 503, 504, 511); also 'un bellissimo quadro della Beata Vergine di Tiziano' (Venuti, 1767, p. 224).

History: Bequest of Cardinal Leopoldo dei Medici, 1675.

Bibliography: C. and C., 1877, II, p. 440 (follower or imitator of Titian); Uffizi catalogue, 1910, p. 237; Uffizi catalogue, 1930, sala XVII, no. 967 (school of Titian).

X–27. Madonna and Child with St. John the Baptist and Male Donor Plate 207

Panel. 0·75 × 0·92 m.

Munich, Alte Pinakothek.

School of Titian (Francesco Vecellio), about 1520.

The style of the full-length figures seated in a landscape is Titianesque without in any way approaching the high technical qualities of Titian's own work. The head of the donor surpasses the other figures, while the weakest of all is the badly drawn, mis-shapened, and awkwardly posed Madonna. At the left the crouching St. John the Baptist kneels upon a stone in front of a brown-black curtain and a column. Although the distant blue hills have a pleasing quality, the summarily indicated landscape does not measure up to Titian.

Condition: Abraded and somewhat retouched.

History: Archduke Leopold Wilhelm, Vienna, 1659 (Inventory, p. xcii, no. 109, Titian); gift to Joseph I at Düsseldorf.

Bibliography: Teniers, 1660, pl. 61; C. and C., 1877, II, p. 424 (Titian, *c.* 1520); Reber, 1895, no. 1109 (Titian); Suida, 1935, pp. 57, 163 (Titian and assistant); Berenson, 1957, p. 188 (early Titian); Munich, 1958, no. 977 (Titian); Valcanover, 1960, I, pl. 49 (Titian).

VARIANT:

Bucharest, former Royal Collection, canvas, 1·25 × 1·82 m., eighteenth century; St. Catherine replaces the male donor here (Bachelin, 1898, no. 64, illustration); formerly Fenaroli Collection, Brescia (C. and C., 1877, II, p. 424).

X–28. Madonna and Child with SS. Roch and Sebastian

Canvas. 1·80 × 2·20 m.

Pieve di Cadore, Parish church.

Francesco Vecellio.

A ruined, mediocre work which shows familiar characteristics of Francesco Vecellio and none of Titian.

Bibliography: Tizianello, 1622, unpaged, p. 11 (Titian or Francesco Vecellio); Ridolfi (1648)–Hadeln, I, p. 153 (Titian); C. and C., 1877, I, p. 53 (partly by Francesco Vecellio); Valcanover, 1951, p. 207 (Titian?); Fiocco, 1955, pp. 83–84, (Francesco Vecellio); Berenson, 1957, p. 193 (Francesco Vecellio); Valcanover, 1960, I, p. 92 (partly by Titian, *c.* 1510).

X–29. Noah, Drunkenness of

Canvas. 1·03 × 1·57 m.

Besançon, Musée des Beaux-Arts

Giovanni Bellini.

Universally given to Giovanni Bellini except by Heinemann, who attributes the picture to Titian.

Bibliography: Besançon, 1957, no. 5; Berenson, 1957, p. 30, pl. 264 (Giovanni Bellini); Heinemann, 1960, p. 271, fig. 585.

X–30. Ostension of the Holy Cross

Canvas. 2·24 × 1·52 m.

Brescia, Pinacoteca Civica.

Moretto da Brescia.

This mediocre work, said to have once borne the signature of Moretto, datable about 1516–1518, was reassigned to Titian by Roberto Longhi unconvincingly.

Bibliography: Gombosi, 1943, p. 99, pl. I (Moretto); Longhi, 1947, pp. 191–192 (Titian); G. Panazza, 1959, p. 122; Valcanover, 1960, I, p. 96 (wrong attribution).

X–31. Resurrection

Canvas. 1·33 × 0·82 m.

Florence, Contini-Bonacossi Collection.

Palma Vecchio.

This picture was universally ascribed to Palma Vecchio until Longhi decided to upgrade it to Titian. Nothing about the figure of Christ justifies such an attribution. The rather fine blue-and-white of the sky and the grey earth supply the setting for the Risen Christ, in white drapery, Who carries a white flag with a red cross.

History: Archduke Leopold Wilhelm, Vienna (Teniers, *Theatrum pictorium,* 1660; Palma Vecchio); Milan, Vitold Rajkiewtschi; Milan, Crespi Collection, *c.* 1904–1914 (*Galerie Crespi,* 1914, p. 58); Milan, Chiesa Collection (sale New York, American Art Galleries 16 April 1926, as Palma Vecchio).

Bibliography: Frizzoni, 1906, p. 116 (Palma Vecchio); Spahn, 1932, p. 165, pl. xxx (Palma Vecchio); Longhi, 1927, p. 219 (Titian); Suida, 1935, pp. 12, 185, fig. 301a (Titian); Berenson, 1957, p. 124 (Palma Vecchio).

X–32. St. Catherine of Alexandria

Canvas. 1·35 × 0·98 m.

Madrid, Prado Museum.

Palma Giovane.

More than a doubtful attribution to Titian, this figure in three-quarter length can reasonably be assigned to Palma Giovane like the similar example in the Uffizi at Florence. The saint's blonde tresses, golden brocaded dress, and light-blue cloak stand against a dark curtain at the left and dark stormy clouds to the right. See the companion *St. Margaret* (Cat. no. X–35).

History: Sent to the Escorial in 1593 as Titian's work (Zarco Cuevas, 'Inventario', 1930, p. 46, no. 1016); in the Sacristy in 1599 (Padre Sigüenza, edition 1923, p. 418, Titian); Iglesia Vieja in 1800 (Ceán Bermúdez, v, p. 43); taken to the Prado Museum in 1839.

Bibliography: Madrazo, 1843, p. 190, no. 865; Poleró, 1857, p. 183, no. 865; 'Inventario general', 1857, p. 180, no. 865 (from Escorial); C. and C., 1877, II, p. 378 (workshop); Berenson, 1957, p. 188 (copy); Prado catalogue, 1963, no. 447 (doubtful attribution).

X–33. St. Jerome
Panel. No dimensions.

Padua, Doctor L. Sotti.

Venetian School, sixteenth century (?).

A half-length figure against the sky and no landscape; from the photograph published in 1891 the attribution to Titian appears highly doubtful.

History: Counts Burin, Padua.

Bibliography: Cavalcaselle, 1891, pp. 6–7.

X–34. St. John the Baptist, Head of
Canvas. 0·50 × 0·75 m.

Cleveland, Museum of Art.

Venetian School, about 1580.

A late reference to a picture of this subject, which Titian is said to have painted for Aretino after a sculpture by Jacopo Sansovino (Ridolfi (1648)–Hadeln, I, pp. 175–176), reflects an unreliable tradition. Neither the sculptor nor the painter is otherwise known to have dealt with the subject, and Aretino makes no reference to it. The inscription on the banderole ECCE AGNVS DEI is frequently associated with the Baptist. Technique and colour, although undeniably Titianesque, seem rather to suggest the hand of a gifted follower, possibly the youthful Palma Giovane. The attribution to Lorenzo Lotto, Berenson notwithstanding, is unconvincing.

History: Italico Brass, Venice; purchased by the Cleveland Museum in 1953.

Bibliography: Fiocco, 1924, p. 199 (Titian, *c.* 1560); Suida, 1935, pp. 136, 180 (Titian, *c.* 1550); Tietze and Tietze-Conrat, 1936, pp. 140–141 (not Titian); Berenson, 1956, p. 106 (Lotto); Cleveland, 1956, no. 22 (Lotto); Berenson, 1957, p. 101 (Lorenzo Lotto).

X–35. St. Margaret
Canvas. 1·16 × 0·91 m.

Madrid, Prado Museum.

Palma Giovane.

Another version, in the Uffizi, almost exactly like this item, is given to Palma Giovane. The exaggerated pose, the weak design, and the general coarseness of the figure seem to eliminate Titian's participation and to place the work within the orbit of Palma Giovane's facile but mediocre mentality. See the companion *St. Catherine of Alexandria* (Cat. no. X–32).

History: Beroqui identified it with the picture, author unspecified, sent to the Escorial in 1574, $5\frac{1}{2} \times 4\frac{1}{2}$ pies (1·54 × 1·28 m.), but there is nothing to support this supposition (Zarco Cuevas, 'Inventario', 1930, p. 82, no. 1446); Padre de los Santos mentions in the Sacristy of the Escorial in 1657 'una santa Margarita, de mano de Ticiano, de más de medio cuerpo' (edition 1933, p. 240); in the sacristy as Titian in 1764 (Padre Ximénez, 1764, p. 308); still in the sacristy in 1800 (Ceán Bermúdez, v, p. 42); Padre Bermúdez mentions it in 1820 (p. 86, no. 8); brought from the Sacristy of the Escorial to the Prado in 1839.

Condition: Damaged by past neglect; recently restored.

Bibliography: See also History; Madrazo, 1843, p. 167; 'Inventario general', 1857, no. 775; C. and C., 1877, II, p. 446 (workshop; half length); Beroqui, 1946, p. 137 (workshop); Longhi, 1925, pp. 45–48 (Titian); Prado catalogue, 1963, no. 446 (workshop).

OTHER VERSION:
Florence, Uffizi, no. 928, canvas, 1·165 × 0·98 m., there called Palma Giovane (Uffizi catalogue, 1927); in Cardinal Leopoldo dei Medici's collection in 1675 as by Titian (Longhi, 1925, edition 1967, pp. 14–15, Titian; Valcanover, 1960, II, p. 73, doubtful attribution); Salvini, 1964, p. 87 (Palma Giovane).

X–36. St. Mark

Mosaic.

Venice, St. Mark's.

Orazio Vecellio.

The design of the large mosaic of St. Mark over the main portal of the cathedral, dated 1545 and signed by Valerio and Francesco Zuccati, was first attributed to Titian by Ridolfi (1648). It is difficult indeed to see any reason why Titian should have been responsible for the conventional attitude of this dull figure, even when the natural rigidity of the medium is taken into consideration. Only the fact that in 1563, during a litigation between the authorities of St. Mark's and the mosaic artists, Titian testified for his friends that he had prepared designs for the mosaics in the vestibule of St. Mark's supports this theory. On the other hand a disinterested witness said that Orazio had done them. In recent years Lorenzo Lotto has been proposed as the designer, but again the stylistic evidence is not impressive.

Bibliography: Ridolfi (1648)–Hadeln, I, p. 203 (Titian); Zanetti, edition 1771, pp. 570–580 (account of litigation of 1563); C. and C., 1877, I, p. 434, II, p. 331 (cartoons from Titian's workshop, chiefly by Orazio, used by the Zuccati); Suida, 1935, p. 69 (Titian); Tietze, 1936, II, p. 312 (Titian); Longhi, 1947, pp. 192–194 (Lotto) ; Lorenzetti, 1956, p. 172 (Titian); Berenson, 1957 (omitted); Valcanover, 1960 (omitted); Kennedy, 1963, p. 5, note 24 (Titian).

X–37. St. Tiziano Plate 232

Canvas. 1·82 ×0·59 m.

Lentiai, Parish church.

School of Titian (Cesare Vecellio?), about 1550–1570.

This mediocre canvas, a copy of Sebastiano del Piombo's *St. Louis of Toulouse* in San Bartolommeo in Rialto at Venice, has been recently assigned unconvincingly to Titian himself. The best part of the altarpiece, the *Dead Christ Supported by Two Angels* (Cat. no. X–11), was given to Cesare by Pallucchini. It is difficult to see any reason for associating the master with these compositions.

Bibliography: C. and C., 1877, pp. 434, 488–489 (Cesare Vecellio); Valcanover, *Mostra*, 1951, pp. 67–68 (studio of Titian); Valcanover, 1951, pp. 203–204 (Titian; colour print); Pallucchini, 1953–1954, II, p. 49 (Titian); Valcan-

over, 1960, II, pl. 36 (Titian); omitted by Berenson, Suida, and Tietze.

X–38. Supper at Emmaus Plate 228

Canvas. 1·63 ×2·00 m.

Dublin, National Gallery of Ireland.

School of Titian, about 1540.

Nearly all critics agree that this version is a studio product at best. Even the possibility that Titian designed the composition appears remote. The lack of correlation between the setting, especially the heavy curtain in the centre, and the figures is painfully evident. A fluted column behind Christ, visible in X-rays, indicates a change of setting during the painting of the picture.

Condition: Recently cleaned.

History: Abbate Celotti, Venice (sale 1836); Prince Demidoff, Paris (1836–1870).

Bibliography: Wilczek, 1928, p. 162 (school of Titian); Mayer, 1938, p. 304 (Titian, 1542–1545); Dublin, 1956, no. 84 (Titian); Berenson, 1957, p. 185 (question mark); Valcanover, 1960, I, pl. 184 (studio).

VARIANT:

Paris, St.-Louis-en-l'Ile; formerly Vienna, Archduke Leopold Wilhelm (Teniers, 1660, pl. 72, as Titian); Madeleine, Paris, 1810–1876; from 1883 to present in St. Louis (Mayer, 1938, pp. 304–305, lost; Berenson, 1957, p. 87, Giovanni da Asolo).

X–39. Tobias and the Angel Plate 234

Panel. 1·70 ×1·46 m.

Venice, Accademia.

Sante Zago (?), about 1515.

Raphael's dark-grey wings spread wide against a faded sky, and his costume consists of wine-red drapery over a white tunic, while Tobias wears gold over white. The generally hard, mediocre nature of the picture raises considerable doubt that Titian had any part in this work. The rather charming white dog and the landscape, though much darkened, produce a finer effect. Boschini's statement in 1664 that the picture had been mistaken as Titian's, although painted by a minor follower, Sante Zago, cannot be ignored. Recently Creighton Gilbert

argued convincingly for the acceptance of that tradition, although chronology poses a problem since Zago first appears *c.* 1530.

Condition: Excessive early restorations; cleaned in 1833 and 1956.

History: Santa Caterina, Venice, until the early nineteenth century. The escutcheon relates to a member of the Bembo family.

Bibliography: Not listed by Sansovino, *Venetia*, 1581; Ridolfi (1648)–Hadeln, I, p. 153 (Titian); Boschini, 1664, p. 430 (Sante Zago) and 1674, preface; C. and C., II, 1877, p. 432 (probably by Sante Zago); Suida, 1935, p. 14 (Titian); Tietze, 1936, II, p. 311 (replica); Mayer, *Gazette des Beaux-Arts*, 1937, p. 34 (Titian); Gilbert, 1952, pp. 121–129 (Sante Zago); Berenson, 1957, p. 191 (copy); Valcanover, 1960, I, p. 92 (doubtful attribution); Moschini Marconi, 1962, p. 264, no. 458 (follower of Titian).

PLATES

THE MADONNA

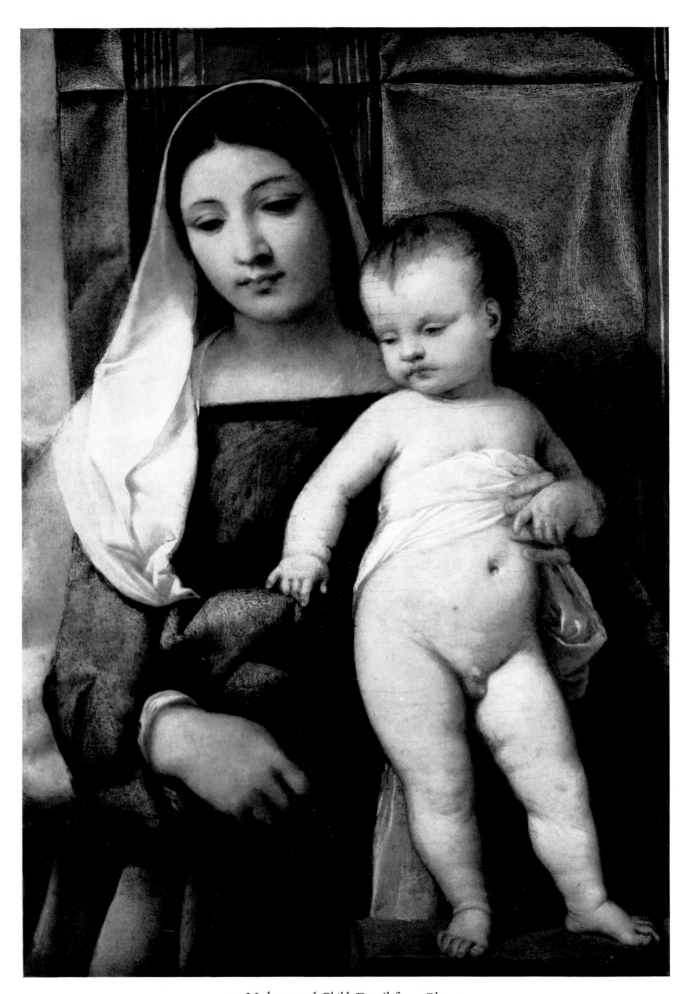

1. *Madonna and Child*. Detail from Plate 3

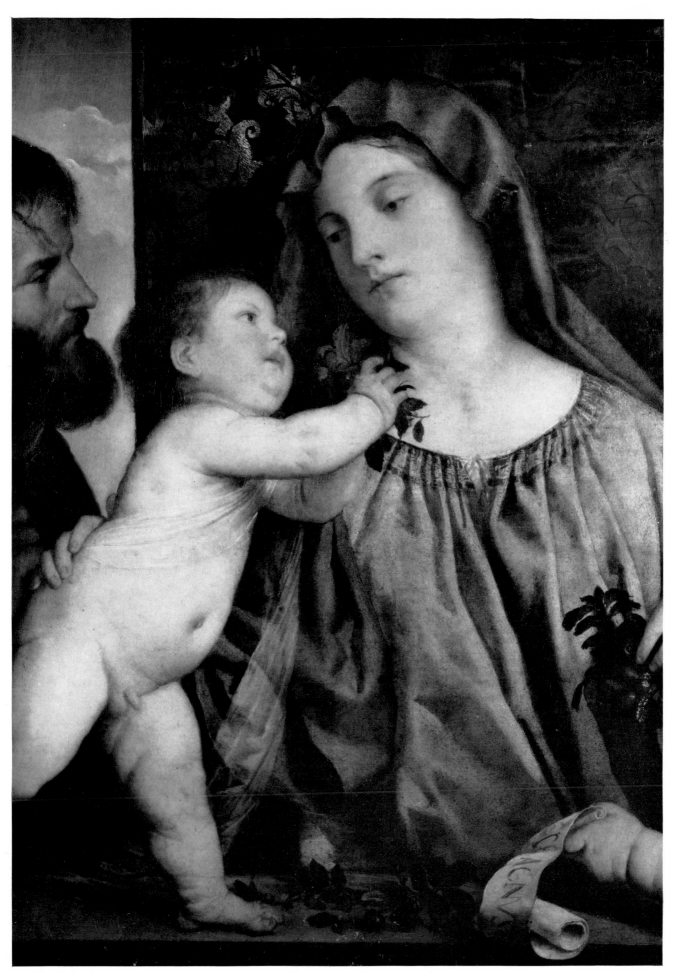

2. *Madonna and Child*. Detail from Plate 4

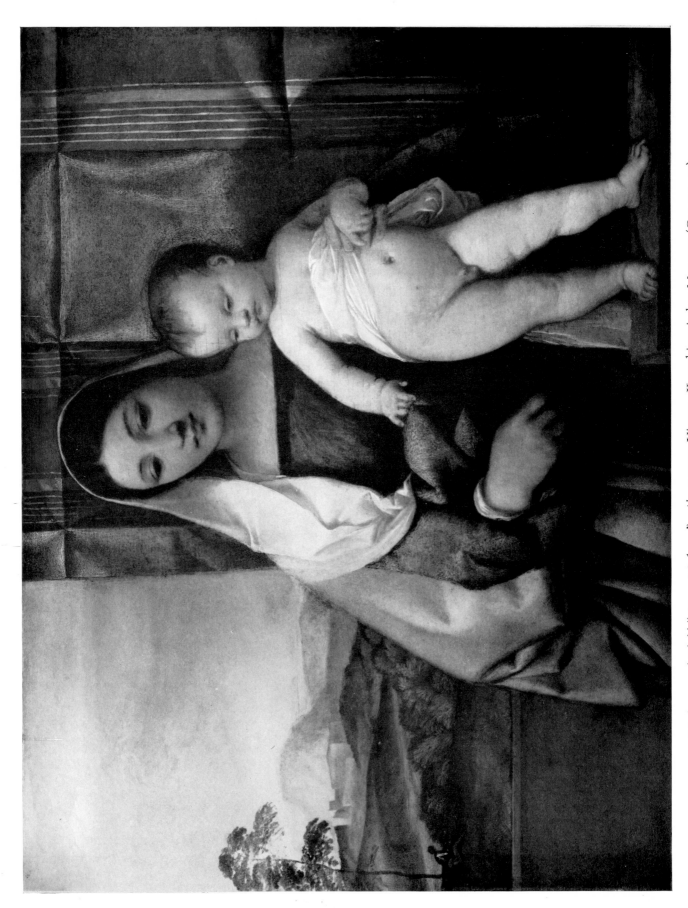

3. *Madonna and Child ('Gipsy Madonna'). About* 1510. Vienna, Kunsthistorisches Museum (Cat. no. 47)

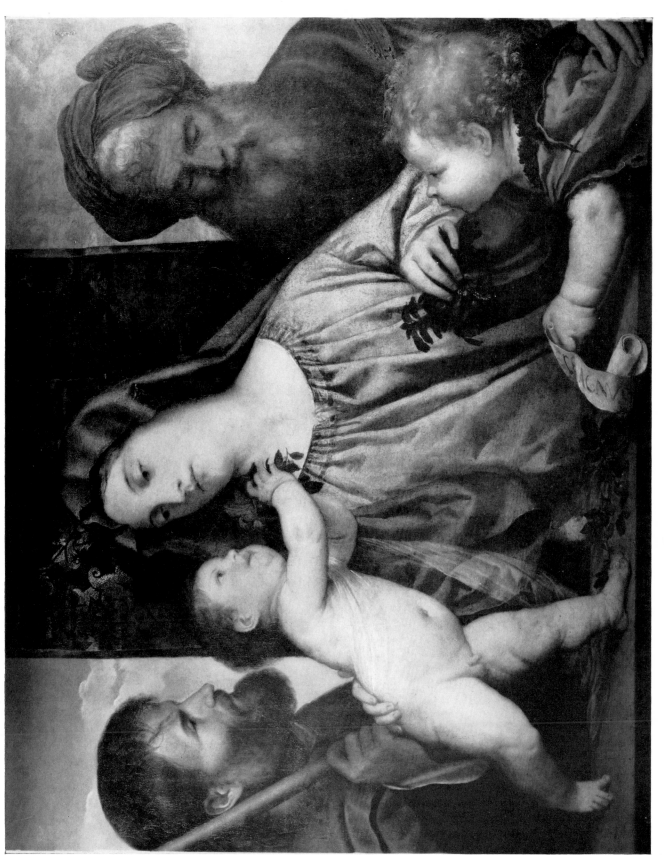

4. 'Madonna of the Cherries'. About 1515. Vienna, Kunsthistorisches Museum (Cat. no. 49)

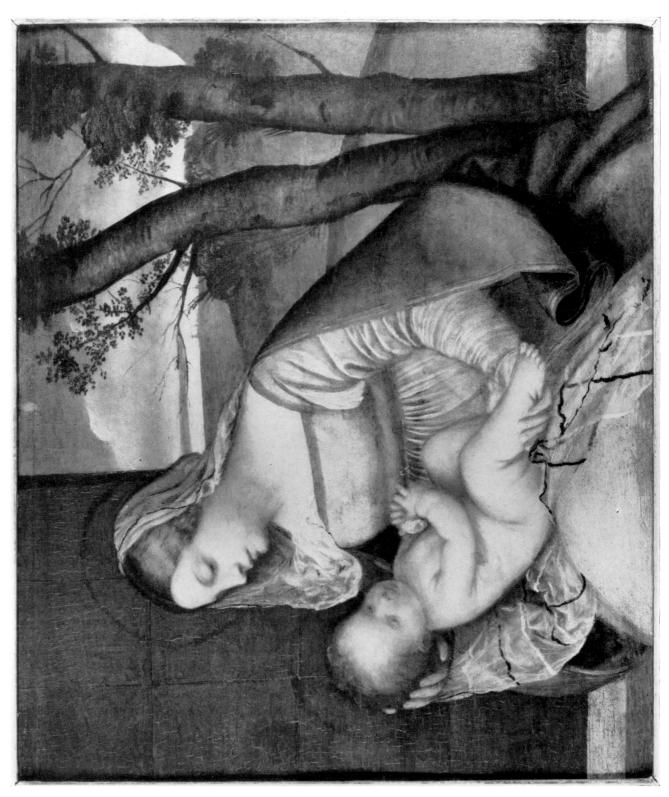

5. Titian(?): *Madonna and Child*. About 1511. New York, Metropolitan Museum of Art (Cat. no. 48)

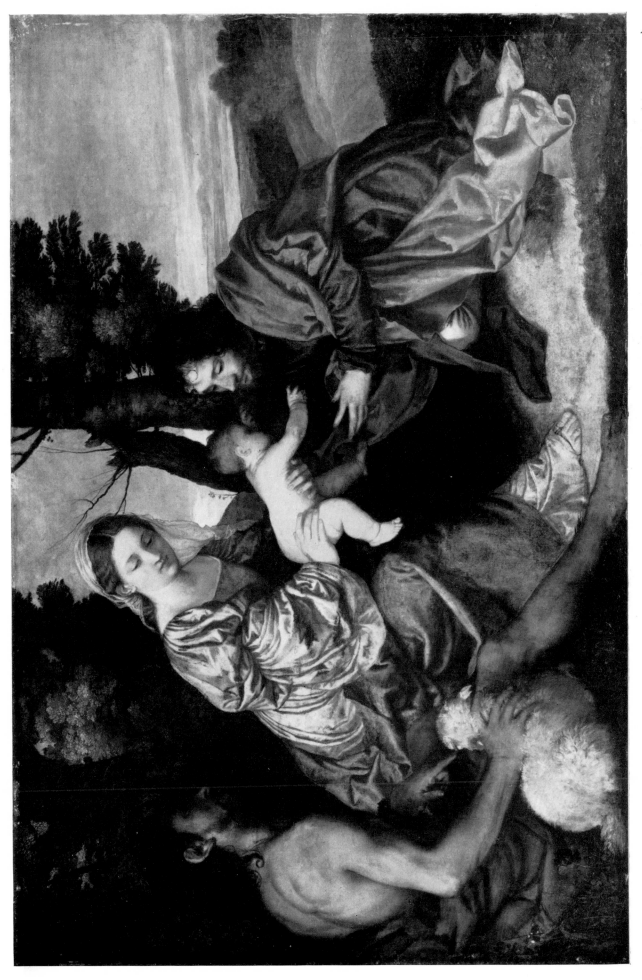

6. *Holy Family with St. John the Baptist and a Donor. About* 1510. Edinburgh, National Gallery of Scotland, on loan from the Duke of Sutherland (Cat. no. 42)

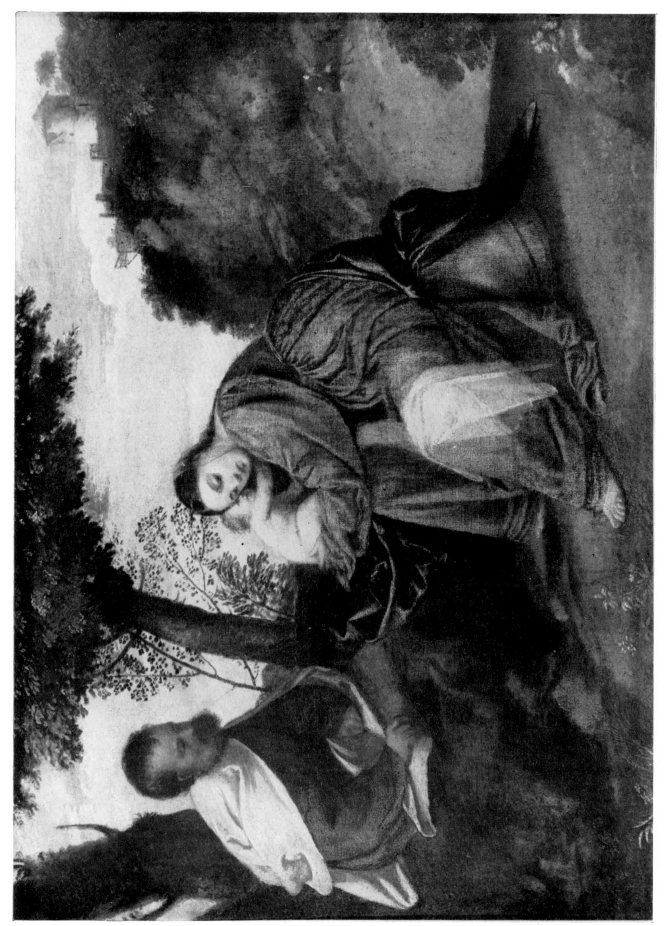

7. *Rest on the Flight into Egypt*. About 1515. Longleat, Marquess of Bath (Cat. no. 90)

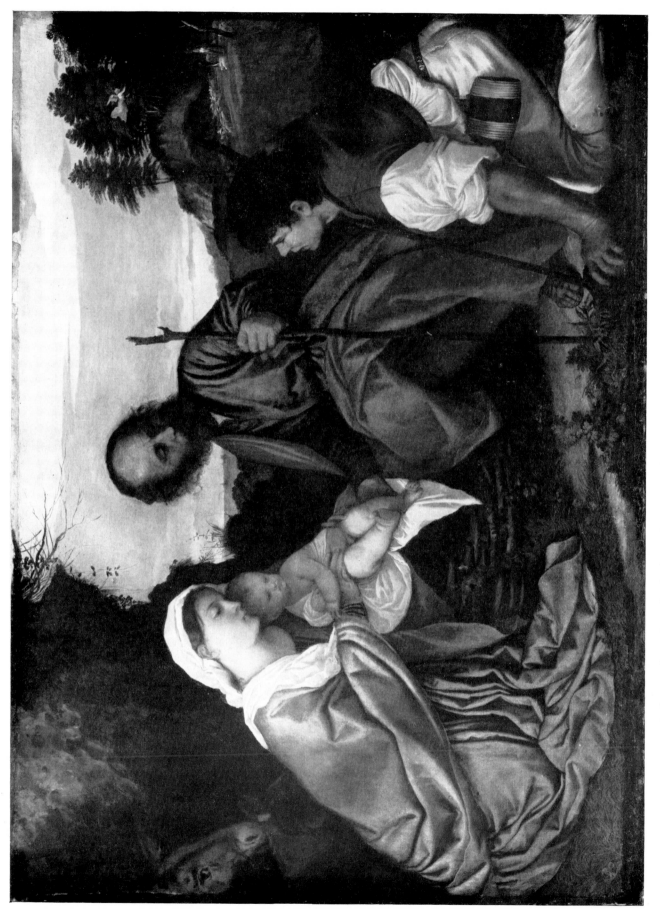

8. *Holy Family with a Shepherd in a landscape.* About 1510. London, National Gallery (Cat. no. 43)

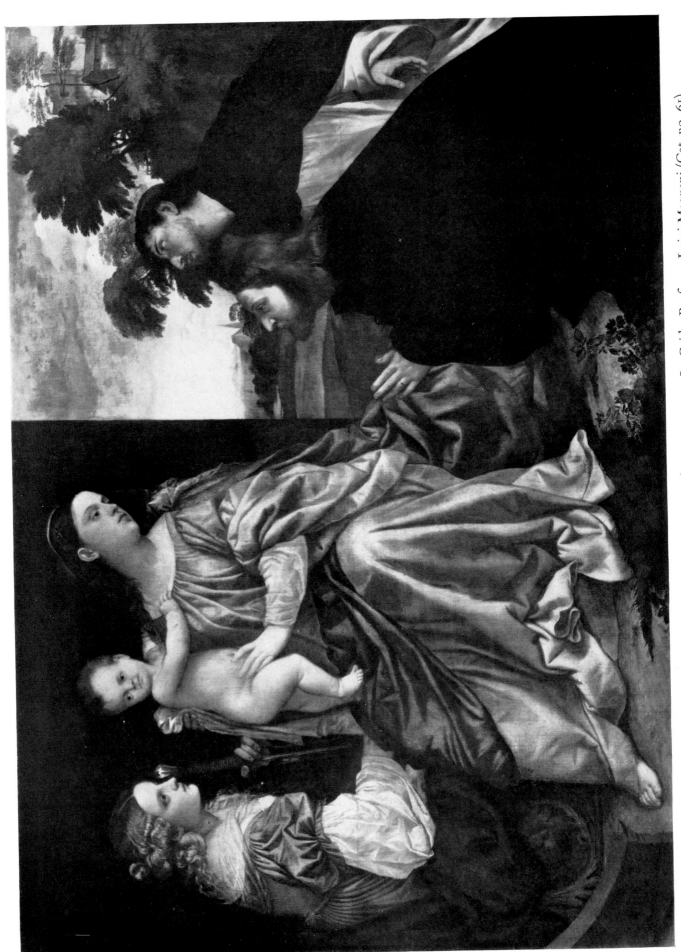

9. *Madonna and Child with SS. Catherine and Dominic and a Donor.* About 1515–1520. La Gaida, Professor Luigi Magnani (Cat. no. 61)

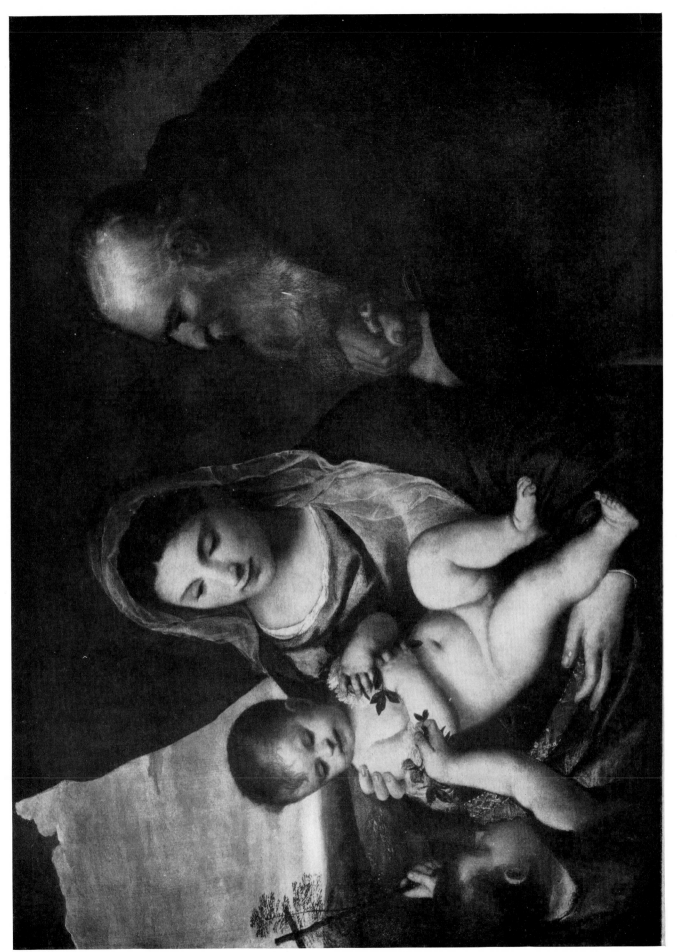

10. *Madonna and Child with St. Anthony Abbot and the Infant Baptist. About 1520. Florence, Uffizi (Cat. no. 58)

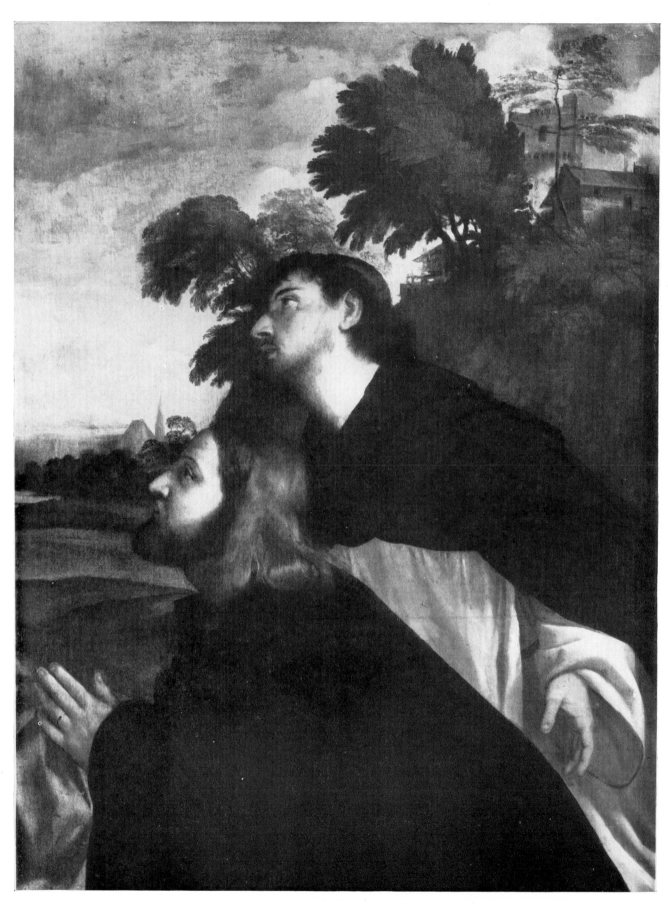

11. *St. Dominic and a Donor.* Detail from Plate 9

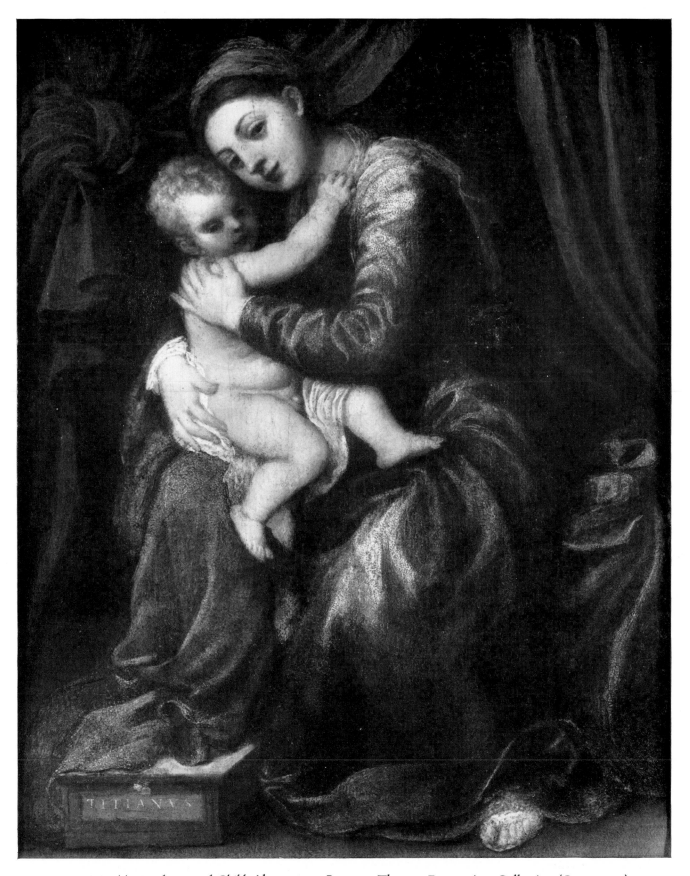

12. Titian(?): *Madonna and Child*. About 1515. Lugano, Thyssen-Bornemisza Collection (Cat. no. 50)

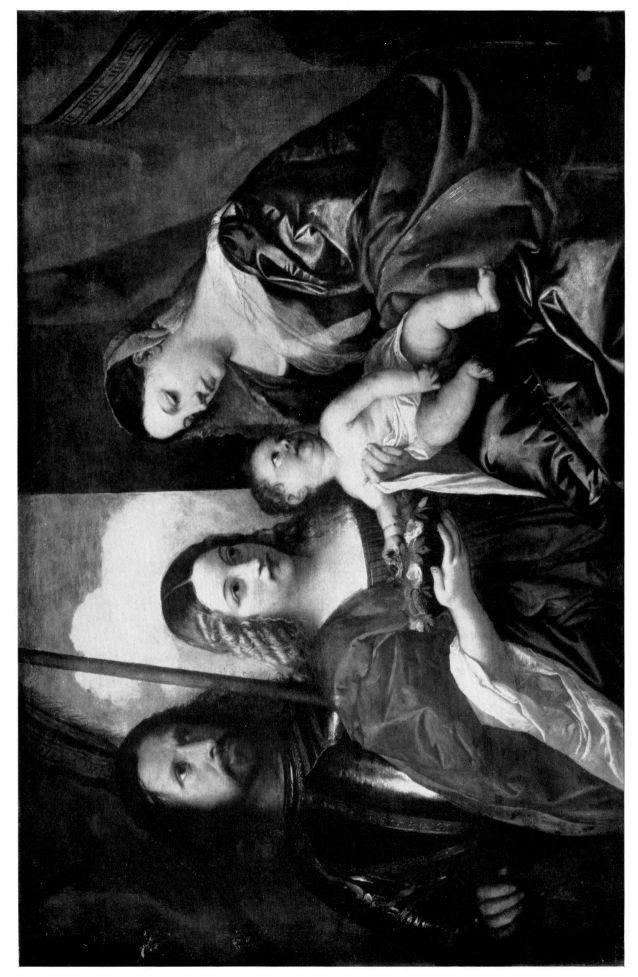

13. *Madonna and Child with SS. Dorothy and George. About 1515. Madrid, Prado Museum (Cat. no. 65)*

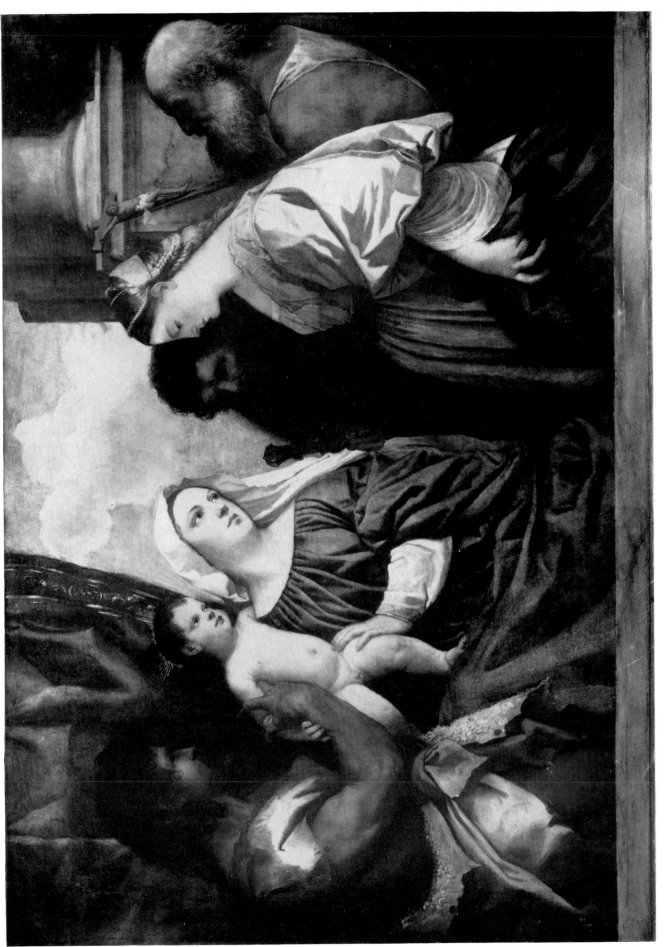

14. Titian and workshop: *Madonna and Child with SS. John the Baptist, Mary Magdalen, Paul and Jerome*. About 1520. Dresden, Staatliche Gemäldegalerie (Cat. no. 67)

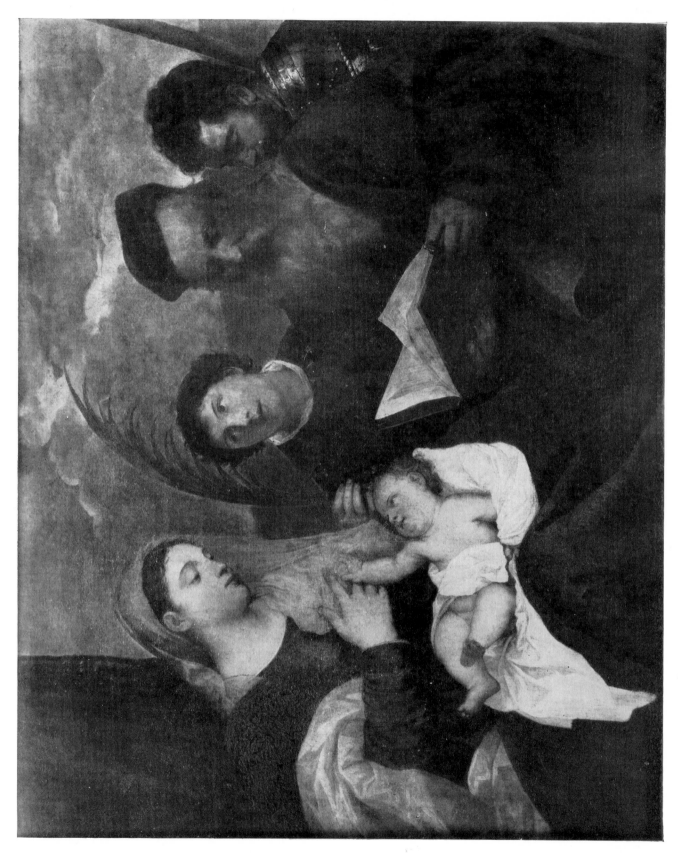

15. *Madonna and Child with SS. Stephen, Jerome and Maurice. About 1520.* Paris, Louvre (Cat. no. 72)

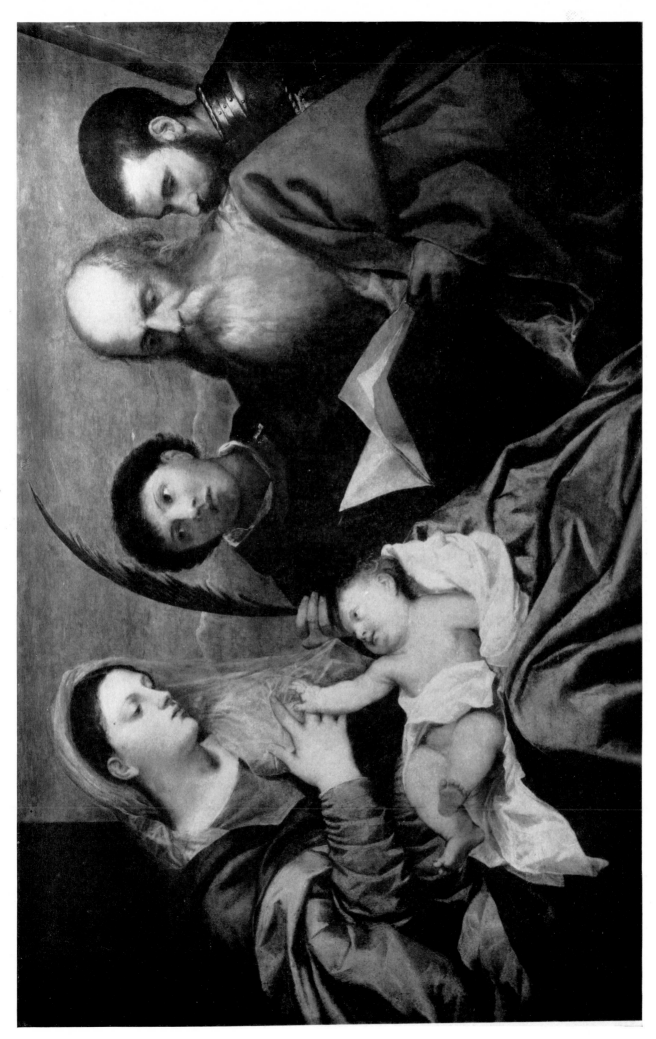

16. Titian and workshop: *Madonna and Child with SS. Stephen, Jerome and Maurice. About 1520. Vienna, Kunsthistorisches Museum (Cat. no. 73)

17. *Cherubs.* Detail from Plate 18

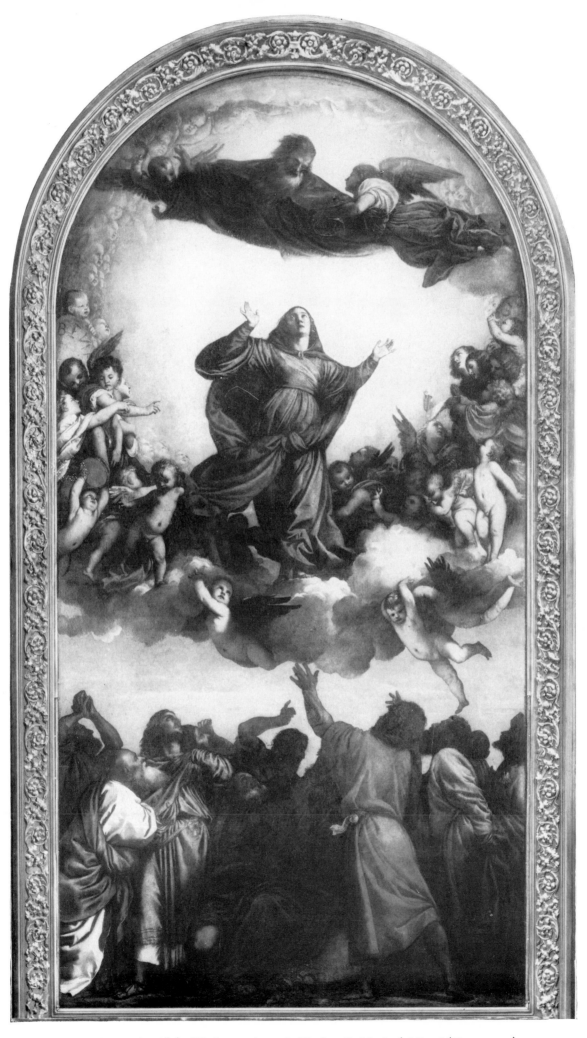

18. *Assumption of the Virgin*. 1516–1518. Venice, S. Maria dei Frari (Cat. no. 14)

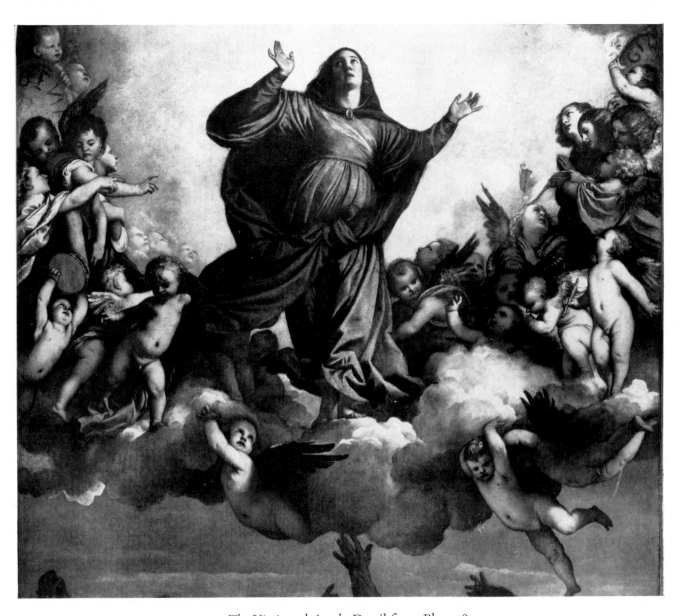

19. *The Virgin and Angels*. Detail from Plate 18

20. Roman relief, first century A.D.: *Putti*. Venice, Museo Archeologico

21. *Cherubs*. Detail from Plate 18

22. *Apostles*. Detail from Plate 18

23. *Madonna and Child with SS. Catherine, Nicholas, Peter, Sebastian, Francis and Anthony of Padua.*
About 1520–1525. Rome, Pinacoteca Vaticana (Cat. no. 63)

24. *Madonna and Child with SS. Francis and Aloysius and Donor.* 1520. Ancona, Museo Civico (Cat. no. 66)

25. *St. Aloysius and Alvise Gozzi*. Detail from Plate 24

26. *Madonna and Child with Angels.* 1523. Venice, Ducal Palace (Cat. no. 51)

27. *Landscape.* Detail from Plate 24

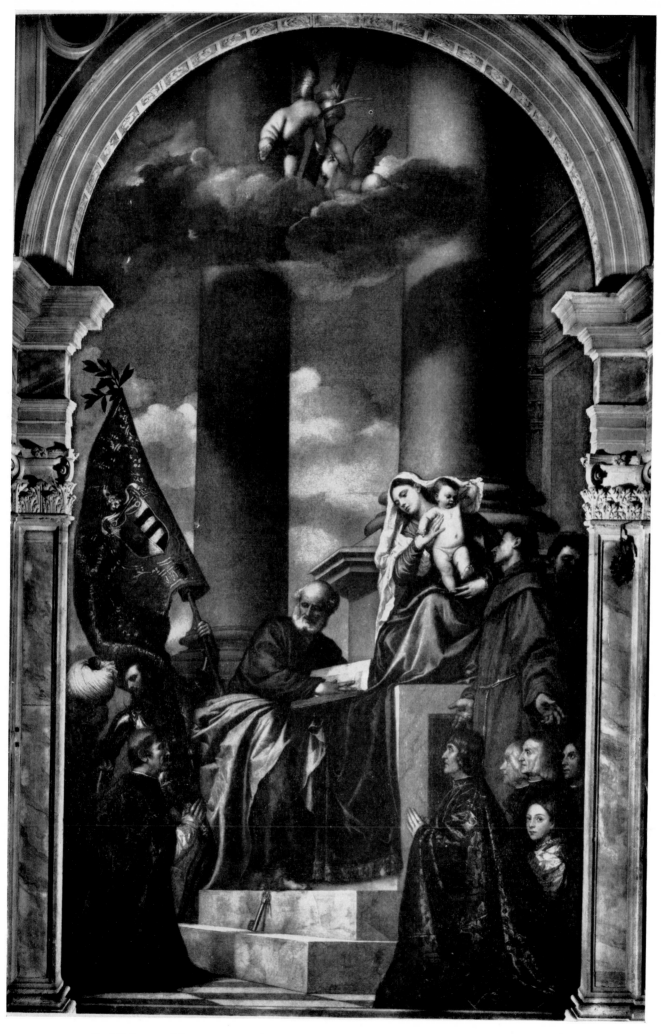

28. *Madonna of the Pesaro Family.* 1519–1526. Venice, S. Maria dei Frari (Cat. no. 55)

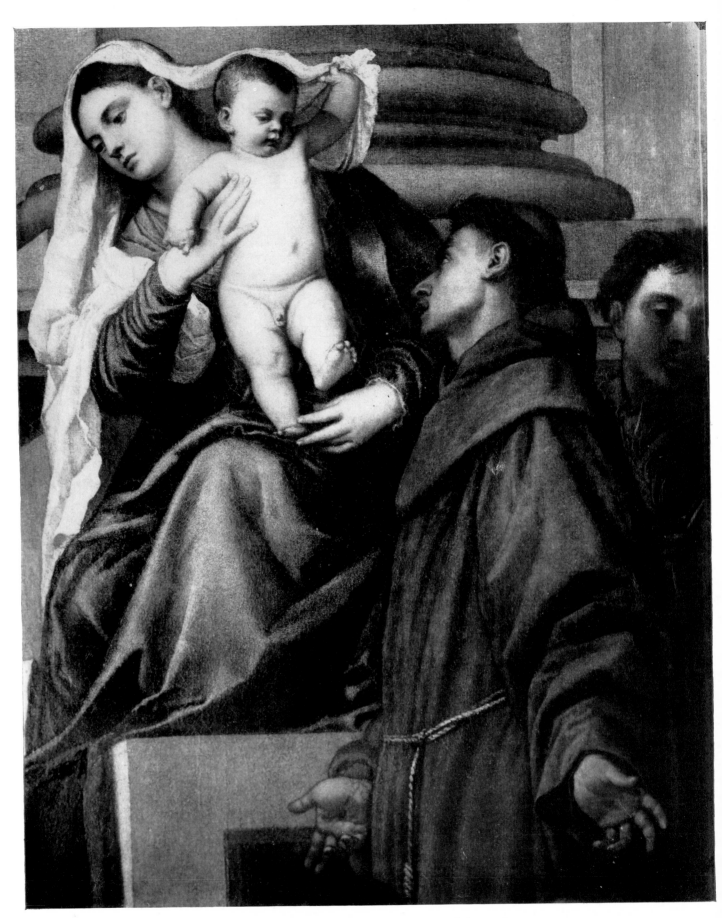

29. *Madonna and Child with St. Francis*. Detail from Plate 28

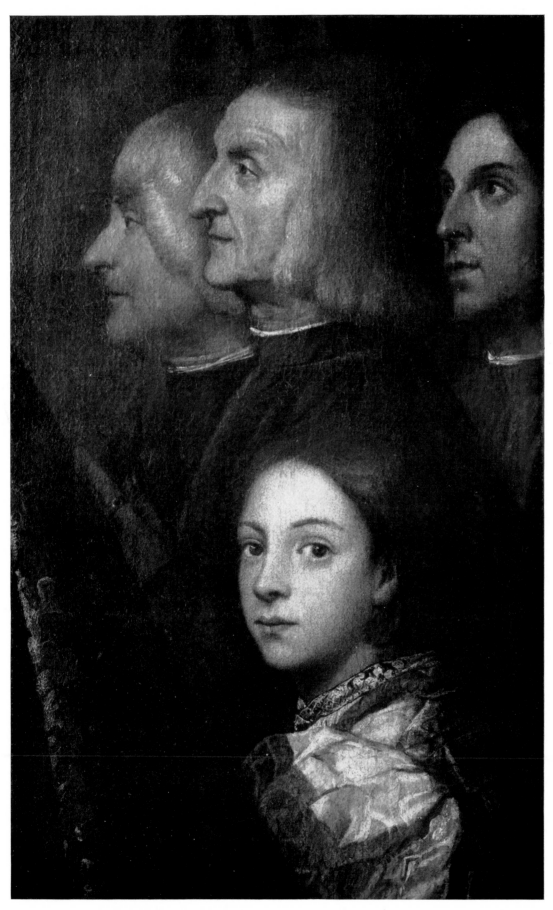

30. *Benedetto Pesaro and the Pesaro Family*. Detail from Plate 28

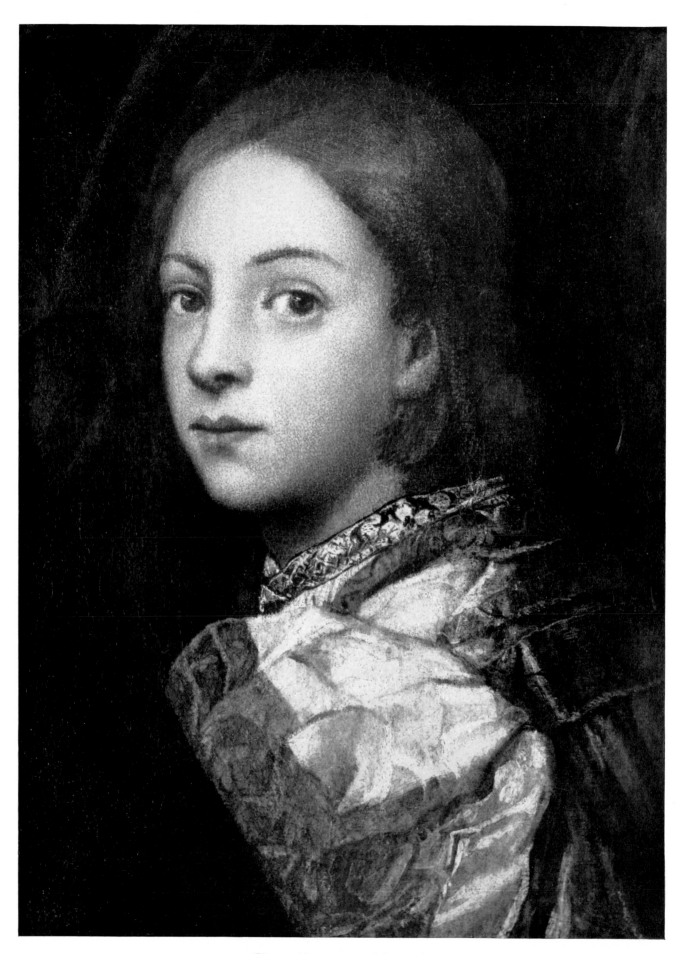

31. *Giovanni Pesaro*. Detail from Plate 28

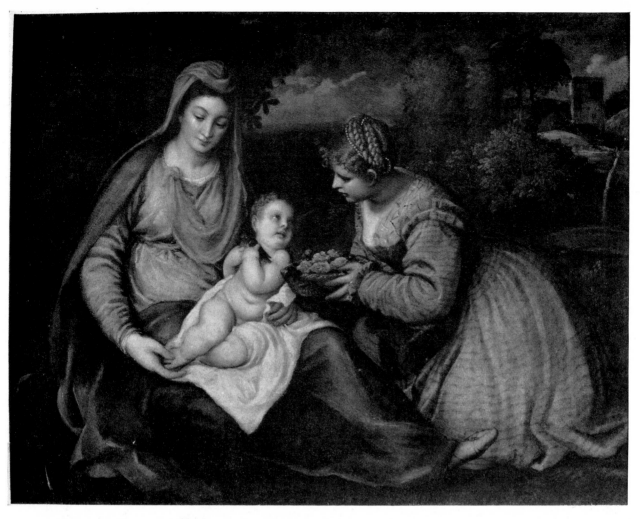

32. Workshop of Titian or copy: *Madonna and Child with St. Dorothy*. About 1530–1540.
Philadelphia, Museum of Art (Cat. no. 64)

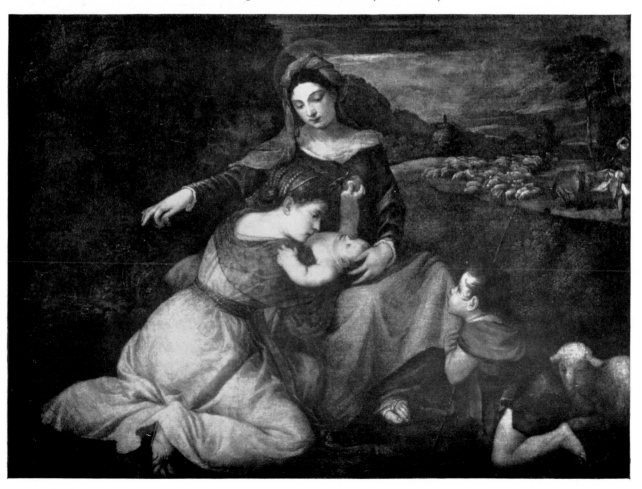

33. Sixteenth-century variant: *Madonna and Child with St. Catherine and the Infant Baptist* (Cf. Plate 35).
Florence, Pitti Gallery (Cat. no. 59, variant)

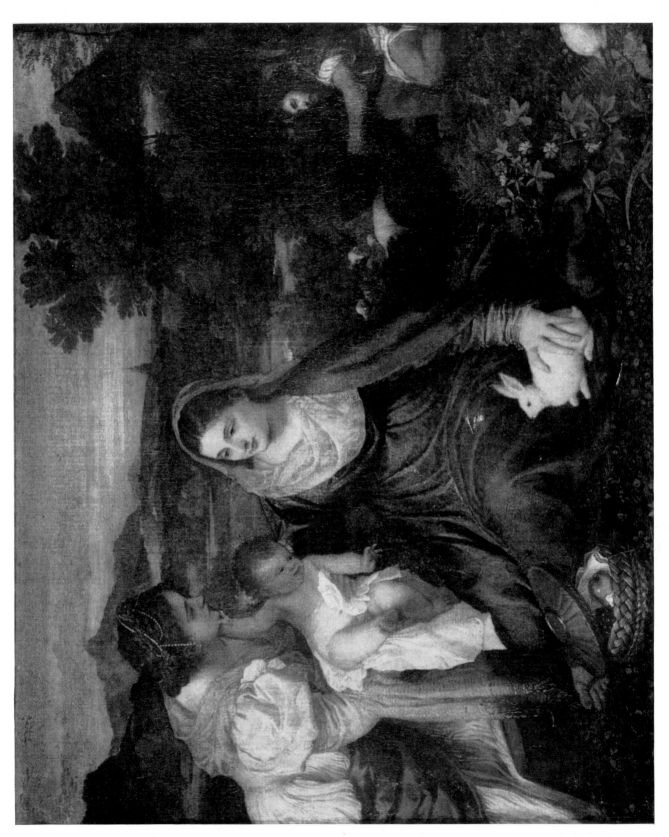

34. *Madonna and Child with St. Catherine and a Rabbit. About* 1530. Paris, Louvre (Cat. no. 60)

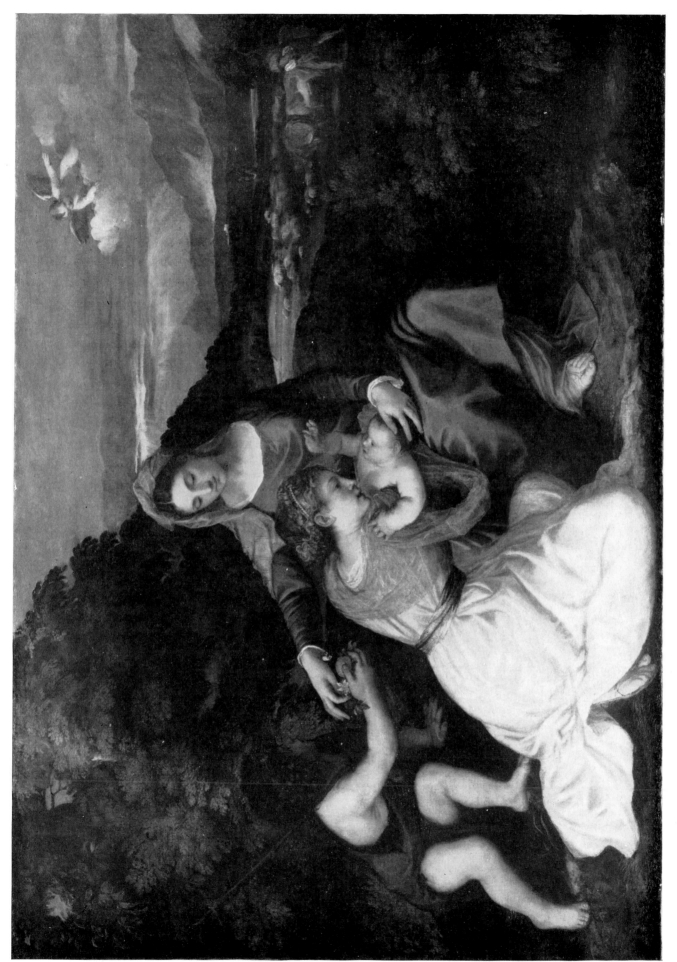

35. *Madonna and Child with St. Catherine and the Infant Baptist in a Landscape. About 1530. London, National Gallery (Cat. no. 59)*

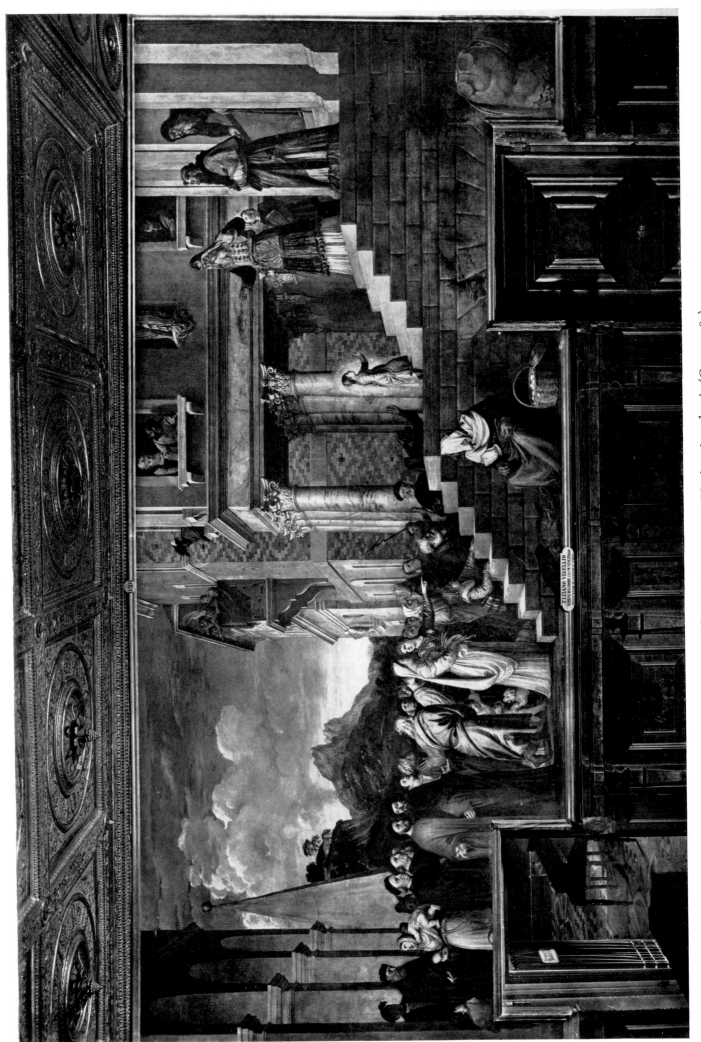

36. *Presentation of the Virgin.* 1534–1538. Venice, Accademia (Cat. no. 87)

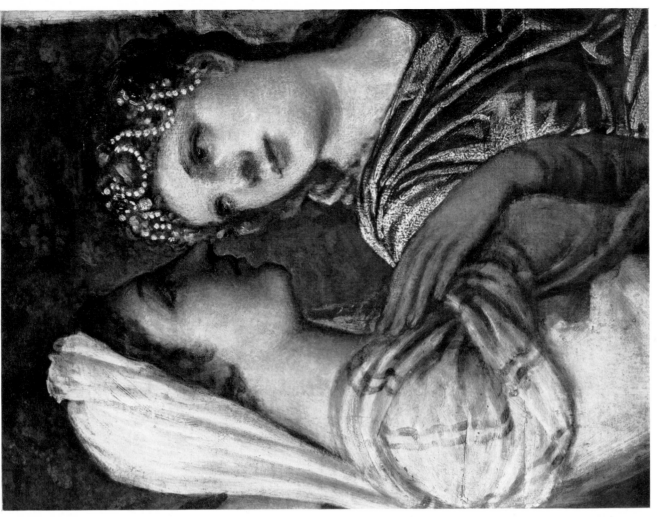

38. *Two Spectators*. Detail of Plate 36

37. *Two Spectators*. Detail of Plate 36

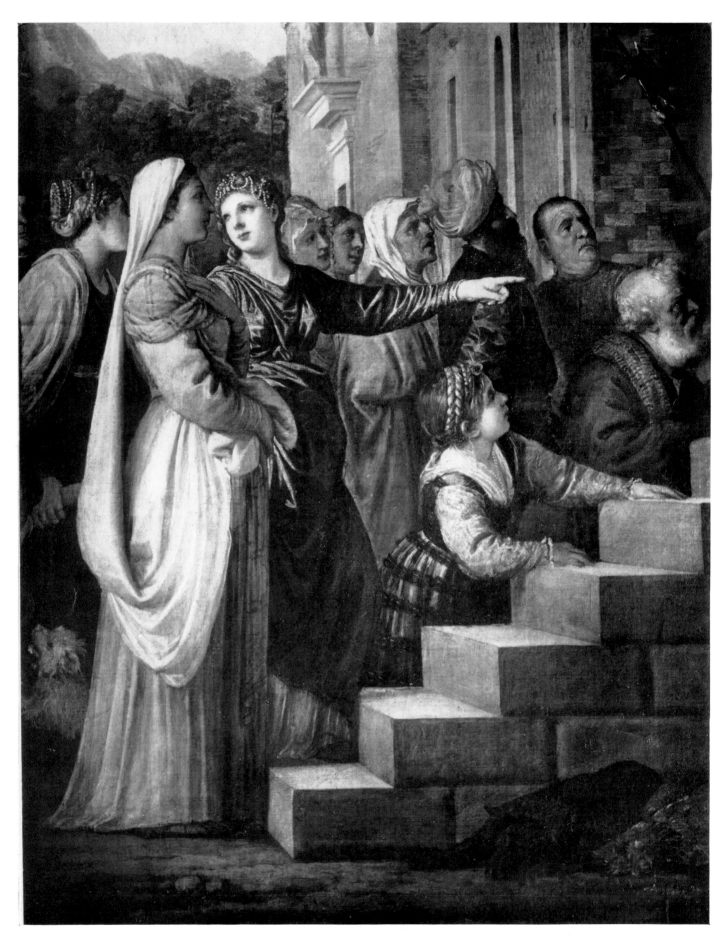

39. *Spectators*. Detail of Plate 36

40. Titian and workshop: *Rest on the Flight into Egypt*. About 1535. Escorial, Nuevos Museos (Cat. no. 91)

41. Martin Rota after Titian: *Rest on the Flight into Egypt* (Cat. no. 91, engraving)

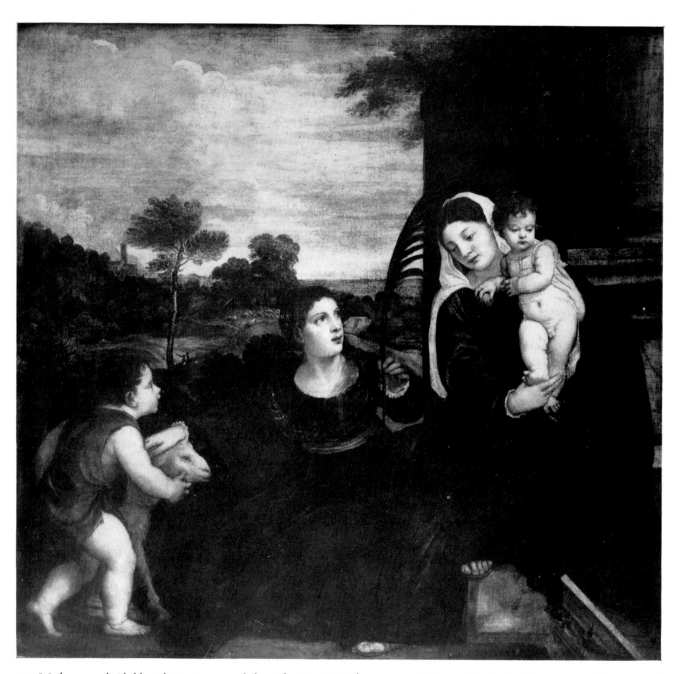

42. *Madonna and Child with St. Agnes and the Infant Baptist*. About 1535. Dijon, Musée des Beaux-Arts (Cat. no. 56)

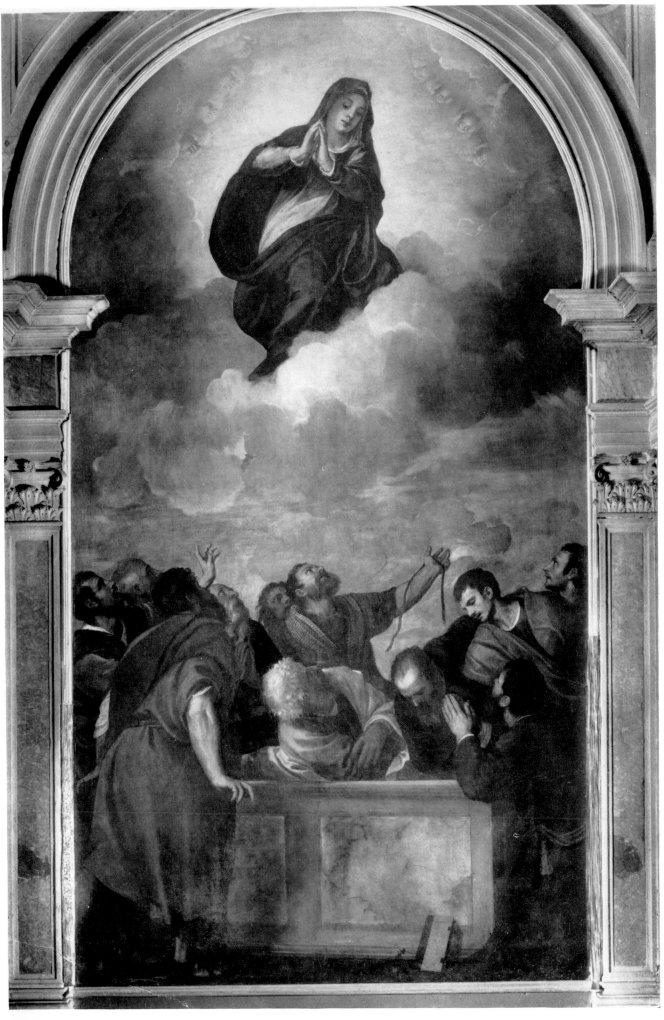

43. *Assumption of the Virgin*. About 1535. Verona, Cathedral (Cat. no. 15)

44. *Apostles*. Detail from Plate 43

45. *Apostles*. Detail from Plate 43

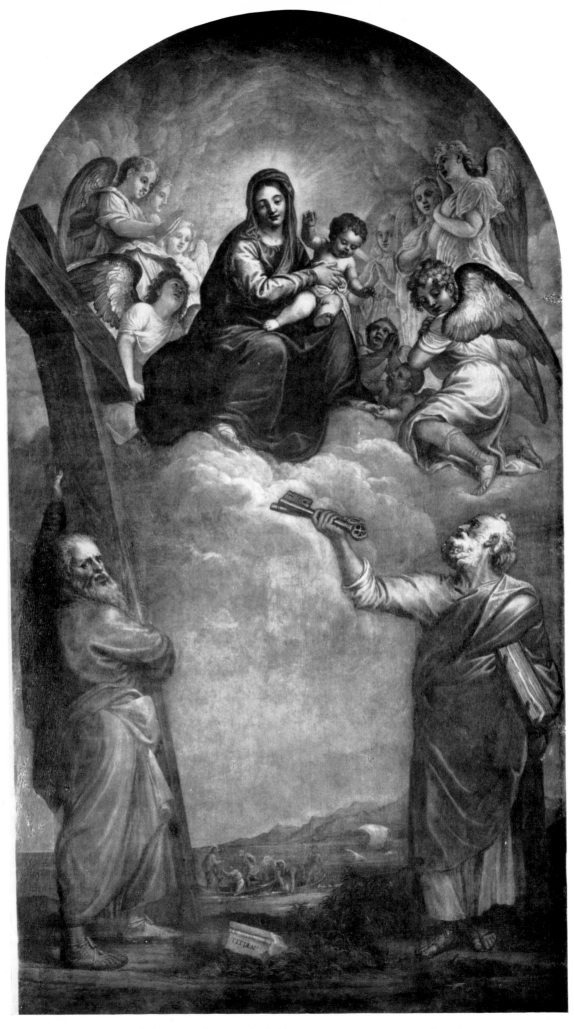

46. Titian and workshop: *Madonna and Child Appearing to SS. Peter and Andrew*. 1542–1547.
Serravalle, S. Maria Nuova (Cat. no. 70)

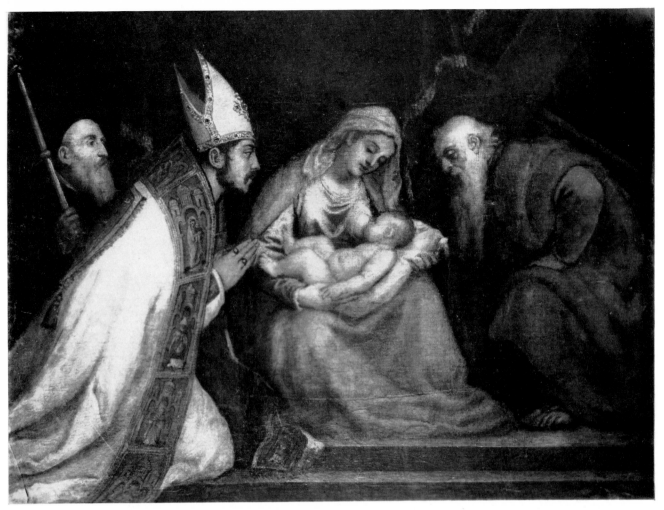

47. Titian and workshop: *Madonna and Child with SS. Andrew and Tiziano, and Titian as Donor.* About 1560.
Pieve di Cadore, Parish Church (Cat. no. 57)

48. *Miraculous Draught of Fishes.* Detail from Plate 46

49. *Landscape*. Detail from Plate 50

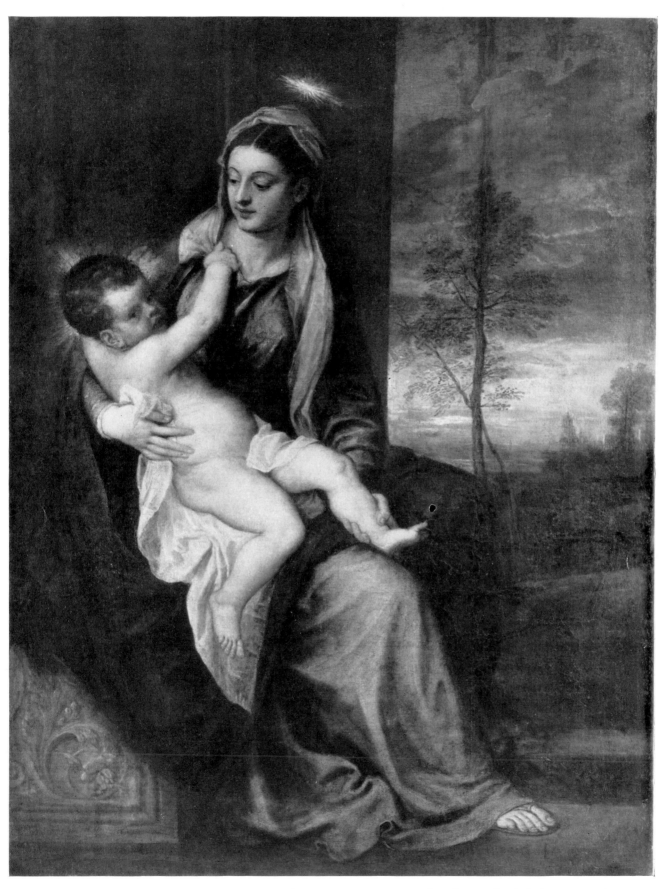

50. *Madonna and Child in an Evening Landscape.* 1562–1565. Munich, Alte Pinakothek (Cat. no. 53)

52. Titian and workshop: *Madonna and Child with St. Mary Magdalen.*
About 1555. Leningrad, Hermitage Museum (Cat. no. 68)

51. Workshop of Titian: *Madonna and Child with SS. Peter and Paul.* 1543–1550.
Castello di Roganzuolo, S. Fior (Cat. no. 71)

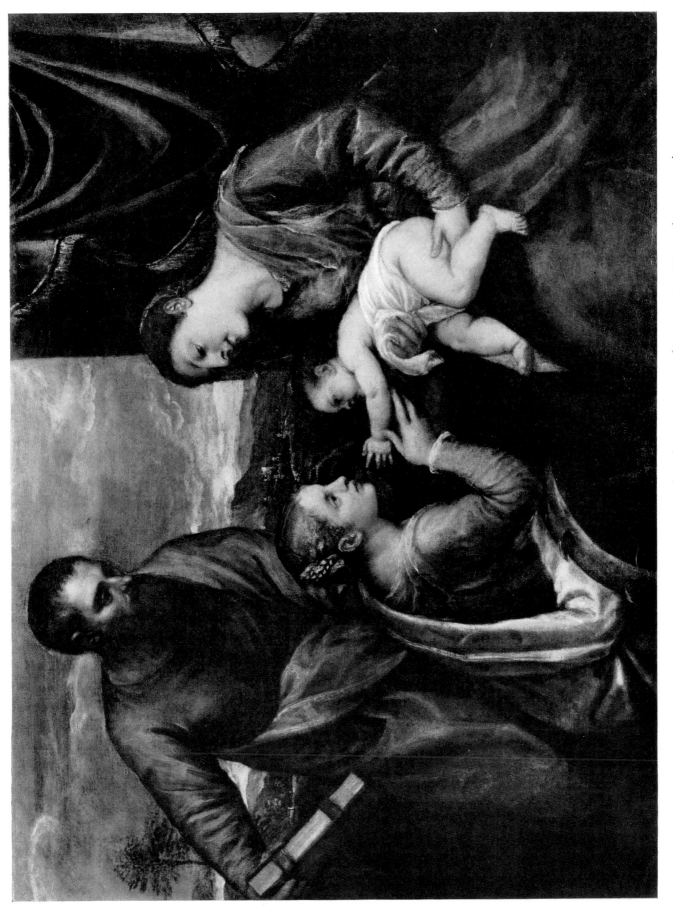

53. *Madonna and Child with SS. Catherine and Luke.* About 1560. Kreuzlingen, Heinz Kisters (Cat. no. 62)

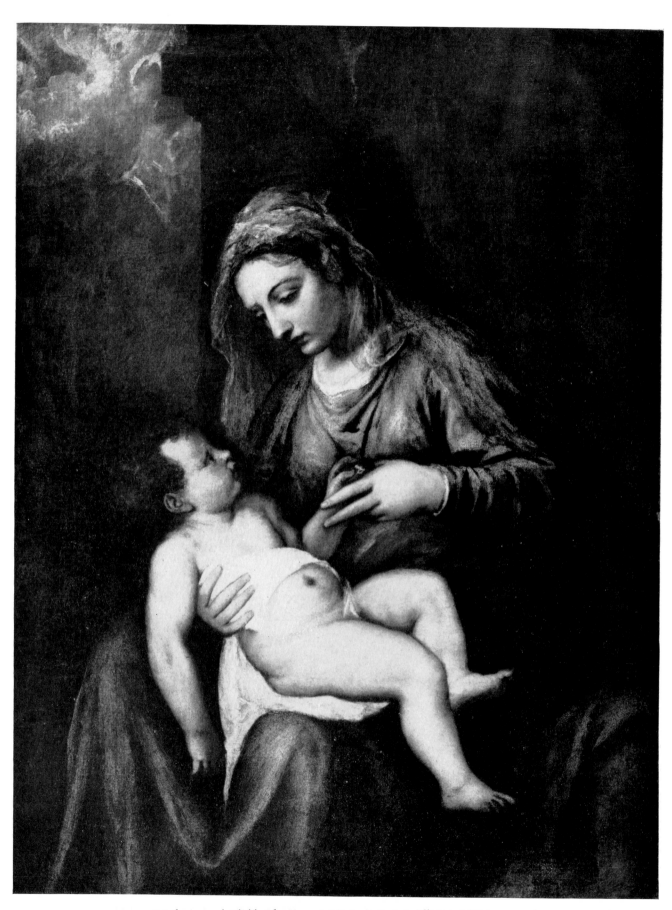

54. *Madonna and Child*. About 1560. Rome, Luigi Albertini (Cat. no. 52)

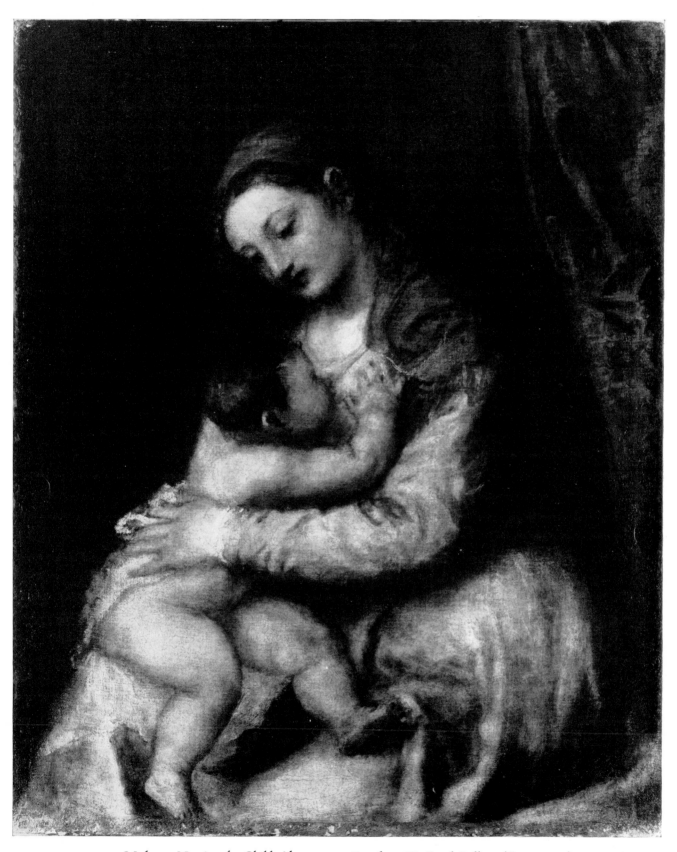

55. *Madonna Nursing the Child*. About 1570. London, National Gallery (Cat. no. 54)

THE LIFE OF CHRIST

56. *The Virgin Annunciate*. Detail from Plate 57

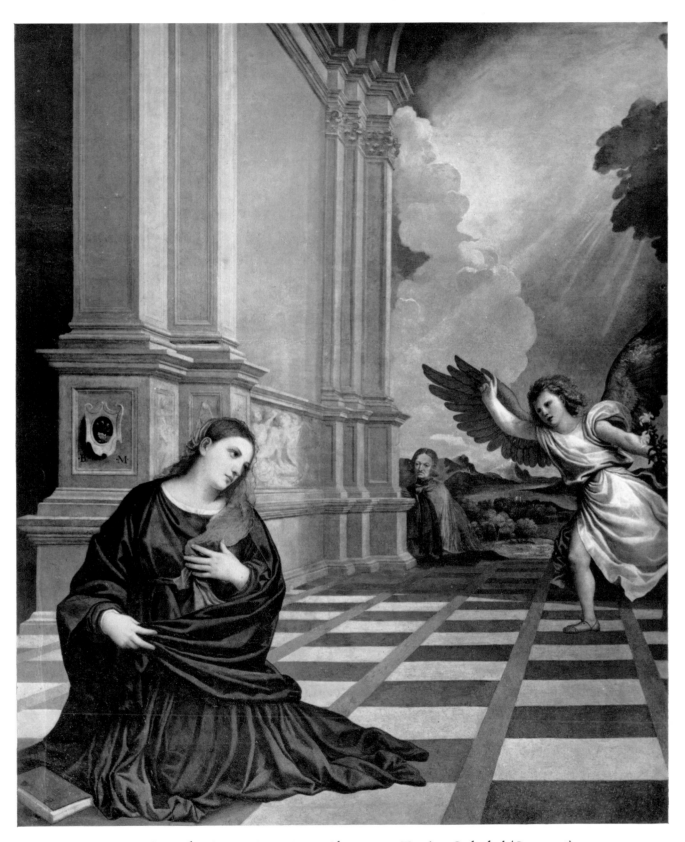

57. Titian and assistant: *Annunciation*. About 1519. Treviso, Cathedral (Cat. no. 8)

58. *Annunciation*. About 1530. Venice, Scuola di San Rocco (Cat. no. 9)

60. Titian and workshop: *Annunciation*. About 1557. Naples,
S. Domenico Maggiore (Cat. no. 12)

59. Caraglio after Titian: *Annunciation*. 1536 (Cat. no. 10, engraving)

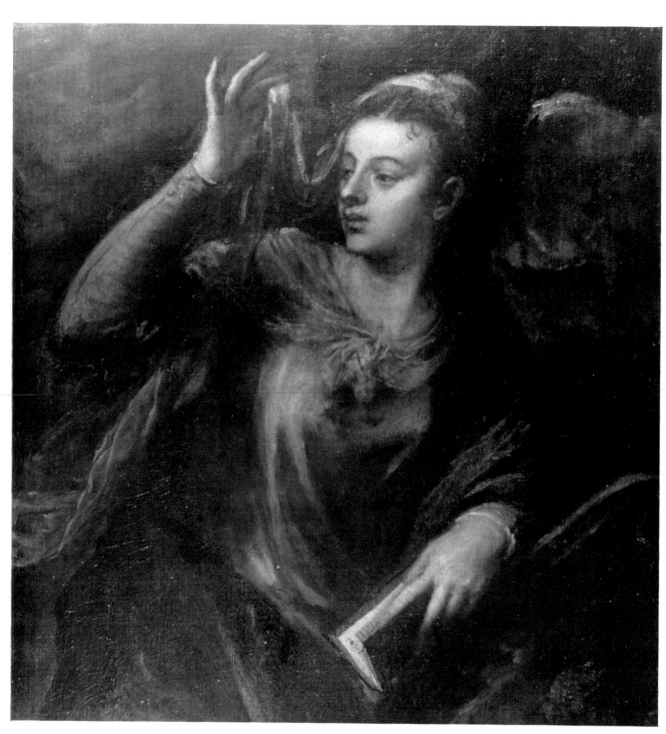

61. *The Virgin Annunciate*. Detail from Plate 62

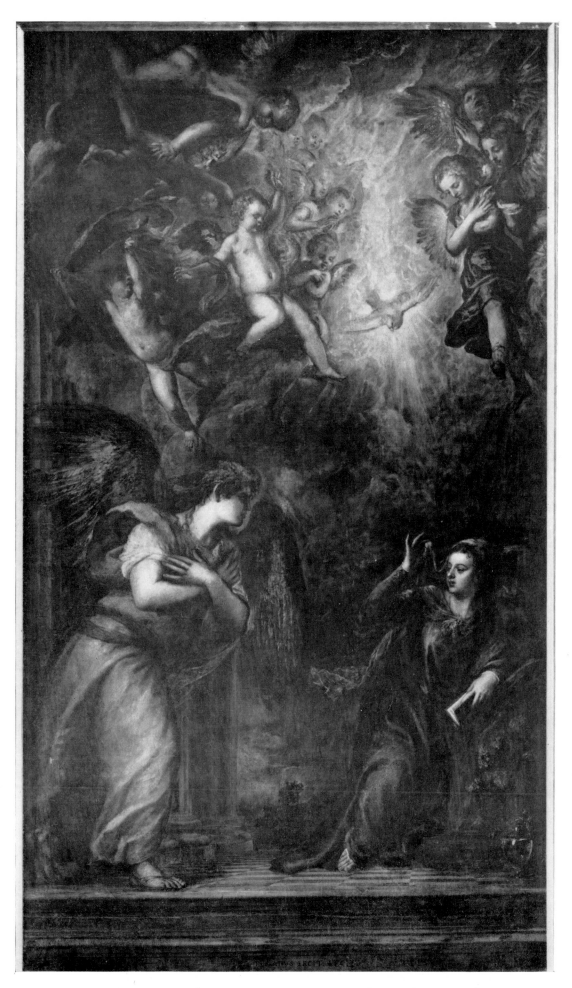

62. *Annunciation*. About 1560–1565. Venice, S. Salvatore (Cat. no. 11)

63. *Man of Sorrows*. About 1510. Venice, Scuola di S. Rocco (Cat. no. 75)

64. *Christ Carrying the Cross*. About 1510. Venice, Scuola di S. Rocco (Cat. no. 22)

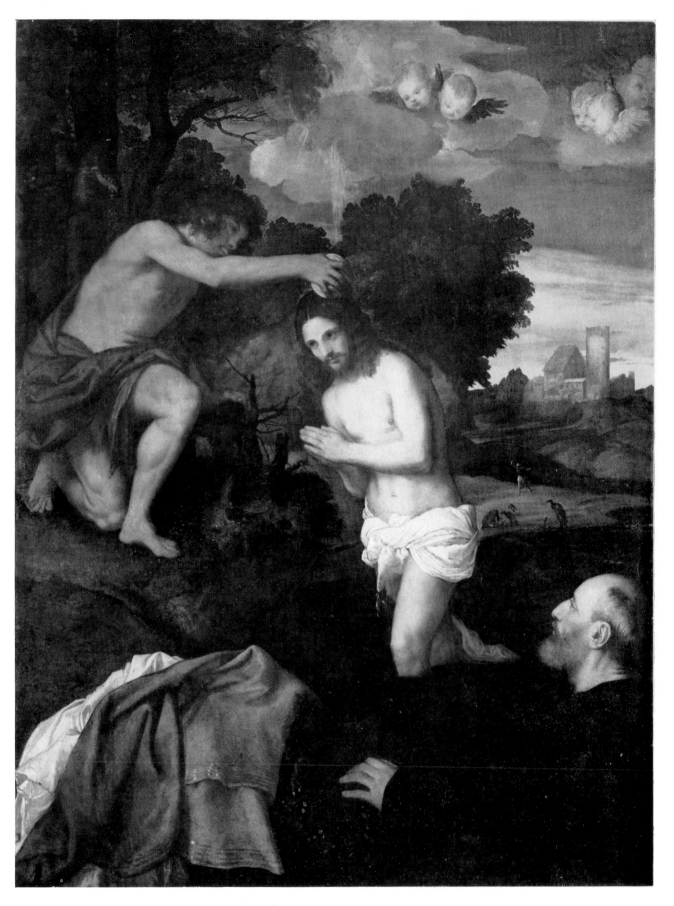

65. *Baptism*. About 1515. Rome, Capitoline Museum (Cat. no. 16)

66. *Landscape*. Detail from Plate 65

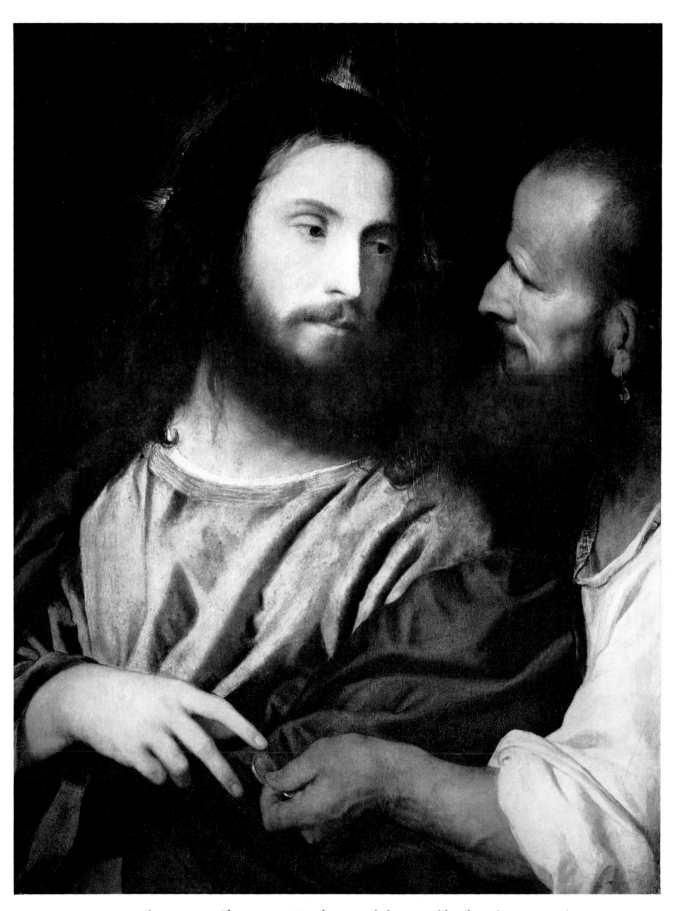

67. *Tribute Money*. About 1516. Dresden, Staatliche Gemäldegalerie (Cat. no. 147)

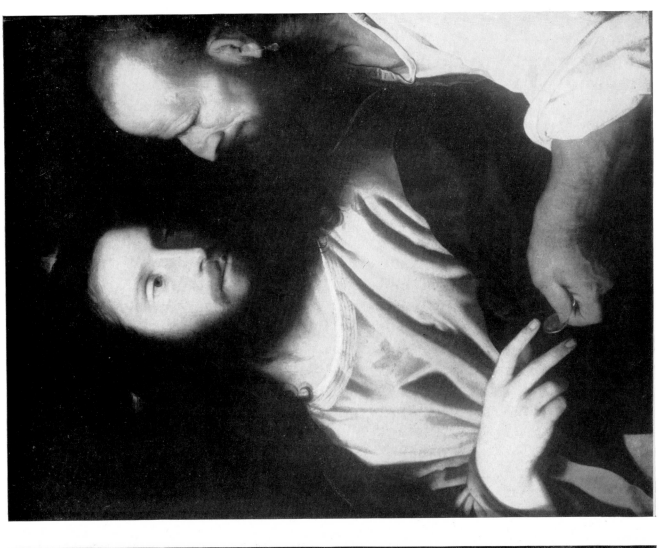

69. Replica: *Tribute Money* (Cf. Plate 67). About 1516–1520. Madrid, Descalzas Reales, Museum (Cat. no. 147, replica)

68. *Christ.* Detail from Plate 67

70. *Christ and the Adulteress.* About 1511. Vienna, Kunsthistorisches Museum (Cat. no. 17)

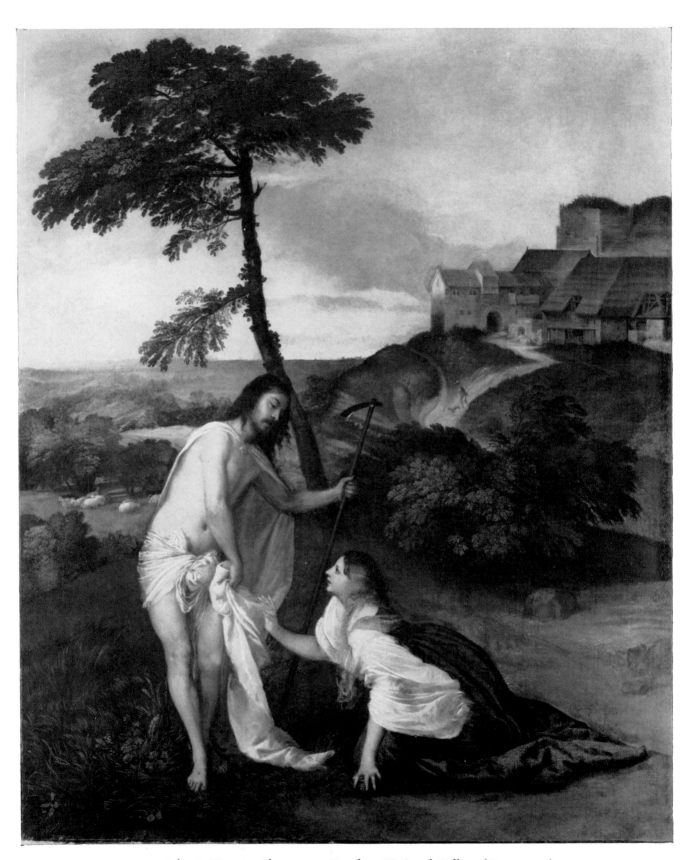

71. *Noli Me Tangere*. About 1512. London, National Gallery (Cat. no. 80)

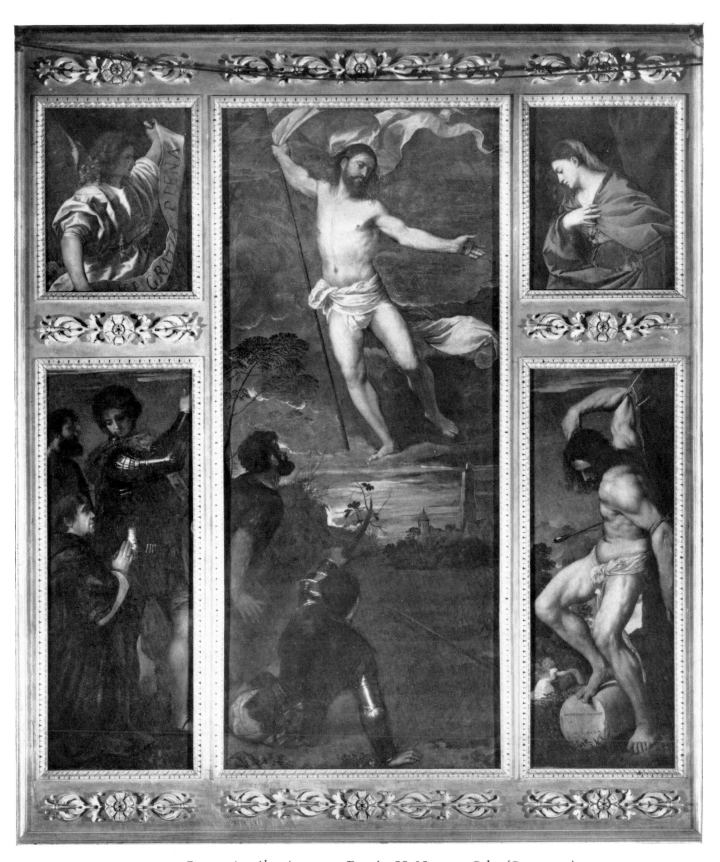

72. *Resurrection Altarpiece.* 1522. Brescia, SS. Nazaro e Celso (Cat. no. 92)

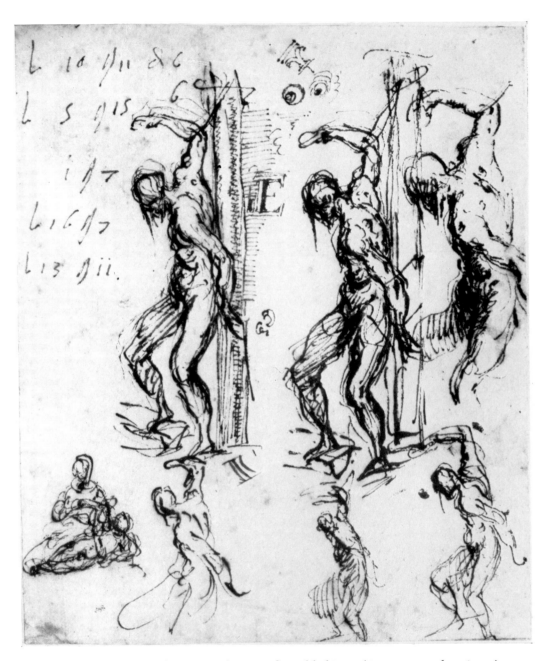

73. *Studies of St. Sebastian*. Berlin, Kupferstichkabinett (Cat. no. 92, drawing 1)

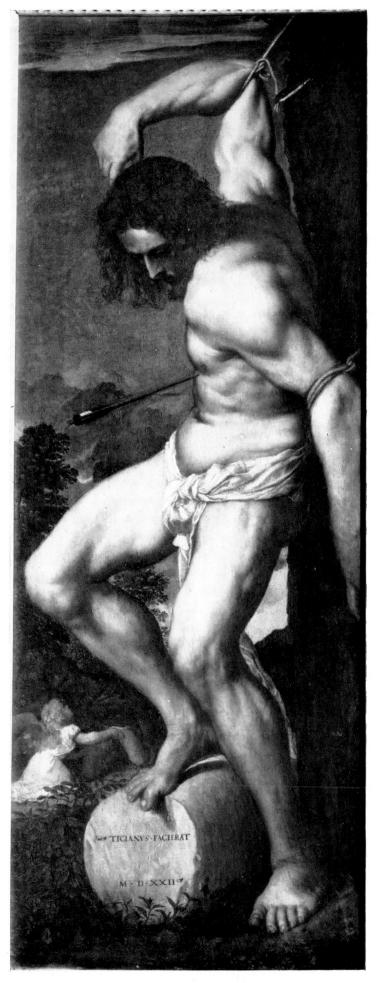

74. *St. Sebastian*. Detail from Plate 72

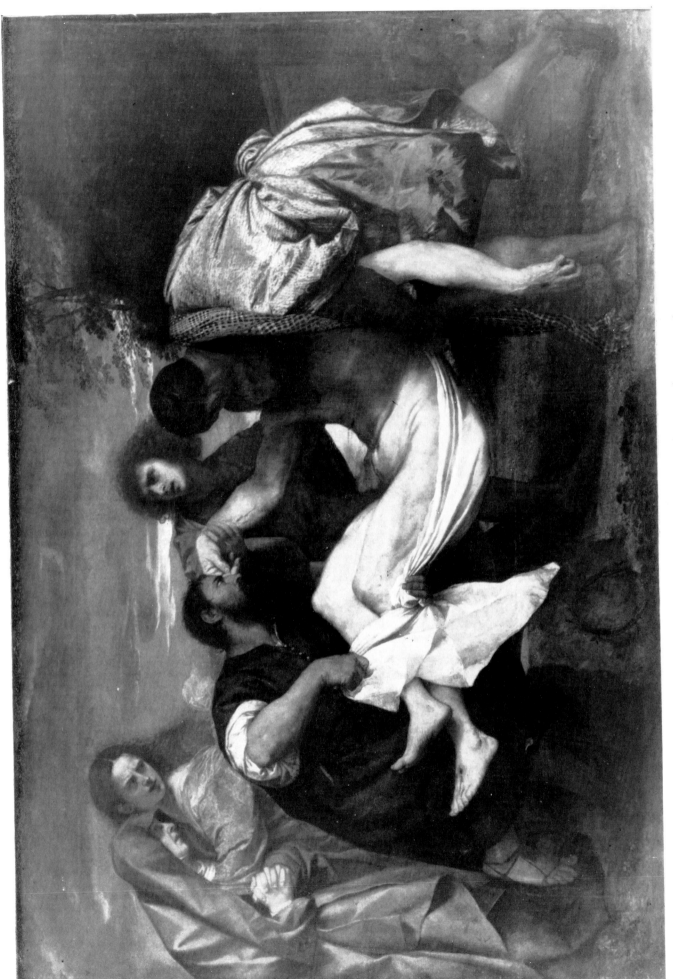

75. *Entombment.* About 1526–1532. Paris, Louvre (Cat. no. 36)

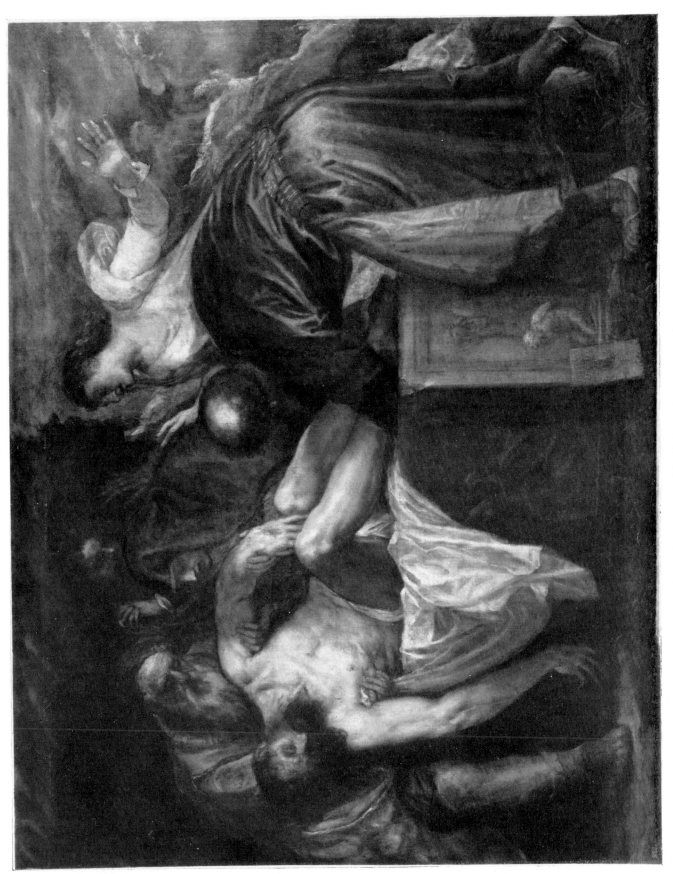

76. *Entombment.* 1559. Madrid, Prado Museum (Cat. no. 37)

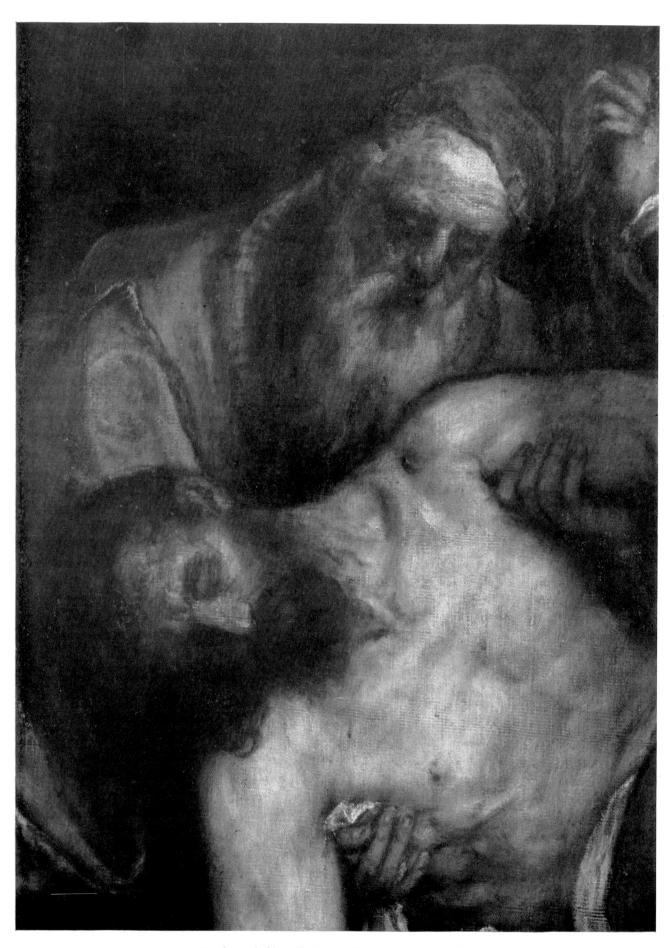

77. *Nicodemus holding the Dead Christ*. Detail from Plate 76

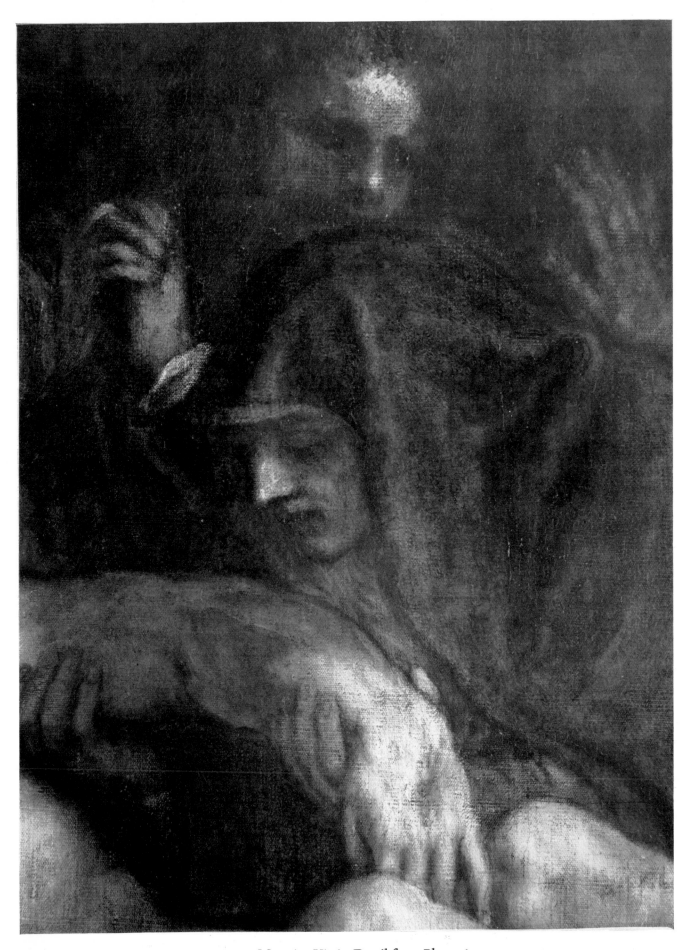

78. *Mourning Virgin*. Detail from Plate 76

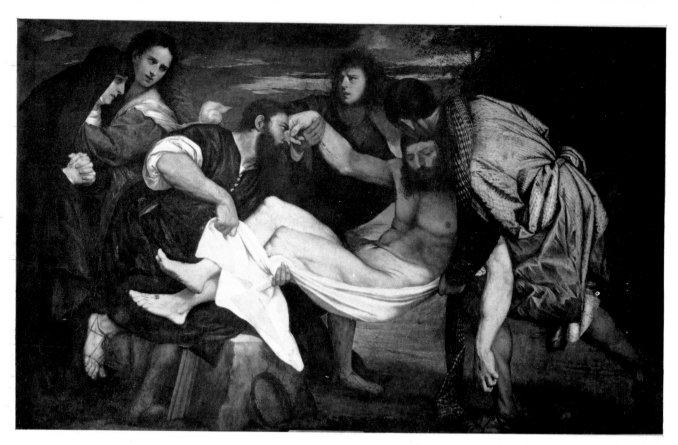

79. Copy after Titian: *Entombment* (Cf. Plate 75). Vercelli, Museo Borgogna (Cat. no. 36, replica)

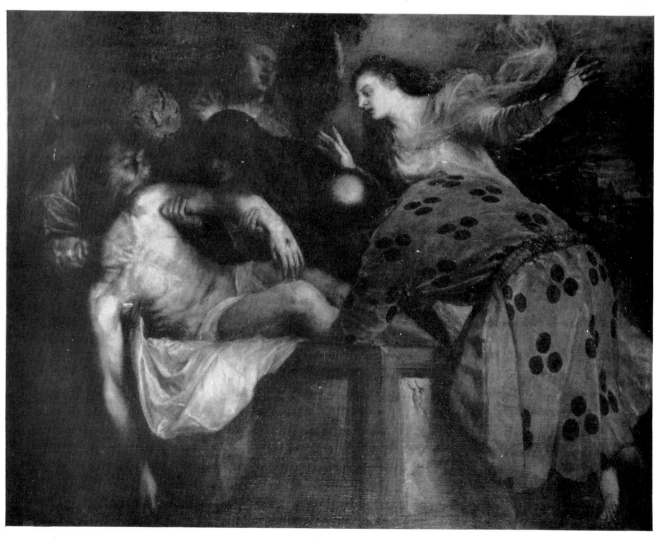

80. Workshop of Titian: *Entombment*. About 1570. Madrid, Prado Museum (Cat. no. 38)

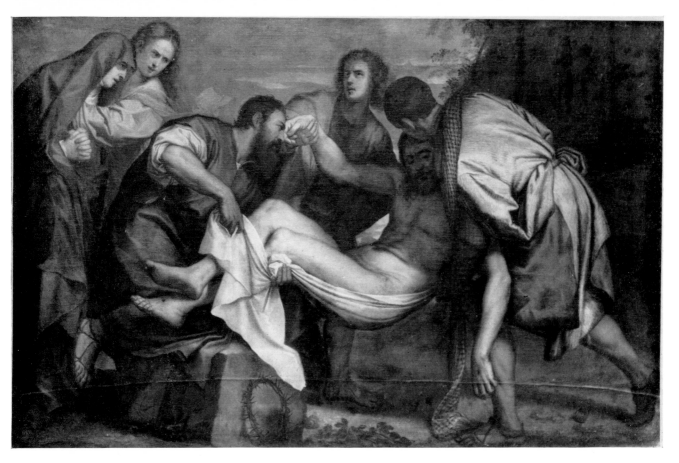

81. Copy of Titian: *Entombment* (Cf. Plate 75). Seville, Hospital de la Caridad (Cat. no. 36, copy 8)

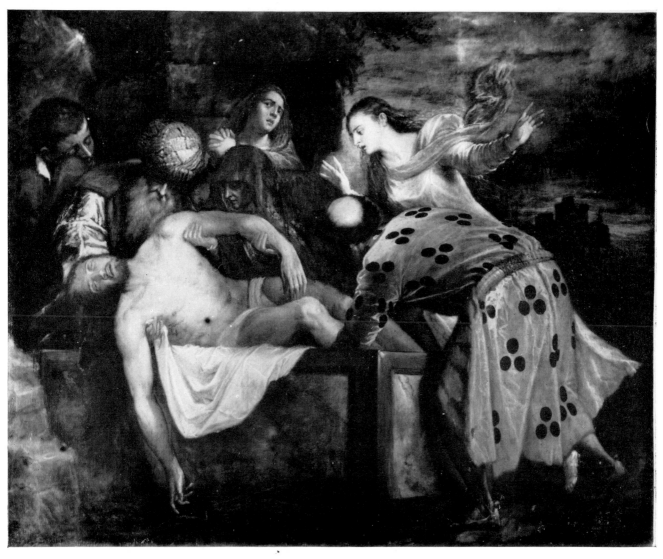

82. Copy attributed to El Mudo: *Entombment* (Cf. Plate 80). Salamanca, Cathedral (Cat. no. 38, copy 3)

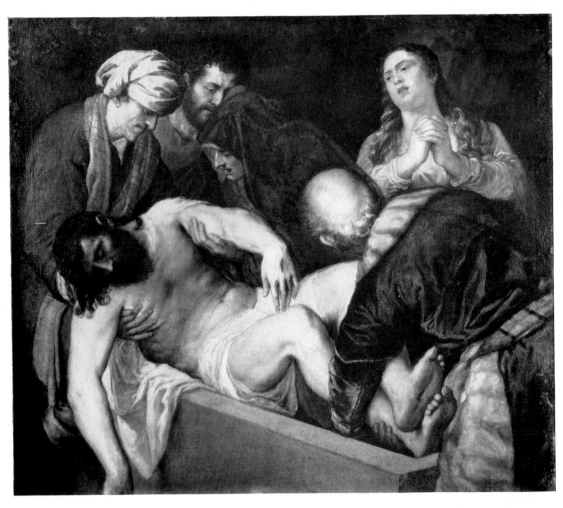

83. Workshop or copy of Titian: *Entombment*. Late sixteenth-century. Vienna, Kunsthistorisches Museum
(Cat. no. 39)

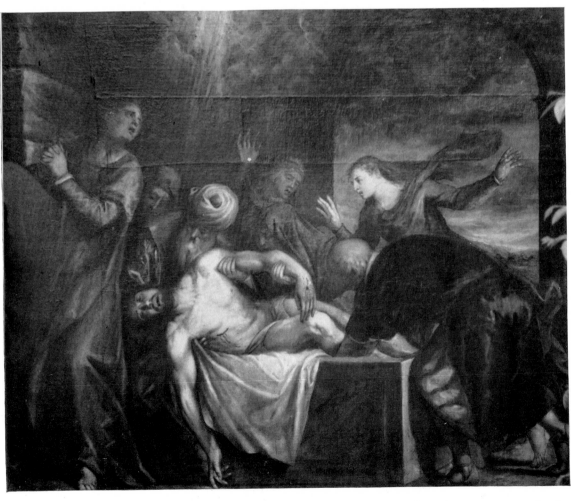

84. School of Titian: *Entombment*. About 1580. Milan, Ambrosiana Gallery (Cat. no. 37, variant)

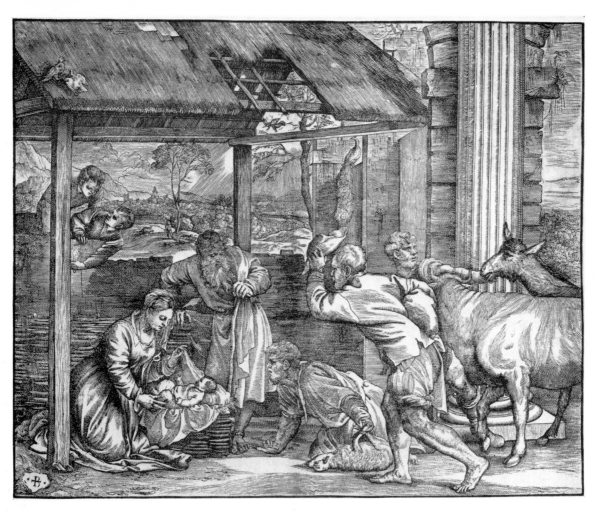

85. Master IB (Giovanni Britto?), woodcut after Titian: *Nativity* (Cat. no. 79, prints)

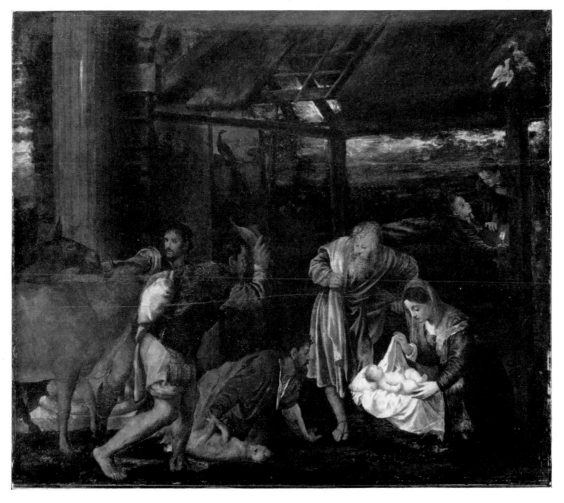

86. Copy of an original of 1532–1533: *Nativity*. Oxford, Christ Church Gallery (Cat. no. 79, copy)

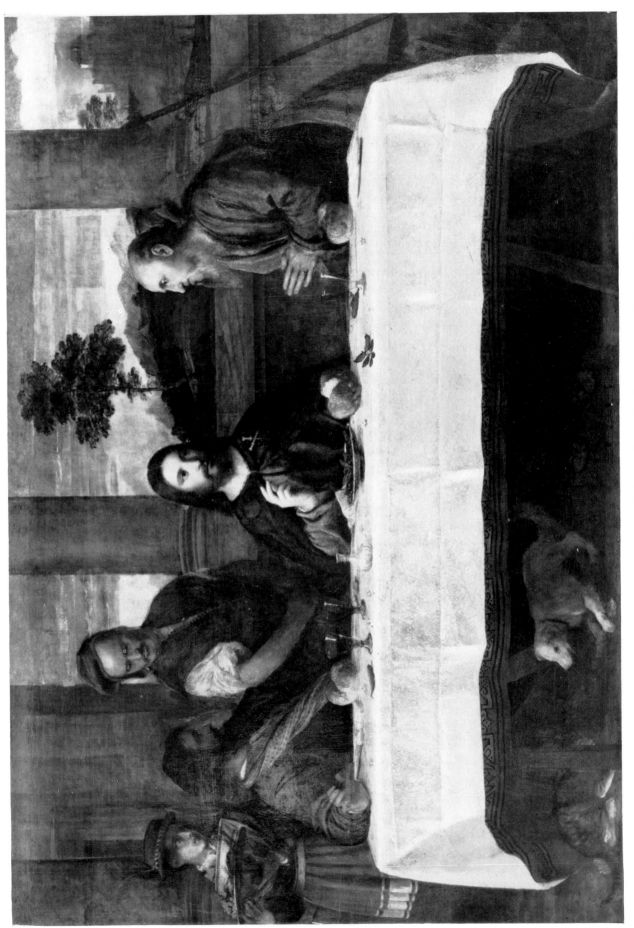

87. *Supper at Emmaus.* 1531. Brocklesby Park, Earl of Yarborough (Cat. no. 142)

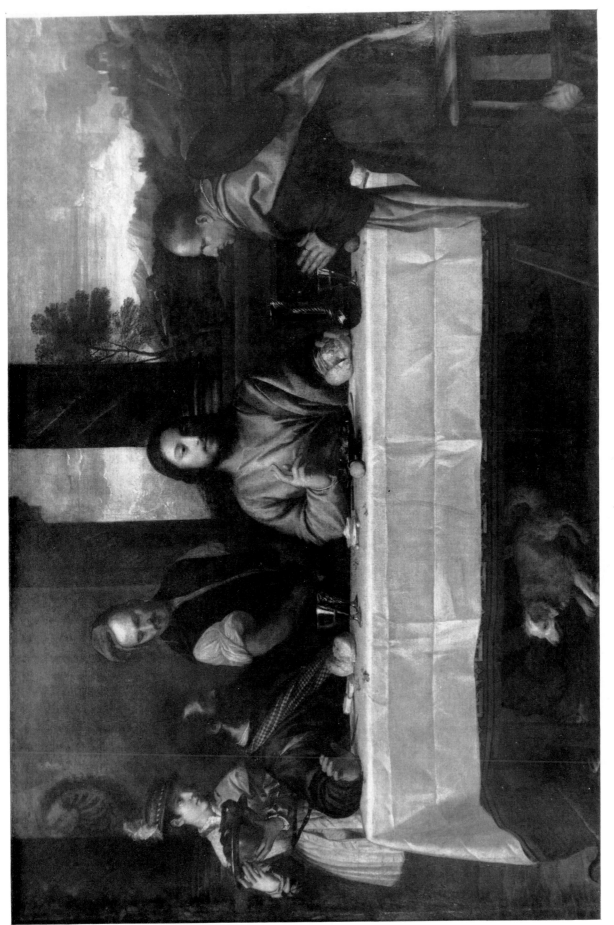

88. *Supper at Emmaus.* About 1535. Paris, Louvre (Cat. no. 143)

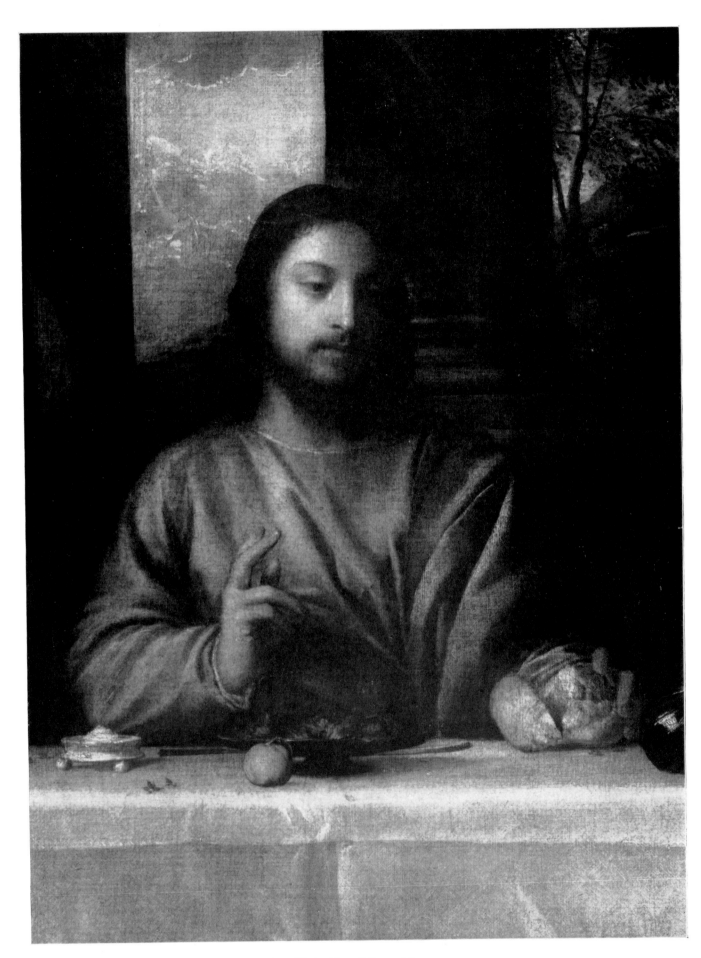

89. *Christ*. Detail from Plate 88

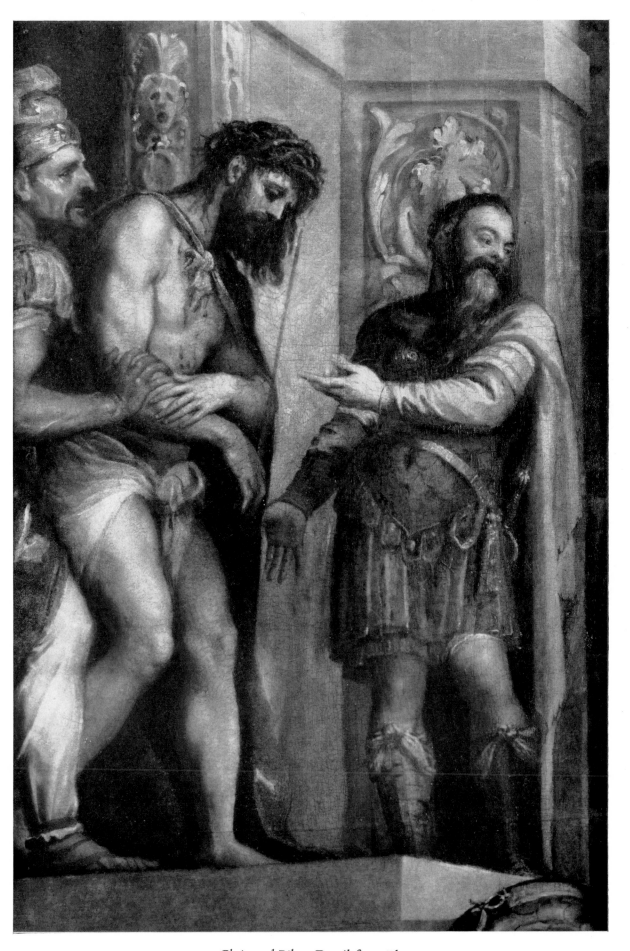

90. *Christ and Pilate.* Detail from Plate 91

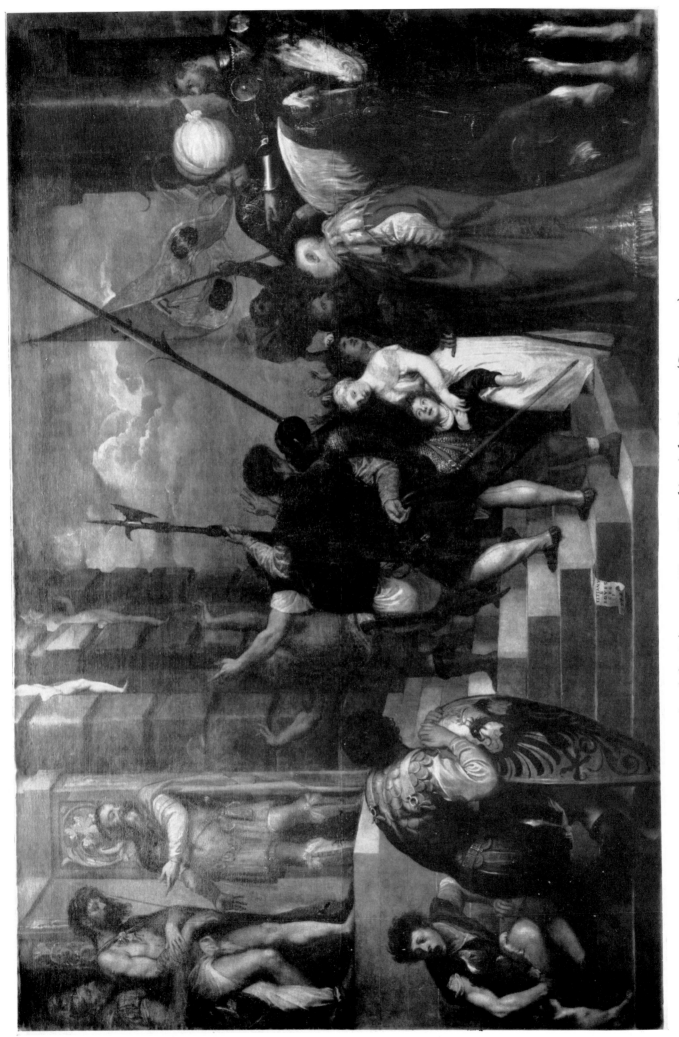

91. *Christ before Pilate.* 1543. Vienna, Kunsthistorisches Museum (Cat. no. 21)

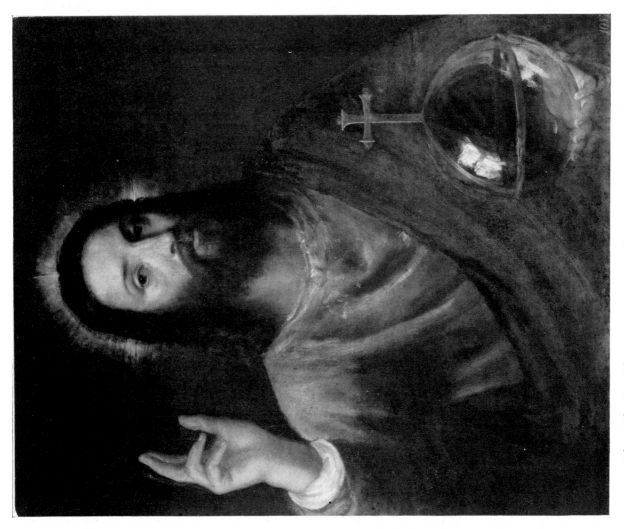

93. *Christ Blessing.* About 1570. Leningrad, Hermitage Museum (Cat. no. 18)

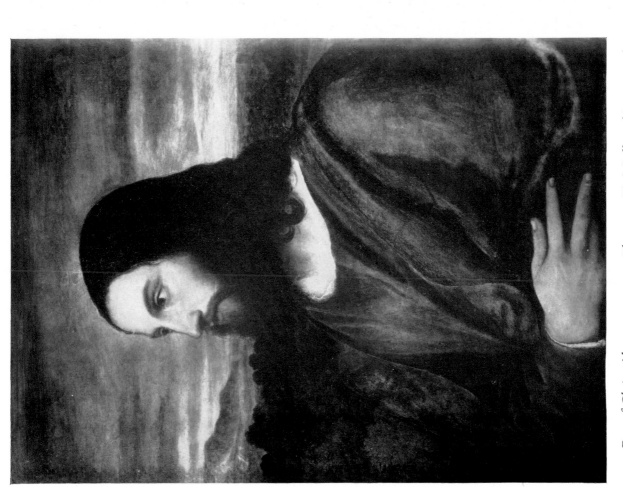

92. *Bust of Christ.* About 1532–1534. Florence, Pitti Gallery (Cat. no. 19)

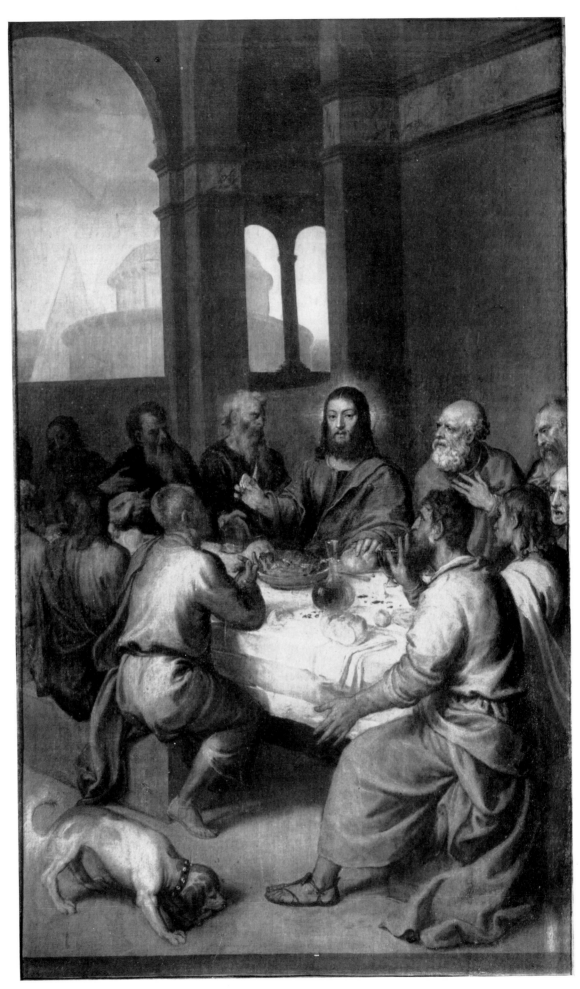

94. *Last Supper*. 1542–1544. Urbino, Galleria Nazionale delle Marche (Cat. no. 45)

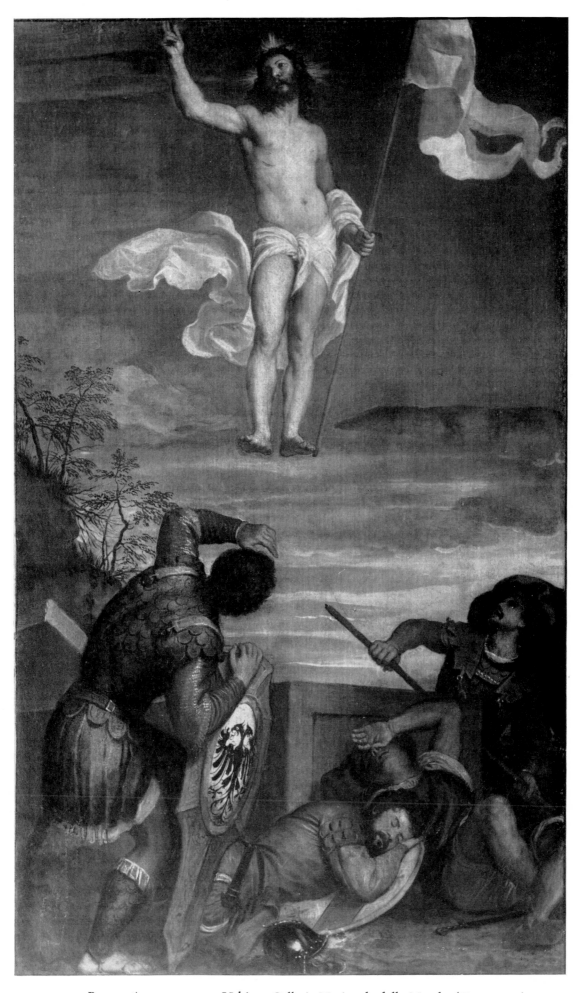

95. *Resurrection*. 1542–1544. Urbino, Galleria Nazionale delle Marche (Cat. no. 45)

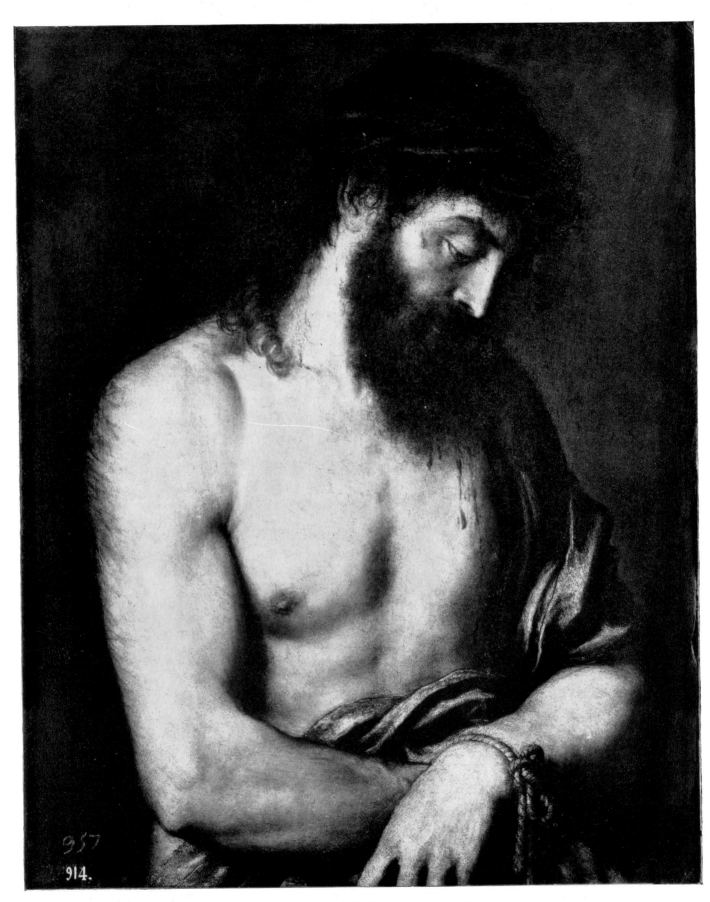

96. *Ecce Homo*. 1547. Madrid, Prado Museum (Cat. no. 32)

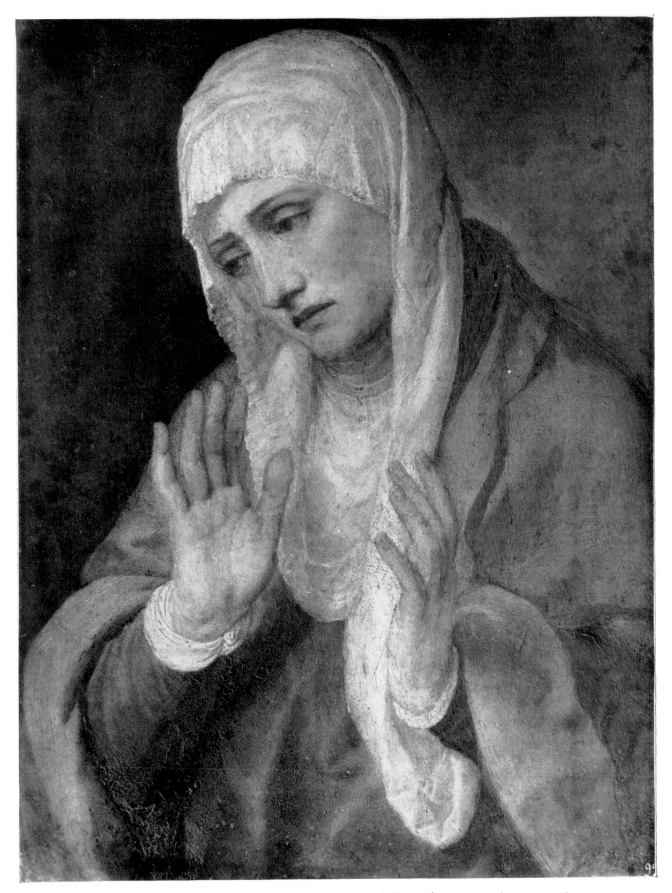

97. *Mater Dolorosa with Raised Hands.* 1554. Madrid, Prado Museum (Cat. no. 77)

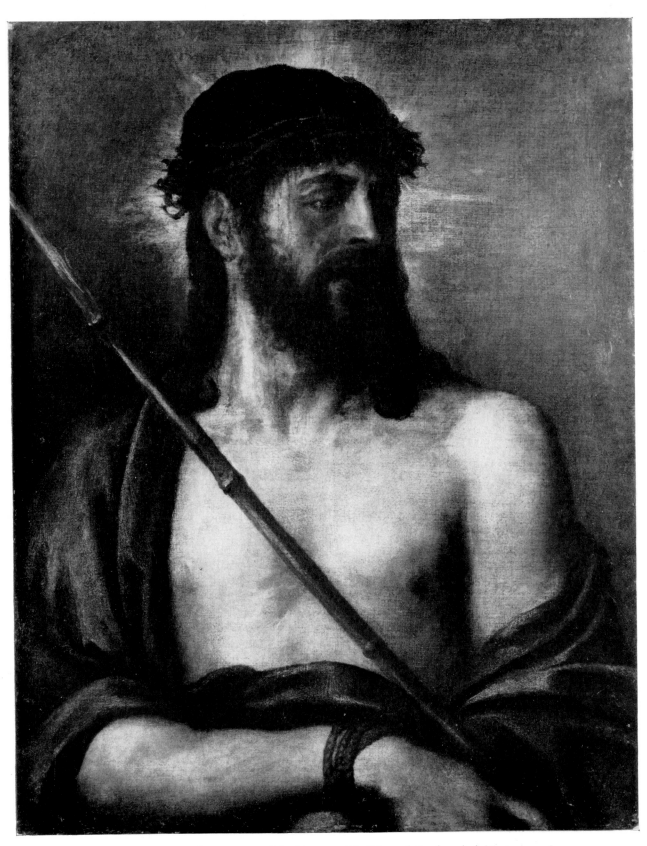

98. *Ecce Homo*. About 1560. Sibiu (Roumania), Muzeul Brukenthal (Cat. no. 33)

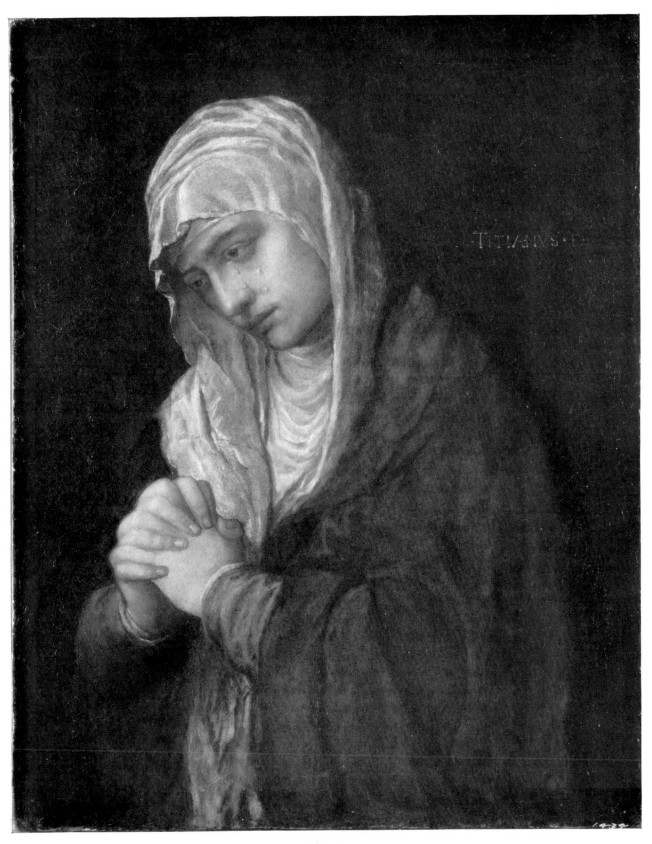

99. Follower of Titian: *Mater Dolorosa* (Teniers type). Sixteenth century. Unknown location
(Cat. no. 78, copy 7)

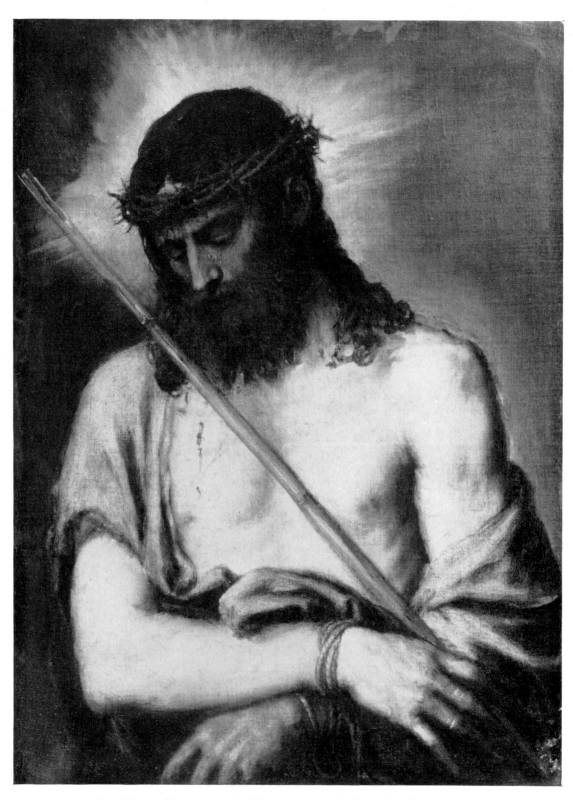

100. *Ecce Homo*. About 1560. Dublin, National Gallery of Ireland (Cat. no. 34)

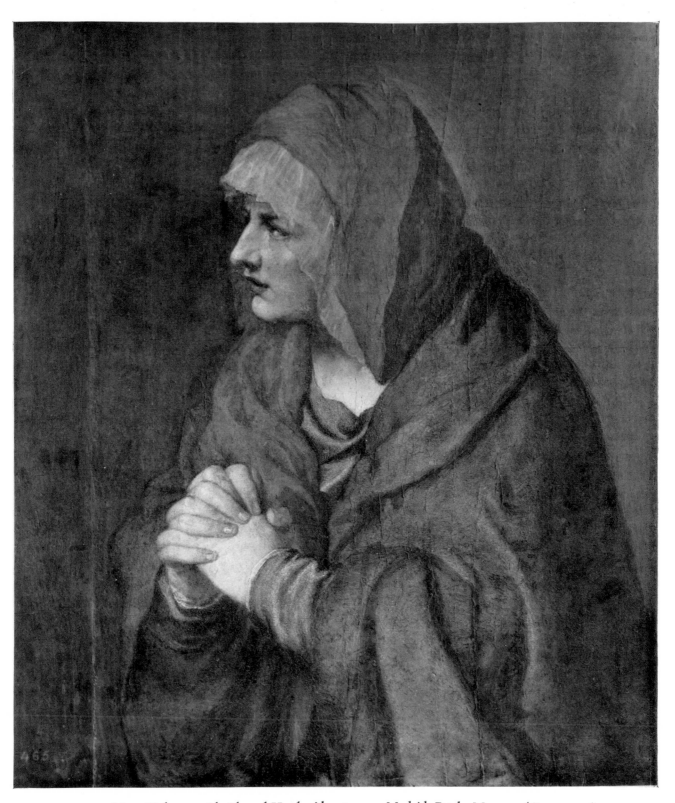

101. *Mater Dolorosa with Clasped Hands.* About 1555. Madrid, Prado Museum (Cat. no. 76)

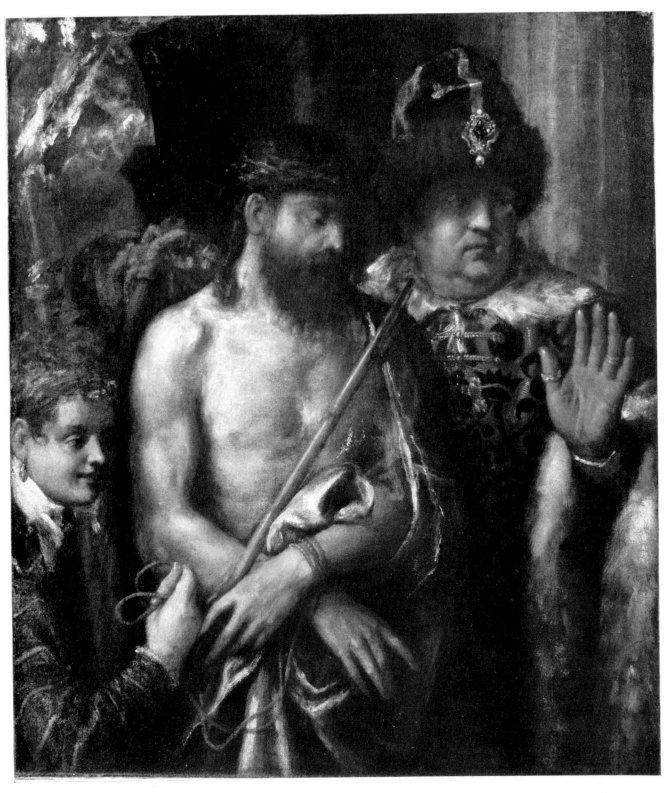

102. Titian and assistants: *Christ Mocked*. About 1575. St. Louis, City Art Museum (Cat. no. 28)

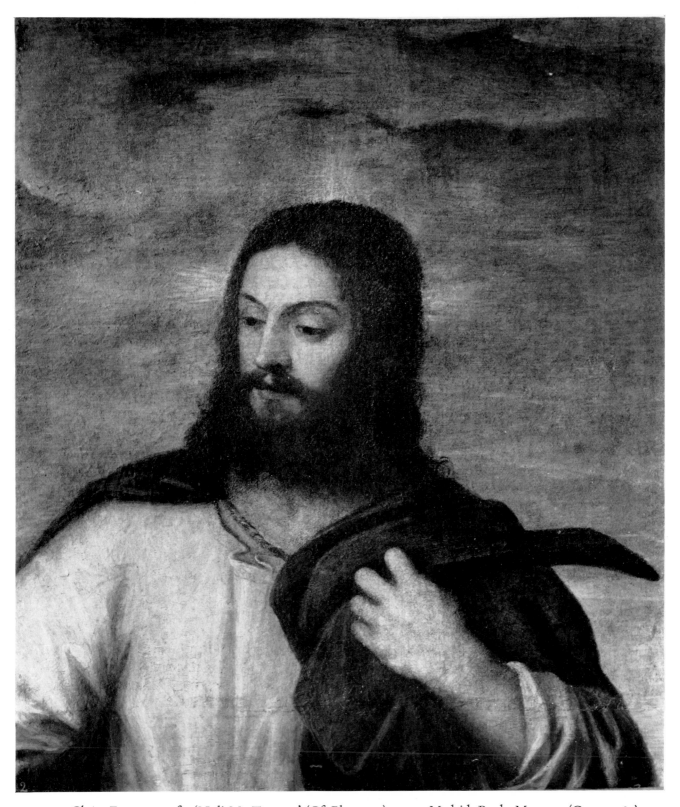

103. *Christ*. Fragment of a 'Noli Me Tangere' (Cf. Plate 230). 1553. Madrid, Prado Museum (Cat. no. 81)

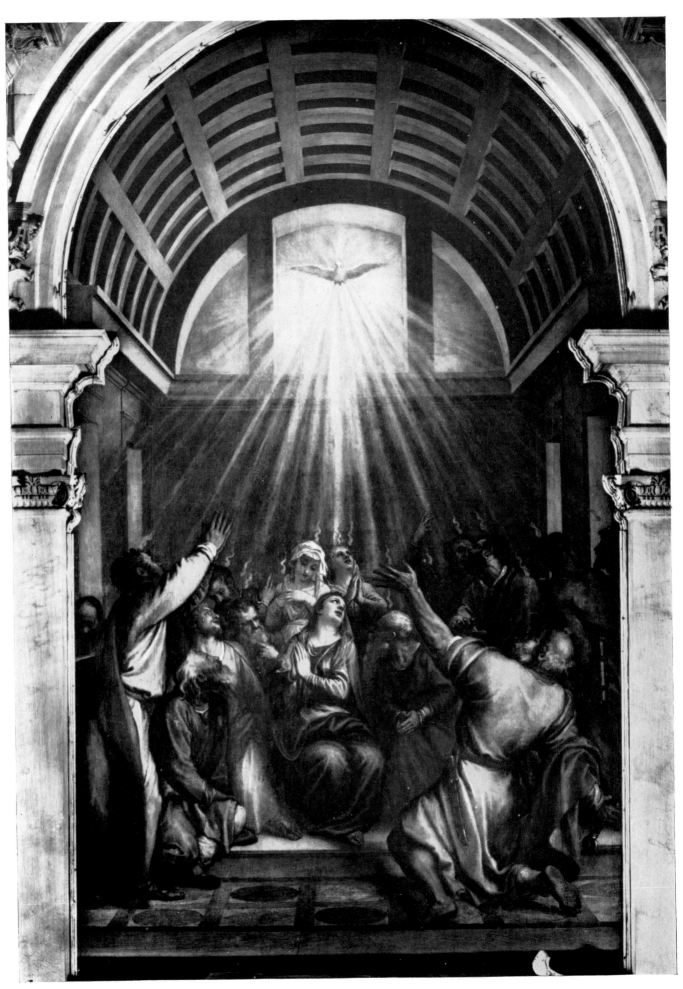

104. *Pentecost*. About 1550. Venice, S. Maria della Salute (Cat. no. 85)

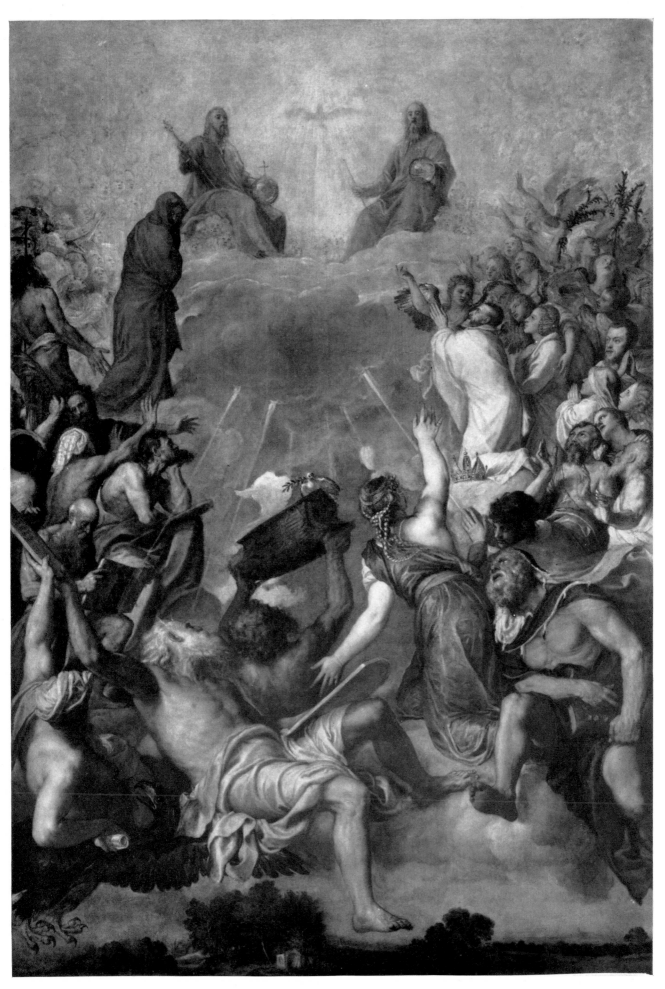

105. *Trinity* ('Gloria'). About 1551–1554. Madrid, Prado Museum (Cat. no. 149)

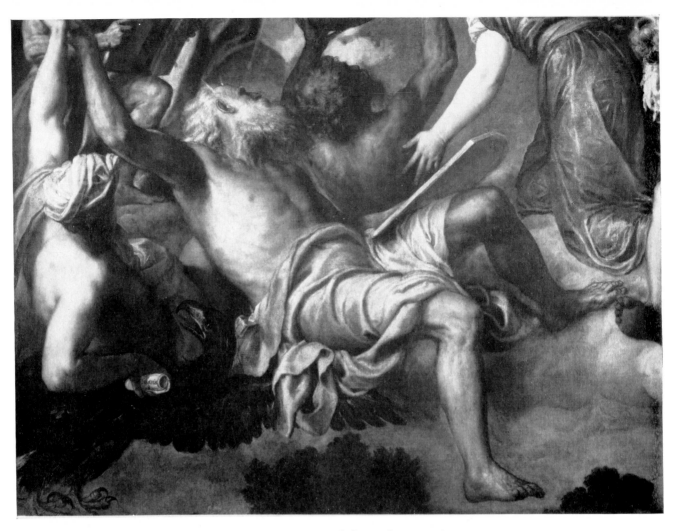

106. *Moses.* Detail from Plate 105

107. *Landscape.* Detail from Plate 105

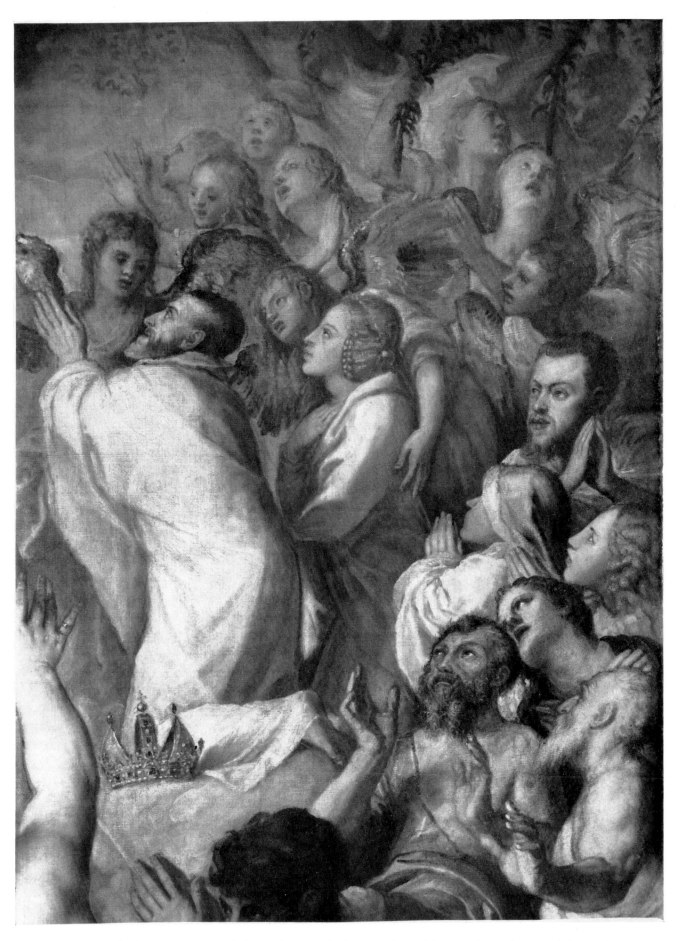

108. *Emperor Charles V, Empress Isabella, Philip II and other Members of the Royal Family*. Detail from Plate 105

109. *Noah*. Detail from Plate 105

110. *Temptation of Christ*. About 1540–1545. Minneapolis, Institute of Arts (Cat. no. 144)

III. Titian and workshop: *Apparition of Christ to the Madonna*. About 1554. Medole, S. Maria (Cat. no. 13)

112. *Christ on the Cross and the Good Thief.* About 1566. Bologna, Pinacoteca Nazionale (Cat. no. 30)

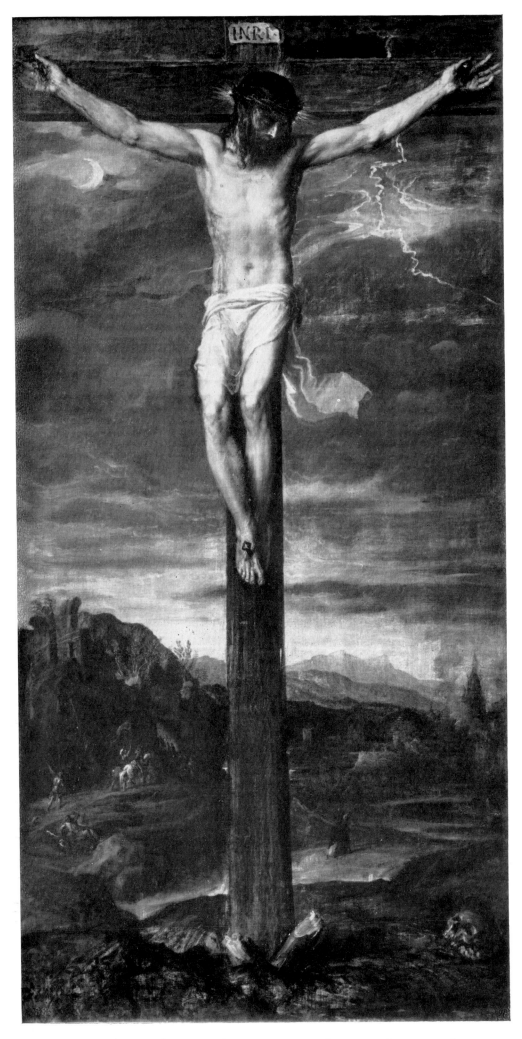

113. *Christ on the Cross*. About 1555. Escorial, Sacristy (Cat. no. 29)

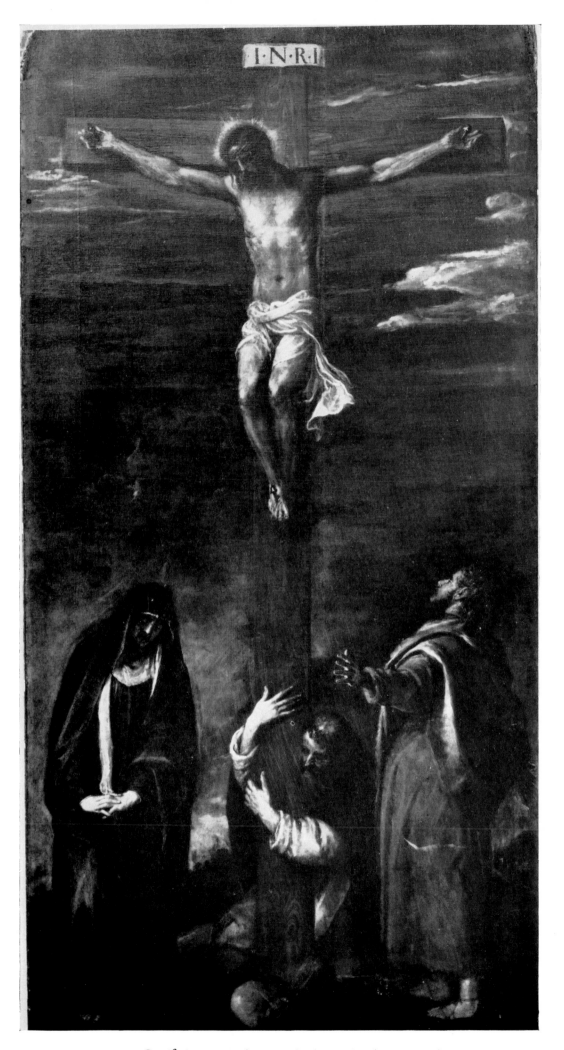

114. *Crucifixion.* 1558. Ancona, S. Domenico (Cat. no. 31)

115. *St. Dominic.* Detail from Plate 114

116. *Judas and four Apostles*. Detail from Plate 117

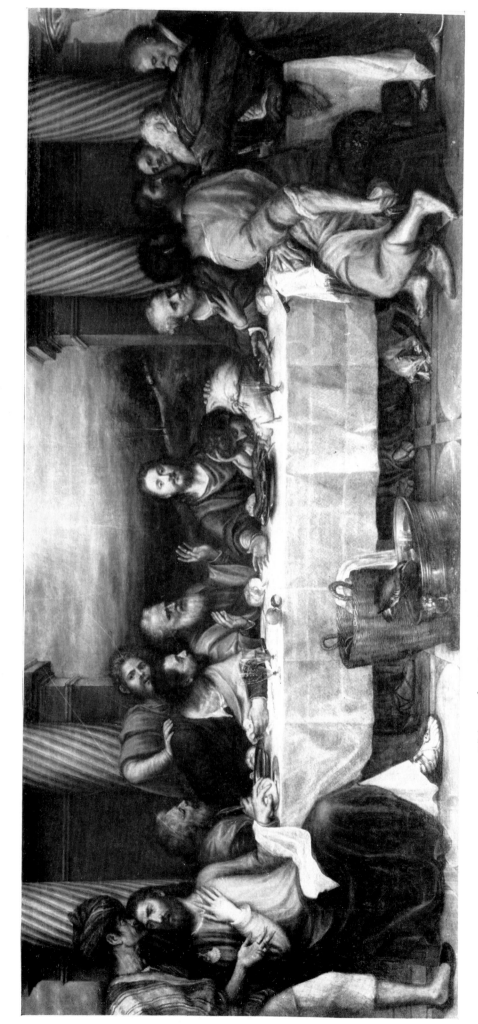

117. Titian and workshop: *Last Supper.* 1557–1564. Escorial, Nuevos Museos (Cat. no. 46)

118. *Still Life.* Detail from Plate 117

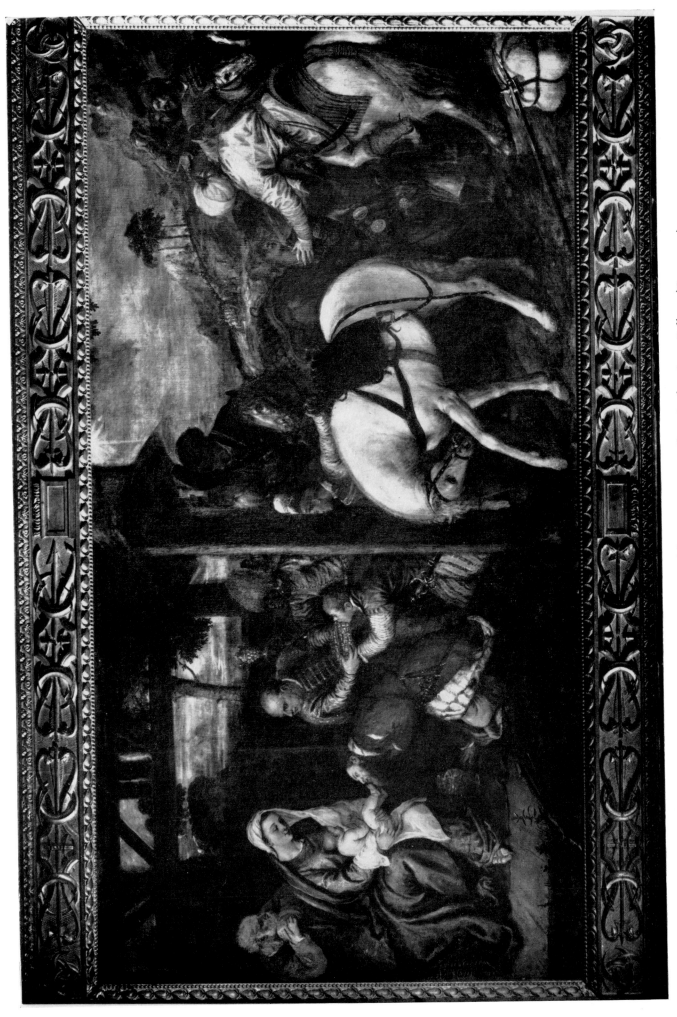

119. Titian and workshop: *Adoration of the Kings*. 1557. Milan, Ambrosiana Gallery (Cat. no. 2)

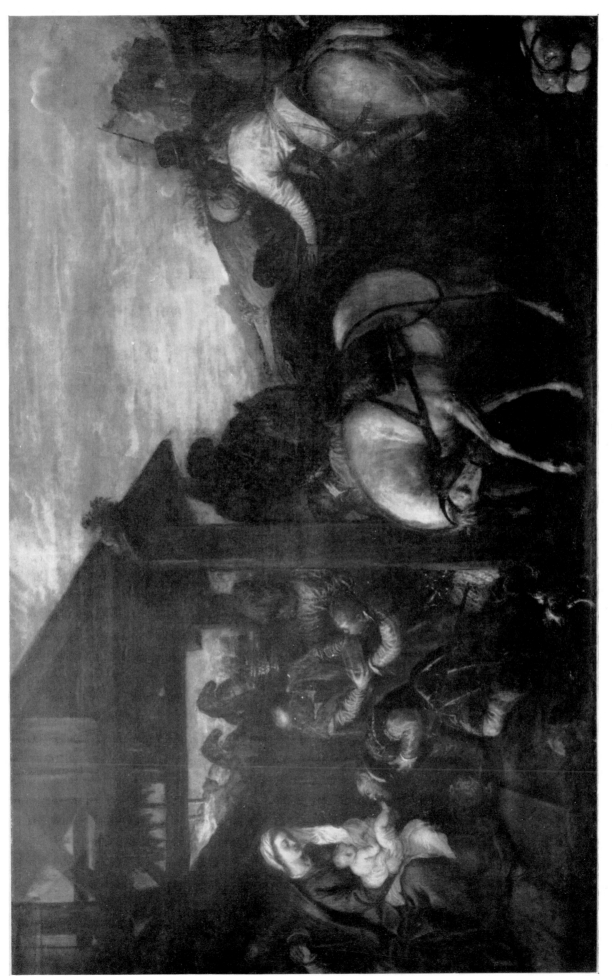

120. *Adoration of the Kings*. 1559–1560. Escorial, Nuevos Museos (Cat. no. 3)

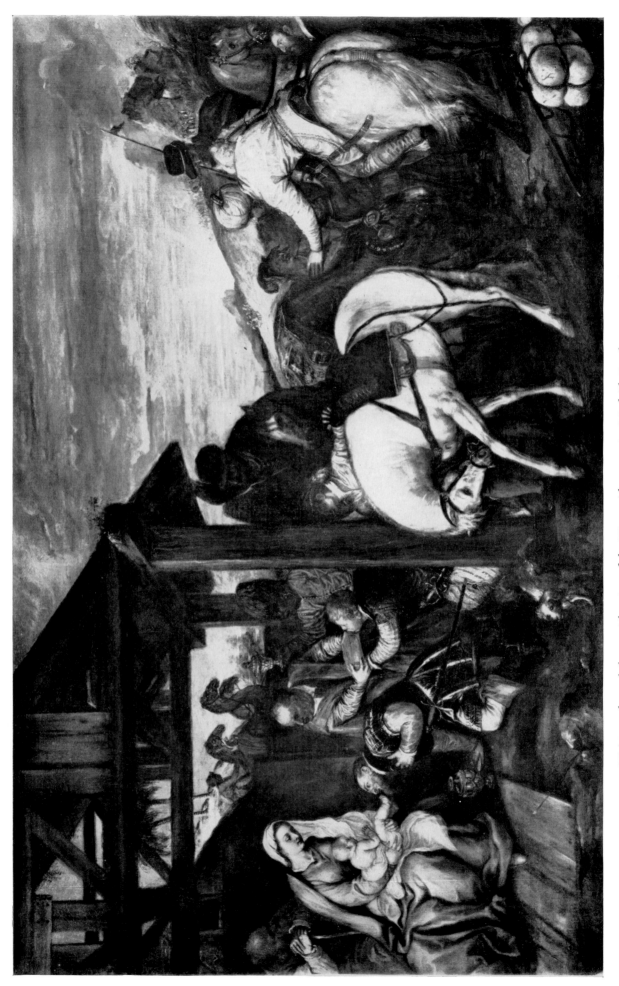

121. Titian and workshop: *Adoration of the Kings*. About 1560. Madrid, Prado Museum (Cat. no. 4)

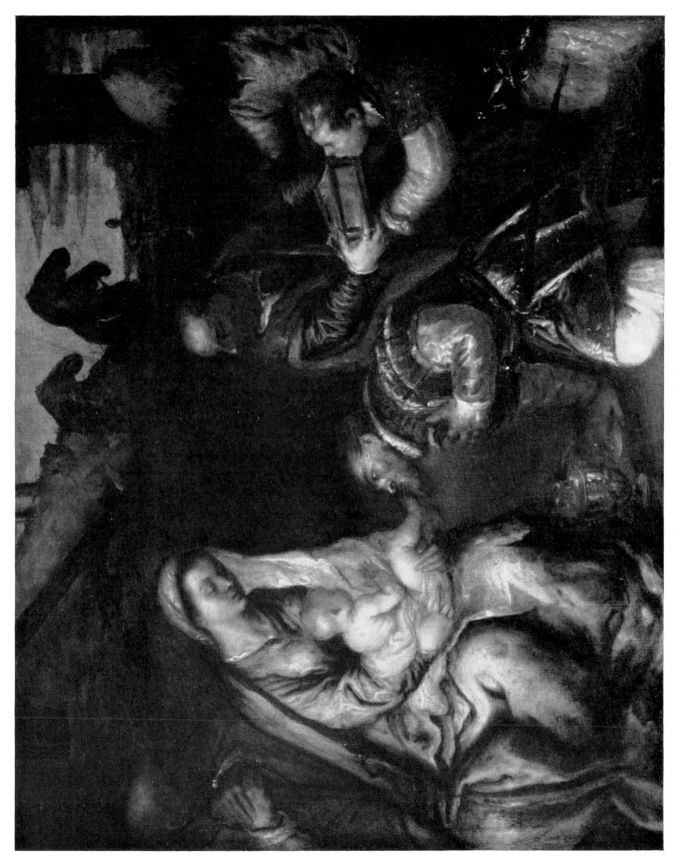

122. *Adoration of the Kings.* Detail from Plate 123

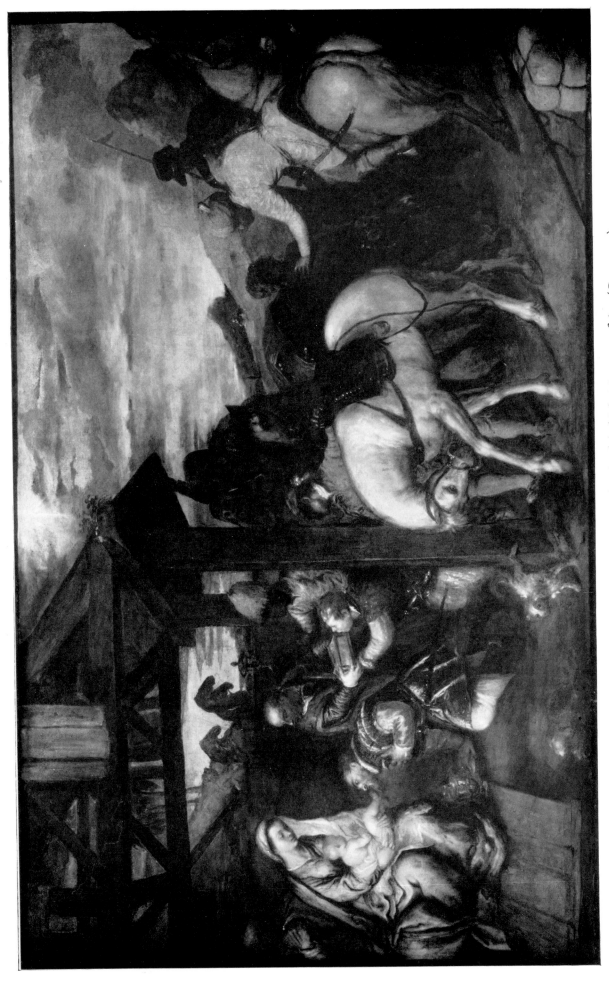

123. *Adoration of the Kings.* About 1566. Cleveland (Ohio), Museum of Art (Cat. no. 5)

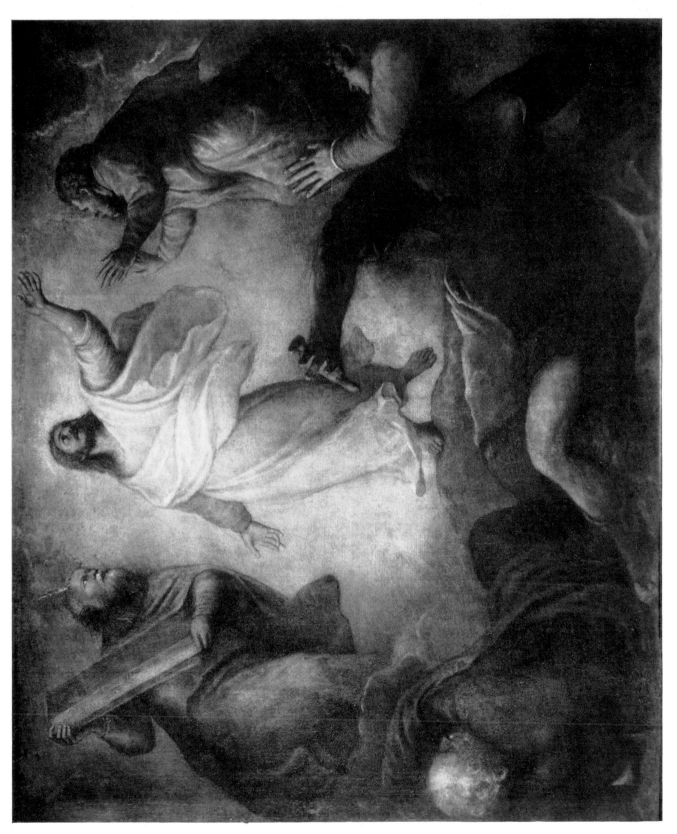

124. *Transfiguration*. About 1560–1565. Venice, S. Salvatore (Cat. no. 146)

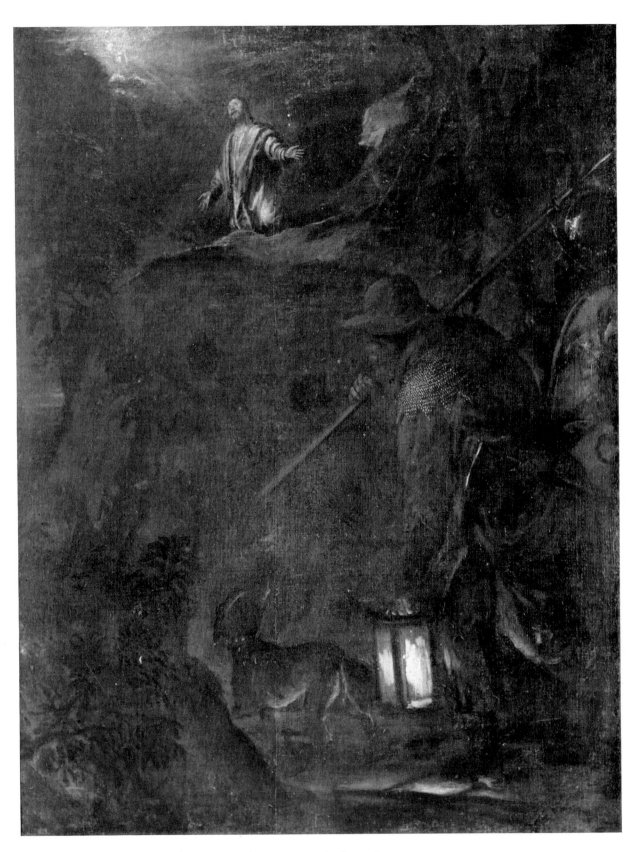

125. *Agony in the Garden.* 1562. Madrid, Prado Museum (Cat. no. 6)

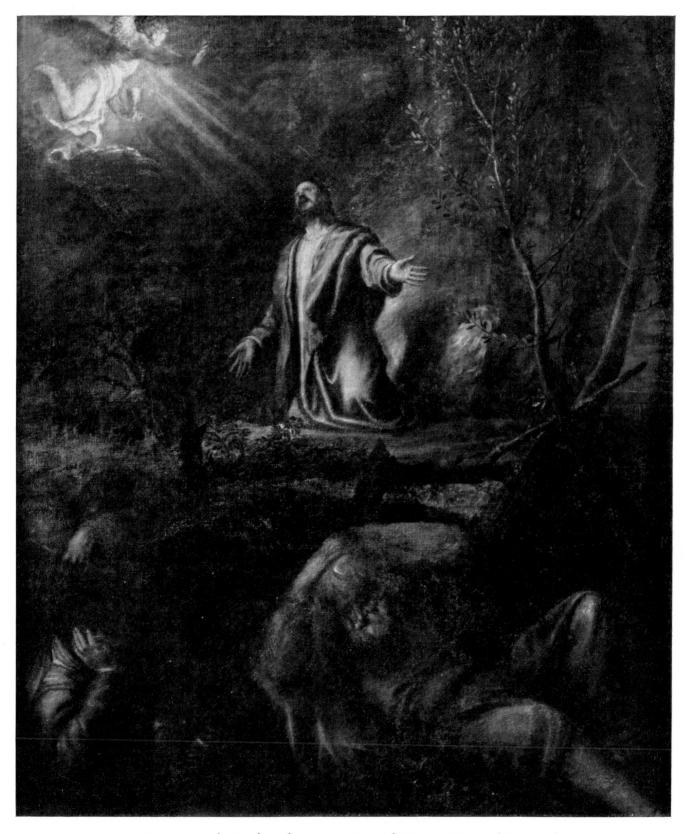

126. *Agony in the Garden*. About 1563. Escorial, Nuevos Museos (Cat. no. 7)

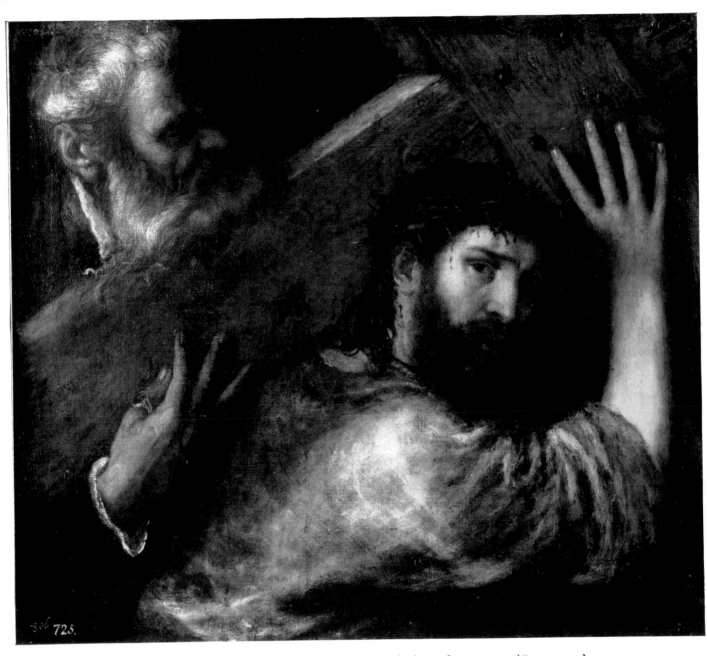

127. *Christ Carrying the Cross.* About 1565. Madrid, Prado Museum (Cat. no. 24)

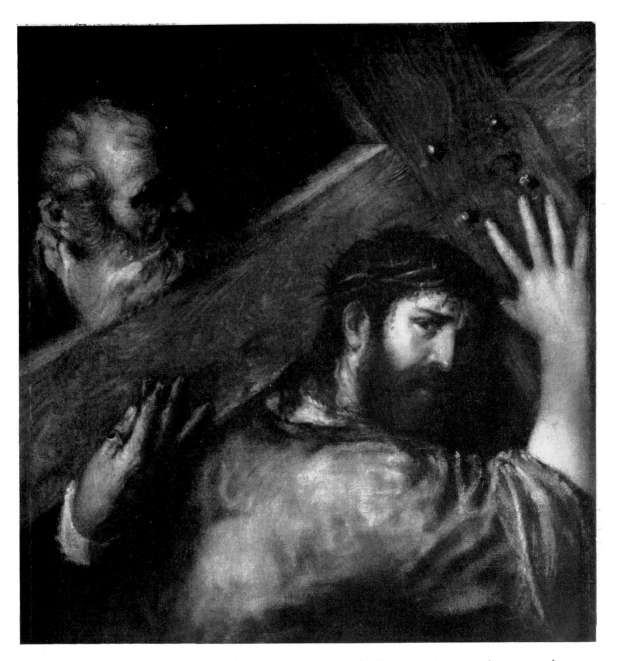

128. *Christ Carrying the Cross*. About 1565. Leningrad, Hermitage Museum (Cat. no. 25)

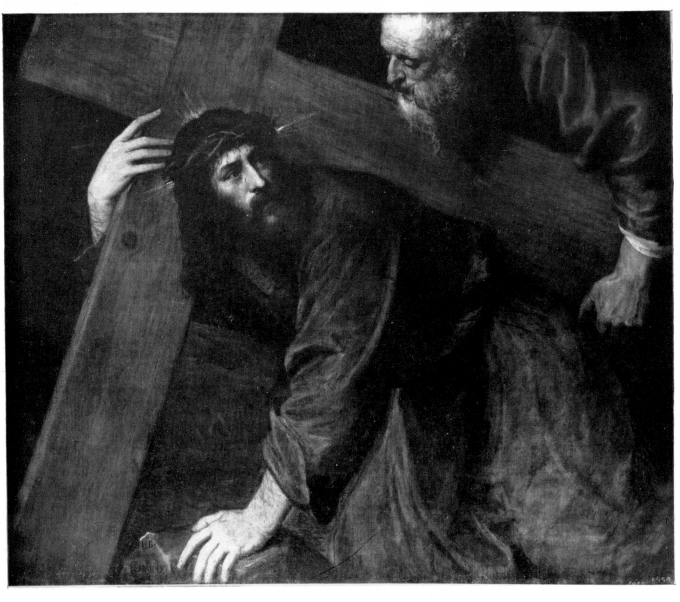

129. *Christ Carrying the Cross.* About 1560. Madrid, Prado Museum (Cat. no. 23)

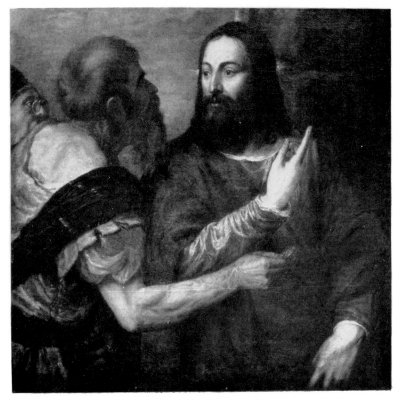

130. Sixteenth-century copy after Titian: *Tribute Money* (Cf. Plate 131).
Seville, Duque del Infantado (Cat. no. 148, copy 3)

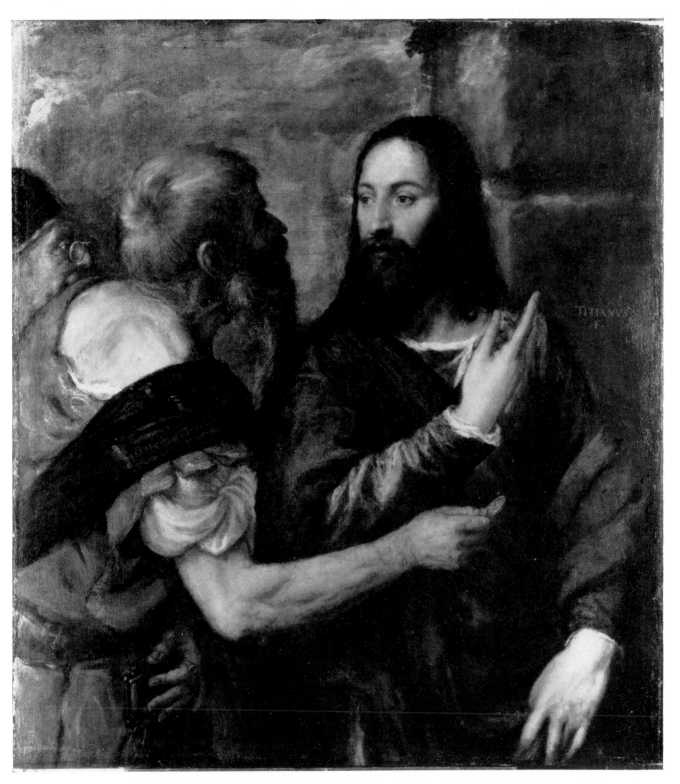

131. *Tribute Money*. 1568. London, National Gallery (Cat. no. 148)

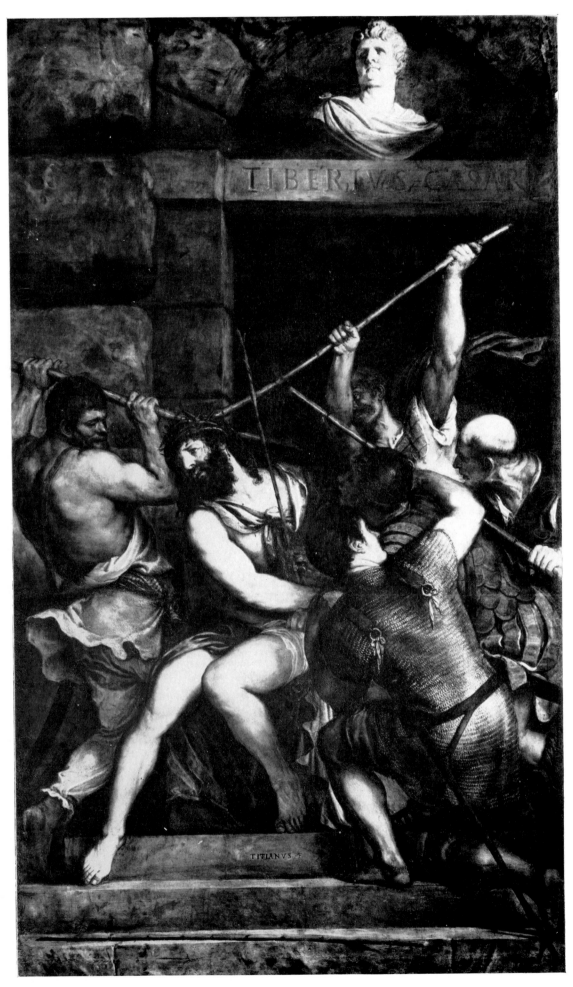

132. *Christ Crowned with Thorns*. About 1546–1550. Paris, Louvre (Cat. no. 26)

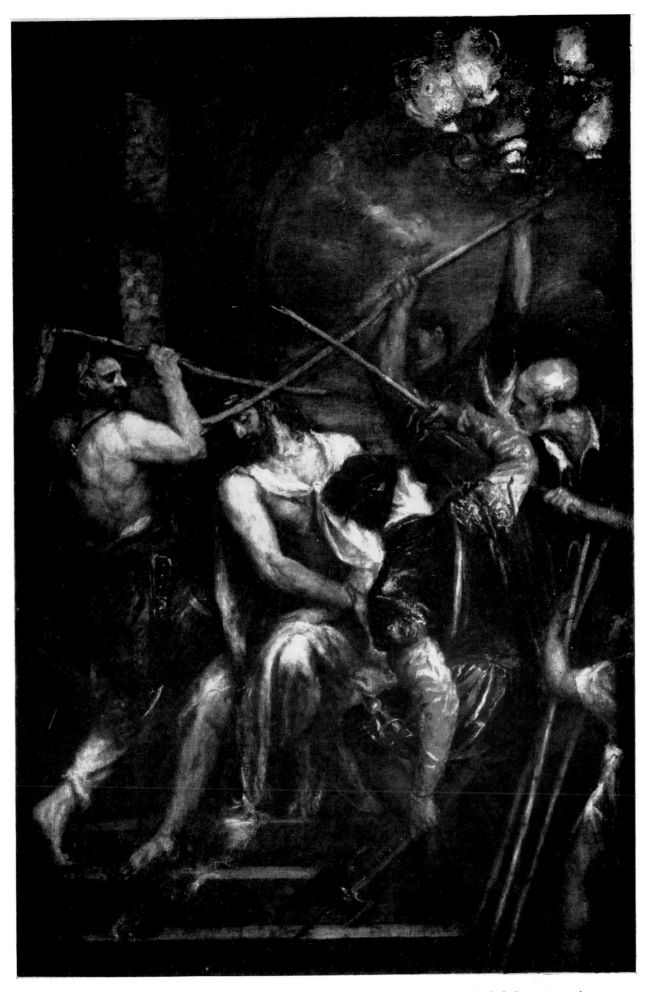

133. *Christ Crowned with Thorns.* About 1570–1576. Munich, Alte Pinakothek (Cat. no. 27)

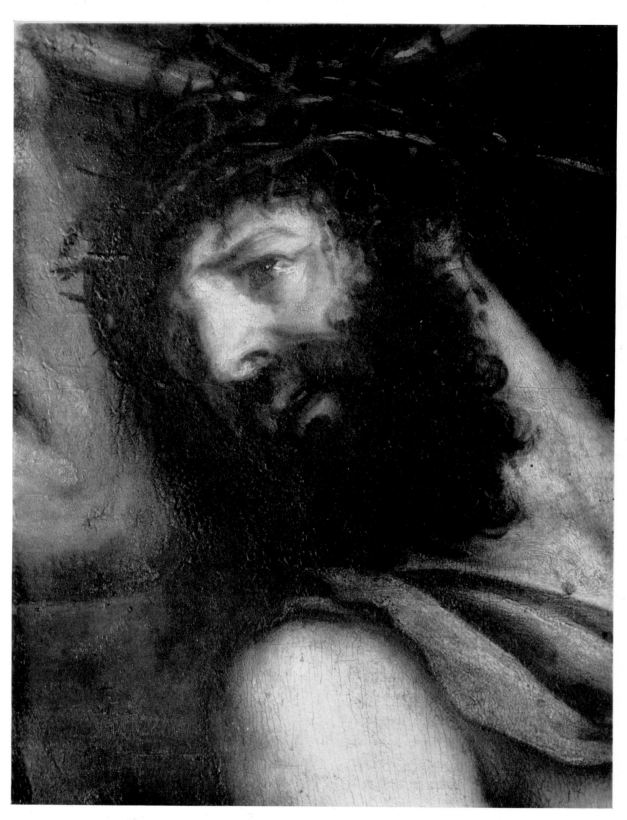

134. *Head of Christ*. Detail from Plate 132

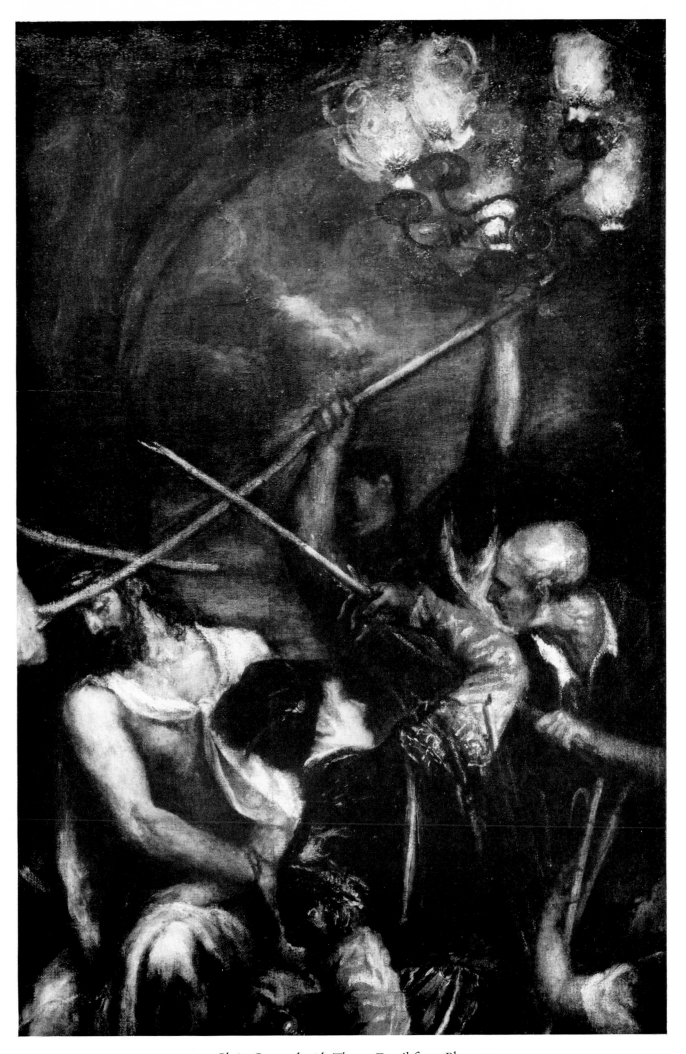

135. *Christ Crowned with Thorns*. Detail from Plate 133

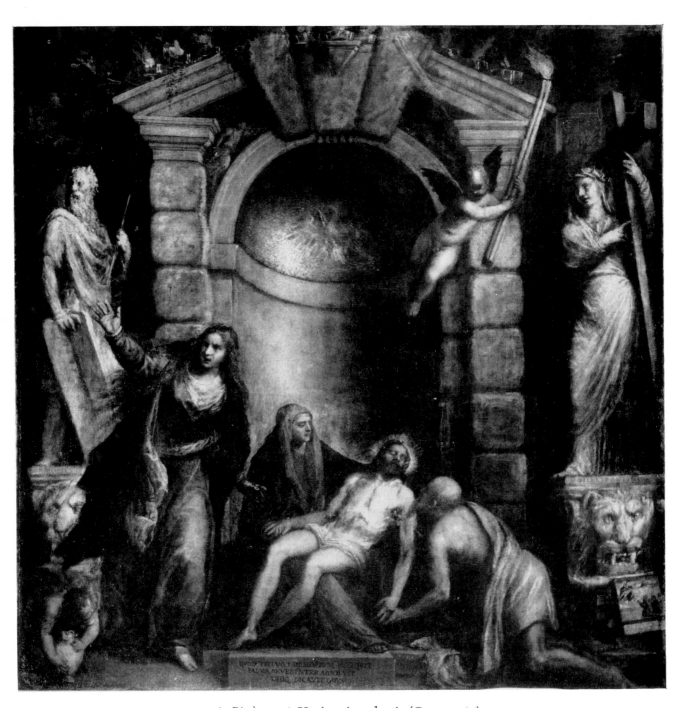

136. *Pietà*. 1576. Venice, Accademia (Cat. no. 86)

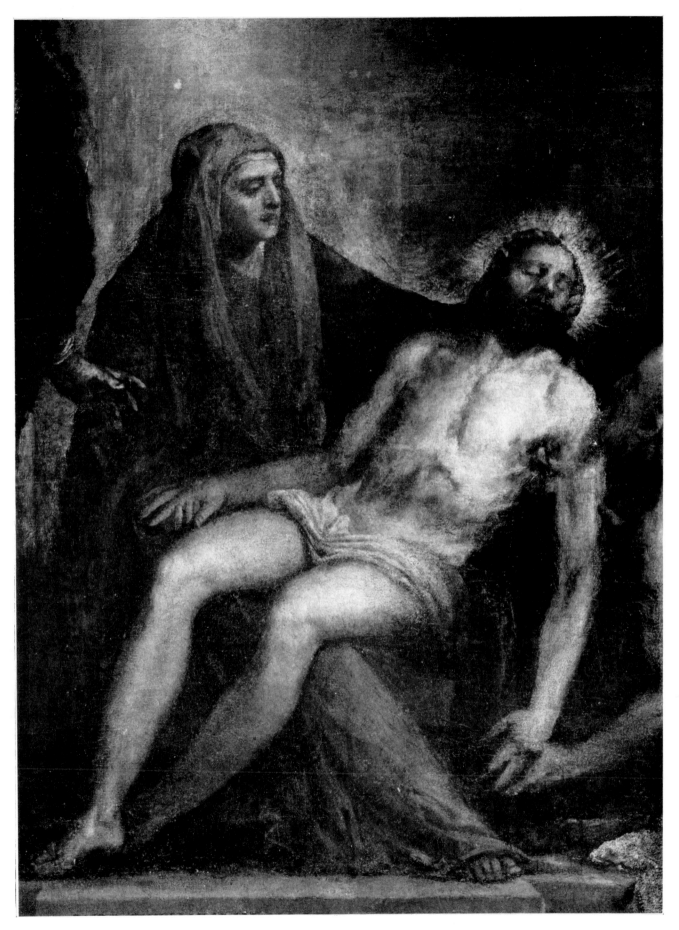

137. *Dead Christ and Mourning Virgin.* Detail from Plate 136

138. *Moses*. Detail from Plate 136

SAINTS AND OTHER
RELIGIOUS THEMES

139. *St. Anthony—Miracle of the Speaking Infant.* 1510–1511. Padua, Scuola del Santo (Cat. no. 93)

140. *St. Anthony holding the Infant.* Detail from Plate 139

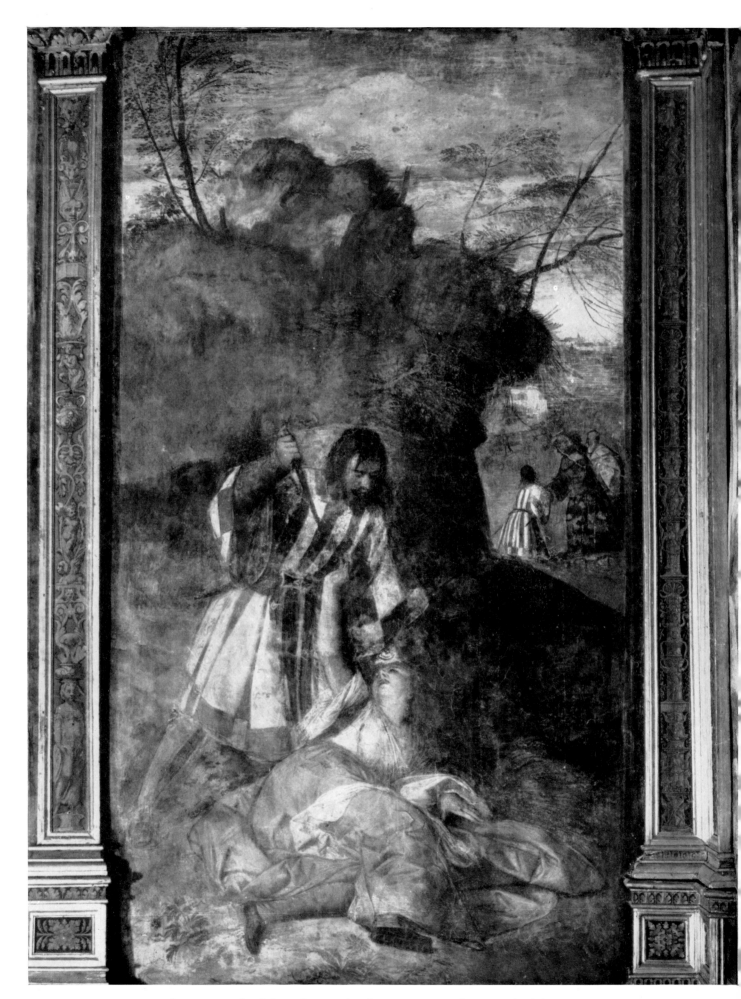

141. *St. Anthony—Miracle of the Jealous Husband.* 1510–1511. Padua, Scuola del Santo (Cat. no. 95)

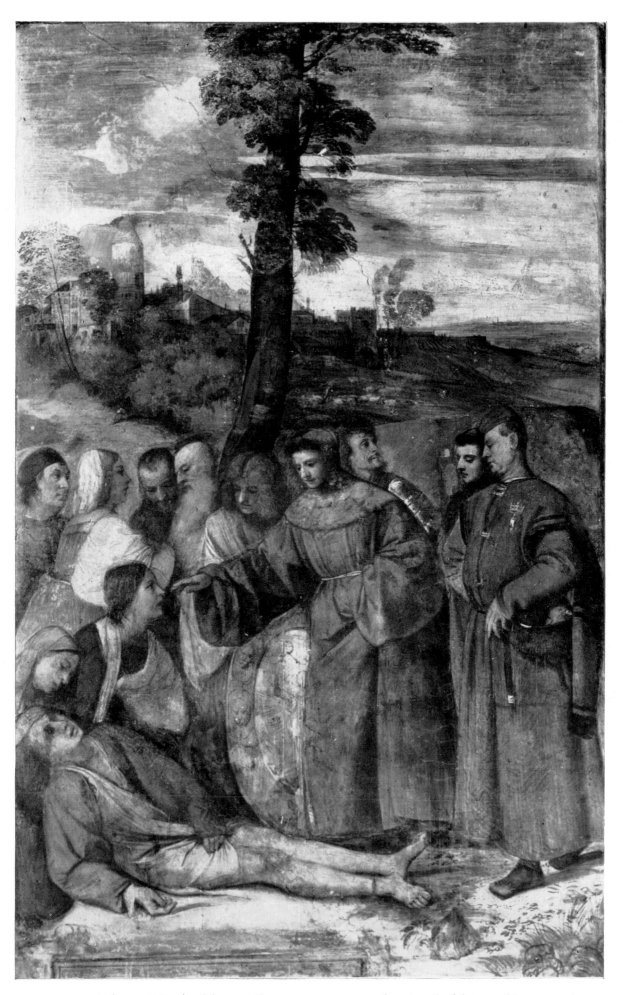

142. *St. Anthony—Miracle of the Irascible Son.* 1510–1511. Padua, Scuola del Santo (Cat. no. 94)

143. *Landscape*. Detail from Plate 142

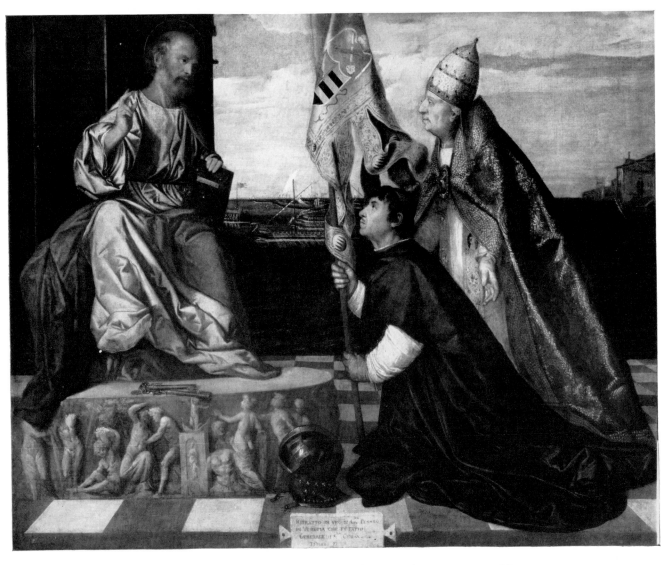

144. *St. Peter Enthroned, Adored by Pope Alexander VI and Jacopo Pesaro*. About 1512.
Antwerp, Musée Royal des Beaux-Arts (Cat. no. 132)

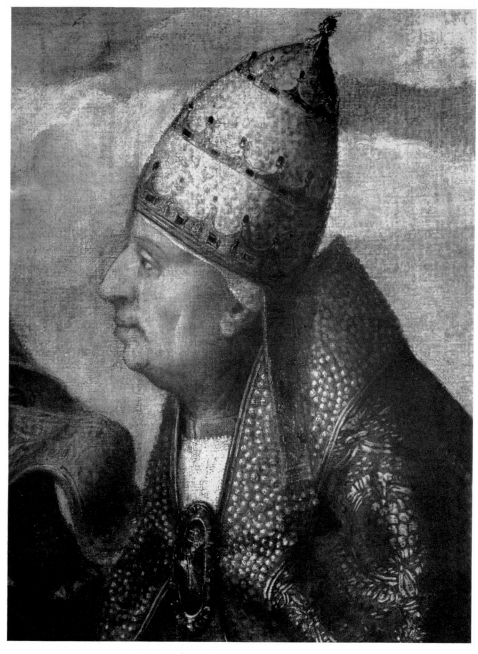

145. *Pope Alexander VI.* Detail from Plate 144

RITRATTO DI VÑO DI CA
IN VENETIA CHE FV FAT
GENERALE DI S.TA CHIE

146. *Pedestal with Relief.* Detail from Plate 144

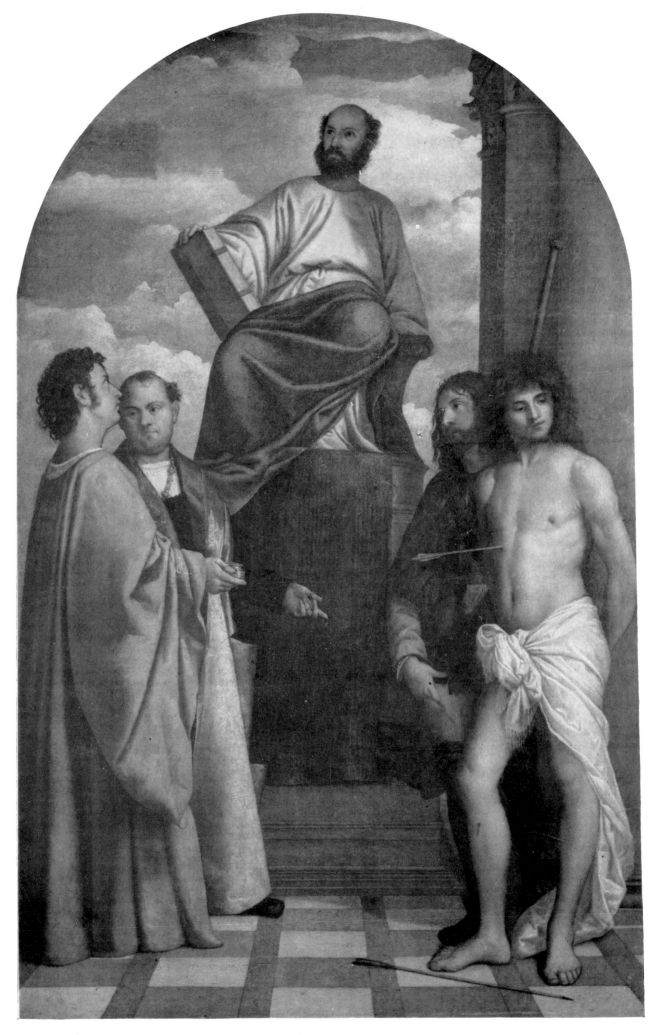

147. *St. Mark Enthroned*. About 1511–1512. Venice, S. Maria della Salute (Cat. no. 119)

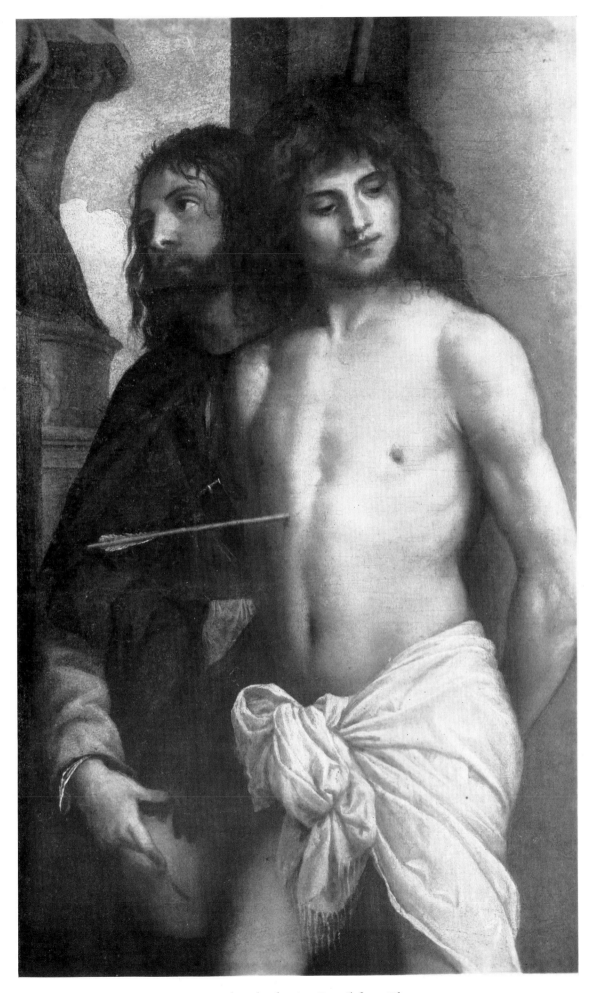

148. *SS. Roch and Sebastian.* Detail from Plate 147

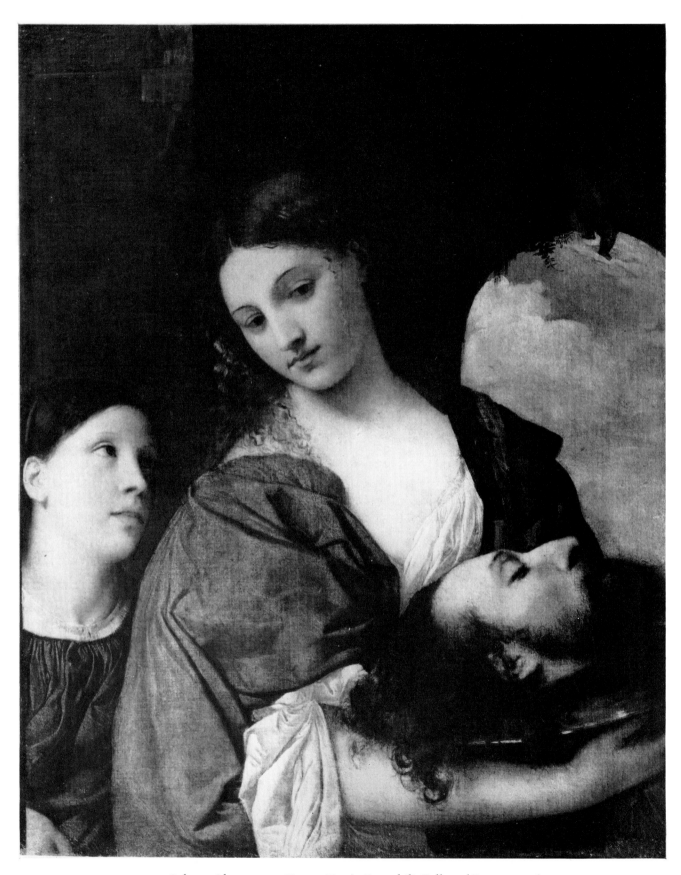

149. *Salome*. About 1515. Rome, Doria Pamphili Gallery (Cat. no. 137)

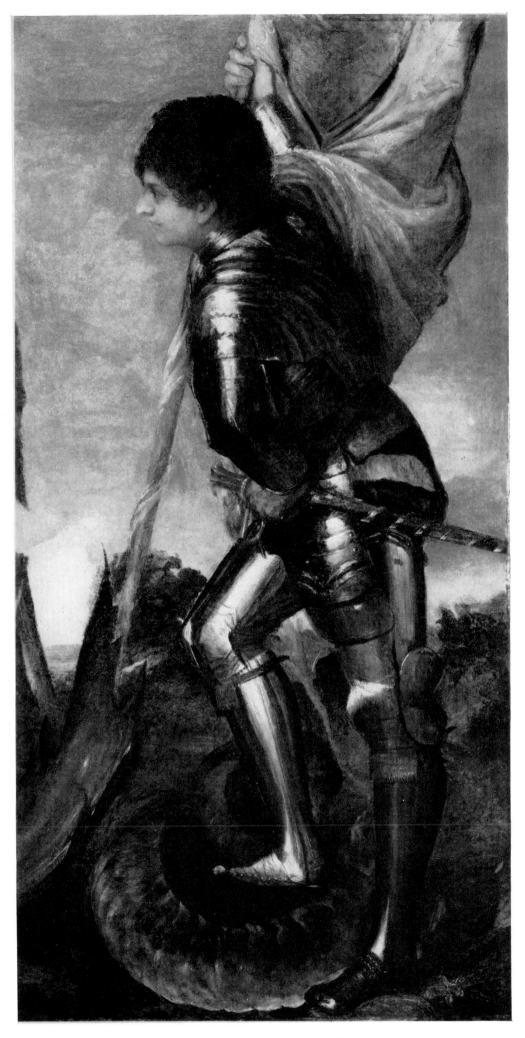

150. *St. George*. About 1516. Venice, Cini Collection (Cat. no. 102)

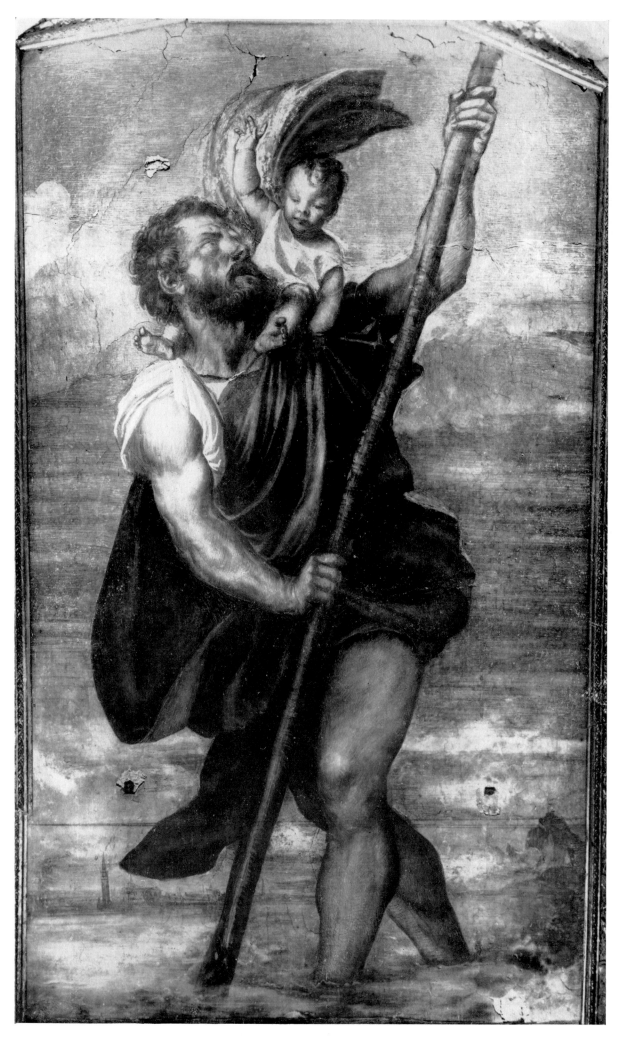

151. *St. Christopher*. About 1523. Venice, Ducal Palace (Cat. no. 98)

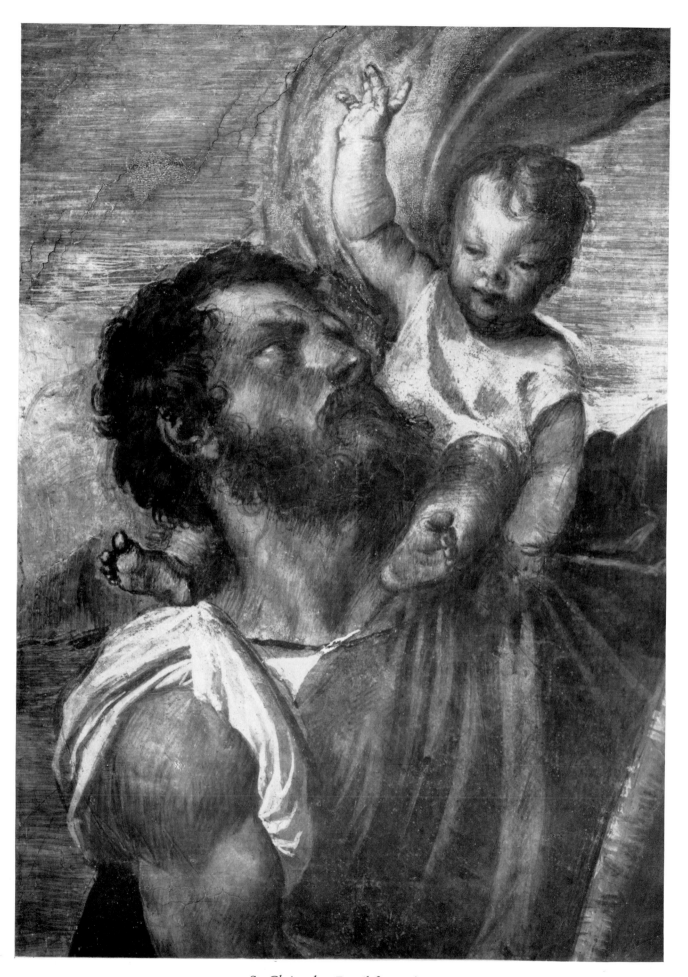

152. *St. Christopher*. Detail from Plate 151

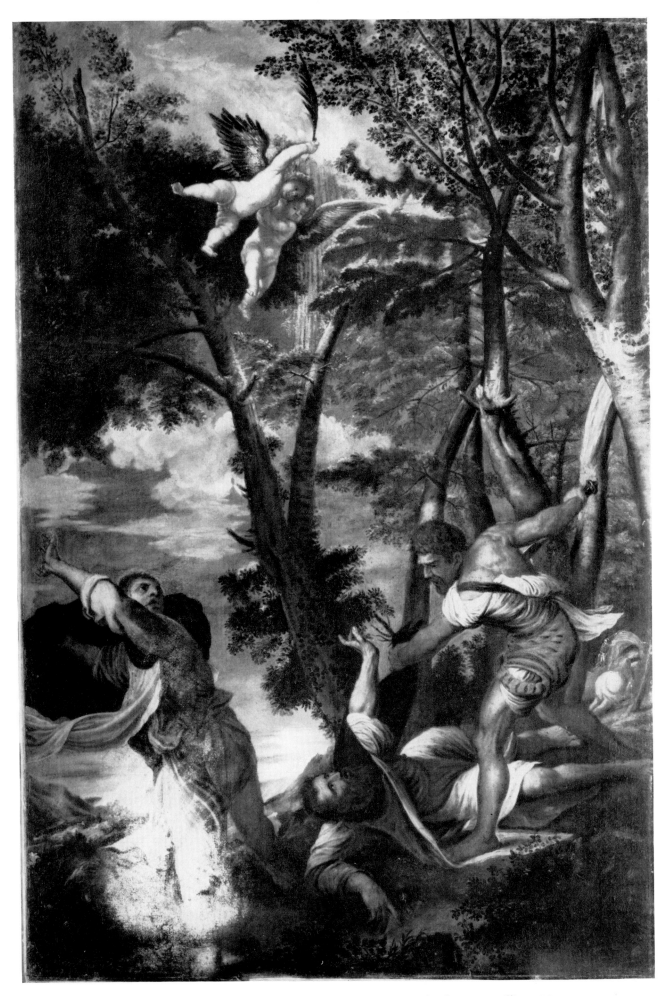

153. Copy after Titian: *Martyrdom of St. Peter Martyr*. Cambridge, Fitzwilliam Museum
(Cat. no. 133, copy 3)

154. Martin Rota, woodcut after Titian: *Martyrdom of St. Peter Martyr* (Cat. no. 133, replica 1)

155. *St. Jerome in Penitence.* About 1531. Paris, Louvre (Cat. no. 104)

156. *Vision of St. John the Evangelist on Patmos.* 1544–1547. Washington, National Gallery of Art, Samuel H. Kress Collection
(Cat. no. 111)

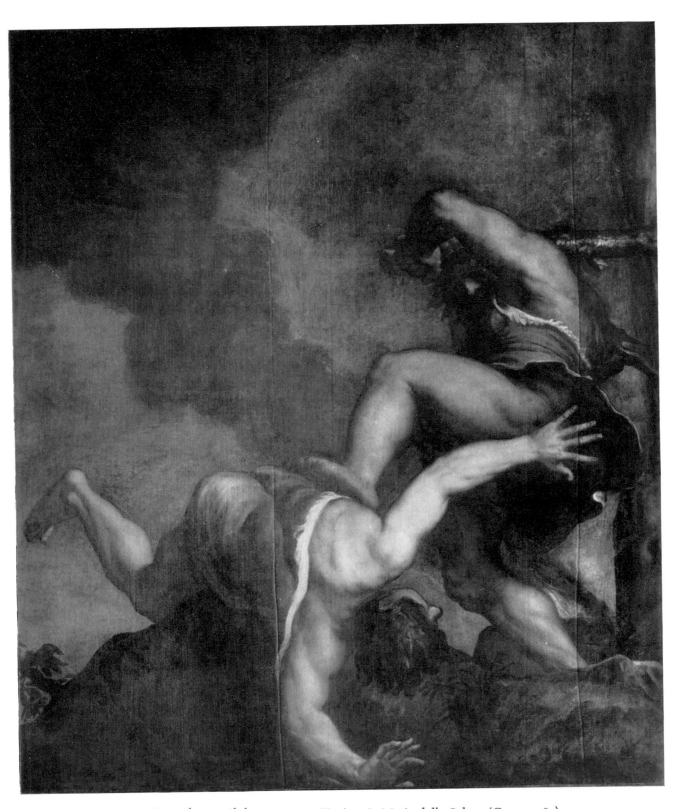

157. *Cain Slaying Abel*. 1543–1544. Venice, S. Maria della Salute (Cat. no. 82)

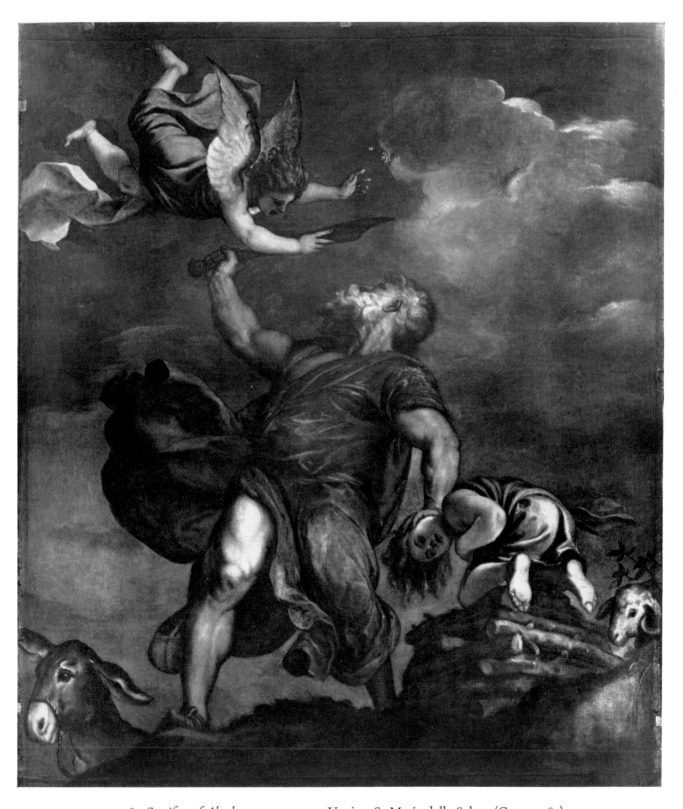

158. *Sacrifice of Abraham*. 1543–1544. Venice, S. Maria della Salute (Cat. no. 83)

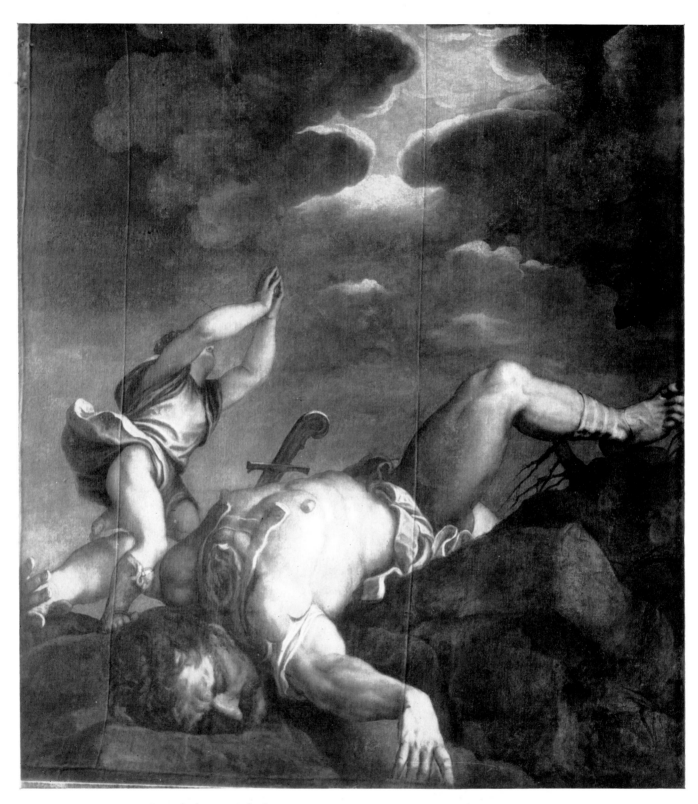

159. *David Slaying Goliath*. 1543–1544. Venice, S. Maria della Salute (Cat. no. 84)

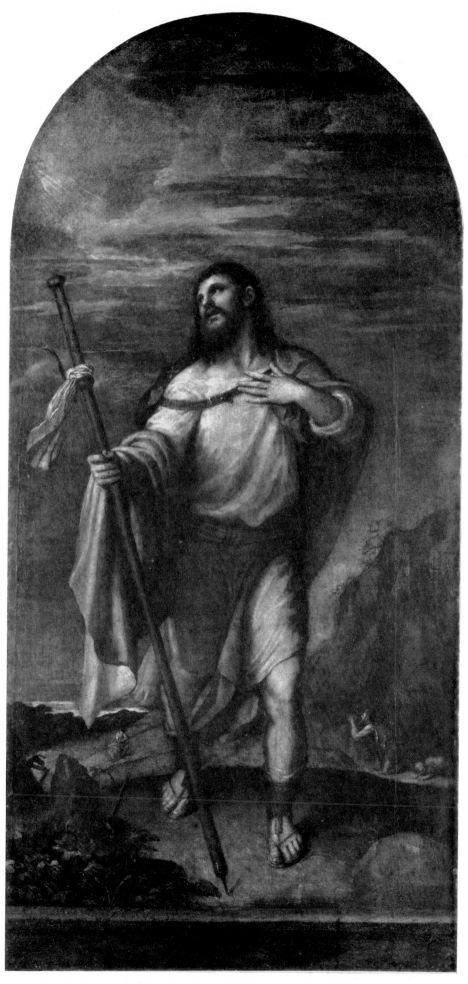

160. *St. James Major*. About 1550. Venice, S. Lio (Cat. no. 103)

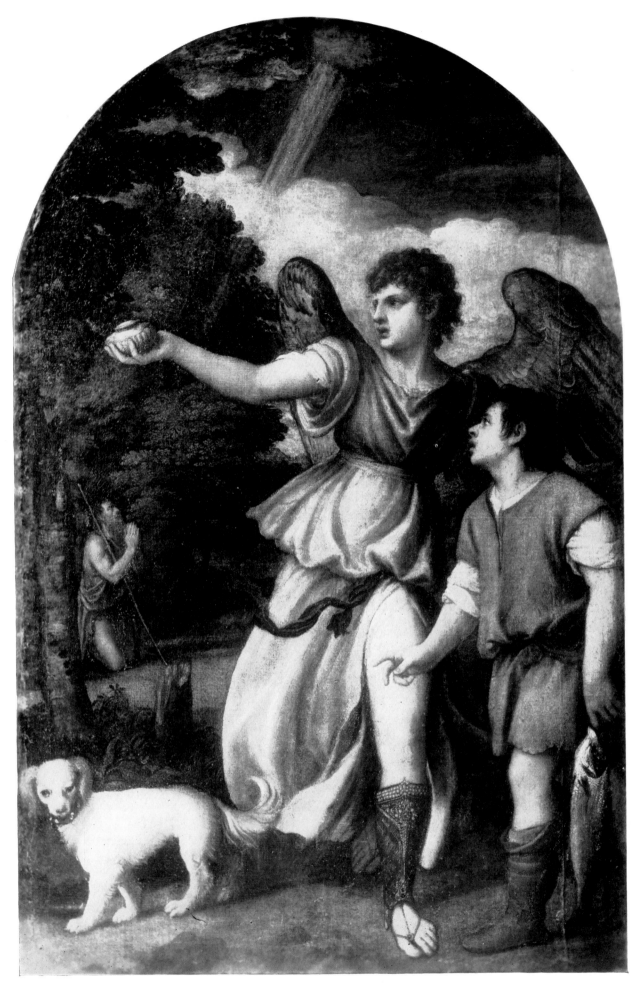

161. *Tobias and the Angel.* About 1550. Venice, S. Marziale (Cat. no. 145)

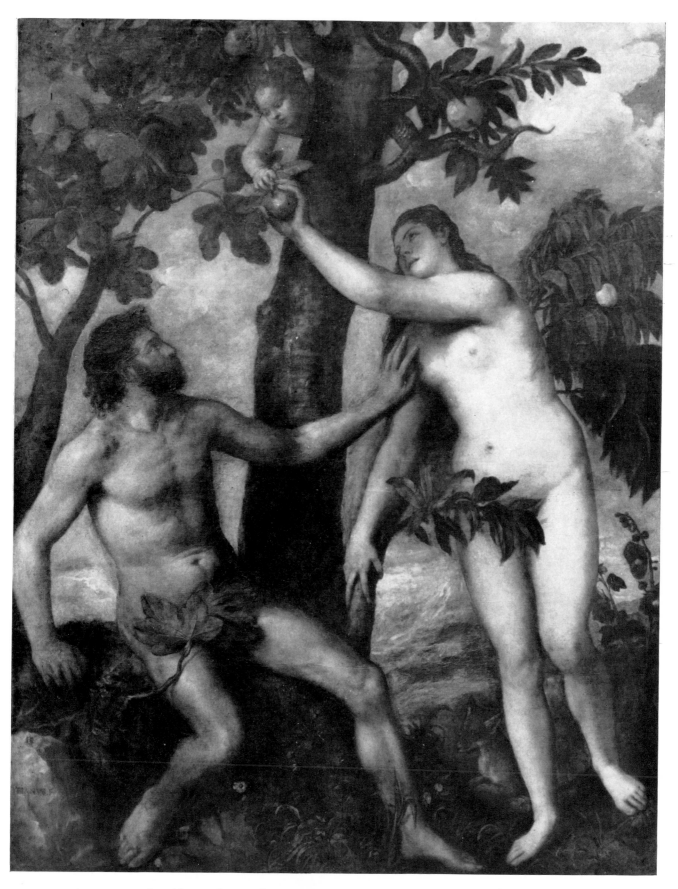

162. *Adam and Eve*. About 1550. Madrid, Prado Museum (Cat. no. 1)

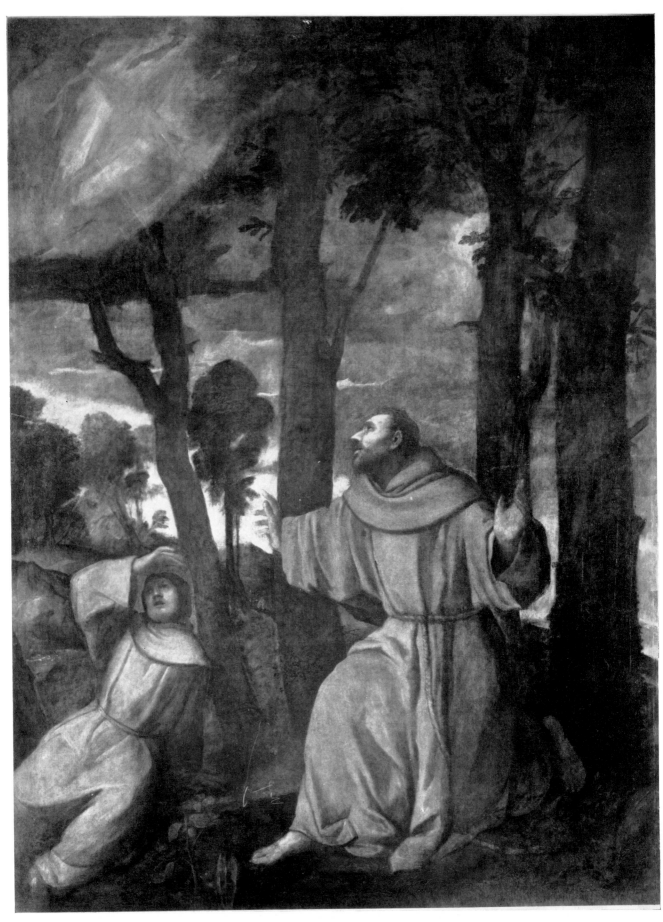

163. *St. Francis Receiving the Stigmata.* About 1545–1550. Trapani, Museo Pepoli (Cat. no. 100)

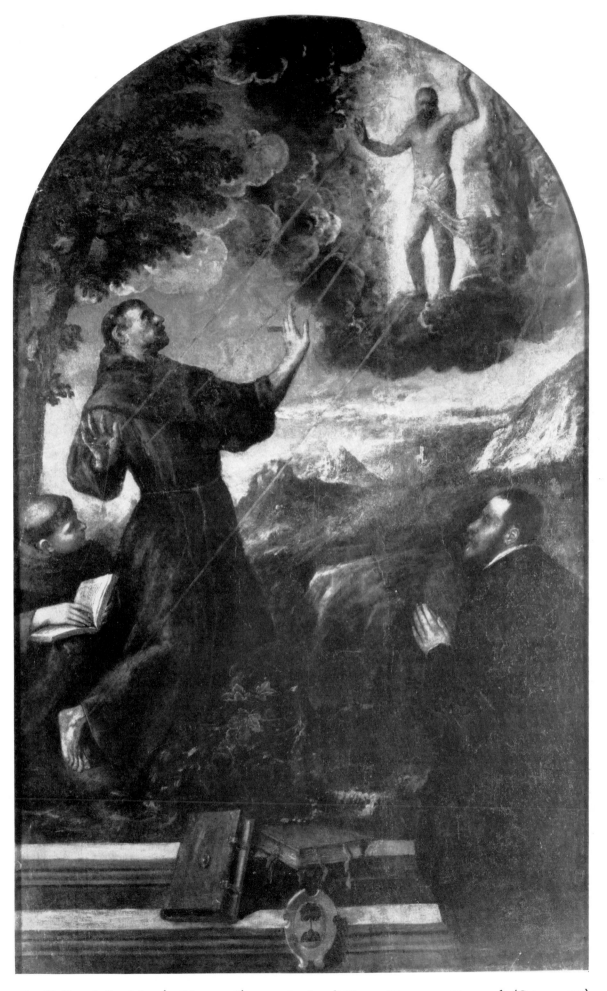

164. *St. Francis Receiving the Stigmata*. About 1561. Ascoli Piceno, Pinacoteca Comunale (Cat. no. 101)

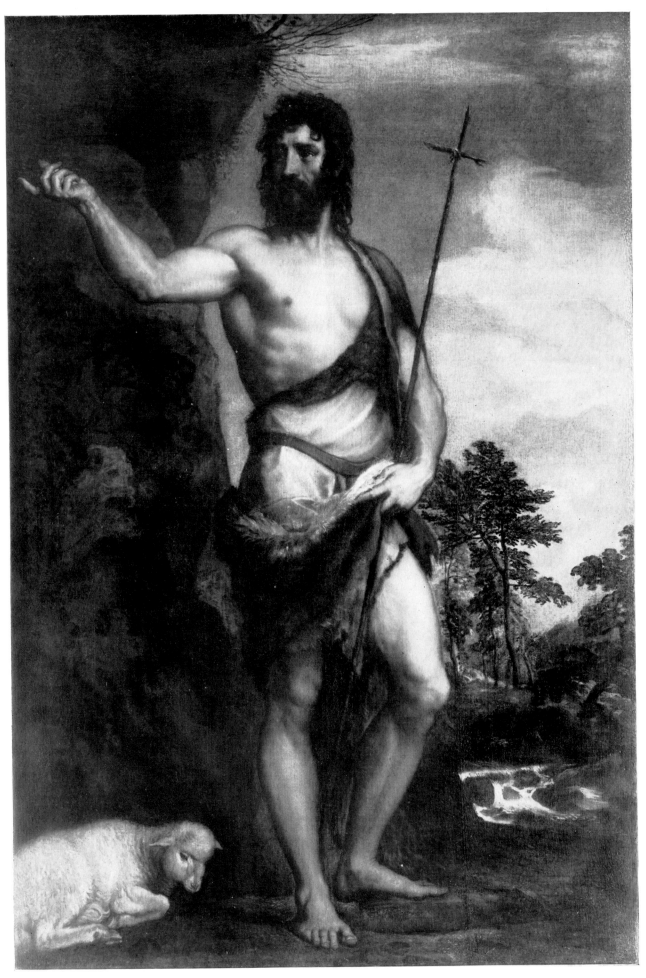

165. *St. John the Baptist*. About 1545–1550. Venice, Accademia (Cat. no. 109)

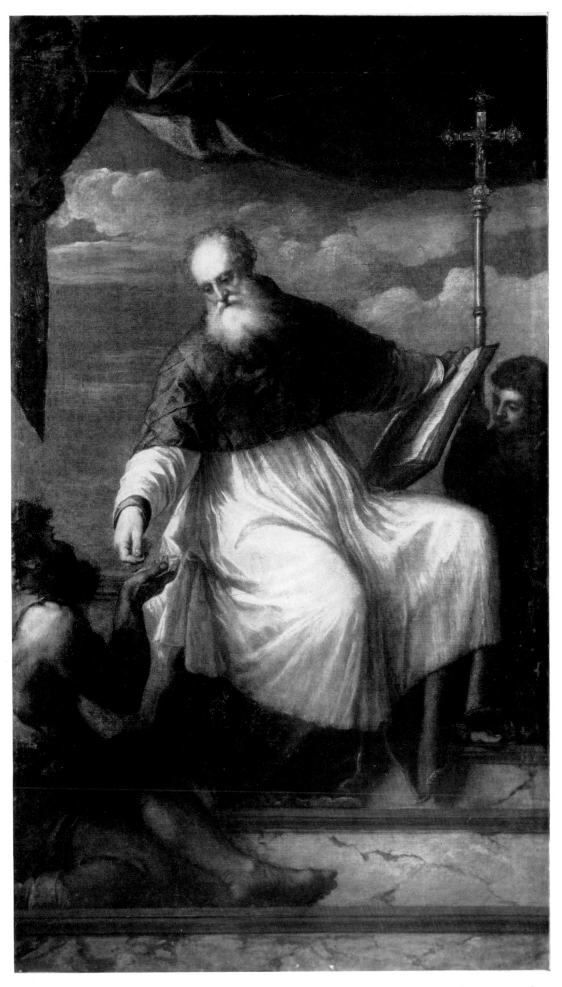

166. *St. John the Hospitaller.* About 1550. Venice, S. Giovanni Elemosinario (Cat. no. 113)

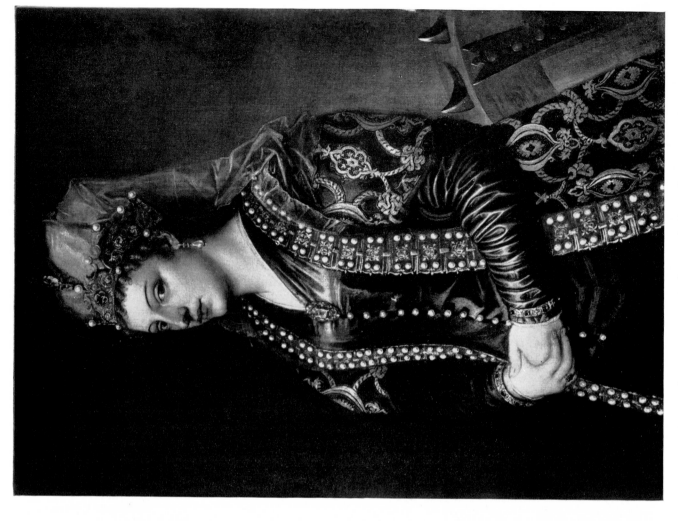

168. Copy after Titian: *St. Catherine of Alexandria*. Sixteenth century. Florence, Uffizi (Cat. no. 97)

167. *St. John the Baptist* (damaged). About 1560. Escorial, Nuevos Museos (Cat. no. 110)

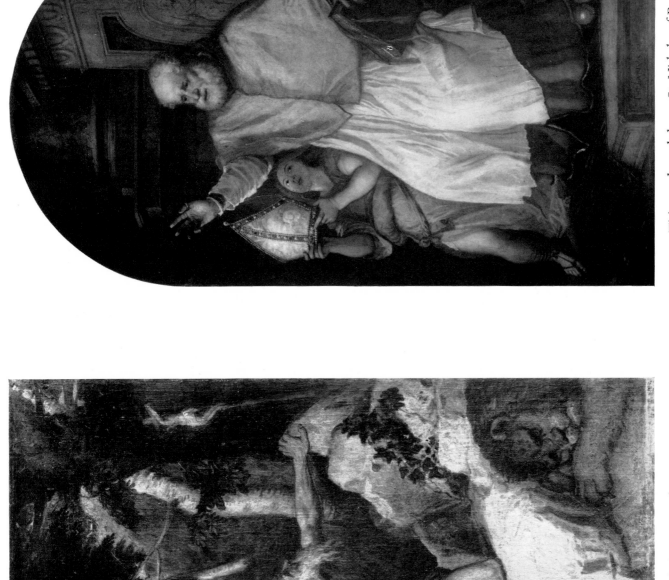

170. Titian and workshop: *St. Nicholas of Bari.* 1563.
Venice, S. Sebastiano (Cat. no. 131)

169. Titian and workshop: *St. Jerome in Penitence.* About 1555.
Rome, Accademia di San Luca (Cat. no. 106)

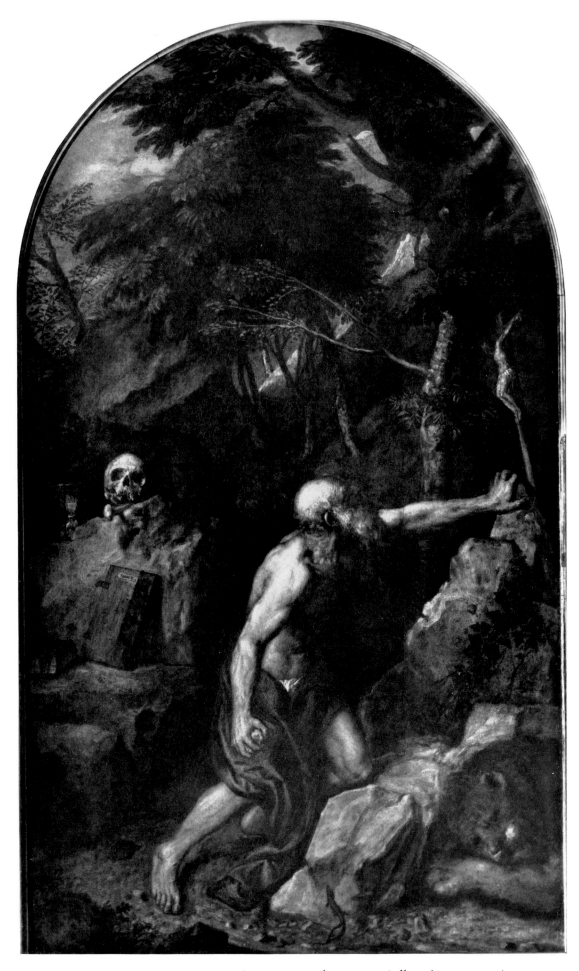

171. *St. Jerome in Penitence*. About 1555. Milan, Brera Gallery (Cat. no. 105)

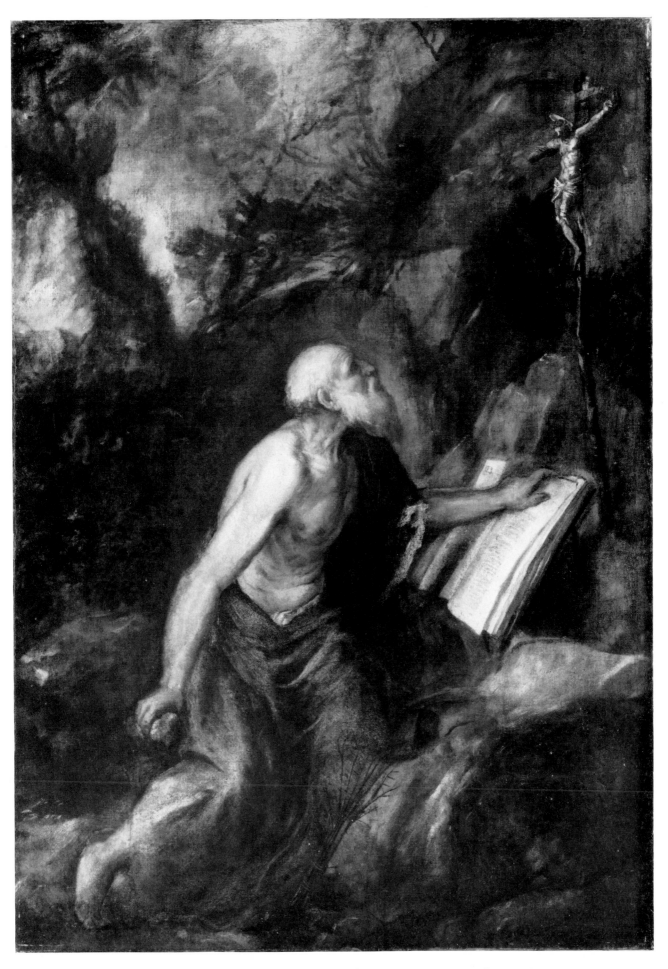

172. *St. Jerome in Penitence*. About 1570. Lugano, Thyssen-Bornemisza Collection (Cat. no. 107)

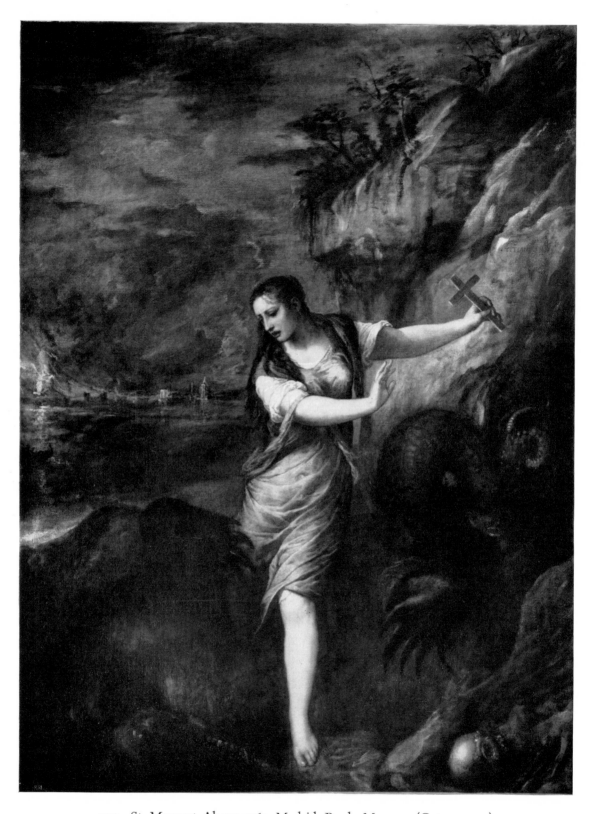

173. *St. Margaret*. About 1565. Madrid, Prado Museum (Cat. no. 117)

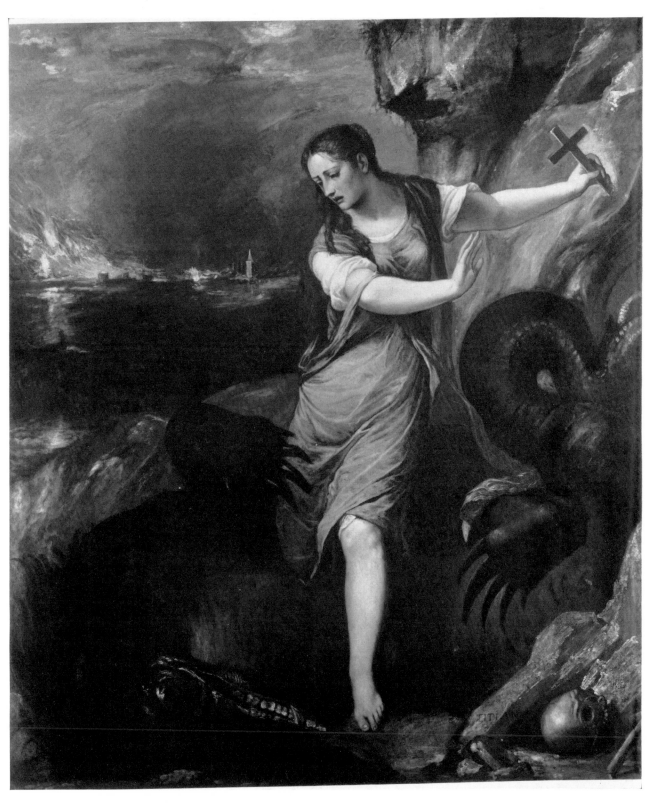

174. *St. Margaret*. About 1565–1570. Kreuzlingen, Heinz Kisters (Cat. no. 118)

175. Workshop of Titian: *St. Margaret*. 1552. Escorial, Apartments of Philip II (Cat. no. 116)

176. Copy of Titian: *St. Margaret* (Cf. Plate 173). Calahorra (Logroño), Cathedral Museum (Cat. no. 117, copy 2)

177. *Landscape*. Detail from Plate 174

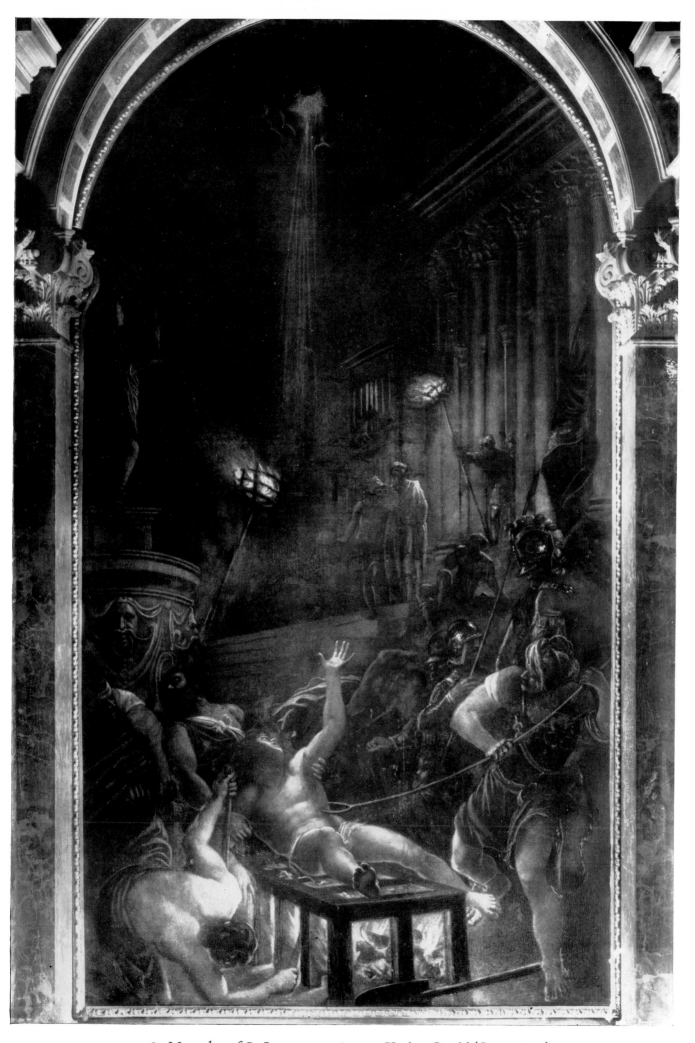

178. *Martyrdom of St. Lawrence.* 1548–1557. Venice, Gesuiti (Cat. no. 114)

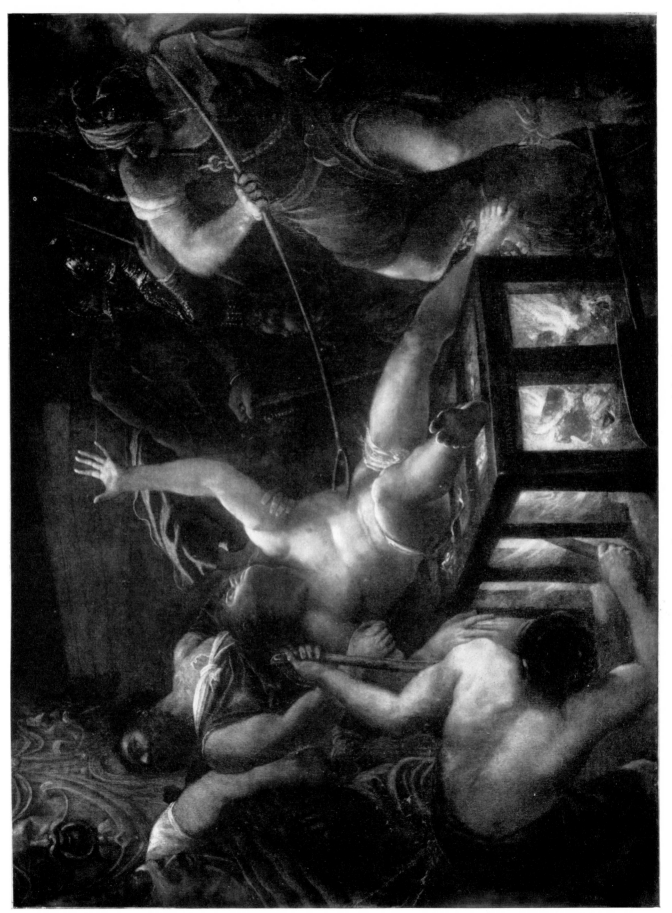

179. *Martyrdom of St. Lawrence. Detail from Plate 178*

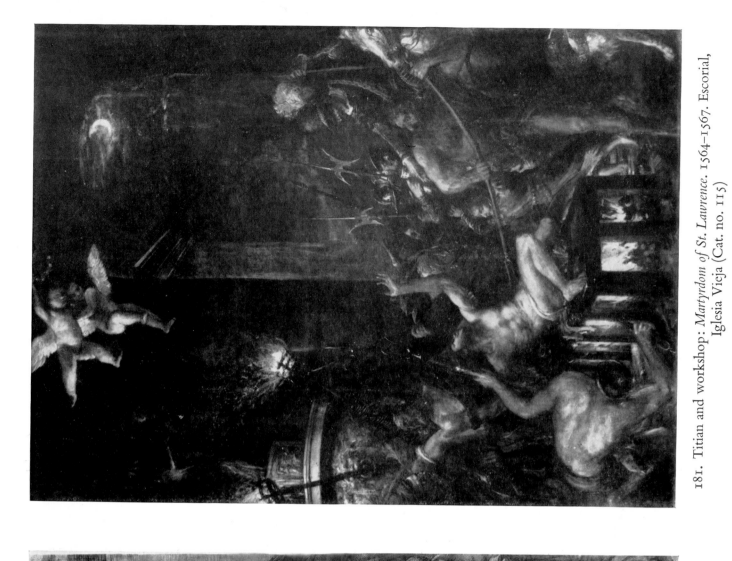

181. Titian and workshop: *Martyrdom of St. Lawrence*. 1564–1567. Escorial,
Iglesia Vieja (Cat. no. 115)

180. Cornelius Cort, engraving after Titian: *Martyrdom of St. Lawrence*
(Cat. no. 115, engraving)

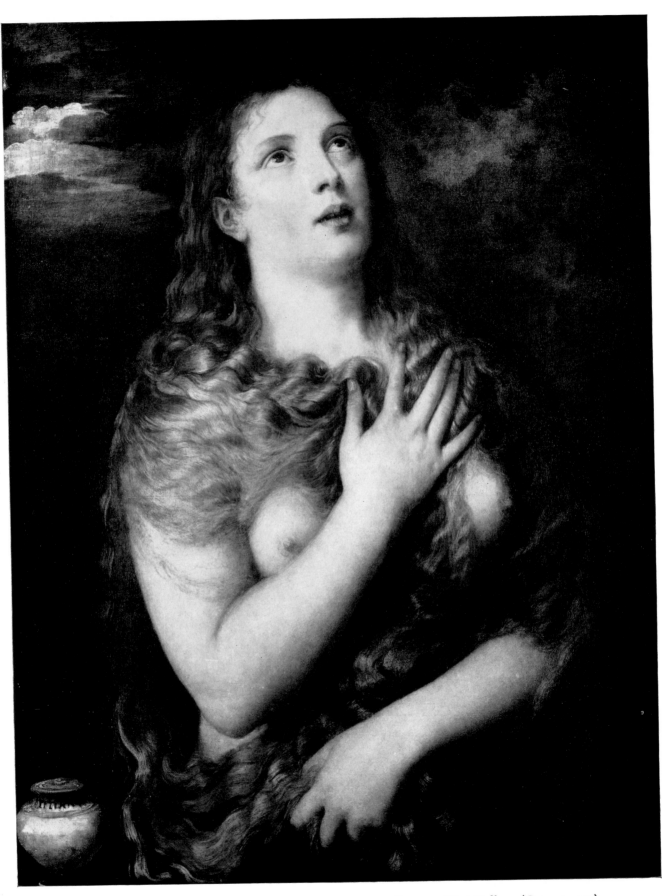

182. *St. Mary Magdalen in Penitence*. About 1530–1535. Florence, Pitti Gallery (Cat. no. 120)

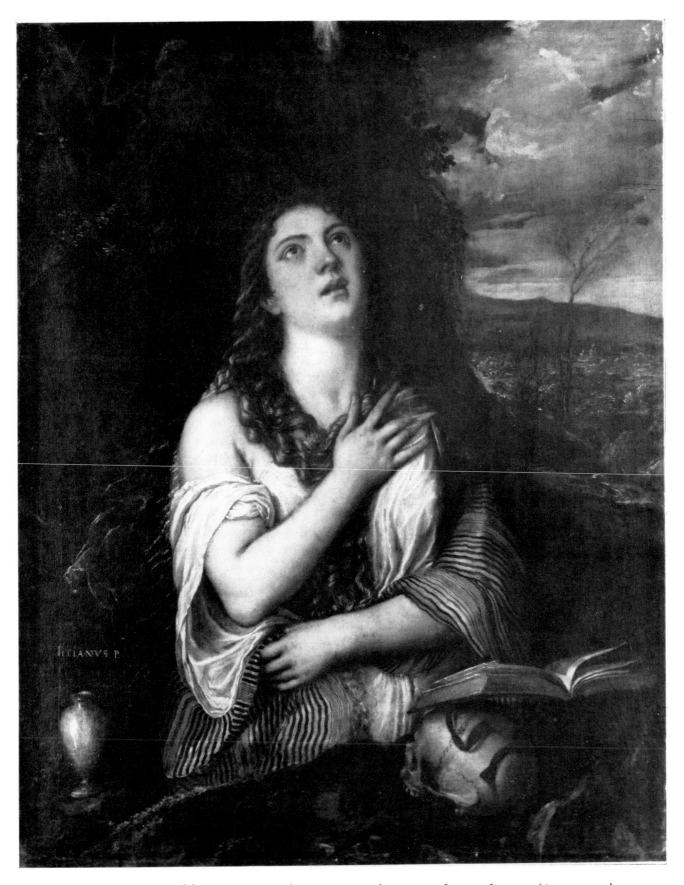

183. *St. Mary Magdalen in Penitence*. About 1550. Naples, Museo di Capodimonte (Cat. no. 122)

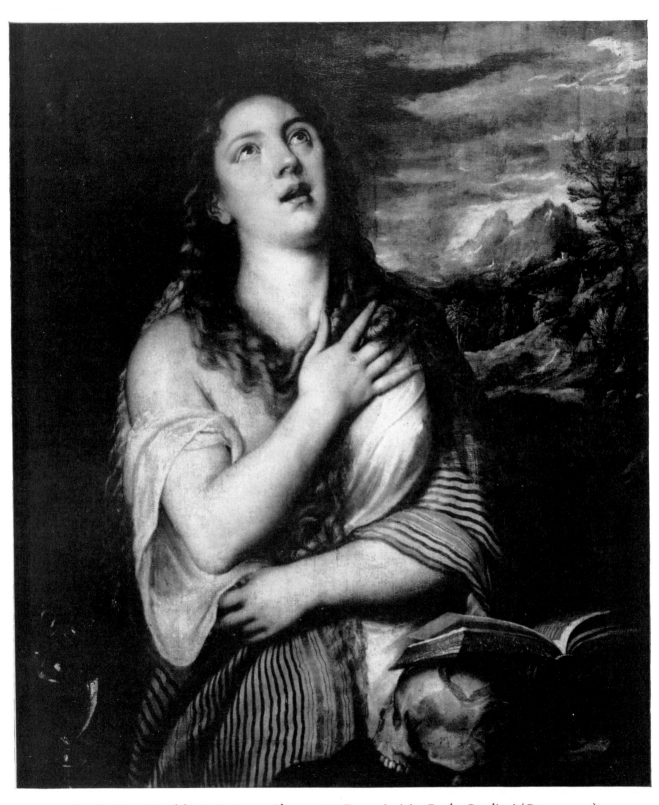

184. *St. Mary Magdalen in Penitence*. About 1560. Busto Arsizio, Paolo Candiani (Cat. no. 124)

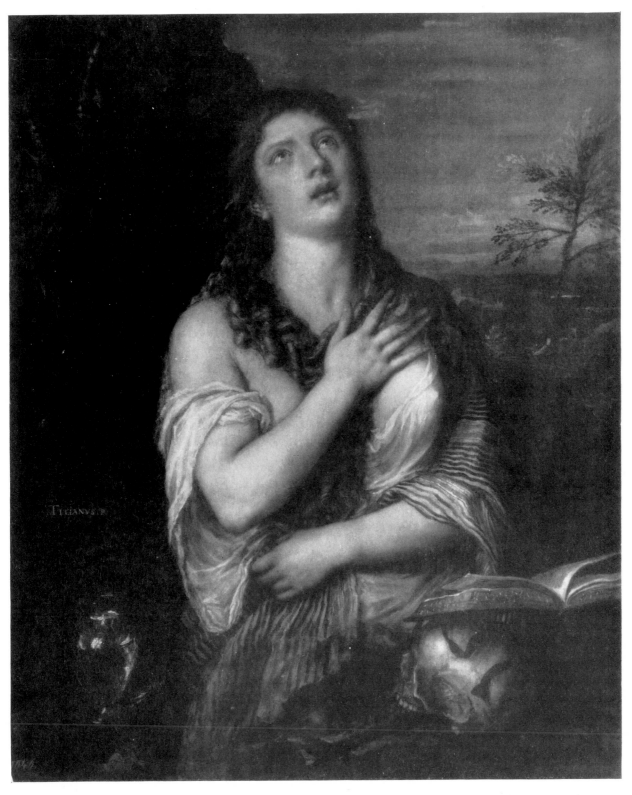

185. *St. Mary Magdalen in Penitence*. About 1560. Leningrad, Hermitage Museum (Cat. no. 123)

186. *Landscape.* Detail from Plate 184

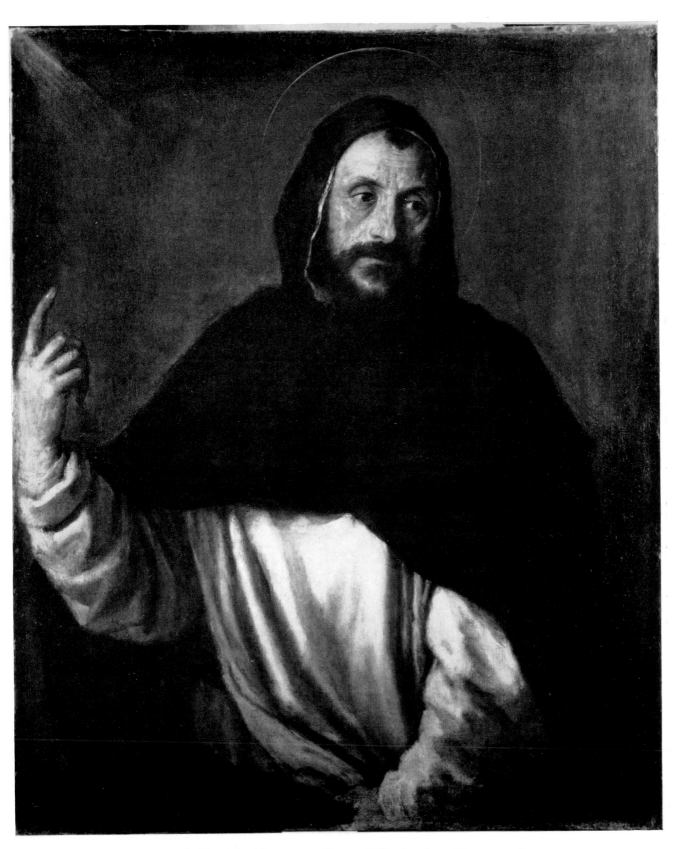

187. *St. Dominic.* About 1565. Rome, Villa Borghese (Cat. no. 99)

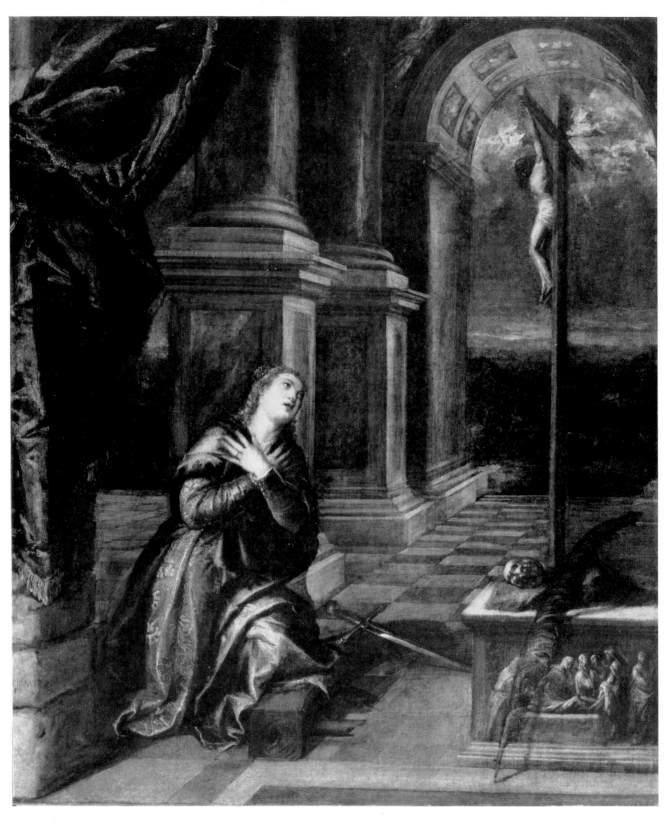

188. Workshop of Titian: *St. Catherine of Alexandria in Prayer*. About 1568.
Boston, Museum of Fine Arts (Cat. no. 96)

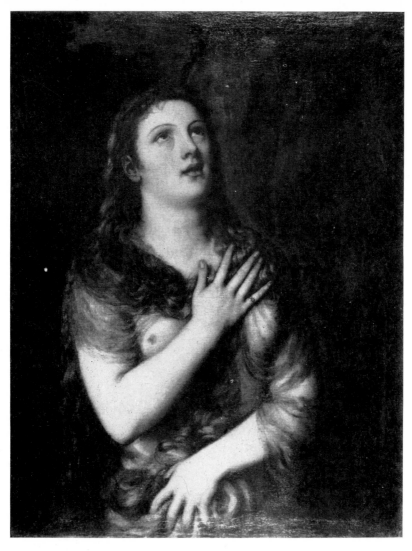

189. Workshop of Titian: *St. Mary Magdalen in Penitence*. About 1540.
Milan, Ambrosiana Gallery (Cat. no. 121)

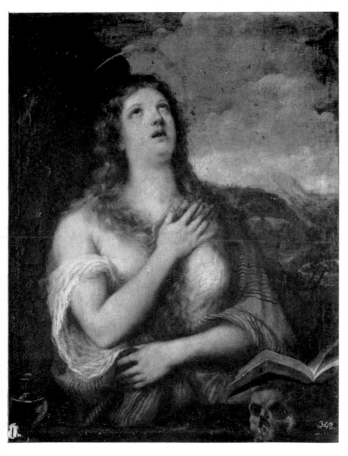

190. Luca Giordano: Ruined copy of Titian's lost
St. Mary Magdalen in Penitence. About 1695.
Escorial, Iglesia Vieja (Cat. no. 127, copy)

191. Cornelius Cort, engraving after Titian:
St. Mary Magdalen in Penitence (Cat. no. 127)

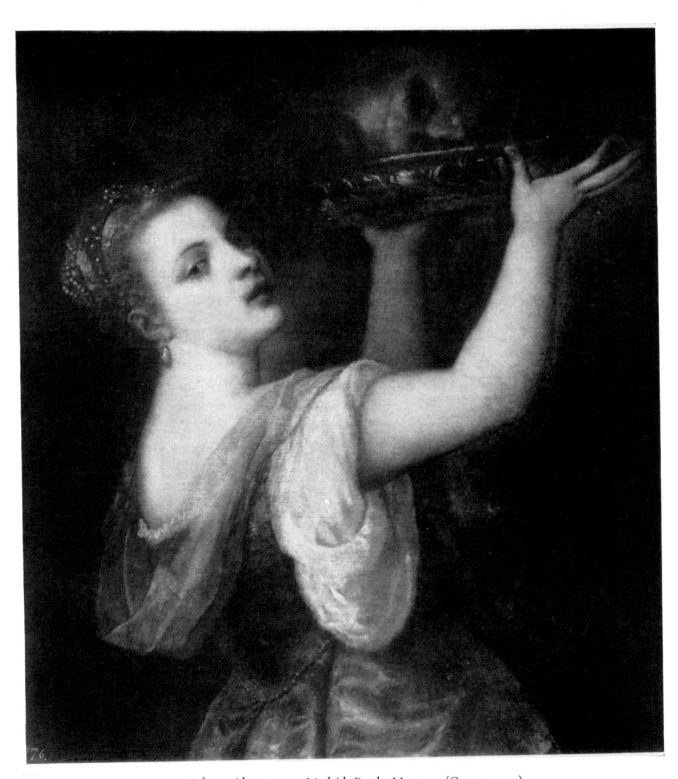

192. *Salome*. About 1550. Madrid, Prado Museum (Cat. no. 141)

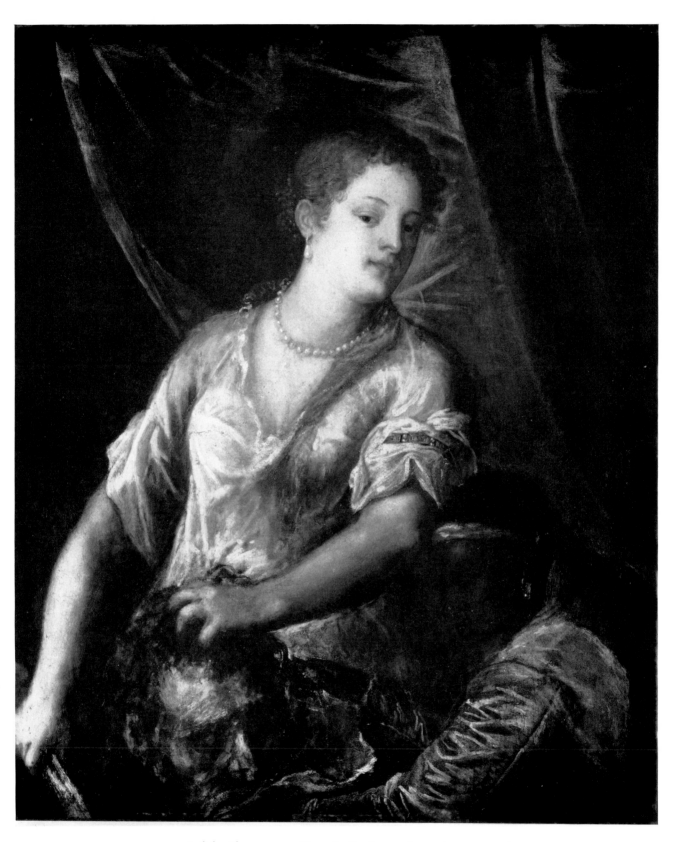

193. *Judith*. About 1570. Detroit, Institute of Arts (Cat. no. 44)

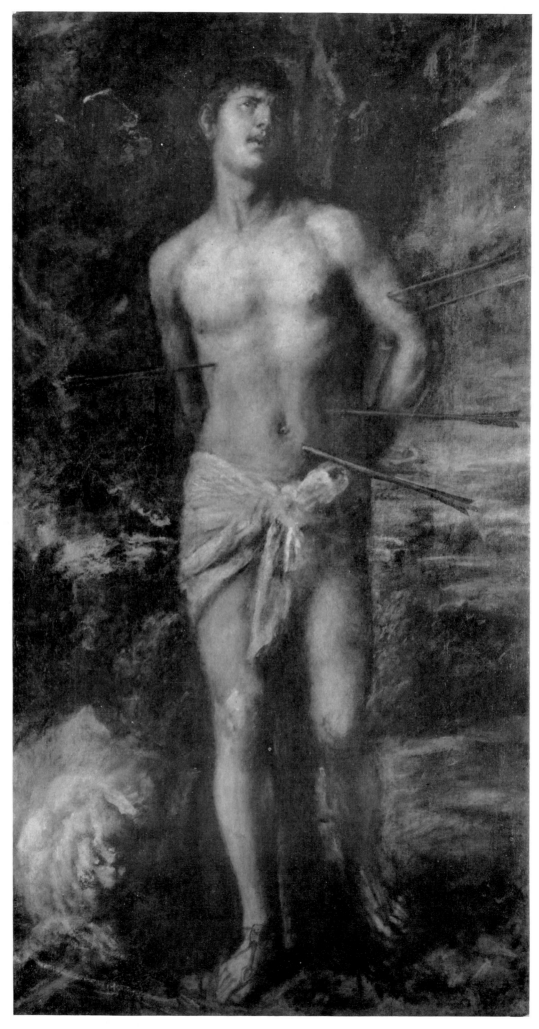

194. *St. Sebastian*. About 1575. Leningrad, Hermitage Museum (Cat. no. 134)

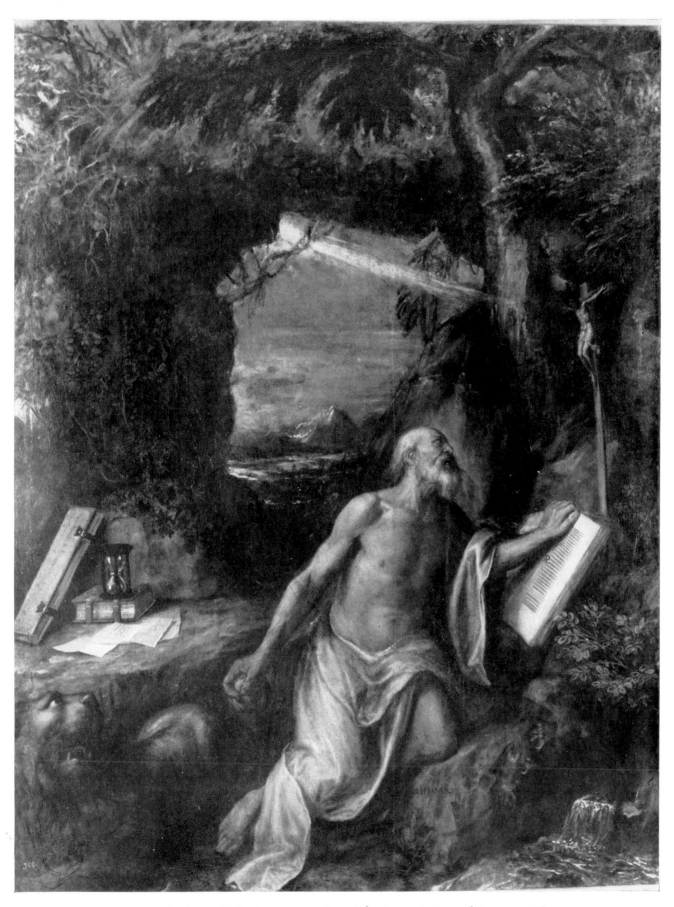

195. *St. Jerome in Penitence.* 1575. Escorial, Nuevos Museos (Cat. no. 108)

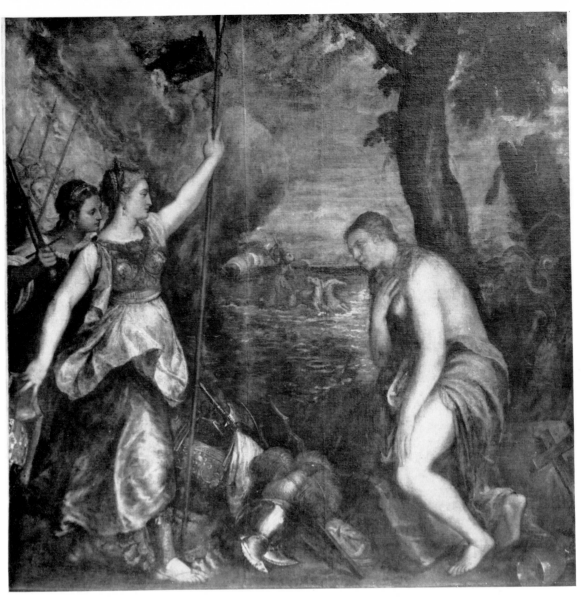

196. *Religion Succoured by Spain.* 1572–1575. Madrid, Prado Museum (Cat. no. 88)

197. Workshop of Titian: *Religion Succoured by Spain.* About 1575.
Rome, Doria Pamphili Gallery (Cat. no. 89)

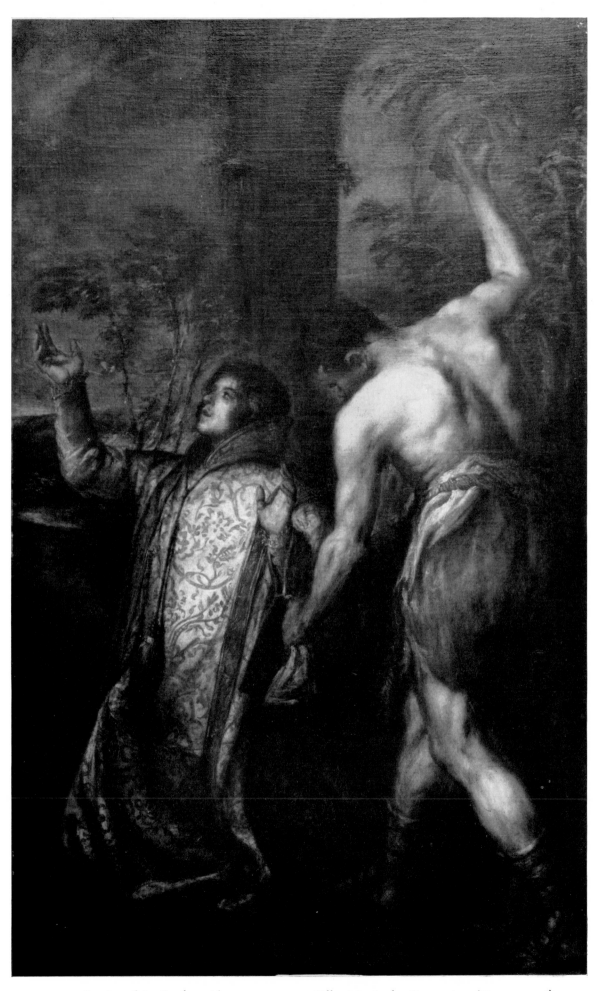

198. *Stoning of St. Stephen*. About 1570–1575. Lille, Musée des Beaux-Arts (Cat. no. 136)

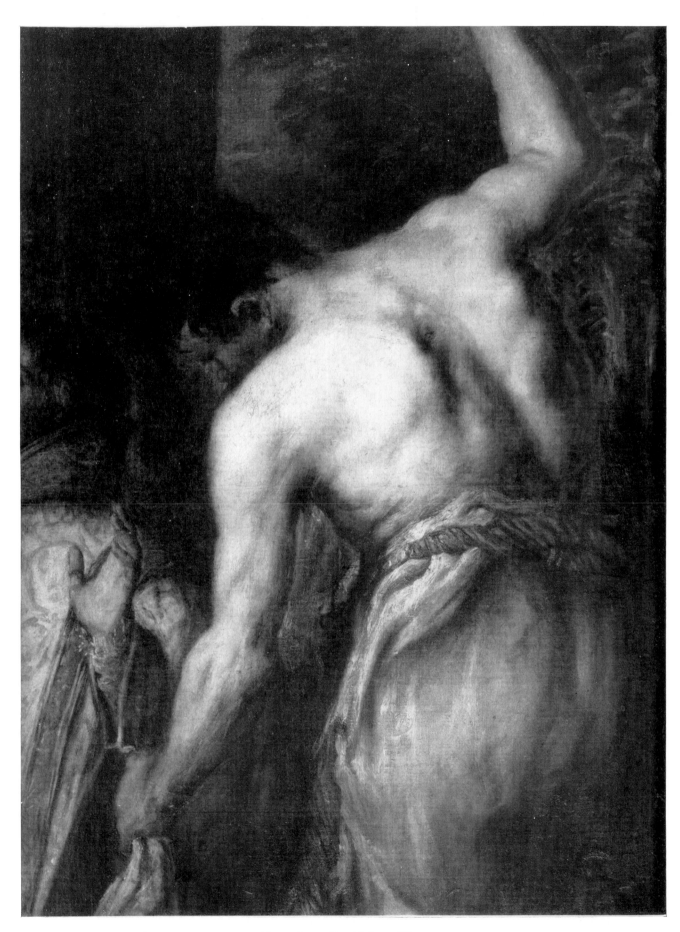

199. *Executioner*. Detail from Plate 198

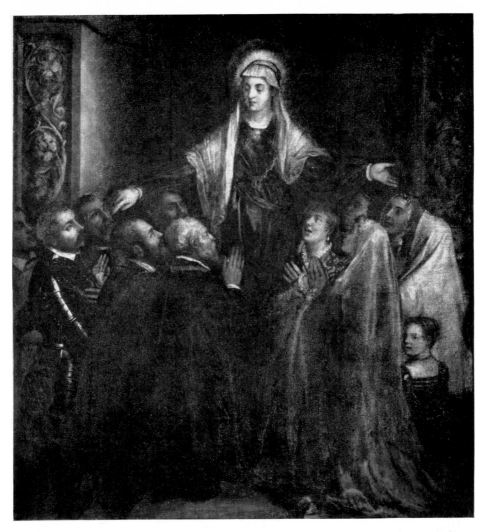

200. Workshop of Titian: *Madonna of Mercy*. About 1573. Florence, Pitti Gallery
(Cat. no. 74)

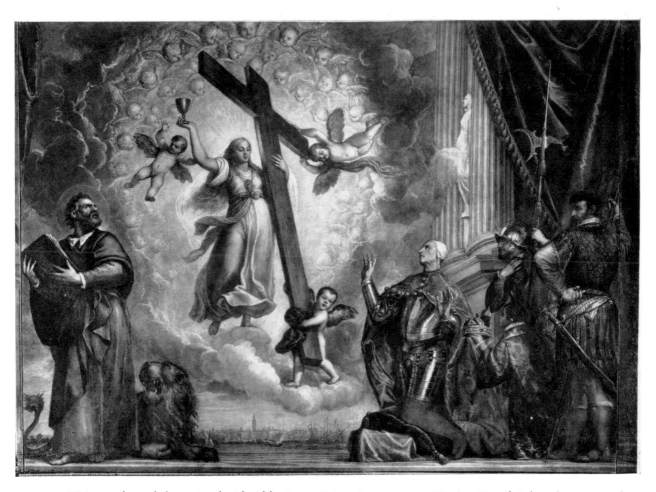

201. Titian and workshop: *Faith Adored by Doge Grimani*. 1555–1576. Venice, Ducal Palace (Cat. no. 40)

202. *Titian's Signature*. Detail from the *Crucifixion* at Ancona (Plate 114)

APPENDIX

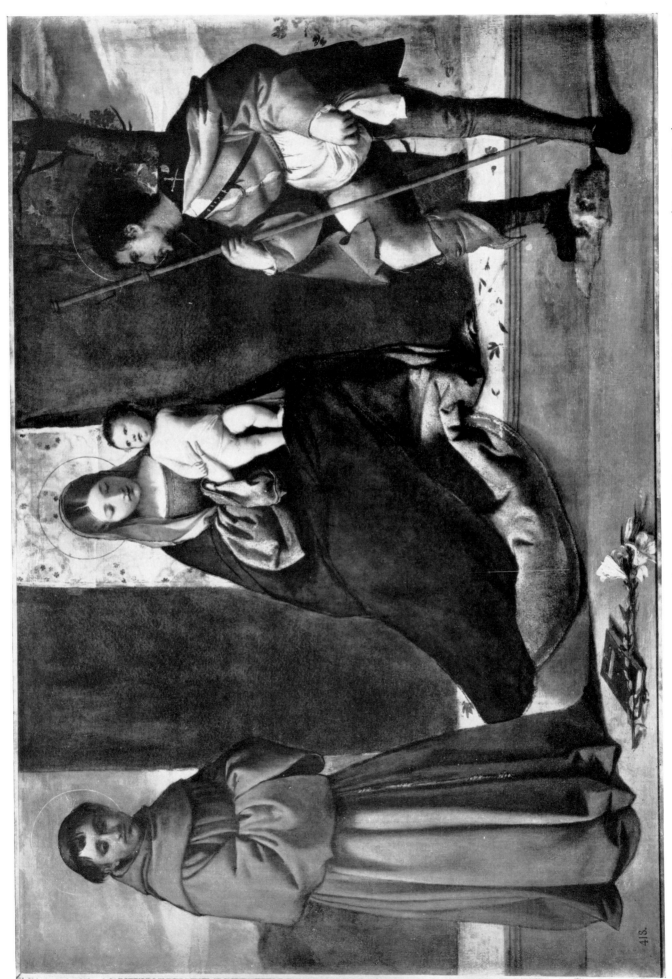

203. Giorgione: *Madonna and Child with SS. Anthony of Padua and Roch.* About 1505. Madrid, Prado Museum (Cat. no. X-19)

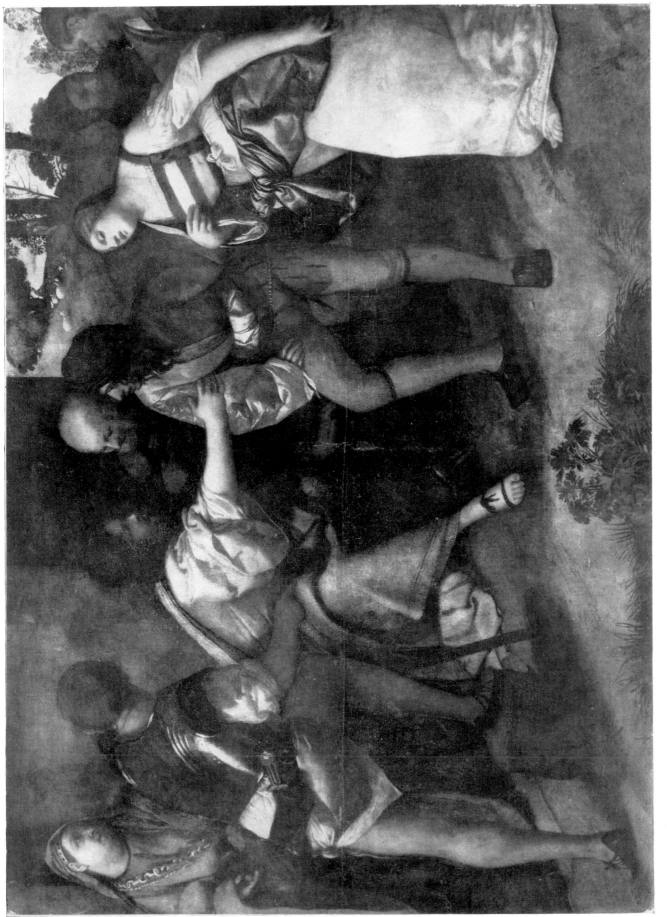

204. Giorgione: *Christ and the Adulteress*. About 1505. Glasgow, Art Gallery (Cat. no. X-4)

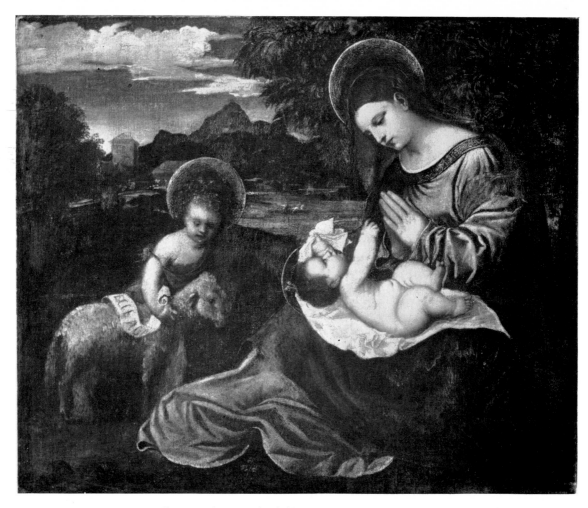

205. Francesco Vecellio: *Madonna and Child with the Infant Baptist.* Verona, Museo Civico
(Cat. no. X-23, version 3)

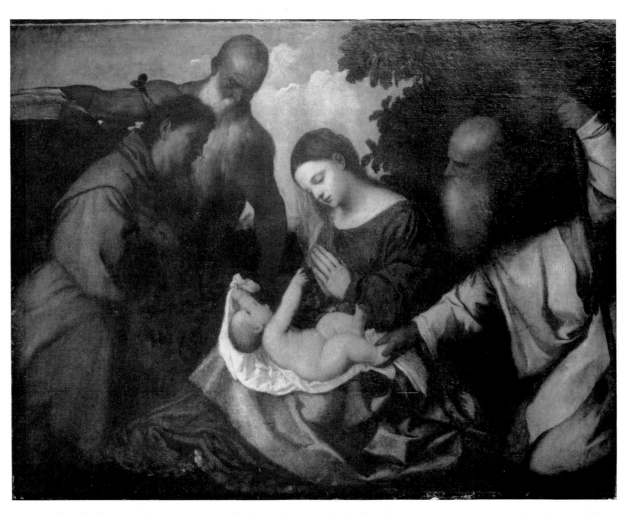

206. School of Titian (Francesco Vecellio): *Madonna and Child with SS. Francis, Jerome and Anthony Abbot.*
Munich, Alte Pinakothek (Cat. no. X-23)

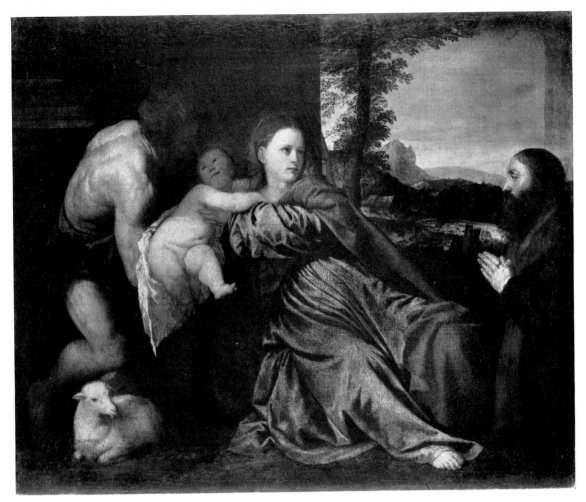

207. School of Titian (Francesco Vecellio): *Madonna and Child with St. John the Baptist and Male Donor.*
About 1520. Munich, Alte Pinakothek (Cat. no. X-27)

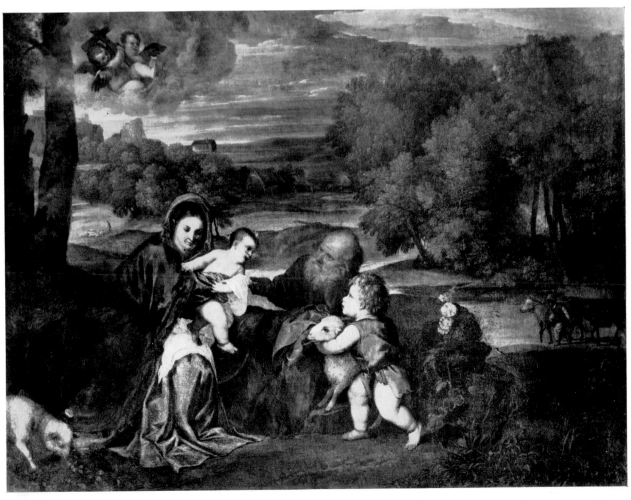

208. Polidoro Lanzani: *Holy Family with the Infant Baptist.* About 1530. Paris, Louvre (Cat. no. X-14)

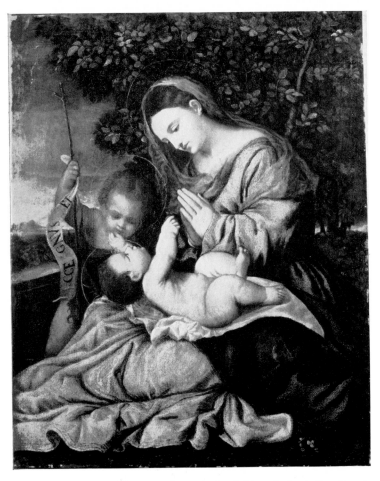

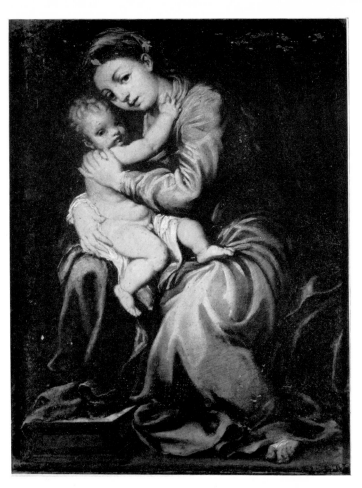

209. Francesco Vecellio: *Madonna and Child with the Infant Baptist.*
San Diego (California), Timken Gallery
(Cat. no. X-23, version 2)

210. Copy after Titian: *Madonna and Child* (Cf. Plate 12).
Late sixteenth century. Rome, Palazzo Spada
(Cat. no. 50, copy)

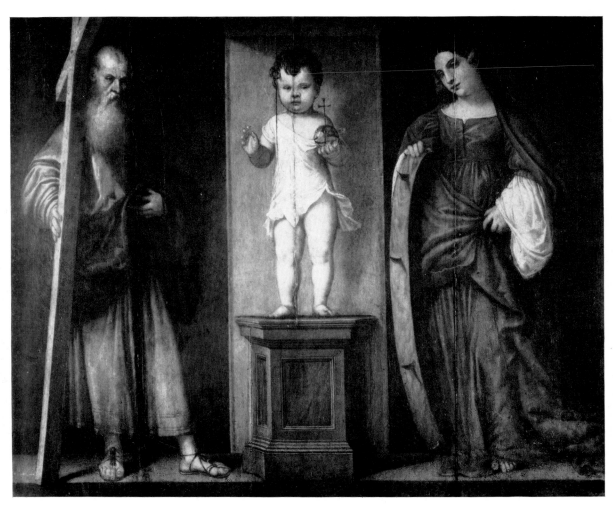

211. Francesco Vecellio: *Infant Christ between SS. Andrew and Catherine.* Venice, S. Marcuola (Cat. no. X-16)

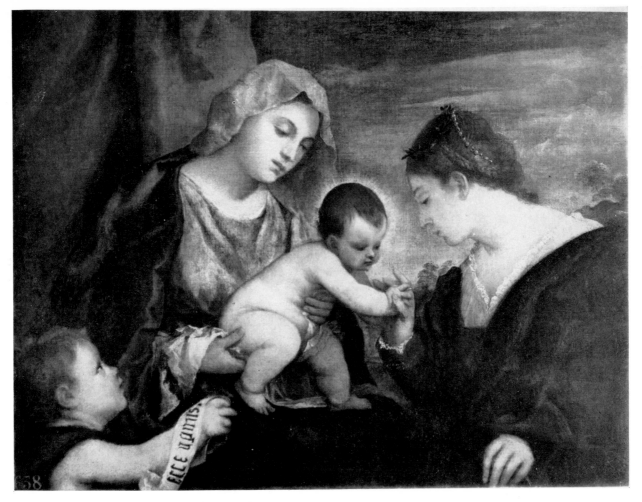

212. Francesco Vecellio: *Madonna and Child with St. Catherine and the Infant Baptist.*
Hampton Court Palace, Audience Chamber (Cat. no. X-20)

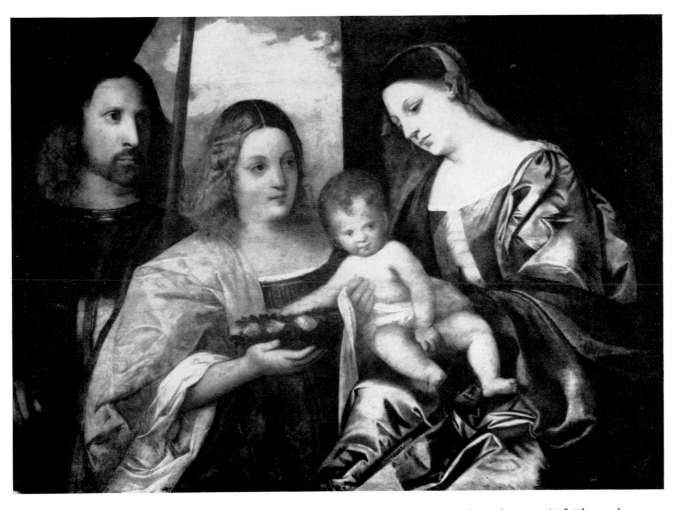

213. Michael Cross(?), copy of Titian: *Madonna and Child with SS. Dorothy and George* (Cf. Plate 13).
Hampton Court Palace (Cat. no. 65, copy)

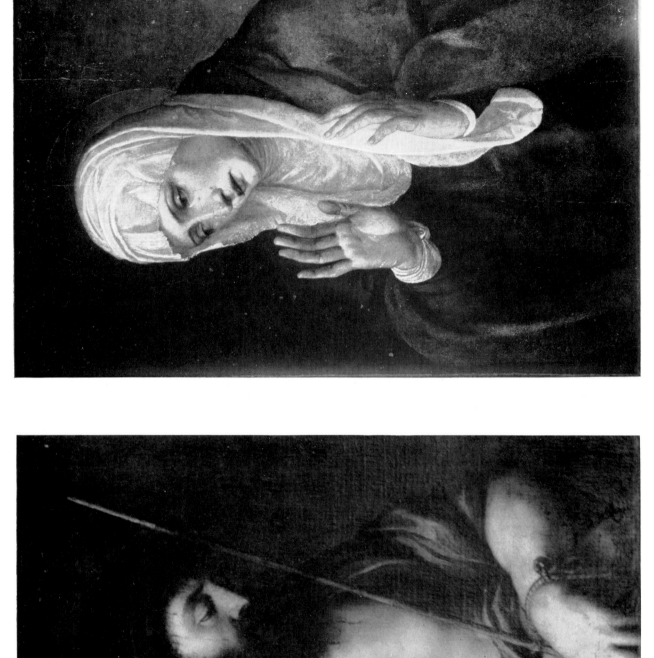

215. Copy of Titian: *Mater Dolorosa with Raised Hands* (Cf. Plate 97).
Sixteenth century. Villandry, Carvalho Collection (formerly) (Cat. no. 77, copy)

214. Workshop of Titian: *Ecce Homo* (Cf. Plate 96). Chantilly, Château
(Cat. no. 32, replica)

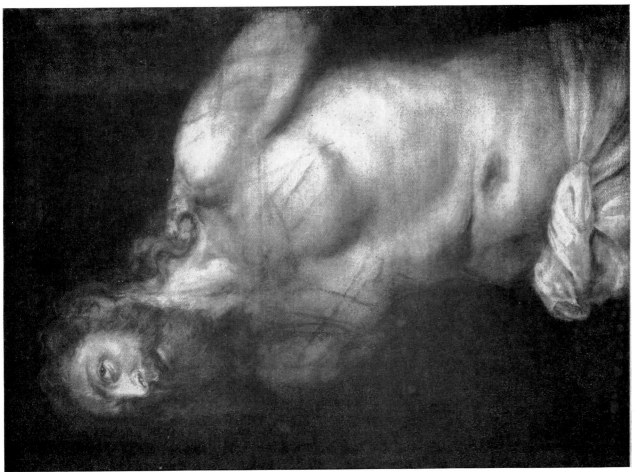

217. Titian(?): *Flagellation*. Mid-sixteenth century. Rome, Villa Borghese
(Cat. no. 41)

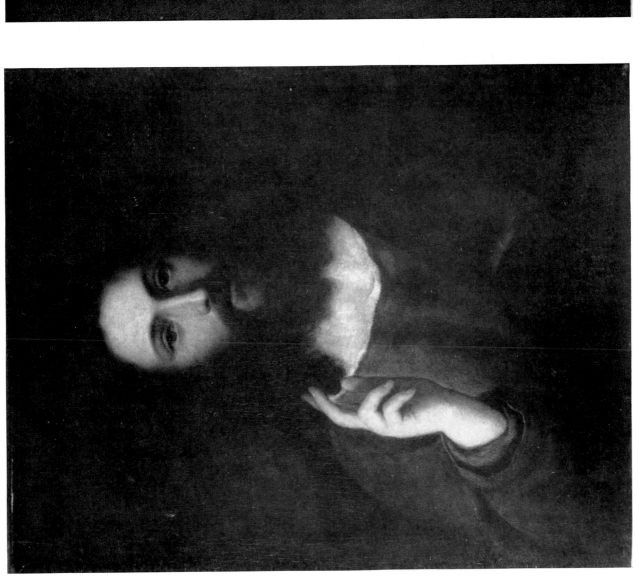

216. Venetian School: *Christ Blessing*. About 1520–1530. Cobham Hall, Earl of Darnley
(Cat. no. 18, related work 1)

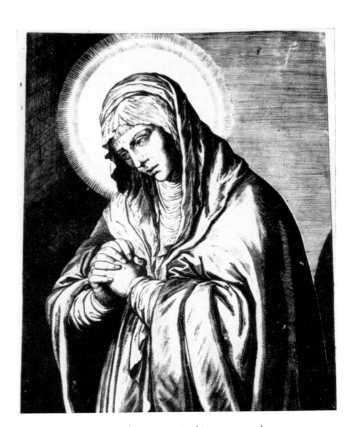

218-219. Bertelli, prints after Titian (reversed): *Ecce Homo; Mater Dolorosa*. 1564 (Cat. no. 35).

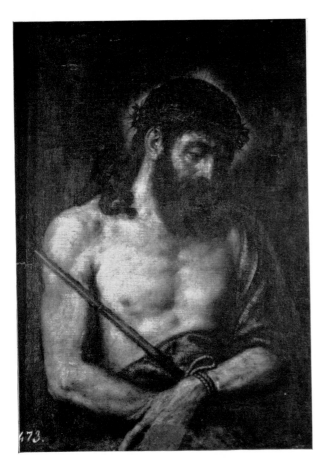
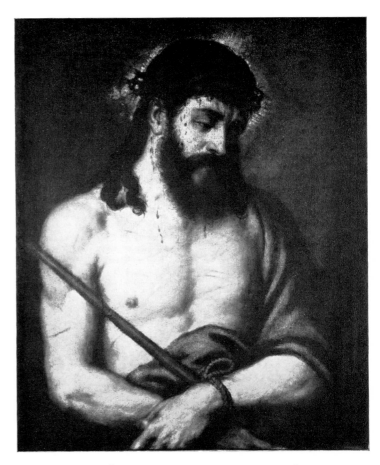

220. Copy of Titian: *Ecce Homo*. Late sixteenth century. Escorial, Nuevos Museos (Cat. no. 35, copy 3)

221. Copy of Titian: *Ecce Homo*. Late sixteenth century. Milan, Ambrosiana Gallery (Cat. no. 35, copy 4)

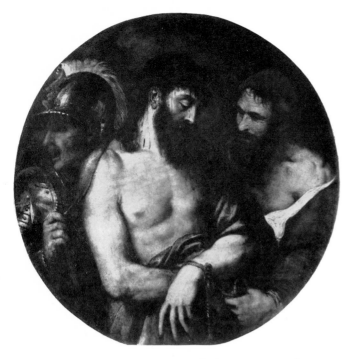

222. Follower of Titian: *Christ Mocked*. Late sixteenth century. Paris, Louvre (storage) (Cat. no. 28, related work 3)

223. Workshop of Titian: *Christ Mocked*. About 1560. Madrid, Prado Museum (Cat. no. 28, related work 2)

224. Bonasone, engraving after Titian: *Christ on the Cross* (Cf. Plate 225)

225. Orazio Vecellio: *Christ on the Cross*. 1559. Escorial, Nuevos Museos (Cat. no. X-7)

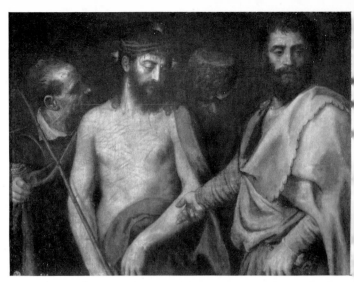

226. School of Titian: *Dead Christ Supported by Two Angels.*
About 1550–1570. Lentiai, Parish Church (Cat. no. X-11)

227. Follower of Titian: *Christ Mocked.* About 1580.
Escorial, Nuevos Museos (Cat. no. X-6)

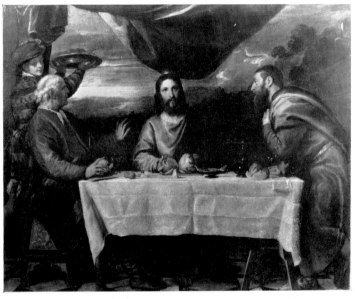

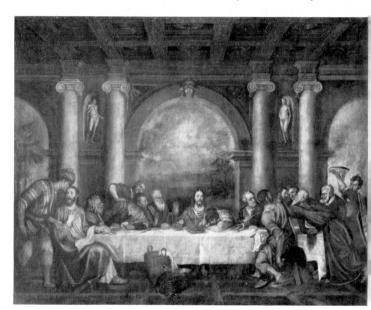

228. School of Titian: *Supper at Emmaus.* About 1540.
Dublin, National Gallery of Ireland (Cat. no. X-38)

229. Copy of Titian: *Last Supper* (before mutilation; Cf. Plate 11
Milan, Brera (storage) (Cat. no. 46, copy 4)

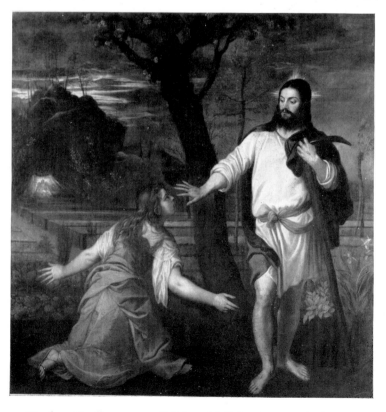

230. Sánchez Coello, copy of Titian: *Noli Me Tangere* (Cf. Plate 103).
Escorial, Upper Cloister (Cat. no. 81, copy 1)

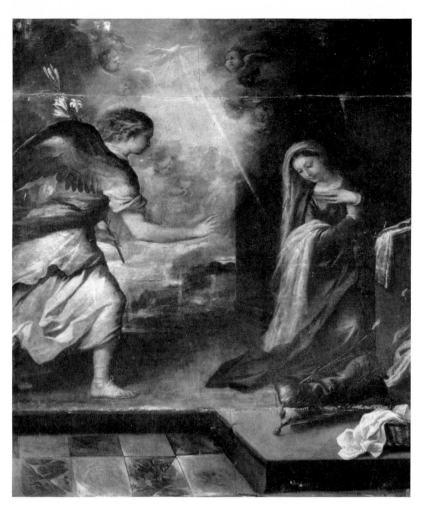

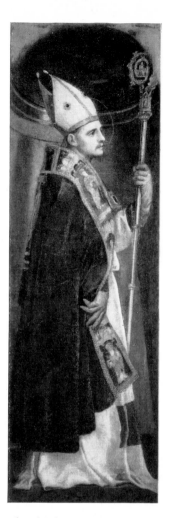

231. Neapolitan School, after Titian: *Annunciation* (Cf. Plate 60). About 1660. Peñaranda de Bracamonte (Salamanca), Carmelite Convent (Cat. no. 12, copy 2)

232. School of Titian (Cesare Vecellio?): *St. Tiziano*. About 1550–1570. Lentiai (Belluno), Parish Church (Cat. no. X-37)

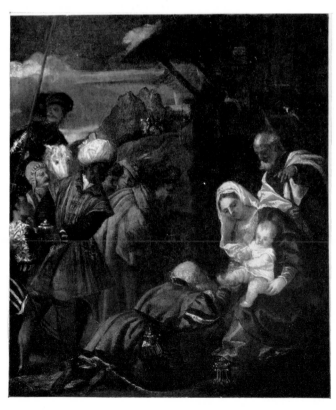

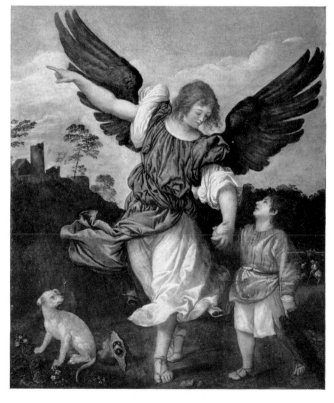

233. Venetian School: *Sketch for an Adoration of the Kings.* About 1550. Vienna, Kunsthistorisches Museum (Cat. no. 5, wrong attribution 5)

234. Sante Zago (?) *Tobias and the Angel.* About 1515. Venice, Accademia (Cat. no. X-39)

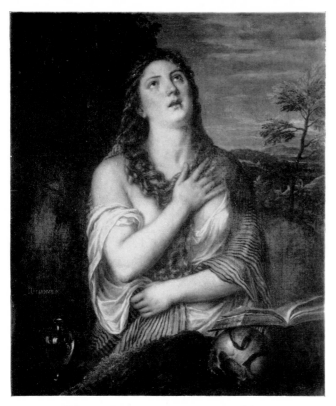

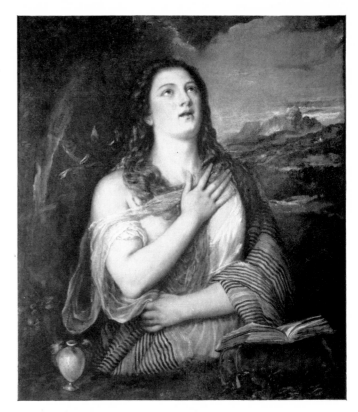

235. Workshop of Titian: *St. Mary Magdalen in Penitence* (Hermitage type; Cf. Plate 185). About 1560–1570. Stuttgart, Staatsgalerie (Cat. no. 125)

236. Workshop of Titian or copy: *St. Mary Magdalen in Penitence* (Escorial type). About 1560–1570. Malibu (California), Paul Getty (Cat. no. 129)

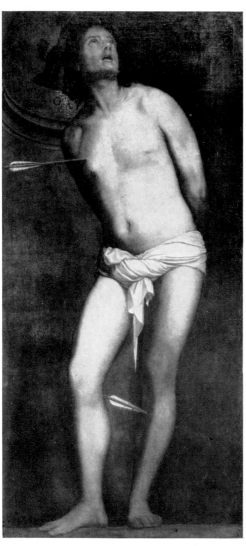

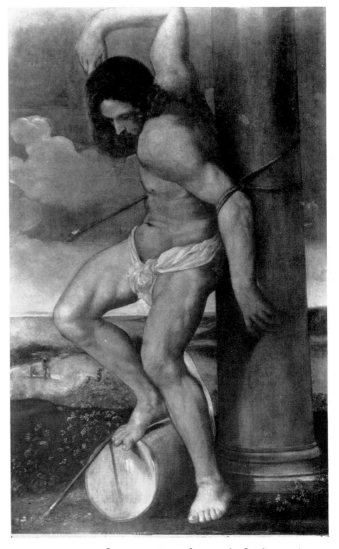

237. Copy of Titian: *St. Sebastian* (Escorial type). Vienna, Harrach Collection (Cat. no. 135, copy)

238. Copy of Titian: *St. Sebastian* (Cf. Plate 74). Epinal, Musée des Vosges (Cat. no. 92, copy 1)

INDEX

This Index is divided into two parts: an Index of Names and Subjects and an Index of Places. The latter starts on p. 381. Numerals refer to pages unless otherwise specified.

INDEX OF NAMES AND SUBJECTS

abbozzo, meaning of, 39 note 207

Albani, Francesco, 3

Alexander VI, Pope, 12–13, 152

Andrew, St., of Crete, 72

d'Anna family (van Haanen) in *Christ before Pilate*, 79, 80

antique influence on Titian, 18–19, 24–25, 29–30, 82, 90, 129, 139

antiques, collection of, see Grimani, Cardinal Domenico

Aragón, Pedro de, Spanish viceroy, 72

Arcadian mood, 9

Aretino, Pietro, arrival in Venice, 20; *Dialogo della pittura*, 1; death of, 32; *Ecce Homo*, 87; friend of Titian, 1, 14–15, 16, 19–20; portrait of, 1, 79; *La Talanta*, 25

Arianism, 166

Arundel, Earl of, Thomas Howard, collection of, 103, 130, 156

Arundel, Lady, 7

Assonica, Francesco, of Padua, collector, 126

Averoldo, Altobello, 126–127

d'Avalos, Alfonso, portrait of, 79

Badoaro, Silvio, 148

Bagley, Thomas, 153

Barberini, Cardinal Francesco, visit to Spain, 71, 92

Baroque, proto-, form, 6, 35–36

Bartolommeo, Fra, 17, 143

Bassano, Francesco, 36, 67, 168

Bassano, Jacopo, 63, 100, 105, 118, 168

Bassano, Leandro, 84, 168

Beazzano, 18

Beccaruzzi, 125

Bellini, Gentile, 7, 10, 128

Bellini, Giovanni, *Assumption*, 75; *Baptism*, 77; frescoes in Ducal Palace, Venice, 12; *Feast of the Gods*, 12; influence on Titian, 98, 99; *Noah, Drunkenness of*, 177; San Zaccaria altar, 107; teacher of Titian, 7–8; style of, 17, 26, 143, 169, 170, 171–172, 173

Bellini, Jacopo, 26, 152

Bembo, Cardinal Pietro, 10, 18, 29, 143

Bembo family (escutcheon), 180

Bembo, Francesco, 150

Benedict XIV, Pope, 77

Bernini, Gianlorenzo, trip to Paris, 113

Bertelli, prints after Titian: *Ecce Homo* and *Mater Dolorosa*, 88–89, Plates 218, 219; *Nativity*, 117–118; *Martyrdom of St. Peter Martyr*, 155

Bessarion, Cardinal, 18

Boldrini, print of *Nativity*, 118, 132–133

Bonaparte, Joseph, 148, 156

Bonaparte, Lucien, collection at Rome (formerly), *Ecce Homo* (copy), 88; *Madonna and Child with SS. Catherine and Luke* (Kreuzlingen), 107; *St. Peter Martyr, Martyrdom of* (copy, lost), 155

Bonasone, Giulio, prints by, 68, 91, 92, 118, 126, 170; see also Master I. B., monogramist

Bonati, Giovanni, 77, 83, 155

Bonifacio dei Pitati (Bonifazio Veronese), 68, 134, 138, 176

Bordone, Paris, *Annunciation*, 69–70; *Baptism* (attributed to), 76; *Christ and the Adulteress*, 169; *Christ Mocked*, 84; *Flight into Egypt*, 172; *Holy Family*, 94–95

Bordonon, 169, 174

Borgia, see Alexander VI

Borghini, criticism of Titian, 1–2

Borromeo, Cardinal Federico, 65

Borromeo, San Carlo, 65

Boschini, Marco, criticism of Titian, 3

Bracamonte, Gaspar de, see Peñaranda, Conde de, 73–74

Bramante, 29

Britto, Giovanni, 22

Broccardi, Malchiostro, 69–70

Buckingham, first Duke of, George Villiers, collection of, 3, 80, 150, 167

Buonconsiglio, Giovanni, 173

Burning Bush of Moses, symbolism, 72

Cadore, Battle of, 10–12, 27

Caletti, Giuseppe, 4

Cambiaso, Luca, 116

Campagnola, Domenico, 134, 173–174

Campagnola, Giulio, 173–174

Cano, Alonso, 102

canvas, use of, 36–37

Caprioli, Domenico, *Madonna and Child* (formerly attributed to), 98

Caraglio, *Annunciation*, engraving, 70–71, 73, Plate 59

Carducho, Bartolomé, 141

Cariani (Giovanni Busi), 118, 155, 169–170, 171, 172, 174

Carlo Borromeo, see Borromeo

Carpaccio, Vittore, 10, 123, 128, 129, 152

Carracci, Annibale, 3, 5, 154, 155

Carracci, Lodovico, 155, 164

Cassana, Niccolò, 153, 154

Castiglione, Baldassare, 18

Castro, Giacomo di, 4, 72, 73, 74

Catena, Vincenzo, 159, 173

Catharism, 166

Catterina, sister of Titian, 15

Cecilia, wife of Titian, 14–15

Cennini, Cennino, 37

Cerezo, Mateo, 87–88

Champaigne, Jean Baptiste de, copy after Titian, 155

Champaigne, Philippe de, copies after Titian, 78, 90, 151

Charles I of England, collection of, 3, *Adoration of the Kings* (incorrect location), 67; *Entombment*, 5, 89–90, 90 (lost

copies); *Last Supper* (fragment), 97; *Madonna and Child with St. Luke and Donor* (variant; Hampton Court), 107; *Madonna and Child with SS. Catherine and Luke* (Kreuzlingen), 107; *Madonna and Child with SS. Dorothy and George* (copy; Hampton Court), 109; *Rest on the Flight into Egypt* (two incorrect provenances), 125, 126; *Roman Emperors*, 23 note 130; *St. Jerome in Penitence* (Paris), 133–134; *Martyrdom of St. Lawrence* (copy), 140; *Nativity* (copy; Oxford), 118; *St. Margaret* (Kreuzlingen), 142–143; *St. Mary Magdalen* (several copies), 144; *St. Peter Enthroned* (Antwerp), 153–154; *St. Sebastian* (copy), 127; *Salome*, 160; *Supper at Emmaus* (Paris), 161

Charles IV of Spain, collection of, 66

Charles V, Emperor of Germany, Austria, Netherlands, and Spain, *Annunciation*, 26–27, 71; Augsburg, 31–32; Asti, 27; battle of Pavia, 19; benefice for Pomponio, 15; Busseto, 27–28; coronation at Bologna, 1, 21; death of, 33; escutcheon of, 79, 161; legend of Titian's brushes, 22; *Mater Dolorosa*, 116; *Portrait of Alfonso I d'Este*, 16; portraits by Titian, 1, 21–22, 79; *Trinity*, 165–166; visits to Italy, 21–22; Yuste, collection at, 35, 37

Christina of Denmark, Duchess of Milan (niece of Charles V), portrait of, 31

Christina, Queen of Sweden, collection at Rome, 3, 4, 5; *Magdalen*, 147–148; *Salome*, 158–159; *Christ and the Adulteress*, 169–170

Cigoli, Lodovico, 154

Clement VII, Pope, 19–20, 166

Clement XIV, Pope, 108

Clovio, Giulio, collection of, *Christ Blessing*, 78; *St. Mary Magdalen* (lost), 151

Cobos, Francisco de los, 16

Cochin, print, 126

Cochlaeus, 165–166

Colonna, Pompeo, 19

Colonna, Vittoria, *St. Mary Magdalen*, 150

copies of Titian, 3–5, 4 notes 25 and 27

Cornaro, Caterina, Queen of Cyprus, 130

Cornelia (Malaspina), 15

Corona, Domenico, 173

Corona, Filippo, 129

Corona, Gianantonio, 129

Correggio, *Agony in the Garden* (Apsley House, London), 69; ceiling paintings at Parma, 120

Cornelius Cort, prints of, 72, 140, 148, 150, 166–167, Plate 191

Cortona, Pietro da, 3, 104, 155

Coxie, Michael, *Annunciation*, 71; *Mater Dolorosa*, 86

Coypel, Charles, collection of, *St. Mary Magdalen* (lost), 151

Crasso, Lazzaro, 123

criticism of Titian, 1–6

Cross, Michael, copies after Titian, 71, 90, 109, 144, 167

Crowe and Cavalcaselle, criticism of Titian, 6

Daniel, life of, by Giorgione, 169–170

David, Gerard, 76

Degas, Edgar, *The Jealous Husband* (copy of Titian), 129

Delacroix, 5, 90

Dente, see Girolamo di Tiziano

Dente da Ravenna, Marco, 18

Diane de Poitiers, devices of, 64, 65

di sotto in su, 25

Dolce, Lodovico, 41–42

Domenichino, 155

Donatello, 101, 128–129

Donato, Doge Francesco, 112

Dürer, 99, 163, 166

Enríquez de Cabrera, Juan, Admiral of Castile, 140, 153

d'Este, Alfonso I, 13, 16 (portrait), 124, 126–127

d'Este, Alfonso II, wedding of, 117

d'Este, Ippolito II, Cardinal of Ferrara, 64, 65

d'Este, Isabella, 24, 42 note 221, 133, 150

d'Este, Lucrezia, 157

Eucharist, prefiguration of, 97

Farnese, Cardinal Alessandro, 15, 28, 29, 30, 121, 130, 145, 155; see also Paul III

Farnese, Ottavio, 28, 29, 30

Fernández de Navarrete, Juan, 88, 92, 97

Ferdinand I of Austria, 3

Ferrara, Cardinal of, see d'Este, Ippolito II

fig tree, symbol of redemption, 110

Ferrari, Gaudenzio, *St. Jerome* (Lyon Museum), 82

Fontana, Giulio, engraving of *Religion Succoured by Spain*, 124

Forabosco, 145

forgers of Titian's works, 4

Franceschi, Andrea dei, 123

Francis I, King of France, 19, 65

Gamberato, 131

García Hernández, Spanish ambassador, 41

Garofalo, 164

gazelle, painted by Titian, 17

Galle, Cornelius the Elder, 165

Gentile da Fabriano, 10

Géricault, Theodore, copy of Titian's *Assumption*, 76; copy of Titian's *Christ Crowned with Thorns*, 83

Ghezzi, Giuseppe, 4

Giordano, Luca, 4 (forgeries of Titian), 66, 71, 72, 73; see also Escorial, *St. Mary Magdalen*, 148–149

Giorgione, works by and attributions to: *Bravo*, 9; *Christ and the Adulteress*, 169–170; *Christ Carrying the Cross*, 80, 170; *Circumcision*, 171; *Dead Christ Supported by One Angel*, 171; Fondaco dei Tedeschi, frescoes, 8–9 and notes 44–45; *Fugger Youth*, 9; *Holy Family*, 94; *Knight of Malta*, 9; *Madonna and Child (Gipsy Madonna)*, 98–99; *Madonna and Child*, 174; *Madonna and Child with SS. Anthony and Roch*, 174; *Madonna and Child with SS. Dorothy and George*, 109; *Man of Sorrows*, 115; *Nativity*, 118; *Noli Me Tangere*, 119;

Rest on the Flight into Egypt, 125; *St. George*, 132–133; *St. Jerome*, 134; *Salome*, 157–159; *Tribute Money*, 165; *Sleeping Venus*, 9 note 46; forgeries of Giorgione's works, 4; Giorgione and Titian, 8–9, 9 note 46, 41–42, 98–99, 113, 143, 152

Giorgionesque, 17, 115, 133, 168, 171

Giotto, 128–129

Giovanni da Asolo, 118, 179

Giovanni da Udine, 25

Girolamo del Santo, see Tessari

Girolamo di Tiziano (Girolamo Dente), 140

Giulio Romano, ceiling decorations at Mantua, 82, 130; influence on Titian, 23–25, 82; Mannerism, 25; *Nativity*, 25; *Roman Emperor*, 23; *St. Margaret*, 141

Giustiniani collection (formerly), *St. Mary Magdalen in Penitence*, 145; *Salome* (Pordenone), 159

Gonzaga collection, Mantua, 19, 23–25

Gonzaga, Duke Federico II, 13, 150

Gonzaga, Ferrante, governor of Milan, 32

El Greco (Domenikos Theotokopoulos), 37, 39, 69, 72, 92, 130, 141

Gregory XIII, Pope, 102

Grimani, Cardinal Domenico, collection of antiques, 18, 24, 82

Grimani, Giovanni, inventory of 1563, 24 note 135

Gritti, Doge Andrea, 19, 100, 111, 131

Guise, Jean de, Cardinal of Lorraine, 19

Hals, Frans, 38

Hannibal, 25

Hapsburg, escutcheon, 79, 96, see also Charles V and Philip II

Haro y Guzmán, Gaspar de, Marqués de Heliche and Marchese del Carpio, 144

Henry II of France, devices from Fontainebleau chimney, 64, 65

Henry III of France, 80

illusionism, Venetian, 37–39

Immaculate Conception, iconography of, 102

Imperiale, Vincenzo, collector, 169

imprimatura, meaning of, 37 note 204

Inquisition, 166

Isabella, Empress, *Annunciation*, 71; portrait by Titian, 28, 165

isocephalism, 123, 128

ivy, symbol of eternal life, 135

Jacobello del Fiore, 154

Jode, Peter de, engraver, 28

Josephus, *Jewish Antiquities*, 120

Juana, Princess, 165

Key, Willem, 87

Khevenhüller, 92

Lamberti, Bonaventura, 4

Lando, Doge Pietro, portrait of, 79

Landscape by Titian, 17

Lanzani, Polidoro, 66, 107, 172, 175, 176

Laocoön, 18–19

Laocoön caricature, 18 note 100

Last Judgment, controversy of, 165–166

Lavinia, daughter of Titian, 14, 32, 79, 160

Leganés, Marqués de, collection of, 144

Leo X, Pope, 10, 127

Leonardi, agent of Francesco Maria della Rovere, 21

Leonardo da Vinci, 17, 143, 161, 163

Leoni, Leone, 33

Leopold Wilhelm, Archduke, see Vienna

Lomazzo, criticism of Titian, 2

Lombardi, Alfonso, 21–22

Lorraine, Cardinal of, see Guise

Lotto, Lorenzo, in Rome, 17; stylistic relationship to, 99; *St. John the Baptist. Head of* (attributed to), 178; *St. Mark* (attributed to), 179

Lucia, mother of Titian, 7

Lutheranism, 166

Madruzzo, Cardinal, 31

Malombra, Pietro, 11

Mancini, Domenico, 118, 170, 171

Manichaeanism, 166

Mannerism, in Titian's work, 25, 26, 30, 38, 100, 123

Mantegna, 24, 75, 128

Maratta, Carlo, copies after Titian, 110, 140

marble, used for pictures, 37

Margaret of Parma, 28

Empress Maria, 164

Marino, Giovanni Battista, 143

Mary of Hungary, 31, 32, 119, 142, 165

Mary Tudor, Queen of England, 37

Massolo, Lorenzo, 139

Master I. B., print of *Nativity*, 81, 118

Maximilian, I, Emperor, 7, 10

Maxmilian II of Austria, collection of, version of *Religion Succoured by Spain* (lost), 124

Mazarin, Cardinal, collection of, 72

Mazo, Juan Bautista, copies after Titian, 88, 92 (wrongly attributed)

Mazza, Damiano, 157, 165

Medici, Cardinal Ippolito dei, 21

Medina de las Torres, Duke of, 126

Michelangelo, *Bound Slave*, 18; criticism of Titian, 2; drawings of Medici tombs, 20; exequies of, 34; influence on Titian, 2, 12, 17, 18, 29–30, 35, 74, 75, 100, 135, 139, 153; *Risen Christ*, 35, 74; visit to Venice, 20–21

Minerva, 139, 140 (symbol of triumph?)

modello by Titian, 83

Molino, Domenico, *Ecce Homo* (copy of Titian), 87

Montagna, Bartolomeo, 129

Monterrey, Conde de, Manuel de Guzmán, 3, 104

Moretto da Brescia, 110, 127, 128, 177

Mosaico, Francesco del, see Zuccati
El Mudo, see Fernández de Navarrete, called El Mudo
Murillo, Bartolomé, 102
musical instruments, 16
Muttoni, Pietro, see Vecchia

Nadalino da Murano, 156
Nardi, Jacopo, 16
Navagero, Andrea, 10, 18
Nave, Bartolomeo della, see Venice, Bartolomeo della Nave
Nicodemus, Gospel of, 74
Northwick, Lord, collection of, 71, 147–148, 155, 158

Odescalchi Collection, Rome, 4 note 27, 148, 159, 169–170
Odoni, Andrea, 24 note 134
Ordóñez, Bartolomé, 74
Organi, dagli, see Trasontino
Orléans Collection, at Paris, 67, 94, 119, 147–148, 159, 160, 162, 172
Orsa, sister of Titian, 15

Pacheco, Francisco, 2, 141, 142
Padovanino, *Christ and the Adulteress* (attributed to), 77; *Christ, Bust of* (attributed to), 79; as imitator of Titian, 4; *Judith* (London), 95; *Madonna and Child* (attributed to), 100; *Rest on the Flight into Egypt* (copy), 126; *Salome* (error), 160
pageantry, Venetian, 26
Palladio, 10 note 50
Pallavicini, Giuseppe, copies after Titian, 155, 172
Palma Giovane, *Cain and Abel*, 121; *Christ on the Cross and the Good Thief*, 85; *Mater Dolorosa*, 117; *St. Catherine*, 177; *St. Margaret*, 178; Titian's *Pietà*, 34, 37, 122–123
Palma Vecchio, 9, 13, 84, 94, 152, 154, 174, 177
panel, use of, 36, 37, 37 note 201
Paolo Veronese, 12, 25, 38, 70, 165
Paphos, 156
El Pardo Palace, Madrid, fire of March 1604, 31; portrait gallery of, 31
Partenio, see Aretino, Pietro
Paul III, Pope, 27, 28, 29, 88, 166
Peñaranda, Conde de, Gaspar de Bracamonte, 73, 74
Pérez, Antonio, collection of, *Adam and Eve*, 63; *Adoration of the Kings* (Prado), 65, 67; *Entombment*, 91–92
Perrenot, Antoine, Cardinal Granvelle, collection of, *Ecce Homo*, 88; *St. Mary Magdalen*, 151
Perugino, 11, 75
Pesaro, Benedetto, 102
Pesaro, Jacopo, 12–13, 102, 152–153
pest in Venice, 33–34
Peterzano, Simone, 88, 91
Philip II, King of Spain, 31, 32, 33, 64; collection of, 63, 64, 65, 68, 81, 86, 89, 90, 91, 97, 109, 124, 136, 140, 141, 148, 155, 165, 166, 168; Titian's letter to, 40

Philip IV, King of Spain, collection of, 23, 67, 104, 126, 156, 160, 164
Pignatelli family of Naples, 73
Piles, Roger de, 5
Pinelli, Cosimo, Duke d'Acerenza, 73
Pio, Cardinal Carlo, 77
Pio di Savoia, Prince Giberto, 77
Piombo, Sebastiano del, see Sebastiano
Pisanello, 10
Pitati, see Bonifacio dei
Pius V, Pope, 155
Pius VII, Pope, 108
Polani, Alvise, 15
Polidoro Veneziano, see Lanzani
Pomponio Vecellio, son of Titian, 14–15, 15 note 80, 28, 30, 74
Pordenone, *Christ Mocked*, 84; frescoes in Treviso Cathedral, 70; fresco in San Giovanni Elemosinario, Venice, 138; frescoes in the cloister, S. Stefano, Venice, 120; *Madonna and Child* (variant; Middlebury), 114; *St. Sebastian*, 156; *St. Peter Martyr* (drawings), 154; *Salome* (Doria Pamphili), 158; *Salome* (Sarasota), 159
Porta (Salviati), Giuseppe, 25
Porter, Walsh, collection of, 66–67, 117, 150
Poussin, 3
Pozzo, Cassiano del, on the French collections, 84; on the Spanish collections, 71, 92, 148
Priscianese, Francesco, 16
Prudenti, Bernardino, *Flagellation*, 94

quadro, meaning of, 37
quail, prefiguration of the Eucharist, 97; symbol of maternal devotion, 70
Querena, Lattanzio, 76
Querini, Girolamo, 139
Quintana, 166

Raimondi, Marcantonio, print, 110
Ram, Giovanni, donor of *Baptism*, 76, 77
Raphael, *Disputa*, 75; *Logge*, 122; *Madonna of Foligno*, 110, 112; *Miraculous Draught of Fishes*, 112; relation to Titian, 12, 75; *Stanza della Segnatura*, 63; at Tivoli, 18; *Transfiguration*, 75, 107; works of, 2, 5, 17, 29
Regnier, Nicholas, see Renieri
Rembrandt, 38, 39
Renieri, Niccolò, imitator of Titian, 4
Reynolds, Sir Joshua, 5
Ribera, Jusepe, 102
Richelieu, Cardinal, collection of, *Madonna and Child with St. Catherine and a Rabbit* (Paris), 105–106
Ridolfi, Carlo, *Assumption* (copy), at Rovere di Trento, 76; criticism of Titian, 3
Rizi, Francisco, 167
Roman Emperors, 23–25, 82
Romanino, 134, 170

Romano, see Giulio Romano

Romanticism, 5

Rome, sack of 1527, 19–20

Roomer, Gaspare, 4

Rosa, Pietro, 127

Rosso, Fiorentino, 21, 75

Rota, Martin, prints of, *Flagellation*, 93–94; *Rest on the Flight into Egypt*, 126; *St. Peter Martyr*, 154, Plate 154

Rovere, della, see Urbino, Duke of

Rubens, Peter Paul, collection of works by Titian, 78, 144, 150, 154; copies after Titian, 2, 6, 63, 67, 70, 90; technique of, 38

Rudolf II, Emperor, collection of, *Entombment*, 92; *Magdalen* (lost), 148; *Rest on the Flight into Egypt*, 125; *Salome* (lost), 159

Ruffo, Antonio, collector, 4

Ruskin, John, 5–6

salt monopoly, 10–11

Salviati, Francesco, 25

Salviati, Giuseppe (called Porta), 25

Sánchez, Jerónimo, 155

Sánchez Coello, 119–120

Sanmicheli, Michele, 26, 82, 122, 123

Sansovino, Francesco, son of Jacopo, 15

Sansovino, Jacopo, altar for the *Assumption*, Verona Cathedral, 76; architectural style of, 26, 82, 123; arrival in Venice, 20; figure style of, 100; friend of Titian, 15, 16; frame for the *Annunciation* in San Salvatore, Venice, 72; copy of the Laocoön, 18–19

Santa Maura, victory of (1502), 12, 102, 152

Sarcinelli, Cornelio, 14, 15 note 80

Sarto, Andrea del, 5

Scarsellino, 140

Schedoni, Bartolomeo, 83

Schiavone, Andrea, *Adoration of the Kings*, 67; *Christ Mocked*, 84; *Last Supper* (copy), 97; *Madonna and Child*, 105; *Rest on the Flight into Egypt*, 125; *Tobias and the Angel*, 162

Sebastiani, General François, 101

Sebastiano del Piombo, arrival in Venice, 20; criticism of Titian, 2; influence on Titian, 75, 169, 179; keeper of the papal seals, 28; work of, 29

Segura, Antonio, 167

Seisenegger, Jacob, 22 note 123

Semino, Ottavio, *Last Supper*, 97

Serlio, 20, 26, 82, 122, 123

Servetus, 166

Sesa, Duque de, 33

Sfondrato, Cardinal, 131

Signorelli, 122

Sigüenza, Padre José de, 66

Simancas, correspondence of Titian, 6

Soliman the Great, Sultan of Turkey, portrait of, 79

Spoleto, Battle of (i.e. Cadore), 12

Stefaneschi, G. B., 118

Suetonius, 24

Talanta, La, play by Pietro Aretino, 25

tavola, meaning of, 37 note 201

Teniers, David II, copies after Titian, *Christ and the Adulteress*, 77; *Gipsy Madonna*, 98; *Madonna of the Cherries*, 99; *Madonna and Child with St. Dorothy*, 109; *Madonna and Child with the Infant Baptist and St. Catherine* (variant), 105

Tessari (del Santo), Girolamo, 129, 174

theft of picture at Medole, 74

Tintoretto, attributions to, 63, 85, 157, 170; style of, 13, 25, 36, 176; works, 12, 112, 139

Titian, age of, 40–42; Asti, visit to, 26–27; Augsburg, visit to, 31–32; benefice as keeper of papal seals, 28; Bologna, visits to, 21, 23; colour, 1, 5–6, 8, 34–35; death of, 33–34, rumours of death, 32; Ferrara, visit to, 12, 28; Florence, visit to, 30; funeral of, 33–34; house of Titian at Pieve di Cadore, 7, at Venice, 14, 15–16; Innsbruck, visit to, 31; knighted by Charles V, 22; Mantua, visit to, 23, 25; Milan, trip to, 2, 7, 31; payments and non-payments of Paul III, 28; pensions from Charles V, 27, 33; personal life, 13–16; Pesaro, visit to, 28–29; purchase of lands, 23; Rome, visit to, 28–30, 112; Spain, invitation to, 22; style of, 6–7, 37–39, passim; self-portraits, 79, 121, 136, as St. Jerome, 122; technique of, 36–39, passim; Urbino, visit to, 28

Trasontino, Alessandro, called dagli Organi, instrument maker, 16

Trent, Council of, 27

Trinity, controversy of, 165–166

Trivulzio, Cardinal, 15

Turk, Portrait of, 23

Urban VIII, Pope, 176

Urbino, collection of, *Christ, Bust of*, 78; *Madonna and Child with St. Catherine and the Infant Baptist*, 105; *Madonna of Mercy*, 114; *Nativity*, 117–118; *St. Mary Magdalen in Penitence*, 143, 150

Urbino, Duke (Guidobaldo della Rovere), host of Titian, 28–29; portraits of Duke and Duchess (Francesco Maria della Rovere and Eleanora Gonzaga) by Titian, 27

Valerius, 139–140

Van Dyck, Sir Anthony, collection of Titian's works, 2 note 13; copies of Titian, 2; drawing (attributed), 95; 'Antwerp Sketchbook', 64, 113, 153, 157; 'Italian Sketchbook', 64, 126; technique, 38

Vargas, Francisco de, 32, 165

Varotari, see Padovanino

Vasari, criticism of Titian, 2; drawings for Santo Spirito in Isola, 120–121; Titian's host at Rome, 29; Venice, sojourn at, 25–26

Vasto, Marchese del, 150

Vecchia, Pietro della (Muttoni), 4, 84, 114

Vecellio, Cesare, attributions of Crowe and Cavalcaselle, 103, 105, 161, 179

Vecellio, Francesco, 7, *Christ Carrying the Cross*, 80; *Christ Mocked* (attributed to), 83–84; frescoes at Padua, 129; *Holy Family with the Infant Baptist* (attributed to), 172; *Holy Family with a Shepherd*, 95; *Infant Christ between SS. Andrew and Catherine* (attributed to), 173; *Madonna and Child* (attributed to), 174; *Madonna and Child with the Infant Baptist*, 176; *Madonna and Child with St. Agnes* (attributed to), 103; *Madonna and Child with St. Catherine and the Infant Baptist*, 174; *Madonna and Child with SS. Francis, Jerome, and Anthony Abbot*, 175; *Madonna and Child with St. Helena* (variant; attributed to), 175; *Madonna and Child with SS. Roch and Sebastian*, 177

Vecellio, Gregorio di Conte dei, father of Titian, 7

Vecellio, Marco, *Annunciation*, 72; *Madonna and Child with St. Joseph and Donor* (Dresden), 109; *Madonna and Child with the Magdalen* (Leningrad), 111; *Madonna of Mercy* (Florence), 114

Vecellio, Orazio, assassination of, attempted, 33; attributions to 103, 113, 119, 134, 161; birth of, 14; *Christ on the Cross* (Escorial), 170–171; death of, 33; donor, as, 122; Milan, trip to, 27, 33; *St. Mark* (mosaic), 179

Vecellio, Pomponio, see Pomponio

Velázquez, 38

Venetian composition, i.e., landscape corridor at one side, 123, 128

Venus Genetrix, 152

Verdi, Giuseppe, 27

Vermeyen, Jean, 87

Veronese, see Paolo Veronese

Vincent Ferrer, St., 74

Vincenzo da Pavia, 131

Violante, 13–14

Virués, Alonso de, 166

West, Benjamin, collection of (formerly), *Adoration of the Kings* (never there), 67; *Last Supper* (copy), 97; *St. Mary Magdalen* (lost), 151

Yuste, San Jerónimo, retirement of Charles V, 35

Zago, Sante, *Infant Christ Between SS. Andrew and Catherine*, 173; *Madonna and Child with St. Catherine* (variant), 105; *Tobias and the Angel*, 179–180

Zornoza, Thomas de, 41

Zuccaro, Federico, 11, 141

Zuccati, Francesco (del Mosaico), 14 note 73, 81 (portrait of), 179

Zuccati, Sebastiano, teacher of Titian, 7

Zuccati, Valerio, 179

INDEX OF PLACES

Aarburg, W. Lüthy (formerly), *Adoration of the Kings* (Venetian School), 67

Aceca, Oratory (formerly), *Entombment*, 92

Amiens, Cathedral, *Entombment* (copy), 90

Amsterdam, Dr. H. Wetzlar, *Ecce Homo* (copy attributed to Willem Key), 87

Ancona,
Annunziata (formerly), *Flight into Egypt* (copy), 172
Ferretti Collection (formerly), *Tribute Money* (copy), 164
Museo Civico, *Madonna and Child with SS. Francis and Aloysius and Alvise Gozzi as Donor*, 9, 18, 29, 109, Plates 24, 25, 27
San Domenico, *Crucifixion*, 36, 85, Plates 114, 115, 202; *St. Peter Martyr, Martyrdom of* (copy by Giuseppe Pallavicini), 155
San Francesco ad Alto (formerly), *St. Mark* (lost), 143
Storiani Collection (formerly), *Madonna and Child with SS. Cecilia and John the Baptist* (variant), 114

Antwerp, Musée Royal des Beaux-Arts, *St. Peter Enthroned, Adored by Alexander VI and Jacopo Pesaro*, 12, 69, 152–153, Plates 144–146

Aranjuez, Palace, Chapel (formerly), *Annunciation*, 71, Plate 59; *Entombment*, 91, 92

Aschaffenburg, Gemäldegalerie, *Christ Mocked* (copy), 83

Ascoli Piceno, Pinacoteca Comunale, *St. Francis Receiving the Stigmata*, 132, Plate 164

Asti, meeting of Charles V and Titian (1536), 26–27

Audley End House (Saffron Walden, Essex), *Madonna and Child with St. Catherine and the Infant Baptist* (copy), 175

Augsburg,
Museum (formerly, on loan): *Christ Mocked* (variant), 84; *St. Mary Magdalen in Penitence* (copy), 150
Titian at Augsburg, 31–32

Avila, Cathedral, Museum, *Ecce Homo* and *Mater Dolorosa* (copies), 89

Baltimore, Walters Gallery (storage), *Tribute Money* (partial copy), 164

Barcelona, Cathedral, choir stalls by Ordóñez, 74

Bath (England), Victoria Gallery, *Ecce Homo* (by Domenico Molino?), 87

Bawtry (near Doncaster, Yorkshire), Serlby Hall, see London, Serlby Hall sale

Bayonne, Musée Bonnat, drawings: *Entombment* (copy), 90; *St. Peter Martyr* (copies), 154; *St. Sebastian* (copy), 156

Belluno, Santo Stefano, *Adoration of the Kings* (follower of Titian), 68

Bergamo,
 Accademia Carrara, *Christ and the Adulteress* (Cariani), 170; *Madonna and Child* (Giorgionesque), 174
 Maria Madaschi (formerly), *Supper at Emmaus* (copy), 162

Berlin,
 Benedict & Co. (formerly), *Mater Dolorosa* (non-Titianesque), 117
 Friedeburg Collection, *Christ and the Adulteress* (copy), 170
 Lepke (formerly), *Madonna and Child with St. Catherine and the Infant Baptist* (copy), 175
 Reimer Collection (formerly), *Madonna and Child with St. Catherine and the Infant Baptist* (copy), 175

Berlin-Dahlem,
 Staatliche Gemäldegalerie, *Lavinia with a Basket of Fruit*, 160; *Self-Portrait of Titian*, Fig. 1; *Venus and the Organ Player*, 31
 Kupferstichkabinett, *St. Sebastian and Madonna*, drawings, 110, 127, Plate 73

Besançon,
 Musée des Beaux-Arts, *Noah, Drunkenness of* (Giovanni Bellini), 177
 Antoine Perrenot, Cardinal Granvelle (formerly), *Ecce Homo* (lost), 88; *St. Mary Magdalen in Penitence* (lost), 151

Biel, East Lothian (Scotland), B. C. Barrington Brooke, *Madonna and Child with St. Catherine and a Rabbit* (copy), 106

Blenheim Palace (Woodstock, Oxfordshire), Duke of Marlborough (formerly), *Madonna of the Cherries* (copy by Teniers), 99; *St. Sebastian* (copy), 127

Boadilla del Monte (Madrid), Palace (formerly), *Last Supper* (copy), 97

Bologna,
 Casa Bolognetti (formerly), *St. Peter Martyr, Martyrdom of* (copy by Annibale Carracci, lost), 155
 Casa Ghisilieri (formerly), *St. Peter Martyr, Martyrdom of* (copy by Lodovico Carracci, lost), 155
 Palazzo Sampieri (formerly), *Tribute Money* (copy by Lodovico Carracci, lost), 164
 Pinacoteca Nazionale, *Christ on the Cross and the Good Thief*, 85, Plate 112; *St. Peter Martyr, Martyrdom of* (free adaptation by Domenichino), 155; see also Rome, Villa Madama
 private collection, *Adoration of the Kings* (copy), 67
 private collection, *Madonna and Child* (copy?), 100
 private collection, *St. Peter Martyr, Martyrdom of*, competition drawings (lost), 154

Bordeaux, Musée des Beaux-Arts, *Christ and the Adulteress* (Venetian School), 77; *St. Mary Magdalen in Penitence* (copy), 144

Boston,
 Fenway Court, Isabella Stewart Gardner Museum, *Christ Carrying the Cross* (Giorgionesque), 170; *Rape of Europa*, 6, 33, 35

 Museum of Fine Arts, *St. Catherine of Alexandria in Prayer*, 69, 129–130, Plate 188

Brentford (Middlesex), Syon House, Duke of Northumberland (formerly), *Madonna and Child with SS. Catherine and Luke* (copy), 107

Brescia,
 Dealer (formerly), *Nativity* (lost), 118
 Lechi Collection (formerly), *St. Sebastian* (copy), 127–128
 Pinacoteca Civica, *Ostension of the Holy Cross* (Moretto da Brescia), 177
 SS. Nazaro e Celso, *Resurrection Altarpiece*, 18, 126–128, Plates 72, 74
 Tosi Collection (formerly), *St. Sebastian* (copy), 128

Bridgend, Glamorgan, Wales, D. Speck (formerly), *Madonna and Child with St. Catherine and a Rabbit* (copy), 102

Brocklesby Park (Lincolnshire), Earl of Yarborough, *Supper at Emmaus*, 160–161, Plate 87

Brussels (formerly), *Ecce Homo* (copy by Jean Vermeyen), 87

Bucharest, Royal Collection, *Madonna and Child with St. John the Baptist* (variant), 177; *St. Jerome* (variant), 134

Budapest, National Museum, *Christ and the Adulteress* (copy), 77

Burghley House (Stamford, Northamptonshire), Marquess of Exeter, *Madonna and Child* (copy), 100

Burgo de Osma, Cathedral, *Christ Carrying the Cross* (copy), 81

Burgos, Cathedral, *Christ Mocked* (copy), 83

Busseto, meeting of Paul III and Charles V (1543), 27

Cádiz, Museo de Bellas Artes, *St. Mary Magdalen in Penitence* (copy), 144

Cadore, see Pieve di Cadore

Calahorra (Logroño), Cathedral, Museum, *St. Margaret* (copy), 142, Plate 176

Cambridge (England), Fitzwilliam Museum, *St. Peter Martyr, Martyrdom of* (copy), 155, Plate 153

Castello di Roganzuolo (Veneto), San Fior, *Madonna and Child with SS. Peter and Paul* (workshop), 112, Plate 51

Chantilly, Château, Musée Condé, *Ecce Homo* (workshop), 87; *St. Peter Martyr, Martyrdom of*, sketch (copy), 154

Chatsworth (Derbyshire), Duke of Devonshire, *St. Jerome* (follower of Titian), 134; *St. Peter Martyr*, two drawings (Pordenone), 154

Clermont-Ferrand, Cathedral, *Supper at Emmaus* (copy), 162

Cleveland, Museum of Art, *Adoration of the Kings*, 63, 64, 66–67, Plates 122, 123; *St. John the Baptist, Head of* (Venetian School), 178

Cobham Hall (Cobham, Kent), Earl of Darnley, *Christ Blessing* (Venetian School), 78

Colinsburgh (Fife, Scotland), Earl of Crawford and Balcarres (formerly), *Martyrdom of St. Peter Martyr* (copy), 155

Cologne, Feschenbach sale, *Madonna of the Cherries* (copy), 99

Como, private collection, *Christ Mocked* (copy), 84

Corella (Navarre), San Miguel, *Ecce Homo* (copy), 89

Cracow,
 Czartoryski Museum, *Noli Me Tangere* (copy), 119
 State Museum, *Madonna and Child with SS. Catherine and John the Baptist* (variant), 113
 University Institute, *Mater Dolorosa* (copy), 116

Detroit,
 Edsel Ford (formerly), *Madonna and Child with St. Catherine and a Rabbit* (copy), 106
 Institute of Arts, *Entombment* (copy), 90; *Judith*, 95, Plate 193
Dijon, Musée des Beaux-Arts, *Madonna and Child with St. Agnes and the Infant Baptist*, 103, Plate 42
Dowdeswell (England), Humphrey Ward, *Madonna and Child with St. Catherine and the Infant Baptist* (copy), 105
Dresden, Staatliche Gemäldegalerie, *Christ Mocked* (copy), 83; *Lavinia as a Bride*, 14; *Lavinia as a Matron*, 14; *Madonna and Child with SS. John the Baptist, Mary Magdalen, Paul and Jerome*, 110, Plate 14; *Madonna and Child with St. Joseph and Donors* (variant), 109; *Sleeping Venus* (Giorgione and Titian), 9; *Supper at Emmaus* (copy), 162; *Tobias and the Angel* (copy), 163; *Tribute Money*, 36, 163–164, Plates 67, 68; *Tribute Money* (Flaminio Torre), 164
Dublin, National Gallery of Ireland, *Ecce Homo*, 87, Plate 100; *Supper at Emmaus* (School of Titian), 179, Plate 228
Dubrovnik (Ragusa),
 Cathedral, *Assumption* (follower of Titian), 168–169
 San Domenico, *St. Mary Magdalen with St. Blaise, Tobias and the Angel, and Donor* (workshop), 151
Duncombe Park (Helmsley, Yorkshire), Lord Feversham (formerly), *Madonna and Child with St. Catherine and a Rabbit* (copy), 106

Edinburgh, National Gallery of Scotland, *Diana and Actaeon*, 33, 35; *Diana and Callisto*, 33, 35; *Holy Family*, 94, Plate 6; *Three Ages of Man*, 4, 6; *Venus Anadyomene*, 5
Épinal, Musée des Beaux-Arts, *St. Sebastian* (copy), 127, Plate 238
Escorial, Monastery of St. Lawrence, *Adoration of the Kings*, 33, 63, 64, 65–66, Plate 120; *Agony in the Garden*, 33, 68–69, Plate 126; *Christ Blessing*, 78; *Christ Carrying the Cross* (copy), 81; *Christ Mocked* (follower of Titian), 170, Plate 227; *Christ on the Cross*, 36, 85, Plate 113; *Christ on the Cross* (Orazio Vecellio), 170–171, Plate 225; *Ecce Homo* (Aula de Escritura, lost), 88; *Ecce Homo and Mater Dolorosa* (Capilla del Colegio, copies, lost), 88; *Ecce Homo and Mater Dolorosa* (upper cloister, lost), 88; *Ecce Homo* (Nuevos Museos, copy), 89, Plate 220; *Entombment* (Aula de Escritura), 92; *Entombment* (Infirmary, lost) 92; *Entombment* (Nuevos Museos, copy), 91; *Holy Family with the Infant Baptist* (mistaken: never existed there), 172; *Last Supper*, 96–97, Plates 116–118; *Madonna and Child with St. Catherine and the Infant Baptist in a Landscape* (London), 104; *Noli Me Tangere* (Prado), 119–120, Plate 103; *Noli Me Tangere* (Sánchez Coello), 120, Plate 230; *Madonna*

and Child (Munich), 100–101, Plates 49, 50; *Madonna and Child* (claustros menores, mediocre copy), 101; *Rest on the Flight into Egypt*, 125–126, Plate 40; *St. Jerome in Penitence*, 38, 136, Plate 195; *St. Jerome in Penitence* (claustros menores, weak copy), 136; *St. John the Baptist*, 137, Plate 167; *St. John the Baptist* (lost), 171; *St. Lawrence, Martyrdom of* (Iglesia Vieja), 140–141, Plate 181; *St. Lawrence, Life of* (Bartolomé Carducho), 141; *St. Margaret* (Aula del Moral, copy), 142; *St. Margaret* (apartment of Philip II), 141, Plate 175; *St. Mary Magdalen in Penitence* (Pitti type; lost), 145; *St. Mary Magdalen in Penitence* (lost), 148, Plate 191; *St. Mary Magdalen in Penitence* (copy, Luca Giordano), 148–149, Plate 190; *St. Peter Martyr, Martyrdom of* (copy, Jerónimo Sánchez, lost), 155; *St. Sebastian* (lost), 156; *Trinity* (Aula del Moral, copy), 167

Fano, Ippolito Capilupi (formerly), *St. Mary Magdalen in Penitence* (lost), 150
Ferrara,
 Bevilacqua Collection (formerly), *Madonna and Child with St. Agnes and the Infant Baptist* (Dijon?), 103
 Castle, Alabaster room, 1, 2, 3, 6, 12, 104
 Alfonso d'Este (formerly), *Madonna and Child with St. Catherine and the Infant Baptist in a Landscape* (London), 17, 104, Plate 35; mythological pictures, 104; *Madonna and Child with SS. Stephen, Jerome, and Maurice* (Paris), 113, Plate 15. See also d'Este.
Florence,
 Casa Bicchierai, *Madonna and Child with SS. Stephen, Jerome and Maurice* (copy), 113
 Bianca Cappello, Grand Duchess of Tuscany (formerly), *St. Mary Magdalen in Penitence* (lost), 150
 Contini-Bonacossi Collection, *Last Supper* (copy), 96; *Last Supper* (copy), 97; *Rest on the Flight* (copy), 125; *Resurrection* (Palma Vecchio), 177; *St. Sebastian* (copy), 108
 Prince Corsini (formerly), *Madonna of the Cherries* (copy), 99; *Nativity* (copy), 118
 Cardinal Leopoldo dei Medici (formerly), drawing of a *Flagellation* (lost), 94
 Livio Meo (in 1672), *Christ and the Adulteress* (Giorgione or Titian, lost), 170
 Pitti Gallery, *Christ, Bust of*, 78, Plate 92; *Madonna and Child with St. Catherine and the Infant Baptist* (variant), 105, Plate 33; *Madonna of Mercy*, 114, Plate 200; *Nativity*, 117–118; *Nativity* (copy, G. B. Stefaneschi), 118; *St. Mary Magdalen in Penitence*, 5, 143–144, 150, Plate 182
 private collection (formerly), *Christ and the Adulteress* (lost), 170
 Torrigiano Collection, *Entombment* (variant), 91
 Uffizi,
 Gabinetto dei Disegni e delle Stampe, drawings: *Angel of Annunciation*, 72; *St. Bernardino*, 112; *St. Lawrence, Martyrdom of*, drawing for legs, 131, 139–140; *St. Peter Martyr, Martyrdom of*, two sketches (follower of Titian), 154

Gallery, *Flora*, 13; *Knight of Malta*, 9; *Madonna* (copy of Pesaro Madonna), 102; *Madonna and Child with St. Anthony Abbot and the Infant Baptist* (in storage), 103, Plate 10; *Madonna and Child with the Infant Baptist* (School of Titian), 176; *Madonna and Child with St. Mary Magdalen* (copy), 111; *Mater Dolorosa* (copy), 116; *Francesco Maria I della Rovere, Duke of Urbino*, 27; *Eleanora Gonzaga della Rovere, Duchess of Urbino*, 27; *St. Catherine of Alexandria* (copy), 130–131, Plate 168; *St. Margaret* (Palma Giovane), 178; *Tribute Money* (adaptation, Garofalo), 164; *Venus of Urbino*, 6

Fontainebleau, school of, 21

Frankfurt, Städelsches Institut, *St. Sebastian*, sketches, 127

Fullerton (California), Norton Simon Foundation, *Salome*, 158–159

La Gaida (Reggio d'Emilia), Luigi Magnani, *Madonna and Child with SS. Catherine and Dominic and a Donor*, 106, Plates 9, 11

Gatchina (near Leningrad, Russia), Imperial Palace (formerly), *Nativity* (Leningrad), 118; *St. Jerome*, 134

Genoa,
 Marcello Balbi, Palace (now Royal Palace) (formerly), *Adoration of the Kings* (Cleveland?), 67; *Christ Carrying the Cross* (lost), 82; *Flagellation* (lost), 94; *St. Jerome* (lost), 134, 136
 Balbi di Piovera Palace (formerly), *Madonna and Child with SS. Catherine and Dominic and a Donor* (La Gaida), 106
 Palazzo Durazzo-Pallavicini, *St. Mary Magdalen in Penitence*, 149
 Palazzo Rosso (storage), *Madonna and Child with SS. Catherine and Dominic and a Donor* (copy), 106
 private collection, *Mater Dolorosa* (copy, Luca Cambiaso), 116

Gerona (Spain), Museo de Bellas Artes, *Last Supper* (copy), 97

Glasgow,
 Art Gallery, *Christ and the Adulteress* (Giorgione), 5, 8–9, 169–170, Plate 204; *Madonna and Child with SS. Dorothy and Jerome* (Polidoro Lanzani), 175
 Garscube House, Sir A. Campbell (formerly), *St. Jerome* (derivation), 134

Grange-over-Sands, Miss Young (formerly), *Madonna and Child with SS. Catherine and Luke* (copy), 107

Grantham (Lincolnshire), Belton House, Lord Brownlow, *Presentation of the Virgin* (copy), 124; see also London

Graz, Landesmuseum, *Adoration of the Kings* (variant), 68

Greenville (South Carolina), Bob Jones University, *Bust of Christ, with a Book* (follower of Titian), 78; *Last Supper* (wrong attribution), 98

The Hague,
 sale, *Miracle of the Speaking Infant*, drawing, 129; William III (formerly), *Supper at Emmaus* (copy), 162

Hale, Mrs. Riddle, *Madonna and Child with SS. Catherine and Dominic and a Donor* (copy), 106

Halle, Museum, *Holy Family with the Infant Baptist* (copy), 172

Hampton Court Palace, *Christ Mocked* (copy), 84; *Madonna and Child* (variant), 105; *Madonna and Child with St. Catherine and the Infant Baptist* (Francesco Vecellio), 174, Plate 212; *Madonna and Child with SS. Dorothy and George* (copy, Michael Cross?), 109, Plate 213; *Madonna and Child with St. Luke and a Donor* (variant), 107; *Mater Dolorosa* (copy), 116; *St. Mary Magdalen in Penitence* (2 copies), 144

Huesca, Museo Provincial, *St. Peter Martyr, Martrydom of* (copy), 155; *Salome* (copy), 158

Ischia, Vittoria Colonna (formerly), *St. Mary Magdalen in Penitence*, 150

Kreuzlingen, Heinz Kisters, *Adoration of the Kings* (Venetian School), 67; *Laura Dianti and a Negro Servant*, 4; *Madonna and Child with SS. Catherine and Luke*, 107, Plate 53; *St. Margaret*, 38, 142–143, Plates 174, 177

La Granja Palace (Segovia) (formerly), *St. Lawrence, Martyrdom of* (copy, attributed to Scarsellino), 140; see also Maratta

Leningrad,
 Academy of Arts, *St. Peter Martyr, Martyrdom of* (copy), 155
 Hermitage Museum, *Christ Blessing*, 77, Plate 93; *Christ Carrying the Cross*, 36, 81, Plate 128; *Christ Mocked*, 84; *Flight into Egypt* (follower of Giovanni Bellini), 171–172; *Madonna and Child with the Magdalen*, 111, Plate 52; *Nativity* (School of Giorgione), 118; *Noli Me Tangere*, drawing (attributed to Titian), 119; *St. Mary Magdalen in Penitence*, 146, Plate 185; *St. Sebastian*, 38, 155–156, Plate 194

Lentiai, Parish church, *Dead Christ Supported by Two Angels* (School of Titian), 171, Plate 226; *St. Mary Magdalen in Penitence*, 151; *St. Tiziano* (Cesare Vecellio?), 179, Plate 232

Lerma, Colegiata, *Entombment* (copy), 92

Lille,
 Musée des Beaux-Arts, *St. Stephen, Stoning of*, 38, 157, Plates 198, 199
 Musée Wicar, *St. Peter Martyr, Martyrdom of*, sketches, 154

Lisbon, Margarida Eisen, *Salome* (copy), 160

Liverpool, Walker Art Gallery, *Holy Family with the Infant Baptist* (Francesco Vecellio), 172

London,
 Abbott (1968), *Lavinia with a Casket*, 160
 Agnew and Sons (formerly), drawing of *Entombment*, 90
 Bath House, Lord Ashburton (formerly), *St. Mary Magdalen in Penitence* (destroyed), 148; *Salome* (destroyed), 158
 Bridgewater Collection (formerly), *Last Supper* (copy, attributed to Andrea Schiavone), 97
 British Museum, *Assumption*, drawing for St. Peter, 76; *St. Jerome*, drawing, 135; *St. Peter Martyr, Martyrdom of*,

drawing (copy), 154; *Supper at Emmaus*, drawing (copy), 161

Lord Brownlow (formerly), *Miracle of the Irascible Son* (copy), 129; *St. Mary Magdalen in Penitence* (copy), 147, 151; see also Grantham, Belton House

Charles I, King of England, Collection, see Charles I

Coesvelt Collection (formerly), *Salome* (copy, lost), 160

Courtauld Institute, *Judith* (Padovanino), 95

Grinling Gibbons, *St. Mary Magdalen in Penitence* (lost), 150

Grosvenor House, Duke of Westminster (formerly), *Tribute Money* (copy), 164

Lord Harewood, drawing for *Pentecost* (?), 122

Henniker-Heaton Collection, *Madonna Nursing the Child* (copy), 101

Hockliffe, *Miracle of the Speaking Infant* (copy), 129

Holford Collection (formerly), *Holy Family with the Infant Baptist* (copy), 172

Sir Abraham Hume (formerly), *St. Mary Magdalen in Penitence* (copy), 147, 151; see also London, Lord Brownlow

Koetser Gallery, *Entombment* (copy, Rubens), 90

Lord Lansdowne (formerly), *St. Mary Magdalen in Penitence* (copy), 147

Viscount Lee of Fareham (formerly), *Holy Family with the Infant Baptist* (copy), 172

Leger and Sons (formerly), *Transfiguration* (free copy), 163

Munro sale, *Noli Me Tangere* (copy), 119

National Gallery, *Bacchus and Ariadne*, 12; *Holy Family*, 94, Plate 8; *Madonna and Child with St. Catherine and the Infant Baptist in a Landscape*, 17, 104, Plate 35, Frontispiece; *Madonna Nursing the Child*, 101, Plate 55; *Man in Blue* (Ariosto), 9; *Noli Me Tangere*, 119, Plate 71; *La Schiavona*, 9; *Tribute Money*, 164–165, Plate 131; *Trinity* (copy), 167

Netherlands Gallery (formerly), *Adoration of the Kings* (copy), 67

Lord Radstock (formerly), *Madonna and Child with St. Mary Magdalen* (*copy*), 111; *St. Mary Magdalen in Penitence* (lost), 151

Sir J. C. Robinson (formerly), *Entombment* (copy), 93; *St. Peter Martyr, Martyrdom of* (copy), 155

Viscount Rothermere, *Annunciation* (variant), 71

Count Antoine Seilern, *Madonna and Child with St. Dorothy* (copy, Van Dyck), 109

Serlby Hall, sale, *Entombment* (copy), 90

P. Tubbs Collection, *St. Peter Martyr, Martyrdom of* (copy), 155

Wallace Collection, *Christ and the Adulteress* (copy, Teniers), 77; *Madonna of the Cherries* (copy, Teniers), 99

Lady Wantage (formerly), see Colinsburgh (Fife, Scotland) and Wantage, C. L., Loyd

Longniddry (East Lothian), Gosford House, Earl of Wemyss, *Agony in the Garden* (variant), 69; *St. Sebastian* (two copies), 127

Lucerne, Fischer Gallery, sale *Adoration of the Kings* (doubtful), 67; *Madonna Nursing the Child* (copy), 101

Lugano, Thyssen-Bornemisza Collection, *Madonna and Child*, 99, Plate 12; *St. Jerome in Penitence*, 135–136, Plate 172

Lyon, Musée des Beaux-Arts, *Entombment* (copy, Delacroix), 90

Madrid,

Academia de San Fernando, *Rest on the Flight into Egypt* (copy), 126

Alcázar (formerly), *Christ in the Tomb with the Madonna and Two Angels* (lost), 92; *Ecce Homo* and *Mater Dolorosa*, 88–89, Plates 218, 219; *Ecce Homo* and *Mater Dolorosa*, 86, Plates 96, 97; *Ecce Homo* (copy, Alcoba de la Galería de Mediodía), 88; *Ecce Homo* and *Mater Dolorosa* (copies, Oratory beneath the Choir), 88; *Ecce Homo* and *Mater Dolorosa* (copies, Sacristy), 88; *Entombment* (copy, Mazo), 91; fire of 1734, 38, 86, 141, 160; *Landscape* (lost), 141

Biblioteca Nacional, *Religion Succoured by Spain* (drawing, copy), 124

Descalzas Reales, Museum, *Tribute Money* (replica), 163–164, Plate 69

Juan Alfonso Enríquez de Cabrera (formerly), *St. Lawrence* (lost), 140

Mora Collection, *St. Peter Martyr, Martyrdom of* (copy), 155

Museo Cerralbo, *Mater Dolorosa* (non-Titianesque), 117

Prado Museum, *Adam and Eve*, 63, Plate 162; *Adoration of the Kings*, 63, 64, 66, Plate 121; *Agony in the Garden*, 68, Plate 125; *Allocution of the Marchese del Vasto*, 27; *Andrians*, see *Bacchanalia*; *Animals Entering Noah's Ark* (Bassano), 168; *Bacchanalia*, 2, 6, 12; *Charles V at Mühlberg*, 22 note 121, 31; *Charles V with Hound*, 22 note 123; *Christ Carrying the Cross*, 36, 80–81, Plate 129; *Christ Carrying the Cross*, 36, 81, Plate 127; *Christ Mocked*, 84, Plate 223; *Danae*, 6; *Ecce Homo*, 86, 115–116, Plate 96; *Entombment*, 33, 35, 36, 90, Plates 76–78; *Entombment*, 91, Plate 81; *Federico II Gonzaga*, 16; *Madonna and Child with SS. Anthony of Padua and Roch* (Giorgione), 8–9, 174, Plate 203; *Madonna and Child with SS. Dorothy and George*, 13, 109, Plate 13; *Mater Dolorosa with Clasped Hands*, 115, Plate 101; *Mater Dolorosa with Raised Hands*, 86, 115–116, Plate 97; *Noli Me Tangere*, 119–120, Plate 103; *Philip II in Armour*, 32; *Religion Succoured by Spain*, 124, Plate 196; *St. Catherine of Alexandria* (Palma Giovane), 177–178; *St. Lawrence, Martyrdom of* (copy), 140; *St. Margaret*, 38, 141–142, Plate 173; *St. Margaret* (Palma Giovane), 178; *Salome*, 160, Plate 192; *Trinity*, 35, 165–167, Plates 105–109; *Venus and Adonis*, 36–37; *Venus with the Lute Player*, 16; *Venus with the Organist*, 16; *Worship of Venus*, 12

San Ginés, *Annunciation* (copy, Luca Giordano), 73

San Isidro (formerly), *Adoration of the Kings* (lost), 68

San Jerónimo (formerly), *St. Margaret* (Prado), 141–142

San Pascual (formerly), *St. Peter Enthroned* (Antwerp), 153

Urzáiz Collection (formerly), *Christ Mocked* (lost), 84

Maidenhead, Taplow House, Joseph Sanders (formerly), *St. Mary Magdalen in Penitence* (copy), 147

Malibu (California), J. Paul Getty Museum, *St. Mary Magdalen in Penitence*, 149, Plate 236

Manchester, Exhibition (1857), *Miracle of the Speaking Infant*, drawing, 129

Mantua,

Gonzaga Collection (formerly), *Entombment* (Paris), 17, 89–90; *Madonna and Child with St. Catherine and a Rabbit* (Paris), 105–106, Plate 34; *Nativity* (copy, Oxford), 118; *St. Jerome in Penitence* (Paris), 133–134, Plate 155; *St. Mary Magdalen in Penitence* (lost), 144; *Supper at Emmaus* (Paris), 161, Plate 88–89

Ducal Palace, *Hall of Psyche*, by Giulio Romano, 25

Palazzo del Te, Decorations by Giulio Romano, 25

Marseilles, Château de Borély, *Salome*, (copy), 158

Medole,

benefice of, 15

S. Maria, *Apparition of Christ to the Madonna*, 35, 74, Plate 111

Messina, Museo Civico, *Holy Family with St. George* (follower of Giovanni Bellini), 173

Middlebury (Vermont), A. Richard Turner, *Madonna and Child with SS. Barbara and Zaccharius* (Pordenone), 114

Milan,

Ambrosiana Gallery, *Adoration of the Kings*, 63–65, 67, Plate 119; *Ecce Homo* (copy), 89, Plate 221; *Entombment* 91, Plate 84; *Madonna and Child with SS. John the Baptist and Cecilia* (variant), 113–114; *Madonna and Child with St. Catherine and the Infant Baptist* (variant), 175; *St. Mary Magdalen in Penitence*, 144–145, Plate 189

Brera Gallery, *Last Supper* (copy), 97, Plate 229; *St. Jerome in Penitence*, 135, Plate 171

Dealer, *Madonna and Child* (probably Francesco Vecellio), 176

Ospedale Maggiore, *Adoration of the Kings* (formerly, now Ambrosiana), 65; *Christ Crowned with Thorns* (copy), 83

private collection, *St. Mary Magdalen in Penitence* (remote), 145

private collection, *Supper at Emmaus* (copy), 162

Minneapolis, Institute of Arts, *Temptation of Christ*, 162, Plate 110

Modena, Galleria Estense, *Holy Family with the Infant Baptist* (copy), 172

Moscow, Golgoroukoff Collection, *Holy Family*, drawing (copy, attributed to Van Dyck), 95

Munich,

Alte Pinakothek, *Charles V Seated*, 31; *Christ Crowned by Thorns*, 37, 39, 83, Plates 133, 135; *Fugger Youth*, 9; *Madonna and Child*, 38, 100–101, Plates 49, 50; *Madonna and Child with SS. Francis, Jerome, and Anthony Abbot* (Francesco Vecellio), 175–176; *Madonna and Child with St. John the Baptist and Male Donor* (Francesco Vecellio), 176–177

Bayerische Staatsgemäldesammlungen, *St. Mary Magdalen in Penitence* (storage; copy), 149–150; *Christ Mocked* (variant), 84

Kurfürstliche Galerie (formerly), *St. Mary Magdalen in Penitence*, 150

Helbig, sale, *Holy Family* (copy), 94

private collection, *Entombment* (copy), 91

Murano, S. Maria degli Angeli, *Annunciation*, see Aranjuez

Nantes, Musée des Beaux-Arts, *St. Jerome in a Landscape* (copy), 134

Naples,

Capodimonte, Gallerie Nazionali, *Danae*, 30; *Madonna and Child with the Magdalen* (storage; copy), 111; *St. Mary Magdalen in Penitence*, 145–146, Plate 183; *Paul III Seated without Berretta*, 28; *Paul III and His Grandsons*, 29; *Salome* (copy), 158

S. Domenico Maggiore, *Annunciation*, 72, Plate 60

New Haven (Connecticut), Yale University Art Gallery, *Circumcision* (Giorgionesque), 171

New York,

American Art Gallery (formerly), *Madonna and Child with SS. Francis and Aloysius and Alvise Gozzi as Donor* (copy), 110

Dealer, *Christ Carrying the Cross* (Venetian School), 82

Historical Society, *Christ Mocked* (copy), 84; *Madonna and Child* (copy), 100

Lewisohn Collection (formerly), *Madonna and Child with St. Catherine and a Rabbit* (drawing, copy), 106

Metropolitan Museum of Art, *Madonna and Child*, 98, Plate 5

Dr. A. F. Mondschein, *Christ Carrying the Cross* (partial copy), 81

private collection, *Dead Christ Supported by one Angel* (Venetian School), 171

private collection, *Hannibal*, by Titian, 25

private collection, *Madonna and Child with St. Mary Magdalen* (workshop), 111

Silbermann Gallery (formerly), *Entombment* (copy), 93

Wildenstein Gallery, *Christ Mocked* (attributed to Pietro della Vecchia), 84

Novara, Ferrari Collection (formerly), *St. Mary Magdalen in Penitence* (copy), 151

Nottingham, Welbeck Abbey, Duke of Portland, *St. Mary Magdalen* (head, copy), 144

Oxford, Christ Church Gallery, *Christ, Bust of* (copy), 79; *Madonna* (copy of Pesaro Madonna), 102; *Nativity* (copy), 118, Plate 86

Padua,

Monsignore Buonfio, *St. Mary Magdalen in Penitence* (lost), 151

Duomo, Museum, *Madonna and Child* (copy attributed to Padovanino), 100

Eremitani, Ovetari Chapel, *Assumption* by Mantegna, 75

Museo Civico, *Christ and the Adulteress* (copy attributed to Padovanino), 77

private collection, *Madonna and Child with St. Catherine and the Infant Baptist* (copy), 105

Scuola del Carmine, *Life of Christ and the Virgin* (Domenico Campagnola and others), 173–174

Scuola del Santo, *Miracles of St. Anthony*, 9–10, 42, 128–129, Plates 139–143

San Gaetano, *Christ Before Pilate* (copy), 80; *Mater Dolorosa* (copy), 116

Dr. L. Scotti (formerly), *St. Jerome* (Venetian School), 178

Via del Busanello (formerly), *Madonna of the Cherries* (copy), 99

Palencia, Cathedral, *Entombment* (copy), 91

Palma in Mallorca, Marqués de la Cernia, *Adam and Eve* (copy), 63

Palmas, Las (Canary Islands), Museo del Cabildo Insular, *Christ* and *Madonna* (half length, copies), 88

Pamplona (Spain), Buendía Collection, drawing of *Apostles* (copy), 76

Panshanger (Hertfordshire), Lord Desborough (formerly), *Madonna and Child* (Lugano), 99, Plate 12; *Madonna and Child with SS. Catherine and Luke* (Kreuzlingen), 107, Plate 53

Paphos (Cyprus), 12

Paris,

Atri Gallery (formerly), *Adoration of the Kings* (copy), 67

Philippe de Champaigne, see Champaigne

Dufourny sale, *Entombment* (copy), 93; *Madonna and Child with SS. Francis and Aloysius and Alvise Gozzi as Donor* (*copy*), 110

Ecole des Beaux-Arts, drawings, *Jealous Husband*, 129, Figure 2; *Sacrifice of Abraham*, 121, Figure 3

Louvre, *Christ Crowned with Thorns*, 35, 36, 74, 82, Plates 132, 134; *Christ Mocked*, 84, Plate 222; drawings of *Apostles*, 76; *St. Peter Martyr, Martyrdom of*, drawings (copies), 154; *Entombment*, 5, 17, 89, Plate 75; *Holy Family with the Infant Baptist* (Polidoro Lanzani), 172, Plate 208; *Madonna and Child with St. Catherine and a Rabbit*, 17, 105, Plate 34; *Madonna and Child with St. Dorothy* (copy, Teniers), 109; *Madonna and Child with SS. Stephen, Jerome, and Maurice*, 113, Plate 15; *St. Jerome in Penitence*, 133, Plate 155; *Supper at Emmaus*, 161–162, Plates 88, 89; *Young Woman at her Toilet*, 13

Orléans Collection, see Index of Names

St.-Louis-en-l'Ile, *Supper at Emmaus* (variant), 179

Spiridon Collection (formerly), *Madonna and Child with the Infant Baptist* (copy), 176

Sedelmeyer (formerly), *Tribute Money* (copy), 165

Rothschild Collection, *La Bella of Titian* (Palma Vecchio), 13–14

Parma,

Galleria Nazionale, *Christ Carrying the Cross* (copy), 80

Palazzo del Giardino (formerly), *Christ Blessing* (lost), 78; *St. Mary Magdalen in Penitence* (Naples), 145–146, Plate 183; *St. Mary Magdalen in Penitence* (copy; lost), 151

Pavia,

Battle of, 19

Certosa, *Last Supper* (Ottavio Semino), 97

Peñaranda de Bracamonte (Salamanca), Carmelite Convent, *Annunciation* (Neapolitan School), 73, Plate 231

Philadelphia,

Museum of Art, *Madonna and Child with St. Dorothy*, 108, Plate 32

Widener Collection (formerly), *Madonna of the Cherries* (copy), 99

Piacenza, Marchese Annibale Scotti (formerly), *Tribute Money* (lost), 164

Pieve di Cadore, 7

Parish church, Frescoes including the *Nativity* (destroyed), 117; *Madonna and Nursing Child with SS. Andrew and Tiziano, and Titian as Donor*, 103, Plate 47; *Madonna and Child with SS. Roch and Sebastian* (Francesco Vecellio), 177

Poggio Imperiale, villa of, *Christ Carrying the Cross* (copy), 90

Prague, Castle Museum (Hradschin or Hradčany Castle), *Madonna of the Cherries* (copy), 99; *Madonna and Child with the Infant Baptist* (Francesco Vecellio?), 176

Princeton,

F. J. Mather (formerly), *Madonna and Child with SS. Barbara and Zaccharius* (Middlebury) (Pordenone), 114

University, Museum of Art, *Madonna of the Pesaro Family*, sketch (copy), 102–103

Raleigh, North Carolina, Museum of Art, *Nativity* (School of Giorgione), 118

Richmond, Cook Collection (formerly), *Madonna and Child with St. Catherine and the Infant Baptist* (variant, Francesco Vecellio), 175

Riga, German Legation, *Madonna and Child with St. Catherine and the Infant Baptist* (variant), 175

Rome,

Accademia di San Luca, *St. Jerome in Penitence*, 135, Plate 169; *Tribute Money* (copy), 164

Luigi Albertini, *Madonna and Child*, 100, Plate 54

Aldobrandini Collection (formerly), *Ecce Homo*, 88; *Flagellation*, 94; *Madonna and Child with St. Catherine and the Infant Baptist* (London), 104; *Madonna and Child with SS. Stephen, Jerome, and Maurice* (Paris), 113; *Madonna and Child with Three Saints* (lost), 114; *Religion Succoured by Spain*, 125; *St. Mary Magdalen in Penitence*, 145; *Salome*, 157–158

Barberini Collection (formerly), *Madonna and Child with the Infant Baptist* (lost), 176; *St. Mary Magdalen in Penitence*, (lost), 151

Bonaparte, Lucien, see Bonaparte

Capitoline Museum, *Baptism*, 76, Plates 65, 66; *Hercules* in bronze, 24

Queen Christina, see Christina, Queen of Sweden

Dealer, *Madonna and Child* (copy?), 101

Doria-Pamphili Gallery, *Religion Succoured by Spain*, 124–125, Plate 197; *St. Mary Magdalen in Penitence* (storage, two copies), 145; *Salome*, 157–158, Plate 149

Doria-Pamphili Palace (formerly), *St. Jerome* (Orazio Vecellio), 134

Martino Longhi Juniore, *St. Jerome* (lost), 135

Ludovisi Collection (formerly), *Bacchanalia*, 3; *Madonna and Child with St. Catherine and the Infant Baptist in a Landscape* (London), 104

Monte Giordano, Orsini Palace (formerly), *Adoration of the Kings* (Milan), 65

Fulvio Orsini Collection, *St. James* (lost), 133

Palazzo Borghese (formerly), *Holy Family* (London), 95; *Madonna and Child with the Magdalen* (copy), 111; *Mater Dolorosa* (copy), 117; *St. Mary Magdalen in Penitence* (lost), 150–151

Palazzo Senatori, Mayor's Office, *Madonna and Child with St. Catherine and the Infant Baptist in a Landscape* (copy, Pietro da Cortona), 105

Palazzo Spada, *Madonna and Child* (copy), 100

Pope Paul III, *Ecce Homo* (lost), 88

Pinacoteca Vaticana, *Madonna and Child with SS. Catherine, Nicholas, Peter, Sebastian, Francis, and Anthony of Padua*, 107, Plate 23

Cardinal Pio di Savoia, *St. Peter Martyr, Martyrdom of* (copy, Giovanni Bonatti, lost), 155

Pope Pius V, *St. Peter Martyr, Martyrdom of* (lost), 155

S. Pietro in Montorio, Borgherini Chapel, *Transfiguration* by Sebastiano del Piombo, 75

San Giorgi sale, *St. Peter Martyr, Martyrdom of* (copy), 155

Sciarra Collection (formerly), *Madonna and Child*, 99

Soprintendenza alle Gallerie, *Tribute Money* (copy), 164

John R. Tilton (formerly), *St. Mary Magdalen in Penitence*, 147

Villa Borghese, *Flagellation*, 93, 94, Plate 217; *Sacred and Profane Love*, 6, 13; *St. Dominic*, 131, Plate 187; *Tribute Money* (variant, copy), 165

Villa Madama, *St. Sebastian* (copy), 127

Rovere di Trento, *Assumption* by Carlo Ridolfi, 76

Rovigo, Museo Civico, *Madonna and Child* ('Gipsy Madonna') (copy), 98

Sacramento (California), E. B. Crocker Art Gallery, *St. Jerome* (School of Titian), 134

Säfstaholm, Count Frederic Bonde, *Madonna and Child* (copy), 101

Salamanca,
 Cathedral, Sala Capitular, *Christ Carrying the Cross* (copy), 81
 Old Cathedral, *Entombment* (copy), 92, Plate 82

Salisbury, Wilton House, Earl of Pembroke, *St. Mary Magdalen in Penitence* (copy), 145

S. Andrea del Fabbro, benefice of, 15

San Benedetto da Polirone, 23

San Diego (California), Timken Gallery, *Madonna and Child* (probably Francesco Vecellio), 176

Saragossa (formerly), *St. Mary Magdalen in Penitence* (copy), 147

Sarasota (Florida), Ringling Museum, *Ecce Homo* (copy attributed to Peterzano), 88; *Salome* (Pordenone), 159

Seebarn Castle (Austria), *Madonna and Child with St. Dorothy* (copy), 109

Segovia, Cathedral, *Entombment* (copy), 92

Serravalle (Vittorio Veneto), S. Maria Nuova, *Madonna and Child Appearing to SS. Peter and Andrew*, 29–30, 112, Plates 46, 48

Seville,
 Duque del Infantado, *Tribute Money* (copy), 165
 Hospital de la Caridad, *Entombment* (copy), 90, Plate 80

Sibiu (Roumania), Muzeul Brukenthal, *Ecce Homo*, 87, Plate 98

Soria (Spain), San Pedro, *Entombment* (copy), 92

South Queensferry (Scotland), Earl of Hopetoun (Marquess of Linlithgow), *Adoration of the Kings* (error), 67

St. Denis, Maison de la Légion d'Honneur, *Christ Mocked* (copy), 84

St. Louis (Missouri), City Art Museum, *Christ Mocked*, 83, Plate 102

Stockholm,
 Dr. Emil Hultmark (formerly), *St. Mary Magdalen in Penitence* (copy), 147
 King of Sweden, *Madonna and Child* (copy?), 101
 National Museum, *Holy Family with the Infant Baptist* (copy), 173; *St. Jerome in a Landscape* (follower of Titian), 134

Stoke Park, Lord Taunton (formerly), *St. Peter Martyr, Martyrdom of* (fragment), 155

Stuttgart, Staatsgalerie, *Nativity* (Venetian School), 118; *St. Mary Magdalen in Penitence*, 146–147, Plate 235

Switzerland,
 private collection, *Judith-Salome* (copy), 95
 private collection, *Rest on the Flight into Egypt* (copy), 126

Tarnobrzeg, Prince Tarnowski, *Mater Dolorosa* (copy), 117

Toledo,
 Cathedral, Vestry, *Christ on the Cross* (copy), 85
 Museo de Santa Cruz, *Entombment* (copy), 91

Tours, Musée des Beaux-Arts, *Entombment* (copy), 90

Trapani (Sicily), Museo Pepoli, *St. Francis Receiving the Stigmata*, 131–132, Plate 163

Treviso, Cathedral, Broccardi Chapel, *Annunciation*, 69–70, Plates 56, 57

Troyes, Musée des Beaux-Arts, *St. Sebastian* (copy), 127

Turnhout (Belgium), Palais de Justice, *Christ Before Pilate* (copy), 80

Urbino, Ducal Palace, *Last Supper*, 95–96, Plate 94; *Resurrection*, 95–96, Plate 95

Utrecht, Huffel sale, *Madonna and Child with St. Anthony Abbot and the Infant Baptist* (copy), 104

Valladolid, Colegio de los Ingleses, *Noli Me Tangere* (copy), 119

Venice,

Accademia, *Decorative panels*, 138; *Pietà*, 37, 122–123, Plates 136–138; *Presentation of the Virgin*, 34, 123–124, Plates 36–39; *St. John the Baptist*, 136–137, Plate 165; *Tobias and the Angel* (Sante Zago?), 179–180, Plate 234

Silvio Badoaro, *St. Mary Magdalen in Penitence* (lost), 150

Barbarigo Collection (formerly), *Christ Blessing* (Leningrad), 78; *Christ Carrying the Cross* (Leningrad), 82; *Christ Mocked* (studio of Titian?, Leningrad) 84; *Madonna and Child with the Magdalen* (Leningrad), 111; *St. Jerome* (lost), 134; *St. Mary Magdalen in Penitence* (Leningrad), 146; *Tobias and the Angel* (partial copy), 163

Duchesse de Berry (formerly), *Salome* (copy), 158

Biri, 16

Signore Cadorin (formerly), *Madonna of the Cherries* (copy), 99

Casa Contarini (formerly), *St. Peter Martyr, Martyrdom of*, *modello* (Palma Vecchio), 154

Casa Grande of Titian, 15–16

Casa Orsetti (formerly), *Flagellation*, 94

Casa Ruzzini (formerly), *St. Mary Magdalen* (lost), 151

Chiesa Evangelista Tedesca (formerly Scuola dell'Angelo Custode), *Christ Blessing*, 78

Cini Collection, *St. George*, 132–133, Plate 150

Niccolò Cornaro (formerly), *St. John the Baptist*, 137

Niccolò Crasso (formerly), *St. Mary Magdalen* (lost), 151

Ducal Palace, *Battle of Cadore* (destroyed), 10–12, 27; *Faith Adored by Doge Antonio Grimani*, 93, Plate 201; *Antonio Grimani, portrait of* (destroyed), 11 note 55; *Humiliation of Frederick I Barbarossa*, 10–11; *Madonna and Child Accompanied by SS. Mark, Alvise, Bernardino and Marina with Andrea Gritti as Donor* (lost), 111–112; *Madonna and Child with Angels*, 100, Plate 26; *St. Christopher* (fresco), 131, Plates 151, 152

Fondaco dei Tedeschi, frescoes by Giorgione and Titian, 8–9, 41, 128; salt monopoly, 10–11

Galeazzo Galeazzi (formerly), *St. John the Baptist* (copy), 137

Gesuiti, *St. Lawrence, Martryrdom of*, 2, 34, 35, 36, 37, 139–140, Plates 178, 179

Grimani Collection, see Grimani

Andrea Loredan (formerly), *Flight into Egypt* (follower of Giovanni Bellini; Leningrad), 125, 171–172

Manfrin Collection (formerly), *Adoration of the Kings* (lost), 68; *Entombment* (copy; Vercelli), 90

Alvise Mocenigo IV (formerly), *St. Peter Martyr, Martyrdom of* (copy, lost), 155

Museo Correr, *Christ Carrying the Cross* (copy), 80

Bartolomeo della Nave (formerly), *Adoration of the Kings* (Venetian School; Vienna), 68, Plate 233; *Adoration of the Shepherds* (Giorgionesque; Vienna), 168; *Christ and the Adulteress* (Vienna), 77, Plate 70; *Christ, Bust of* (Vienna), 79; *Ecce Homo* (Sibiu), 87, Plate 98; and *Mater Dolorosa* (lost), 87, 116 (see Plate 99); *Madonna and Child with SS. Stephen, Jerome and Maurice* (Vienna), 114, Plate 16

Palazzo Corner-Spinelli (formerly), decoration by Vasari, 25

Palazzo Correr (formerly), *Christ before Pilate* (lost), 80

Palazzo Grimani, decorations, 25

Michele Pietra (formerly), *Christ and the Adulteress* (lost, Giorgione), 170; *Christ Mocked* (lost), 85; *St. Peter Martyr, Martyrdom of* (lost, copy), 155

Girolamo and Barbon Piso, *Christ and the Adulteress* (lost, Giorgione), 170

Francesco Pospisil, *Madonna and Child with St. Catherine and the Infant Baptist* (copy), 105

private collection, *Tribute Money* (variant; copy), 165

Renieri Lottery, *St. Sebastian*, half length (lost), 156

Rialto bridge, 20 note 112

S. Andrea alla Certosa, *Christ Carrying the Cross* (lost), 82

Sant' Angelo (formerly), *Pietà* (Accademia), 123

S. Canciano, 16, 40

S. Giacomo di Rialto, *Annunciation* (Marco Vecellio), 72

SS. Giovanni e Paolo (formerly), *Last Supper* (destroyed), 97; *St. Peter Martyr, Martyrdom of* (destroyed), 1, 5, 17, 153–155, Plates 153, 154

San Giovanni Elemosinario, *St. John the Hospitaler*, 138–139, Plate 166

San Lio, *St. James Major*, 133, Plate 160

San Marcuola (Ermagora), *Infant Christ between SS. Andrew and Catherine* (Francesco Vecellio), 173, Plate 211

S. Maria dei Crociferi (formerly), *St. Lawrence, Martyrdom of*, see Venice, Gesuiti

S. Maria dei Frari, *Assumption of the Virgin*, 5–6, 8, 29, 69, 74–76, Plates 17–19, 21, 22; *Madonna of the Pesaro Family*, 12–13, 17, 101–102, Plates 28–31; tomb of Jacopo Pesaro, 102; statuette of Madonna and Child (Pisan School), 102; Confraternity of the Immaculate Conception, 102

S. Maria dei Miracoli (formerly), *St. Mary Magdalen* (lost), 151

S. Maria del Carmine, *Assumption* (partial copy, Lattanzio Querena), 76

S. Maria della Salute, *Cain Slaying Abel*, 120–121, Plate 157; *David Slaying Goliath*, 120–121, Plate 159; *Sacrifice of Abraham*, 120–121, Plate 158; *Evangelists and Fathers of the Church*, 120–121; *Pentecost*, 76, 121, 122, Plate 104; drawing for *Pentecost*, 76; Sacristy, 25–26; *St. Mark Enthroned*, 143, Plates 147–148

S. Maria Nuova (formerly), *St. Jerome* (Milan), 135

St. Mark's, *Nativity* (destroyed), 117; *St. Mark*, mosaic (Orazio Vecellio), 179

San Marziale, *Tobias and the Angel*, 162–163, Plate 161

S. Salvatore, *Annunciation*, 36, 71–72, Plates 61–62; *Transfiguration*, 163, Plate 124

S. Samuele, 14

S. Sebastiano, *St. Nicholas of Bari*, 151–152, Plate 170

S. Spirito in Isola, 26, 120–121, 122, 143

San Trovaso, *Flagellation* (Bernardino Prudenti), 94

San Zaccaria, *Mater Dolorosa* (copy), 117

Scuola di San Giovanni Evangelista (formerly), *St. John the Evangelist on Patmos* (Washington), 121, 137–138

Scuola di San Rocco, *Annunciation*, 70, Plate 58; *Christ Carrying the Cross*, 80, Plate 64; *Man of Sorrows*, 115, Plate 63

Scuola dei Sarti, *Madonna and Child with SS. Joseph, Barbara, and a Donor* (lost; as Giorgione or Titian), 114

Paolo del Sera (formerly), *Nativity*, 119

Camillo Sordi, *Christ and the Adulteress* (lost, Giorgione), 170

Monsignore Luigi Vason, *Mater Dolorosa* (copy), 117

Gabriel Vendramin (formerly), *Christ Mocked*, 84; *Dead Christ*, 171

Dal Zotto Collection, *St. Jerome* (variant), 134

Vercelli, Museo Borgogna, *Entombment* (copy), 90, Plate 79

Verona,

Casa Muselli (formerly), *St. Mary Magdalen in Penitence* (lost, perhaps later Hume, London), 151

Cathedral, *Assumption of the Virgin*, 76, Plates 43–45

Museo Civico, *Madonna and Child* (probably Francesco Vecellio), 176

Vicenza,

Palace of the Curia, frescoes by Titian (lost), 10 note 50

private collection (formerly), *Madonna and Child with SS. Dorothy and Jerome* (school of Titian), 175

Vienna,

Harrach Collection, *St. Sebastian* (copy), 156, Plate 237

Kunsthistorisches Museum, *Adoration of the Kings* (Venetian School), 68, Plate 233; *Adoration of the Shepherds* (Giorgionesque), 168; *Bravo*, 9; *Christ and the Adulteress*, 77, Plate 70; *Christ, Bust of*, 79; *Christ Before Pilate*, 26, 34, 79–80, Plates 90, 91; *Entombment*, 92, Plate 83; *Madonna and Child* ('Gipsy Madonna'), 8, 36, 98, Plates 1, 3; *Madonna of the Cherries*, 99, Plates 2, 4; *Madonna and Child with SS. Stephen, Jerome, and Maurice*, 114, Plate 16; *Madonna and Child* (variant, Andrea Schiavone), 105

Archduke Leopold Wilhelm (formerly), 3; *Adoration of the Kings* (Venetian School), 68, Plate 233; *Adoration of the Shepherds* (Giorgionesque), 168; *Christ and the Adulteress*, 77, Plate 70; *Christ, Bust of*, 79; *Christ before Pilate*, 80, Plates 90, 91; *Ecce Homo* (Sibiu) and *Mater Dolorosa* (lost), 87, Plates 98, 99; *Entombment*, 92, Plate 83; *Judith* (lost), 95; *Madonna and Child* ('Gipsy Madonna'), 98, Plates 1, 3; *Madonna and Child with St. Anthony Abbot and the Infant Baptist* (Florence), 104, Plate 10; *Madonna and Child with St. Dorothy* (possibly Philadelphia), 108, Plate 32; *Madonna and Child with St. John the Baptist and Male Donor* (Francesco Vecellio) (Munich), 177, Plate 207; *Madonna and Child with SS. Stephen, Jerome, and Maurice*, 114, Plate 16; *Mater Dolorosa*, 116, Plate 99; *Nativity* (lost), 119; *Resurrection* (Palma Vecchio), 177; *Rest on the Flight into Egypt* (Longleat), 125, Plate 7; *St. Catherine* (Venetian School), 130; *St. Mary Magdalen* (lost), 151; *Supper at Emmaus* (Paris), 179

Liechtenstein Collection (formerly), *St. Sebastian* (copy), 128

Dr. A. von Peez, *Mater Dolorosa* (copy), 117

private collection, *Salome* (copy), 159

private collection, *St. Jerome, Head of* (copy), 135

Villandry, Carvalho Collection, *Mater Dolorosa* (copy), 116, Plate 215

Wantage, Lockinge House, C. L. Loyd, *Last Supper* (copy), 97

Washington, National Gallery of Art, *Madonna and Child with the Infant Baptist* (Polidoro Lanzani), 176; *St. John the Evangelist on Patmos, Vision of*, 137–138, Plate 156

Wentworth Woodhouse, *Tribute Money* (copy), 165

Windsor Castle, *Madonna and Child* ('Gipsy Madonna') (copy by Teniers), 98

Yuste, San Jerónimo, Charles V's Collection (formerly), 86, 116, 166; *Trinity* (copy by Antonio Segura), 167

Zara, Santa Maria, *Mater Dolorosa* (copy), 117

Zurich, Guhl Collection (formerly), *Madonna and Child with St. Catherine and the Infant Baptist* (variant), 175